German Expressionism

GERMAN EXPRESSIONISM

Primitivism and Modernity

Jill Lloyd

1991
Yale University Press
New Haven & London

Preceding page shows detail of fig. 77, Karl Schmidt-Rottluff, *St John*.

Designed by Mary Carruthers
Set in Linotron Sabon by Best-set Typesetter Ltd., Hong Kong
Printed in Hong Kong by Kwong Fat Offset Printing Co., Ltd.

Library of Congress Cataloging-in-Publication Data

Lloyd, Jill.
 German expressionism: primitivism and modernity, Jill Lloyd
 p. cm.
 Includes bibliographical references (p.).
 ISBN 0-300-04373-2
 1. Expressionism (Art)—Germany—Themes, motives. 2. Primitivism in art—Germany. 3. Modernism (Art)—Germany. 4. Art, Modern—20th century—Germany. I. Title.
 N6868.5.E9L55 1990 90-31786
 709′.43′0904—dc20 CIP

Contents

Introduction vi

SECTION I ART AS LIFE/LIFE AS ART 1

1 Turning Away from History: The *Jugendstil* Renewal 3

2 The Expressionists' Redefinition of *Jugendstil* 13

3 The *Brücke* Studios: A Testing Ground for Primitivism 21

4 Primitivism in Public Places 50

5 Expressionist Wood Carving: Ideals of Authenticity 67

SECTION II PRIMITIVISM VERSUS MODERNITY: THE EXPRESSIONIST DILEMMA 83

6 Urban Exoticism in the Cabaret and Circus 85

7 The *Brücke* Bathers: Back to Nature 102

8 The Lure of the Metropolis 130

9 Emil Nolde and the Paradox of Primitivism 161

SECTION III THE POLITICS OF PRIMITIVISM 189

10 A South Seas Odyssey: Max Pechstein's Visionary Ideals 191

11 Emil Nolde's Critique of Colonialism 213

Notes 235

Bibliography 258

Acknowledgements and Photographic Credits 263

Index 265

Introduction

GERMAN EXPRESSIONISM was one of the splinter movements at the beginning of the twentieth century which took as its starting point the innovations in late nineteenth-century art and, within the space of a few years, spread like wildfire across Europe, changing the face of modern art.

The Expressionist movement began in 1905, when a group of young architecture students in Dresden founded the artists' association known as *die Brücke*. By 1912, another group, based in Munich and centred around the Russian artist, Vassily Kandinsky, founded the *Blaue Reiter* exhibiting society, which emerged as the second main wing of German Expressionism. By the end of the first decade of the century, a number of associations and societies in Germany were dedicated to the propagation of modern art. This trend had its roots in the late nineteenth century, when various regional Secession movements set themselves apart from the ruling academic art of the times. The New Secession, founded in 1910 in Berlin, and the Rhineland organization known as the *Sonderbund*, which staged its first exhibition that same year, provided a meeting ground for the various Expressionist groups and an opportunity to present their work, alongside their French and Italian contemporaries, in the context of international avant-gardism.

This drive towards internationalism took place in a political and social climate of gathering nationalist tensions, which erupted in the outbreak of world war in August 1914, a caesura which also marked the end of first-generation Expressionism. This book is less a narrative history of Expressionism than an attempt to uncover and analyse the forces that underlay the period of German and European history that led up to the First World War. The tendency to describe the genesis of modern art in this period as a separate and isolated history, characterized solely by its forward-looking initiatives and formulated in opposition to the conservative forces operating in society as a whole, needs to be redressed. In German Expressionism conflicts between backward- and forward-looking attitudes, between, for example, nationalist and internationalist aspirations, generated much of the internal energy of the movement. This is nowhere more clearly expressed than in the crucial, pivotal dichotomy between the Expressionists' primitivism and their modernity.

The speed and drama of modernization in Germany at the end of the nineteenth century meant that many of the dilemmas and contradictions that this involved showed up in sharp relief. Attempts were made early on to grasp and describe the conflicting positive *and* negative effects of modernity. The philosopher Georg Simmel, whose lectures were immensely popular in Berlin before 1914, was one of the main spokesmen of his times. He vividly described the Janus-faced associations of modernity that surfaced on every level of public and private consciousness during these years. In Simmel's monumental *Philosophie des Geldes* (1900; *The Philosophy*

of Money), he explored the workings of the capitalist economy as a metaphor for the psychological experiences of the modern world: by 'abstracting' or depersonalizing every aspect of our relations, money allowed simultaneously for greater freedom and greater loneliness. It acted as a liberating agent and yet involved, at the same time, alienation, reification, and inhuman rationalization. In *Facing up to Modernity* (1977), Peter Berger enlarged on Simmel's characterization of modernity:

> In the contemporary world this dynamic of modernization/countermodernization is readily visible. There continue to be aggressive ideologies of modernity, confidently asserting that the transformations of our age are the birth pangs of a better life for humanity... There also exist a variety of countermodern ideologies, both in the so-called advanced industrial societies (as in the countercultures and in segments of the ecology movement...) and in the countries where modernization is a more recent event (as in miscellaneous blends of neotraditionalism, nationalism, and indigenous modifications of the socialist vision).[1]

Berger's description of the modern era as a dualistic phenomenon containing its own mirror image, charts out a conceptual landscape whose broad sketchy features began to emerge in the Romantic age. All previous histories of primitivism have rightly located its beginnings in Romanticism; but conventional interpretations of the primitivist impulse in European culture as an imaginative *alternative* to the changes underway in the modern world fail to take on board the complex, dualistic character of modernity itself. Far from presenting simply imaginative counter-images, primitivism provided modern artists, as I hope to show, with a means of negotiating the internal paradox of modernity, of spanning between its positive and negative, its forward- and backward-looking tendencies. In the hands of the German Expressionists, primitivism became a nexus of contradictory currents, neither revolutionary nor conservative in exclusive terms, but potentially both of these things. In a positive sense, primitivism could be used to engage with the contradictions of modernity. But the danger of false reconciliation, of a retreat from the real complexities of history into lazy universalism, remained. Primitivism could be used as a critical tool to question the dominant values of Western bourgeois society – or as a panacea, a cure for all ills.

In his 1863 essay, *Le Peintre de la vie moderne*, Charles Baudelaire addressed these issues when he described how modern life consists of an ironic recognition of the dichotomy between primitivism and modernity. The artist Constantin Guys personified this dichotomy, appearing as the 'man-child', a sophisticated urban stroller who orders his experiences through intellect and memory, yet who possesses the freshness of vision of a convalescent or child: 'a genius for whom no edge of life is blunted'.[2] In the era of German Expressionism we find these same issues recurring in a very different climate. By 1905, Baudelaire's ironic optimism, which affirms man's ability to stay afloat the conflicts and contradictions of the modern world, no longer held true. In its place we find idealism – or despair. The pendulum of Expressionist emotion swings widely, and in between man walks on a narrow ledge, on a bridge or a tightrope, suspended between conflicting possibilities.

The life and art of Paul Gauguin are a more familiar starting point for histories of primitivism in modern art. In his essay on Gauguin in *Primitivism in 20th Century Art* (MoMA 1984), Kirk Varnedoe also suggested that modernist primitivism involves a network of contrasts and analogies between the modern world and the 'other', wherever this might be located in 'epoch, culture or psyche'.[3] But Varnedoe failed to explore the underlying historical and philosophical foundations of these relationships. In the MoMA exhibition, which attempted to chart the history of primitivism over a broad span of modern art, 'affinities' between the primitive and the modern were visualized as superficial formal similarities sliding glibly across the intervening space of historical difference. Varnedoe's insistence on the revolutionary impetus of modernism led him to make simplistic distinctions. He insisted on

locating Gauguin in relation to a progressive primitivism with a new psychological emphasis, 'free from biological and historical considerations'. He continued:

> It is important to locate Gauguin here, rather than only in a Romantic heritage, for the same period witnessed other forms of primitivism – folk movements with nationalist overtones – with more distinct ties to Romanticism and very different implications for the twentieth century... Primitivism before Gauguin had recurrently been joined with a progressive, reforming spirit. This pairing continues in a central strain of twentieth-century art, where the Primitive is held to be spiritually akin to the new man, and his forms commensurable with the look of the future.[4]

In essence, Varnedoe is not wrong. But his unitary and unproblematic understanding of modernism as a progressive force led him to present only one half of the equation. The anti-modernism of the National Socialists – perhaps surprisingly – had led to similar conclusions in 1937, when they attacked the Expressionists and other modern artists in the Degenerate Art Exhibition, accusing them of cultural Bolshevism and comparing their work to 'nigger daubings'. By so doing, they unwittingly confirmed the revolutionary potential of Expressionist art for post-war historians. In German twentieth-century art history we often operate according to these sad and truly primitive values. Emil Nolde, who joined the Danish section of the National Socialist Party as late as 1933, was nevertheless vilified alongside the other Expressionists in the Degenerate Art Exhibition. His was a special case, but he represents in an extreme form the paradoxes and contradictions at the heart of the Expressionist movement. The political ambivalence of Expressionism, which was frequently expressed in the dichotomy between primitivism and modernity, has rarely been confronted in previous histories of the movement. It is a central issue in this book.

Recognition of some of the internal divisions and contradictions of modernism surfaced in the famous debate about Expressionism between Ernst Bloch and Georg Lukács in *Das Wort* in 1938.[5] While Bloch saw Expressionist modernism as an oppositional force, Lukács insisted that, because of the Romantic individualism of the Expressionist world view, the artists unwittingly colluded in the 'ideological decay of the Imperialist bourgeoisie' and failed to affect anything more than a 'pseudo-critical, misleading abstract mythicizing form of Imperialist pseudo-opposition'.[6] Their 'use' of the art of non-European cultures was symptomatic. Bloch claimed that the Expressionists' interest in tribal and folk art showed that they wanted to create an art of and for the people. For him the primitivizing revival of folk art also involved a critique of consumerism:

> The countryman in the nineteenth century exchanged his painted wardrobe for a factory display cabinet, his old, brightly-painted glass for a coloured print and thought himself at the height of fashion. But it is unlikely that anyone will be misled into confusing these poisoned fruits of capitalism with genuine expressions of the people.[7]

Lukács considered Bloch's comments on popular art to have confused all the issues. 'Popular art', he wrote:

> does not imply an ideologically indiscriminate 'arty' appreciation of primitive products by connoisseurs... For if it did, any swank who collects stained glass or negro sculpture, any snob who celebrates insanity as the emancipation of mankind from the fetters of the mechanistic mind, could claim to be a champion of popular art.[8]

Bloch, he claimed, saw cultural heritage simply as 'a heap of lifeless objects in which one can rummage around at will, picking out whatever one happens to need at the moment. It is something to be taken apart and stuck together again in accordance with the exigencies of the moment.'[9]

In this exchange, Bloch and Lukács formulated a central question which must be posed in a critical examination of modernist primitivism. Could the inspiration the

Expressionists drew from non-European and folk art be used as a disruptive strategy to challenge the norms and values of European culture? Or was it, as Lukács suggests, merely an appropriative device, reaffirming precisely those values they set out to undermine? Despite the heroization of Expressionism in reaction to Nazi persecution, the relevance of these questions to an understanding of the political status of modernism continues to occupy us today.

In 1974, Peter Bürger's influential *Theorie der Avantgarde* made a new intervention in these ongoing debates by breaking with the Anglo-American tendency to describe modernism as a general, post-Romantic phenomenon, and proposing a more finely differentiated theory of bourgeois modernism and radical avant-gardism.[17] For Bürger, like Marcuse and Habermas, modernist art holds a precarious, ambivalent position in bourgeois society because of its isolation from the praxis of life. This characteristic of modernism, expressed most pertinently in its formalist, self-referential mode, repeats a more general dilemma of modernity in that its 'autonomy' invoves both freedom and isolation from society. Bürger accepts Marcuse's suggestion that all needs which cannot be satisfied in everyday bourgeois society are transferred to the realm of art. He continues:

> In bourgeois society art has a contradictory rôle: it projects the image of a better order and to that extent protests against the bad order that prevails. But by realizing the image of a better order in fiction, which is a semblance (*Schein*) only, it relieves the existing society of the pressure of those forces that make for change. They are assigned to confinement in an ideal sphere.[10]

The radical contribution of the avant-garde, in Bürger's theory, was its recognition of the challenge to its own 'stranded' social status. The crux of the avant-garde revolt was their ambition 'not to isolate themselves but to reintegrate themselves and their art into life'.[11] As Jochen Schulte-Sasse comments:

> Modernism may be understandable as an attack on traditional writing techniques, but the avant-garde can only be understood as an attack meant to alter the institutionalized commerce with art. The social rôles of the modernist and the avant-garde artist are thus radically different.[12]

Bürger refers primarily to Dada and Surrealism in his discussion of avant-garde practice. But his distinctions also help us to understand an earlier rupture in German modernism, between the late nineteenth-century Secessionists and the Expressionists. Expressionism, which in many ways occupies a transitional position in the history of modern art, also spans across Bürger's categories, relating to aspects of both. The roots of Expressionism in the decorative arts movement known as *Jugendstil*, guaranteed an engagement with the debates concerning art and life. The first section of my book, entitled *Art as Life/Life as Art*, shows how the volatile agent of the Expressionists' primitivism also lies at the heart of their ambivalent relation to the distinctions and turning points in Bürger's theory of modernism. Typically, in the 1920s, Otto Dix and Georg Grosz complained about the snobbish exclusivity of Expressionist art while continuing to deploy many of its thematic and stylistic modes.

Nothing could have been more painfully indicative of Expressionism's problematic place in conventional histories of modernism than the inadequacy of the German section of the MoMA Primitivism exhibition, which comprised some still-life paintings of exotic artefacts and badly placed sculptures. The organizer, William Rubin, accused *die Brücke* and Emil Nolde of simply 'quoting' non-European art in their still lifes – thus making a less significant contribution to the history of modernism than the *stylistic* integration of non-European 'influences' he finds in Cubism. The Germans' 'emotive misrepresentation' of the expressions and gestures they found in tribal art as signs of anxiety and anger was, he claims, mere ethnocentrism. His own formalist readings of tribal objects and the modernists' stylistic responses to such are, on the contrary, signs of a fruitful 'appropriation of

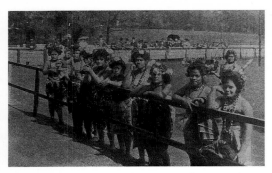

1. Samoans at the Hamburg Zoo. Photograph. *BIZ*, May 1910.

the art of other cultures'. Rubin concludes: 'Ours is the only society that has prized a whole spectrum of arts of distant and alien cultures. Its consequent appropriation of these arts has invested modernism with a particular vitality that is a product of cultural cross-fertilization.'[13]

In contrast to the political naïvety of Rubin's introduction, which failed to address the issue of power relations between Eurpoean and non-European societies, Donald Gordon's catalogue essay on Expressionist primitivism recognized the dichotomy between primitivism and modernity as the field in which Expressionist art operates, and he began a schematic historical analysis of this dilemma. Gordon's essay, like Ettlinger's pioneering article, 'German Expressionism and Primitive Art' (1968), and Britta Martensen-Larsen's more recent 'Primitive Kunst als Inspirationsquelle der Brücke' (1980), provided information and ideas of considerable value for my own study. All these authors are at pains to show that Expressionist primitivism involved more than the formal influence of tribal and folk art. But their concentration on dates of discovery and the tracing of more or less convincing 'exact' sources, distracts them from pursuing broader historical issues. In the case of Expressionist drawings after specific tribal artefacts or written references, I have done my best in this book to locate the objects concerned. Otherwise I have avoided source hunting entirely, in the spirit of Adorno's dislike for 'systems of metaphysical closure, which for reason of domination reduce differences or qualities to comparable identities and eliminate heterogeneity in favour of exchangeable homogeneity'.[14]

The Expressionists' visits to ethnographic museums in Dresden, Hamburg and Berlin, were not one-off voyages of discovery but rather an integral part of their working lives. Alongside these visits more popular sources of information – cabaret acts, circuses, illustrated weeklies and exotic presents from relatives and friends – played an equally important rôle. Commercial exhibitions and the popular *Welt-Panorama* and *Panoptikum* helped create an atmosphere in which far-off lands and cultures became relevant and available. The colonial and commercial *Völker-schauen*, usually staged in the zoological gardens before 1914, were a particularly important source for the Expressionists' romantic ideas about non-European peoples. In March 1910, Kirchner wrote to Heckel:

> The Ethnographic Museum (Dresden) is open again. Just a small part of it, but this is a real enjoyment and a refreshment – the famous Benin bronzes and some things by the Pueblos from Mexico are still exhibited and some negro sculptures... A circus is here again and in the zoo Samoans and Negroes are coming this summer.[15]

Kirchner slips easily in this passage from his description of the museum to the practice of importing natives from the colonies for their curiosity value (figs. 1 and 2). After the turn of the century, exotic 'exhibitions' in the Dresden zoo – which included an Indian village in 1905 and Sudanese, African and Samoan groups in 1909 and 1910, like the spectacular Wild West shows which visited the city in 1906 and 1907 – were a major popular attraction. It is important to stress these 'alternative' sources for *Brücke* primitivism because they bring us closer to the creative experiences of the artists. The Expressionists' ideas and responses to non-European art were partly shaped by romantic propaganda and their primitivism, which was an aspect of their ambitions after 1910 to forge a consciously modern German art in an international context, was also a response to the living fabric of experience in colonial Germany. In my final chapters on the South Seas journeys of Max Pechstein and Emil Nolde, I aim to provide a detailed discussion of their art in relation to the power structures of imperialism. Looked at this way, the Expressionists' primitivism is a fluid and transforming complex of responses to contemporary issues rather than a fixed and rigid phenomenon, depending on particular ethnographic sources as visual influences.

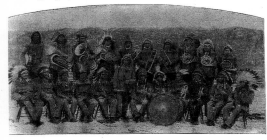

2. Red Indian Musicians on a European Tour. Photograph, *Dresdener Illustrierte*, August 1910.

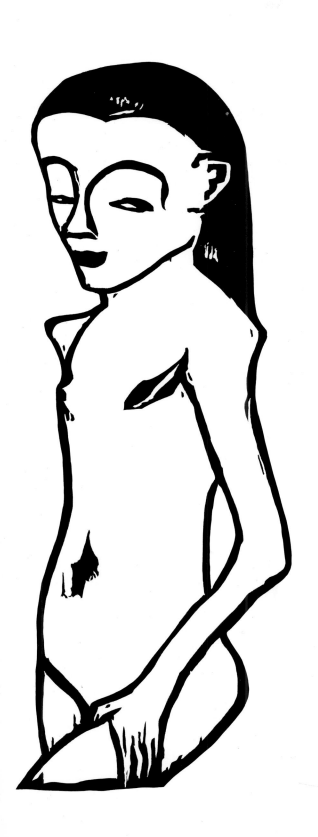

ART AS LIFE/
LIFE AS ART

1 Turning away from History: The *Jugendstil* Renewal

It was a lucky coincidence that real talents met, whose character and gifts in human terms too, left them no other choice than to become artists. Their life style, home and work, which for 'regular' people were unusual to say the least, did not involve a conscious 'épater les Bourgeois', rather the quite naïve and pure necessity to bring art and life into harmony. And it is this more than anything else that has had a great influence on the forms of contemporary art.

E.L. Kirchner, March 1923[1]

THE AMBITION of *die Brücke* to bring art and life into harmony relates, like many of their primitivist ideas, to attitudes and possibilities first charted out in Germany by the *Jugendstil* reform movement in the decorative arts at the turn of the century. Conventional histories of *die Brücke* have tended to treat their relation to *Jugendstil* and their primitivism in much the same way, concentrating on the early years in Dresden and proposing specific sources and exact dates of discovery.[2] Even more recent and complex histories of the group such as Georg Reinhardt's *Die frühe Brücke* (*The Early Brücke*) which explores more diffuse similarities and shared ideals, continue to search for exact visual sources rather than the various ways in which the widespread visual and aesthetic principles of *Jugendstil*, evident for example in new advertising styles, would have reached the young *Brücke* artists (fig.3).[3] Most important *Jugendstil* is viewed as a formative influence rather than a transforming set of principles that remained important to *die Brücke* throughout the years of their association from 1905–13. Martin Urban writes:

> The initial stylistic relations between Kirchner, Nolde, Pechstein, the Munich artists and *Jugendstil* didn't mean much, because they quickly overcame this influence and they despised all decorative accessories. They had their own ideas about a new art; they were a new generation who followed different, as yet unknown paths. They stepped out of the gold frame...[4]

Urban's distinction between the spirit of the two movements is important. But, as I hope to show, the principles underlying *Jugendstil*, such as anti-historicism, the cults of authenticity and renewal and the breakdown of traditional artistic hierarchies, were transformed in a general and particular way into Expressionist primitivism. The Expressionists' aim to equate art and life moved away, as Urban suggests, from *Jugendstil* ivory-tower aestheticism towards a new vitalism. At the same time, however, they found themselves lodged in a problematic zone between a private and a public world – affirming life but rejecting society.

(Preceding page) Detail of fig. 47

Primitivist Directions in Jugendstil *Theory*

The acceleration of German colonial expansion after 1896 coincided with developments in Western aesthetics and ethnology which encouraged *Jugendstil* artists to look towards non-European art for inspiration. In *Aperçus vue d'une synthèse d'art* (1895; Reflections on a Synthesis of Art), the Belgian *Jugendstil* architect Henry Van de Velde rejected the idea that a true union of art and life could be affected through the agency of artistic realism. He advocated instead the cultivation of decorative and applied arts and the projection of imaginative creation into three-dimensional space via the *Gesamtkunstwerk* or 'total work of art'.[5] This shift away from realism towards decoration and expression coincided with a changing evaluation of tribal art which lent credence to the *Jugendstil* challenge to nineteenth-century aesthetic norms. As Joseph Maschek remarks, the last two decades of the nineteenth century questioned the views expressed in Gottfried Semper's influential *Der Stil in den technischen und tektonischen Künsten* (1860). This proposed an evolutionary and materialist theory of art, beginning with simple utilitarian objects which were then decoratively elaborated and culminated in realism and representation.[6] Lord Avebury's separation of paleolithic and neolithic cultures meant that the distinction between prehistoric and surviving primitive peoples was being dispelled around 1890; most important, this shook the foundations of the evolutionary Semperian mode by introducing the notion that art had developed *from* paleolithic representation *to* neolithic ornamental abstraction rather than vice versa. Various strategies emerged in response to this new information; for example, the 'degeneration' theory, which proposed an evolution from realism to decoration brought about by generations of inefficient copying.

But there were also more positive interpretations in the air which related to Alois Riegl's relativist critique of Semper's absolute aesthetic theory. Riegl himself attacked traditional hierarchies by directing attention away from classical to late Roman art and by proposing a serious discussion of decorative rather than fine art traditions.[7] Ernst Grosse's *Die Anfänge der Kunst* (1894; *The Beginnings of Art*) adopted Riegl's terms and insisted that style could not be explained as craft ineptitude; on the contrary, 'it must be referred to will', and abstract and ornamental forms were thus seen as the result of a volition quite different in type to that seeking

por voluntad propia

representational and realistic images. Around the turn of the century this vein of argument began to cross with ideas about the expressive potential of tribal art which was often compared to caricature – a style actively revived in the *Jugendstil* periodicals. Edward Fuchs' *Die Karikatur der europäischen Völker*, (1901–3; *European Caricature*) sought to displace the authority of idealizing academic art in favour of the forceful immediacy of caricature with tribal art for corroboration:

> We shall find that caricature is to a certain extent the form from which all objective art originates. A single glance into the ethnographic museum gives proof of this...so too the uncivilized natives. A child makes his first attempts to draw exactly like the first artists of mankind, he extracts the distinctive features, he contrasts, he characterizes, he caricatures.[8]

Ernst Ludwig Kirchner, Erich Heckel, Max Pechstein and Emil Nolde all made caricature portraits during their early careers referring to *Jugendstil* precedents,[9] and in 1911 Nolde translated his caricatural mode into the series of *Mask Still Lifes*, depicting tribal masks. This transition is one we shall have to study in more detail; for now suffice it to say that the changing evaluation of tribal art at the turn of the century supported the *Jugendstil* concern with ornament as a result of psychological volition. This could easily be translated into early modernist theories concerning the expressive value of pure form.[10]

Despite the dissolution of straightforward evolutionary theories of artistic practice at the beginning of the century, before 1914 non-European societies were almost universally explained as the earliest stages of human development, a notion which persisted as a political factor to justify the ambitions of European colonial rule. This double-take on non-European societies was fundamentally necessary for a positive evaluation of 'primitive' culture, which was from the beginning a politically ambivalent phenomenon. From the point of view of *Jugendstil* theory, non-European art represented a challenge to artistic realism, which had degenerated into nineteenth-century academicism. As such it could be linked to their own reformative aims. At the same time the 'original', 'youthful' status of tribal societies in the European imagination was associated with aspirations for renewal and rebirth. In 1903 Hermann Obrist, one of the founders of the Debschitz-Obrist School of Fine and Decorative Art, which Kirchner attended for two semesters in 1903–4, explained his interest in non-European art and other examples of 'early' artistic activity:

> We have already seen that there is little reason to admire or to regret the passing of the architecture and works of art made in recent times, although much of this is beautiful. It is much better to imitate the creations of relatively primitive peoples – like the early Greeks and medieval artists, or to go even further back to the ancient Vikings or even the natives from the South Seas. But this doesn't mean that we should imitate their styles. Not at all. But we should create as they created – unconsciously, genuinely, simply, naturally, without thousands of stimuli and distractions.[11]

Obrist's interest lies on the level of creative impulse rather than visual influence, although elsewhere non-European decorative styles were also used as a stylistic model by *Jugendstil* artists.[12] 'Primitive' art is interpreted by Obrist, significantly, as an original and creative alternative to the worn academicism of the times. All ages preceding the Renaissance (excepting classical Greek art), in which realist skills were not considered a priority, could provide inspiration. Despite the persisting tendency to seek inspiration in the art of the past, primitivism was thus originally defined in contradistinction to academic historicism, which, as Nikolaus Pevsner points out, '...is the tendency to believe in the power of history that suffocates originality and replaces it by an activity that is inspired by the precedent of a particular period.'[13]

In the first issue of the Munich periodical *Jugend* in 1896, Julius Diez's comic spoof on Hans Makart's Viennese *Festive Procession* illustrated the scope of *Jugendstil* dissatisfaction with outworn nineteenth-century values (fig.4). Diez's beribboned and

4. Julius Diez, *The Triumphal March of Stupidity*, *Jugend*, 1896.

5. Wilhem Volz, *Persina*, *Jugend*, 1903.

6. Cover design, *Jugend*, 1903.

bedecked figures shuffle along carrying banners labelled 'academic art', 'aristocratic pride', 'vain dilettantes', 'philistines', 'beer sots', 'prudes', and they are all dressed up in sham historical costumes. As an alternative to the charade of historicism *Jugend* proposed, on the one hand, a direct and immediate relationship with nature, expressed visually in the pantheistic illustrations and botanical designs which filled its pages (fig.5). On the other hand *Jugend* illustrators embraced modern-life subjects – park, café and circus scenes – which were anti-historicist in their commitment to the here-and-now rather than the past (figs.6,7). *Jugend* was one of the periodicals read by *die Brücke* in Dresden when they were architectural students at the Technical University before 1905;[14] and, as we shall see, this dialogue between nature and modernity, between country and city, was of no mean significance for their art. In *Jugend*, country and city subjects were located in opposite geographic locations, but they were analogous in terms of the double-pronged attack on historicism.

Just as the positive evaluation of 'primitive' art and society as a regenerative force depended on a particular constellation of values which both attacked and reconfirmed evolutionary codes, so too the late nineteenth-century approach to modernity was complex and ambivalent. Although preoccupation with renewal and impatience with nineteenth-century historicism promoted an engagement with modernity, there was also a strong vein of nostalgia in *Jugendstil*, a longing for a 'lost' organic unity between art and life. From the time of his engagement with the *Jugendstil* periodicals *Dekorative Kunst* and *Pan* in the 1890s, Julius Meier-Graefe attacked the specialized and mechanized values of the new industrial age which he felt had ruptured the unity of art and society. He hoped to 'heal' this rift by promoting the decorative arts. In the introduction to his *Entwicklungsgeschichte der modernen Kunst* (1904; *Modern Art*) – also known to *die Brücke* during the early Dresden years[15] – Meier-Graefe discussed the conditions of alienation governing both the production and consumption of art in the modern world: the artist no longer knows for whom he is producing and art has been reduced to a commodity, an investment value in the hands of the modern collector. He opposes to these conditions a nostalgic vision of the past:

> Once the symbol of the holiest, diffusing reverence in the church and standing above mankind like the divinity itself, the picture has become the diversion of an idle moment; the church is now a booth in a fair; the worshippers of old are frivolous chatterers...[16]

Meier-Graefe advocated the cultivation of handiwork and craft traditions in the decorative arts as a means of forging a direct and meaningful relationship between art and society. In this way it might be possible to raise the taste and values of 'the folk' rather than lower art to suit 'the crowd'.[17]

During the 1890s Meier-Graefe had attended Georg Simmel's lectures in Berlin, and his ideas relate to Simmel's critique of modernity which we find most fully developed in his *Philosophie des Geldes*. Simmel, who had studied history, psychology, ethnology and philosophy, aimed to combine these various disciplines in his description of modernity. He believed that the emotive and subjective basis of 'primitive' and medieval societies had been replaced by the objective, quantifying and calculating spirit of modern times, and transformations in the money economy pointed towards more wide-ranging social and psychological change:

> ... In an underdeveloped or only slightly developed money economy the relatively narrow range of dependance of its members was of a much more specific personal nature. It was with such fixed, familiar, as it were irreplaceable people that the ancient Germanic peasant or the American Indian tribesman, the member of the Slav or Indian domestic community, indeed in many cases even medieval man, had relationships of economic dependency. The fewer interdepen-

dant functions are involved, the more permanent and significant were their representations...[18]

In the process of civilization, subjective and objective experience fall apart. In positive terms, Simmel sees this as the basis of all freedom, allowing man to view the world objectively; on the other hand, the 'objective' relationships of the modern world promote feelings of isolation and alienation: '...the work to order prevalent in the medieval crafts, which only in the last century divided coinsiderably, gave the consumer a personal connection with the commodity...subjectivity is bound to retreat into cool reserve and anonymity once a number of intermediate agencies spring up between the manufacturer and the customer, removing any personal contact between them'.[19] Moreover, the specialized activities of the modern world become:

> a self-contained ideal construct, so that people, no longer individually distinguishable, merely pass through the function...without being allowed to find in its narrowly circumscribed specialized demands scope for their whole personality. The personality which merely performs a funtion or occupies a position is as irrelevant as that of the occupant of a hotel room...[20]

But art practice held for Simmel a very special position in the 'objective' constellation of the modern world: it was the one area of modern experience which still testified to the emotive and subjective origins of mankind, and it avoided the alienating division between producer and product characteristic of divided labour:

> The autonomy of the work of art signifies that it expresses a subjective, spiritual unity. The work of art requires only one *single* person, but it requires him totally, right down to his innermost core. It rewards the person by its form, becoming that person's purest reflection and expression...Conversely, where the division of labour prevails, the achievement becomes incommensurable with the performer; the person can no longer find himself expressed in his work; its form becomes dissimilar to the subjective mind and appears only as a wholly specialized part of our being that is indifferent to the total unity of man.[21]

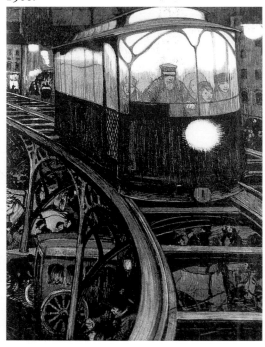

7. Adolf Münzer, *Electrical Railway, Jugend,* 1900.

For the new generation of architects, artists and designers who grew out of the *Jugendstil* movement in the first decade of the century, Simmel's double-edged engagement with modernity was particularly significant. For they sought a solution to the rupture between art and society, not in a rejection of modern historical reality, but rather in a combination of artistic and utilitarian values, by putting art at the service of industry. The 'subjective' and 'spiritual' associations of art practice were considered capable of healing the alienating and fragmented conditions of modern society by introducing a new authenticity into mechanized labour. And so a reform of industrial processes through craft was envisaged rather than any radical rethinking of the social basis of production; bourgeois commercialism was to be replaced by *volk* industrialism.

To chart this transformation in *Jugendstil* and the rôle non-European and medieval art played in this process, we must look more carefully at the work and ideas of Karl Ernst Osthaus. But before leaving Simmel it is important to note the immense influence of his thought and writings on the pre-war Expressionist generation.[22] In Simmel we find a pivot or a turning point because he charts out a sociology which still refers to an evolutionary schema and yet sees civilization and modernity as complex psychological phenomena, involving both gain and loss. Simmel has been described as an 'impressionist' philosopher, whose sharp sense of paradox and ability to view his subject from several angles simultaneously involved him in a web of relativist observations, amongst which his own point of view and political standpoint disappear from sight, like an invisible thread.[23] This comment is certainly not irrelevant to our study of the new relativist attitudes we shall find operating in Western primitivism. But in Simmel's case it applies to his description of modernity.

Much ink has been spilt concerning the date of the *Brücke* artists' first visits to the Dresden Ethnographic Museum.[24] As I plan to demonstrate, it is likely that Kirchner and Pechstein visited the collection before 1906, responding to discussion about non-European art in the decorative arts movement. But exclusive emphasis on this collection and the date of 'discovery' has provided a false picture of the artists' sources for a knowledge of non-European art and the spirit of their visits to ethnographic collections. These visits were in fact a continuing practice in Dresden, Hamburg and Berlin, and non-European art was made availabe to them in various ways – in magazines, in commercial exhibitions and even in cabaret acts. Kirchner had an extensive library including many ethnographic publications dating from the first decade of the century, although we do not know when these books were acquired.[25] One of the important early sources for their knowledge of non-European art was Karl Ernst Osthaus' Folkwang Museum in Hagen, where it was possible to view these artefacts in a *Jugendstil* context which was more sympathetic and relevant than the scientific arrangements in the ethnographic museums. The Folkwang Museum also offered Erich Heckel his first experience of Gauguin's paintings, including *Contes Barbares* (1902). In February 1907 Heckel wrote enthusiastically to Cuno Amiet, the new Swiss member of *die Brücke*, about his visit to the Folkwang: 'I've just seen the first Gauguins – wonderfully strong'.[26]

The history of the Folkwang Museum provides an example of the theoretical revaluation of non-European art in practice, and shows how this was linked to the reform movement in the decorative arts. Plans for the museum date back to 1896, when Osthaus inherited his grandparents' industrial fortune and dreamt of founding a natural sciences museum in his home town, Hagen, to demonstrate the wonder and unity of the natural world to a population condemned to live in the industrial Rhineland. At this stage, he was inspired by the *anti-modern* ideologies of the German nationalist movement and by Julius Langbehn's attack on urbanization in his notorious 'volkish' *Rembrandt als Erzieher* (1890; *Rembrandt as Educator*). Osthaus' first article, 'What is the reason for the alienation of our painting from the German folk?' (1894) complained about the lack of a specifically German culture in modern cities.

In 1898, Osthaus began to collect ethnographic and tourist art as 'racial documents' for his Folkwang Museum and he even briefly considered founding an Islamic museum. He employed the architect Carl Gérard to provide a historicist design in the imperial German style for the museum, and the building was already underway when Osthaus discovered an article by Meier-Graefe about Henri Van de Velde in *Dekorative Kunst*.[27] Osthaus' conversion to *Jugendstil* was sudden and dramatic: Van de Velde was engaged to design the museum interior, and when it opened to the public in July 1902 the non-European artefacts were displayed alongside Osthaus' growing collection of modern European art and design from an aesthetic rather than a scientific point of view, in order to guide contemporary production with an example of 'unalienated' objects.[28] Groupings were made according to techniques in order to inspire modern designers: in 1904, for example, Osthaus mounted an exhibition of Javanese, Japanese, Oriental and Indian textiles alongside fabrics prepared by the Hagen textile industry after designs by Peter Behrens. In his foreword to the first catalogue of the collection in 1912, Ostaus complained that, 'cultural development in the Rhineland hasn't kept in step with economic growth', and he described his ambition to 'permeate the whole of life with rhythm and beauty.'[29] In an undated manuscript of *c*.1914, Osthaus discussed the rôle of non-European art in his collection:

We had already seen that the museum's collection of old decorative art in particular provided a model for contemporary artistic creation. In this respect, the rarity and scientific value of the individual objects are not so much emphasized

(although this too is not inconsiderable in many instances), as their artistic, inspirational worth. The first rule of this collection is quality. In accordance with this law, the art of all periods and all areas of the world is displayed in an exemplary selection.[30]

refraise

Rather than retreating from the modern industrial world into aesthetic isolation, Osthaus now held fast to his belief that the revival of craft traditions could be used to resuscitate art and design in the industrial age. Various activities sponsored by Osthaus promoted these ambitions: in 1909 he founded the travelling German Museum for Commerce and Trade and, in 1910, the West German Federation for Applied Art (known as the 'Guild') to encourage big businesses and decorative art firms in the Rhineland to employ younger artists and designers and to promote artists' designs at large international exhibitions. Eventually the idea was to attract a strong group of artists active in the decorative and applied arts to leave the conventional artistic centres of Berlin, Munich and Dresden and to take up residence in the Rhineland, which, 'with its garland of flourshing towns, offers the material prerequisites for a brilliant development of decorative art'.[31] In 1906 Emil Nolde briefly joined the circle of artists and designers in Soest sponsored by Osthaus, and a letter from Kirchner in 1912 which refers to the possibility of the *Brücke* artists moving to Cologne must also refer to Osthaus' plans.[32] This year Osthaus invited Kirchner to design a stone relief for one of the houses in Hagen designed by the architect Lauweriks, and both Kirchner and Karl Schmidt-Rottluff contributed items to the applied arts section of the 1912 *Sonderbund* which was a major international exhibition of contemporary avant-garde art. Schmidt-Rottluff even sat on the working committee of the Guild on this occasion, together with the *Blaue Reiter* artist August Macke.[33]

After 1910 Osthaus' sponsorship of fine artists for decorative projects stimulated both camps of the Expressionist avant-garde to begin or to resume activity in this field. The 1960 Schleswig-Holstein exhibition devoted to decorative works by *Brücke* artists emphasized the private and intimate nature of their decorative works, but there was in fact a public context for their activity inspired by Osthaus.[34]

One little-treated episode in the *Brücke* artists' Berlin period, the so-called MUIM Institut (Institute for Modern Instruction in painting),[35] demonstrates their involvement with the decorative arts after 1910. Kirchner and Pechstein opened this art school in Berlin-Wilmersdorf, Durlacherstraße 14, in the hope of alleviating their financial hardships. This was indeed a common strategy, and in 1909 a similar enterprise had already been operating from these premises advertised as the Berlin-Wilmersdorf Private School for Decorative Art, offering instruction in 'architecture, decorative painting, artistic handwork, graphic design, ornamental writing, modelling, fashion design, studies of head and nude, lectures, criticism'.[36] The MUIM project, founded in November 1911,[37] also included a range of decorative and fine-art practices, drawing on the classic *Jugendstil* model of the Debrist-Obrist School in Munich where Kirchner studied.[38] A 1911 advertisement outlines their plans:

Modern instruction in painting, graphic design, sculpture, rug design, glass and metal work, painting in architectural contexts. Instruction with new means in a new spirit. Life drawing in relation to composition... In the summer, sketching at the sea-side. Correction is adapted to individual needs and talents. Contemporary life is the point of departure for creation. Conversation provides access to the new art movements. Introduction to understanding and inspiration by means of observation and experience (also for non-practioners).[39]

The MUIM project was not a success and only attracted two pupils, Hans Gewecke and Werner Gothein, who allied themselves closely to Kirchner. But the plan shows how the identity of *die Brücke* in 1911 referred equally to their activities in the fine and decorative arts. A letter from Erich Heckel to Gustav Schiefler in July

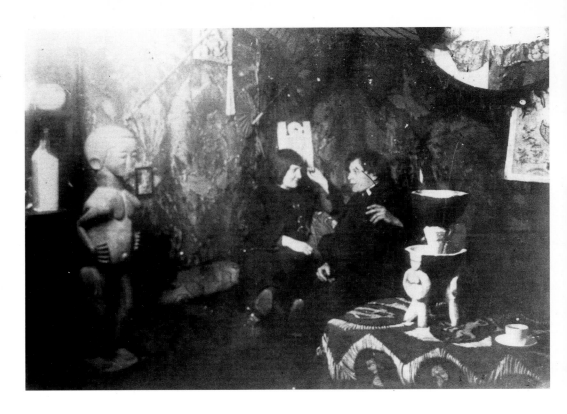

1914 explained how a new union of these two branches of artistic activity, which he describes as painterly handwork, was meant to combat 'the dreadful old academic traditions'.[40] In the photographs of Kirchner and his girlfriend Erna in the MUIM atelier (fig.8), we see that non-European art was used as an alternative to the sterile traditions of the academy and as a model for decorative art. This photograph shows them seated in an exotic bohemian studio under Japanese sunshades flanked by hangings, embroidery inspired by coptic art and wooden carvings. The Buddhist figure on the wall behind their heads is a copy by Kirchner after an illustration in John Griffith's book on Ajanta cave-temples (fig.9),[41] and the two-tiered bowl and large standing wooden figure are strongly Africanized. In fact the carved figure is a pastiche of an African sculpture with hybrid features, quite unlike Kirchner's other contemporary sculptures which are far less directly indebted to African models. Dominating the studio space, this figure replaces the traditional academic plaster cast, proclaiming the virtue of direct handcraft rather than intellectual copying and replacing classical ideals with 'primitive' inspiration.[42]

Before turning to look in more detail at the beginnings of *die Brücke* in Dresden, two more aspects of Osthaus' display of non-European art at the Folkwang Museum should be mentioned. Before 1912 Osthaus specialized in Far and Near Eastern art, purchasing his collection from a variety of sources across Europe, including dealers and museums; indeed his activities provide a facinating review of the outlets for non-European art before 1914.[43] By 1902 there were some African decorative objects in the collection, but he did not purchase African sculpture until 1912, from Karl Brummer and Paul Guillaume in Paris, and then, in 1914, from J.F.G. Umlauff's Ethnographic Institute in Hamburg, where he acquired a major collection of African pieces from a Frobenius expedition to West Africa. These entered the museum in April that year.[44] But the transition from Eastern to tribal objects was not clear cut, and he continued to purchase Oriental art from these same dealers. His first exhibition of the Frobenius collection, which was described as 'exotic' art, was in the context of a more general show including Japanese and Egyptian artefacts. Often in histories of Western primitivism habits of evolutionary thinking make claims for a 'progression' from Oriental to tribal art, but the real situation was more

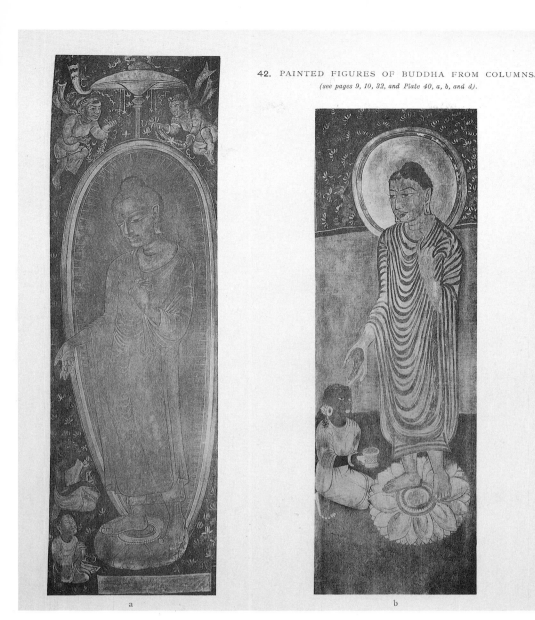

AJANTÂ.
CAVE X.

a b d

9. Painted Buddha, Ajanta Cave X, plate 42 in John Griffiths, *The Paintings in the Buddhist Cave-Temples of Ajanta Khandesh, India.*, vol. 1, London 1896.

fluid and complex. We shall see this overlap between Eastern exotic and tribal art recurring as an important aspect of Expressionist primitivism.

In fact, a progressive or evolutionary evaluation of non-European art would have been contrary to the spirit of Osthaus' collection. His manuscript guide of *c.*1914 makes clear that 'historical' organization and distinctions between fine and decorative art were avoided. On the upper floor alone, a kaleidescope of styles and periods were presented, ranging from Buddhist art and early Christian ceramics to Gauguin, Cézanne and Le Fauconnier. In another room we find paintings by Gauguin and Emil Bernard, a temple painting from Bali, sculptures from Egypt, Korea and Ceylon, a Romanesque St John from Bavaria, Matisse, Nolde, Kokoschka, Kandinsky and 'negro' sculptures from the Congo. Just like the *Blaue Reiter Almanach* (1912), which illustrated works of non-European art alongside the Expressionist avant-garde, Osthaus aimed at a synthetic, ahistorical presentation, according to standards of artistic quality. Although dissatisfaction with academic historicism at the turn of the century prompted the initial response to non-European art, ahistorical and formalist principles were partly a *result* of such juxtapositions of tribal and modern art. Because the non-European objects were prised out of their original

contexts and set adrift as artistic objects, some organizational principle had to be found to make sense of them. The search for an alternative to the evolutionary and scientific modes of nineteenth-century positivism resulted in an ahistorical and aesthetic reading of the objects which then became available for readings of modern European art. In this sense primitivism and modernism stand in a reciprocal rather than causal relationship at the beginning of the modern period.

It is this shift which we see in action in the organization of the Folkwang Museum. Osthaus presented his collection in 1914 as a relativist challenge to the absolute standards of classical beauty and realism which had dominated nineteenth-century aesthetics, as 'an extension of our horizons beyond the boundaries of European art which rids us of European classical prejudices'.[45] In fact, the descriptions of the Folkwang Museum before 1914 suggest a strange hybrid of Victorian and modernist values; a jamboree of styles and periods which re-presents historicist eclecticism in a primitivist mode, which inverts rather than truly subverts nineteenth-century object fetishism inspired by mass production. These grey areas in Osthaus' thought and practice, which look both forwards and backwards, were to play a significant rôle in the history of Expressionism. After 1910, he encouraged *die Brücke* and Nolde to formulate a distinctive national style in the context of European avant-gardism and to become involved in the reform of industrial production through art and craft. These were potentially problematic and contradictory aspirations. But before we address these problems we must look first at the roots of the *Brücke* group's relation to *Jugendstil* theory and practice in the Dresden years, and at their transformation of *Jugendstil* principles into a primitivist mode in the private, bohemian and 'alternative' space of the artist's studio.

2 The Expressionists' Redefinition of *Jugendstil*

THE *BRÜCKE* artists' sympathy with *Jugendstil* arose from their early training. Before 1905, Fritz Bleyl, Heckel, Kirchner and Schmidt-Rottluff all studied at the Technical University in Dresden, where they came into contact with several important figures in the decorative arts reform movement. In his memoirs, Bleyl, who pursued a career in architectural decoration after leaving *die Brücke* in 1907, records the particular impact of Fritz Schumacher, professor for structural engineering and head of interior design and drawing at the Technical University, in whose drawing classes he and Kirchner first met.[1] In 1905, Heckel sketched after Grünewald's *Pietà* in Aschaffenburg during a summer excursion organized by Schumacher.[2] Schumacher's own memoirs describe the conditions in the drawing studio in Dresden on his arrival, crowded as it was with dirty plaster casts, not of genuine classical sculpture but rather of historicist imitations dating from the turn of the century. In the midst of this he found a group of eager young students, including Bleyl and Kirchner, 'who had heard about the awakening of decorative art'. In an attempt to bring new life to the dusty drawing classes, Schumacher dispensed with the plaster casts and replaced them with, 'genuine medieval architectural sculpture...Ornamentation was brought into closer contact with life via the example of old carved wooden frames dating from the Renaissance and Baroque ages which I obtained from Munich...'.[3] This insistence on replacing copies, both in terms of style and technique, with what he thought to be *authentic* fragments of hand-carved and modelled decoration, reveals certain priorities we shall find recurring in *die Brücke*. In their MUIM atelier similar principles taken one stage further resulted in their own hand-carved Africanized sculpture which substituted for the academic plaster cast.

Bleyl's memoirs claim that Schumacher was trying to break free from stylized architecture and to encourage in his students and himself 'more liberated creation ...after overcoming *Jugenstil*'.[4] Schumacher was also at the centre of the debates about modern interior design that culminated in the Third German Decorative Arts Exhibition in 1906. This exhibition brought together all the leading figures in the decorative arts in Dresden who acted as formative influences on the *Brücke* artists: Otto Gussmann (1869–1925), professor for murals at the Dresden Academy, under whom Pechstein worked from 1902–6 and who became a non-active member of *die Brücke*, acted together with Gotthardt Kuehl (1850–1915) as general director of the exhibition buildings. Wilhelm Kreis (1873–1955), professor for interior decoration at the Dresden School of Decorative Arts, under whom Pechstein studied before moving to Gussmann, and in whose private architectural practice Heckel was employed as a technical draftsman from 1905–7, was responsible for the house displaying local Sachsen decorations in the 1906 exhibition. It was indeed the

10. Max Pechstein, *Altarpiece*, 1906. Destroyed. Photo archive Dr Günter Krüger, Berlin.

subject of interior decoration, which engaged all these professors, that proved to be of lasting significance for *die Brücke*. In Kirchner's *Chronik der Brücke* (1913), his description of his own and Heckel's ambition, 'to bring the new painting into harmony with interior space',[5] refers back to the principles stressed by Schumacher and Gussmann in their discussions about interior design, where they particularly emphasised the agreement of part and whole in the orchestration of an interior.[6] Their practical interpretation of Max Klinger's exposition of the *Gesamtkunstwerk* was particularly important – a notion which the artists of the *Blaue Reiter* group were to explore in a much more abstract way, involving the interaction of different art forms.[7] For *die Brücke* the *Gesamtkunstwerk* remained a practical, tangible hypothesis, most fully realized in their studio decorations, which extended and transformed the principles of their early training. As late as 1922, when Heckel was working on the Anger Museum murals in Erfurt, he wrote to Schumacher, 'that I must often think when working on this project about my Dresden designs and about the laws of interior space they involved'.[8]

In August 1906, a review of the Dresden Decorative Arts Exhibition in the magazine *Kunstwart*, described the changes underway in the realm of design in terms of a new sense of 'reality in relation to functional expediency and truth to materials': this was replacing the, 'formal/aesthetic' priorities of *Jugendstil* or Secession Style.[9] Despite the new practicality which began to enter the decorative arts movement, and which we have seen operating in Osthaus' ambitions to reform rather than replace industrial production by craft activity, many of the idealistic philosophical principles of *Jugendstil* persisted in the era of the *Werkbund* association for decorative arts and later in the Weimar Bauhaus. Most important was the notion that the 'spiritual' and subjective basis of art production could reform the materialistic and commercial foundations of industry; hence the persistence of religious installations in all the major design exhibitions before 1914. In the *Kunstwart* review of the 1906 Dresden exhibition, special praise was reserved for a model cemetery, which directs public attention to an area where 'the soulless industralism of our times perhaps celebrates the most shameful orgies'. Alongside the new aesthetics of functionalism that emerged at the Cologne *Werkbund* exhibition in 1914, large sections were devoted to the Evangelical and Catholic churches where the Expressionists contributed works. The 1906 Dresden exhibition displayed the first clear signs of this inner tension between materialism and spirituality which was to have far-reaching consequences for the modern movement, and which we shall find deeply written into the theory and practice of Expressionism.

Both Heckel and Pechstein were directly involved in the 1906 exhibition, where they worked jointly on the Sachsen House. Alongside an altarpiece which Pechstein made for the exhibition (fig.10), he executed two ceiling-paintings for this house, a mother and child, for which he received a silver medal, and a bed of tulips for the Hans Kühne room, where he also designed a tiled niche for a fountain. Heckel, whom Wilhelm Kreis had commissioned to design the exhibition space for paintings, met Pechstein here and commiserated with him about the toning down of the colours of his tulip painting, which was considered too assertive. The two young artists recognized their mutual 'impulse to break free...from the...reigning artistic philistinism', and it is at this point that Pechstein's memoirs first mention his knowledge of the carved and painted beams from Palau in the Dresden Ethnographic Museum (fig.34). He made an analogy between his own ceiling painting and the beams by comparing their effect to a blazing field of sunflowers or tulips.[10] Indeed, in contemporary reviews of the exhibition, mention was made of Peter Behrens' use of 'primitive' stimuli for innovations in interior design, which had been inspired by his knowledge of the Folkwang collection. Ernst Zimmerman's not altogether favourable account of Behrens' room nevertheless saw in this the seeds of a truly new movement:

Only Peter Behrens really attempted a renewal of mural decoration. Of less

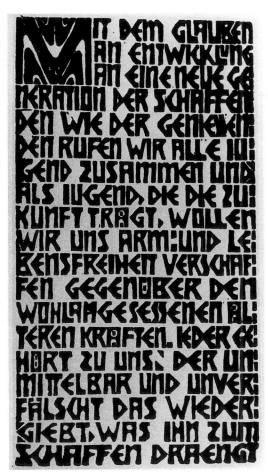

11. E.L. Kirchner, *Programm der Brücke*, 1906,
Woodcut, 15 × 7.4cm. Brücke-Museum, Berlin.

importance is his return to the most simple and primitive wall painting conceivable in his large music room – especially as the pure geometric ornamentation he uses here shows all too little of that heavenly gift which we usually call imagination... But the true artist will find in these innovations a new way of freeing artistic conception.[11]

It was here that the young artists discovered a thick volume with photographs of modern art including Gauguin and Van Gogh.[12] The 1906 exhibition had long-term effects for the history of *die Brücke* and Heckel established contact with Max Seifert, who visited the Sachsen House and commissioned Kreis to design a new showroom for his lighting factory where *die Brücke* held their first Dresden exhibition in September 1906. Seifert, who frequently commissioned artists to design his light-fittings, also became the first non-active member of *die Brücke*. His factory, located in the workers' suburb of Dresden-Lobtau, was hung with high quality *Jugendstil* light-fittings, and it was in this context that *die Brücke* paintings and graphics were first aired in a Dresden group show.[13]

In the existing literature on *die Brücke*, connections between their training in the decorative arts and their emerging primitivism have been made in several instances. Ettlinger, for example, cites a 1903 article in the English arts and crafts magazine *The Studio* (which Bleyl claims they knew in the Dresden years)[14] by Praetorius on the art of New Guinea, as a possible source for their knowledge of non-European art. Ettlinger suggests that it was the descriptive spirit of the article that made an impact, and he points out a similarity in wording between Praetorius' article and the *Programm der Brücke* (fig.11), which Kirchner carved to accompany the Seifert exhibition. Ignorant of the roots of tribal art in highly organized conventions, Praetorius wrote: 'There can be no doubt that the Papuans of former days produced their artistic work from natural desire or instinct, not acquired by the influence of seeing the works of others'.[15] In turn, Kirchner described the *Brücke* artists' own aspirations in similar terms: '...each one belongs to our ranks who directly and honestly renders that which inspires him to create'.[16] It is unlikely that Kirchner would have read English, and Ettlinger's attempt to pin the *Jugendstil* influence down to a single article is typical of a misplaced attempt at art historical accuracy. Praetorius' description of New Guinea art is symptomatic of the changing evaluation of non-European art which appealed to *Jugendstil* aesthetics, and his sentiments are similar to those expressed by Obrist with whom Kirchner was in direct contact in 1903.[17] *The Studio* like the other *Jugendstil* periodicals Bleyl mentions as early reading matter, such as *Jugend* and Avenarius' *Kunstwart*, all contained references to non-European art during the early 1900s.[18] The earliest signs of a visual influence of tribal art in Kirchner's work could well refer to drawings of non-European decoration that appear in these journals;[19] and it is impossible to tell whether the decorative borders in brush and ink in Kirchner's illustrations to *The Arabian Nights*, or the ornamental letter 'M' at the beginning of his *Programm der Brücke*, refer to tribal or *Jugendstil* models.

In Fritz Schumacher's memoirs of the early Dresden period, written like so many of the documentary sources years after the events described, he does recall an incident which suggests that Kirchner had already absorbed the primitivist spirit of *Jugendstil* aesthetics before the completion of his architectural studies in 1904:

> One day he [Kirchner] turned up in my office and spread out a folio of coloured drawings for a quite extravagent modern interior and told me this was his doctoral thesis. He asked me to perform the necessary formalities so that he could assume his title. I had to inform him that the doctoral examination required scholarly research rather than an artistic sketch, which displeased him, I think. He made it clear that the civilized world only had disappointments in store and it was only with primitive people that some form of recovery could be found. I thought of Gauguin. He took this all so seriously that I certainly expected immediate departure from Europe when he left.[20]

In the course of time, Schumacher's story has taken on a legendary guise. But Kirchner's plans for an extravagent decorative interior and his opposition of an intuitive 'primitive' lifestyle to the bourgeois belief in education and learning, give a new bohemian twist to common themes in *Jugendstil* aesthetics, predicting his own primitivist practices in the *Brücke* studios. It is quite possible that both Kirchner and Pechstein, inspired by the discussion about non-European art in the decorative arts movement, made early visits between 1904 and 1906 to the Dresden Zoological and Anthropological-Ethnographic Museum. This was located in the Zwinger Museum, only a short walk from their early lodgings in the American quarter and in Dresden-Friedrichstadt, and entry was free.[21] But in both their cases, these possible early visits would have been made in the reformative spirit of *Jugendstil* primitivism and did not involve direct visual influence. In order to explore the broad-based primitivist attitudes growing out of *Jugendstil*, which predated their direct responses to non-European artefacts, we need to look in more detail at the organizational principles of *die Brücke*.

The Organization and Connotations of Die Brücke

In his thesis on the early Brücke years, Georg Reinhardt published a drawing which records the union of *die Brücke*, on 7 June 1905.[22] The artists' correspondence during this initial period of communal work helps us to reconstruct the organization and aspirations of the group. In January 1906, following Emil Nolde's exhibition at the Gallery Arnold in Dresden, Schmidt-Rottluff wrote to him inviting him to join *die Brücke*: 'Moreover, the group arranges each year several exhibitions, which tour in Germany, in order to relieve the individual members of these business concerns. A further aim is the creation or an exhibition space – an ideal at the moment as we don't have the money.'[23] In September 1906 Heckel sent a letter of invitation to the Swiss artist Amiet, explaining the system of active and non-active members. The artists were intent on exhibiting, 'how and what we please, without art gallery selection...we want to offer the folk in our portfolios a chance of artistic enjoyment.'[24] In October he continued: 'The *Brücke* subscription is 1 mark monthly or 12 marks yearly. We arrange exhibitions and I hope, dear Herr Amiet, you will lend us some of your own works for his purpose. 10% is deducted from sales which the *Brücke* arrange. Otherwise there is complete freedom.'[25] Consequently the main function of *die Brücke* was to set up an exhibition and sales organization, led by Erich Heckel, which relieved the individual members of financial and organizational problems. By touring their own exhibitions, they hoped to avoid outside pressure from art dealers, and eventually to bypass this altogether by creating their own exhibition space – an ambition which extended to the Berlin years. They also avoided the intrusion of dealers or middle-men by sending a yearly graphics portfolio directly to their active and non-active members. Previously it has been suggested that only the non-active members paid a subscription, in return for which the artists prepared the graphics portfolio. But a letter from Schmidt-Rottluff to Amiet in 1908 confirms the suggestion in Heckel's second letter that the group was run on a co-operative basis, with each member contributing his share. The costs of sending work individually to the 1909 *Salon des Indépendants* in Paris meant that the active members were to be excused from paying their *Brücke* fees for that year, although these exhibiting plans were eventually cancelled.[26]

From the beginning, the *Brücke* organization involved a potentially contradictory mixture of idealism and pragmatism. The thrust of their arrangements was to avoid the alienating rift which the art market had driven between the artist and his public, to ensure greater freedom and self-determination, and to forge a relationship of mutual responsibility expressed in the co-operative organization of the group. But at the same time they pursued an active and ambitious exhibitions policy to promote

their art in dealers' galleries which, during the Berlin years, led them increasingly further away from their original ideals and inevitably involved negotiations and compromises with the conventional structures of the art world.

There are several precedents in the late nineteenth century to inspire the foundation of just such an organization. In Meier-Graefe's *Entwicklungsgeschichte der modernen Kunst*, he speaks of the Van Gogh brothers' desire to found a society to exhibit the best works of modern artists at home and abroad,[27] and the international artists organization *Les Tendances nouvelles* had worked along these lines since 1904.[28] In 1870, Friedrich Nietzsche had conceived of a brotherhood of intellectuals dedicated to a life of contemplation and art as an alternative to modern society,[29] and August Strindberg had tried to put this Nietzschean concept into operation during the 1890s. In *The Cloister* he describes his efforts to found,

> a non-confessional monastery of intellectuals who, at a time when industry and finance had pushed themselves so much to the fore, could not feel at home in the atmosphere of materialism which they themselves had been misled into preaching...the aim of the this monastery was to be the training of supermen by means of asceticism, meditation, and the practice of science, literature and art'.[30]

In the Chemnitz literary club Vulkan, which Heckel and Schmidt-Rottluff attended around 1901, Nietzsche and the Scandinavian authors Ibsen and Strindberg were read avidly.[31] But their own full-blooded bohemian interpretation of these ideas in the *Brücke* studios, and the practical organization of their group as an ambitious exhibiting society, represented a transformation of a late nineteenth-century theme — rather like the new practical emphasis in the decorative arts movement after 1906, which moved away from the ivory-tower aestheticism of *Jugendstil* while retaining many of its philosophical premises.

Related themes, which draw on the ideas of Meier-Graefe and Georg Simmel we have already discussed, recur in the decorative arts journals before 1914. In *Deutsche Kunst und Dekoration* (1911/12) an article by Georg Swarzenski shows how these ideas filtered through to a more immediate discussion of the state of the contemporary art market:

> In ancient cultures the artist worked for a small circle of people who were traditionally committed to the arts and encouraged understanding of them. Today he works for a broad unspecified crowd in which perhaps a general receptivity slumbers, but who are incapable of developing a decisive sense of quality and of subjective and objective achievement. This unhappy situation is also mirrored in the commercial position of art. Artists and the public have never been so isolated from each other as they are today — and the average work of art has never been so marked by the imprint of mass production.[32]

In another magazine, the *Werkstatt der Kunst* (in 1913), the writer Dr Halbe suggested some positive tactics for artists' organizations to counteract this state of affairs and these accord closely with the initiative already taken by *die Brücke* in 1905.[33] Halbe encouraged artists to unite on a broad and flexible front, concentrating on the presentation of their work rather than manifestos and principles which would promote splinter groups and factions. He advocated the foundation of co-operative societies rather than limited companies as the latter required high amounts of capital investment and this criteria for membership would let in unwelcome, exploitative elements. Above all artists should avoid dealers intent on their own profits, and encourage instead art critics, art historians and businessmen. The model for such an organization should be the *Arbeitergemeinschaft*, a workers' co-operative with low contributions from a broad spectrum of society, which could be paid in instalments. This money should be used to buy materials, to protect publication rights and to found publishing companies and exhibiting facilities. Halbe also advocated travelling exhibitions, like those *die Brücke* organized. Their own membership list, which included sixty-eight non-active members in 1910,

shows a mixture of professionals, businessmen and intellectuals – but it included none of the art dealers with whom they had been actively co-operating since 1905.[34]

In 1913, Kirchner's attempt to produce a manifesto, the *Chronik der Brücke*, did indeed polarize the individual members and prompt the dissolution of the group. Their more flexible and open-ended aspiration in 1906 'to attract all revolutionary and fermenting elements'[35] and to promote 'a forward-driving art uninhibited by convention'[36] was elaborated in Kirchner's *Programm der Brücke*: 'With belief in the development of a new generation of creators and a new audience we call together the youth of today. And, as youths who carry the seed of the future, we want to create for ourselves room to move and to live in opposition to the comfortable, established forces.'[37] Reinhardt has remarked on the similarity of this statement to certain *Jugendstil* precedents, particularly the opening comments by Max Burckhardt and Hermann Bahr in the first volume of *Ver Sacrum*, which called on 'the spirit of youth, which is animated by the breeze of Spring, through which the present is always transformed into 'modernity – the driving force behind artistic creation'.[38] In this case, the same aspirations for rebirth and renewal which directed *Jugendstil* aestheticians towards the inspiration of non-European and 'primitive' art leads them to embrace modernity; both are associated with the regenerative and creative forces of youth which – and we shall have cause to return to this – aspires towards the future. This testifies to the Nietzschean spirit of *Ver Sacrum*. In *Also sprach Zarathustra* 'Thus Spoke Zarathustra', the child is described as a new beginning: 'The child is innocence and forgetfulness, a new beginning, a sport, a self-propelling wheel, a first motion, a sacred "yes".'[39]

The inspiration of Nietzsche's *Zarathustra* during the early *Brücke* years has often been discussed,[40] and the name of the group is generally thought to refer to a passage in Zarathustra's prologue:

> Man is a rope, fastened between animal and Superman – a rope over an abyss. A dangerous going-across, a dangerous wayfaring, a dangerous looking-back, a dangerous shuddering and staying still. What is great in man is that he is a bridge and not a goal; what can be loved in man is that he is a going-across and a down-going.[41]

The significance of the group name *Brücke* has been interpreted in several ways.[42] Leopold Reidemeister suggested that it refers to a bridge between artist and public affected by the constitution of the group with its active and non-active members, thus playing the 'healing' rôle in modern society that Meier-Graefe had ascribed to the decorative arts. Reinhardt, referring to a 1905 woodcut by Kirchner depicting figures and a bridge which was probably intended as an early group insignia (fig.12), writes that the near shore represents the conservative and conventional elements associated with bourgeois and academic traditions, while the far shore signifies the renewal of art and life towards which *die Brücke* strove.[43] But the central motif in this woodcut is the bridge itself, and in Nietzsche's text the emphasis is on the *process* of transformation, the halting and precarious position of man caught between two states, looking backwards and forwards. In many ways this was a position in which man had been stranded by Darwin's attack on his holy and biblical origins. In Zarathustra's prologue Nietzsche writes:

> Could it be possible! This old saint has not yet heard in his forest that God is dead!... All creatures hitherto have created something beyond themselves and do you want to be the ebb of this great tide rather than overcoming man?... Once you were apes, and even now man is more of an ape than any ape...[44]

Nietzsche's philosophy as a whole spans between the aspiration to transcend the human condition and the danger of slipping backwards into a state of barbarism, just as civilization hinges on a precarious balance between progress and degeneration. The image of the bridge in Zarathustra is a powerful metaphor for man's

12. E.L. Kirchner, *Brücke Insignia*, 1905. Woodcut, 5 × 6.5cm. Brücke-Museum, Berlin.

13. Otfijatheko Brant-Sero, 'a Red Indian scholar.' Photograph. *BIZ*, May 1910.

position, stretched between spirit and body, between past and future, strung out between contradictory alternatives.

Although the Nietzschean metaphor of the bridge was used to describe the state of *modern* man, it is important to realize that a similar set of associations began to cluster around the Western image of 'primitive', non-European man in the years immediately preceding 1914. Again, we need to search for these references in popular, daily discourse, which provides indispensable material for our understanding of the multi-layered image of the 'primitive' that surfaces in Expressionist art. After 1909, the year when the *Brücke* artists entered a new and overtly primitivist phase discussed in detail below, numerous articles began to appear in the daily and weekly press about the 'modernization' of non-European man,[45] a phenomenon which was visually expressed in popular journalism via the new graphic techniques of photographic montage and collage. For example, a new image of native man was promoted by Otijatekha Brant-Sero, 'the Mohawk-Indian' who lectured at the Geographical Society in Dresden in April 1910 about the traditional practices of Red Indian society and the changes provoked by Western contact. In the newspaper report we read that, 'not without satire, he described the attempts of his progressive tribal brothers to forge a bridge between uncivilized peoples and the sometimes doubtful blessings of the restless modern world'. In the *Berliner Illustrierte Zeitung* (*BIZ*) the following month, the position of the 'modern' Red Indian was symbolized by a photographic montage which situates him between a locomotive engine and a mountain range (fig.13).[46] Although a degree of critical irony entered this type of discussion, so that, for example, Thomas Cooke was described as 'the true successor of Rameses 11' in a contemporary article about modern Cairo,[47] a certain confidence about 'primitive' man's ability to negotiate the fissure between his own past and the future imposed on him by Western rule was promoted by the popular press, in line with the demands of colonial propoganda.[48] A photograph in the *BIZ* in 1912 (fig.14), showing an African native suffering from 'jumping sickness' in the French Congo, leaping across the crevice between two precipices, takes on an added resonance in the light of this broader historical discourse, and provides a means of ironically affirming the historical juncture of 'primitive' man.[49] Such images could

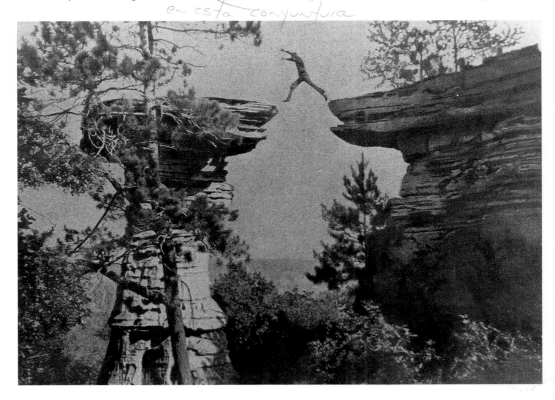

14. 'Newly discovered Jumping Sickness, in the French Congo.' Photograph. *BIZ*, March 1912.

be used as dramatic and yet complex and ambivalent metaphors for the state of the modern world.

In the literature on Expressionism, the social orientation of the *Brücke* artists has also been interpreted in Nietzschean terms. Reinhardt, for example refers to their early communal sketchbook, *Odi Profanum*, [50] whose name, Heckel explained, was derived from the Horatian ode, *Odi Profanum Vulgus*. Reinhardt links this to the passage in Zarathustra's prologue: 'I love the great despisers, for they are the great venerators and arrows of longing for the other shore'.[51] Wilhelm Arntz insists that their contempt 'was for the profane crowd, not the crowd in a social sense, but rather the soulless, care-worn masses of the bourgoisie'.[52] This spirit of contempt for the petty bourgoisie and the materialistic values of their times underlies the organization of *die Brücke*, rather than any specific ambitions for social reform, although the year of their group foundation also witnessed direct political action on the part of the Dresden Social Democratic Workers Movement, which organized strikes and demonstrations for electoral reform in December that year, inspired by the 1905 revolution in Russia. But the course of Expressionism was to run another route, always treated with suspicion by the social democratic movement. Before 1914, the kind of artists' organization described by Dr Halbe in the *Werkstatt der Kunst*, and which *die Brücke* put into action, became increasingly popular. In 1909 the *Sonderbund Westdeutscher Kunstfreunde und Künstler*, in which Osthaus was a leading organizational force, was constituted along similar lines to *die Brücke* but on a more ambitious scale, uniting artists, collectors, museum directors – and in this case dealers too – dedicated to the cause of modern art and design. In 1910, the New Secession planned to inaugurate a circle of non-active members who received annually one graphic work in return for a subscription of 30 marks.[53] What emerged in these organizations was not the broad public spectrum advocated by Dr Halbe, but rather a small circle of liberal bourgeois enthusiasts. Lucius Grisebach rightly points out that the bohemianism of *die Brücke* was a topsy-turvy version of their own middle-class backgrounds, and that the visits their bourgeois intellectual supporters like Gustav Schiefler and Botho Graef made to the bohemian studio settings were 'flights in their own dreamland'.[54] In Bürger's terms this constitutes a modernist counterculture rather than a radical avant-garde.

> The modern trend has radicalized the autonomy of bourgeois art vis-à-vis contexts of employment external to art. This development produces, for the first time a counterculture, arising from the centre of bourgeios society itself and hostile to the possessive individualistic achievement and advantage-oriented lifestyle of the bourgeoisie... In the artistically beautiful the bourgeoisie once could experience primarily its own ideals and redemption, however fictive, of a promise of happiness that was merely suspended in everyday life. But in radicalized art it soon had to recognize the negation rather than the compliment of its social practice.[55]

The attempt to create an organizational structure which was removed from the alienating commercial conditions of the art market and modelled on a more direct and authentic relationship between producer and consumer as this was thought to function in 'primitive' societies, necessitated the separation of a small, educated and open-minded section of the bourgeoisie from the public at large. The latter, as Lukács rightly observed, could neither understand nor support the efforts of modern artists. German modernism was thus 'cut off from the mainstream of society', despite its idealistic attempts to counteract the reified conditions of the modern world and to bridge the gulf between art and its public. Later this cultural élite who supported modernism in Germany represented one of the last stands of bourgeois liberalism in the darkening political climate of the 1920s and 1930s.

3 The *Brücke* Studios:
A Testing Ground
for Primitivism

EXPRESSIONIST SCHOLARS have frequently pointed to the communal *Brücke* studios in Dresden as the location where their overt primitivist mode was first evolved. There has been a tendency, however, to view the inspiration of tribal and exotic artefacts for the studio decorations as less important than the signs of non-European stylistic influence in the paintings and sculptures by *die Brücke* after 1910. Donald Gordon, for example, suggests that Kirchner used the stimulus of tribal art to create studio 'trappings';[1] later the artist began to integrate the stylistic principles derived from non-European sources into his own artistic vocabulary, so that paintings like *Half-Length Nude with Hat* (1911; G.180) show signs of 'Cameroon-inspired angularity'.[2] Gordon's distinction follows the model of Mark Roskill's dual concepts of 'japonaiserie' and 'japonisme', which he used to describe the impact of Japanese art on later nineteenth-century French painting.[3] He explains 'japonaiserie' as little more than the superficial borrowing of exotic trappings, which could be integrated into Western style, but which *precedes* a more thoroughgoing appreciation of the stylistic principles of Japanese prints. Leaving aside the fact that most of the examples Roskill cites display a combination of his categories, this kind of modernist value judgement, which exalts the importance of style over subject, has unfortunate consequences when applied to German art, with its greater emphasis on content. Such an approach fails to appreciate the ideological background of Expressionist primitivism and the reasons for the adoption of tribal models. References to non-European art appear first in the studio decorations because it was here, in the 'unalienated' artistic space of the studio that they attempted to bridge the gap between the decorative and fine arts, reintegrating art into life praxis according to the *Jugendstil* understanding of 'primitive' societies. In 1928, Kirchner defended applied art by referring to the 'primitive' origins of decorative form:

> What does 'decorative' mean after all? The more art progresses, the more clear this distinction becomes, and with it the disdain for certain works of art that serve practical ends. Today we've almost reached the point where the necessity and justification for decorative art are denied. But primitive peoples the world over only knew this form of art, because they lacked the context to 'hang' other forms — a house or a room.[4]

The non-European art that attracted the *Brücke* artists' attention first of all — the Palau beams and Ajanta temple paintings — were in both cases related to decorative environments, and thus relevant for their own studio spaces, rather than random or arbitrary stylistic models. The tendency to underplay the importance of the studio environments has meant that only Kirchner's decorative schemes have received due attention; those executed by Erich Heckel, Otto Mueller and Max Pechstein, which

15. E.L. Kirchner, *Interior*, 1905/6. Pen and ink, 35 × 50cm. R.N. Ketterer, Campione d'Italia.

15. E.L. Kirchner, *Interior*, 1905/6. Pen and ink, 35 × 50cm. R.N. Ketterer, Campione d'Italia.

16. Erich Heckel's parents' house, Berlinerstraße 65. Photograph, March 1987.

were also important sites for their primitivism, have been largely ignored.[5] The primitivism of the studio spaces depends on the coexistence of several factors: first, the notion of an 'unalienated' artistic environment in a *Jugendstil* tradition, where the barriers between art and life could be dissolved; second, the direct references to non-European art; and third, the evolution of an iconology of the 'primitive', which involves both subject and style, and emerges in the paintings and drawings of the studios by Kirchner and Heckel.

The earliest meeting place for the group of young architecture students was Kirchner's *Bude* (fig.15), where they began their 'quarter-hour' life drawing sessions, and which Bleyl describes as, 'that of a real bohemian, full of paintings lying all over the place, drawings, books, materials. Much more like an artist's romantic lodgings than the home of a well-organized architecture student.'[6] This room set the bohemian tone for the later studios but had, apparently, no decorations. Heckel lived in his parents' house in Berlinerstraße 65 in Dresden-Friedrichstadt (fig.16), where he created an attic studio and organized the *Brücke* business affairs after June 1905. In 1907 Kirchner moved into a ground-floor studio in Berlinerstraße 60, next to a cobbler's shop and the café-bar *Berliner Hof*; in November 1909 he moved from here to a new atelier in Berlinerstraße 80, which we find recorded in several contemporary photographs.[7] Reinhardt and others claim that the artists' decision to rent studio space in the workers' area near to the Friedrichstadt Bahnhof, rather than in a more fashionable area suited to their class and backgrounds, relates to their anti-bourgeois aspirations.[8] Schmidt-Rottluff's 1905 woodcut *I'm a Poor People's Child* is one of the few works directly referring to the working population of the Friedrichstadt, although the industrial environment, which starkly contrasted with the elegant Baroque city centre of Dresden, is recorded in many *Brücke* sketches and early graphics. The main reason for their residence there was the fact that Heckel's middle-class family lived in this area because his father was a railway engineer, and he was thus in an excellent position to hear of local cheap accommodation for the young artists. Heckel repeatedly complained of financial hardships in his early letters to Amiet; and in an interview in *Kunstwerk* in 1958/9, he explained that the studio decorations saved them the purchase of other furnishings:

'We needed somewhere to sit – so we made the stools ourselves, also the batik curtains.'[9] Ernst Gosebruch's description of a visit to Otto Muelller's atelier in Berlin supports this argument: 'it must be said that Otto Mueller's gay decorations gave his studio a kingly air, a real style, behind which one never noticed the poverty'.[10] Behind the facade of exotic decorations, Gosebruch insists, there lurked in all the *Brücke* studios piles of unsold paintings, and the unheated ateliers had hard couches instead of beds, usually occupied by ailing girlfriends during the winter months.

The exact chronology of the studio decorations has been much disputed, but the general opinion now is that they were executed not in the earliest years of communal activity, but rather between 1908 and 1911.[11] Bleyl's memoirs, although not completely reliable with regard to dating, support this theory as he suggests that there were no decorations in Kirchner's atelier when he left *die Brücke* in the autumn of 1907, but that when they met again the studio was decorated in a very bohemian style.[12] A firmly dated contemporary report by the Dresden journalist Ernst Köhler-Haußen, who visited Kirchner's first Berlinerstraße studio in September 1907, also fails to mention any studio decorations.[13] It is most likely that all Kirchner's decorations were made for his second Berlinerstraße atelier after November 1909, and it is certainly this space that features in the studio photographs and in all witness accounts of the decorated studio. In December 1910 Gustav Schiefler visited Kirchner's second studio and reported:

> Out of necessity he had rented a remarkable studio in a Dresden suburb, a narrow shop, which had a large glass window to the street and a small adjacent space that served as a bedroom. These rooms were fantastically decorated with coloured textiles which he had made using the batik technique; with all sorts of exotic equipment and wood carvings by his own hand. A primitive setting, born of necessity but nevertheless strongly marked by his own taste. He lived a disorderly lifestyle here according to bourgeois standards, simple in material terms, but highly ambitious in his artistic sensitivity. He worked feverishly, without noticing the time of day . . . Everyone that comes into contact with him, must respond with strong interest to this total commitment to his work and derive from it a concept of the true artist.[14]

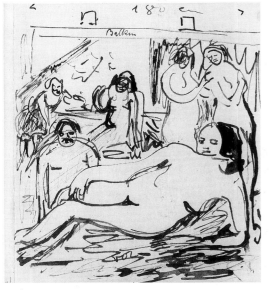

17. Erich Heckel, Sketch for a Mural in Berlinerstraße 65, Dresden-Friedrichstadt, 5 February 1909, Dresden. Pen and ink. Altonaer Museum, Hamburg.

In fact, the first documentary evidence to help date the studio decorations refers not to Kirchner's studio but to Heckel's attic rooms in his parents' house. The likelihood that Heckel rather than Kirchner initiated this practice would help explain his objections to Kirchner's version of the group history in the *Chronik*, where we read: 'Heckel and Kirchner tried to bring the new painting into harmony with interior space, Kirchner decorated his rooms with murals and Heckel assisted.'[15] A letter from Heckel to Rosa Schapire dated 5 February 1909, includes the first sketch of a studio mural (fig.17), and a description of the colours, 'overall tones zinc yellow, lime green, red, some black.' Heckel also recorded his dissatisfaction with the results: 'The mural doesn't please me now. But I'll finish painting the whole room first, before I whitewash it again.' Before repainting a photograph was taken of this first studio mural.[16]

The mural is interesting for two reasons, despite its relative failure as a decorative work. First for its subject which depicts a casual group of male and female nudes rather than the bather scenes which were to dominate all subsequent decorations. In the foreground we see a large reclining female figure, flanked by seated and standing nudes; to the left, two more women, one of whom is casually dressed, sit at a table which is fitted into the corner of the sloping ceiling. The scene could easily be taking place in the studio itself, and it is comparable to numerous drawings, paintings and graphics by Heckel and Kirchner showing the bohemian studio lifestyle, sometimes with male and female figures in overtly erotic contact, but mainly just moving freely around the studio. The mural carries the *Brücke* lifestyle over onto the walls, expanding the studio space imaginatively, and dissolving the barriers between art

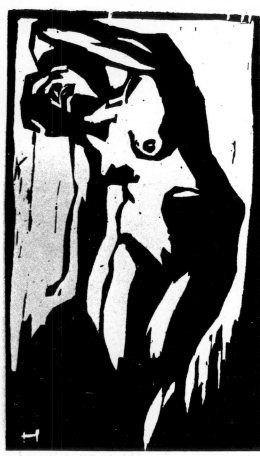

18. Erich Heckel, *The Dance*, 1905. Woodcut, 20.1 × 11.2cm. Brücke-Museum, Berlin.

19. E.L. Kirchner, *Standing Nude with Crossed Arms*, 1905. Woodcut, 43 × 15.8cm. Brücke-Museum, Berlin.

20. Wall painting, Ajanta. Cave XV11, plate 55 in John Griffith's book.

21. Wall painting, Ajanta. Cave XV1, plate 48 in John Griffith's book.

22. Erich Heckel, *Reclining Girl*, 1909. Oil on canvas, 80 × 95cm. Location unknown.

and life praxis. A year earlier Heckel had written to Amiet about his approach to decoration: 'Our aim is also decoration, a calm effect, but on the other hand everything pushes in the direction of spontaneity and passion.' Although this statement might appear to engage with Henri Matisse's ideas about decoration and harmony, Heckel's letter precedes the publication of Matisse's *Notes d'un peintre* in December 1908.[17] In fact, Heckel is referring to local discussion in the Dresden decorative arts movement, and to the principles outlined by Ernst Zimmerman in his summary of new departures in the 1906 Decorative Arts Exhibition: 'The first aim of all art is to produce harmony, unity and calm. Room decoration in this sense tries to represent the space as a closed entity, closed to the outside world and self sufficient.'[18]

The qualities of passion, spontaneity and vitality which Heckel wished to add to his concept of decoration and which characterize *Brücke* art in general, reminds us of their reading of Nietzsche's *Zarathustra*. Their understanding of Nietzsche had become a driving force in their pursuit of an anti-bourgeois, bohemian lifestyle, and they tried to incorporate it into their actual working methods. In their 'quarter-hour' life drawings the idea was to work quickly and spontaneously, and so to avoid the laboured and rigid norms of academic style. If we compare Heckel's *The Dance* (fig.18) and Kirchner's *Standing Nude with Crossed Arms* (fig.19), we see how in the woodcuts too Heckel began to translate the lessons learnt in these quick sketching sessions more quickly than Kirchner into the graphic medium. While Kirchner's elongated, frontal and stylized nude is still firmly rooted in *Jugendstil* tradition, Heckel's *The Dance* has 'come alive'. The quickly carved wood block with its broad areas of black and white, its broken and irregular contours and the lively turning axis of the nude's body, show how the new ideals of spontaneity and passion broke free from the frozen angularity of *Jugendstil* style.

Although the subject matter of Heckel's first mural attempts to render these new active qualities in the bohemian *Brücke* lifestyle, the balance between decoration and vitalism he described in his letter is not achieved on a stylistic level: in the surviving photograph the mural looks overworked and stilted in comparison to the later decorative schemes. But it is stylistically interesting because it displays the first decorative reference to non-European art by a *Brücke* artist. The two standing female figures behind the reclining nude are derived from the illustrations Heckel discovered before Kirchner in John Griffiths' *Paintings in the Buddhist Cave Temples of Ajanta* in the Central Dresden Library in January 1908 (figs.20–1). As Martensen-Larsen points out, the same illustrations influenced Heckel's 1909 oil painting, *Young Man and Girl* and, I would add, *Reclining Girl* (fig.22). In the same letter to Amiet where Heckel speaks of his aim to combine decoration and spontaneity he continues:

> I admire Gauguin very much, I have seen some very beautiful paintings by him in the Folkwang Museum. Do you know the Indian fresco paintings in the Buddhist cave temples? There is a...publication with photographs by Griffith...I discovered it recently in a library here. They are very good works.[19]

In Gauguin's primitivizing works and in the Indian wall paintings Heckel found the combination of 'primitive' spontaneity and harmonious decorative effects he was searching for. His recognition of the relationship between the Indian murals and Gauguin, whose original work he first saw in the *Jugendstil* environment of the Folkwang Museum, was perceptive, in as much as Gauguin had used similar exotic Eastern sources to evoke his idealized vision of Tahiti. But Heckel's knowledge of Griffith's book almost certainly came via Wilhelm Kreis, who had journeyed to India in 1905 to study Indian temples; and indeed the second volume on Ajanta, which recorded the ornamental details in the Temples, looks more or less like a pattern book for *Jugendstil* design. This coincidence of Post-Impressionist and *Jugendstil* stimuli directed Heckel's attention towards a non-European source; transforming concepts of decoration were just as important as the precedent of a primitivizing fine

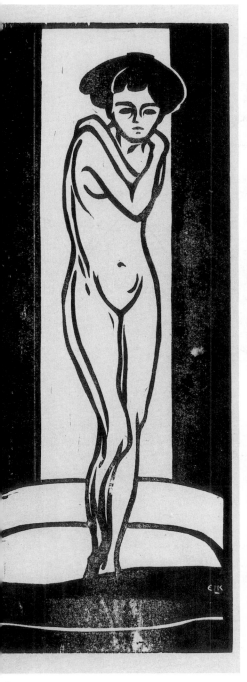

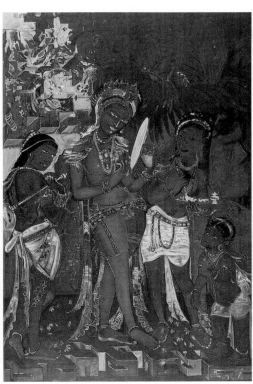

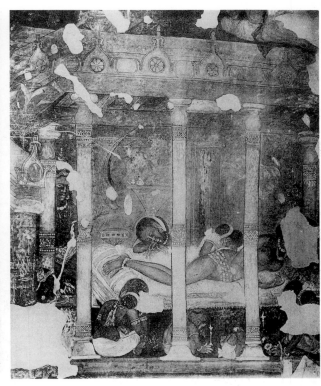

23. E.L. Kirchner, *Benin Bronze Relief*, 31 March 1910, Dresden. Pen and ink, 10 × 14cm. Altonaer Museum, Hamburg.

art tradition. In the spring of 1909, when Heckel travelled to Rome, his interest in decoration guided his response to Italian art too. In his letters to Amiet he described domestic architecture and decorative schemes rather than the great tradition of Renaissance oil painting: 'the ancient mosaics and frescos in Venice, Ravenna and Rome interest me very much. They are wonderfully simple and strong. The Pompei wall paintings are also very fine in part, interesting.'[20]

In his 1966 article, 'Kirchner in Dresden', Donald Gordon suggests that Kirchner's response to Gauguin in the Galerie Arnold exhibition, which ran concurrently with the *Brücke* show there in September 1910, was a catalyst for his first serious *stylistic* response to non-European art. Before this, he remarks, tribal art was merely a 'curiosity', inspiring the studio décor, but 'after the Gauguin exhibition non-Western sources became for Kirchner the essential raw material for the ultimate attainment of a personal style'.[21] There is no doubt that the Gauguin exhibition made a strong impact on Kirchner: he designed the poster (Dube H.713), based on Gauguin's *Portrait of his Mother, Aline* (1893), which had been published in *Kunst und Künstler* in 1908 as an illustration to *Noa-Noa*. Kirchner used a blue woodcut print on yellow paper to incorporate the original hues of the painting.[22] In 1911 he executed three paintings which are a virtual pastiche of Gauguin: *Nude Reclining on Drapery* (G.184), which refers to Gauguin's *Manao Tupapau, The Spirit of the Dead, Wakes* (1892), *Two Nudes with Sculpture* (G.195), in which the central figure quotes Gauguin's *Hina Tefatou, The Moon and the Earth* (1893) and *Fränzi, Shoulder Length Portrait* (G.183) which resembles Gauguin's *Marahi Metuano Tehamana. The Ancestors of Tehamana* (1893).[23] In fact it is more likely that the Gauguin exhibition provided confirmation that Kirchner's interest in non-European art was an appropriate direction for an modern artist to be moving in, rather than acting as a catalyst. Possibly Kirchner, like Heckel, found that the exoticism of Gauguin's work opened his eyes to the charm of the Ajanta wall paintings, as he made twenty drawings after the illustrations in Griffith's book between the autumn of 1910 and the spring of 1911.[24] But his intense engagement with non-European art and his repeated visits to the Dresden Ethnographic Museum in the spring and summer of 1910 preceded the Gauguin show.

In March 1910, Kirchner wrote a letter to Heckel about the reopening of the

24. E.L. Kirchner, *Mother and Child Sculpture*, 31 March 1910, Dresden. Pen and ink, 23.7 × 7.5cm. Altonaer Museum, Hamburg.

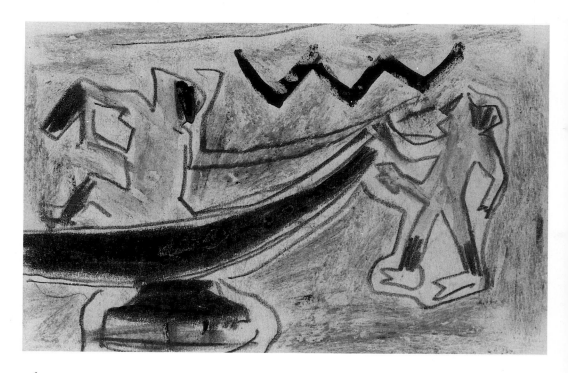

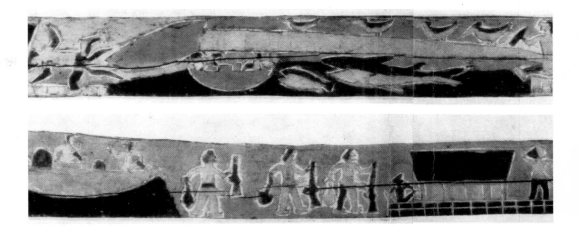

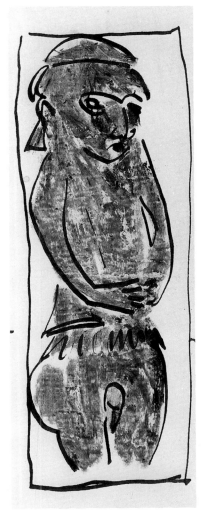

Dresden Museum in which he sketched two African sculptures, a Benin bronze relief and a Cameroon figure[25] (figs.23–4). Three more drawings of Benin reliefs are in the Kirchner estate, one of which shows the same flute-playing figure from another angle.[26] A second undated letter[27] contains a sketch after a small New Guinea figure (fig.26); and on 20 June he sent Heckel a postcard sketch of a section of the Palau beams, showing a figure with a large phallus (figs.25 and 27), remarking 'the beam always looks beautiful again'.[28] This message refers back to a previous mutual knowledge of the Palau beams and underlines the recurrent nature of their visits to non-European collections which extended beyond the Dresden years. In 1911 and 1912 Kirchner sketched in the Berlin Ethnographic Museum, copying two Eskimo bone carvings in January 1911[29] (figs.28–9), and a Cameroon figure in June 1912 (figs.30–1).[30]

There seem to have been two events which fired Kirchner's interest for non-European art in 1910. Already during the previous summer, when he and Heckel

26. E.L. Kirchner, *Female Sculpture*, undated. Brush and ink, blue and red crayon. 15.2 × 5.2cm. Altonaer Museum, Hamburg.

27. Palau beam from a mens' clubhouse (bai). Palau Islands, western Micronesia, before 1860. Carved and painted wood. Dresden Museum für Völkerkunde.

25. (facing page below) E.L. Kirchner, Sketch for Palau beams (detail), 20 June 1910, Dresden. Pencil, ink and coloured crayon, 9 × 14.1cm, Altonaer Museum, Hamburg.

28. E.L. Kirchner, *Dancing Eskimos*, 5 January 1911, Berlin. Pencil, 14 × 9cm. Altonaer Museum, Hamburg.

29. Eskimo bone carvings, Museum für Völkerkunde, Berlin.

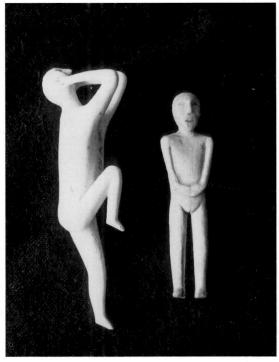

31. *Male Carved Figure from Cameroons*,
Museum für Völkerkunde, Berlin.

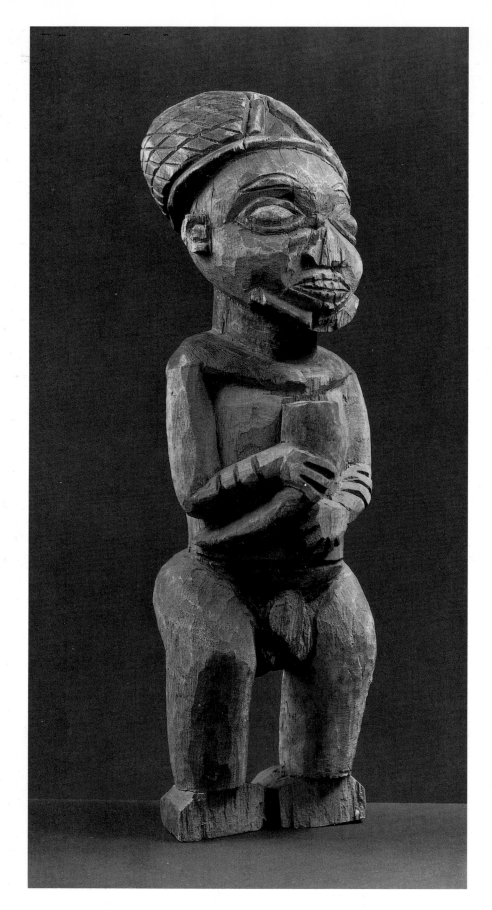

30. E.L. Kirchner, *Cameroon Figure*, 26 June
1912, Berlin. Ink and coloured crayon, 14.1 ×
9cm. Altonaer Museum, Hamburg.

32. E.L. Kirchner, *Bathers Throwing Reeds*, 1909. Coloured woodcut, 20 × 29cm. Brücke-Museum, Berlin.

33. E.L. Kirchner, *Bathers Throwing Reeds*, 6 September 1909, Dresden. Ink and coloured crayon, 9 × 14cm. Altonaer Museum, Hamburg.

had spent several weeks sketching and painting at the Moritzburg ponds in a wooded lakeside area outside Dresden, the Palau beams had inspired his postcard drawing of bathers in the reeds (fig.33), which he then used for his coloured woodcut of the same subject, *Bathers Throwing Reeds* (fig.32).[31] The spiky figures in the drawing, with their jerky movements in a colour scheme of yellow, yellow-ochre and black, clearly refer in a quite literal way to the Palau beams in the Dresden collection. These were probably two halves of a single beam, carved on both sides, the first of their type to be brought back to Germany by Carl Semper in 1862 and bought for the museum in 1881 (fig.34). The beams show scenes from the daily life and mythology of the islands, including a favourite local myth about a native with a giant penis, capable of penetrating his wife on a neighbouring island (fig.24).[32] The beams are roughly carved and coloured with vegetable dye, creating a quite different effect from the later, more clearly delineated and strongly coloured Palau beams which entered the Berlin ethnographic collection in 1907 as part of a whole mens' club house (fig.119). The choice of the Palau beams by the *Brücke* artists is an interesting one, as the excellent South Seas collection in the Dresden museum also included a rich selection of three-dimensional Oceanic sculpture.[33] Their initial interest in the carved and painted wooden beams surely related to the important rôle woodcuts played in their own early work.

29

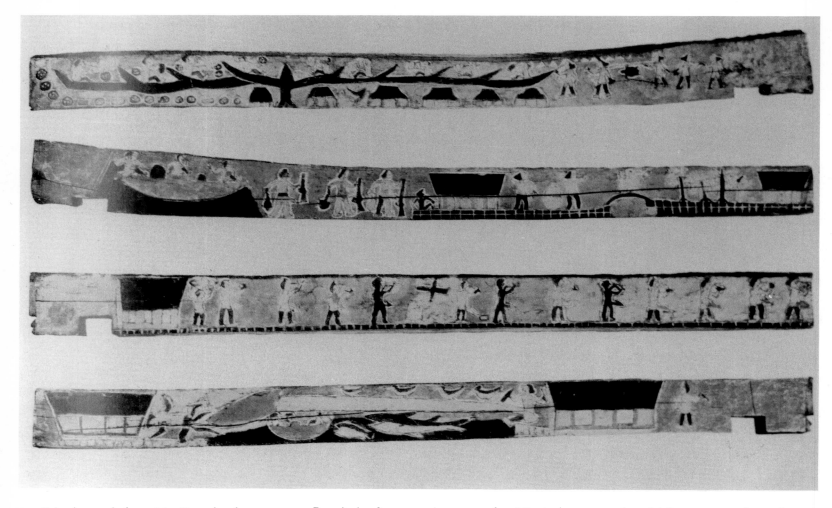

34. Palau beams, before 1860. Carved and painted wood. Dresden Museum für Völkerkunde, Berlin.

35. Erich Heckel, *Boomerangs and Bows and Arrows* 2 October 1909, Dangast. Ink and coloured crayon. Altonaer Museum, Hamburg.

But it is the experience at the Moritzburg ponds which seems to have been a necessary catalyst for their own creative use of this non-European visual stimulus. As we shall see, the Moritzburg summers provided an opportunity for the *Brücke* artists to recreate their bohemian studio lifestyle in an open-air setting. Stripped of their clothes and 'civilized' trappings, the artists and their models were 'at one' with nature and led the life of modern 'primitives' – bathing in the nude and playing games with bows and arrows and boomerangs on the model of Karl May Red Indian stories (fig.35). It was in this context that the style of the Palau beams became relevant for first time, not as a purely formal development but rather as a matching of style to subject.[34]

In the late spring of 1910, Kirchner's romantic enthusiasm for what he understood as 'primitive' lifestyles enjoyed a second boost when an African village with dancers went on show at the zoological gardens in Dresden. This formed part of a series of side-shows of exotic peoples organized by Carl Marquardt, which had begun in May 1909 with a group of Sudanese natives. All of Marquardt's shows included a selection of ethnographic artefacts – as well as live natives – and they provided another important opportunity for the *Brücke* artists to experience non-European art beyond the sterile environment of the 'scientific' installations at the Zwinger Museum.[35] Already in March 1910, Kirchner wrote enthusiastically about the group of Samoans expected at the zoo that summer (who arrived in mid-August), and whom Heckel recorded that autumn in a lithograph, *Samoan Dance* (Dube L.82). In May 1910 an advertisement appeared in the *Dresdener Neuesten Nachrichten* for, 'The African village. New customs from Africa, including a marriage feast in central Africa, amazing shots fired by two African riflemen'[36] and Kirchner made several

36. E.L. Kirchner, *Head of a Negress*, 15 May 1910. Pencil, brush and ink, coloured crayon. 14 × 8.9cm. Altonaer Museum, Hamburg.

37. E.L. Kirchner, *Four Nudes in the Studio*, undated (28 November 1909). Pen and ink, 9.2 × 12.8cm. Altonaer Museum, Hamburg.

drawings of African dancers, of their heads and figures (fig.38). His postcard to Heckel, dated 15 May 1910, depicting the head of a negress (fig.36), certainly records a particular visit to the African village, rather than a circus act, as Karlheinz Gabler previously suggested.[37] Kirchner's Gauguinesque *Negro Dancer* (1910; G.186) was inspired by the same event. Gordon's undue emphasis on Gauguin's rôle in the genesis of Kirchner's primitivism in 1910 mistakenly interprets the response to non-European art as a pure fine art phenomenon. In fact, it was a much richer and more complex issue than this, and Gauguin was just one of several factors. Most important, Kirchner's primitivism in 1910 referred simultaneously to non-European art works and exotic notions of primitive societies; the latter, inspired by romantic literature and colonial propaganda, promoted events like the African village to fire the popular imagination with an interest in colonial activity. No great effort is needed to read the political implications of such spectacles, staged, according to evolutionary prejudices, next to the animals in the zoo. Indeed a contemporary report about a second exotic show in Dresden during the summer of 1910, 'Captain Kösters Ethnographic Exhibition', in the exhibition palace where the 1906 Decorative Arts Exhibition had been installed, makes clear reference to these political aims: 'In order to awake and to support interest and understanding for our colonial ambitions in the broad mass of the German folk...all in all the exhibition is intended to render colonial ideas convincing and to have an educational effect.'[38] The *Brücke* artists' concept of the primitive was partly shaped by these means, and Kirchner and Heckel enthusiastically collected black performers to act as models in their studios. Their ideas were marked by the imperialist consciousness of their times despite their rebellious challenge to bourgeois mores and values.

In November 1909, Kirchner moved into his new atelier at Berlinerstraße 80. A sketch of nude models in a letter from the end of the month shows how the Palau drawing style, which first emerged in the Moritzburg bather scenes, was equally well-suited to render bohemian studio life (fig.37): the same letter contains sketches of a couple making love and a group of wildly dancing nudes.[39] The overtly erotic motifs carved by the natives on the beams they used to decorate their mens' club houses as well as their raw 'anti-academic' style, must have provoked the *Brücke* artists' interest. Kirchner's dual facination with 'primitive' life and 'primitive' art could be explored most effectively in the *Jugendstil*-inspired field of interior decoration, which aimed to heal the rift between life and art praxis. Most probably he began his studio decorations in his new atelier during the late autumn of 1909, the year after a model club house was acquired by the Dresden Ethnographic Museum, which would have made clear to the *Brücke* artists how the beams were installed as part of a decorative environment in Palau.[40] Kirchner must have continued to work on the studio decorations during 1910 and 1911, and all the drawings, paintings and photographs of the decorations show the characteristic two-roomed space of Berlinerstraße 80, with its corner doorways hung with brightly painted curtains.[41]

Kirchner's studio decorations are recorded in two paintings showing a female nude lying in front of Palau-style decorations: Kirchner's *Girl under Japanese Umbrella* (1909; fig.39), and Heckel's *Girl with a Rose* (1909; Vogt 1909/7). In Kirchner's painting the 'Palau' figures are virtually identical to those carved on the end of a divan which appears in a 1914 photograph of his Körnerstraße atelier in Berlin (fig.55).[42] Hence the 1909 paintings do not show wall decorations, but rather refer to one of the first pieces of carved furniture which appears in several other drawings of the period (e.g. Kirchner's *Crouching Girl Nude* (1909/10). Significantly, it seems that the Palau beams inspired Kirchner to carve first of all, and the style was only later translated into painterly terms.[43] The foreground figures in both Kirchner's and Heckel's paintings are worked in the 'soft' Fauve style that characterizes their work during the first half of that year. In this they were influenced by Pechstein and the Fauve group who exhibited contemporaneously with *die Brücke* at the Gallery Emil Richter in Dresden in September 1908.[44] The practice of executing pairs of paintings, whereby Kirchner and Heckel worked on close or

38. E.L. Kirchner, *Drawings of Performers in 'the African Village'*, May 1910. Coloured crayon, 18 × 15.5cm. R.N. Ketterer, Campione d'Italia.

identical subjects, testifies to their very close and co-operative relationship in 1909–10, when Heckel must have crossed the road of Berlinerstraße from his parents' house on a daily basis, to enjoy the freer ambiance of Kirchner's studio. Possibly these pairings also suggest a degree of friendly rivalry. But there is an important difference in their references here to non-European art. For Kirchner it involves just the subject of his painting; his style relates wholly to Western models. In Heckel's painting we also see traces of non-European stylistic influence; the elegant curves of Ajanta are juxtaposed to the spiky black contours of the Palau figures behind. In 1910, Heckel repeated the same motif in a more fully-fledged Palau style: his etching *Reclining Child* (1910; Dube R.79), shows the angular figure of an adolescent model reclining in front of increasingly spiky and jagged Palau-inspired decorations. But the coexistence of exotic Eastern *and* tribal artistic stimuli – which Kirchner alludes to in the juxtaposition of the 'Palau' carvings and the Japanese sunshade – is extremely characteristic of *Brücke* primitivism. As we have seen in the case of Osthaus' collection, interest in Eastern and tribal artefacts and styles co-existed, and only a false evolutionary methodology seeks to demonstrate how orientalism developed unproblematically into 'tribal' primitivism. Kirchner, for example, made his sketches of the Ajanta temple paintings and African sculpture concurrently.

In the *Brücke* studios and paintings this coincidence of Eastern and tribal styles results in the raw-edged exoticism we find recurring in the curtain and wall hangings in Kirchner's studio. An undated letter late in 1909,[45] containing a preparatory sketch for Kirchner's painting *Bathing Nudes in a Room* (1909–26;G.108), suggests that the curtains were hanging by then, although in other related drawings for this painting they are not indicated.[46] Two 1911 photographs of the studio show

39. E.L. Kirchner, *Girl Under Japanese Umbrella*, 1909. Oil on canvas, 92 × 80cm. Kunstsammlung Nordrhein-Westfalen, Düsseldorf.

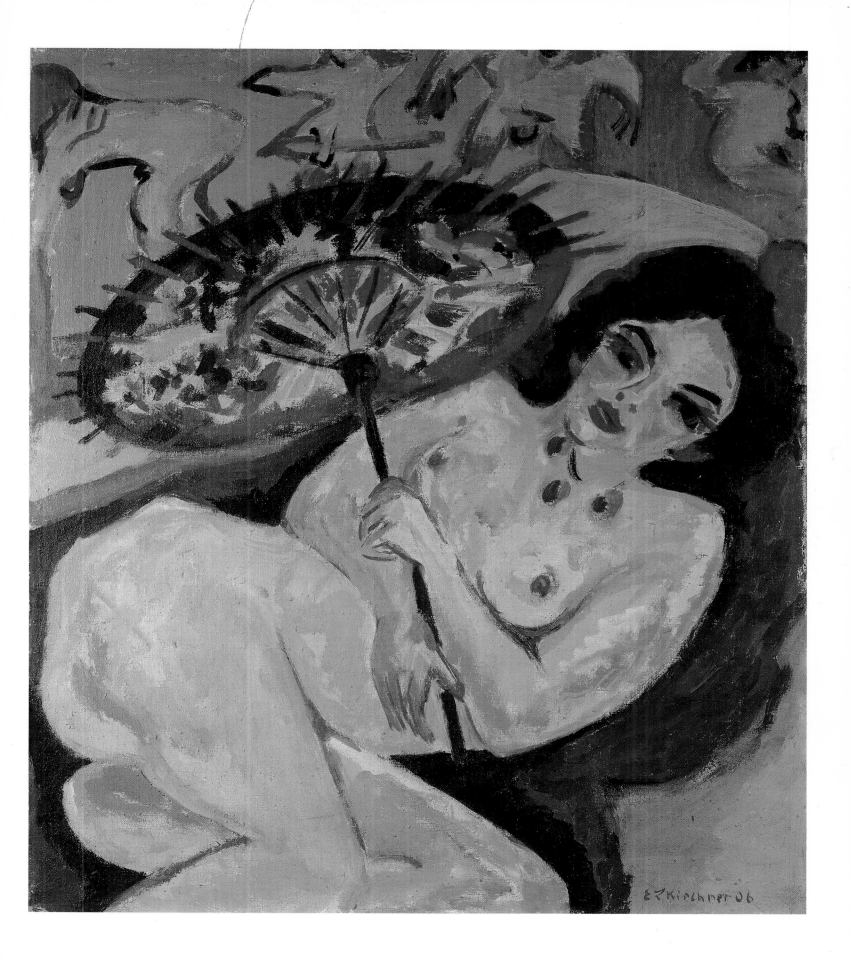

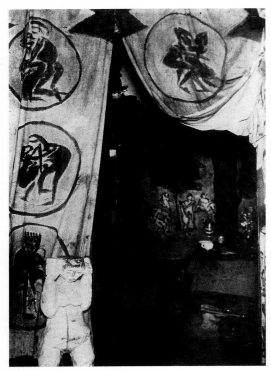

40. E.L. Kirchner, *Brücke* curtains, Berlinerstraße 80, *c.* 1911. Photo archive H. Bolliger and R. N. Ketterer, Campione d'Italia.

41. Doorway, Ajanta Temples, Khandesh, India.

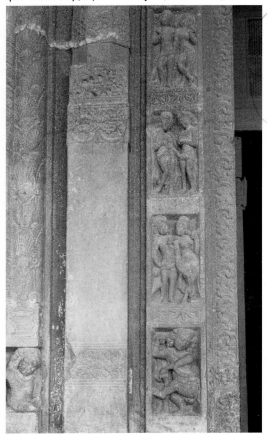

different versions of these curtains, suggesting there were two sets, or a repainting in a different colour scheme (figs.40 and 62). Although the rondel designs, which depict a king and love-making couples, have often been associated with the spiky Palau style they refer more directly to the open sexuality of the native carvings and they relate closely to the doorway motifs at Ajanta (fig.41). But stylistically, they are more reminiscent of Indonesian shaddow puppets which were well represented in the Dresden Ethnographic Museum.[47] Indonesian shadow puppets were also used in contemporary cabaret acts (fig.42),[48] and in fact the 'erotic silhouette' which Kirchner features in his curtains was enjoying a certain vogue in the cabaret, where scantily clad dancers appeared behind the protective screen of a floodlit sheet (fig.43).[49] Fig.44 shows wall hangings in the smaller 'rest room', painted on old bed linen and depicting bathers in erotic poses beneath trees and sunshades, and Kirchner's copy after the Ajanta Buddha. This was later used to decorate the MUIM space but can be seen more clearly here. Martensen-Larsen tried to establish a rational chronology for these decorations, in accordance with Kirchner's later statements in the *Davoser Tagebuch* where he claims to have changed the studio decorations in line with his developing style.[50] But her suggestion that the photograph of *Fränzi and an Unknown boy in the Dresden Studio* shows the earliest phase of decorative activity, and that fig.44 shows two different figure styles from 1908–9 and 1910 respectively, is wholly unconvincing.[51] It is impossible to make such stylistic distinctions from these photographs, which all date from 1910 and 1911 and show the studio in Berlinerstraße 80 after November 1909.[52] The subjects of these wall hangings, which Kirchner took with him to Berlin, were drawn from the Moritzburg summers, and so they were certainly not begun before the winter of 1909. More likely, Kirchner worked on these decorations after his second trip to Moritzburg in 1910, as the fully developed 'Palau' style and the subjects relate much more closely to his works of that year. Gabler suggests that the colour scheme of the decorations was also inspired by the Palau beams: chrome-yellow, red and black.[53]

The bathing scenes in Moritzburg and the bohemian studio life are analagous in terms of their vitalist Nietzschean spirit. Both are set in 'alternative' locations on the fringes of society, where the hard and fast boundaries which separated art and life praxis could be dissolved. Thus both were appropriate sites for the deployment of primitivist styles and themes. In his drawings and paintings of the studio Kirchner often makes direct comparisons between liberated nudity and sexuality in the studio and the activities of the painted bathers on the wall. But there is also a contrast – between the outdoor bathing scenes in nature and the interior, hermetic space of the studio where art is made.

Traces of one other decorative scheme from the Dresden years survive, which Heckel apparently executed in his studio at Falkenbrückestraße 2a where he moved in the winter of 1910–11. A postcard sketch dated 3 January 1911 shows a vertically divided scene (fig.45); the lower area depicts bathers in a rolling hilly landscape, and the upper half three clothed men and a reclining female nude, reminiscent of his first 1909 studio decorations (see fig.15). Heckel writes: 'I am making sketches for a curtain...it has already been sewn.'[54] Maschka Mueller, Otto Mueller's wife, whom the Brücke artists met in the Spring of 1910 at the first exhibition of the New Secession, apparently helped Heckel to sew the curtains, as their correspondence in January and February 1910 frequently refers to this project.[55] In November 1911, a postcard from Heckel to Sidi Riha – his dancer girlfriend and future wife – in Berlin, depicts a scene based on the bottom half of his initial sketch, showing bathers in a hilly landscape. He describes this as 'sketch for a wall painting', probably referring to plans for his new Berlin Studio, as it is unlikely that he would have begun new decorations on the point of leaving Dresden.[56]

Heckel's curtains appear in the background in several 1911 works; for example in a 'pair' of paintings by Kirchner and Heckel depicting the negress dancer Nelly, and in Kirchner's *Negro Couple* (1911;G187), which shows their black models, Sam and Milli, who possibly came from the Zirkus Schumann.[57] Heckel's *Nelly* (fig.46)

42. Behind the scenes at Ernst von Wolzogen's Buntes Theater, during the shadow puppet performance of *König Ragnar Lodbrok*. Photograph, *c.* 1901.

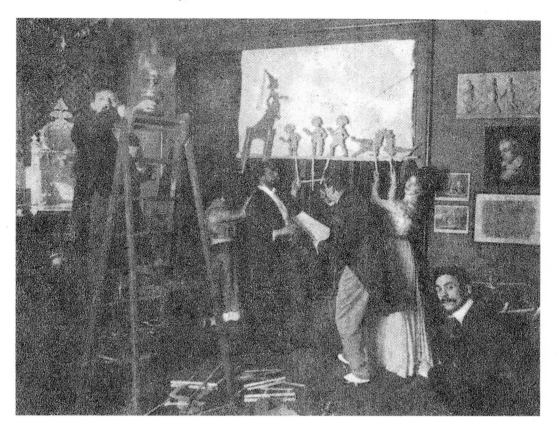

43. Cabaret photograph, *BIZ*, November 1911.

44. E.L. Kirchner, *Brücke* atelier, Berlinerstraße 80, *c.* 1911. Photo archive H. Bolliger and R. N. Ketterer, Campione d'Italia.

45. Erich Heckel, *Sketch for Curtain Designs*, 3 January 1911, Dresden. Coloured crayon, Altonaer Museum, Hamburg.

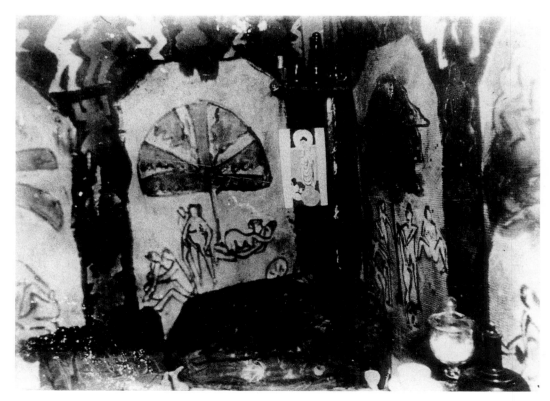

46. Erich Heckel, *Nelly*, 1910. Oil on canvas. Destroyed.

47. Erich Heckel, *Standing Child*, 1910. Coloured woodcut, 37.5 × 24.8/27.8cm. Brücke-Museum, Berlin.

and Kirchner's *Portrait of a Woman* (G185), show the dancer in fashionable city clothes sitting in front of the hills and bathers, whereas Kirchner's negro couple is depicted nude, as if they have just 'stepped out' of the bather scene on the wall. In all these works, the rounded contours of the female bodies rhyme with the rounded hills behind; in Heckel's *Nelly*, the hills function in a quite literal sense as a body metaphor, suggesting that which her city clothes conceal. Heckel's reworking of the same subject in a coloured woodcut depicting his adolescent model Fränzi in front of the studio curtain, *Standing Child* (fig.47), presents instead an ironic contrast between the bare angular limbs of the girl, her pointed mask-like face, her spare torso, and the opulent hills behind. These visual contrasts seem to be played off against a series of conceptual analogies about what constitutes the 'primitive': the landscape with bathers, the studio setting, the mask-like face and the child herself, as yet unbound by 'civilized' conventions. The link between childhood and concepts of the primitive was common at the time, growing out of evolutionary modes of thought and continually used as a justification for colonial power, but also

36

48. Doris Grohse, *Portrait of Dodo*, 2 November 1910. Pencil. 14 × 9cm. Altonaer Museum, Hamburg.

49. E.L. Kirchner, *Marzella with Japanese Instrument*, undated (March/April 1910). Pen and ink, 19 × 12cm. Altonaer Museum, Hamburg.

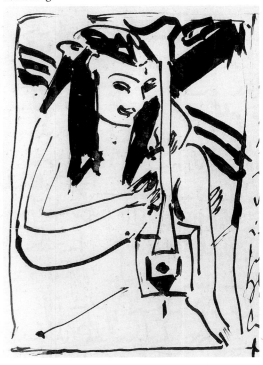

associated at the beginning of the century with more positive ideas about renewal and regeneration. Koch-Grünberg's *Anfänge der Kunst im Urwald* (1907; *The Beginnings of Art in the Tropical Rain Forest*), which was in Kirchner's library, was one of the earliest ethnographic publications to propose this new type of positive evaluation. Similar ideas recur in contemporary literature about child art: for example in Siegfried Levinstein's *Kinderzeichnung bis zum 14. Lebensjahr* (1905; *Childrens' Drawings up to the Age of Fourteen*), which was reviewed by the Expressionist patroness and non-active member of *die Brücke*, Dr Rosa Schapire.[58] In some *Brücke* drawings traces of a response to child art occur alongside their references to non-European influences.[59] Kirchner also valued his own childhood drawings and he allegedly salvaged them from sketchbooks, loving to reproduce them beside his own mature works. Grohmann links this enthusiasm to Gauguin's nostalgia for the primitive.[60] When the adolescent models Fränzi and Marcella entered the *Brücke* studios in February 1910[61] they would probably have been encouraged to draw too, and Kirchner's and Heckel's Moritzburg sketches that summer show a response to child art. Heckel, in particular, began to hold the pencil or charcoal in an awkward manner, avoiding the more sophisticated and dexterous effects of 1908 and 1909. But Kirchner's later woodcuts after his childhood drawings, like the examples of child art included in the *Blaue Reiter Almanach*, look more like a sophisticated artist's idea of child art than the genuine article (fig.48).[62]

Fränzi and Marcella play an important rôle in the primitivist iconography of the studio paintings. Often the girls, who are depicted both clothed and nude, are seated on carved furniture inspired by tribal models. An undated letter,[63] shows Fränzi playing a Japanese musical instrument (fig.49), and they are frequently associated with the primitivist decorations in the studios. Heckel's *Sisters* (fig.50), shows them sitting nude at a table painted with Palau motifs so that the angular bodies of the girls rhyme with the spiky Palau figure style. While this painting presents in a quite straightforward way the reality of studio life, many of the Fränzi and Marcella paintings are more self-consciously constructed. Kirchner's *Fränzi at Breakfast* (1910;G.105), depicts a similar scene, but the visual and conceptual analogies between the nude child, the sculpted wooden figure on the table and the wildly dancing figures in the borders of the wall hangings are more consciously staged. In other paintings the artists play with visual contrasts between the clothed figures of the girls in the interior space, and the 'outside' nude bathers on the walls.[64] Heckel's *Girl with a Doll* (fig.51), is also a self-consciously constructed work which plays on the ambivalent naïvety and seductiveness of the adolescent girl, whose own nude body is juxtaposed to the clothed doll on her knee. The painting is 'signed' by the presence of Heckel's legs in the top left-hand corner from Kirchner's *Portrait of Erich Heckel* (1910/20;G.167). It is of course possible that this portrait just happened to be hanging in the corner of the studio, but this is unlikely. The legs are used not only as a signature, but also to introduce a male presence which sets off the ambiguous sexuality of the young girl. Such references to child sexuality, in line with Freud's theories, were part of the bohemian attack on bourgeois morality.

Both Gordon and Ettlinger describe the studio furniture and decorations in these paintings as exotic trappings, but in fact the studio props are knitted into a dialogue of contrast and analogy with the figures. Heckel and Kirchner achieve in these works a type of environmental portraiture, which has nineteenth-century precedents in the work of Degas, Gauguin, Seurat and Van Gogh, and a local pedigree in the tradition of Dutch genre painting. Gotthardt Kuehl, one of the general directors of the 1906 Decorative Arts Exhibition, used similar devices in his realist genre paintings like *In The Classroom* (c.1886), where the portrait of the mother on the wall and the annunciation scenes in the window rondels create a sentimental atmosphere.[65] The *Brücke* studio scenes use similar methods at the same time as they undercut literary and sentimental associations. The sham realism of Degas' interior portraits, and the mysterious symbolic mood of Gauguin's paintings

the *Brücke* artists so admired, have been replaced by the expressive immediacy of simultaneous visual analogies and contrasts. In this network of analogy and contrast, which involves both subjects and styles, the *Brücke* artists evolved something approaching an iconology of the 'primitive', capable of expressing in a direct and immediate way the abstract and conceptual basis of their primitivism. Although I would not necessarily suggest a concrete or direct relationship, it is interesting to note how close this method comes to the techniques of photographic collage and montage in popular journalism, which, as we have already seen, proposed a complex, multivalent image of 'primitive' man in immediate visual terms.

Primarily it is the children, the black dancers and circus artists, and the female models who feature in this primitivist studio iconography. They appear alongside genuine tribal artefacts which Heckel almost certainly received as presents from his brother Manfred, who was working as an engineer in German East Africa and visited Dresden in the summer of 1910.[66] In postcard sketches and paintings around the time of Gustav Schiefler's visit to the Dresden studios in December 1910, these African objects, including a Cameroon leopard stool, African textiles and a Tanzanian mask, began to appear in the studio scenes.[67] One textile, which is preserved in the *Brücke* Museum today, features in a pair of paintings by Kirchner and Heckel showing Sidi Riha nude with a painted face. Heckel's *Nude* (fig.52), and Kirchner's *Nude with a Painted Face* (1910;G.156), show the rounded, opulent nude set against the angular animal motifs in the African textile behind. With her painted mask-like face – possibly inspired by the African dancers at the zoo – and blatant display of her sex, which is characteristically more overt in Kirchner's painting, she is one of the female types most frequently associated with the 'primitive' by the *Brücke* artists.[68] Sidi's reappearance in front of a second African textile in Heckel's paintings *Girl playing a Lute* (Vogt 1913/14) and *Convalescent* (Vogt 1913/3), presents a different female type, much more characteristic of the Berlin years, when the vitalist optimism of the Dresden period was on the wane. In Heckel's triptych *Convalescent* the African textile is used as part of a primitivist iconography, alongside the Africanized sculpture in the left-hand panel and the sunflowers to the right, which seem to be set in ironic juxtaposition to the 'civilized', ailing woman in the centre panel. But there is a new feeling of human sympathy in Heckel's Berlin work, and the burning orange-brown of the African textile sets the mood for an almost tragic awareness of this opposition.

In Kirchner's *Seated Woman with Wood Sculpture* (see fig.197), we find a different kind of 'civilized' woman. His girfriend Erna is depicted here as a 'modern' urban type, smoking her cigarette beside the Africanized MUIM sculpture. Although her fashionable clothes contrast with the nudity of the sculpture, their mask-like faces are the same. Women appear in the Dresden works mostly as 'primitive' elemental beings, sometimes set off by a piquant, 'civilized' foil, like a fashionable hat, an elegant fan or slippers. In the Berlin studio paintings, the women function as ciphers of civilization and modernity, contrasting with the primitivist decorations and sculptures; and yet, a new set of comparative references are evolved which we shall find most explicitly stated in Kirchner's Berlin street scenes. The women act as a kind of intermediary force, as an interface between references to the primitive and the modern.

Various decorative schemes in the *Brücke* artists' Berlin studios in which they continued their primitivist mode are worthy of attention. In the spring of 1910, Otto Mueller joined the group and under the influence of his new associates began to decorate his Berlin studios. Painted and carved furniture are depicted, for example, in Kirchner's *Otto and Maschka Mueller in the Studio* (1911;G.197). Mueller occupied two studios in the Mommsenstraße; first number 60, which Heckel took over from him in the autumn of 1911, and then number 66. Reinhardt points to another decorative scheme rendered in several *Brücke* works, which he suggests existed at Mommsenstraße 60. An exotic background features in Mueller's drawing *Studio Pause* (c.1910) and in Pechstein's coloured woodcut *Somali*

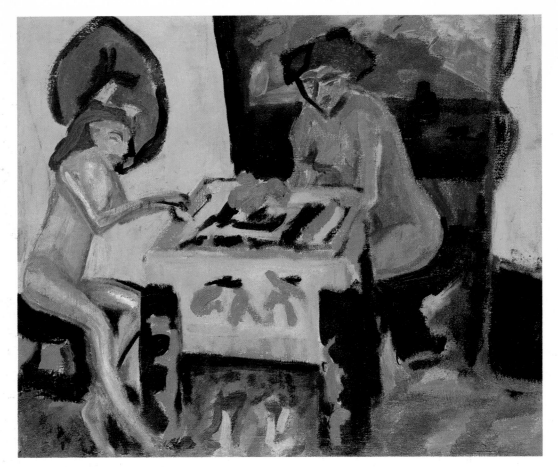

50. Erich Heckel, *Sisters*, 1910. Oil on canvas, 69.5 × 79.5cm. Staatliche Museen Preußischer Kulturbesitz, Nationalgalerie, Berlin.

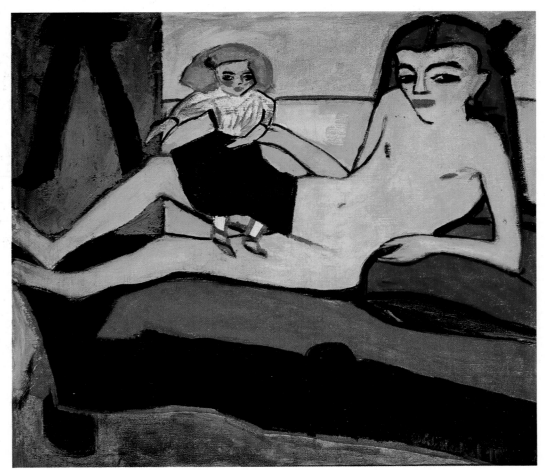

51. Erich Heckel, *Girl with a Doll*, 1910. Oil on canvas, 65 × 70cm. Private collection (Courtesy Serge Sabarsky, New York).

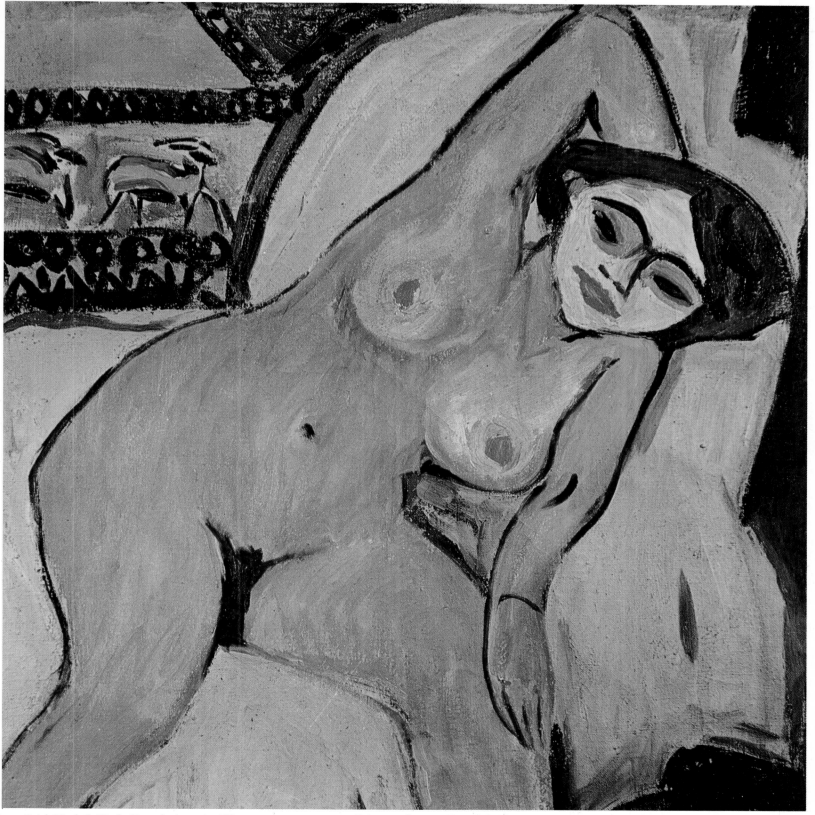

52. Erich Heckel, *Hude (Dresden)*, 1910. Oil on canvas, 80 × 70cm. Private collection, Switzerland.

53. Max Pechstein, *Somali Dancers*, 1910.
Coloured woodcut, 34 × 36cm.

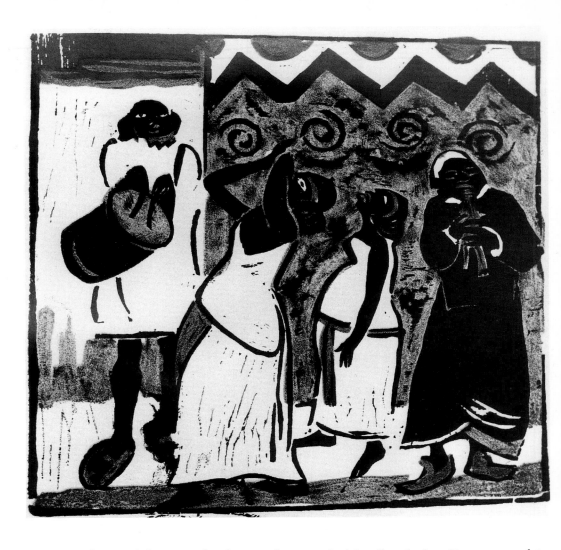

Dancers (fig.53). The same background recurs in his oil painting *Dance 2* and in Georg Tappert's poster for the sixth exhibition of the New Secession in 1911. A very similar exotic motif occurs in Heckel's woodcut of Pechstein's lost oil painting *Idle Women* (1910;Dube H180), but this time as a rug rather than a wall painting. Reinhardt's theory is that the decorative scheme derives from an 'afro-exotic, namely a Somali dance group', which Mueller, Pechstein and Tappert witnessed in Berlin in 1910 and which Mueller used as inspiration for his decorations.[69] This theory supports my more general point that the *Brücke* artists' experience of the 'primitive' was drawn from the living fabric of their lives in colonial Germany rather than simply from the dusty cases of the ethnographic museums.

Photographs survive of Mueller's decorations in Mommsenstraße 66, which display a figure style derived from early Greek and Egyptian art (fig.54). Mueller expressed enthusiasm for this art, and in January 1911 he sketched from Greek vases (fig.55); the large figure in this sketch suggests the pose for the left-hand figure in his studio interior. But the wall paintings are also inspired by Matisse's decorations for the Moscow banker, Shchukin, which were illustrated in the *Blaue Reiter Almanach* and exhibited at the Berlin Secession in 1913. Indeed several other *Brücke* works of this period reveal the impact of Matisse's *La Danse* and *La Musique* (1908): Amiet's *Red Apple Harvest* (1912) and Schmidt-Rottluff's *Bathers* (1913) are just two examples.[70] Matisse's ideas about decoration in *Notes d'un peintre* had been translated into German in 1909 and enjoyed a popular response among the artists of the New Secession.[71] Like Matisse, Mueller sought in his work calm and

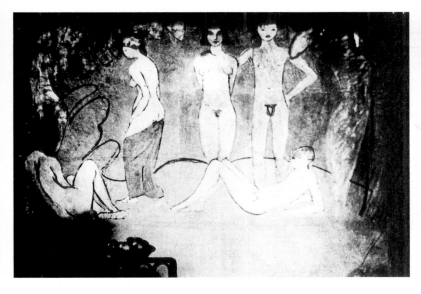

54. Otto Mueller, murals in his Berlin atelier, Mommsenstraße 66, 1911/12. Destroyed. Photo private collection.

monumental decorative effects without the added ingredients of spontaneity and passion Heckel described in 1908. This separates his work from that of the other *Brücke* artists and explains his enthusiam for early Greek and Egyptian, rather than tribal, art.

A sketch in the Heckel estate shows that he also planned wall paintings for the Mommsenstraße 60 atelier (fig. 56). These were related to the 1911 'curtains' in his Dresden studio showing bathers and seated figures. Alfred Hentzen claims that Heckel and Sidi decorated their first Berlin atelier with 'batik'.[72] In the sketch we see a very loose and abstract drawing style, developed by Heckel in his fast sketches, which is truly hieroglyphic in the same sense as Kirchner's Berlin drawings; that is

55. Otto Mueller, *Nude with Greek Vase*, 5 January 1911, pencil. Altonaer Museum, Hamburg.

56. Erich Heckel, *Nude in a Room*, 1912. Pencil and watercolour, 45.7 × 36.5 cm. Brücke-Museum, Berlin.

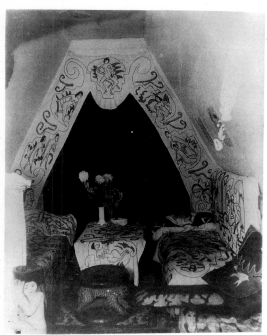

57. E.L. Kirchner's atelier, Berlin-Steglitz, Körnerstraße 45, 1914/15. Photo archive H. Bolliger and R.N. Ketterer, Campione d'Italia.

to say, a network of lines and marks, sometimes applied over an abstract layer of colours, which stands as an equivalent for, rather than as a representation of, the chosen subject. A second drawing, *Nude in a Room* (1912), shows traces of wall paintings, or possibly the curtains he brought with him from Dresden, as the rounded hills and bathers recur. This drawing also shows a new version of the curtains in Kirchner's Dresden atelier: this time the rondels contain single figures drawn in the swinging, rhythmic Ajanta style of 1912. These curtains were apparently red, featuring in *Two Girls under a Red Curtain* (Vogt 1912/4) and in the drawing *Washing Herself* (1912). In the drawings, the figure style of the studio nudes is closely related to the motifs on the curtains, almost as if they had stepped out of the decorative work. In *Two Girls* and *Sick Girl* (Vogt 1912/10), which contains the seeds of the triptych form of *Convalescent* (1913), we find, on the contrary, an opposition between the restricted movements of the clothed women and the freely moving nudes in the curtain rondels.

The decorations in Kirchner's studio at Durlacherstraße 14, where the MUIM Institute was situated, have already been described (see fig.7). Kirchner wrote of this new atelier in a letter to Frau Schiefler, which must date from early 1912: 'my space is somewhat more conventional than it was in Dresden, but some interesting things like the divan with a carved figure by me and the tea table with three figurative columns are still to be seen'.[73]

One new element in the MUIM decorations is the embroidered tablecloth, inspired by a coptic design and sewn by Erna and Gerdi Schilling. Kirchner, we learn in a letter to Gustav Schiefler in February 1912, was hoping to gain financially from this new handicraft: 'If it interests you, I'll send you a pair of table cloths designed by me and embroidered on felt. Years ago I made a lot of things like this and it seems there's an interest in them now.'[74] He was probably referring to a 1904 writing-case with embroidery.[75] The letter shows how Kirchner recognized a propitious climate for a revival of the *Jugendstil*-based craft techniques of his early career, techniques which had been continued and transformed during the intervening period in the context of the studio decorations.

In November 1913, Kirchner moved into a new atelier in Körnerstraße 45, and photographs of these attic rooms show that both the old wall hangings on bed linen from Dresden, and new embroidered and appliqué works were used as decorations (fig.57). The embroidered motifs still show bather scenes and couples, but the overt and blatant depictions of sexuality have vanished, and a new domestic element appears. The studio contained an embroidered tent-arrangement on the end wall, which flanked two sofa beds and a table with similarly embroidered cushions and covers. This appears in Kirchner's painting *The Tent: Interior in Berlin Studio* (1914;G.393), where the female nude with Erna's features is modelled like one of the embroidered designs. Kirchner depicts himself in a red jacket with a vivid green face in front of the nude, setting up a familiar opposition of clothed and nude figures and a new sexual tension which often marks his Berlin works. In this case, the psychological tension and opposition between the two figures is heightened by their physical contact along the woman's thigh and the top of Kirchner's arm. Just as the free and uninhibited sexuality of the bohemian Dresden years has been replaced by a new and disturbing sexual tension, so too the studio decorations have become more fixed and static. Two 1915 photographs, which show Hugo Biallowns dancing nude in an increasingly shabby atelier space, indicate that the old studio atmosphere could be rewon on occasion, but in a less relaxed, more extreme form (fig.58). The alternative to this scene of wild revelling is Kirchner's spectral self-portrait photograph in military uniform, and the descriptions of him sitting in the darkened room after his release from the army surrounded by the ghostly white faces of his painted sculptures. It was only later, after the nervous shocks of city life and the war had passed, that Kirchner could regain his confidence in the positive union of art and life on a new and more domestic basis in his mountain retreat in Davos in Switzerland.

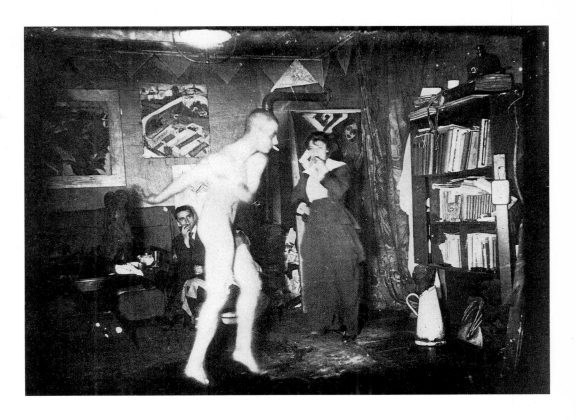

58. Werner Gothein, Hugo Biallowons and Erna Schilling in Kirchner's atelier, Berlin-Steglitz, Körnerstraße 45, 1915. Photo archive H. Bolliger and R.N. Ketterer, Campione d'Italia.

59. Max Pechstein, *At the Seashore*, 1910/11. Textile inks on muslin, 255 × 200cm. Brücke-Museum, Berlin.

In this later environment, which falls outside the scope of the present study, a new interest in folk art appeared which was entirely absent from the pre-1914 primitivism of the *Brücke* decorations, despite the lively interest in German folk art in Dresden at the time. This is an important point, because it distinguishes *Brücke* primitivism from that of the *Blaue Reiter* and of Emil Nolde, who made an enthusiastic analogy between European folk art and non-European styles. Partly this can be explained in terms of the conservative, anti-modernist interpretation proposed by Oskar Seifert, who spearheaded the revival of folk art in Dresden, and who described *Jugendstil* as 'foreign rubbish'.[76] In more general terms, indigenous folk art, like the rolling farming landscape of Göppeln to the south of Dresden, could easily be associated with a type of bourgeois, picturesque *Gemütlichkeit* in conservative Dresden, which was *anti-modern* in emphasis, and quite foreign to the modernist aspirations which Kirchner in particular subscribed to before 1914.

In 1912, Max Pechstein left *die Brücke* after exhibiting separately at the Berlin Secession. He moved out of Durlacherstraße 13 to a new atelier at Offenbacherstraße 1; and his memoirs record how he decorated this space to disguise the lack of furniture – although his financial hardships had been much alleviated by his more or less constant employment on decorative commissions in the burgeoning Berlin housing industry after 1908. His vision of penniless bohemia was more of a romantic ideal than a reality by this stage. The single surviving item of decorative work from the pre-war studios which used to be in Pechstein's Offenbacherstraße atelier is now preserved in the Brücke Museum (fig. 58). This is a large muslin sheet painted with a paradisal scene of frolicking bathers, set in a South Seas island with palm trees; a material realization of Pechstein's dreams and fantasies about leaving Europe and following Gauguin's path to the South Seas to visit the Palau Islands, which became a reality for him in 1914. Both the style and subject of the wall hanging are decidedly European in the tradition of Gauguin and Matisse: once again the ring of dancers behind the foreground group are inspired by Matisse's Shchukin decorations.

After his return from Palau in 1917, Pechstein decorated his atelier in Kürfursten-

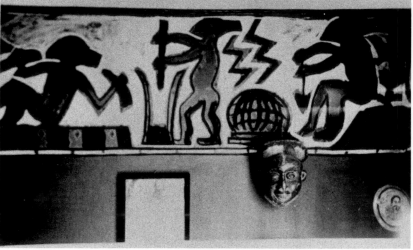

60. Max Pechstein, decorations in Kurfürstenstraße 126, *c.* 1919. Destroyed. Photo archive Günter Krüger, Berlin.

straße 126 with a rather pedestrian and stilted copy of the Palau beam carvings (fig.60). Totally Europeanized before his journey and little more than a pastiche of non-European style afterwards, Pechstein's studio decorations fail to achieve the integration of primitivist themes and styles into the fabric of his own life experience; and it was this more than anything else that had guaranteed the freshness and vitality of the early *Brücke* studios.

After leaving his Durlacherstraße studio in May 1912, Pechstein had moved temporarily into Hugo Perls' Mies van der Rohe villa in Zehlendorf and, interestingly, he adapted the styles and subjects of the early *Brücke* studios here to decorate a bourgeois dining room. Perls, a wealthy art collector and legal expert in the Ministry of Foreign Affairs, described the murals:

> Max Pechstein had decorated the dining-room in the house Mies van der Rohe designed. He produced 38 nudes, all in ochre, green and blue on white grounds. Later I gave the paintings, which were on canvas, to Justi for his 50th birthday. He built a fine room for them in the Nationalgalerie but they disappeared soon after and I do not know what happened to them...[77]

Surviving sketches and photographs of the decorations (figs.61–2), show that they related closely to Pechstein's bather paintings, inspired both by Moritzburg and by his summer trips to Nidden on the Baltic coast. In stylistic terms, they come close to early Hodleresque nudes which featured in his decorative schemes for the 1906 Decorative Arts Exhibition.[78] Pechstein also made metalwork radiator screens in the dining room and salon, an example of the type of work meant to have been included in the MUIM teaching programme. In the dining room screen the motif of three standing nudes, which recurs in contemporary stained glass designs by Pechstein, is integrated into a decorative frame with *Jugendstil* overtones. In the context of the entire decorative scheme, the bather motif becomes a determining factor, breaking down the boundaries between interior and exterior space; the rhythmic movements of limbs and hills are played off against the stark geommetry of Mies' neo-classical architecture. Whereas in the bohemian ambience of the *Brücke* studios the bather decorations became part of a living iconography of the primitive, an integral part of their ambition to effect a creative interchange between art and life, here they merely set the tone for a cultivated and civilized bourgeois existence.

Pechstein's decorations in the Perls villa are comparable to those executed by *Jugendstil* designers in private houses like Gustav Klimt's 1911 mosaic frieze for the *Palais Stoclet* in Brussels. The *Jugendstil* roots of the *Brücke* decorations reassert themselves, and the primitivist, bohemian studio hangings are adapted, without too

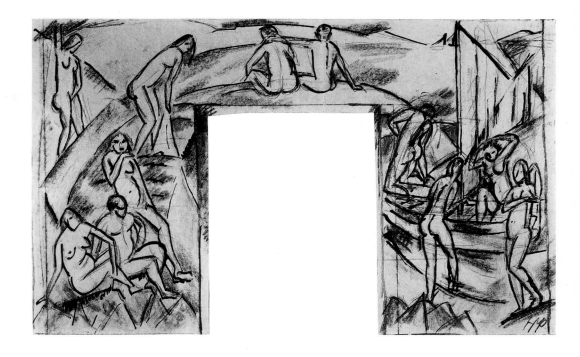

61. Max Pechstein, Sketches for the wall decorations in the Perls villa, Berlin, 1912. Photo archive Günter Krüger, Berlin.

62. Max Pechstein, Wall decorations in the dining room of the Perls villa, Berlin, 1912. Oil on canvas. Destroyed.

much trouble, to meet the needs of Pechstein's bourgeois client. His notions of interior decoration engaged with a set of ideas about the rôle of the artist in bourgeois society which enjoyed a certain currency at the time. In 1911, Pechstein's friend Friedrich Plietzsch, assistant at the National Galerie in Berlin, wrote in his dissertation *Schinkels Ausstattungen von Innenräumen* ('*Schinkel's Interior Decorations*') about Schinkel's ideal of subordinating detail to the decorative effects of the whole, quoting from an 1868 commentry:

> for him art was an indivisible unity, whether this meant building, carving or painting...even if the most modest article of daily use was the vehicle for art. Like the Renaissance masters, he too had the whole of life in view, where the power of great free personalities held sway and beauty held everything in harmony.[79]

Pechstein's harking back to nineteenth-century values, and his adaption of the bohemian *Brücke* style for a bourgeois dining room is not insignificant. I have attempted to show how the primitivist *Brücke* studios broke with the criteria of an evolutionary code: attempts to chart a straightforward development from exoticism to primitivism are irrelevant to the discussion of style in the studio decorations and paintings. So too are value judgements which try to exalt the importance of fine art at the expense of decoration. Evolutionary criteria nevertheless operate in these works in a wider political and philosophical sense. The association of women and children with their concept of the primitive, which we shall find constantly recurring in the studio, bather and street scenes, relates to the sexual and racial politics of social Darwinism, which regarded both women and native communities as 'children' occupying a lower rung on the evolutionary ladder. For *die Brücke* these associations had positive rather than negative connotations, suggesting a life force and an intuitive, 'natural' alternative to the rationalizing and calculating 'masculine' temper of their times. But this touches the ambivalent and problematic heart of their primitivism: for the 'attack' on bourgeois codes and practices inverted rather than truly subverted existing evolutionary criteria, and thus *reproduced* many of the ruling prejudices of their times in a new and 'positive' guise.[80] This also shows up in their notion of 'primitive' sexual prowess, a popular theme in paintings like Max Slevogt's contemporary *Victor* (fig.63), and on which Kirchner in particular dwelt in

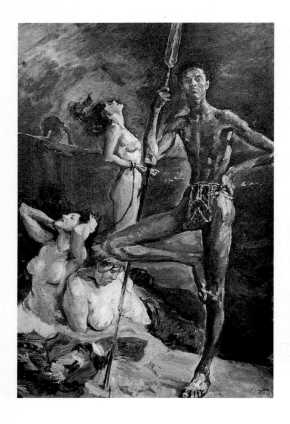

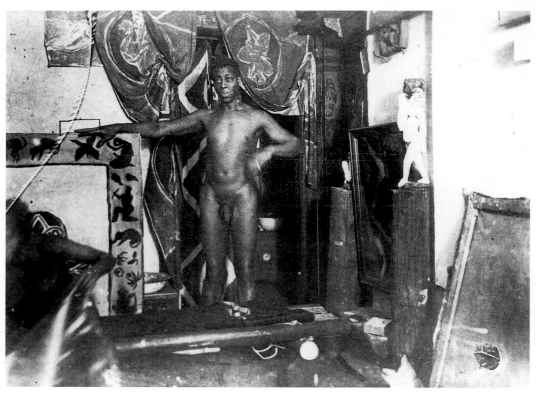

63. Max Slevogt, *Victor*, 1912. Oil on canvas. Kunstmuseum Düsseldorf.

64. Sam and Milli in the *Brücke* atelier, Dresden-Friedrichstadt, Berlinerstraße 80, *c.* 1910–11. Photo archive H. Bolliger and R.N. Ketterer, Campione d'Italia.

his depictions of the black couple, Sam and Milli, who pose nude in one of the 1911 studio photographs (fig.64).[81] The black performers are pictured in the photograph as 'living' sculptures, alongside Kirchner's own *Dancer with a Necklace* (1910), thus personifying the primitivist ambition to affect a synthesis of art and life. But this also involves a voyeuristic aestheticization of the couple, and testifies to the thin line Expressionist primitivism treads between revolutionary aims and a tendency to reconfirm the status quo. If the ambition was to reinvest art practice with the vitality of life, the danger always existed of 'freezing' life into art, of reading history in aesthetic terms.

A comparison between Kirchner's atelier and Makart's studio in Vienna (fig.65), makes clear how the studio decorations as a whole expressed this Expressionist ambivalence. Makart's exotically decorated studio, which cost over 127,000 gulden and functioned as studio, salon and ballroom, set the style on a grand and princely scale for the bourgeois salon. It was a model of *Gründerzeit* taste. Robert Stiassny's description in 1886 of the room recalls how Makart's visitors encountered there, 'all periods and peoples, a cosmopolitan and synchronic rendez-vous...one met there on a richly decorated German Renaissance chest a Chinese idol or a Hellenistic anathema in terra cotta...antique and medieval weapons...busts, animal skeletons, mummies, oleander trees.'[82] The cheap, hand-made *Brücke* studios, which were the setting for bohemian bacchanals rather than society balls, cut through the historicist paraphenalia of nineteenth-century precedents like Makart's studio. But the Expressionists also retained something of the magpie attitude to other cultures, appropriating periods, peoples and art forms for their own romantic and exotic ends, and creating an environment not dissimilar to Karl May's famous 'Red Indian' study in Radebeul near Dresden. The extreme visual contrast with Makart's studio does not wholly conceal a certain similarity that relates to the imperialist dreams of a bourgeois imagination which collects 'trophies' from the wider world in the private, aesthetic realm of the artist's studio. Both Makart's and Kirchner's ateliers provided an imaginative space into which their bourgeois friends and admirers could project

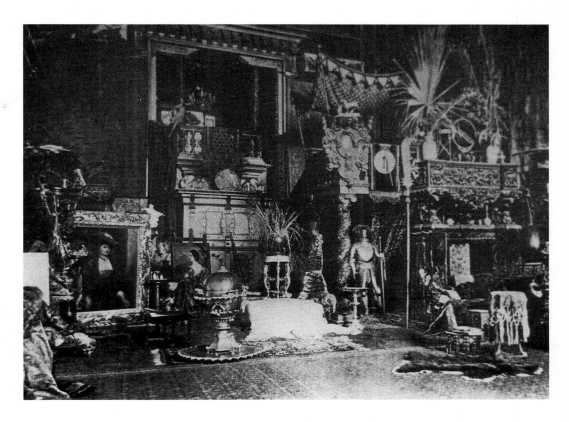

65. Photograph of Hans Makart's studio, Vienna.

their dreams and fantasies. In Kirchner's case, however, the fashionable fancy dress has disappeared, and these imaginative voyages could prove to be an uncomfortable business; there are no padded armchairs nor soft couches for dreamers to rest and linger.

4 Primitivism in Public Places

BY 1911, the Expressionists' primitivism was moving into a public arena. On the one hand, this had to do with their involvement in projects for industrial reform through craft, promoted by Osthaus and most fully realized in Pechstein's stained glass. On the other hand, it involved a new self-conscious search for 'German' identity within the broader context of international modernism before 1914. Following Gordon, Marit Werenskiold has argued that Expressionism was promoted as a national style only *after* 1914, when Paul Fechter's book *Expressionismus* was written in response to the chauvinist climate of the First World War.[1] In fact, the years directly preceding the war involved a fragile balance of national and international aspirations, in keeping with the broader political situation. Geoffrey Perkins and Ron Manheim have demonstrated, in their analyses of the genesis and usage of the term Expressionism before 1914, how this dichotomy operated on a theoretical level.[2] But little attention has been paid to the historical implications of this issue, nor to its practical implications for Expressionist art. These issues are best approached via a study of Expressionist primitivism as it emerged in public decorative works like the 'Gothic' chapel Kirchner and Heckel designed for the 1912 international Sonderbund Exhibition in Cologne.

The language of international Modernism between *c.*1908 and 1912, which recalled Symbolist aesthetics from the turn of the century like Maurice Denis' *Définition du néo-traditionnisme* (1890) often sought to counteract the personal and subjective emphasis of the new 'expressive' art by relating it to a monumental, public tradition of decorative painting. In Germany the New Secession promoted the idea of a modern art 'for walls', following the rift with the original Berlin Secession in 1910 when twenty-nine artists of the Expressionist generation were rejected by the older naturalist jury.[3] The preface to the third New Secession exhibition catalogue in the spring of 1911, which draws on Roger Fry and Matisse for inspiration, stated that the Expressionists' aim was to render 'subjective sensations of an object...distilled into a characteristic expression so that the expression of one's subjective sensation is strong enough to suffice for a mural, in a coloured decoration...'.[4]

Increasingly, the interests and enthusiasms of the Expressionist generation were described in similar terms. For example, El Greco, whose work was popularized in a series of German monographs after 1909 and warmly embraced by the Expressionists,[5] was praised in 1914 for 'striving after a monumental, decorative style of painting' associated with the Middle Ages rather than the Renaissance, and understood by August Mayer as 'expressionist' and 'mystic'.[6] El Greco, along with medieval art, non-European art, folk art, child art and modern European art appeared in the *Blaue Reiter Almanach* as one of the 'spiritual' alternatives to the

materialistic values embodied in post-Renaissance realism. Already in the winter of 1911 another journal, *Umělecký Měsíčník,* which must be regarded as a direct precedent for the almanach, was published by the Czech artists' group Skupina Výtvarných Umélcu. In *Umělecký Měsíčník* we find a similar range of interests and visual stimuli, illustrated alongside innovative designs and architectural plans from the reform movement in the decorative arts, which are not included in the *Blaue Reiter* publication.[7]

In many ways *die Brücke*, in the last three years of their association, stand at a cross-roads between French and Central European avantgardism. In the summer of 1911 Bohumil Kubista, from the Skupina group, joined *die Brücke* and the group exhibited in Prague, Budapest and Moscow between 1911 and 1913.[8] The *Brücke* artists' engagement with Cubist style in 1912 owes much to this Czech connection, as Kubista had reinterpreted the formal experiments of Picasso and Braque in the light of his own 'expressive' and religious imagery which was more relevant to the Germans than the direct example of France. By 1914, this led Kubista to a new and individualistic interpretation of the term 'synthetic' Cubism. He complained about the French obsession with form and surface, 'more concerned with the outer body of the object, and in this sense even Picasso is analytic. Synthesis will only come into being when more attention is paid to the spirit. The chief thing is the spiritual content of the new form.'[9]

As we have seen, the decorative, primitivist mode of the *Brücke* studios provided a private setting to explore the issues that emerged on a public front in modernist aesthetics after 1910. During the final phase of their association, *die Brücke* responded to public discussion about the rôle of decoration, and produced a series of primitivist schemes which engaged with the 'spiritual' direction promoted by the Central European avant-garde and Wilhelm Worringer's publications on the Gothic, *Abstraktion und Einfühlung* (1908; *Abstraction and Empathy*) and *Formprobleme der Gothik* (1911; *Problems of form in Gothic Art*). Worringer described the Gothic style as a hybrid mode, expressive of Northern man's psychology, and mediating between the impulses towards representation and abstraction. An amalgam of contradictory currents, the Gothic style also formulated a new expressive synthesis, a higher, transcendent realism, described by Worringer as a synthesis of objective and subjective realities. 'Gothic' art was loosely understood (as we have seen in Simmel's writings and in Meier-Graefe) to symbolize a lost organic unity between life and art, embodied in the spiritual environment of the church interior.

The spiritual and socially 'organic' associations of the Gothic style made it an appropriate tool for the rejuvination of modern industry – expressed, for example, in the revival of stained glass and mosaic to decorate modern buildings. Pechstein became directly involved in these projects, executing designs for Gottfried Heinersdorff's stained-glass atelier. This activity provides an interesting example of how close 'progressive' reformative activity in the decorative arts could come to official, conservative practice in Wilhelmine Germany. Much of Heinersdorff's work was carried out by the firm of Puhl und Wagner, which had been founded as a mosaic workshop in 1889 under the personal protection of Wilhelm II. The Kaiser approved of mosaic and stained-glass decorations because they suggested a relation between his own empire and the Holy Empire of the Middle Ages. Paul Schwechten's bombastic official architectural projects, like the Kaiser-Wilhelm Memorial Church and the Anhalter Railway Station were decorated with 'medieval' mosaics and stained glass in the style of nineteenth-century historicism. Heinersdorff set out to replace historicist medievalism with a new and pungent 'Gothic' primitivism; but the transition from one mode to the other was obscured by the fact that both official and modernist circles used the 'Gothic' as a sign of national identity.

Max Pechstein's early training in the decorative arts was more protracted and thoroughgoing than that of his *Brücke* colleagues. In 1896, he had been apprenticed to a decorative painter and joined a traditional workshop with ten apprentices specializing in the popular illusionistic techniques of Wilhelmine decoration: flower

66. Drawing of entrance to an apartment block, Berlin-Friedenau. Architecture by Schneidereit and Wünsche; decorations by Max Pechstein. Destroyed. Photo archive Günter Krüger, Berlin.

67. Photograph entrance hall in a Berlin apartment block. Architecture by Alfred Wünsche; decorations by Max Pechstein. Destroyed. Photograph from *Innen Dekoration*, 21, July 1910.

painting, landscapes, baroque ornamentation, theatrical perspectives and imitation marble. In 1900, he took his guild examinations and moved to Dresden where he enrolled at the School of Decorative Arts in the studio where interior decoration was taught. In 1902, he transferred to the Academy where he became a pupil of Otto Gussmann. His designs for the Dresden Cathedral and other successful decorative schemes must have encouraged Gussmann to recommend him for the 1906 Decorative Arts Exhibition where he met Erich Heckel. At the end of that year, Pechstein received his first important commission for stained glass – a window for the town-hall in Eibenstock. By February 1907, he was writing to Gottfried Heinersdorff about sketches for six apartment block windows commissioned by the architect Bruno Schneidereit in Berlin-Friedenau.[10]

In 1907, Pechstein won the Rome Prize and went to Italy where he was enthusiastic about Etruscan art, Ravenna and the mosaics at San Apollinare Nuovo. From there he travelled to Paris, and in his 1923 monograph Max Osborn claimed that Pechstein was less interested in contemporary French art than in 'the Gothic sculptures at Notre-Dame and St Denis, the ancient French monuments in the Musée Cluny, and the ethnographic curiosities at the Trocodéro'.[11] In the summer of 1908, Pechstein moved to Berlin when Schneidereit invited him to work on the decorations for the Haus Cuhrt, a new apartment block on the fashionable main street in the west end, Kürfurstendamm. This provided the other *Brücke* artists with a base in Berlin before they took up permanent residence there in the autumn of 1911, and Pechstein was assured of a steady income, working on various decorative schemes for the burgeoning apartment blocks on Kürfurstendamm and Kaiserallee. The nature of the enterprise was commercial, but Schneidereit was a progressive architect involved in decorative reform. He became a non-active member of *die Brücke* and was on the working committee for the West German Federation for Applied Art after 1910. Bright glass was used in the apartment blocks to dispel the urban gloom; and window-walls and walls facing the windows were usually painted too. The governing idea was a harmony of architecture and decoration, 'an entire spatial composition',[12] influenced by Max Klinger's ideas concerning the interaction of the arts (figs.66–7).

From May to August 1909, Pechstein exhibited a two-part window for an apartment by Alfred Wünsche in the 'Zoo-Exhibition of Interior Decoration and Products by the Berlin Wood Industry' where he received good reviews. The same year he was commissioned to design a large window for the music room of bank director Tetzner in Chemnitz (fig.68; compare fig.69). Pechstein used very brightly coloured glass: blue-violet and orange with blue-green accents. The window design had an exotic flavour, and the three female figures relate to those in Pechstein's exotic oil painting *The Yellow Cloth* (1909;fig.71), which was influenced by Gauguin and Delacroix and enjoyed popular success at the Berlin Secession that year.[13] In the winter of 1912, Pechstein also drew some exotic designs for Max Reinhardt's production of *Genoveva* (fig.70) which were rejected as Reinhardt preferred stark, uncluttered stage sets. However, the project gave Pechstein added experience in the orchestration of interior space.[14]

Of course, Pechstein's decorations for private bourgeois rooms, including Perls' Mies van der Rohe villa in Zehlendorf, like the bohemian *Brücke* studios, had little to do with the broader ambitions promoted by Osthaus to reinvest mass production with the integrity of fine art practice. Typically Osthaus most admired Pechstein's freely conceived designs, like his windows for Alfred Wünsche's exhibition building for the *Terrasit Industrie GmbH*, made for the Exhibition of Clay, Cement and Chalk Industries in 1910 in Berlin (fig.72). These windows were exhibited at the Folkwang Museum in 1911 and sent on a travelling exhibition of Osthaus' German Museum for Commerce and Trade.[15] But some of Pechstein's stained glass came closer to a practical realization of Osthaus' ideals: for example, he designed small cheap glass panels for Gottfried Heinersdorff, known as 'Decorate-your-Home'. These were conceived as mass-produced decorations for the common household,

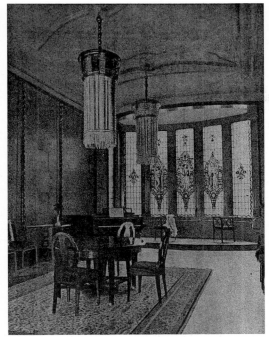

68. Photograph of bank director Tetzner's Music Room in Chemnitz, with windows by Max Pechstein, 1910. Destroyed.

69. Max Pechstein, *Three Standing Female Nudes*, 1910. Three-part window in coloured glass, each 135 × 29cm. Brücke-Museum, Berlin.

70. Max Pechstein, *Designs for Genoveva*, 1912. Pen and ink. Brücke-Museum, Berlin.

and they were one of Heinersdorff's less sophisticated attempts to adapt stained glass production to modern requirements.

Gottfried Heinersdorff developed his ideas about the revival of stained glass techniques in a series of articles which culminated in his 1913 publication *Die Glasmalerei* (*Stained Glass Painting*), with an introduction by Kurt Glaser. In 1912, Heinersdorff named Jan Thorn-Prikker, a member of the Folkwang circle as from 1910, Harald Bengen and Max Pechstein as the three most promising young artists involved in stained glass design.[16] In this text he explained his central notion of direct unmitigated relationships between artists and artisans, between designs and products, echoing Simmel's ideas about art production. The traditional division of labour between artists' designs on paper and workshop execution was to be bridged by the new concept of the artist-craftsman, who executed his own designs.

71. Max Pechstein, *The Yellow Cloth*, 1909. Oil on canvas. Destroyed.

tiene mucho de Nietzsche

In his introduction to *Die Glasmalerei*, Glaser elaborated this line of argument. The aim of recent departures in stained glass design, he insisted, was to halt the nineteenth-century decline of the medium into pseudo-easel painting or small-scale work in coloured glass and so to regain 'the moving effects of the old windows in our Gothic cathedrals…that is to say, mysterious, painterly and architectonic, ornamental and psychological effects'.[17] Glaser compared and contrasted Gothic stained glass with the new revivalist movement in terms of a transforming primitivist impulse, pointing out that '…therefore we can see that the recent, self-conscious, almost refined primitivism of the new artistic generation is quite original, although it has some points in common with the great mature primitivism of the ancients'.[18] The young artists' aspirations to achieve monumental, 'spiritual' effects distinguished their work, in Glaser's view, from the mere decorative essays in the medium by Henri Van de Velde, Tiffany and Melchior Lechter.

Glaser considered Thorn-Prikker the most important exponent of the new movement and discussed his work in terms of its primitivist 'Gothic' qualities: 'Thorn-Prikker is attracted by the great primitives. His imagination looks back across many centuries, to embrace Giotto fervently, to search for the spirit of Gothic and Early Christian art.'[19] Thorn-Prikker, Glaser continued, was drawn to the formal and expressive values of medieval stained glass rather than to the old legends and stories. He used light falling through coloured glass to orchestrate space, like the chords of organ music, and reduced and simplified to achieve expressive power. Despite the 'Gothic' inspiration of his work, Thorn-Prikker was 'essentially modern'.[20] To adapt stained glass to the needs of the modern world it was necessary to find new subjects. Modern industry should also stimulate talent by means of commissions. Repetition of religious subjects, Glaser observed, quickly becomes empty formalism in the twentieth century, and he called for stained glass 'where social poetry can be represented'.[21] Thorn-Prikker's windows for the station at Hagen, commissioned by Osthaus in 1910, provided a model for how the formal and psychological potential of religious stained glass could be rewon for modern subjects. The theme of these windows was the artist as instructor for decoration, and they were executed in Heinersdorff's workshop. Glaser wrote of the 'Gothic' character of modern concrete and iron buildings which were crying out for stained glass as 'an organic part of a universal building concept'. He hoped that 'the noble ancient art of stained glass has now been reawoken after a deep sleep across the centuries, and that this reawakening heralds something like a renaissance of the Gothic spirit'.[22] The illustrations in *Die Glasmalerei*, which recall those in the *Blaue Reiter Almanach*, show glass dating from the twelfth to the seventeenth centuries – from the cathedrals in Marburg, Cologne and Erfurt. The eighteenth and nineteenth centuries are passed over because of their associations with decline, and the new exponents of stained glass design complete the book.

Glaser's comments raise familiar themes: he proposed the Gothic revival as a social and artistic model to counteract the secular, fragmented and materialistic bias of the modern world. But – and this is of some importance – 'Gothic' primitivism was not seen as a nostalgic, romantic alternative to modernity. On the contrary, an engagement with the themes and challenges of modern life were considered an essential condition of revival. Glaser's notion of the primitive is located at the juncture between past and future, just like modernity itself, looking both backwards and forwards. It is a Janus-faced concept, signalling in two directions.

Contemporary discussion about Max Pechstein's stained glass also referred to its 'Gothic' qualities. A 1913 article illustrating his Tetzner windows suggested that his glass recalls, 'the classic great age of the dark Middle Ages'.[23] Georg Biermann, writing in 1919, insisted that Pechstein's art transcended the boundaries between 'craft and art'. His work was:

> craftsmanship, like the religious paintings created anonymously by the painters' guilds for the churches and chapels on chalk-white walls, or on wooden altar

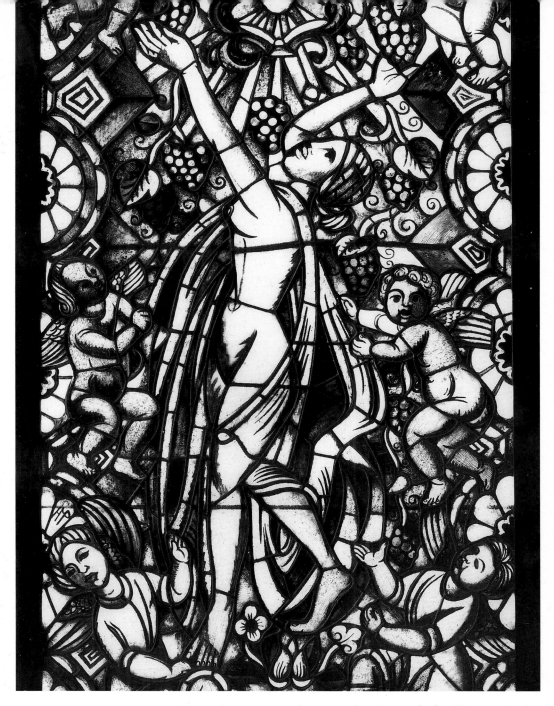

72. Max Pechstein, 1913. *Autumn*, Stained glass window. Stiftung Preußischer Kulturbesitz, Kunstgewerbemuseum, Berlin.

pieces. To conquer walls with painting they (Pechstein and the Expressionist generation) penetrated the craft workshops and personally supervised the casting of their stained glass windows or ceramics, in order to recover lost techniques through experimentation.[24]

Once again, Biermann emphasizes the direct, unmitigated contact between mind and hand, which is the prerequisite for authenticity in the age of mass production. But in fact Pechstein's glass was not always produced by his own hand, and there was, of course, a theoretical contradiction involved in the notion that 'handcraft' could be extended beyond the realm of individual practice to rejuvinate modern industry. The most 'Gothic' of Pechstein's pre-war designs were the windows he made as part of the project to renovate the Fritz Gurlitt Gallery in Berlin in 1913 – *Spring*, *Woman with Animals* and *Autumn* (fig.72). The gestures, colours, subjects and irrational scale of these figure compositions all recall Gothic models, although

Woman with Animals relates to Pechstein's contemporary sketches of bathers and *Autumn* refers to a Pechstein drawing related to Botticelli's *Birth of Venus*.[25] The windows present complex layers of reference to 'Gothic' models and to contemporary experience. Günter Krüger has pointed to some conventions of Cubist composition, facilitated by the splinters of coloured glass which Pechstein also explored in his 1913 still-life paintings.[26] *Autumn* also relates to his depictions of dance and cabaret subjects. In 1913, Stravinsky's *Rites of Spring* was performed by the Russian Ballet in Berlin, and the spirit of the maiden dancing herself to death to renew the life of the soil may well have influenced Pechstein's image. In many ways the windows show an attempt to rethink 'Gothic' effects in terms of a contemporary, 'modern' vocabulary. As for the theme of artist-craftsman, Pechstein did not make all three windows himself. *Spring* and *Autumn* are mono grammed by Pechstein, but *Woman with Animals* was executed by assistants in Heinersdorff's stained glass workshop.

The significance of the 'Gothic' as a national style, symbolizing a great period of northern achievement in the plastic arts, was implicit rather than explicit in stained glass revival. Throughout the Wilhelmine era in Germany, discussion about national identity in the arts had been aggressively encouraged by Wilhelm II and his spokesman in the Academy, Anton von Werner, as they both sought to promote German art as a cultural symbol of the political ambitions of the empire.[27] A new type of radically conservative and nationalistic art literature was spawned, stressing the northern 'Germanic' tradition. Julius Langbehn's *Rembrandt als Erzieher* was the most notorious and widely read of these 'volkish' books.[28] In opposition to these chauvinistic official policies, the Secession movements in Germany and several of the more progressive museum directors sought to introduce modern French and European art. This liberal, international direction came under increasing attack from the right as Wilhelm II stepped up his imperialist programme in the years immediately preceding 1914. In 1908, Heinrich von Tschudi's dismissal from his position in the Berlin National Gallery, following a controversy about his purchases of French art, was symbolic of this official determination to push through a chauvinist cultural programme at home and abroad. The official line encouraged a conservative reaction, and in 1911 Carl Vinnen's *Protest Deutscher Künstler (German Artists' Protest)* was signed by members of the Academy and the Secession who objected to the 'preferential treatment' given to foreign artists and the 'high prices' paid for French as opposed to German acquisitions.[29] In his foreword to the *Protest* Vinnen denied narrow chauvinist motives and aimed his attack on 'the aesthetes and the snobs' in the Sonderbund organization who were encouraging art to move in a 'theoretical and abstract' direction.[30] German art, Vinnen insisted, was characterized by visionary depth of imagination, regardless of its realistic or symbolic ambitions. But the 'individuality' of the Germans was being subverted by, 'a huge and financially powerful international organization'[31] promoting a succession of fashions and styles and encouraging expensive purchases of French art instead of paintings by more worthy Germans.

What is interesting about Vinnen's popularist attack – and this is entirely ignored in Peter Bürger's theory of avant-gardism – is its challenge to the exclusivity, the social isolation of modern art and its connections with international capital, but from a conservative viewpoint rather than from a radical left-wing stance. Vinnen's *Protest* provoked a decisive response in progressive circles who rallied together to issue a rejoinder, *Im Kampf um die moderne Kunst: die Antwort auf den Protest Deutscher Künstler*, (*The Fight for Modern Art. An Answer to the German Artists' Protest*), published in 1911 by Reinhold Piper in Munich. The Expressionist generation and their supporters shared the Secessionists' distaste for chauvinist disavowals of French modernism; indeed the *Blaue Reiter Almanach*, published by Piper the following spring, was dedicated to von Tschudi's memory. But several important contributions to the 1911 *Antwort* stressed the importance of developing a national identity in modern German art, which might then advance on an equal rather than

an inferior footing with its French counterpart. Both Osthaus and Moeller van der Bruck associated this revival of national culture with a new union of architecture, painting and sculpture, with 'monumental painting' and 'modern German architecture' which Osthaus describes as 'an independent realization of German painting and sculpture'.[32] Dr Wilhem Niemeyer from Hamburg associated this national identity with the 'Gothic' tradition, in contrast to the classical heritage of French art:

> Our task on the contrary is the same as that of the Naumberg sculptors, as Holbein's and Leibl's, namely to combine an aesthetic of abstraction with specific truth to nature...long before the new painting became a topic of discussion, a type of painting had emerged in Germany that was related to French art, but was nevertheless different and national.[33]

Niemeyer's terms show the strong influence of Worringer's writings, whose influential thesis *Abstraktion und Einfühlung* had first proposed the Gothic style as a unique synthesis of a southern, empathetic, realist tradition with a 'primitive' urge to abstract.

Worringer's own contribution to the *Antwort* was the first programmatic discussion about primitivism in modern German art, which he described as a distinguishing and central characteristic. Worringer was essentially a disciple of Riegl, and in 1911 he continued to attack evolutionary theories of art which asserted European superiority. The stylization of 'primitive' art did not result from inferior ability but rather from 'another kind of volition...a volition concerned with large, elementary presuppositions, which we can hardly imagine from the standpoint of our present, moderated grasp of life'.[34] In 'primitive' societies, Worringer argued, art was not a luxury but rather a vehicle of 'elementary sensations of necessity', engaging with a level of reality beyond surface appearances. By drawing inspiration from non-European traditions which were 'unsullied by knowledge and experience' modern artists could liberate themselves from 'a rational way of seeing', and transform the outward, literary symbolism that Vinnen understood as a national virtue into a new inner reality – thus freeing themselves from a contradictory relationship between descriptive form and symbolic content.[35]

Worringer pointed out that artists always sought inspiration in the past and suggested that the extreme swing of the pendulum which reached back to 'primitive' art resulted from the over-sophistication of modern society. Artificial, 'learned' ways of seeing had eclipsed the power of 'elemental nature' and it was this that modern art aimed to restore by following a primitivist direction which should lead to a rediscovery of its own identity. Primitivism for Worringer – and for Kandinsky[36] – was a means rather than an end to guarantee future advance,

> for whose sake we cultivate the present. This modern primitivism should not be a final goal. The pendulum never remains fixed at the broadest sweep. This primitivism should be seen much more as a means of passage, as a great long drawing of breath, before the new and decisive language of the future is pronounced.[37]

Worringer still adhered to the nineteenth-century obsession with progress. But he now conceived of this in terms of *a cutting loose from history*, as a plunging of elemental depths to assure rejuvination and renewal.

In many ways Worringer circumvented the dichotomy between French and German identity by lifting discussion onto the level of the primitive and universal. But he also suggested that modernist primitivism translated the imaginative, symbolic, German tradition into a non-literary mode. The lack of certainty and visual instinct in German art necessitated an outward looking, searching, mentality that Worringer interpreted in positive rather than negative terms as its most fundamental quality:

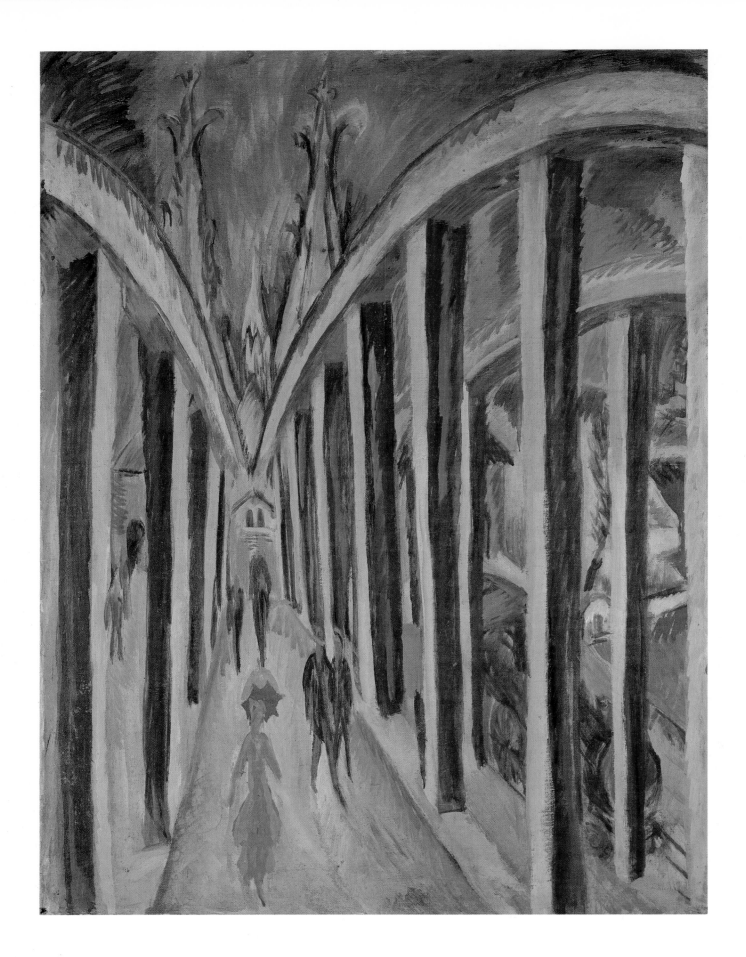

73. E.L. Kirchner, *Bridge over the Rhine in Cologne*, 1914. Oil on canvas. 120.5 × 91cm. Staatliche Museen zu Berlin, Nationalgalerie, Berlin.

74. E.L. Kirchner and Erich Heckel, *Madonna*, chapel in the Sonderbund exhibition, Cologne 1912. Textile inks on linen. Destroyed. Photo archive H. Bolliger and R.N. Ketterer, Campione d'Italia.

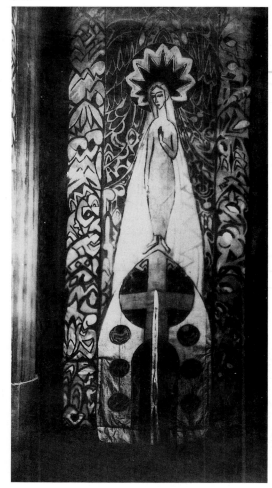

that we always pick up clues from outside…must always lose ourselves in order to find our true self – that has been the tragedy and the greatness of German art from Dürer to Marées. He who would cut our art off from the debate with other art worlds would deny our own national tradition. Because it is this that gives German art its own dynamic.[38]

Worringer's sophisticated analysis of German character was unusual; elsewhere in the Expressionist movement we find a fragile balance between national identity and international aspirations emerging in the years immediately preceding 1914. Primitivism was used by the Expressionists during these years as a way of engaging with this dichotomy. It was also employed to reconcile contradictory factors on a 'universal', ahistorical level, which Worringer viewed in 1911 as a positive synthetic force. Let us now look at this process in action.

Joseph Masheck has pointed out that the iconography of Kirchner's studio paintings occasionally includes references to early German art alongside other symbols of 'primitive' vitality.[39] For example, the poses of the female figures in *Two Women: Two Midinettes* (1911–12;G.189) are similar to those of medieval sculptures; and the elegant nude in Kirchner's more famous *Standing Nude with Hat* (1910–20;G.163) quotes the pose of Lukas Cranach's small *Venus* which we know Kirchner admired in the Städel Museum in Frankfurt. All these female figures are framed by exotic studio decorations. But Kirchner and the other *Brücke* artists engaged most directly with the 'Gothic' revival' in their preparations for the Cologne Sonderbund in 1912. Kirchner's emphasis on German tradition in his controversial *Chronik der Brücke* owes much more to his experiences in Cologne in 1912 than to the early history of *Brücke* woodcuts, which come far closer to *Jugendstil* than Dürer.[40] Kirchner's painting *Bridge over the Rhine in Cologne* (fig.73), which depicts the modern railway station and iron bridge alongside Cologne's Gothic cathedral, takes up the dramatic realization of Kurt Glaser's ideas about 'modern Gothic' that we find manifested in the cityscape of Cologne.

Unpublished correspondence between Osthaus and Wilhelm Niemeyer makes clear that *die Brücke* and Emil Nolde were involved in plans to found a union in 1911 to combine the German and Central European avant-gardes in a single organization. The thrust of these plans was to create a non-French group capable of asserting its own independent identity, and, by so doing, to provide an alternative to the Francophile bias of the Berlin Secession and Karl Scheffler's art magazine, *Kunst und Künstler*. The group, with Osthaus as president, was to have its own magazine,[41] but these plans came to grief because it proved impossible to find a suitable exhibition space.[42] In their own annual report in 1911, *die Brücke* mention plans for a major exhibition devoted to the *international* avant-garde, proposing a model which is usually associated with the activities of the *Blaue Reiter*. Alongside the international modern movement, they planned to show 'similar endeavours in the art of other peoples and ages'.[43] But despite this universalist dimension they asserted their national heritage in an international context in the 1912 Sonderbund exhibition in Cologne by undertaking to decorate a 'Gothic' chapel (fig.74).

A description of the *Brücke* chapel is given in the Sonderbund catalogue: 'Chapel (room 15). Stained glass window with scenes from the life of Christ and decorative designs by Jan Thorn-Prikker, Hagen I.W. executed by the stained-glass workshop of Heinersdoff Berlin. Painting on walls and ceilings (madonna and ornamental decorations) by Erich Heckel and E.L. Kirchner, Berlin.' An undated letter from Kirchner to Gustav Schiefler, which must have been written after his return to Berlin in May, provides a fuller description: 'I've been with him [Heckel] in Cologne, where we decorated a chapel in the Sonderbund exhibition. That is to say we've made batik decorations like those you saw in my Dresden studio.' Thorn-Prikker's windows are described:

…the many sensuous colours – red, green and blue – give the whole a mood of

mystical consecration. The whole thing is modern-Gothic. On the 13 metre high back wall I painted a Madonna, 4 metres high. It's a fine thing to paint a Madonna. The side walls first showed six scenes of miracles from the old and new testaments, but they were transformed by us into ornamental designs to create more spirituality. The colours of the chapel are violet red and a sharp green with blue.'[44]

The stylistic details of the Sonderbund chapel owed more to ornamental *Jugendstil* than to Gothic art, although the spirit of the enterprise obviously referred to Gothic examples. The technique which Kirchner describes as 'batik' consisted of covering the walls with raw linen, as in the Dresden studios, and using a mixed technique of painting and printing. Erika Billeter has pointed out that this Indonesian technique was known from the Dutch East Indian colonies and was popular in Holland in the 1890s.[45] Thorn-Prikker was influenced by Javanese batik in works like *The Three Brides* (1893) and probably he introduced Osthaus to these textiles as he modelled the wallpaper in his house at Hohenhof in Hagen on them in 1911. Generally the technique was enjoying a revival: in 1908, for example, the Reimann School for decorative art in Berlin took out a patent on the so-called 'Batik-pencil', and mounted an international batik exhibition. In the Sonderbund chapel Kirchner and Heckel combined 'Gothic', in terms of spirit and theme, with an exotic technique in the context of *Jugendstil* interior design. Once again a composite notion of the 'primitive' emerges, and it is difficult to distinguish between the exotic and 'Gothic' stimuli. For example, the characteristic combination of green and purple that Kirchner began to use at this date is usually associated with the colour illustrations of the Ajanta temple paintings he knew from the Dresden library. His oil painting *Striding into the Sea* (fig.76), was apparently inspired by the colour scheme and figure style of Ajanta. But green and violet also feature frequently as a colour combination in the stained glass of Cologne cathedral. It is not important to decide which is the 'correct' source, but rather to realize the multiple possibilities and overlayed references which correspond to the complex associations of the 'primitive' in 1912.

Kirchner's letter to Schiefler also raises the question of whether abstract or figurative styles were best suited to convey 'spirituality'. He records how Heckel and he decided to replace their original narrative scenes from the Old and New Testament with a decorative design 'to create more spirituality'. This may well reflect the influence of the *Blaue Reiter* group in Munich and of Kandinsky's essay *Über das Geistige in der Kunst* (*The Art of Spiritual Harmony*, published in December 1911), where he stated his belief in an abstract, dematerialized art based on a mixture of figurative traces and abstract pictorial effects in order to convey spiritual resonance. Macke suggested that Kirchner and Heckel should do the Sonderbund chapel decorations, and in November 1912 Kirchner wrote to Franz Marc describing their work there.

Originally four Evangelist heads in beaten tin by Karl Schmidt-Rottluff (fig.77) were also planned for the Sonderbund chapel, in keeping with the idea that interior design should unite different media and art forms. Reidemeister points out that these heads, which were rejected by the Sonderbund jury, revealed a mixture of 'Gothic' and contemporary influences. The heads are very similar to Schmidt-Rottluff's contemporary experiments with Cubism in his 1912 paintings *The Pharisees, Woman Reading* and *Woman's Head with a Mask*, but Reidemeister suggests Hans Mult-scher's *Wurzach Altarpiece* in the Kaiser-Friedrich Museum in Berlin as a direct source.[46] Gordon's attempt to add a specific non-European source, a rare leather Ekoi headdress, is visually unconvincing and lacks documentary proof.[47] The mask-like heads make a far more general reference to tribal art, and the attempt to recast international, Cubist avant-garde style in a 'spiritual' Gothic mode appropriate to the religious subject of the tin reliefs is typical of the broader philosophical implications of Expressionist primitivism.

The Sonderbund exhibition in 1912 presented an international survey, in contradistinction to the attempts of 'narrow minds who want to confine German art

in narrow boundaries',[48] nevertheless encouraged the *Brücke* artists to create an identifiable German space within the larger imaginative and geographical boundaries of the exhibition. The Sonderbund also confirmed the relationship between modernist avant-gardism and primitivism that Worringer had proposed in his 1911 essay. The catalogue introduction pointed towards 'the ubiquitous return to the primitive, be it Gothic art, the sculptures of barbarous peoples, or ancient pictures of Saints.'[49] Schmidt-Rottluff's attempt to unite a 'national' indigenous primitivism, referring to northern 'Gothic', with avant-garde primitivist style is very typical of this period of *Brücke art*. Their multi-layered primitivist vocabulary provided them with a means of drawing together different, and potentially contradictory and divisive, aspirations.

In 1914 the Expressionists were given a second opportunity to execute decorative projects at the Cologne Werkbund exhibition, where Osthaus once again played a leading role as president of the section devoted to commercial art and as a member of the general selection jury. The declared aims of the Werkbund were very much in line with the principles Osthaus had been advocating since 1902: '...the transformation of commercial products via 'a synthesis of art, industry and craft'.[50] Although Kirchner's decorations for the tobacco producer and art collector Joseph Feinhals are the most important and best known, Schmidt-Rottluff and Pechstein also contributed decorative work to the exhibition. In the main hall displaying 'outstanding examples of ancient and modern decorative art as a model for decorative production and museum exhibitions',[51] a cupboard designed by Schmidt-Rottluff was displayed. Pechstein exhibited sketches in a section devoted to Gottfried Heinersdorff's glass workshop. The twelve most important designers of the new movement – including Henri Van de Velde, Hermann Obrist, August Endell, Peter Behrens, Bruno Paul and Josef Hoffmann – were named the 'twelve apostles' of the 'new German movement in applied art'.[52] In a section of the main hall devoted to the Evangelical Church, Pechstein's *Head of Christ*, lent by Alfred Flechtheim, was hung alongside Emil Nolde's religious paintings *The Last Supper* (1909), *Christ Mocked* (1910) and *Christ with the Children* (1910).

But Kirchner's decorations on this occasion adopted a determinedly secular theme. Joseph Feinhals, joint president with Osthaus of the West German Sonderbund Organization since 1910, commissioned Kirchner to decorate his special exhibition, Art in Commerce and Trade, which was a sub-section of the exhibition (fig.75). Feinhals, who bought Kirchner's *The Grove* (G.198) at the 1912

75. E.L. Kirchner, decorations for J. Feinhals in the Werkbund exhibition, Cologne 1914. Destroyed. Photo archive H. Bolliger and R.N. Ketterer, Campione d'Italia.

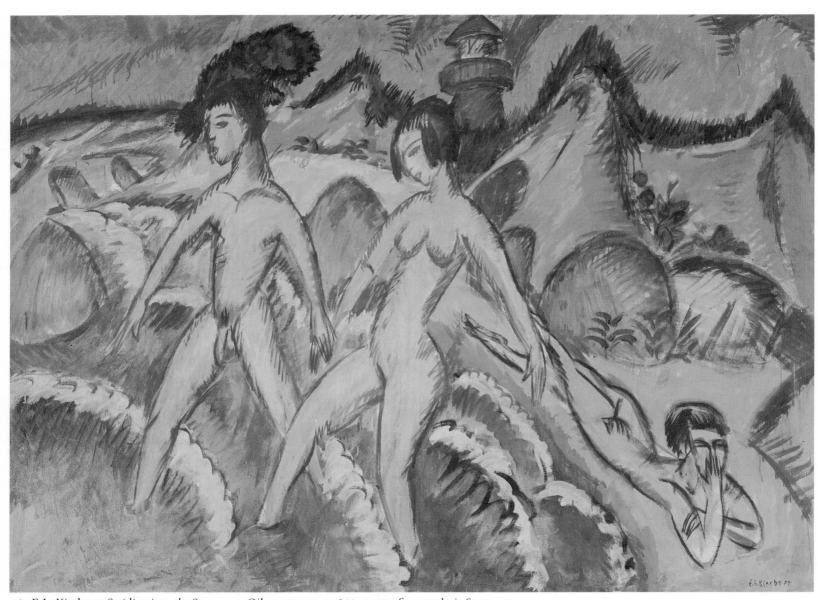

76. E.L. Kirchner, *Striding into the Sea*, 1912. Oil on canvas, 146 × 200cm. Staatsgalerie Stuttgart.

77. Karl Schmidt-Rottluff, *Four Evangelists, Matthew, Mark, Luke and John*, 1912. Brass relief, painted in oil, each head 42.5 × 33cm. Brücke-Museum, Berlin.

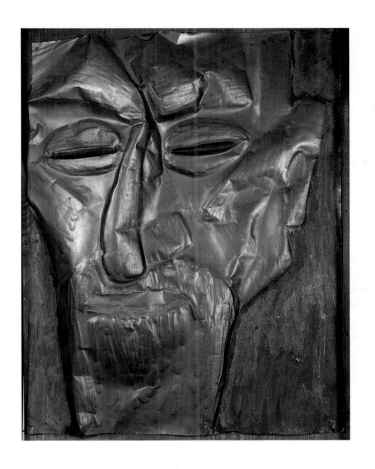
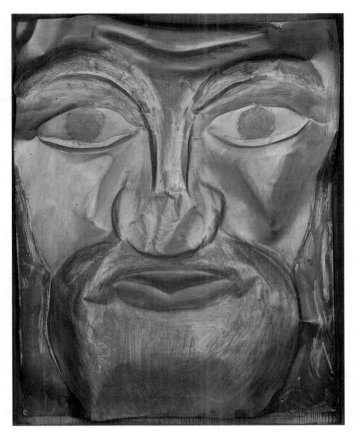
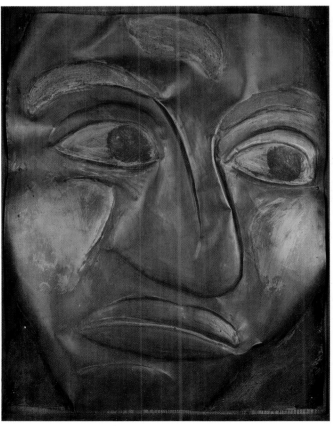
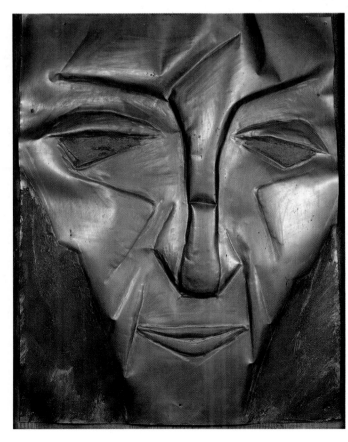

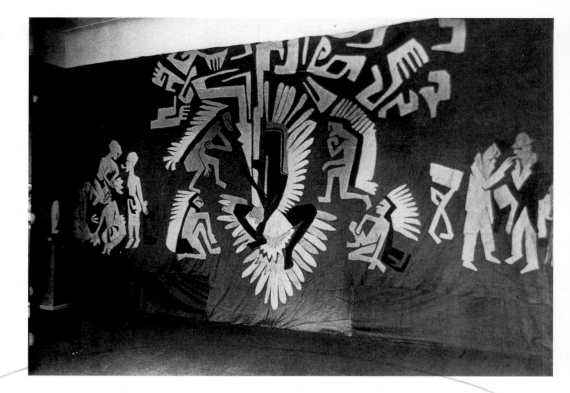

78. E.L. Kirchner, decorations displayed in the Feinhals villa in Cologne, built by Josef Olbrich in 1908. Coloured materials. Destroyed. Photo archive H. Bolliger and R.N. Ketterer, Campione d'Italia.

79. Tlingit ceremonial shirt with geometric and crest designs. Buckskin with red, black and white pigment, sinew and fibre. Thread trade cloth, 155cm wide. Peabody Museum, Harvard University since 1904.

Sonderbund, presented an exhibition 'The Fine Arts in Tobacco Production Then and Now'.[53] This included old tobacco packets, fashion plates, pamphlets, caricatures, woodcuts, engravings and coloured etchings dating from the seventeenth to nineteenth centuries from Holland, Germany and England. There were pipes from Delft, shop signs, a collection of recent cigar and cigarette packings from the Feinhals firm – and African sculptures. Presumably the African sculptures were used to allude 'historically' to the rôle negro slaves had played on the tobacco plantations, a social structure which was perpetuated under new terms of reference by imperial rule of native communities. This provides an interesting example of the various uses for tribal art beyond the narrow confines of the ethnographic museums in Wilhelmine Germany; it also points to the widespread manifestations of imperialist mentality. Western exploitation of black peoples could be referred to 'neutrally' by using aesthetic representations to distance reality, and many ways Kirchner's decorations result from the workings of a similar mentality.

Kirchner's wall hangings for the Feinhals room (fig.78) also referred to the exotic, non-European origins of tobacco. They consisted of a decorative scheme for three portable walls on tobacco brown material, measuring about 8 feet by 3 feet, onto which figures in black and two light colours were sewn. This appliqué technique clearly shows the influence of Erna's embroidered decorations for Kirchner's Körnerstraße studio. The scene represented a Red Indian chief in a rich feathered costume surrounded by four warriors smoking the 'peace pipe'. At the outer edges European figures were shown distributing tobacco throughout the world. Gabler suggests that the decorations refer stylistically to 'middle American cultures'.[54] But in fact they come much closer to the art of the north-west coast Indians, adopting Tlingit or Kwakiutl models (fig.79). This is of some interest as it suggests that Kirchner matched his style to his subject quite carefully: it is one of the few pieces of evidence to suggest his more scholarly knowledge of ethnography.[55] Early ethnographic 'adventure' films like Edward S. Curtis' *In the Land of the War Canoes* (1914) dramatized the romantic image of Red Indians, which Karl May's Winnetou novels had popularized, with a high degree of ethnographic accuracy. There were also more popular precedents for matching exotic styles and subjects: at the Berlin

80. Yenidze cigarette factory, Dresden-Friedrichstadt. Photograph, March 1987.

81. Advertisement for Yenidze cigarettes, *Dresdener Neueste Nachrichten*, 1910.

zoo pavilions were built in the style appropriate to the regions of the world from where the animals originated. Most important, there was the example of the Yenidze cigarette factory on the fringes of Dresden-Friedrichstadt, which was built in the shape of a mosque in 1908 to produce 'oriental' tobacco. This dominant landmark on the Dresden skyline (fig.80) appears in at least one Kirchner drawing,[56] and pre-1914 advertisements for Yenidze cigarettes (fig.81), depicting Arab traders handing tobacco to European smokers, must have provided direct inspiration for Kirchner's 1914 decorations.

The most interesting aspect of the Feinhals scheme is Kirchner's emphasis on the peaceful exchange of markets and products — a naïve representation of colonial power relations. Feinhals planned the exhibition as an advertising venture and, in effect, Kirchner's decorations are used for commercial propaganda. In a very obvious way this serves to highlight the fundamental contradictions underlying the position adopted by Osthaus and his circle. The presentation of 'primitive' artefacts in the Folkwang Museum and the revival of the 'Gothic' style proposed alternative 'spiritual' and 'authentic' models for the reintegration of art and society in the modern age; the aim was to counteract the materialistic, commercial values of the times. But because plans for reform were visualized in *aesthetic* rather than political and historical terms, references to 'organic', 'primitive' models could easily be used to legitimize precisely the economic and political systems they apparently opposed. From the outset, Osthaus and his supporters mixed idealism and pragmatism, primitivism and modernity, and tried to put romantic aesthetic notions into industrial production. Kirchner's depiction of European commerce as an emissary of peace distributing pleasure throughout the world (the added irony that they are disseminating a dangerous drug would not have been evident in 1914), unwittingly employs artistic primitivism to 'naturalize' and thus legitimize the kind of commercial venture that the Expressionists theoretically opposed. It is possible and even likely that Feinhals suggested the subject, and Kirchner was in no position in 1914 to turn down a commission. But to explain away the decorations in this way ignores the wider implications they embody.

Directly after the First World War Osthaus himself seemed to become aware of

65

the problems and contradictions arising from his pre-war position. In a 1918 article, *Ex Ungue Leonem*, Osthaus provided a full description of the merciless Darwinian battle for survival of the fittest in modern society, which his activities had sought to oppose:

> The world was ruled by the theory of the struggle for the survival of the fittest. Everyone against each other. Individuals were at each other's throats, one business fought another, one people fought another...machines suppressed hand tools ...each transaction involved an exact calculation of usefulness. Free creativity lost its meaning. Artists retreated from the arena of production. In their place, pattern cutters arrived, who were able to exploit the artistic forms that had evolved over 5000 years. Machines dictated the rest. Business men controlled everything and the world slowly lost its soul. One value after another disappeared until finally bare necessity was the sole God on the throne.[57]

To counteract this unhappy state of affairs, Osthaus had proposed a new rôle for the artist 'via his intervention in the workshops of production he bore witness to the desire to construct a new culture from its roots'; but gradually officials and institutions began to use the new movement for their own ends: 'art had to help to conquor world markets'.[58] The post-war situation offered little consolation as it rejected individual expertise and initiative in favour of types and norms. The only remedy Osthaus could envisage was to seek inspiration in the great art of the past – in Greek Temples or Gothic cathedrals. But he suspected that this type of structure, in which art and society are bound together by spirituality, had become redundant in the modern world where religion itself was secularized. His conclusion to these pessimistic speculations was to propose a retreat into the museum, where the art he once saw as capable of infiltrating and reforming society could be preserved for future generations: 'Perhaps the museums will be called upon to become the churches of the future.'[59]

Osthaus, who had encouraged the Expressionists to project their aspirations to reinvest modern life with the integrity of art into a public arena, ended up in the classic modernist position, isolated in the aesthetic realm of the museum. As such, modern art was 'stranded' from an active social rôle, ironically mirroring the way that the tribal artefacts modern artists used for inspiration were lifted out of their social and religious contexts and enclosed behind the glass of Western display cases. This was indeed the way that Osthaus' Folkwang Museum was experienced by contemporary visitors. Recalling his schoolboy outings to the museum before 1914, Dr Heinrich Nettmann has recalled:

> The great hall containing Georg Minne's fountain looked celebratory, with subdued light falling through Van der Velde's stained glass window. It almost looked like a cathedral for art. This impression remained as one moved through the entire museum. There weren't many visitors there...the people of Hagen did not show much interest...'[60]

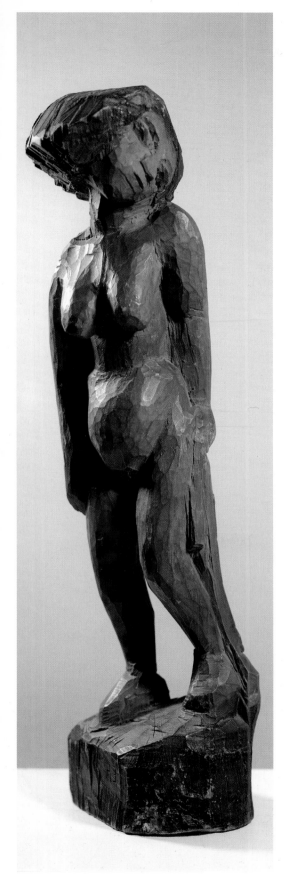

5 Expressionist Wood Carving: Ideals of Authenticity

THERE IS one other area where we find the *Brücke* artists transforming *Jugendstil* practices into a primitivist mode, namely in their wood carving. In 1904 and 1905, Kirchner, Bleyl, Heckel and Schmidt-Rottluff began to make linocuts and woodcuts strongly inspired by *Jugendstil* style and technique; Japanese woodblock prints were also influential.[1] Their attraction to the carved and painted beams from Palau certainly related to their own activity as carvers, and their two-dimensional woodcuts, originally inspired by the bold, flat, black-and-white contrasts which we find in *Jugendstil* developed into three-dimensional sculptural activity which made increasing reference to tribal models, both directly and indirectly. The *Brücke* artists engaged most directly in their wood carvings with notions of authenticity and hand-craft inspired by ideas about the direct, unmitigated relationship between the artist and his materials we have noted circulating in the arts and crafts movement, and which Georg Simmel interpreted as a means of preserving spiritual authenticity in the machine age. The *Brücke* artists' wood carving allows us to locate them more exactly in relation to issues of modernism and modernity, making clear points of contact and difference.

Direct reference to tribal styles in *Brücke* wood carvings only began in 1909 with the Moritzburg and studio subjects.[2] But Kirchner and Heckel had been making sculpture since around 1906, and we soon find primitivist attitudes developing which paved the way for a direct use of tribal art. Sculpture was considered sufficiently important to inspire the search for a sculptor to join the group: in September 1906 Heckel reported to Amiet that they were considering issuing an invitation to the Belgian sculptor Georg Minne, whose famous, *Fountain with Five Kneeling Youths* (1898–1905) was located in the entrance of the Folkwang Museum.[3] In March 1907 Heckel first mentioned the Dutch sculptor Lambertus Zijl, who appeared in the active members list that year.[4]

There is some evidence to suggest that it was Heckel, once again, who took the initiative as far as three-dimensional carving was concerned. His earliest sculptural works are three terracotta heads, but by the end of 1906 he was carving in wood and he sent Emil Nolde a photograph of the results.[5] On 2 March 1907, a letter to Nolde reports: 'I have completed two new wood sculptures – the wood was very hard, but it is a fine thing to come up against resistance and then to have to employ all your physical strength.'[6] An undated letter of 1907 from Ada Nolde to Schiefler, praised, 'the beautiful austere wooden sculptures' Heckel had placed in her room in Dresden.[7] The surviving piece from 1906 is the Hamburg *Caryatid*, carved from alder and painted green. The work now looks like a very amateurish and experimental attempt at three-dimensional form. It is made on a very small scale and roughly carved from a rectangular block, then scored, beaten and chipped. There is no visual evidence of

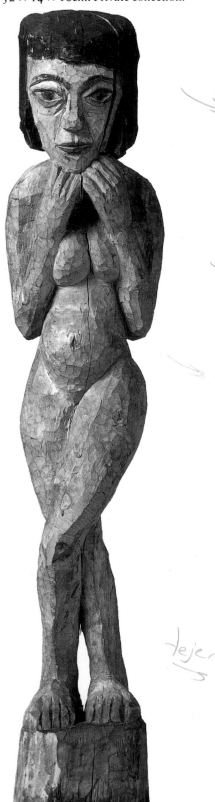

82. (*preceding page*) Erich Heckel, *Bathing Woman with Towel*, 1913. Maple painted black and red, 52 × 14 × 10cm. Private collection.

83. Erich Heckel, *Standing Woman Holding her Chin*, maple with black and yellow paint, h: 141cm. Kunstgewerbe, Museum, Hamburg.

references to tribal art here, and, in a letter to Vriesen in 1946, Heckel credibly denied all knowledge of Gauguin's sculpture and early Greek works during his Dresden years. But he added in an interview in 1954: 'I would never have been able to carve hard wood without the emotion that one must encounter in Africans.'[8] Although this is very much a *post facto* explanation, it seems right to locate any reference to tribal art on the level of feeling and aspiration, rather than exact visual influence. Heckel's letter to Vriesen continued with an explanation of his sculptural priorities: 'In sculpture, forms should be beaten or cut from the tree trunk or the stone without a clay model or transfer processes',[9] making clear his drive towards direct, unmediated handcraft. This was indeed central to the *Brücke* artists' understanding of tribal artefacts as direct and spontaneously created objects, made to function in authentic and unalienated societies. Little information existed at this date about the strict traditional procedures of tribal sculpture and, as we have seen, *Jugendstil* had promoted ideas about spontaneous creation. The *Brücke* artists obviously took no notice of complaints in the socialist press about the changes imposed on non-Western societies by capitalist imperialism. Anyway, after the socialist defeat in the 1907 elections, these were effectively silenced.[10] *Die Brücke's* positive response to tribal art tells us primarily about their critical responses to the conditions of their own times. The idea of forging a 'unalienated', directly crafted handwork betrays the influence, once again, of *Jugendstil* attitudes. But there is an a new element in this early sculpture, which has to do with its crudity and the relationships between form and block, that departs from *Jugendstil* precedents.

In his essay, 'Wooden Sculptures by Kirchner, Heckel and Schmidt-Rottluff in the Museum of Decorative Arts, Hamburg' (1930–1), Max Sauerlandt explained the difference between *Brücke* sculpture and existing sculptural traditions at the turn of the century: 'Even more in sculpture than painting at that time, the boundaries between nature and art had become indistinct due to a "monstrous facility".'

In *Brücke* sculpture, by way of contrast: 'The pure saturated colours applied to the wood never hide the structure of the wood nor the traces of working. Every blow of the axe and every cut of the knife remain directly available to our eye – as if we can feel and taste them.'[11]

Sauerlandt suggested that the *Brücke* artists' sympathy for their material and the honesty of their craft technique, which was not 'disguised' by a highly finished surface, avoided the artifice of late nineteenth-century sculpture in favour of a direct response to 'nature'. These attitudes and techniques determine the primitivism of their sculptural practice.

At its best, Heckel's sculpture has a strong feeling for the integrity of the block. By 1912–13 this manifested itself in the strong vertical emphasis and quiet, contained gestures of the figures in works like *Standing Woman Holding her Chin*, and *Bathing Woman With Towel* who seem to be hugging the tree trunks from which they are carved (figs. 82 and 83). A photograph of earlier, lost figures dated 1910–12 (fig.84) reveals a more energetic, cruder technique. One figure has only half emerged from the tree trunk, and in Heckel's surviving *Bathing Woman With Towel* (1913), the back edge of the head is left blunt and flat to suggest, once again, the presence of the block. In his 1909 drawing *Young Girl* (fig.85), a figure roughly sketched on a tree trunk is juxtaposed to a black nude model so that their arms join in a single hand. Heckel knits together the different mediums and aspects of his primitivist vocabulary, emphasizing process and creation rather than finish.

The *Brücke* artists' knowledge of African sculpture has been difficult to ascertain exactly, because the Ethnographic Museum in Dresden originally claimed that only a few small African pieces from Togoland and the Cameroons were on view before 1910; then, when the museum reopened that year, that fifty large-scale Cameroon sculptures were purchased for the collection.[12] Since then, Martensen-Larsen has reported that the Zwinger catalogue also records Benin pieces, on show since 1900, including reliefs, figures and heads;[13] and she refers to the rich Benin collection purchased for the museum by A. Baessler in 1899. Archive sources in Dresden

68

84. Photograph of sculptures in Erich Heckel's studio, *c.* 1910. Photo archive, Heckel Estate, Hemmenhofen.

85. Erich Heckel, *Young Girl*, 1909. Pencil, 45.2 × 35cm. Brücke-Museum, Berlin.

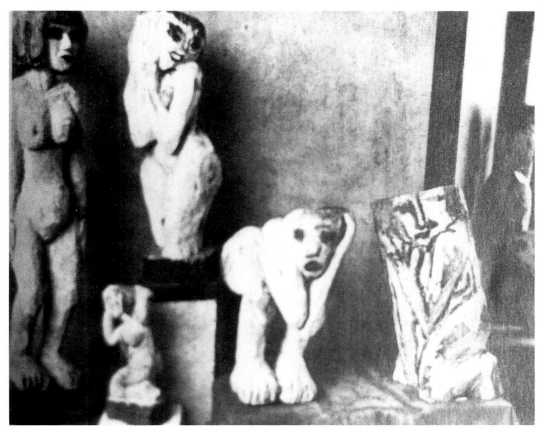

86. Karl Schmidt-Rottluff, *Female Half-Nude*, 8 November 1909, Hamburg. Pen and ink. Altonaer Museum, Hamburg.

confirm that African sculpture was available before 1910, including some large figures like a yellow, painted Cameroon figure (Pohl 1886) and a large Yoruba figure (Baessler 1907). But the Cameroon collection, which was undoubtedly most influential on the *Brücke* artists, was thin on the ground before 1908–10, when several important collections entered the museum, providing a new and intense visual experience of some of the most lively African figure carving.[14] This certainly coincided with a new and serious phase of sculptural activity for Heckel and Kirchner. In 1910, as we have seen, Kirchner began to sketch both Cameroon wood carvings and Benin bronzes. But we must remember that both artists were spending protracted periods in Berlin by this date, where an excellent collection of Cameroon sculpture was on view. The tendency to concentrate solely on the Dresden collection has blinded previous researchers to other possible sources.

In a 1954 interview, Schmidt-Rottluff stated that Cameroon sculpture was the dominant influence on *die Brücke*, and certainly photographs of their hand-carved studio furniture support this statement.[15] The earliest direct reference to African sculpture occurs in a postcard sketch from Schmidt-Rottluff to Heckel dated 8 November 1909 which depicts a Cameroon figure (fig.86). The sketch is problematic because it is made upside down on the front of the postcard as if it were an afterthought. But it is in Schmidt-Rottluff's hand, and the postcard has no other illustrations, suggesting strongly that it was executed before he posted the card in Hamburg.[16] Schmidt-Rottluff must have visited a collection in Hamburg, just as Kirchner visited the Berlin Ethnographic Museum in 1911 and 1912. Schmidt-Rottluff's sketch is of interest not solely on account of its early date, but also because it directs our attention beyond the confines of the ethnographic museums. Very little Cameroon material was available in the Ethnographic Museum in Hamburg at this time. Despite purchases during the early years of the century, these objects were

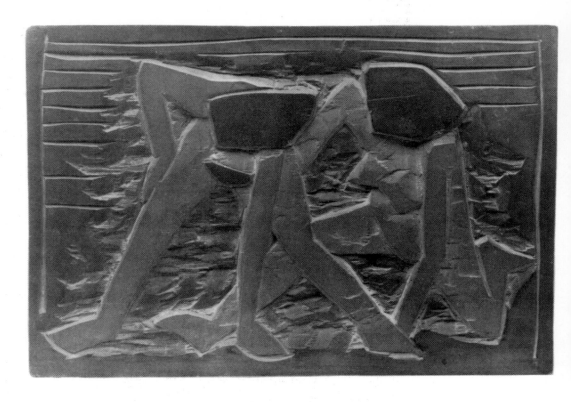

87. Karl Schmidt-Rottluff, *Two Women*, 1911.
Painted wood bas-relief, 19.5 × 27.8cm. Brücke-
Museum, Berlin.

not exhibited until the opening of the new museum in 1912.[17] Probably Schmidt-
Rottluff saw Cameroon sculptures in a private collection, or in the gallery of the
main Hamburg dealer, Julius Umlauff, whose Institute for Ethnography comprised a
private museum and a commercial gallery. This was a rich source of West African art
before 1914, set up on the model of a scientific ethnographic museum, but pricing
objects according to their aesthetic worth.[18] August Macke, who collected the
ethnographic material for the *Blaue Reiter Almanach* in 1912, and began his own
collection in the same year, was certainly familiar with Umlauff's showrooms. It is
likely that the Cameroon pipe figures in Schmidt-Rottluff's possession by 1922 came
from the same source.[19]

As we have seen, the connection between international avant-gardism and
primitivism was well established by 1912, and this began to be reflected in commer-
cial exhibitions. Kurt Glaser's review of Wilhelm Feldmann's new Berlin gallery in
December 1913, praised the decision to show 'antique and exotic sculptures' in an
exhibition of the Café du Dôme artists (Pascin, Grossmann, Purman, and Bondy)
alongside Georges Braque, Van Dongen, Vlaminck, Matisse, Picasso and
Pechstein.[20] The juxtapositions in Osthaus' Folkwang Museum were certainly not
exceptional by this date.

In the light of this connection between 'avant-garde' modernism and primitivism,
Schmidt-Rottluff first began to make use of his knowledge of African art in a series
of 1912 paintings which also display Cubist effects. His primary interest in flat, two-
dimensional forms during the *Brücke* years meant that his sculptures were all made
in relief before 1916.[21] In 1911, an almost literal transcription of the Palau beams
in his wooden relief *Two Women* (fig.87) coincided with a more creative use of the
Palau style in woodcuts like *Model* (1911;Schapire H.55). The mask-like wooden
relief *Bearded Man* (1912) and the four *Evangelist Heads* in beaten tin made for
the Sonderbund chapel in 1912 (see fig.77), relate directly to his primitivist Cubist
paintings that year.[22]

In his woodcuts Schmidt-Rottluff continued to make references to non-European
art: *Cats 1* (1914;Schapire H.148), is inspired by Egyptian feline statues – for
example, those from the Saite period *c*.600 BC. In *Idle Courtesans*, (1914; Schapire

70

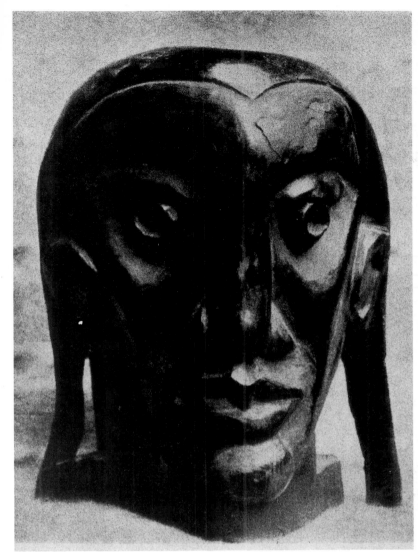

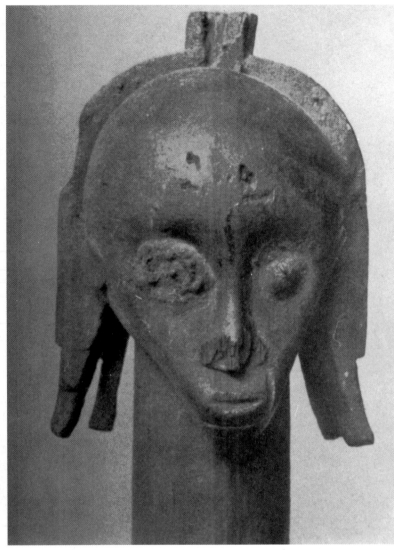

88. Max Pechstein, *Head*, 1913. Wood, h: 40cm. Destroyed.

89. Brummer Fang head.

H.133), the striations on the womens' bodies refer more generally to African sculpture; and Martensen-Larsen suggests that the broken nose in Schmidt-Rottluff's woodcut *Christ* (1918;Schapire H.208) (which first appears in *Three People at Table* (1914;Schapire H.167), relates to a Sumatran head in the Berlin Ethnographic Museum.[23] In 1915, the emphasis shifted determinedly to African sculpture and volumetric effects were translated into two-dimensional terms in woodcuts like *Girl Friends* (Schapire H.170), *Portrait of Rosa Schapire* (Schapire H.183) and *Mother* (1916; Schapire H.194).

In 1915, Carl Einstein's *Negerplastik (African Sculpture)* was published and the illustrations in this book directly influenced Schmidt-Rottluff's three-dimensional wood carvings in 1917.[24] During his war service on the Eastern front Schmidt-Rottluff must have had with him a copy of Einstein's text, which had been favourably reviewed by Rosa Schapire.[25] In 1918 Schmidt-Rottluff's woodcuts *Youth* (Schapire H.211) and *Girl from Kowno* (Schapire H.209) referred back to Einstein's book, quoting a Teke head from the Congo and a Baule mask respectively.[26] The only other free-standing *Brücke* sculptures which come as near as Schmidt-Rottluff's to a particular African source are Pechstein's *Head* (fig.88), which relates closely to the famous Fang head in Charles Brummer's collection, illustrated in the 1912 edition of *Umělecký Měsíčník* (fig.89), and Kirchner's carving

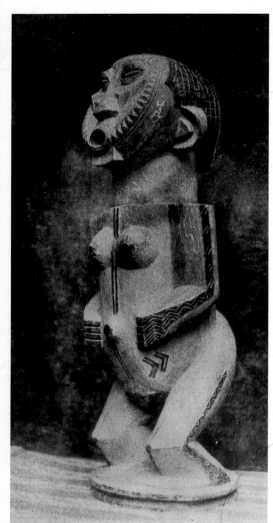

90. Max Pechstein, *Moon*, 1919. Wood, h:105cm. Destroyed.

for the MUIM Institute. By way of contrast Pechstein's *Moon* (fig.90) displays hybrid African features, and traces of Marquesan Tiki figures. Attempts to specify a particular African source are unconvincing.[27]

Einstein's *Negerplastik* was certainly the most important literary contribution to the history of Expressionist primitivism. Rhys Williams has suggested that the formalist bias of Einstein's descriptions of African art and his understanding of European avant-gardism relate to his engagement with French Cubism rather than German Expressionism. This is true only in a limited sense. Williams' theory that the book was a masked anti-nationalist defence of Cubism during the war years – when Expressionism was being promoted as a national force by Paul Fechter – is not unconvincing.[28] But despite Einstein's distaste for emotive, ahistorical descriptions of non-Europeans as 'eternally primitive'[29] (which he considered just as unsatisfactory as evolutionary evaluations of their art), his text is steeped in the aesthetics of Expressionism. Most important, he distinguished between the formalist and abstract tendencies in modern French art and the transcendental realism of African sculpture. He proposed a higher union of objective and subjective realities, of the impulses towards abstraction and towards realism, in the religious integrity of African sculpture – which thus occupies a similar aesthetic zone to the Gothic in Worringer's influential *Abstraktion und Einfühlung*. Einstein writes:

in formal Realism, which should not be understood as imitative Naturalism, transcendence is a given... The work of art is not viewed as an arbitrary and artificial creation, but rather as a mythic reality, which is more potent than nature... Religious African art is categorical and possesses a...being which excludes all limitations.[30]

In an undated letter to Schiefler quoted by Gerhard Wietek, Schmidt-Rottluff explained his aims and his attraction to Egyptian art in terms that come very close to Einstein's text:

In various ways I have arrived at an intensification of forms, which certainly contradict scientifically derived theories of proportion, but which correspond and tally in their spiritual relationships. I have often hugely exaggerated heads in relation to other bodily parts, as the seat of the psyche, of all expression. It's just the same with breasts. They are an erotic moment. But I want to free this from the transitoriness of experience and to establish a relationship between cosmic and earthly moments. Perhaps we could speak of a transcendental eroticism. In our cynical times that sounds a bit mystical, but remains to us in the art of the past – in Egypt, Michelangelo. What lends them their eternal interest? Above all it's the experience of transcendence in earthy things.[31]

Schmidt-Rottluff's library in the Brücke Museum includes the 1920 edition of Einstein's *Negerplastik* and Wilhelm Hausenstein's *Exoten, Skulpturen und Märchen* (1920; *Exotic Peoples, their Sculptures and Tales*). In this latter text, Hausenstein followed Einstein's example, suggesting that non-European art rejects Western naturalism in favour of a higher reality, striving to render 'truth' rather than appearances. It is very probable that Einstein and other texts which take up his line of argument influenced subsequent aesthetic statements by Expressionist artists.[32] But Einstein's book itself grew out of his Expressionist experiences,[33] and his emphasis on the religiosity of African art relates to one dominant aspect of Expressionist primitivism around 1912. The *Blaue Reiter* artist Franz Marc publicly defended the Expressionist movement at this time by stressing the artists' involvement with a 'higher' spiritual reality beyond the world of appearances.[34]

Like Heckel, Kirchner began to make small sculptures in clay and pewter during the early Dresden years which appear in one of the earlier studio photographs taken *c.*1909. A small clay relief survives from this period depicting a couple arousing each other, used to decorate the Dresden and Berlin studios.[35] Gordon suggests that Kirchner's larger-scale figure sculpture only began in 1910, inspired by the new

91. Photograph of sculpture in E.L. Kirchner's Dresden atelier, *c.* 1910.

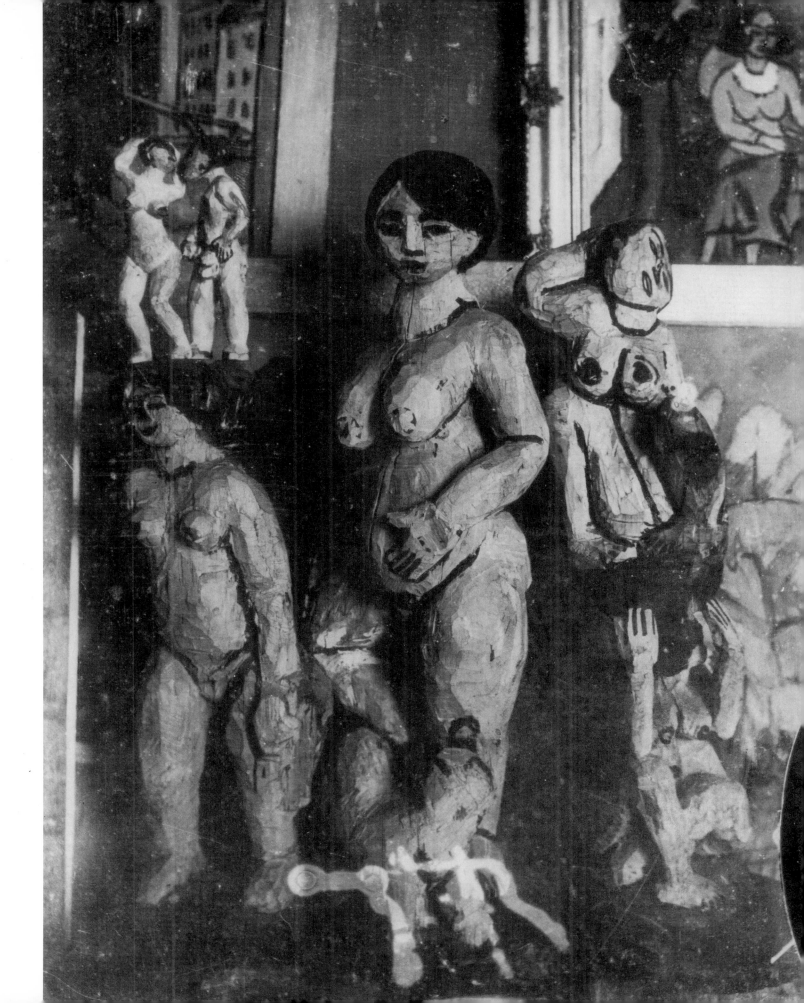

92. E.L. Kirchner, *Dancer with a Necklace*, 1910. Painted wood, 54.3 × 15.2 × 14cm. Private collection.

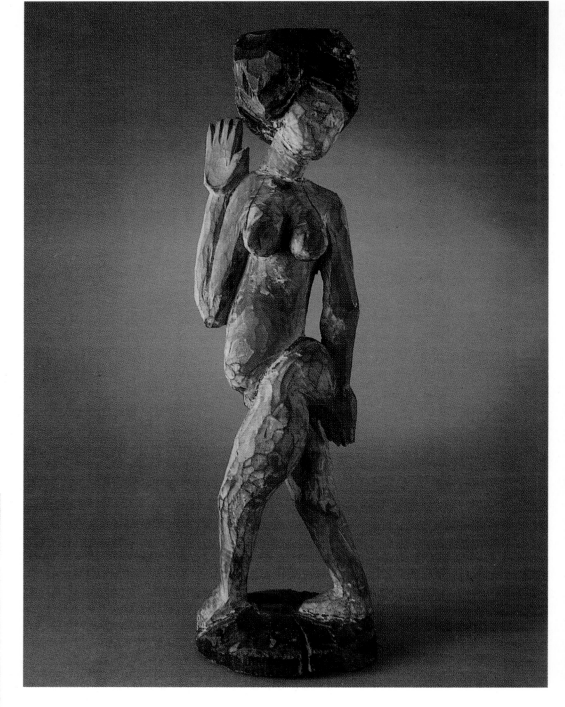

93. Erich Heckel, *Kirchner*, 16 December 1910, Dresden. Coloured crayon. Private collection.

Cameroon wood carvings in the Dresden Ethnographic Museum. While this is generally plausible, precise visual references to African sculpture occur only in Kirchner's hand-carved studio furniture. His free-standing figure sculptures relate in a more general way to African precedents, and the primitivism of these pieces has more to do with creative methods and attitudes to material, than with direct 'quotations' from non-European sources.

Many of Kirchner's early sculptures from 1909–10 are destroyed or missing, and our knowledge of them comes chiefly from photographs (fig.91). The few remaining examples show that they were roughly hewn, like Heckel's, and painted with bold

74

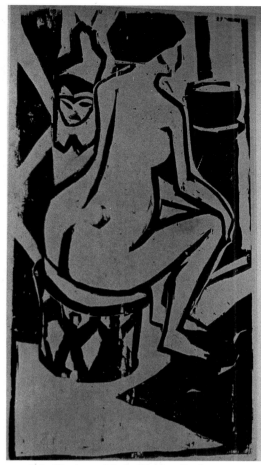

markings in black and white, which might well owe something to Kirchner's understanding of tribal decoration, although the forms and compositions have little to do with African art. In contrast to Heckel, the roughness of Kirchner's technique, which does certainly owe something to his knowledge of African carving, and his bold iconography, go hand in hand with an immensely sophisticated feeling for space and movement. The exciting rediscovery of Kirchner's *Dancer with a Necklace* (fig.92), which was previously known only from a Dresden studio photograph, provides an interesting example of how his sculpture evolved from two-dimensional relief into three-dimensional form. The dancing figure has now lost her painted face and necklace, possibly inspired by tribal fetishes, as there are few precedents for such additions in Western sculpture. In a similar way to Heckel's *Bathing Woman With Towel* (fig.82), the top of the head is left flat and the breasts are also oddly blunted, hinting at the presence of the block. The carving technique is very visible although the actual marks of the chisel are rather small and delicate. Kirchner also indicates the frontality of the wooden block by the positioning of the nude figure's arms, which lie on a frontal axis around which the rest of her body turns in radically different directions. Although the sculpture still refers to the two-dimensional woodcut block[36] she twists her way out of flat frontality into three-dimensional space.

This ability to visualize spatial effects made it possible for Kirchner to use the visual stimuli of the carved Palau beams and the Ajanta wall paintings for his sculpture in the round. The swinging hips, large breasts and compositional rhythm of *Dancing Woman* (1911) refer to Ajanta, although the strong yellow and black colouring of this piece recall the Palau beams in Berlin. Later sculptures like *Dancer* (1912) and *Dancer with her Leg Raised* (1913) have more delicate, Gothic proportions. *Nude Girl* (1912),[37] like the related oil painting (G.163) and graphics (Dube R.528 and H.207), refers to Lucas Cranach's small Venus in the Frankfurt Städel, which both Kirchner and Otto Mueller admired. In a very different way Heckel's heavier and graver sculptures of female figures in 1912–13 recall early German art, particularly fourteenth-century wooden sculpture.

Only Kirchner's carved studio furniture, which we know from photographs, paintings and drawings, relates in a precise, direct way to Cameroon sculpture. The carved divan that appears in his 1909 painting *Girl under Japanese Umbrella* and in the photograph of his Körnerstraße studio, draws inspiration from the Palau beams; even the carved head on the tree trunk that supports the divan relates to the large wooden sculptures over the entrance to Palau club houses, which Kirchner would have seen in the Berlin Ethnographic Museum (fig.119). But the figure style in this carving is related to the rounder, fuller figures in his 1909 paintings and has not yet developed the spiky, jagged contours characteristic of the Palau style. Only later in December 1910, postcards from the *Brücke* artists to Louise Schiefler show that Kirchner had begun to carve objects and furniture relating to African models, at the same time as genuine African items began to occur in Heckel's studio scenes. First, a card from Heckel dated 16 December 1910 (fig.93) shows Kirchner seated on an Africanized stool, very similar to the one in Kirchner's own painting *Fränzi in front of a Carved Stool* (fig.98). In a Kirchner woodcut *Nude Girl in a Bath*, dated 1909, (fig.94), the nude is sitting on a similar stool with a figurative chairback, but the base of this stool is entirely different and clearly derives from a Cameroon model (fig.95).[38] A second postcard from Kirchner to Frau Schiefler, dated 24 December 1910[39], depicts a Cameroon leopard stool and a pineapple she had sent the artists for Christmas, which recurs in Heckel's oil painting *Girl with a Pineapple* (Vogt 1910/4). This leopard stool is a genuine African object which features alongside another Africanized stool, supported by a kneeling female figure apparently carved by Kirchner, in his 1910 woodcut *Three Nudes* (Dube H.182).[40] This leopard stool is visible in the photograph of Kirchner's Körnerstraße studio (see fig.57). By 1913 Schmidt-Rottluff had acquired a similar stool which appears in a photograph of his Berlin studio[41] and in his coloured sketch *Two Nudes with an African Sculpture* (1913).

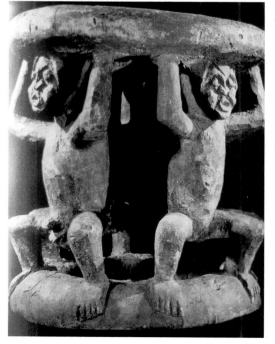

94. E.L. Kirchner, *Nude Girl in a Bath*, 1909. Woodcut, 28.5 × 34.25cm. Sammlung Buchheim.
95. Chieftain's stool, Bafum, Cameroon Grasslands. Wood, h:37.4cm. Museum für Völkerkunde, Dresden.

96. E.L. Kirchner, *Sculpture, Woman with Bowl on her Head*, 14 June 1911, Dresden. Pencil. Altonaer Museum, Hamburg.

97. E.L. Kirchner, *Head of an Artist*, 6 September 109. Brush and ink, coloured crayons. 14 × 9cm. Altonaer Museum, Hamburg.

Kirchner's own carved furniture relates very closely but not exactly to African models. A postcard dated 14 June 1911, from Kirchner to Heckel, depicts a squatting female figure carrying a bowl on her head (fig.96), which Martensen-Larsen suggests is based on a Baluba throne.[42] The position of the figure's legs departs freely from the conventions of the African model. A postcard to Frau Schiefler dated 27 June 1911, describes his work on this piece: 'I have made a seated figure with a bowl on its head',[43] which features in several drawings and graphics and in the photograph of his Körnerstraße studio.

Kirchner's *Fränzi in front of a Carved Chair* (fig.98) provides a good example of how the primitivist studio furniture is redeployed in Kirchner's paintings. The first idea for the Fränzi portrait is in a postcard drawing dated 6 September 1909, depicting a woman in a red hat with a large mask-like face (fig.97). Behind her left shoulder, Kirchner's early wooden sculpture, *Standing Girl* (1909–10) appears, setting an exact precedent for the Fränzi composition. In 1910 Kirchner began to make sketches for a related portrait of Fränzi's sister, Marcella; in June she appears on a postcard sitting on the edge of a bed with her arms crossed in a fashion very similar to Edvard Munch's *Puberty* (fig.99).[44] Other drawings relating more closely to the Fränzi portrait show Marcella sitting on the leopard stool and next to Kirchner's studio curtains. In the final 1910 portrait (G.113), she sits in the original 'puberty' position beside a painted curtain. In the Fränzi painting Kirchner apparently proceeded with Munch's work in mind as, in a large coloured drawing[45] and in the 1910 portrait, the carved chair occupies exactly the same position as the looming shadow behind the young girl's shoulder in Munch's *Puberty*. This looming shape is a distorted version of the girls own shadow which takes on a phallic form and represents her fears about awakening sexuality. The painting also strongly recalls Gauguin's primitivizing *Young Girl with Fan* in the Folkwang Museum (fig.100). Kirchner's *Fränzi*...has none of the brooding psychology of Munch and Gauguin; rather the psychological implications are exteriorized into the material presence of the primitivist studio chair. The bold, decorative juxtaposition of the girl's green, mask-like face and the pink carving avoids the literary overtones of Munch, al-

98. E.L. Kirchner, *Fränzi in front of a Carved Stool*, 1910. Oil on canvas, 70.5 × 50cm. Sammlung Thyssen-Bornemisza, Lugano.

76

99. Edvard Munch, *Puberty*, 1892. Oil on canvas, 149 × 112cm. National Gallery, Oslo.

100. Paul Gauguin, *Young Girl with Fan*. Folkwang Museum, Essen.

though the association of the child and the primitive chair is thematically significant. In this way Kirchner's primitivism is used to transform the literary mood of his Post-Impressionist sources, and to achieve a new expressive immediacy.

In a letter from Kirchner to Gustav Schiefler dated 27 June 1911, which refers again to his squatting nude carving with a bowl, he writes: 'It is so good for painting and drawing to carve figures. It gives drawing more determination and it is a sensual pleasure, when blow for blow the figure grows out of the tree trunk. In every trunk a figure is to be found, you only need to pare away the wood.'[46] This notion of 'peeling' the figure out of the material is graphically illustrated in a 1912 sketch, showing two figures whose limbs relate to the natural formations of the tree trunks they are carved from (fig.101). On the back of the drawing Kirchner wrote: 'The figure on the other side remained unfinished, probably it is still lying on the beach in Fehmarn today. In 1912 I wanted to make a dancer, and by chance I found in Fehmarn an ideal piece of wood for her. I just drew the form of the trunk and composed and drew the figure inside it. This is the drawing.'[47] Kirchner's ideas about being directed by the forces of nature support Sauerman's comments about the triumph of nature over artifice, which promotes an 'unalienated' and directly expressive sculpture. In July 1913 Kirchner sent a photograph of his portrait bust *Head of Erna* (fig.102) to Gustav Shiefler, stressing once again this aspect of his sculptural approach: 'Here is a wooden sculpture, which I carved from beached oak wood.'[48] In this work the wood grain is left in its raw state, suggesting also the

101. E.L. Kirchner, *Sketch for Sculpture*, 1912. Pencil, 48.5 × 38cm. Bündner Kunstmuseum, Chur.

102. E.L. Kirchner, *Head of Erna*, 1913. Wood painted ochre and black, 35.5 × 15 × 16cm. Robert Gore Rifkind Collection, Beverly Hills, California.

texture of Erna's hair, and it is this feeling for the natural potential of the material that differentiates Kirchner's sculpture from that of late nineteenth-century forerunners like Georg Minne. In Minne's wood sculpture *The Prayer* (1894), he manipulates the material first and foremost to representational ends, so that the textures of the wood are transformed into the wrinkles on the nun's hands or face. In his marble *Kneeling Figure* (fig.103), the solid material is stretched into a thin membrane between the boy's thumb and forefinger, or pulled taught across his shoulder to suggest the structure of bone and muscle beneath the skin. In Kirchner's *Head of Erna*, on the contrary, the wood grain suggests Erna's hair at the same time as it asserts its own material presence, independent of representational ends. The importance of wood as a material in its own right, which is also stressed by the rough demonstrative carving technique, also differentiates *Brücke* sculpture from Ernst

103. Georg Minne, *Kneeling Figures*, 1898.
Marble, h:78cm. Mr and Mrs Nathan Smooke,
Puyvelde.

Barlach's work, which has a more conceptual emphasis, depending on a sculptural idea which can then be explored in different mediums and dimensions. Barlach's wood carvings are more highly finished and display a less assertive material presence.

In Kirchner's case, the primitivism of his sculptural work exists on the deep level of his feeling for material and the relationship between material and representation, rather than in a superficial imitation of non-European style. Typically he combines this primitivist feeling for material with a highly-tuned and sophisticated sense of space and movement. Kirchner elaborated his ideas about sculpture in his essay, 'Über die plastischen Arbeiten E.L. Kirchners' (1925; 'E.L. Kirchner's Sculptural Work') written under his pseudonym, Louis de Marsalle. Like Heckel, Kirchner wrote of his rejection of clay and plaster models as 'unartistic', in favour of a direct engagement with his material: '...how different a sculpture looks, which the artist himself forms with his own hands from genuine materials, where every rise and fall is shaped by the sensitivity of the maker's hand, where the strongest blows and the gentlest carving, directly express the artist's feelings.'[49] Kirchner objects to the loss of immediate and direct contact between the artist and his creation in traditional sculptural practice:

> ...when it becomes clear that in these old methods of working only the clay model really is by the artist, the final result and all the work involved being done by other hands, you easily understand the dismal uniformity of our sculpture exhibitions. Often one must ask onself when looking, what really remains of the artist in these works of art.[50]

Once again, this touches on the themes treated by Simmel and Meier-Graefe at the turn of the century, concerning direct and authentic creative activity as an alternative to the alienating and fragmented conditions of divided labour, which Kirchner saw

operating in nineteenth-century sculptural methods. His notions of originality and authenticity stem from the early Dresden years in Schumacher's Studio. But whereas the arts and crafts movement sought a solution to the alienating conditions of the age in the cultivation of handwork and craft traditions, the *Brücke* artists tried to reclaim a sense of authenticity via their transforming notions of the 'primitive'. This promoted and encouraged principles which were of central and fundamental importance to ideologies of bourgeois modernism. The logical conclusion of the search for authenticity, as we see in this quotation from Kirchner's 1925 essay, was the all-encompassing importance of the individual artist-creator, expressing his subjective feelings in objective form. Hence the tension that arose in German Expressionism between the collective and cooperative aspirations of the movement and the assertive individualism of its separate members. Their enthusiasm for 'anonymous' 'primitive' art,[51] which they believed to represent a whole, organic and socially integrated form of art production, paradoxically promoted the cults of subjectivity and individualism because of the attempt to recreate 'authentic' contact between the hand and the heart. Simmel recognized this new emphasis on subjective individualism as one of the fundamental symptoms of the modern age. Cut loose from the bonds of community, the modern individual enjoyed a new and expansive freedom to the same extent as he suffered from feelings of isolation and estrangement.

In 'Über die plastischen Arbeiten' Kirchner made an important distinction between his understanding of 'modernism' and 'modernity', which also clarified his relationship to *Jugendstil*. He described his avoidance of representational detail and the simplifications in his sculpture as 'an impulse towards monumentality',[52] rather than as a move towards greater abstraction. He insisted on the importance of 'human beings and creatures' rather than 'meaningless forms…already in these terms [Kirchner's] sculpture distinguishes itself from other modern sculpture which – with few exceptions – is more or less decorative in intent.'[53] This is extremely important because it lies at the heart of the transformation of *Jugendstil* tradition undertaken by *die Brücke*. By 1925 Kirchner saw a direct link between *Jugendstil* ornamentation at the turn of the century and the subsequent development of modern art in an abstract – and for him meaningless – direction. In 1912, his decision to replace religious narrative with abstract design in the Sonderbund chapel acknowledged the 'spiritual' potential of abstraction, but in this case too abstract design was used to underline the effect of his figurative Madonna, rather than as a self-sufficient means. In contrast to the 'empty' formalist concerns of modernist abstraction, he considered his own art to have achieved a balance between formal solutions and 'spiritual content'. He continued, 'that is its unique German quality. It means something, you can think when you confront it, without it becoming literary.'[54]

The self-referential tendency in modern art, which exalts the primacy of style over subject by becoming increasingly involved with its own techniques, materials and means of expression, has been described by Peter Bürger as a negative direction resulting in a kind of semantic atrophy. Significantly, the emphasis on material as material in *die Brücke* sculpture functions in a figurative rather than an abstract context; it never becomes in itself the subject of their art. The distinction Kirchner makes between German Expressionism and mainstream modernism – which Ernst Bloch later endorsed – comes close to that which Carl Einstein made in 1915 between French modernism and African art. Einstein characterized the latter in terms of its spiritual rather than formal bias, and its pursuit of a 'higher' transcendental realism rather than abstraction. As we have already seen, his understanding of African art as a higher synthesis of abstraction and realism, of subjective and objective impulses, came close to Worringer's ideas about the 'Gothic' tradition which he developed most fully in his *Formprobleme der Gothik*. Kirchner's understanding of a similar impulse in his own work as a specific German quality relates closely to Worringer, and his later confusion in the 1930s about national identity[55] has its roots in the pre-1914 period, when he attempted to reconcile a sense of national and international identity in the spirit of Worringer.[56]

Most important, all thest texts relate in a central way to the Expressionist world view. 'Primitive' art, be it African or 'Gothic', was interpreted as a mediating, synthesizing force, capable of transcending the rift between spirituality and materialism which Nietzsche's philosophy had diagnosed as the tragic dilemma of modern man. German Expressionism employed notions of the primitive to negotiate this dichotomy, which is at the philosophical core of their art and which also operates on the level of individual works: in Kirchner's *Head of Erna* the wooden texture of the carving is neither material nor 'idea' in an exclusive sense but both of these things at once. Whether or not this philosophical and artistic 'synthesis' – which their primitivism was felt to affect – could be maintained on a historical level is another question altogether; and one which we must now set out to address.

While Kirchner distinguished his art from mainline modernism, he nevertheless continued to insist on his *modernity*: 'Kirchner', he wrote:

> as far as I know [is] the only sculptor today whose forms are not derived from antiquity. He renders experience, as he does in his painting, directly from the forms of contemporary life...these works, are equally far from the Greeks and the Africans, because they directly stem from the observation of present-day life.[57]

In most of Kirchner's later writings he overstates his case and elsewhere in his diaries, the *Davoser Tagebuch*, he openly admitted his admiration for African carvings.[58] But the essence of his statement is correct, as his primitivism does not simply 'quote' tribal art but rather translates these visual and conceptual stimuli into the fabric of his own experience: in the bohemian studios, in the bathing expeditions, in his feeling for material. Let us now look in more detail at the ways in which *Brücke* primitivism looked beyond the private, 'alternative' space of the studio and the public institutions of the art world and sought to engage more directly with the themes and subjects of modernity. Let us look in particular at Kirchner's attempts to fulfil his own ambition: 'to create a picture of the times out of all this confusion...for this is my real task.'[59]

PRIMITIVISM VERSUS
MODERNITY
THE EXPRESSIONIST
DILEMMA

6 Urban Exoticism in the Cabaret and Circus

BY 1914, primitivism had become a central issue in the debates about modernism and modernity in German art. After the 1910 split in the Berlin Secession, when the Expressionists' primitivism began to be acknowledged as a critical force, its relevance was questioned in both the naturalist and 'avant-garde' camps of German modernism. In a controversial exchange of articles with Franz Marc in 1912, Max Beckmann condemned:

> this dependance on ancient primitive styles which in their own times grew organically out of a common religion and mystic awareness. [I find it] weak because Gauguin and the like weren't able to create types out of their own confused and fragmented times which could serve us in the way that the gods and heroes served the peoples of old. Matisse is an even sadder representative of this ethnography museum art – from the Asian department.[1]

Beckmann attacked the Expressionists' primitivism for its lack of intrinsic relation to their own historical tradition. Two years later, Ludwig Meidner condemned the fake naïvety of the primitivist world view. Answering the rallying call of Futurist avant-gardism, he demanded that 'all the younger painters get together and flood out exhibitions with big city pictures'. He continued,

> Unfortunately all kinds of primitive races have impressed some of the young German painters and nothing seems more important to them than Bushman painting and Aztec sculpture... But let's be honest! Let's admit that we are not negroes or Christians of the early Middle Ages!... Why then imitate the mannerisms and points of view of past ages, why proclaim incapacity a virtue? Are those crude and shabby figures we now see in all the exhibits really an expression of the complicated spirit of modern times?[2]

Kirchner's Berlin street scene, *Five Women on the Street* (1913; see fig.189) shows his engagement with city imagery. But what marks out these predatory figures with their mask-like faces and jagged Africanized forms from contemporary city painting, is precisely the paradox of their primitivism, which goes hand in hand with their modernity. In his diaries and letters Kirchner spoke repeatedly of his desire to uncover a style of beauty appropriate to his own times and described Emil Nolde in contrast as 'often sickly and too primitive'.[3] Were the primitivist references in his Berlin street scenes merely, as Meidner suggests, a kind of counterfeit clumsiness, a use of style inappropriate to subject? Or did they represent an attempt on Kirchner's part to visualize the complex and contradictory forces, the backward and forward looking tendencies, underlying modernity? First, we must try to answer these questions by exploring the relationship between Kirchner's consciously modern and

primitivist subjects in the Dresden years: the scenes of urban entertainment and the bathers. Then we must turn to the Berlin paintings to see how these two aspects of his work met and fused in his single, powerfully contradictory images of the street.

Two years before Meidner's attack on Expressionist primitivism, Kandinsky had approached the same subject from a diametrically opposite viewpoint. In accordance with Georg Simmel's double-edged notion of modernity, Meidner regarded the temper of his times as a positive challenge; for Kandinsky it was an unavoidable ill. Both agreed, however, that the modern mind could not replicate the innocence and authenticity of the 'primitive' soul. In *Über das geistige in der Kunst*, Kandinsky admitted that, despite an affinity of 'internal truths', primitive and modern artists were divided by an unbridgeable gulf:

> our minds...are injected with the despair of unbelief, of lack of purpose and ideal... This doubt and the still harsh tyranny of the materialist philosophy, divide our soul sharply from that of the primitives. Our soul rings cracked when we seek to play upon it, as does a costly vase, long buried in the earth, which is found to have a flaw in it when it is dug up once more. For this reason the primitive phase, through which we are now passing, with its temporary similarity of form, can only be of short duration.[4]

In his own paintings before 1914, Kandinsky did not fully realize the implications of this thesis. Certainly the broad notion of the primitive, which he and the *Blaue Reiter* artists formulated in their 1912 Almanach as a 'spiritual' alternative to the materialistic emphasis of Western Realism, was too imprecise and wide-ranging to provide a significant formal model. A particular aspect like Egyptian stone reliefs could be extracted from the general concept and used in the artists' own works.[5] But generally they had to rethink the implications of the 'primitive' in terms of the stylistic possibilities of their times. For Kandinsky this involved a move towards the dematerialized forms of abstraction, but he continued to represent the battle between materialism and spirituality characteristic of his day, in terms of the *subjects and iconography* of his 'primitive' sources. The saints and angels who populate his apocalyptic compositions are drawn directly from the biblical woodcuts and folk motifs illustrated in the Almanach. Only August Macke, in his 1912 essay *Masken (Masks)*, spoke of the need to redefine the 'primitive' in terms of the subjects and experiences of the present, mentioning the cinema, military marches and cabaret as modern equivalents for tribal ceremonies.[6] His own paintings, like *Mounted Indians by a Tent* and *Indians on Horseback*, draw their primitivist subjects from the world of popular entertainment inspired by Karl May, and they come closest to *die Brücke* in mood and feeling.

There has been a tendency to view this exotic modern/primitive subject painting as an inferior precursor to stylistically integrated primitivism, but as we have already seen in the *Brücke* studio scenes, attempts to apply these modernist preconceptions to German Expressionism are seriously flawed. Precisely because their primitivism had a conceptual basis which went beyond questions of formal influence, exoticism was an important constituent. It provided a rich meeting ground for elements of the 'primitive' and the modern, which involved subjects as well as styles, and a network of shifting relationships between the two. Let us look first at how this occurred in the *Brücke* artists' consciously modern cabaret and circus scenes.

The Cabaret and Circus

Themes of urban entertainment, more specifically cabaret and circus, which began to appear in the work of Kirchner, Heckel and Pechstein in 1908, had their most

obvious roots in French nineteenth-century art, beginning with Daumier and continuing via Manet, Degas, Toulouse-Lautrec and Seurat to Van Dongen and the Fauvists. Within this tradition there were of course many variants: theatre, ballet and café-concert became part of a rich patchwork of urban life subjects. Approaches were also varied, ranging from Daumier's and Manet's primary interest in the audience and spectators, to Degas' dramatic contrasts between the glamour of performance and the workings of back-stage life. The metaphoric potential of these subjects guaranteed their potency and lasting relevance. Themes of urban entertainment had strong Baudelairean overtones in Manet, Degas and Seurat, symbolizing the artifice both of modern life and picture making. In Toulouse-Lautrec's work, cabaret subjects crossed with the theme of outsiders: prostitutes, clowns, bohemians – drifting people on the fringes of society, who provided a metaphor for the status of the modern artist as an outsider.

There is some evidence that the first circus and cabaret subjects by the *Brücke* artists were inspired by French precedents. During Pechstein's study trip to Paris in 1908, he established contact with Kees Van Dongen, who probably arranged the 1908 Fauve exhibition alongside *die Brücke* at Emil Richter's gallery in Dresden.[7] Van Dongen was the Fauve artist who most frequently treated cabaret themes, alongside his paintings of prostitutes, courtesans and dancers. During Pechstein's Parisian stay a one-man exhibition of Van Dongen was mounted at Henri Kahnweiler's gallery in March 1908, and he was also represented at *Les Indépendants* that spring. In the Kahnweiler catalogue he was described as a true master of dance and café-concert subjects, and in the 1908 Richter exhibition one of his exhibits was an unidentified circus artist. Reinhardt has pointed out that the appeal of these works lay in their open sexuality and in Van Dongen's sensual and lively handling of movement and colour.[8] As early as 1909 Paul Fechter remarked on the similarity between Van Dongen's and Pechstein's works, in his review of the Berlin Secession that year, writing, 'Van Dongen seems to be one of the strongest talents, although this time we only sense this indirectly'. Van Dongen's influence can be felt in Jawlensky's and Pechstein's paintings, notably *The Yellow Cloth* (see fig.70), which Fechter described as a strong piece.[9] In 1910–11 references to Van Dongen's work continued to appear in Pechstein's paintings, such as the large-scale *Dance* (fig.104), which Max Osborn described as 'a group from a wild and low variety or from a bordel or the hareem of a fairy-tale prince'.[10] Echoing Baudelaire, he remarked that the central dancer was dressed with 'brutal refinement',[11] and the background (which also relates to Otto Müeller's studio decorations) showed 'oriental hangings' with ornamental spikes and curves. On a stylistic level some of Kirchner's 1909 paintings like *Reclining Nude With Pipe* (1909–10;G.56) and *Portrait of Dodo Seated* (1909;G.219v.), come closer to Van Dongen than to any other of the Fauve artists.[12] But the *Brücke* artists' experience of the cabaret was also on a more direct level. From the winter of 1908–9 postcard greetings began to record visits made by Kirchner, Heckel and Pechstein to cabaret and circus performances in Dresden, Hamburg and Berlin.

Cabaret or variety acts had moved from France to Germany in the mid-nineteenth century, beginning as incidental entertainment in bars and cafés known as *Singspielhallen* (song and dance halls). Then from the 1870s, the cabaret developed in two directions: first, the popular *Tingeltangel* and secondly the high class *Variétépalast*. The acts to be seen in both were varied, ranging from song and dance to comedians, acrobats, snake-charmers, magicians and – after the British model – groups of women performers known as 'sisters'. The five Barrison Sisters who appeared in the famous Wintergarten variety theatre in the 1890s in Berlin were a renowned example, and their act was symptomatic of the taste of the times. Appearing in children's clothes, they evinced a peculiar mixture of naïvety and lasciviousness, which is reminiscent of the note struck in the paintings and drawings of Fränzi and Marcella by Kirchner and Heckel. One of their most popular songs ran:

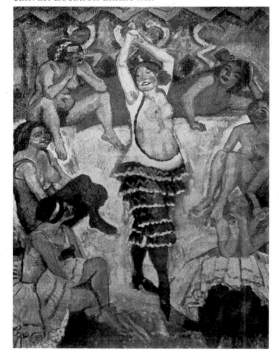

104. Max Pechstein, *Dance*, 1910. Oil on canvas. Location unknown.

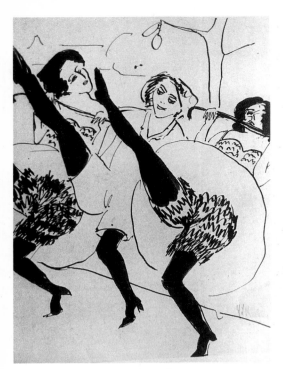

Papa won't buy me a Wauwau, Wauwau
Papa won't buy me a Wauwau
I have a little cat
I like her like a pet
But I want to have a Wauwau Wau.[13]

At the end of the act they turned their backs to the audience and raised their skirts to reveal layers of frilly underwear – such as we see in Kirchner's *Hamburg Dancers* (fig.105). While 'family variety' stressed the rôle of comedians, acrobats and magicians, sexuality and erotica were a constant theme in the evening cabaret acts. At the lower end of the scale it was common practice for the dancers and waitresses to double as prostitutes.

The *Brücke* artists' postcards from 1909 onwards are a fascinating source for the history of cabaret at the beginning of the twentieth century in Germany. They record a large variety of acts ranging from cancan dancers to trapeze acts, boxing matches and jugglers, (figs.106–8). Kirchner, Heckel and Pechstein visited all types of variety and cabaret venues as their postcards refer to famous acts like the Albion Sisters, who performed at the Wintergarten, the Apollotheater and the Passagetheater in Berlin, and to more obviously down-market performances. A postcard from Kirchner to Heckel dated 8 January 1911 and posted in Berlin, depicting a dancing couple, carries the cryptic message, 'the women are a bit rough'.[14]

During this period, the presence of acrobatic acts in the cabarets meant that an extremely close relationship with the circus existed, and it is not always possible to tell which *Brücke* works refer to circus and which to cabaret. In May 1905, for example, an advert appeared in the *Dresdener Rundschau*, advertising a new family circus-variety at the Bergkeller in Dresden, and in the *Dresdener Salonblatt* in April 1910, a review of the Zirkus Angelo reminds the public that 'some variety numbers should not be missing in a modern circus'.[15]

In both circus and cabaret the *Brücke* artists would have seen a wide variety of 'exotic' acts, which became an increasingly popular attraction during the pre-war years of colonial expansion in Germany. Reference has already been made to the crucial rôle played by the popular native displays at the Dresden zoo in 1909 and 1910, which sparked the young artists' imaginations and provided a vivid and

105. E.L. Kirchner, *The Hamburg Dancers*, 1910. Pen, brush and ink, 44.8 × 35cm. Private collection.

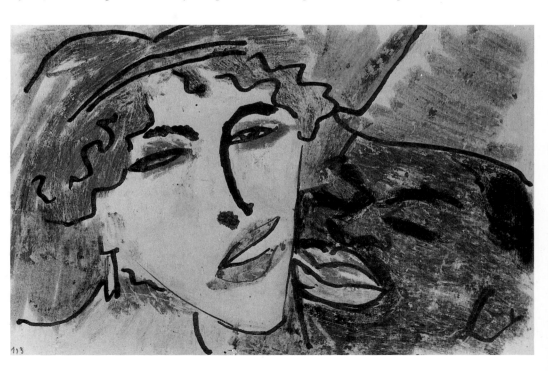

106. Max Pechstein, *Two Heads*, 3 April 1910, Berlin. Pen and ink and coloured crayon. Altonaer Museum, Hamburg.

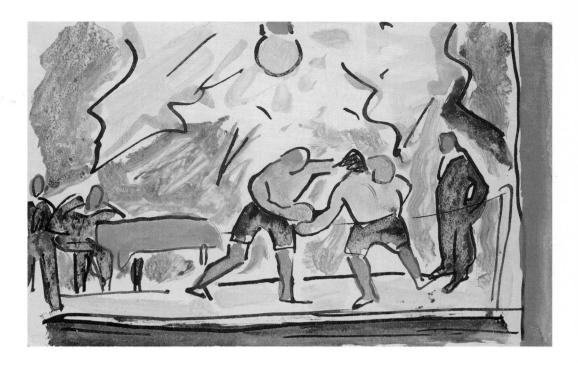

107. Max Pechstein, *Boxer in the Ring*, 4 November 1910, Berlin. Reed pen and ink and watercolour. Altonaer Museum, Hamburg.

romantic picture of 'primitive' lifestyles. At the beginning of the century the circus also displayed natives for entertainment value. Hagenbeck in Hamburg acquired a whole Indian village for his circus, which was to be seen at the Dresden zoological gardens in April 1905.[16] Sarrasani's circus showed Indian natives, Chinese acrobats and a Singalese temple dancer, while the 'Indianer Geo Dear' appeared at the Zirkus Angelo in Dresden in April 1910.[17]

Although the zoological gardens were the most important source for the *Brücke* artists' knowledge of non-European peoples, these other forums of popular entertainment are not negligible. In 1905, the year of their group foundation, numerous advertisements for exotic acts in the cabaret featured in the local Dresden press. In

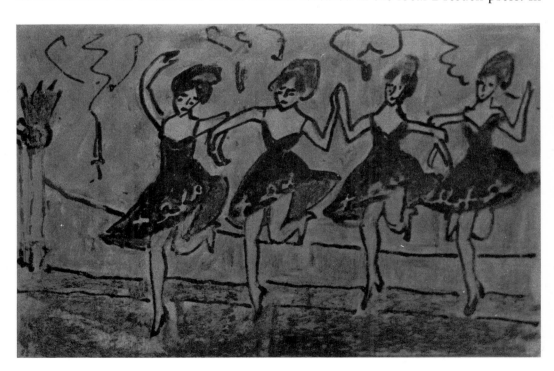

108. Erich Heckel, *Variety Act*, undated (1911 Dresden). Pen and ink and coloured crayon. Altonaer Museum, Hamburg.

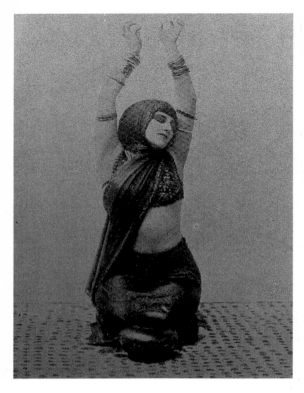

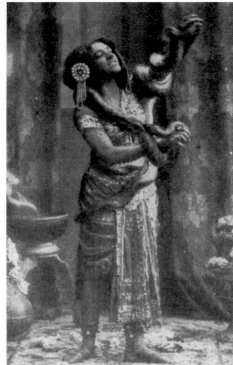

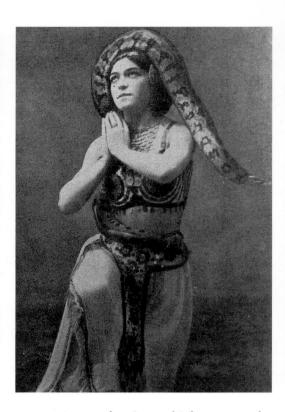

109. Miss Harrison at the Berlin Passage-Theatre, January 1910.

110. Makara, the 'Javanese' snake charmer. *Dresdener Illustrierte Neueste*, January 1910.

111. The Egyptian dancer, All'Aida, at the Eispalast, Berlin, August 1912.

February 1905 a 'Hawaiian princess' was appearing at the Central Theater, and a Japanese troup of acrobats, 'the Naniwa', made a guest appearance at the Vittoria-Salon, the second major Dresden cabaret.[18] In September that year at the Eden-Theater in Dresden-Neustadt, Otto Endlein's appearance as 'a musketeer, like a gatecrasher in a Hareem' must have provided the kind of visual experience that Kirchner captured in his contemporary illustrations to *The Arabian Nights*.[19] These cabaret acts continued throughout the Dresden years (in February 1908, for example, Javanese girls danced at the Vittoria-Salon),[20] and in Berlin a rich scala of exotic performers were recorded in the pages of the *BIZ* before 1914. Photographs of these acts show that few genuine non-European performers appeared. In January 1910 the 'snake-dancer' 'Miss Harrison' was to be seen at the Berlin Passagetheater (fig.109), followed by Makara, the 'Javanese' snake-charmer, whose photograph also appeared in the *Dresdener Illustrierte Neueste* (fig.110).[21] In February, a sister performer met a sorry fate: 'beautiful Mirka...a snake-dancer who was recently overcome by her snakes during a performance and killed'.[22] In May 1912 the 'Indian' dancer Roshanava, daughter of an English colonial official, was appearing at the Eispalast in Berlin; she was followed in June by Tortola Valencia, 'a new Egyptian dancer who is presently enjoying huge success on the European stage'. In August 'the Egyptian snake dancer All'Aida' made her début (fig.111).[23] It was this kind of act that inspired Ludwig von Hoffman's *Exotic Dance*, illustrated in *Kunst und Künstler* in 1908.[24] Indeed, popular dance routines also drew romantically on non-European examples. In 1909 the new and fashionable 'Apache Dance' (fig.113) was illustrated in the *Dresdener Illustrierte Neueste*, and described as 'the dance of an Apache with his lover...the very basic feelings of this class of mankind are symbolically expressed'.[25]

These cabaret, circus and variety acts were an important source for the *Brücke* artists' concept of primitive exoticism, because they occurred right at the heart of urban entertainment. A photograph of the famous Tortola Valencia on a donkey in Hyde Park (fig.112), which appeared in the *BIZ* in July 1912, shows how these dancers, just like non-European natives, were seen to occupy a mediating zone between the primitive and the modern: in this case she appears in a collage of

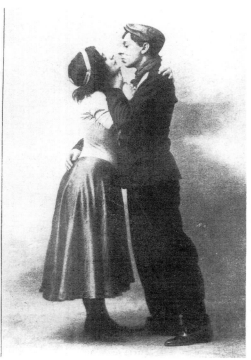

112. 'Tortola Valencia' on a donkey in Hyde Park, London. *BIZ*, June 1913.

113. The Apache-Dance, *Dresdener Illustrierte Neueste*, April 1909.

114. Erich Heckel, *Chinese Artists*, 10 November 1911, Dresden. Pencil and coloured crayon. Altonaer Museum, Hamburg.

photographs between 'King David of Uganda, the ruler of the powerful Central African Empire who is presently on a tour of Europe' and the Austrian military traitor, Colonel Redl.[26]

There is much evidence that *die Brücke* were fully aware of this aspect of cabaret and circus. In the first volume of his autobiography *Das Eigene Leben* (1931; *A Life of His Own*), Emil Nolde, who began to draw and paint cabaret subjects in 1910, records how he spent his wages visiting the 'song and negro cabarets' the north of Berlin at the turn of the century.[27] Postcards from Heckel, Pechstein and Kirchner record Chinese jugglers, Russian dancers and exotic belly dancers. For example, a postcard dated 6 May 1911 (fig.114) to Heckel's dancer girlfriend Sidi from 'Ernst und Erich', records 'Chinese and then an Indian dancer', in the Flora Variété in Dresden, which Berndt Hünlich has related to a particular show beginning on 3 May 1911: 'Tschin Maa's 8 holy 'Chungusen', world famous Chinese juggler and magician. What's more – Ruth St Radjhah, Indian dancer and a terrific opening programme.'[28] This summer a variety act in the garden at Hammers Hotel in the Augsburger Straße must have been particularly attractive, as both artists returned to see the performance again. On 10 May 1911 Heckel drew the Chinese 'Water-juggler' on a postcard to Sidi, writing, 'once again in the Flora today. The Chinese are really good, the costumes wonderfully colourful.' Kirchner made a drawing and lithograph of the 'Indian' dancer that summer and similar subjects recur in contemporary graphics and paintings: for example, Kirchner's *Turkish Ballet* (1911;Dube L.177), *Indian Dancer* (1911;Dube L.173), *Negro Dancer* (1909–20;G.74), *Negro Dancer* (1910–11; G.186) and *Negro Dance* (fig.115). In his *Indian Dancer in Yellow Skirt* (1911;G.189v) from the Flora Variété, we also see an exotic background stage. Similar subjects were taken up by the New Secession artists after 1910: at the Cologne Sonderbund in 1912 George Tappert exhibited two such paintings, *Mulatto* and *Negro Operetta*.

Some paintings and drawings include decorations in variety theatres which make obvious reference to exotic, non-European models. Kirchner's *Panama Girls* (1910; fig.116) and *Variety* (1911) show decorations inspired by Indian and Far Eastern art, which also influenced the ornamental backdrop in Pechstein's oil painting *Cabaret*. Non-European art was actually used in cabaret acts. A backstage photograph of

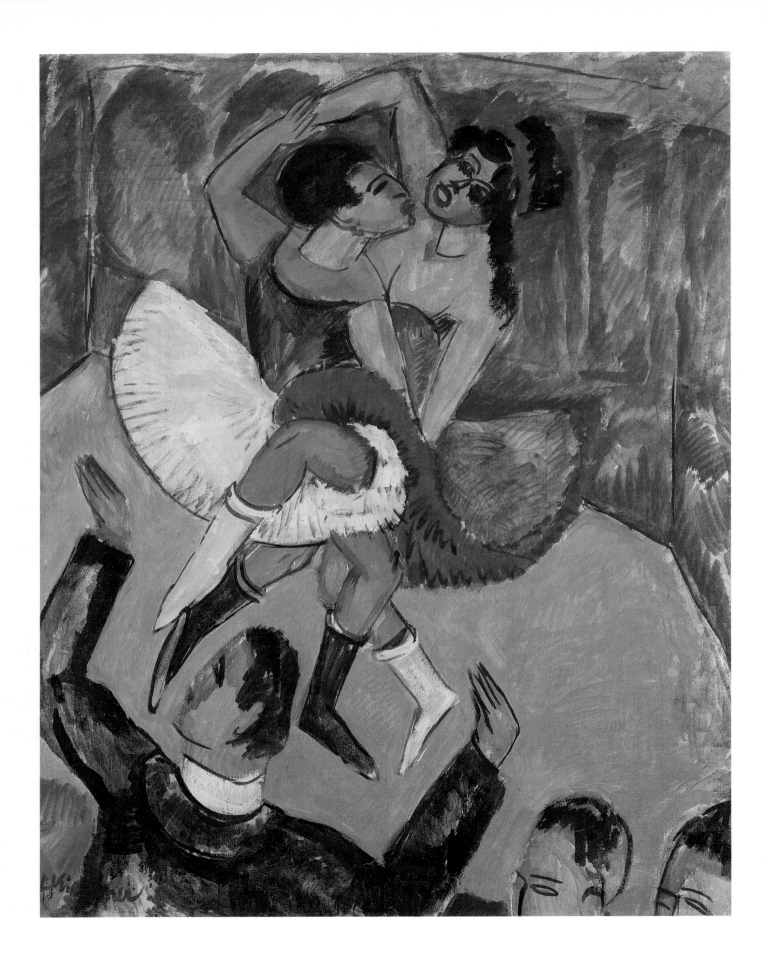

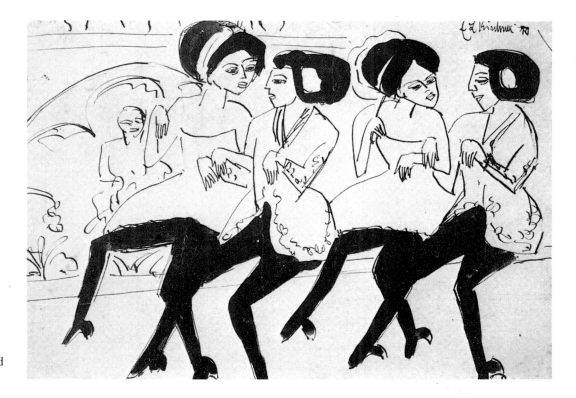

115. E.L. Kirchner, *Negro Dance*, 1911. Oil on canvas, 151.5 × 120cm. Sammlung Nordrhein-Westfalen, Düsseldorf.

116. E.L. Kirchner, *Panama Girls*, 1910. Pen and ink, 37.5 × 51.8cm. Sammlung Buchheim.

Ernst von Wolzogen's Buntes Theater *c.*1901 (see fig.42), which made guest appearances in Dresden in 1905, shows a shadow puppet performance underway in Javanese style.[29] A postcard from Pechstein to Heckel dated 19 January 1910 depicting a shadow puppet behind a fashionable woman's head (fig.117), probably records a similar act. As I have already suggested, Mueller's studio decorations were influenced by exotic cabaret sets.

Some of the *Brücke* drawings and paintings depicting cabaret and circus subjects also refer on a stylistic level to non-European art. In Kirchner's drawing *Panama*

117. Max Pechstein, *Head of a Woman and Shadow Puppets*, 19 January 1910, Berlin. Brush, pen and ink. Altonaer Museum, Hamburg.

118. E.L. Kirchner, *Dancer doing the Splits*, 3 February 1912, Berlin. Pencil and coloured crayon. 9 × 14cm. Altonaer Museum, Hamburg.

Girls (fig.117) the same jagged, articulated movements and gestures which also appear in his 1909 sketch for the woodcut *Bathers Throwing Reeds* recur. In front of the exotic 'Eastern' cabaret decorations the girls appear as Palau-like figures, as if he is playing off his own contemporary interests in non-European art, Ajanta and Palau, against each other. [30] The exotic 'oriental' emphasis of the cabaret provided an important stimulus for the persistence of Eastern styles alongside the *Brücke* artists' 'tribal' primitivism, and it is not too far-fetched to presume that Kirchner's enthusiasm for the 'Indian' dancer at the Flora in May 1911 related closely to his contemporary interest in Griffith's book about Ajanta cave painting. This mixed style recurs in contemporary cabaret subjects by Heckel such as *Dancers* (Vogt

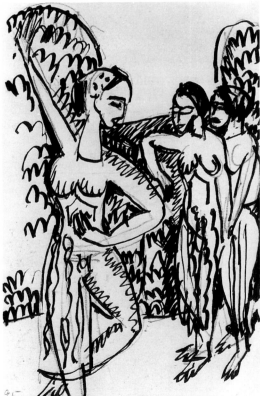

120. E.L. Kirchner, *Three Dancers in the Variety*, 27 May 1912, Cologne. Pencil, brush and ink. 14 × 9cm. Altonaer Museum, Hamburg.

119. Facade of mens club house (bai), from the Palau Islands, 1907. Carved and painted wood. Museum für Völkerkunde, Berlin.

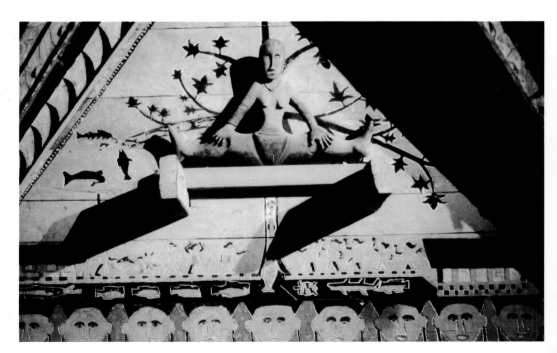

121 and *below* 122. E.L. Kirchner, *Two Flutists and a Dancer*, 1911. Pencil and pen and ink. *Musicians and Dancer*, 1911. Pencil. Both drawings in the Kirchner estate, Campione d'Italia. Both are details from wall paintings in Ajanta, Cave 1. Plate 6 in John Griffith's book.

123. Ajanta cave drawings.

1910/2), where the repeated movements are inspired by the dance routine in part, but the frieze-like effect is reminiscent of the Palau carvings and, in this case, Egyptian stone reliefs.[31]

It is in fact likely that some of the exotic routines in contemporary cabaret would have provoked ready associations with non-European art. A postcard from Kirchner to Sidi dated 3 February 1912 shows a *Dancer doing the Splits* (fig.118), with the message 'Today I saw my first full splits.' The spectacle seems to have brought to mind the large, carved gable-figures in the round over the entrance to Palau club houses (fig.119), as Kirchner depicts the dancer in a similar way. In May 1912, during their Cologne visit, Heckel and Kirchner reported to Sidi that the variety was 'not much to write home about'. Kirchner's drawing shows three women dancers in a style closely related to his Ajanta drawings (fig.120), as if the exotic act once again brought the wall paintings to mind. Indeed, many of Kirchner's 1911 drawings after the Ajanta illustrations in Griffith's book show exotic figures dancing and playing musical instruments (fig.121–2). The most fruitful way of looking at the relationship between the exoticism of the pre-war cabaret and the *Brücke* artists' attraction to non-European art is in reciprocal or correlative terms. Certainly the exoticism of the cabaret helped form and shape their notion of the primitive, and in turn the visual and stylistic influence of non-European art fed back into their depictions of the acts.

On the most obvious level it was the real exoticism of the cabaret that made it a relevant source of inspiration and a subject for *Brücke* primitivism. As I have aimed to show, this link was well established by the first decade of the century, when the cabaret performer Patty Frank was assembling his impressive collection of North American Indian art, which formed the core of the Karl May museum in Radebeul in 1928. It is also likely that some of the more far-reaching implications of the cabaret in its literary form related to the primitivism of *die Brücke* on a deeper level. At the turn of the century, cabaret began to attract the attention of many intellectuals and artists who saw in its lively and popular status an opportunity for artistic reform. Julius Bierbaum's novel *Stilpe* (1897) recounts the story of a bohemian hero who founds a literary variety theatre, Momus, with aspirations to renew the relationship between art and life through the energy, free sexuality and immediacy of the cabaret. Stilpe writes with enthusiasm about his programme for Momus:

The Renaissance of all arts and the whole of life with Tingeltangel as a model! What is art today? A colourful glittering cobweb in the corner of life. We want to throw it as a golden net over the whole people and the whole of life. Then everyone will come to us in the Tingeltangel, they will flee the theatres and museums as anxiously as they flee the churches and we shall dance in a new culture...[32]

Bierbaum also made a selection of contemporary German poetry, the *Deutsche Chansons*, including poems by himself, Richard Dehmel, Arno Holz, Detlev von Liliencron, Frank Wedekind and Ernst von Wolzogen, for use in a future artistic variety theatre. In his preface to this collection he related his aspirations for a literary cabaret to contemporary *Jugendstil* developments in the visual arts: 'The whole of life must be conquered by art. Painters are making chairs today with the ambition that they shouldn't be something to admire in museums but really use, without compromising their sense of quality. This is how we want to write poetry, not just to be read in solitude but to be sung by a crowd looking for action.'[33]

The idea of merging art and life in *Jugendstil* fashion and affecting a mutual regeneration was also discussed at the time with reference to dance. Carl Einstein, in an open letter to the dancer Napierkowska, written on the occasion of her appearance at the Berlin Wintergarten in January 1912 (fig.124), continued the attack on the narrow confines of conventional intellectualism: 'While our eyes forgot all those books and their intellectual offerings, we watched a body that was self-sufficient and awoke stirrings in us...art and life met, as if in a whip which the sun caresses and which moves and dances in the wind.'[34]

In the life style and art of *die Brücke*, the *Jugendstil* aspiration to affect an interchange between life and art had been transferred to the private world of the studios and developed via the primitivist impetus of the studio decorations. Interestingly, Max Pechstein's 1910 paintings of dance subjects share ambiguous locations – possibly a cabaret stage, or possibly Mueller's studio. In Heckel's drawing *The Rehearsal* (fig.125) he depicts a dance rehearsal in his studio; the gestures of the dancer rhyme with those of the surrounding carved figures and mirror reflections, echoing the shape of the rounded hills in the decorative wall-hangings behind.

Another shared aspect of *Brücke* primitivism and the discussion around the cabaret at the beginning of the century, was the influence of Nietzsche. In *Zarathustra* Nietzsche stressed the liberating and regenerative powers of dance to debunk and renew fossilized bourgeois values. In Ernst von Wolzogen's Überbrettl cabaret in Berlin and Wedekind's Elf Scharfrichter in Munich, satire and political cabaret were used to effect a Nietszchean attack on bourgeois society, although they continued to

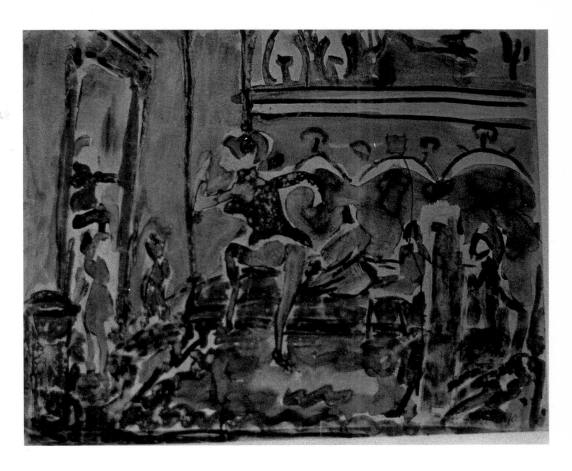

125. Erich Heckel, *The Rehearsal*, 1910. Watercolour and tempera, 39 × 59.3cm. Sammlung Buchheim.

attract middle-class audiences.[35] All these associations must be held in mind when we look at cabaret images by *Brücke* artists. It was not until 1911 that they became involved in literary cabaret in Berlin, when Schmidt-Rottluff and Heckel designed programmes for the Neo-Pathetische Kabarett, and Kirchner drew scenery for Simon Guttman's pantomimes. At this stage their mutual Nietzschean affiliations would have become obvious.

Like their early Dresden cityscapes, the depictions of cabaret and circus scenes by Kirchner, Heckel and Pechstein before 1911 are relatively straightforward, and seldom display the richness of visual association and compositional planning we find in the studio paintings. In drawings like *Dancer with a Blue Dress* (1908) or paintings like *Czarda Dancers* (1908–20;G.49) and *Tightrope Walker* (fig.126), Kirchner relishes the colour and movement of the cabaret acts, often building the pictures around intense juxtapositions of complementary colours. Occasionally he picks up on the potential for sexual abandon in the cabaret scenes, a subject of current interest in the studio and bather subjects. His drawing *Hamburg Dancers* (fig.105) shows the dancers with legs splayed and underwear showing in an attitude of full-blooded sexual abandon, very different from the titillation of the Barrison Sisters.

It is the intensity of expression in these paintings, with their planes of bright contrasting colours, animated compositions and extreme gestures, that infuse them with a spirit of Nietzschean vitalism, a 'coming alive' of the image which we have already observed as a transforming force in their early *Jugendstil*-oriented drawings and graphics. The recurrent motifs of dancers throwing up their legs and tightrope walkers, which feature in both Kirchner's and Heckel's cabaret and circus scenes, are also Nietzschean images. In *Zarathustra* the tightrope walker is used as a metaphor of transformation in a similar way to the bridge, and in the chapter 'Of The Higher Man', Nietzsche writes: 'Lift up your hearts my brothers, high! higher! And do not

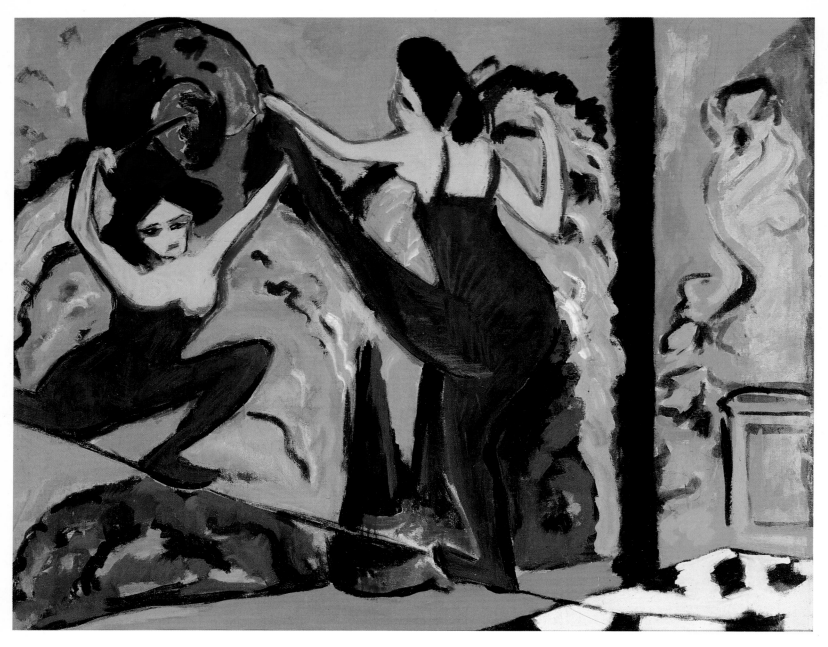

126. E.L. Kirchner, *Tightrope Walker*, 1909. Oil on canvas, 120 × 149cm. Private Collection.

forget your legs, too, you fine dancers; and better still, stand on your heads!... You Higher men, the worst about you is; none of you has learned to dance as a man ought to dance – to dance beyond yourselves!'[36]

Reinhardt suggests that Kirchner's cabaret and circus paintings may also have been influenced by literary descriptions like Martin Beradt's *Tagebuch eines Dekadenten* (1909; *Diary of a Decadent*).[37] But there is no reason to suppose a direct influence, and it should suffice to say that a large number of fictional publications with similar themes appeared in these years. Hermann Bang's *Die Vier Teufel*, (1911; *The Four Devils*) and Felix Holländer's *Der Eid* (1911; *The Oath*) are two further examples.[38] It is more relevant, considering the tone and intensity of pictorial realization, to consider seriously the recurrence of Nietzschean motifs.[39]

After 1911, cabaret and circus subjects were used by Kirchner as a sign of his commitment to modernity. His woodcut illustrations for Herwarth Walden's newly founded magazine *Der Sturm* in 1911–12 mostly showed these subjects,[40] and he used his woodcut *Dancers in the Eispalast* (1911; Dube H.83) as the design for the

127. E.L. Kirchner, *Japanese Acrobats*, 1912. Woodcut, 27.2/27.8 × 24.6cm. Sammlung Buchheim.

title page of a planned magazine, *Zeit im Bild*. After 1912 the free, swinging movements of the earlier scenes are often replaced by a tighter, jerky geometry, particularly in the woodcuts, so that the figures appear almost wooden and marionette-like (fig.127). Similar stylistic developments can be seen in paintings and drawings of other subjects at this date, associated with Kirchner's experiments with Cubist style after 1912. In paintings like *Circus Rider* (1914; G.382) and *Blue Artists* (fig.128), a Cubist multi-viewpoint is pushed to radical expressive extremes – bird's-eye and worm's-eye views are combined with frontal presentations. These clashing viewpoints suggest the actual experiences of spectating in the circus, like sensations of vertigo, which are written into our observation of the paintings and are inscribed in Kirchner's subjects. In this way he uses conceptual pictorial devices to bring his paintings closer to visual and emotive experience. Elsewhere in the later variety and circus scenes like his large drawing *At the Variety* (1911) Kirchner frames us off from the spectacle by including spectators inside the scene, making us reflect on our own act of observation. The most sophisticated treatment of this kind of device occurs in Nolde's 1911 cabaret scenes like the engraving *At the Cabaret II* (see fig.205), which taps a complicated, ambiguous mood, involving an ironic exchange of rôles between actors and spectators. This reflects Nolde's critical attitude to the artificiality and rôle-playing involved in city life. Erich Heckel's *Clown with a Doll* (Vogt 1912/9) also presents a more complex mood, reflecting some of the tragi-comic implications of clowning.[41] Generally the shift that can be observed in the treatment of cabaret and circus themes from 1908 to 1914 moves from an intensely direct, celebratory and 'alive' handling of theme and style to a more circumspect, self-conscious mode, including on occasion an element of ironic distancing between spectator and spectacle. Kirchner's *Circus Rider* and *Blue Artists* provide a unique combination of direct emotional effects and distancing devices by taking as their subject the complex mixture of involvement and voyeurism we experience as spectators.

The shift from relatively straightforward to more complex pictorial treatment, relates to the rich and multifold associations of the cabaret during this period. While cabaret was seen in literary and intellectual circles as a symbol of reform and re-newal it also came to symbolize a pace of living, an engagement with the rush and excitement of the city in pre-war Germany. In her autobiography, *Eine Tür steht Offen* (1954; *A Door Stands Open*) the actress Tilla Durieux described her experi-ence of the cabaret and nightclubs: 'Lunapark, Halensee, Palais de Dance – one-step and wooden leg...it was as if everyone was suffering from an unconscious anxiety – driven to enjoy life, to laugh, to mess around, before the outbreak of horror.'[42]

Also within the apparently popular and simple framework of cabaret performance there were rich opportunities for irony and nuance. Style in cabaret relied on setting off one mood against another in ironic juxtaposition, and this determined the popular as well as the sophisticated literary cabaret. The Barrison Sisters' child-like clothes acted as a piquant foil to the prurient tone of their act, and the exotic trappings, snake-charmers and belly dancers set off the mood of urban sophistica-tion. Internal contradiction as an ironic device also characterized the performances: an article in the *BIZ* in September 1911 advertised, 'a very unique curiosity...a white Negress who is presently performing in a Berlin entertainment palace'.[43] The following month an article described the influence of British and American black comedy on the historical development of clowning. Originally the clown had performed acrobatic acts during the intermission, but by 1911 his musical and acrobatic talents were set off against his foolish appearance, and he often used an elegant woman or gentleman as a foil.[44] What is important here, and worthy of our attention, is the *method* of internal juxtaposition and polemical definition in the cabaret form, which we shall find recurring frequently in our analysis of the relationship between primitivism and modernity in the art of *die Brücke*.

Interestingly, contemporary observers regarded the double-edged references to primitivism and modernity in *die Brücke* art in negative *and* positive terms. For

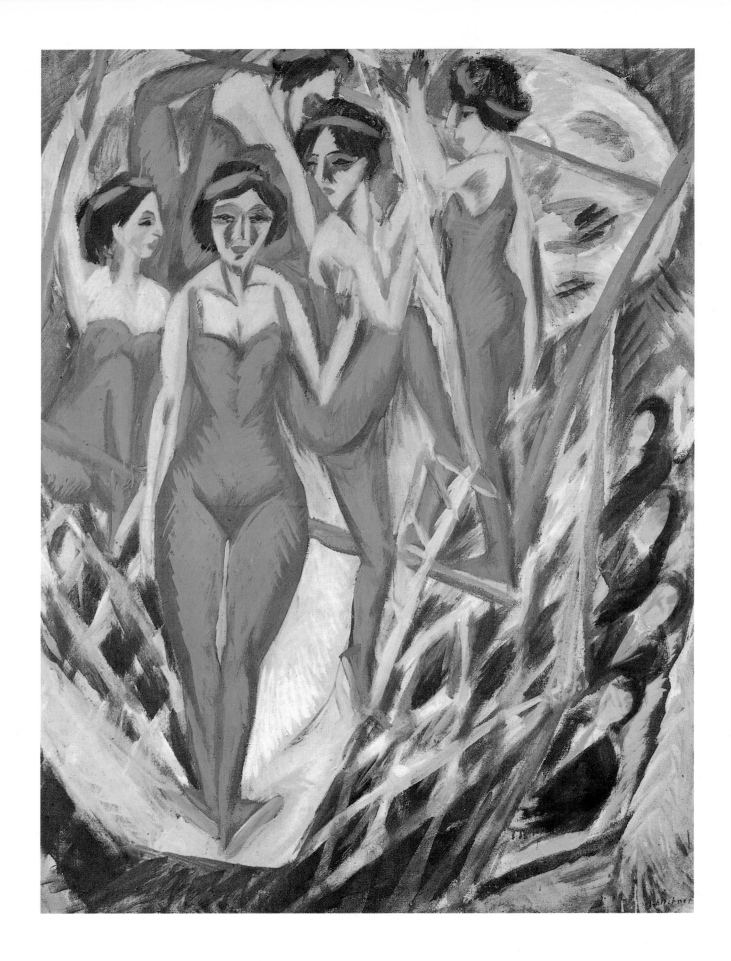

128. E.L. Kirchner, *Blue Artists*, 1914. Oil on canvas, 119 × 89cm. Private collection.

example, Richard Stiller's review of their second exhibition at the Emil Richter Gallery in Dresden in 1909 suggested that it is time to follow a particular artistic goal single-mindedly, instead of flirting in a half-barbaric half-civilized manner – for nothing but that manner's sake'.[45] But in 1920, Max Osborn's commentary on the Berlin phase of *die Brücke* regarded the implicit paradox of their primitivist modernity in a more favourable light. He wrote: 'the uncompromising modernity of their intentions and their outlook found rich nourishment in this city, this genuine product of the times. This may seem to contradict the impulse to return to a primitive and absolute state...Civilization should be overcome – but through civilization, together with civilization.'[46] Before turning to look at the Berlin imagery in more detail, let us first explore the dichotomy Osborn acknowledges between city and country, between artifice and nature, during the Dresden years.

7 The *Brücke* Bathers: Back to Nature

WHEN WE turn to look at urban imagery in modernist art from a wider perspective, we find that the principle of definition by antithesis we saw operating in the cabaret recurs in more general terms through the counter-imagery of city versus country. In the study of mid-nineteenth century French art it is commonly acknowledged that negative attitudes towards the city were articulated in Barbizon landscape painting by means of positive or nostalgic images of the countryside.[1] Only in the 1860s and 1870s, after the first impact of industrialization had been assimilated in France, did celebratory images of the city's poetic aspects begin to appear in early Impressionism. But the celebration of modernity advocated by Baudelaire was a fragile and tenuous attitude and in the 1880s it was eclipsed by nostalgic evocations of the countryside, such as in Gauguin's Brittany paintings. In Pont-Aven, Gauguin's enthusiasm for the vanishing traditions and religiosity of Breton peasants prepared the ground for his explicitly primitivist Tahitian paintings. In each case the qualities of stillness and poetry uncovered in the countryside and then in the South Seas, provided an inverted image of the changes underway in the city, and for this reason references to modernity often show through the weave of these primitivist images. The sophisticated exoticism of Gauguin's Tahitian paintings testifies to the impossibility of achieving a pristine 'primitive' ideal, not least because the societies late nineteenth-century artists held up as alternatives to modernity – be it the indigenous countryside or distant exotic lands – were themselves undergoing radical historical change under the impact of industrialization and colonial rule. The 'primitive' was an imaginary concept rather than a reality, used to debate and to define by antithesis Western notions of civilization and modernity.

In Germany, where the speed of modernization meant that the contradictions this involved were experienced in a more concentrated and dramatic way, distinct and yet related patterns emerge. Before the failure of the 1848 bourgeois revolution, Adolf von Menzel produced a positive image of the civilizing, progressive forces of industry in his *Berlin-Potsdam Railway* (1847). The sweep of the railway line in this painting, headed by a black steam train, travels outwards from the city to the country, and forges a new relationship of contact and exchange between the two. But the reality of increased mobility between town and country was countered in Germany by a dramatic experience of rupture and contrast between past and present, manifested in the cultural polemics of city versus country.

During the 1850s, a conservative, nationalist ideology of the countryside began to take hold, when publications like Wilhelm Riehl's *Land und Leute* (1857–63; *Land and People*), described the traditional customs of rural life and the eternal rhythms of the landscape as symbolizing the 'culture' of the German '*volk*', which was fundamentally opposed to mechanized, materialistic 'civilization', represented

by the cities and 'rootless' peoples like the Jews.[2] In 1890, Julius Langbehn's *Rembrandt als Erzieher* merged these volkish themes with a call for a new artistic creativity opposed to the sterility of historicist style. His attack on rationalism and praise of intuition and mysticism proposed a new kind of radical conservatism aimed specifically at the visual arts, which has been described in the literature on volkish ideology as a type of 'conservative primitivism'.[3] By concentrating on landscape and intuition, this trend in German thought and literature presented German nationalism in a 'naturalized' guise, apparently transcending the exigencies of historical circumstance.

In the visual arts, various kinds of countryside imagery emerged within the spectrum of non-academic painting in the 1880s and 1890s. Arnold Böcklin's mythological landscapes were most popular among volkish apologists,[4] and the *Worpswede Stimmungslandschaften* (mood landscapes), by Carl Vinnen and his associates, also proposed a romantic vision of the countryside that could be readily associated with conservative aspirations. On the other hand, we find peasant paintings which engage with a broader ideological spectrum by Wilhelm Leibl and Max Liebermann. Leibl's work was admired by Langbehn and promoted as a new kind of *Heimatkunst* (Homeland Art). His renderings of Bavarian customs and costumes with a kind of ethnographic realism in paintings like *Three Women in the Church* (1879-82) sought a synthesis of northern tradition, referring back to Cranach and Holbein, and French realism, drawing inspiration from Courbet. Liebermann located his peasant paintings of the 1870s and 1880s in the democratic tradition of Dutch genre painting rather than the mystic intuitive mode that Rembrandt represented for Langbehn and his followers; and he was inspired by the socialist writings of Ferdinand Lasalle.[5] In the 1890s, he allied himself with the modernist internationalist faction, becoming president of the Berlin Secession in 1898; at this stage he turned increasingly towards 'modern' urban subjects. What we are concerned with here is not so much the establishment of direct and conscious links between *die Brücke* and earlier treatments of city versus country in German art, but rather the sketching out of historical possibilities and potential meanings for the theme, which, by 1905, were multiple and complex, involving the recurrence of similar subjects and preoccupations with different shades of meaning. The relationship between style and content was not necessarily straightforward, and very various possibilities existed for mixing conservative subjects with modernist styles or vice versa. Paula Modersohn-Becker's Worpswede peasant paintings stress the irrational, mystical depths of countryside customs in a consciously international modernist style and they are a classic example of this synthesis, which we shall find recurring in Emil Nolde's work.[6]

In many ways Adolph von Menzel is a more relevant – although unlikely – precursor for Kirchner's engagement with the subjects of city versus country, nature versus artifice. In 1848, Menzel's faith in the powers of liberal social democracy guiding the industrial boom were shaken, and after this date he pictured modern society in an ironic, critical light. The enlightened monarchy of Frederick the Great became his ideal of civilization, to which he compared the shallow artificiality of his own times, a brittle mask for the baser 'natural' instincts we find surfacing in *The Ball Supper* (1878). Here the crowd jostles and pushes, stepping on each others' elegant costumes; the officers struggle to hold simultaneously plate, glass and helmet. The ideal unity between nature and civilization, which is expressed in his evocation of Frederick the Great's court in *Flute Concert at Sancoussi* (1852) by the synthesis of natural and artificial light, has been superceded by a brash artificiality, which releases rather than controls the baser instincts. When we move inside the railway carriage in *A Journey through Beautiful Nature* (fig.129) we find a variation on the same theme. The subject of the painting is not the romantic landscape view the title suggests, but rather a crowd of city dwellers crammed into their elegant costumes, whose access to nature is frustrated at every turn. Both windows are blocked by figures, and the woman stares gormlessly at another traveller's back as

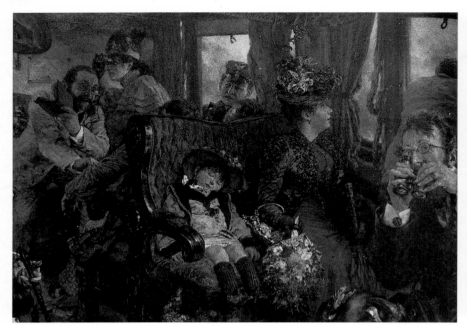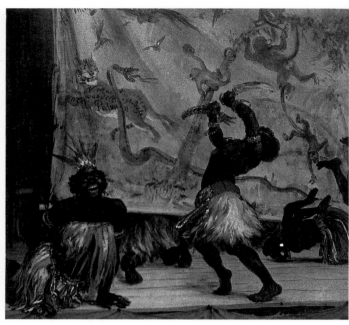

129. Adolf von Menzel, *A Journey through Beautiful Nature*, 1892. Gouache on paper, 27.7 × 37.2cm. Private collection, Hamburg.

130. Adolf von Menzel, *The Zulus*, 1885. Watercolour and gouache on paper, 27.5 × 30.3cm. Hamburger Kunsthalle.

she clasps her civilized bouquet of dried flowers. Behind, a traveller waves his Baedecker at a sleeping companion while nature slips by unseen. To the right, another figure goggles in the direction of the spectator, direct contact between eye and nature blocked by spectacles and binoculars, as if an experience of natural beauty is only possible in terms of such giant magnification. A child sleeps peacefully at the centre of the composition, apparently finding within itself that for which the others vainly search outside. In this case an ironic rupture between nature and artifice, which are also the paradoxical ingredients of Menzel's artistic realism, replaces the positive mediation between city and country we found in the *Berlin-Potsdam Railway*. Menzel – himself an outside inside Prussian court life, selling successfully to middle-class patrons while never fully integrating into either social group – uses this paradox of content and style to throw into question the relationship between civilization and nature. This relationship, previously stable and coherent while civilization was seen as an inevitable and positive force, was experienced as mutable and problematic in his own age.

A coloured drawing in Menzel's 1885 sketchbook, *The Zulus* (fig. 130), introduces the relationship between nature and 'natives'. The wildly dancing negroes on a cabaret stage repeat the forms of the monkeys, parrots and snakes on the ornamental curtain behind. The inscription on the tiger refers to a passage in Goethe's *Die Wahlverwandtschaften* (*Elective Affinities*) in which he comments ironically on the problematic relation between man and nature in the modern age. Goethe writes of a true and ideal unity between man and nature, concluding:

Sometimes when I have been seized by curiosity to see such exotic things I have envied the traveller who can behold these wonders in an everyday living relationship with other wonders. But then he too suffers a change. You cannot walk among palm-trees with impunity, and your sentiments must surely alter in a land where elephants and tigers are at home.[7]

Goethe and Menzel are commenting on a common fear, stemming from the period of pre-evolutionary theories during the Enlightenment and apparently confirmed by Darwin's *Origin of the Species* (1859), that the dividing barriers between 'higher' and 'lower' nature were under threat. In 1866 the anatomist Schaafhausen had declared that 'the wall of separation between the early world and the present world,

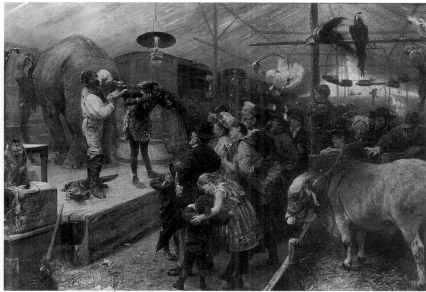

desaprovado

131. Adolf von Menzel, *At the Zoo*, 1863.
Destroyed.

132. Paul Meyerheim, *In the Animal Hut*, 1894.
Oil on canvas, 88 × 129cm. Staatliche
Kunstsammlungen Dresden, Gemäldegalerie
Neue Meister. Purchased 1894.

133. 'Human and Gorilla Skeletons', *BIZ*,
December 1910.

between man and the animal, has crumbled',[8] and the same fears were given serious and chilling literary form in Joseph Conrad's *Heart of Darkness* (1902). Léon Poliakov has connected the rise of racial theories to this phenomenon, suggesting that 'European narcissism needed a clear dividing line between 'them' and 'us''.[9] Goethe's irony in this passage from *Die Wahlverwandschaften*, like Menzel's cabaret stage or the windows and binoculars in *Journey through Beautiful Nature*, are self-conscious distancing devices of a different kind, reinstating a physical and conceptual space between man and nature under new terms of reference. In Menzel's work these barriers, which ironically rupture the unity of man and nature, are both transparent and reflective like two-way mirrors, throwing back our own image and questioning the superiority of modern civilization. Modernity for Menzel, like Baudelaire, has a bestial element:[10] the railing in *At the Zoo* (fig.131), separates the fashionable onlookers from the animals. But who is behind the bars – them or us? In Menzel's lithograph *Bear Pit at the Zoo* (1851) traditional hierarchies are thrown into question as the spectator is imaginatively located in the bear pit, looking up at the lookers-on. Menzel disrupts previously unquestioned hierarchies and introduces a new thematic and compositional relativism in order to effect an ironic critique of the values and pretensions of modern society. But this does not involve a positive revaluation of non-European man. As his *Zulus* drawing testifies, Menzel still regards the native as close to animal nature – a kind of caricature of modern man.

The sophisticated, relativizing, pictorial tactics in Menzel's oeuvre recurred on a cruder, popular level in many aspects of daily visual experience in pre-1914 Germany. In Paul Meyerheim's *In the Animal Hut* (fig.132) we find the native mediating between men and animals and throwing into question the relationship between the two. In the popular press we find numerous articles and illustrations which address the 'fragile' boundary between animal and human nature, ranging from obvious to more oblique topics. In the *BIZ* (1910) we find a visual comparison between human and gorilla skeletons (fig.133); and towards the end of the decade a strong vogue for animal dressage took hold of the popular imagination. These acts with animals dressed in human clothing and performing tricks (fig.136) were a popular aspect of urban cabaret, which once again became a kind of melting pot in which the relations between 'civilization' and 'nature' could be questioned. Often the visual and literary juxtapositions in the popular press are most telling: for example, the article in the *Dresdener Neueste Nachtrichten*, in September 1910, which reported the incident in the Samoan 'enclosure' when a crowd of ruffians threatened the natives, was immediately followed by a short report about the 'Miracle-Monkey' Moritz 1 from

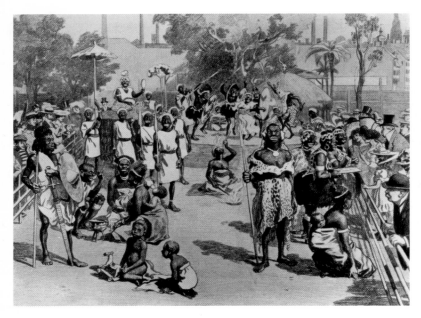

134. 'The Whites Visiting the Blacks', *Fliegender Blätter*, 1905.

135. 'The Blacks Visiting the Whites', *Fliegender Blätter*, 1905.

136. 'A new artiste. A bear on roller-skates'. Beneath, Jack Johnson, the black boxer, and his European wife. *BIZ*, June 1911.

Hagenbeck's circus: 'Old Hagenbeck said to an interviewer with much enthusiasm "that is no monkey, it is a little man"!'[11]

In the bourgeois satirical journals too, we find similar issues raised with reference to the relationship between European and non-European man. Exactly contemporary to Menzel's *Zulus* drawing, we find an 1885 cartoon in which Bavarians rather than natives are exhibited in Hagenbeck's zoo. In 1903, a popular and significant invertion of the *Zulus* theme, *The Civilized Cannibal*, depicts a wild-looking native on a cabaret stage in front of a gawking European audience, who are informed by the ringmaster: 'This man-eater, ladies and gentlemen, would eat you up at once, if it wasn't prohibited by bourgeois law.'[12] Most significantly, in 1905, we find a pair of cartoons, first *The Whites Visiting the Blacks* (fig.134) which depicts European voyeurs offering presents to a group of proud, self-contained natives on show in a circus enclosure; on the horizon we see a smoking cityscape. *The Blacks Visiting the Whites* (fig.135), turns the tables to show 'modern' European society, with its women artists, its tennis players, its marching soldiers and *international* Secession, as a funfair in the middle of a tropical village, observed by a group of surprised and amused African natives. In both cartoons a fence still separates the Europeans and the natives, but in imaginative terms the dividing line is ironically transversed. The 'primitive' and the 'modern' are presented as both opposite – and the same.

All this may seem to have taken us far away from our subject of city versus country in the *Brücke* artists' cabaret and bathing scenes, but we are in fact on the main street rather than a byway. It is precisely these issues concerning the shifting, oblique relations between civilization and nature in the modern age, first emerging in a high art form in Menzel's paintings, which will guide us in uncovering previously overlooked relations and similarities between Kirchner's and Nolde's work. The same issues will enable us to distinguish in a clear and radical way between their approaches to the subjects of primitivism and modernity.

The last three graphic portfolios sent by *die Brücke* to their non-active members between 1910 and 1912 presented their work as a dynamic contrast between countryside and urban images.[13] Attempts have been made to interpret the alternating phases of Kirchner's work in particular in terms of the city versus country debates. For example, Dube writes: 'The nude figure in the landscape reflects the ideal of unity in the natural world, the figures in the big city streets reflects alienation

106

and displacement.'[14] But Expressionist scholars have seldom acknowledged the wide range of available attitudes to the issue of city versus country at the beginning of the century. Radical polarization by conservative factions, who mourned the loss of 'Germanic' roots in the countryside, were countered by attempts to reconcile these two areas of experience in modernist projects like the garden city. Frequently the distinctions between these extreme positions were not clear cut, and in the middle ground there emerged an intricate network of relations which we have already seen operating in Menzel's work. Now we must try to locate Expressionist painting in relation to these areas of historical debate.

Nudism

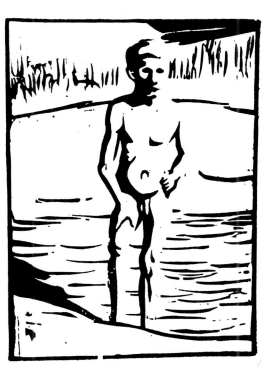

137. E.L. Kirchner, *Bathing Boy*, 1904. Woodcut.

Die Brücke landscapes are populated by bathers, rather than peasants or nymphs, and the depiction of nudes in the open air was one of their earliest and most important subjects. In 1913 Kirchner spoke of the nude as 'the basis of all fine art', studied by *die Brücke* 'in a free and natural state'.[15] Before the foundation of the group in June 1905, several drawings, woodcuts and watercolours of male bathers were made, which Bolliger and Reinhardt suggest date from their first visit to Moritzburg, in the summer of 1904.[16] In Kirchner's woodcut *Bathing Boy* (fig. 137), the contours of the right-hand side of the body are dissolved by light, binding the child to the landscape and the image to the surface of the picture plane. There are artistic precedents for this subject in both Romantic and Naturalist traditions. Although a transparent barrier of distance usually separates figure and landscape in Romantic paintings, children are integrated into their natural surroundings. In Philip Otto Runge's *The Huelsenbeck Children* (1805) the small figures are shown bursting with a kind of vegetable energy. In Max Liebermann's naturalist scene *Bathing Boys* (1896–8) the children are also 'at one' with nature, as their movements repeat the rhythms of the tide and wind.[17] But beyond the terms of artistic tradition, there is also evidence to suggest that the bather motif in *Brücke* art was inspired by the nudist cult which emerged in the 1890s as part of the anti-bourgeois and *anti-modern* reaction to city life.[18] Let us first look at the principles behind this movement in a little more detail.

Nudism or *Freikörperkultur* was just one of a series of anti-urban reform movements advocating such antidotes to city experience as vegetarianism, homeopathy, land reform, sun and air therapy and dress reform. In 1906 the Youth Movement and *Wandervogel* were founded in Steglitz in Berlin and that same year the newly founded German Association for Reformative Living described its aims as, 'a renewal of the bodily and spiritual strength of the people through education about the laws of nature. By these means the German Association for Reformative Living encourages individual initiative to reform personal lifestyle... and eventually to create a true, humane cultural community.'[19] In 1893, these principles were put into action at the Vegetarian and Fruit Tree Colony Eden, in Oranienburg north of Berlin. This was felt to offer an ideal alternative lifestyle to the neighbouring city, defining once again in oppositional terms the impact of modernity: 'In Eden the sale of alcohol is forbidden, there are no tobacconists, no pornography, no modern cinema, no cabaret, no gambling, no casinos... all such concerns are turned away at the gates of Eden.'[20] Although the alternative lifestyle at the famous naturist colony *Monte Verità* in Ascona attracted many progressive figures in politics and the arts, the anti-modernist stance of projects like Eden involved more typically the infiltration of conservative and often anti-semitic elements.[21]

In this network of reform movements, nudism played a central rôle. In 1902 the Society for Bodily Fitness was founded, and a year earlier the first 'Sun-and-Fresh-Air Sports Bath' for men opened on Kürfurstendamm in Berlin. In Dresden the nudist movement was also promoted as one aspect of the local reformative sana-

toriums, which had achieved world-wide fame since the foundation of Heinrich Lahmann's *Weiße Hirsch* in 1888. Ada Nolde received treatment there in 1907, during the brief but close alliance between her husband and the *Brücke* group. Her presence in Dresden at the time was an important direct link between the young artists and the reform movement. 1905 had witnessed not only the foundation of the *Brücke* group but also the Society for Forest Relaxation to promote 'fresh air culture' in the woods surrounding Dresden, 'which already today makes available the fresh forest air to countless citizens in need of relaxation throughout the summer'.[22] By this date, the nudist movement was enough of a local vogue to provoke a satirical poem in the *Dresdener Rundschau* at the beginning of the 'fresh-air season' which hardly merits quoting in full:

Luft-Bad ist jetzt sehr modern
Bei den Damen, bei den Herrn,
Weil es wirkt sehr mild und kühle
In der heißen Sommerschwüle...

Fresh-Air bathing is now
the modern thing,
For women, for men,
Because it's effect is very
mild and cool,
in the hot summer fug.

Allerdings – und das ist schad-
Kann genießen man dies Bad
Nur geschützt durch hohe Mauern
Weil sonst böse Nachbarn lauern...

Indeed – and that's a pity-
You can only enjoy this
bath protected by high walls.
For otherwise nasty neighbours
steal a look.[23]

Already in the 1890s, on another level of Dresden society, far removed from the industrial landscape of the Friedrichstadt where the *Brücke* artists' studios were located, one of the major spokesman for nudism, Heinrich Pudor (b.1865) (who assumed the 'Germanic' surname Scham), established himself at Loschwitz on the bohemian intellectual outskirts of the city. From here Pudor published a series of pamphlets influenced by the writings of Nietzsche and Langbehn which, in a spirit of radical conservatism, attempted a theoretical justification for nudism. Pudor conceived of man as a potential work of art, a Greek god who had been perverted and made ridiculous by the trappings of civilization. Like many of his contemporaries, Pudor idealized the Middle Ages, claiming that 'Germans' mainly went around nude at that time. In contrast modern men, with their sunshades, curtains, clothes, hats, houses and cities, were mere *Kleiderpuppen* (mannequins), disguised by the illusionistic trappings of dress and cut off from their instincts: 'In effect the man of today is little more than a head – little more than a face – for you see nothing of the rest.'[24] Pudor's pessimistic prognosis for the further development of modern society cited perverted evolutionary models, indebted to Lamarck rather than Darwin. For example, hats, he claimed, would soon displace head hair just as clothes had displaced all-over body hair. By 1917 humans shall be born wearing hats. Evolutionary regression to a 'pure' vegetable state is used however as a positive image of regeneration: 'man must learn to think of himself as a plant – then he shall begin to grow nicely again'.[25] While civilized man is like a camelia in a hot house, his true 'natural' state is that of a fir tree in a wood or an oak on a high mountain.

Visual representations of such ideas can be found in *Jugendstil* illustrations by Fidus (alias Hugo Höppener) published in contemporary periodicals like *Die Schönheit*, *Sphinx*, and *Jugend*. His depiction of a nude figure raising his arms to worship the sun in the gesture of the sunworshipper (fig.138) became a kind of visual catch-phrase for the aspirations of *Freikörperkultur*.[26] In Fidus' illustration to the poem *Happiness* published in *Jugend* in 1897 we find two bestial images of sexuality: a Christian snake twined around the woman and a Darwinian ape clutching the man's loins, juxtaposed to the positive image of asexual children dancing in front of a frieze of leaves. Nudism, in both Pudor's and Fidus' terms, was

138. Fidus, *Sunworshipper*, 1913. Watercolour.

intended to promote a pure, clean thinking attitude to the human body rather than regression to 'animal' sexuality.

Through nudism man was to achieve a new and ideal union with nature, and in many ways this represented an attempt to fix and stabilize the volatile relationship between civilization and nature, town and country under new *anti-modern* terms of reference. In Pudor's writings, despite the radical polarization of town and country a paradoxical relationship between artifice and nature recurs. Stripped of the disguise of civilization, he insisted, man in his natural state of nudity would become a work of art governed by neo-classical ideals of beauty. These neo-classical ideals were often reflected in the poses struck by male models in contemporary nudist photographs (see fig.156). Pudor's vision of the heroic, blond-haired, red-lipped, bronze-bodied Germanic men of the future predicted the ideals of National Socialism. Although a right-wing conservative tone dominated the pre-1914 nudist cult, *Freikörperkultur* and *Bodenreform*, like the contemporary youth movement and *Wandervogel*, were often conceived as a way out of the rigid alternatives of contemporary politics.[27] Fidus' illustration for the magazine *The German Peoples' Voice – for German Land Reform* (fig.139), depicts a three-pronged rune pointing towards alternative political paths. Communism leads in the direction of misty, treacherous mountain peaks while capitalism points towards a lethal cliff edge. *Bodenreform* follows the direction of a long, straight pathway crowned by a vision of palm trees and a glowing sun rising behind a citadel. The city is reconciled with nature in terms of an illusory resolution to the contrasts and contradictions of modern experience, here literally pictured in the form of an oasis.[28]

The 'alternative' status of the nudist cult and youth movement, which sought to establish a position outside the mainstream values of contemporary society, was inevitably a politically ambivalent phenomenon, and it is perhaps in this sense that an underlying relationship with Expressionism exists. The reform movement came close to the social position of Expressionism and other contemporary attempts to reform the basis of art as an institution 'outside' conventional structures in the Sonderbund and New Secession organizations. Like these new artistic groupings, the naturist movement represented a counter-culture whose political ambivalence was aptly described in the 1974 Leverkusen exhibition, 'Landscape – Antithesis or Escape?': 'Landscape only as a means of escape? Partly we must answer this question with a clear yes. But the landscape also has more meaning today, as a legitimate sensual and aesthetic corrective in a world geared towards expediency and gain. This world has long been obviously represented by our cities.'[29]

The roots of this dilemma are certainly found in the pre-war period, but the critical potential of the 'back to the land' movement was only developed in the 1920s in the workers' sport associations. Before 1914, the nudist movement primarily represented conservative anti-modernism in an anti-bourgeois guise. Gordon has pointed out that the commitment to the positive implications of progress and development which we find in the *Programm der Brücke* – and which Worringer in 1911 associated with artistic primitivism – separates the early history of Expressionism in Germany from the conservative *anti-modernism* of the volkish nature cult.[30] But Langbehn himself regarded his *Rembrandt* as, 'a bugle call to the young and aspiring generation of today which represents the future'.[31] In fact modernism and volkish-conservatism were not rigidly separate phenomena, but rather parallel developments within a particular historical context. We should be able to discuss Expressionism in relation to these trends without a sense of political embarrassment, and thus achieve a finer sense of difference, as well as appreciating similarities and relations.

Kirchner's themes and motifs certainly did cross on occasion with the contemporary nudist cult. The vignette he carved to celebrate the foundation of *die Brücke* in 1905 (see fig.12) quotes the famous motif of the sunworshipper popularized in Fidus' illustrations. In 1905 the visual iconography of the nudist movement had also been reinterpreted in self-conscious primitivist terms by Sascha Schneider (1870–1927), professor at the Weimar Art School, who had studied at the Dresden Academy and forged a close friendship with Karl May. In 1905 Schneider made a series of drawings for May's texts, published in a portfolio titled 'Upwards Towards the Sun!' In his drawing *In the Mahdi's Territory*, we find exactly the same motif of the sun worshipper recurring as an illustration to May's exotic adventure stories. The Fidus-like style of these drawings is not dissimilar to Max Pechstein's earliest pre-*Brücke* designs, but a direct relationship is less likely than a mutual store of ideas and images inspired by current historical developments and – more directly – by Nietzsche's writings.[32]

Die Brücke would have had ample opportunity to become acquainted with the local nudist movement promoted by Pudor who, in 1906, listed eleven establishments in the Dresden area practising nudism, including Eduard Bilz's newly opened *Lichtluftbad* between Radebeul and Moritzburg (fig.140). In Moritzburg itself the Upper Forest Pond was used as a nudist bathing resort by the Society for Community Health, Dresden North and Vicinity in 1910,[33] and it was during this summer that the *Brücke* bather paintings came closest to the concerns of the nudist movement. But when we look at the bather paintings which precede and follow the 1910 experience, we find more finely wrought, complex relations between city and country references, between images of nature and of artifice. Let us now try to differentiate more carefully between the various phases of *Brücke* bathers.

Moritzburg

After the early trips to Moritzburg and Göppeln, a regular rhythm of summer excursions was established. From 1907 Schmidt-Rottluff spent long periods in Dangast near Bremen, joined on occasion by Heckel and Pechstein. In 1908 Kirchner visited Fehmarn and Pechstein spent his first summer in Nidden in 1909. But the most significant experience for their primitivist bather compositions was their communal work at the Moritzburg ponds in the summers of 1909, 1910 and 1911 (fig.141).[34] These secluded woodland ponds lie at a certain distance from the public, man-made Moritzburg lakes directly adjacent to the Chateau which have often been falsely described as the setting for *Brücke* bather scenes.[35] Female bathers and mixed bathing groups began to appear in Moritzburg paintings by Kirchner and Heckel in 1909. In both cases the chronology of these works is far from satisfactory, and misdating occurs in the oeuvre catalogues. But close similarities between their motifs,

140. Advertisement for the *Bilz Luft-Bad*, Dresden-Radebeul. In the catalogue of the 1911 Hygiene Exhibition, Dresden.

141. Moritzburg Ponds, Boxdorf. Photograph, March 1987.

and some firm dating with the help of postcard sketches makes clear that works previously dated 1908 are in fact fruits of their first communal trip to Moritzburg in 1909.[36] Just as their studio paintings from this year can be paired, so too their bathers are often painted from slightly different viewpoints, as they sat side by side before their motif. In many ways these Moritzburg summers transferred the bohemian studio atmosphere into an open air setting.

Both Kirchner and Heckel concentrated in 1909 on large-scale figure groups which dominate the landscape and reveal their various experiments with post-Impressionist style. Kirchner's *Reclining Blue Nude with Straw Hat* (fig.142), presents a play between the 'artificiality' of art making – the bold handling of the blue body and complementary yellow hat – and the 'naturalness' of the motif. The nudity of the figures in this and other 1909 paintings is set off by a modern 'urban' trapping, like those which often occur in Kirchner's studio scenes. The jaunty straw hat, like the red shoes against the grass in *Two Pink Nudes at the Lake* (G.89), and the sunshade in *Two Girls Under Umbrella* (1910; G.140)[37] are complementary in terms of subject as well as colour contrast. They mark out the nudes as determinedly modern and direct in the tradition of Manet's *Déjeuner sur l'herbe* of 1863, rather than timeless and rooted like the nymphs and peasants who populated the symbolist and realist wings of late nineteenth-century landscape painting.

In Heckel's *Pair in the Open Air* (fig.143), and Kirchner's two ambitious bather scenes, *Bathers at Moritzburg* (fig.144), and *Group of Bathers in Moritzburg* (1909; G.94), there are thematic implications which add a further dimension to the bather subjects. These paintings show encounters between male and female bathers, and the position of the woman's head and arms in Heckel's *Pair in the Open Air* makes oblique reference to traditional depictions of Adam and Eve expelled from paradise. The Fruit Tree Colony *Eden* in Oranienberg recalls the popularity of such references amongst the naturists, but the visual allusion here suggests Eden after rather than before the Fall. It is a knowing paradise which is the context for Kirchner's depictions of sexual encounters in scenes like *Bathers at Moritzburg*. In this painting he presents us with a wild and liberated paradise, but the female bather standing beneath the tree in Eve's traditional position is wrapping a cloth around her hips. A

142. E.L. Kirchner, *Reclining Blue Nude with Straw Hat*, 1909. Oil on canvas, 68 × 72cm. Senator Dr Franz Burda, Offenburg.

143. Erich Heckel, *Pair in the Open Air*, 1909. Oil on canvas, 80 × 70cm. Galleria W. Henze, Campione d'Italia.

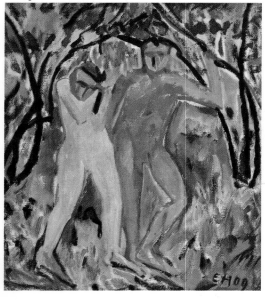

strange, contradictory mood results and this relates to Kirchner's extensive alterations in the right-hand side of the painting. Once again he seems to be treading a fine line between innocence and self-awareness, between his vision of a liberated 'natural' state, whereby the figures take on the colours of surrounding nature, and the inhibitions of civilization.[38] Kirchner's references to sexuality in the bather scenes differ from the asexual aspirations of the nudists, affirmed in Fidus' illustrations and described by Janos Frecot as a new kind of 'sunspirited prudery'.[39] In 1905, Karl Vanselow had founded the Society for Sexual Reform which produced the magazines *Sex and Society* and *Sexual Reform*; but sexual segregation was almost universally practised in the nudist colonies like Bilz' establishment near the Moritzburg ponds, and by the youth movement before 1914.[40] It would seem that these earliest Moritzburg works do not simply celebrate a naïve union between man and nature, but suggest instead a finer, more complex counterpoint. Rather than working in a purely spontaneous, unreflective manner, the artists mixed immediacy with consideration, and employed inherited traditions of representation, both in terms of subject and style.

The scale and ambitions of Kirchner's *Bathers at Moritzburg* (150 × 200 cm), make it unlikely that it was painted *en plein air*. All the other 1909 Moritzburg paintings suggest that Kirchner and Heckel were accompanied by three female models that year, and most likely this large group scene was painted in Kirchner's Dresden studio at the same time as his studio decorations with Moritzburg subjects. The seated figures in the left of the composition, with their combination of profile

144. E.L. Kirchner, *Bathers at Moritzburg*, 1909/20. Oil on canvas, 74.9 × 199.7cm. Tate Gallery, London.

145. E.L. Kirchner, *Bathers after Paul Cézanne*, 1909, Berlin. Brush and ink, 9 × 14cm. Altonaer Museum, Hamburg.

and frontal views, suggest that it was executed after Kirchner had seen the Cézanne exhibition at Paul Cassirer's gallery in Berlin that November. He sketched a group bathing scene (fig.145) from an illustration in Maurice Denis' article on Cézanne, published in the Danish magazine *Kunstbladet* that year.[41] From this date he could begin to combine references to Cézanne and non-European tribal art, just as Derain, Matisse and Picasso had done in 1907. But whereas these artists working from within the French tradition began with Cézanne and gradually in the course of 1907 recognized the visual and emotional relevance of African sculpture,[42] Kirchner took the opposite course. Already towards the end of his first Moritzburg summer his postcard dated 6 September 1909 (see fig.32) shows Kirchner visualizing the Moritzburg bathers in terms of the style of the Palau beams.[43] In the autumn he began to explore this primitivist style in the studio decorations, and his subsequent references to Cézanne are not concerned, like those of his French contemporaries, with references to a valid but disputed classical tradition. For Kirchner, Cézanne's painting was a modern visual source which could be used to undercut the nineteenth-century, literary and neo-Romantic associations of the bathers theme which

146. E.L. Kirchner, *Nudes Playing under Trees*, 1910. Oil on canvas, 77 × 89cm. Bayerische Staatsgemäldesammlungen, Munich.

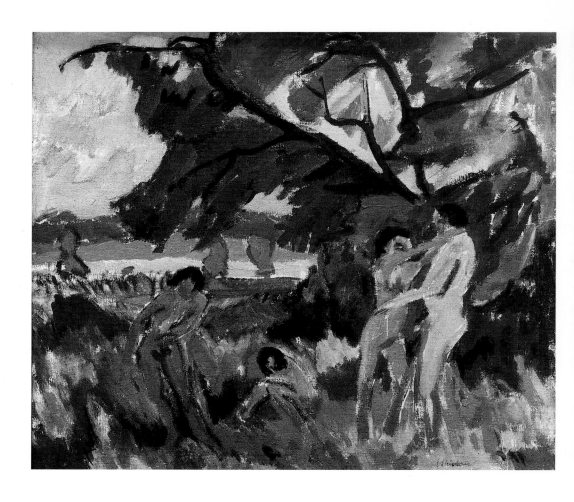

occur, for example, in Arnold Böcklin and in more lightweight 'golden age' paintings by Ludwig von Hoffmann.[44]

In 1910, when Kirchner returned to Moritzburg with Heckel and Pechstein, he began to combine these references in paintings which propose a more full-blooded synthesis of man and nature, closer to the *anti-urban* aspirations of the nudist movement. His overt depictions of a more direct, liberated sexuality, for example in his *Naked Couple in the Sun* (1910;G.145), continue to differentiate his work from the nudists. *Nudes Playing Under Trees* (fig.146) draws on Kirchner's sketch after Cézanne's bathers (fig.147) for the compositional arrangement of trees and landscape and the embracing figures to the right. Kirchner suggests liberation from civilized constraints and regeneration by fusing the figures with the forces and rhythms of nature in a vitalist, Nietzschean spirit. The bold complementary colours and gestural brushwork knit the figures into the landscape so that the right-hand woman, embracing her orange partner, is as green as the tree behind her, restored, as Pudor advocated, to a 'vegetable' state. Although Kirchner's depiction of mixed bather scenes breaks with the male-oriented bias of pre-1914 nudism, his tendency to merge women in particular into the surrounding vegetation, conforms to clichéd representations of woman as nature – in counterpoint to the blatant artificiality of his later city prostitutes. Typically his unconventional depictions of heterosexual sexuality tend to reconfirm rather than undermine traditional sexual politics.

In *Nudes Playing Under Trees* and other 1910 paintings (for example, *Three Nudes at Moritzburg* (G.97) and *Four Bathers* (G.95), Kirchner draws on the jagged, angular style of the Palau beams for his figures.[45] As we have seen, his interest in the carved and painted beams from Palau was rekindled during the spring and summer of 1910 when he was making repeated visits to the Dresden ethnographic collec-

tion.[46] As Reinhardt points out, the use of the Palau style for the Moritzburg bathers
was not simply a formal influence, but rather a matching of style to subject. He
pulled together elements that had co-existed with a certain degree of independence
during his early years of stylistic experimentation but which had now fused: 'the
almost animalistic creativity, the simple primitive life, led to primitive stylistic means
in formal terms, which were not simply understood as a renunciation of form but
rather as an adequate expression of a primitive life style'.[47]

Reinhardt sees the communal Moritzburg summer of 1910 as the fulfillment of the
1906 Manifesto: 'Their desire for naturalness in human behaviour and their impulse
towards impulsiveness and directness of artistic expression were mutually interde-
pendent.'[48] Although he knew the Palau beams several years previously, they only
became relevant for Kirchner during the 'primitivist' Moritzburg summers, when the
artists bathed nude in the open air and played with boomerangs and bows and
arrows in the style of Karl May. A certain fancy dress primitivism also seems to have
gripped the imagination of the reform movement in Dresden that year, when a
carnival at Lahmann's Weißer Hirsch sanatorium was celebrated by the patients
dressing up in Red Indian costumes (fig.147). Once again we find a set of overlap-
ping and yet clearly distinguishable references between *Brücke* activities and the
local reform movement.[49]

Final justification for the rejuvenating and regenerative spirit of the 1910 bather
paintings is found, once again, in Nietzsche. In *Der Wille zur Macht* (1906; *The Will
to Power*) which was in Kirchner's library, we read:

> Man as a species does not represent any progress compared with any other
> animal. The whole animal and vegetable kingdom does not evolve from the lower
> to the higher – but all at the same time, in utter disorder over and against each
> other . . . the domestication (the culture) of man does not go deep – where it does it
> at once becomes degeneration . . . The savage (or in moral terms the evil man) is a
> return to nature – and in a certain sense his recovery, his cure from culture.[50]

In this passage, Nietzsche also addresses the question of the shifting, dissolving boundaries between nature and civilization, between 'modern' and 'primitive' man, which Darwin's theories had apparently confirmed. But here he understands the 'return' to nature and to the wild within ourselves in a positive, regenerative sense. Elsewhere, in his *Unzeitgemaße Betrachtunger* (1872–4; *Thoughts out of Season*) he describes this 'doctrine of becoming, of the flux of all ideas, types and species as a true but fatal idea, bound to open the floodgates to barbarism.'[51] Nietzsche's ambivalence, his awareness of the positive *and* negative potential of this philosophical shift, its regenerative and threatening aspects, is extremely important for the broader implications of our subject. In 1914, when Hermann Bahr wrote his monograph on Expressionism, he used these Nietzschean terms in both ways, to describe the negative barbarism of modern society on the one hand, and, on the other, the positive regenerative force of Expressionist primitivism:

> The way that Expressionism proceeded in a somewhat uncontrolled, even beserk fashion is excused by the circumstances of the times. We live almost in the state of a primitive tribe. Those critics who ridicule the pictures by saying they are painted by wild men don't know how right they are. Bourgeois rule has made wild men of us. Other barbarians than those Robertus feared is threatening her. In order to save the future of mankind from the bourgeoisie we must all become barbarians. Just as early man drew back into himself for fear of nature – so we flee from a civilization that devours the soul of man.[52]

In the Moritzburg paintings Kirchner and his companions drew on the regenerative associations of the primitive and the rejuvinating forces gained from a vital and direct confrontation with nature. As such they adopted a position close to that Nietzsche had advocated in his 1874 essay 'On the Advantages and Disadvantages of History for Life', when he called on youth to cut away the nineteenth-century canker of historical positivism, the absolute values of education and learning, in favour of a more vital and intense *ahistorical* experience of life: 'We shall thus have to account the capacity to feel to a certain degree unhistorically as being more vital and more fundamental, in as much as it constitutes the foundation upon which alone anything sound, healthy and great, anything truly human, can grow.'[53]

Nietzsche's model for this type of culture was that of ancient Greece, but classical references in the visual arts by the turn of the century in Germany had become irrevocably linked to a decadent and academic historicist style. The Expressionists' adoption of tribal art answered the need to 'escape' history in a more radical way. Before moving on we should register a note of reserve on Nietzsche's part, to which we shall have cause to return. His concern was not so much to do away with history entirely, but rather to transform it from a backward into a forward looking process, to put history at the service of life rather than vice versa. Just as Baudelaire conceived of modernity as a paradoxical phenomenon, constituted by an equal commitment to the momentary and transient on the one hand and to the eternal and timeless on the other, so too Nietzsche formulated his notions of the 'ahistorical' and the 'suprahistorical', concluding moreover, in a potentially contradictory vein, that: 'the unhistorical and the historical are necessary in equal measure for the health of an individual, of a people and of a culture.'[54]

The underlying principles of Nietzsche's writings were a primary source of inspiration for both *Freikörperkultur* and the Dresden Expressionists, but several points of difference suggest significantly varied interpretations of his ideas. We can trace these differences by looking at the Nietzschean image of the archer, which recurs as a leitmotif in *Zarathustra* to suggest, like the bridge, the mood and aspirations of the superman. This was interpreted by the nudists in the light of neo-classical aesthetics which guided Pudor's notions of 'natural' beauty and came close to Nietzsche's own hymn to ancient Greece. In his 1894 *Fountain of Youth* pamphlet, Pudor used the metaphor of the archer to describe his powerful nordic man of the future: 'What then is strength? A bow that is not pulled taught has no

116

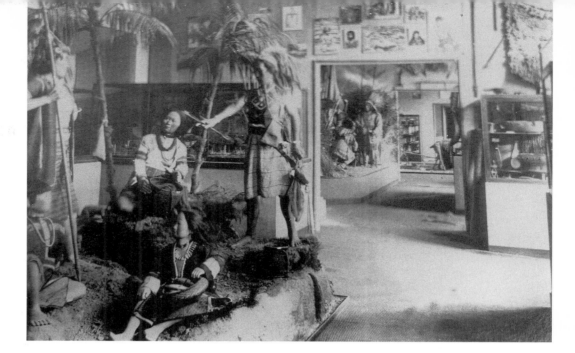

148. North American installation at the Hygiene Exhibition, Dresden 1911.

strength. When it is taught it is also strong...taught string is elastic strength.'[55] In 1911 Kirchner and Heckel designed a poster depicting the popular nudist motif of naked archers for the International Hygiene Exhibition held in Dresden that year, dedicated to the preventative powers of alternative medicine and including sections devoted to 'Sunshine and Fresh Air' and 'Bathing and Health Resorts'. A second poster design by Paul Rößler for the 1911 hygiene exhibition depicting two mounted warriors in the style of Greek vase painting,[56] conformed closely to the neo-classical aesthetics of the nudist movement. The catalogue for the 'popular' section of the exhibition, entitled 'Man as a Work of Art', contains a description of this aesthetic bias:

> illustrated in the following pictures and sculptures of bodily excercises practised by the ancient Etruscans, Egyptians, Greeks and Romans. In late Roman times the exercises often degenerated into crude theatre and in the Middle Ages they were even totally neglected under the influence of purely spiritual excercise.[57]

Here we find a set of aesthetic principles entirely opposed to those we have seen operating in the primitivist and 'Gothic' revivals espoused by the new generation of modernist artists. In the context of the exhibition, however, there was an impressive display of tribal art (figs.148–9), which was another possible 'alternative' source for

149. Installation in the 'historical section' of the Hygiene Exhibition, Dresden 1911.

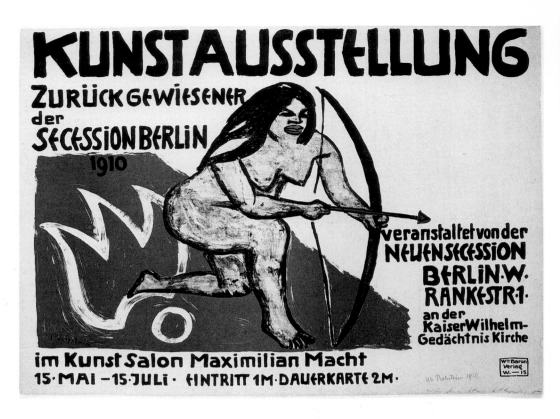

150. (*top*) Max Pechstein, *Fränzi with Bow and Arrow*, 1910. Watercolour and crayon, 44.7 × 35 cm. Private collection.

151. (*above*) Max Pechstein, *The Archer*, 25 April 1910. Black crayon. Altonaer Museum, Hamburg.

153. 'The Archer', *BIZ*, August 1910.

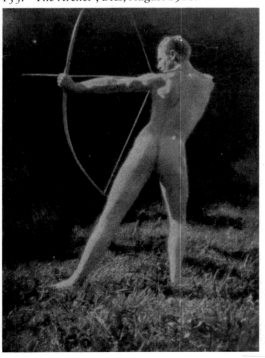

the artists' knowledge of African and North American art. The 'ethnographic sub-section' was conceived as part of a historical exhibition, demonstrating preventative medicine and nature cures in 'past' societies. The primitivist archer motif in Kirchner's and Heckel's design, drawing on the Palau beams for inspiration, had a certain immediate relevance in the context of this exhibition. But the *Brücke* artists would have been alone in appreciating the aesthetic rather than documentary worth of the ethnographic display. Their design repeats the primitivist motif that Max Pechstein had used for the poster advertising the first New Secession exhibition at the Galerie Maximillian Macht in May 1910 (figs. 150–2). This was meant to signify the revolutionary ambitions of the Expressionist generation. The primitivist subject, inspired by Nietzsche, relates to the iconography of the nudist movement; at the same time the raw-edged primitivist style undercuts the neo-classical bias of nudist aesthetics (fig. 153), which had become associated with an historicist style by the turn of the century. Instead the Expressionist designs proposed a more radical, modernist antidote to degenerate civilization.

Pechstein's recollections of the Moritzburg summer make clear that here too, in their open air bohemia, the artists attempted to break down the hard and fast bounderies between life and art.

> We had luck with the weather, not a single rainy day. From time to time a horse market took place in Moritzburg...otherwise we painters set out early with our heavy packs of materials. Our models followed on with bags full of eats and drinks. We lived in absolute harmony, working and swimming. If a contrasting male model was missing, one of us three sprang into the breach.[58]

Kirchner's sketches of Heckel and Pechstein drawing in the lakeside sand, or bent over a model displaying her sex – so that the act of drawing becomes a kind of substitute for the male sexual act – all testify to the free and open interchange between living and art making which had first characterized the studio lifestyle.

118

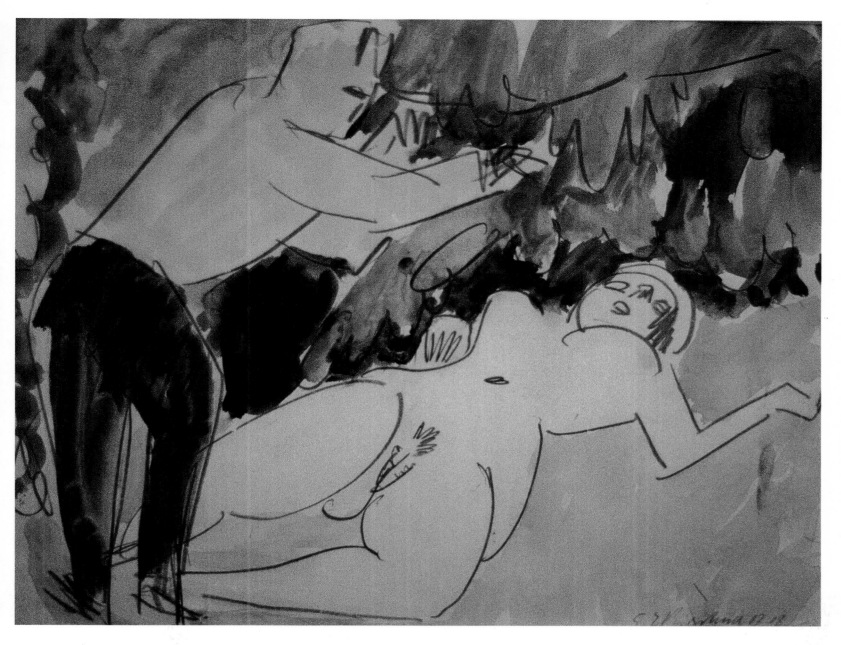

154. E.L. Kirchner, *Painter and Model, c.* 1909.
Pencil and watercolour, 27.5 × 34.5 cm.
Buchheim Sammlung.

152. (*facing page*) Max Pechstein, Poster for the
New Secession exhibition, Kunstsalon
Maximilian Macht, May 1910. Lithograph in
black, grey, green and red, 69.5 × 93 cm. Brücke-
Museum, Berlin.

Painter and Model (fig.154) displays the fresh, gestural sketching style which the
Brücke artists had begun to develop in their quarter-hour nude sessions in 1904–5
and now practised with an increasing sureness of hand. The Expressionist scholar
and collecter Lothar Buchheim has described this sketch as 'fresh, new, unlaboured
and full of passion'.[59]

But this 'spontaneity' of handling and subject is combined with a peculiar kind of
self-reference and self-awareness. Kirchner takes as his subject not only nature, but
artifice too, as the act of art making is written into the texture of the image. In many
ways he creates a type of mediating zone between nature and artifice in such
drawings.

This recurs very frequently in his studio subjects. In a whole series of drawings –
Two Nudes and Two Sculptures (fig.155), *Four Female Nudes in a Room* (1911),
Interior 1 (fig.156) – Kirchner breaks down the barriers between life and art practice
by means of a visual conceit: it is hard to distinguish between the live models in the
studio and the surrounding drawings, paintings, sculptures and decorations, which

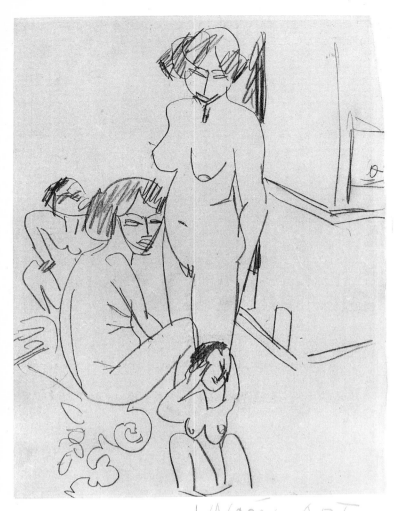

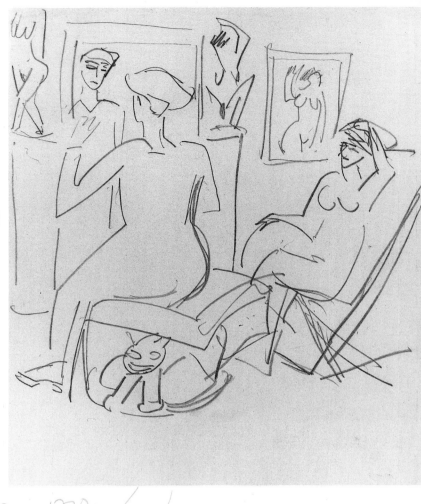

UNØÓN ARTE y VIDA importante

155. E.L. Kirchner, *Two Nudes and Two Sculptures*, c. 1910. Pencil, 36.3 × 27cm. Brücke-Museum, Berlin.

156. E.L. Kirchner, *Interior I*, 1911. Pen, brush and ink, 33.5 × 28.5cm. Brücke-Museum, Berlin.

157. E.L. Kirchner, *Nude Bather in Tub*, 7 February 1912, Berlin. Pen and ink, 9 × 14.1cm. Altonaer Museum, Hamburg.

draw their inspiration from studio life. If art 'comes alive' in these studio scenes, the converse is equally true, as nature itself takes on the appearance of art. We have already seen how this visual dilemma functions in the studio photographs of Sam and Milli, and in many ways the intermediary zone between nature and artifice which we find in Kirchner's studio scenes testifies to the more general Expressionist balancing act between art and life. Particularly in his bath tub subjects – *Girl in a Tub and Two Carvings* (c.1910) and *Woman in the Wash Tub* (fig.157 and 161), the round bath tubs act like plinths transforming the models into living sculptures. In Kirchner's oil painting *Female Nude with Bathtub* (fig.158), the figure is caught in a visual paradox: as she steps out of the decorative backdrop towards the living world of the spectator, she steps onto the bath tub plinth and is transformed into a work of art. Her movement is fraught with contradiction, stranding her in a peculiar intermediary zone between art and life.

These studio scenes are like a microcosm, a melting pot for the themes, styles and subjects which span the broader horizons of *Brücke* art. When Kirchner began to transfer the Moritzburg bathing subjects to the studio walls in November 1909, it also provided him with an opportunity to make thematic juxtapositions, which, as we have seen, involved both contrast and analogy. In drawings like *Nude with a Feathered Hat* (fig.159), Kirchner compares the vitalist and instinctive bathers behind to liberated nudity in the studio. But he also contrasts inside and outside spaces and the 'primitive' bathers with the elegant nude. In his *Studio Scene*

interesante

(fig.160), Kirchner fuses three different layers of imagery into a single motif. In the foreground we find an elegant urban couple visiting the studio, in the middle ground a nude 'bather' and in the background plane a schematic rendering of his cabaret subject *Tightrope Dance* (1909). The nude is sandwiched between two different types of urban imagery.

Indeed, this pattern of contrast and analogy recurs in the thematic structures of Kirchner's oeuvre. Certainly the Moritzburg summer of 1910 was the fullest realization of the aims of *die Brücke* to forge an 'alternative' liberated arena for living and art making, beyond the confines of the studio. But the bather paintings should not be interpreted simply as idealistic counter-images to a degenerate civilization. The gay artificial world of the cabaret and circus contrasts with the 'natural' bather scenes, but these urban images are also infused with the same regenerative spirit of Nietzschean vitalism, expressed in the references to 'primitive' models. Rather than the classic polarization of city and country we find a relation of interchange and interplay: they are comparable scenes set in opposite locations.

Later Bathers

In the autumn of 1911, Kirchner and his *Brücke* colleagues finally moved from the Baroque city of Dresden to industrial Berlin, a move which must have sharpened the real contrast between their experiences of nature during the summer bathing trips and the modern urban milieu. But instead of more radical polarization Kirchner's

158. E.L. Kirchner, *Female Nude with Bath Tub*, 1911. Oil on canvas, 96 × 64.5cm. Klaus Gerhard, Munich.

160. E.L. Kirchner, *Studio Scene*, c. 1910–11. Pen and ink, 34.5 × 41.5cm. Staatlicher Museen Preußischer Kulturbesitz, Nationalgalerie Berlin.

159. E.L. Kirchner, *Nude with Feather Hat*, c. 1911. Black crayon, 44.5 × 34.5cm. Folkwang Museum, Essen.

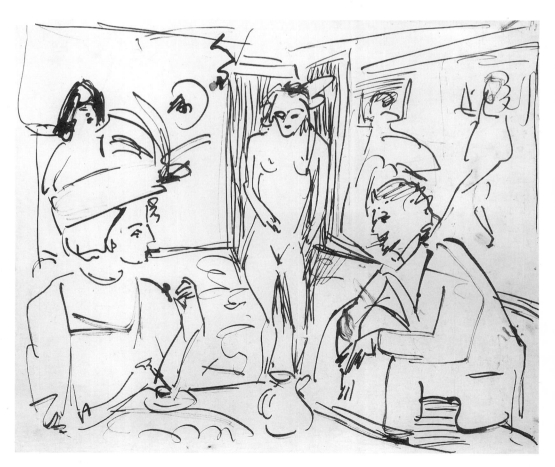

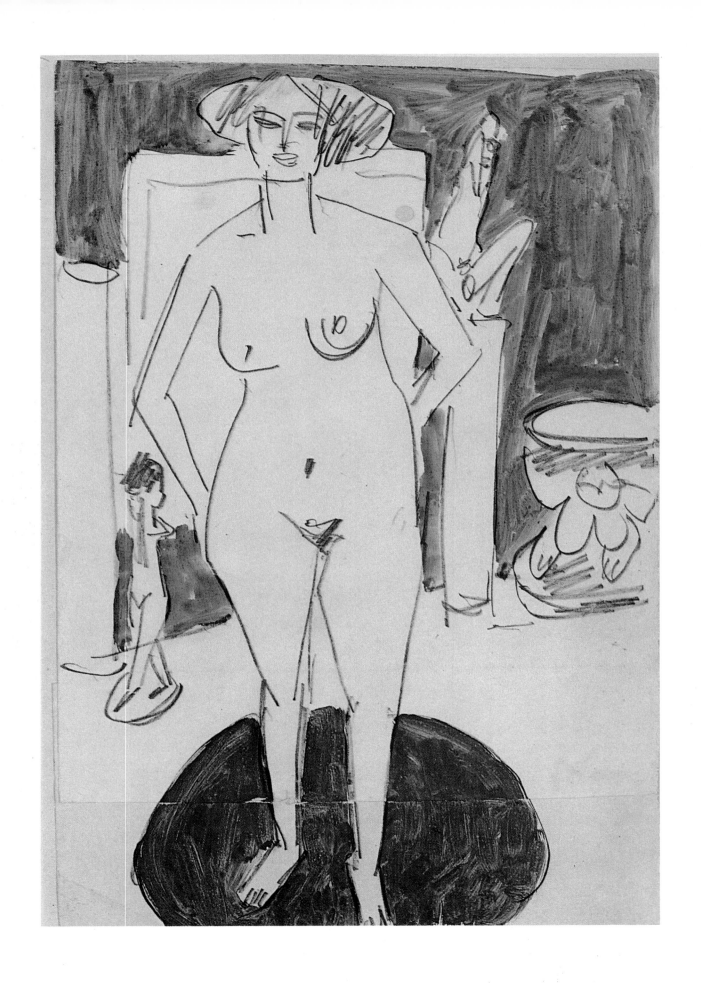

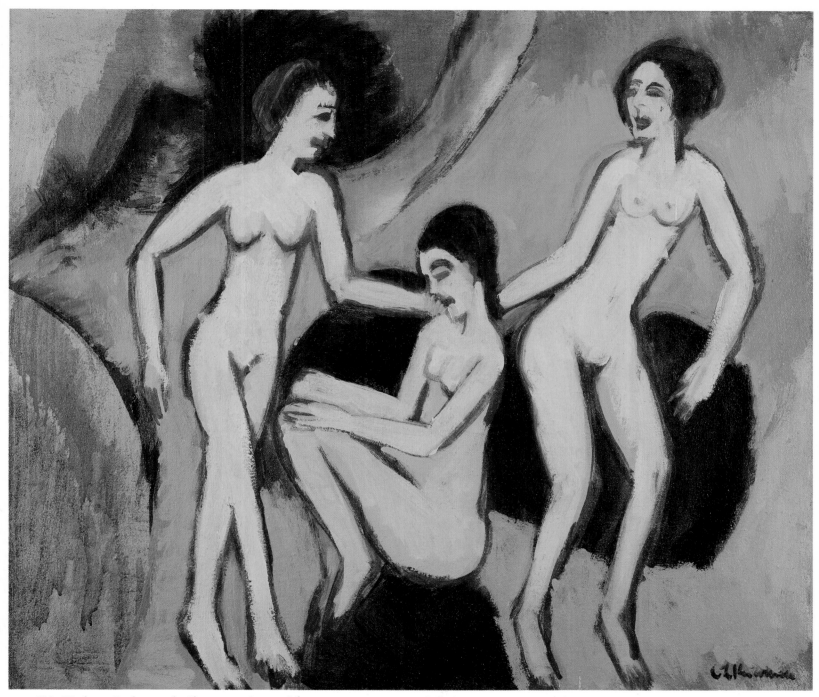

162. E.L. Kirchner, *Bathers at the Shore*, 1913/1920. Oil on canvas, 70 × 80cm. Galleria Henze, Campione d'Italia.

161. E.L. Kirchner, *Woman in the Wash Tub*, 1911. Pencil, watercolour and gouache, 40 × 27cm. Buchheim Sammlung.

163. E.L. Kirchner, *Woman and Two Boys in a Sailing Boat*, 1914. Woodcut, 44.6 × 31.6cm. Museum Folkwang, Essen.

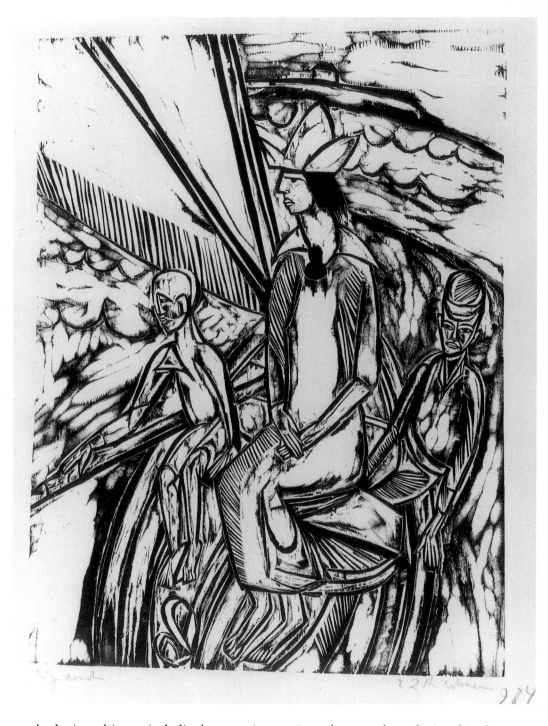

work during this period displays an increasing play on the relationship between nature and artifice, as if he found it more difficult to separate out his experiences of the city and of nature, of inside and outside spaces. The complex interface between life and art which occurs in the post-1910 studio scenes was projected outwards by Kirchner onto the dialogue of city versus country. Although Kirchner and Heckel returned to Moritzburg in the late summer of 1911 before moving to Berlin, it would seem that the harmony and optimism of 1910 were not to be repeated. Apart from short bursts of communal activity, the artists separated and moved away to more distant countryside locations. From 1912 to 1914 Kirchner returned each summer to the island of Fehmarn in the Baltic sea.[60]

During this period, several important changes in Kirchner's working methods occurred. In his Fehmarn bathers like *Four Bathers among the Rocks by the Sea* (1913;G.349), and *Bathers at the Shore* (fig.162), the figures look increasingly like the carved wooden sculptures which appear in contemporary still lifes rather than nudes (see fig.221). They are less fragments of nature than living works of art. Indeed, during the 1913 Fehmarn summer, when Kirchner was accompanied by his MUIM pupils Hans Gewecke and Werner Gothein, he carved figures from driftwood he found on the beach and used them to construct his bather compositions.[61] Already in 1912 he had begun to work from memory in *Brown Nude at the Window* (G.260) and to use photographs to help reconstruct his experiences[62] – methods which belie the immediacy and spontaneity of his 1910 nudes. In these works the wooden sculptures are 'brought alive' as bathing figures, and the figures are simultaneously transformed into works of art, reminiscent of African statuettes rather than the Greek idols Pudor visualized. But the paintings operate in a similar area of paradoxical interchange between artifice and nature, which Kirchner had been exploring for some time in the conceptual space of the studio. What was new in 1913 was the transference of this dialogue into the open air.[63]

Another shift in Kirchner's Fehmarn scenes involves the scale of the figures in relation to the landscape. In the 1910 Moritzburg bathers equal emphasis was placed on figure and landscape, contributing to the effects of free interchange and merger between the two. In 1912 this balance disappears and the bathers veer in one of two directions: they either dominate or are dominated by the landscape. In some paintings, however, Kirchner continued to pursue a relationship of unity, often in a more harmonious style than the Moritzburg scenes. The fusing of man and nature into a single entity by means of open contours and colours gave way to a more controlled and monumental rhyming of forms and colours. The Palau style is superceded by the more decorative influence of Ajanta in *Five Bathers at the Lake* (fig.167) (which draws directly on Kirchner's Ajanta drawings), *Striding into the Sea* (1912;see fig.76), and *Red Nude* (1913;G.347).

Kirchner seems to have regarded Fehmarn as a 'primitive' location, rendering a real journey to the South Seas like those undertaken by Nolde and Pechstein, unnecessary. In December 1912 he wrote to Gustav Schiefler: 'Ochre, blue, green – these are the colours of Fehmarn. A wonderful coast, sometimes with the wealth of the South Seas – fabulous flowers with fleshy stems and in addition a rather degenerate population due to intermarriage.'[64]

The hot colours, exotic vegetation and Ajanta figure style of *Red Nude* reinforce Kirchner's description. In fact, Kirchner did seek out the most remote areas of Fehmarn, preferring the rocky south-east coast to the tamer, flat coastal planes elsewhere on the island.[65] Although a railway link to Hamburg and Lübeck at the turn of the century had forged new links with the mainland, Fehmarn did remain an isolated corner of Germany until after 1945.[66] But Kirchner's fantasies about the riches of a South Seas landscape have little to do with the chilly realities of the Baltic.

A further development in the Fehmarn bathers was the introduction of city figures – often Kirchner's girlfriend and her sister – into the countryside scenes. Whereas the trappings of civilization like the hat in *Reclining Blue Nude with Straw Hat* had acted as piquant foils to nudity, these figures often add a disruptive, contradictory note to the landscape and bathing scenes. They tend either towards the monumental, for example, *Woman and Two Boys in a Sailing Boat* (fig.163), or the diminutive, like the two miniscule figures in *Staberhof Country Seat, Fehmarn I* (fig.168) who look like black spiders in their fashionable city dress against the luscious turquoise, gold and green courtyard. Kirchner also contrasts the farm buildings and elegant family house in his painting, throwing together opposites and creating extreme contrasts, rather like his combinations of different and clashing viewpoints in contemporary circus scenes.

A completely different effect is achieved in Schmidt-Rottluff's landscape woodcuts and paintings of 1914, which introduce clothed women figures. These fruits of his

164. Karl Schmidt-Rottluff, *The Sun*, 1914. Woodcut, 39.9 × 49.8cm.

166. Erich Heckel, *Day of Glass*, 1913. Oil on canvas, 120 × 96cm. Bayerische Staatsgemäldsammlungen, Staatsgalerie moderner Kunst, Munich.

165. E.L. Kirchner, *Cartoons for the Königstein Sanatorium*, 1915, no.3. Oil on paper, height 350cm. Location unknown.

first summer visit to the fishing village Hohwacht on the Baltic coast, evoke a lyrical, elegiac mood. The harmonious contact between the two women is repeated in the relation between figures and landscape, binding them together. Even the gesture of sunworship in his woodcut *The Sun* (fig.164) is more grave than ecstatic, as the familiar Romantic device of the figure seen from behind, together with the sombre juxtaposition of lights and darks, creates a distancing, contemplative mood.

In contrast, the abrupt juxtaposition of nude and fashionably dressed figures in Kirchner's cartoons for the murals he painted at the Königstein Sanatorium (fig.165), is pushed to the limits of caricature — a truly disruptive combination of contradictory elements that echoes the contrasts we find in contemporary journalistic photography, for example, in *BIZ* photographs of a train crashing into a bathing resort, or a nude '*Massai-Neger*' boarding a train in Uganda (figs.169–70).[67] Increasingly Kirchner translated the conflict he sensed between city and country into

167. E.L. Kirchner, *Five Bathers at the Lake*, 1911. Oil on canvas, 150.5 × 200cm. Brücke-Museum, Berlin.

168. E.L. Kirchner, *Staberhof Country Seat, Fehmarn I*, 1913. Oil on canvas, 90.5 × 121cm. Staatliche Museen Preußischer Kulturbesitz, Nationalgalerie, Berlin.

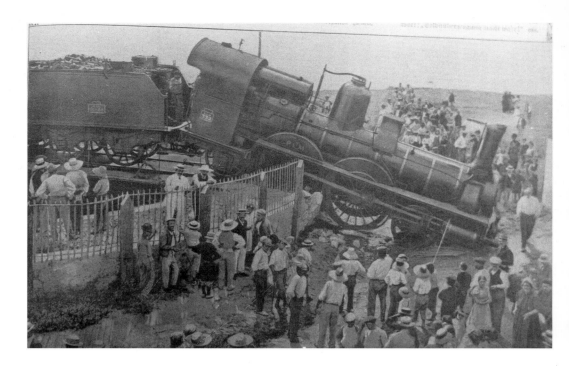

abrasive sexual confrontations, quite different from the vitality and abandon of the Moritzburg scenes.

After 1910 the dialogue between city and country in Kirchner's work introduces an increasingly complex network of relations, which subverts rather than reconfirms polarization. The encroachment of the city on the 'primitive' Fehmarn landscape only reflected the real conditions of social change on the island in a very limited sense. There was no tourist industry on Fehmarn before the 1950s, and the new rail links with the mainland were providing an escape route from the hard working conditions of the place by 1910, rather than a means of urban intrusion.[68] Kirchner's discovery of his imaginary South Seas island on the north coast of Germany

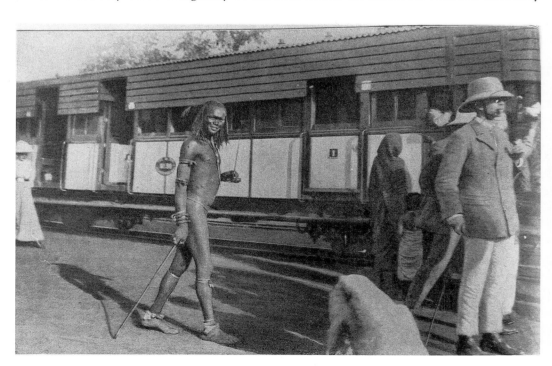

and his depictions of urban invaders, relates in a more general and conceptual sense to historical reality. This was as far as he could pull the 'primitive' away from its mirror image, modernity, without fracturing the relationship of mutual interdependence his work acknowledged between the two. Before 1911 his cabaret and Moritzburg bather scenes were locked in a relationship of contrast and analogy, each suggesting the regenerative powers of the 'primitive' in urban and natural locations. But after the move to Berlin the balance between the city and the countryside tips. No longer a regenerative force, the primitive begins to be absorbed by civilization and the city invades the country. To explain this change we need to look at the other side of the coin and to explore how Kirchner's attitudes to modern urban experience were transformed by the impact of the capital city, Berlin.

8 The Lure of the Metropolis

Bismarck who is so often right is right also in his distaste for huge cities. You write yourself that with a little less 'getting on' we would have more truth in the world. Certainly. And not only more truth, but also more simplicity and unaffectedness, more honour, charity, even more knowledge, industry and thoroughness generally. And, what does getting on mean other than to live in Berlin? To be sure a few people need the large city because of their jobs, but they are lost, particularly lost for their jobs, if they cannot practise the difficult art of living in the big city and at the same time of not living there.[1]

In 1897, a poster advertising the large international trade fair held in Berlin that year depicted the powerful arm of a workman raising his hammer over a distant landscape. The image suggested both real changes underway and the dramatic metaphorical value of the city as a symbol of modernization. During the second half of the nineteenth century, Berlin had expanded at an unprecedented rate to become, after London and Paris, the third largest European city. After the unification of Germany in 1870, Berlin was named capital of the Empire, and indemnity money from France provided the wherewithal to transform the city into a thriving industrial metropolis. Between 1870 and 1910, the population of Berlin increased from 826,000 to over 2 million, and 60 per cent of Germans had converged on the growing cities.[2]

Heinrich Mann's *Berlin, Im Schlaraffenland*, published in 1900 (translated as *Berlin*) satirized the fast moving lifestyle of the city by charting the fortunes of Andrew Zumsee, an impressionable lad, green from the provinces. Mann sardonically caricatures conservatism, by putting its pompous rhetoric in the mouths of straw dogs like Dr Abell, and modernity, with its cash-and-carry attitude to art and love. But modernity wins through and is ironically celebrated in the triumphal procession which ends the book. After a series of precarious victories and dramatic falls from favour, Andrew achieves his original ambition of working as an editor on a Berlin newspaper. The Jewish banker Türkheimer is saved from ruin when black Archduke Wallachia seeks his help to finance the introduction of modern culture into his country; Türkheimer is socially elevated and awarded a medal.

Social mobility in the city was another aspect of the sliding relations between traditional and distinct hierarchies, which represented a threatening wind of change to the conservative wing of the city versus country debate. The 'Berlin-Jewish spirit' was regarded by the champions of volkish ideology as a 'foreign' and disruptive element in the union of German land and 'volk'. Although Berlin had been elevated to the seat of Empire in 1871, and regarded as a symbol of national unification, it came to be used by the conservative nationalists as a metaphor for the negative

171. Konrad von Kardorff, *Königin-Augusta Straße at the Tiergarten*, 1910. Oil on canvas. Berlin Museum.

172. Franz Skarbina, *A Wintry Late Afternoon on the Gendarmen Market*, 1910. Oil on canvas. Berlin Museum.

effects of modernization – fragmentation and alienation – which undermined their romantic concept of national spiritual unity.

The modernist answer to the conservative polarization of city versus country was to propose a positive rather than a nostalgic reconciliation of nature and urban experience, for example, in the garden-city movement or in city Impressionism. In 1908, August Endell published his essay 'The Beauty of Big Cities', which attacked rigid polarization in favour of a positive, celebratory response to Berlin and to modernity. Endell condemned the popular 'regressive' cults advocating a return to nature, to idealized visions of the past, or to antiquated notions of *Heimat*. Although presented in the guise of authenticity, these were in fact, 'surrogates, imitations . . . as if the nature which these superficial souls know is not exclusively formed by the hand of man. As if all culture, all the works of man, were not also nature.'[3] The elevation of nature, the past, or art, into an imaginary Golden Age, in the name of unity and cohesion missing in the modern world, had the effect, Endell insisted, of sundering ideals from contemporary reality and thus fragmenting and splintering modern man's understanding. The city, he continued, should not be regarded as a polar opposite to nature, but rather as an arena where nature and artifice interact to create a distinctly modern beauty, a relative beauty conditioned by the subjectivity of the onlooker and the changing effects of light and weather on the city landscape.

Endell considered the French Impressionists to have demonstrated most successfully this distinctly modern beauty, by painting the effects of mist and rain, dusk and sunlight, on the tree-lined boulevards and parks. In fact, local equivalents for this type of city Impressionism could be found within the Berlin Secession. Max Liebermann, Max Slevogt, Konrad von Kardorff, to name but the prominent figures, all depicted the city parks, tree-lined avenues, bathing resorts and lakes in a loose Impressionist mode.[4] Lesser Ury's paintings of carriages and cars in west-end Berlin and the Tiergarten Park depict the shimmering, softening effects of rain and reflected light on the harsh lines of the city, and come close to fulfilling Endell's theories. Franz Skarbina also painted the changing city seasons (figs. 171–2). But Endell did not consider any of his German contemporaries to be capable of matching the achievements of the French in their own terms, and he called on the energies of a future generation: 'Only then will it become possible to regard the beauty of the cities as a self-evident virtue, like the beauty of the mountains, the plains, the lakes. Only then shall our children grow up in confident possession of this virtue, just as we grew up in confident possession of countryside beauty.'[5]

During the course of his essay, Endell attempted to reinterpret nationalist ambitions in a progressive modernist light, providing an earlier instance of the kind of

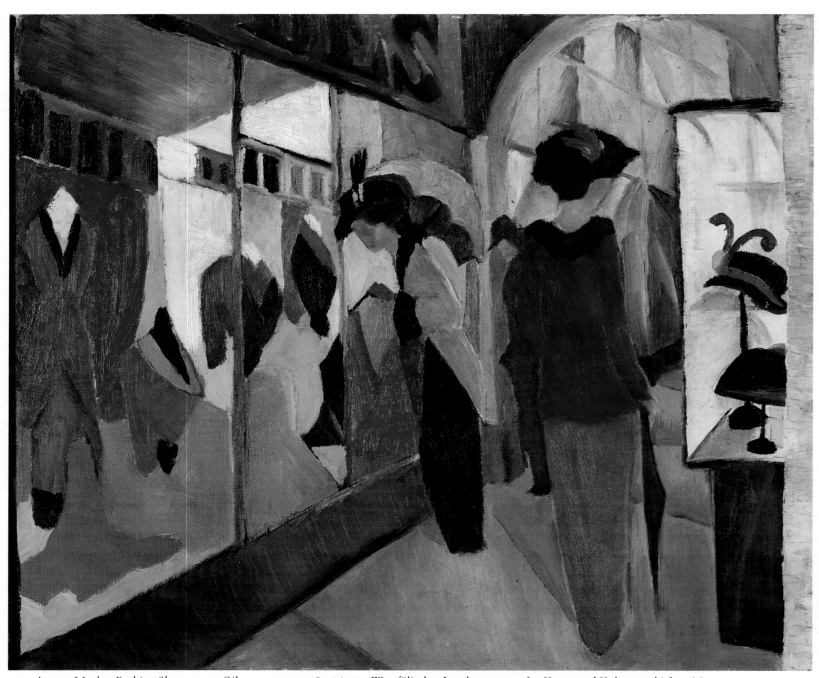

173. August Macke, *Fashion Shop*, 1913. Oil on canvas, 50.8 × 61cm. Westfälisches Landesmuseum für Kunst und Kulturgeschichte, Munster.

position we have already discussed in relation to the 1911 *Antwort* to Carl Vinnen's *Protest*.[6] He condemned narrow-minded nationalism, which falsely elevated the achievements of the Germans over other nations. But he affirmed the necessity for a strong, personal engagement with one's own time and place: 'thereby *Heimat* is not fixed and static, but rather growing, constantly transforming and dependant on our lifestyle and ways of seeing'.[7] Endell dismissed the tendency to look to the past or to the vanishing countryside for models of national unity, and invoked instead 'the authentic love of the Fatherland, the passionate love of the here and now . . . Only constantly renewed attempts to express what we experience can help to dispel confusion and to bring about a unified national feeling.'[8]

Despite their conflicting positions, the ambitions underlying conservative polarizations of city and country, like Pudor's writings on nudism and Endell's modernist reconciliation, are not fundamentally dissimilar. Both are inspired by an ideal of national unity transcending the fractures and fragmentations of historical reality. Their ways of going about this were, of course, radically opposed. Pudor's vision of unity is determinedly anti-modernist, and opposed to the forces of urban growth; Endell attempted to absorb the transient, mutable, qualities of modern experience into a 'higher' national unity that remained sensitive to the exigencies of historical change. Hence the polarization of city and country on the one hand and the synthesis of nature and artifice on the other. Before 1914, modernism and anti-modernism met on a deep level of underlying national pride and this relation was often expressed in unconscious similarities of language and metaphor. Endell's use of images drawn from nature like the forest and the waves to describe the movement of crowds and traffic in the city are precisely those used in conservative crowd theory, for example in Gustav Le Bon's *Psychologie de Foules* (1895; Crowd Psychology).[9]

Endell had called on a new generation of German city painters to uncover the conditions of urban beauty, and Macke's paintings show how the Impressionist mode praised by Endell could be updated in Expressionist terms. His depictions of city zoos and parks show the 'wild' tamed and appropriated by civilization, transformed into a gentle urban exoticism pervading the whole city, as brightly coloured hats perched in shop windows become interchangeable with parrots and birds in the zoo. Both are visually consumed by elegant urban strollers like the women in *Fashion Shop* (fig.173), just as we, the spectators, visually consume the charming paintings. Whereas Menzel depicts contemporary civilization as a veneer of artifice thinly masking 'natural' instincts in the struggle for the survival of the fittest, Macke's paintings exude an optimistic fusion of civilization and nature with the former firmly in control. Their urban scenes present two sides of the same coin, and it was a coin easily flipped in the mobile conditions of the modern age. For example, a contemporary article in the popular *BIZ* described the Berlin aquarium as a 'river in the primeval forest' with living crocodiles at the heart of the city (fig.174). Could the 'wild' be so easily contained?[10]

Often in popular representations – like the urban cabaret – there emerged a multilayered range of responses to city life which was the exception rather than the rule in high art discourse before Expressionism. Two main images of the city emerged in the popular press, often rubbing shoulders with each other. On the one hand, there were the problems associated with the crowded, dark and stuffy accommodation in rented flats to the north, east and south of Berlin, which failed to keep pace with the population boom. On the other hand, there were the attractions of west-end night life: 'Berlin Amuses Itself', a 1912 article in the *BIZ*, describes the hectic round of bars and dance halls where the Berliners could play as hard at night as they worked during the day.[11] Discussion about city planning reflected a kaleidoscope of attitudes. On the one hand, the American model of skyscrapers and commercial centres was praised for it allowed the rest of the city to be set aside for leisure activities, parks and housing.[12] But in February 1913, the journalist Henry Urban described the Woolworth building as a 'temple of dollars' higher than the cathedral spire in Cologne, and peopled by 'dollar hunters'.[13] A serial tale in the *BIZ*

174. 'The main attraction of the new Aquariums in the Berlin Zoo. A tropical jungle river with living crocodiles.' *BIZ*, August 1913.

that summer by Georg Hirschfeld, '*Bellowische Ecke*', followed the fortunes of a family whose old Berlin wine bar is destroyed to make way for the European metropole: 'Light and shadows become sharper under this new sun, which even blinds the eye of some. Inside twenty years Berlin has been Americanized.'[14]

Plans for the new garden cities added a new dimension to the city versus country debates. In December 1912 an article on the city of the future praised the English model of the garden city as the 'modern system' and contrasted the poor conditions in the rented flats at Tempelhofer Feld with the family houses in Hampstead Garden Suburb. The Berlin-Britz colony was praised for its rows of low rent family houses within the 10 pfennig city train zone.[15] Some writers saw these new schemes as an opportunity to bring the comforts of village life within the range of the city. Georg Hermann in 'The Nostalgia of Big City Man', claimed that the strength of his nostalgia for lost 'roots' in the countryside was only matched by his optimism that the future city would reestablish a balanced relationship with nature in new suburban residential areas.[16] In real terms, the boundaries between urban life and nature began to dissolve on the fringes of the city. But the terms used to describe the more extreme contrast in the nucleus of the city between the Tiergarten and the surrounding area are significantly different. Here the language of the 'wild', the 'other', comes into play, obviously provoked by the nearby location of the zoo. In a popular article 'The Most Beautiful Park in the World', the Tiergarten was described as a fine alternative, an oasis of silence and fresh air, at the heart of the metropolis. It was indeed a kind of 'virgin territory' where it was possible to forget the city altogether and where the local wood pigeons were like wild birds undisturbed by human contact.[17] Nearby the tropical *Urwaldfluß* – or Berlin aquarium – was to be found.[18]

As we arrive at the heart of the city, images of the village give way to the language of the jungle, and it is precisely in these popular, daily representations of the city that we are able to excavate something of the texture of historical experience that lies embedded in Kirchner's 1913 street scenes. Let us now try to explore the genesis, subjects and styles of these works more directly.

Die Brücke *Cityscapes*

The earliest *Brücke* cityscapes are primarily descriptive images of Dresden, often concentrating on architectural motifs. Kirchner's thumbnail sketches of the monuments and architectural landmarks of the Baroque city (fig.175) document his environment in the lively notational style of the quarter-hour nudes, departing from the style rather than the subjects of traditional architectural drawing. Indeed, Berndt Hünlich's fascinating and scholarly reconstruction of the sites of *Brücke* motifs in Dresden-Friedrichstadt, which has only recently been demolished, shows how accurate these fleeting sketches were, the results of a trained eye used to grasping fine architectural detail as economically as possible. Schmidt-Rottluff's 1909 lithograph depicting the beginning of the Berlinerstraße (fig.176) adopts the high bird's-eye viewpoint associated with a topographical tradition, which has been dictated, in this case, by the view from his own studio window in Lobtauer Straße 9.[19] Basically these are naturalistic depictions of a familiar environment. Dresden was still a picturesque city in comparison to Berlin, but most of the *Brücke* artists' urban motifs were drawn from the industrial working area of Friedrichstadt where they had their studios. In drawings like Kirchner's *Suburb with Factory Complex* (1909–10) and *Factory in Dresden* (fig.177), the factory buildings on the outskirts of the city show an alternative face of Dresden, a counterpoint to the elegant city centre, as if he was deliberately engaging with a distinctly 'modern' subject, remote from the history and tradition associated with Dresden's Baroque architecture. In 1910, Heckel produced an interesting series of images depicting the fringe areas of the city, its

175. E.L. Kirchner, *The Neustadter Markt in Dresden with the Monument to Augustus the Great*, 1909/10. Pencil, 26.2 × 34.2cm. Galerie Pels-Leusden, Berlin.

176. Karl Schmidt-Rottluff, *Berlinerstraße in Dresden*, 1909. Lithograph, 40 × 34cm. Sammlung Buchheim.

177. E.L. Kirchner, *Factory in Dresden*, 1910. Pencil and watercolour, 26.8 × 34.4cm. Sammlung Buchheim.

suburbs and harbour, and in *Dresden Landscape* (fig.178), the city skyline appears on the horizon, behind the foreground motif of a figure crossing a bridge. This motif, often a railway bridge, recurs in many Brücke cityscapes as a record of the areas they were living in and, like their tightrope walkers and archers, the bridges are replete with Nietzschean associations. Kirchner in particular used the lines of bridges and railway tracks to structure his compositions, combining descriptive, symbolic and purely formal codes of representation in a characteristic manner. In Menzel's *Berlin-Potsdam Railway* (1847) the railway was shown cutting through the hard and fast divisions of city and country; in Kirchner's work its potential symbolic value as an agent of historical change and transformation, like the Nietzschean image of the bridge on a moral and philosophical level, is not to be ignored. But this is just one element in a balance of pictorial modes. In Kirchner's *Gas Tanks and Suburban Railway* (1914;G.385), the train, like the suburb itself, mediates between city and country, but it turns back in on the industrial motif of the gas cylinder. His *Rhine River Bridge at Cologne* (see fig.73) encourages us to compare the wonders of modern and ancient engineering. Although both the figures and the train move forwards across the bridge, Kirchner seems to question rather than affirm the value of 'progress', by contrasting as well as comparing the 'Gothic' cathedral with the modern machine and the fashionable pedestrians.

Kirchner's earliest paintings of Dresden like *Streetcar in Dresden* (1909;G.99), *The Blue House in the Panholder District, Dresden* (1909;G.104), and *Dresden-Friedrichstadt* (1910;G.130), mix architectural and landscape elements, rather like Heckel's near contemporary painting of Moritzburg *Peacock-Chateau at Moritzburg* (Vogt 1910/22), or *Landscape near Dresden – Stormy Landscape* (Vogt 1910/29). Kirchner adopts a low viewpoint, moving away from the conventions of topography, although these paintings remain cityscapes rather than crowd scenes. The one exception is *Street* (fig.179) which depicts a crowded street, prefiguring the Berlin street scenes.[20] Reinhardt suggests a new source for Kirchner's *Street* beyond

178. Erich Heckel, *Dresden Landscape*, 1910.
Oil on canvas, 66.5 × 78.5cm. Staatliche Museen
Preußischer Kulturbesitz, Nationalgalerie, Berlin.

its conventional association with Munch's, *Evening on Karl Johann Straße* (1892),
namely Anton Procházwka's *Street* (1907);[21] in fact the sketch for Procházwka's
painting (fig.180) comes even closer to Kirchner's work.

It is the simultaneous movement away from and towards the spectator that recalls
Munch's painting, although the sensation of distance, emphasized by the cool tones
and architectural perspectives in *Karl Johann Straße*, is replaced by the hot, singing
colours and the crowd of figures at the top of Kirchner's *Street*. These press
downwards and forwards towards the spectator. Both Munch and Kirchner depict
masked types rather than individual characters, but while Munch reveals the death-
mask lying behind social appearance, Kirchner's figures are colourful doll-like
beings, consisting only of their social 'mask' like animated puppets. Munch also

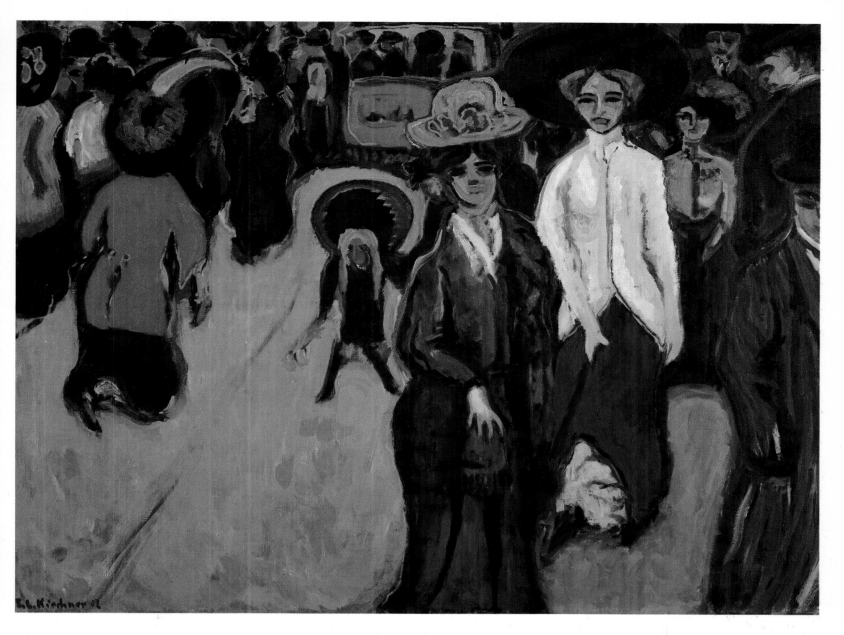

179. E.L. Kirchner, *Street*, 1908/19. Oil on
canvas, 150 × 200.4cm. Museum of Modern Art
New York.

180. Anton Procházwka, *Sketch for Jungmann
Square in Prague*, 1907. Black crayon.
Location unknown.

builds a psychological distance into his painting via the dialogue between the
death-like crowd and the single overcoated figure, usually interpreted as Munch
himself, moving away from the spectator along the road. Kirchner's painting is less
self-contained and the spectator plays the rôle of the oppositional individual, forced
into confrontation with the colourful crowd. It is the directness and urgency of this
confrontation, rather than any overtly sinister factor in the crowd itself, which
compromises the gaiety of the work. While Munch's painting is very obviously
about urban alienation, Kirchner's *Street* depicts both the life and movement of the
crowd and its claustrophobic effects.

Die Brücke *in Berlin*

It is unlikely that Kirchner's first experience of the large metropolis, when he began
to visit Berlin in 1908, provoked feelings of alienation. On the contrary, all the
Brücke artists were attracted to Berlin by the advantages and possibilities of the

capital city. After Pechstein's move there in the summer of 1908, the other *Brücke* artists had a base in Berlin and made frequent visits until the autumn of 1911 when Kirchner and Heckel also moved their studios there. As early as 1907, Heckel wrote to Amiet about the advantages of Berlin as an art centre where it was possible both to see international modern art and to exhibit their own work.[22] By 1906, Kirchner was sending drawings to the Berlin Secession,[23] and as early as 1910, Heckel was negotiating terms for a *Brücke* exhibition at the Kunstsalon Fritz Gurlitt, which finally took place in April 1912 and precipitated enthusiastic reviews.[24] Commenting on their first Galerie Richter exhibition in 1908, Schmidt-Rottluff had written to Amiet about 'the fundamentally reactionary attitude in the city. It is hard to understand why Dresden is seen from outside as an artistic centre – absolutely unjustifiably.'[25] In 1910, the *Brücke* exhibition at the Galerie Arnold had been severely criticized by Richard Stiller in the *Dresdener Anzeiger* and coolly received by the formerly supportive critic of the *Dresdener Neueste Nachrichten*, Paul Fechter.[26] This encouraged their enthusiasm for Berlin. The artists also hoped to better their financial situation, as Pechstein was already mixing in a wide artistic and social circle there.[27]

At first, Kirchner saw Berlin through rose-tinted glasses, full of the enthusiasm of his first visits. He wrote to Heckel: 'You'll be totally suprised when you set foot in Berlin. We've become a large family and you can get everything you need – women and shelter.' By November 1911, he displayed a more realistic appraisal of the situation writing that 'the struggle to survive is very hard here, but there are greater possibilities'.[28] At the end of his first winter in Berlin he replied, belatedly, to Louise Schiefler's enquiries after him: 'it is due to the indecent way of life in Berlin, as you have to fight here to survive. It is terribly vulgar here. I can see that a free and noble culture cannot be created under these conditions and I want to leave as soon as I've conquered these large portraits...'[29] A year later Schmidt-Rottluff warned his friend Beyersdorff against expecting to discover a true 'city of the mind' (*Geistesstadt*) in Berlin, 'but outside Berlin', he added, 'you're always in the wings'.[30]

The Darwinian struggle for the survival of the fittest in the competitive ambiance of the city was, as we have seen, frequently used to describe the negative effects of modernity. In the early months of 1912, dissent within the *Brücke* group was underlined by the conflicting interests and fierce rivalries which characterized the Berlin art world.[31] In December 1911, *die Brücke* withdrew from the New Secession, and at the end of May 1912, Pechstein was expelled from *die Brücke* after giving in to Paul Cassirer's pressure and exhibiting individually at the old Secession in April. Extensive plans for the *Chronik der Brücke* began in 1912.[32] This document was an attempt to secure the history and identity of their own group in the fast moving ambiance of international avant-gardism, which had been promoted by the 1912 Sonderbund exhibition and by the entrepreneural visit of the Futurists to Berlin in April that year.[33] It had the opposite effect, and the clash of individual and group interests splintered the group irrevocably in January 1913. By this time, as Günter Krüger points out,[34] *die Brücke* were mere pawns in a game of power politics being fought between Herwarth Walden and Paul Cassirer, and they found themselves confronted in a very immediate way by the negative, competitive and divisive tactics of 'modern' life they had originally tried to combat with their own creative alliance of pragmatism and idealism. This time the enemy was within their own ranks and, pulled apart by their own supporters, the group broke up from within.

Literary Expressionism and the City

Originally, in 1911, contact with the Berlin art world, and particularly the literary avant-garde, had provided *die Brücke* with new stimuli, and this was certainly one of the most positive and fruitful sides of their encounter with big city life. Alongside

138

an indigenous tradition of city painting, which had been transformed into an Impressionist mode by the artists of the Berlin Secession, there existed a school of Berlin city poetry, originated by Arno Holz and Richard Dehmel at the turn of the century and revitalized by the young Berlin poets in the circles of *Der Sturm*, Der Neue Klub and Das Neopathetische Kabarett.[35] While the naturalist generation was preoccupied with the social problems of city life, which also surfaced in contemporary paintings and graphics by Hans Baluschek and Käthe Kollwitz, the younger poets discovered the city as 'an arena of unforseen intensity and adventure'.[36] Without ignoring the bleaker, alienating aspects of urban experience they attempted to grasp the movement, chaos and dynamic of big city life as a symbol of modernity. Kurt Hiller, president of Der Neue Club, which was founded in the autumn of 1909 and transformed into the Neopathetische Kabarett in 1910, described the task of the new poetry: 'to give pathetic form to the daily experiences of highly sophisticated man; that is, an authentic representation of the thousand great and small pleasures and pains that confront the intellectual city dweller.'[37]

Kirchner's contact with this new city poetry was an important shaping influence on his own changing vision of city life. In 1911, both he and Schmidt-Rottluff painted portraits of the young writer Simon Guttmann (b. 1890), who introduced *die Brücke* to the Neopathetische Kabarett.[38] Heckel and Schmidt-Rottluff designed programmes for the literary cabaret and Kirchner illustrated Simon Guttmann's pantomimes and contributed to the short lived periodical, *Das Neue Pathos*.[39] *Pantomime Reimann: The Dancer's Revenge* (1912;G.227), was painted by Kirchner in response to Hans Reimann's pantomime of that title, which presented a modern updating of the Salomé theme.[40] In 1912, new literary themes began to enter *Brücke* painting.[41] and this discovery of like-minded literary contemporaries gave a new, if temporary, boost to their flagging sense of group solidarity.

An important point of contact with the Berlin literary avant-garde was the all – pervading influence of Nietzsche's writings. The city apocalypse, which became a recurrent theme in their poetry, referred to the third book of *Zarathustra* 'Of the Virtue that Makes Small'. This describes the destruction of the cities as a sure sign of the coming of the new age. In the winter semester of 1909/10 Ernst Loewenson's lecture, 'The Decadence of our Times and the Foundation of the New Club', described Nietzsche as a vital and driving force to counteract 'the declining life force' of Western man, and he explained the literary group's use of the term 'pathos' to refer to 'an exaggerated sense of the intensity of life'.[42] While Loewenson stressed the instinctive, Dionysian aspects of the new literary movement, Kurt Hiller advocated a new urban intellectualism, a *Gehirnlyrik* (intellectual lyric poetry). This was to be based on irony and dissonance, benefiting from the abstract rationalizing spirit of city life that Georg Simmel had first described in his lectures at Berlin University.[43] Both wings of the literary movement tried to tap the complex multi-layerdness of urban experience, combining heightened excitement with anxiety. Karl Schneider describes this process in his essay 'Themes and Tendencies of Expressionist Poetry' (1967):

> The ambivalence of experience is drawn out, which involves sudden swings from ecstasy to anger without more ado and without a break in continuity. In this sense there is no important difference of experience between Ernst Blass' positive representation of cosmopolitan life and [Georg] Heym's demoniacal vision of the city. This merely involves two different aspects of the same elemental experience...[44]

During the months before his death in January 1912, Georg Heym played a central rôle in the Neopathetische Kabarett, whose last important meeting in April that year was a memorial celebration for the poet. Heym's *Umbra Vitae* was published posthumously in 1912, and illustrated by Kirchner from 1919 to 1923. Indeed, his city lyrics come closest in mood to Kirchner's pre-war street scenes. In his poems *Berlin I, II, III,* for example, he achieves expressive effects by throwing

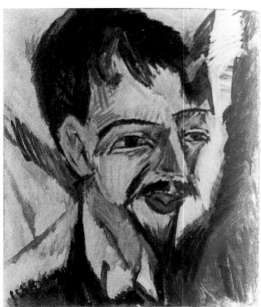

181. E.L. Kirchner, *Portrait of Alfred Döblin*, 1912. Oil on canvas, 51 × 42cm. Private collection.

together images of beauty and ugliness, or, more exactly, images of artifice and nature, which coalesce in a new, multifaceted and suggestive evocation of urban experience. For example in *Berlin II*:

...Die Omnibusse, Rauch und Hauppenklänge.
Dem Riesensteinmeer zu. Doch westlich sahen
Wir an der langen Straße Baum an Baum
Der blätterlosen Kronen Filigran.
Der Sonnenball hing groß am Himmelssaum.
Und rote Strahlen des Abends Bahn.
Auf allen Köpfen lag des Lichtes Traum.

...Buses, smoke and car horns.
Towards the sea of stone. But to the west
We saw along the street of trees
the leafless filagree crowns.
The ball of the sun hung low at the edge of the sky.
And rays of red marked the passage of evening.
The dream of light touched every head.[45]

The other author with whom Kirchner was in close contact in 1912, was Alfred Döblin, whom I would propose as a strong and important influence on Kirchner's vision of urban life in the Berlin street scenes. Several drawings and photographs of Döblin, one of which Kirchner worked over in pencil, relate to the portrait of his literary friend he painted that year (fig.181). In 1913, Kirchner illustrated Döblin's *Das Stiftsfräulein und der Tod* (*The Stick-thin Girl and Death*) with six woodcuts, and he also worked on a series of erotic woodcuts to illustrate Döblin's lost drama, *Comteß Mizzi*.[46] Since the beginnings of his literary activity in the 1890s, Döblin had tried to describe and to characterize the specific quality and mood of modernity.[47] In 1910 and 1911 he published a series of short stories in *Der Sturm*, using the same 'modern' subjects of urban entertainment as *die Brücke*, before their own graphics began to appear in the magazine.[48]

Döblin's importance for Kirchner lay in his reinterpretation of Italian Futurist aesthetics in the light of the particular preoccupations and needs of German modernism. Following the Futurist début in Berlin, Döblin published two articles in *Der Sturm*, and his engagement with Futurism helped him to shape a new narrative mode in line with the demands of modernity. Döblin was attracted by the iconoclastic anti-aesthetic of Futurism;[49] like Marinetti he was strongly influenced by Nietzsche's rejection of romantic idealism and conventional aesthetics of beauty. Both, however, objected to Nietzsche's insistence on the psychological individuality and the historical development of the *Übermensch*. They sought to replace this with the idea of anonymous protagonists seen from the point of view of their arbitrary and often illogical actions and frequently absorbed in the movement and force of the urban crowd. In *Attack on the Professors*, of May 1910, Marinetti described this commitment to modernity as a cutting loose from the historical trajectory of past and future, thus, in terms which begin to describe modernity as an *ahistorical* – and effectively *primitivist* – phenomenon. This is despite the Futurist artists' distaste for non-European style, which they dismissed as 'the superficial and elementary archaisim founded upon flat tints, and which, by imitating the linear technique of the Egyptians, reduces painting to a powerless synthesis, both childish and grotesque.'[50] Marinetti wrote:

Nietzsche's superman proceeds from the philosophic cult of classic tragedy, and presupposes a passionate backward gaze towards paganism and mythology. The German philosopher, in spite of his capacity for penetrating the Future, will ever be remembered as the most obstinate worshipper of ancient beauty...our hero has nothing to do with this bookish creature [Zarathustra]. He is the disciple of

the Engine, the enemy of books, an exponent of personal experience. He is a manifold product not of an inherited culture, but of his own activity.[51]

In Döblin's 'Chinese' novel, *Die Drei Sprünge des Wang-Lun* (1913, published 1915; *The Three Leaps of Wang-Lun*) where he began to practise the literary methods he had advocated in his 1913 essay, 'To Novel Writers and their Critics',[52] he rejected nineteenth-century psychological and historical description of character in favour of arbitrary actions conveyed by abrupt and distorted exclamations, gestures and sounds. The direct and immediate confrontation with reality which results from this method was countered by distancing devices, meant to depersonalize both the protagonists of his novel and the author. Döblin described this method as '*Entselbung*' or '*Entäußerung*': 'I am not me but rather the street, the street lamps, this or that event, nothing more. This is what I mean by the stony style.'[53]

Just as the notion of individual personality is absorbed in a new relation to objects and actions, so too the protagonists of his novel are subsumed in the abstract and geometric patterns of crowd behaviour. Like Kurt Hiller, and, as we shall see, Kirchner himself, Döblin wrote into his vision of modernity many of the abstracting, alienating modes which Simmel had described as characteristics of the modern state. It was Simmel who put his finger on this aspect of avant-gardism, which began in the pre-war years, drawing attention to the,

> passionate revolutionary yearning for a *vita nova*, a determination to struggle for a spiritual form of life that is neither abstract, theoretical or aesthetic but can be grasped practically; not an idealistic withdrawal from the world but a cultivation of it even though in a thoroughly idealistic sense; a deadly hatred of all that is bourgeois, of all mechanization and Americanization but making use of the forces that these tendencies nonetheless produced...[54]

Significantly, Döblin disagreed with the Futurists' single-minded praise of modernity, their exclusive affirmation of the beauty of cars, aeroplanes and machine-guns. His own engagement with the forces of modernity on the level of stylistic practice was coupled with a thematic critique of the negative, alienating aspects of urban industrial life. In *Wang-Lun*, where the attempt to retreat from the modern world proves futile, we find him ironically repeating a Futurist chant:

> This heavenly dove-like flight of the airplanes.
> This sliding chimney under the ground.
> This flash of words across hundreds of miles:
> Who does it serve?
> But I know the men on the street. Their
> telephones are new. The grimaces of greed,
> the alienating fullness of their blueish shaved chins,
> their thin runny noses
> the Crudity with which their hearts beat small in their thickening blood,
> the watery dog-like search for praise, their throats yap across the centuries and fill
> them with – progress.
> Oh, I know all that. I am lashed by the wind so I don't forget.
> In the life of this earth two thousand years are one year.[55]

In many ways, Döblin's own distinctly German cultural pessimism allowed him to put his finger on the etymological paradox of Futurism. Cutting loose from the trajectory of history in the way Marinetti suggested in his 1910 *Attack*, guaranteed freedom from the shackles of the past. But it also severed the link with the future. In *Wang-Lun*, Döblin continues this passage: 'We travel, but we don't know where to. We stay still and don't know where...who can really speak of gain and possession?'[56] Cut off from the past and future, time concertinas and man finds himself, as Lukács suggested, isolated in a kind of eternal present and plagued by a sense of anxiety which Paul Gauguin had perhaps first tried to express in his monumental

primitivist painting, *D'où venons-nous? Qui sommes-nous? Où allons-nous?* (1897). Taken a stage further by the Futurist-Expressionist generation, the notion of present time, of modernity which was fundamentally ahistorical and timeless, began to overlap and coincide philosophically with current ideas about the position of 'primitive' man. Ambivalent feelings about modernity itself, which developed in the circles of the Berlin literary avant-garde, meant that a less optimistic image of the 'primitive' began to emerge, cut loose from the faith in regeneration and future development, and more closely related to the ideologies of cultural pessimism.

Kirchner's Berlin Street Scenes

Before the Futurist exhibition in April 1912, Berlin city painting was a well-established genre within the broad spectrum of Realist and post-Naturalist painting. Julius Jacob's *Houses Going Up* (1910) shows how traditional academic painters could take the changing face of the city as their subject, and younger artists treated similar themes in a freer Post-Impressionist style. Ludwig Meidner's city scenes, *Building the Berlin Underground* (1910) and *Gasometer in Berlin-Wilmersdorf* (1911) show his response to spatial effects in Van Gogh, whose own urban subjects, *View of Montmartre*, *Factory Buildings* and *The Railway Bridge* were exhibited at Paul Cassirer's gallery in October–November 1910.[57] *Brücke* cityscapes, painted in Berlin before 1913, relate to this mode of city painting; indeed Kirchner's *Railroad Underpass in Dresden-Lobtau* (1910–26;G.171) was also influenced by the spatial distortions in Van Gogh's work.[58] Similar spatial effects occur in his Berlin cityscapes, like *Red Elisabeth Riverbank, Berlin* (fig.183), one of a series of paintings by Heckel and Kirchner showing the Luisa Canal, a well-known bathing spot in Berlin before 1914. In this painting and Heckel's contemporary *Canal in Berlin* (Vogt 1912/38), we find an interaction of landscape and architecture. In Kirchner's painting the foreground landscape elements, the water and trees, are regulated and contained by the geometry of the city, while the background frieze of buildings and church, curve and slant in an unstable, organic way. In Schmidt-Rottluff's contemporary paintings of Hamburg streets and buildings, for example *Houses at Night* (fig.182), and *Petriturm Hamburg* (1912) this curving and bending of architectural geometry transforms the urban cityscape into an organic, living entity. Heckel's *Canal* is painted with bright luminous winter colours, while Kirchner chooses heavier leaden tones with bright flashes of red and rust. These background reds contradict the effects of linear recession, but the scene is distanced by the two small figures at bottom right who stand between us and the city motif.

Grohmann has suggested that Kirchner circled around the suburbs of Berlin before confronting the city centre in his famous street scenes.[59] In several of these fringe cityscapes like *Suburb of Berlin* (1912;G.274), a landscape element predominates and the city looms up in the background. Elsewhere the landscape provides a kind of nest in which the suburban architecture rests, for example, *Villa near Grunau* (1911;G.209) and *Garden Restaurant in Steglitz* (1911;G.211). In Heckel's contemporary work we find areas like the Luisa Canal where city and landscape meet, and also pairs of paintings in which the two elements pull apart within the boundaries of the city limits. For example, *Street in Berlin* (Vogt 1911–10) depicts the grid-like black geometry of working-class Berlin, peopled by small spider-like figures. In *Strollers at the Grünewald Lake* (Vogt 1911–11) similar black contours define the serpentine curves of a frieze of trees against a royal-blue lake where small urban figures are strolling. This scene shows none of the natural vitality and growth which characterized Moritzburg; on the contrary the outlying lakes in Berlin take on the sombre mood of the city itself.

Two of Kirchner's urban scenes, *Nollendorf Square* (1912;G.291), and *Street in Schöneberg Park; Innsbruck Street* (1912), have been described as a kind of mediating, transitional stage between the cityscapes and street scenes.[60] If we

182. Karl Schmidt-Rottluff, *Houses at Night*, 1912. Oil on canvas, 76.2 × 84.3cm. Staatliche Museen Preußischer Kulturbesitz, Nationalgalerie, Berlin.

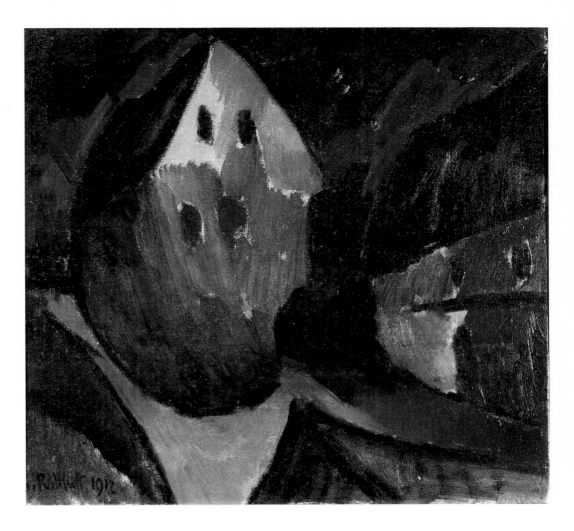

compare Kirchner's *Nollendorf Square* (fig.184) with Max Beckmann's painting of the same location one year earlier, *View onto Nollendorf Square* (fig.185), we see how far he had moved away from the loosely defined post-Naturalist styles of Berlin city painting. Beckmann adopts the bird's-eye view of topographical tradition, and uses his soft, sumptuous and yet heightened colours to convey effects of light, weather and atmosphere, which knit together the buildings and trees. Kirchner also chooses a bird's-eye view, but combines effects of distance and proximity, as he did in the 1908 composition *Street*, by depicting, in this instance, the city square as if seen through a telephoto lens or reflected in a convex mirror, so that the motif seems to be hugging and bending the picture plane. The effect is of having the scene thrust under one's nose and spatial distortion is thus used to expressive ends. In contrast to Beckmann's tree-lined square, we find a crowded, jagged, city geometry, cut across by the diagonals of the tram lines. *Innsbruck Street* presents a variation on the same theme: the city crossing is twisted round onto a horizontal and vertical axis, and a sparsely populated, thin membrane of empty space replaces the crowded convex centre of *Nollendorf Square*. Kirchner described this emptiness as suggestive of 'the entire melancholy of big city streets'.[61]

In the autumn of 1913, after the dissolution of *die Brücke* and his summer trip to Fehmarn, Kirchner began to work on his street scenes. He moved inwards for his subjects from the margins of Berlin to the city centre and sketched fashionable west-end street life. Kirchner later described 'modern' beauty as fluid and variable, characterized by movement rather than 'monumental stillness'. Echoing Kurt Hiller's ideas, he saw this mirrored in 'the nervous faces of people of our times'

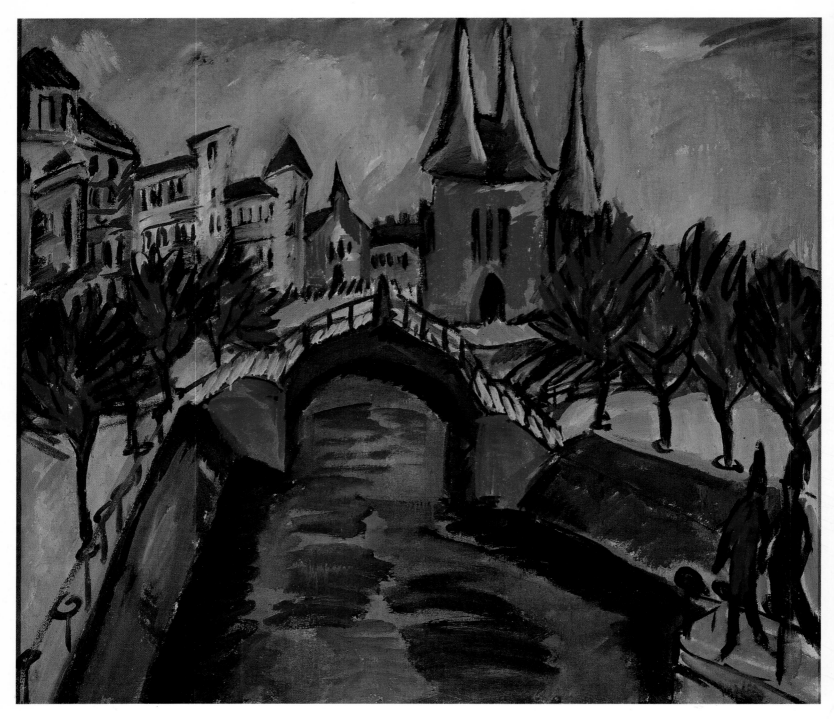

183. E.L. Kirchner, *Red Elisabeth River Bank.*
Berlin, 1912. Oil on canvas, 101 × 113cm.
Bayerische Staatsgemäldesammlung, Munich.

which reflect, 'every smallest irritation'.[62] In *Sick Woman; Woman with Hat* (1913; G.298) and other contemporary portraits, he began to formulate a particular urban physiognomy. But his sketches of street life show groups and pairs of figures, often prostitutes with their clients, whose flux and movement Kirchner both records and intercepts with his fleeting, rapid drawings, (figs.186–7). These small pencil sketches, all on paper measuring c. 20.5 × 16.5cm, in which a spiders webb of black and grey lines replace the more tonal, painterly effects of his charcoal sketches of Dresden, were made as he moved around the city centre. They were the germ of the ten major Berlin street scenes Kirchner painted over the course of the next fifteen months.

184. E.L. Kirchner, *Nollendorf Square*, 1912. Oil on canvas, 69 × 59.7cm. E. Weyhe, New York.

185. Max Beckmann, *Nollendorf Square*, 1911. Oil on canvas. Berlin Museum.

186. E.L. Kirchner, *Carriage in the Street, Leipziger Straße 11*, 1914. Pencil, 20.6 × 16.6cm. Private collection.

Kirchner later suggested that these rapid sketches engaged with the 'modern' spirit of the city: 'They are unselfconscious and aimless, a mirror of the sensations of a man of our times.'[63] As such they differed from the more consciously constructed paintings and graphics, 'the living force of his will comes about through the drawings'.[64] In his 1927 'Zehnder Essay' (recorded in his diary), Kirchner emphasized the directness and immediacy of these first sketches in a typical Expressionist vein:

> The work evolves as an impulse, in a state of ecstasy and even when the impression has long taken root in the artist, its rendition is nevertheless quick and sudden... I learnt to value the first sketch, so that the first sketches and drawings have the greatest worth for me. How often I've failed to pull off and consciously complete on the canvas, that which I threw off without effort in a trance in my sketch without more ado. Then it was so complete and calm that it looked finished... His (Kirchner's) drawings are in fact notes, which he quickly jots down, like writing something...[65]

The direct and instinctive outlet of creative energy we see in Kirchner's first sketches, which Schmidt-Rottluff described in another context as 'something dithyrambic in me, the rush of blood',[66] once again testifies to the cults of authenticity and direct expression. Here they are pushed to a new pitch and intensity in order to override the rational structures and restrictions which were felt to have divided subjective and objective experience in the modern world. The intense rapidity of execution might also be interpreted as a kind of fight against time, an unconscious attempt to eliminate history in their own working processes, and thus to catch modernity on the wing. Alfred Döblin too, with his short explosive sentences, sounds and gestures was attempting to achieve similar 'modern' effects, but the inbuilt sequential structure of narrative form rendered such attempts more difficult. His whole method was wrought with an internal contradiction, as our act of reading inevitably reconstructs a historical trajectory against which the text itself protests. The comparative immediacy of visual experience was more readily adapted to the cult of modernity, and from the mid-nineteenth century the sequential stages of

187. E.L. Kirchner, *Soliciting Prostitute*, 1914.
Pencil, 20.5 × 16.6cm. Private collection.

Kirchner's new way of working (studio)

artistic process, of preparation and finish, had been undermined and telescoped as rapid sketching became the new hallmark of modernist art. Hence Baudelaire's 1863 description of Constantin Guys, the painter of modern life:

> how he stabs away with his pencil, his pen, his brush, spurts water from his glass to the ceiling and tries his pen on his shirt, how he pursues his work swiftly and intensely, as though afraid that his image might escape him; thus he is combative even when alone and parries his own blows...[67]

But, as Paul de Man points out, the paradox of 'modern' literary form had an equivalent in the visual arts.[68] Guys' battle with himself stands for the conflict between the 'ahistory' of his working method – his rapid, fleeting sketches which capture the immediacy and transience of the modern instant – and memory, which is needed to distil and synthesize, to make sense of the random impressions of the instant and to transform multiple sensations into a work of art. With this act of memory history reasserts itself. In 1913, this modernist paradox began to emerge clearly in Kirchner's work and to affect important changes in his working methods. We have already remarked on his use of photographs, his reconstructions of Fehmarn bathing scenes from memory and aided by wooden sculptures, which contradicted the immediacy and spontaneity of his Moritzburg primitivism. In his preparations for the Berlin street scenes, the cult of spontaneity and immediacy reached a new pitch in the rapid summary sketches of street life, where he pushed his characteristic drawing style to new extremes. But after this, Kirchner returned to the studio and began a second set of drawings on a larger format (*c.* 52 × 38cm), using pen, brush and ink to convey linear and tonal effects.[69] His 1913 drawings, *Elegant Pair, Berlin Street Scene, Street Scene with the Small Fiddler* and two 1914 works, *The Corner, Uhlandstrasse* and *Prostitute with a Dog*, all fall into this category. The highly worked pastel drawings, *Street Scene, Street Scene with Green Lady* (fig.188), and *People on the Street* (all 1914), are also studio drawings. Here Kirchner experimented with combinations of male and female figures which had first occurred in his rapid on-the-spot sketches. All these studio drawings are more densely worked and reorganize his experience of the streets into the more synthetic, geometrical compositions which recur in his oil paintings. Kirchner described this practice of taking up and elaborating his first sketches in the studio: 'He remade the same form again from memory, pushing the form further. From this rich material, to a certain extent the essence, there emerge the graphics and paintings. The graphics are often an inbetween stage bridging drawing and painting.'[70] In fact, the graphic works relating to the Berlin street scenes are often made after rather than before the paintings.[71] It is the studio drawings which mediate between the raw material of the city sketches and the intellectually planned, geometrical compositions of the painted street scenes. In the course of his preparations, he shifts the balance from instinct to intellect, emphasizing the rationalized, abstract mass of the city crowd with his geometrical crowd formations. In a 1937 letter to Carl Hagemann, Kirchner explained this conscious element in his working methods as a positive rethinking of artistic tradition, capable of matching the old masters:

> I have the photo of the street scene infront of me (G.363)... What a lot of authentic drawing is needed to make a picture like this! How the figures hold together and build the whole street with nothing other than two entrances. How the movement of the passers-by is captured in the rhomboid formed by their heads, which is repeated twice. In this way life and movement results from geometric, elementary forms. They rest on firm laws which precisely here, in this picture, are rediscovered, that is to say by the artist in the light of his experience of nature. It is the task of the artist after all to sight the richness of nature and to order it anew, to reform it so that what is meant shines forth, clear and pure. It would be interesting to see this picture next to Dürer...[72]

While Kirchner stressed the pictorial advantages of intellectual order in this much

later comment, his compositional geometry in the street scenes expressed first and foremost the nature of his subject, the crowd. Kurt Hiller and Alfred Döblin, following Simmel, had dwelt on the intellectual, abstract and crystalline psychology of city life. Most important, Worringer had also elaborated on Simmel's ideas in *Abstraktion und Einfühlung*, proposing that the psychology of fear and alienation, such as 'primitive' man experienced in the face of a hostile, unknown environment, was expressed through abstract, geometrical pictorial form which attempted to freeze and control the unknowable. In contrast, he proposed that the psychology of empathy, whereby man is at ease and at one with his environment, was best expressed through the organic forms of southern, classical tradition. In northern Gothic art, as man emerged from the Dark Ages, his unstable, unpredictable relation with a hostile climate and environment accounts for the persistence of abstraction in combination with 'empathetic', organic forms. As we have already discussed, the popularity and currency of Worringer's theories for Expressionist art went hand in hand with the Gothic revival of *c.* 1912–14. In Kirchner's case, the potential significance of his use of geometric and organic forms in accordance with Worringer's theories becomes more convincing when we remember that his contemporary Fehmarn and circus paintings, which are, on the one hand, positive counter-images to the alienating experiences of urban life, display curved, spherical compositions. In the street scenes, where the elongated figures and city arches respond to the call for 'modern Gothic' forms, we find a mixture of pictorial geometry and expressive handling, a fusion of organic and non-organic modes which comes close to Worringer's description of the hybrid 'Gothic' style. In this way, different layers of primitivist style are written into Kirchner's urban scenes.

Five Women on the Street (fig.189) has been accepted as the first of the Berlin street scences.[73] The two drawings associated directly with this painting are slightly different from those already discussed.[74] Both are in pen, brush and ink and both were probably made in the studio from memory as compositional sketches. The larger drawing (44.8 × 37cm) shows a more casual arrangement of the fashionably dressed figures, seen from a high and distant viewpoint with a cab to their left. The second drawing, which is drawn on the paper Kirchner usually used to sketch in the streets, shows a more exact compositional study from a closer viewpoint, very similar to the finished painting despite the different position of the woman's arm, far right. A third studio drawing shows a similar group of five figures, some of whom look into a shop window to the right, but in this case there are two men approaching the group of prostitutes. This is probably an experimental variation on the same theme which Kirchner made before or after the painting.[75]

The prostitute excited many associations in this period: she was seen by Karl Kraus as a challenge to bourgeois moral order, and depicted by Max Klinger as a tragic victim of social hypocricy.[76] Kirchner wrote to Gustav Schiefler from the western front in 1916 about his own feelings of identification with the prostitute: 'Now man is like the prostitutes I painted, washed aside and totally gone at any moment.'[77] But this later statement, as Rosalynd Deutsch rightly points out, should not lead us to view Kirchner's prostitutes as romantic alternatives to the dominant social order, like the bohemian artist in the army.[78] On the contrary, they are emblems of urban psychology in the modern age: in many ways they forecast the identification of modern woman and the city which emerged in the Weimar era when fashion was regarded as a way of proclaiming the new womanhood.[79] Corresponding to the geometric compositional structures which slice up the picture plane into triangles, circles and rhomboids, the angular, elongated prostitutes suggest the rationalization and dehumanization of urban capitalist society such as Simmel described in his *Philosophie des Geldes* and in his 1903 essay 'The Big City and the Life of the Spirit':

The ideal of the natural sciences to transform the world into a theoretical calculation, to fix each part in a mathematical formula, corresponds to the

188. E.L. Kirchner, *Street Scene with a Green Lady*, 1914. Pastel, 47 × 29.8cm. Private collection.

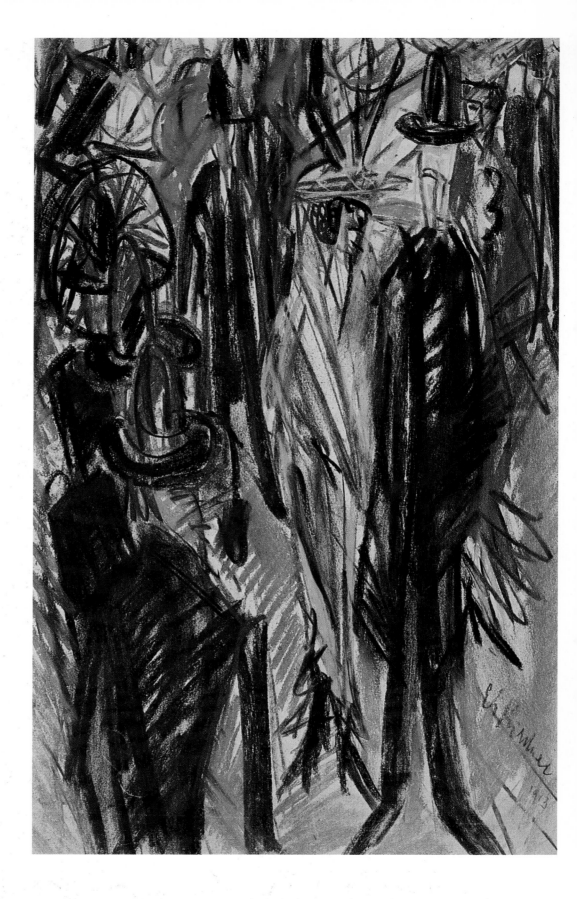

189. E.L. Kirchner, *Five Women on the Street*, 1913. Oil on canvas, 120 × 90cm. Wallraf-Richartz Museum, Cologne.

148

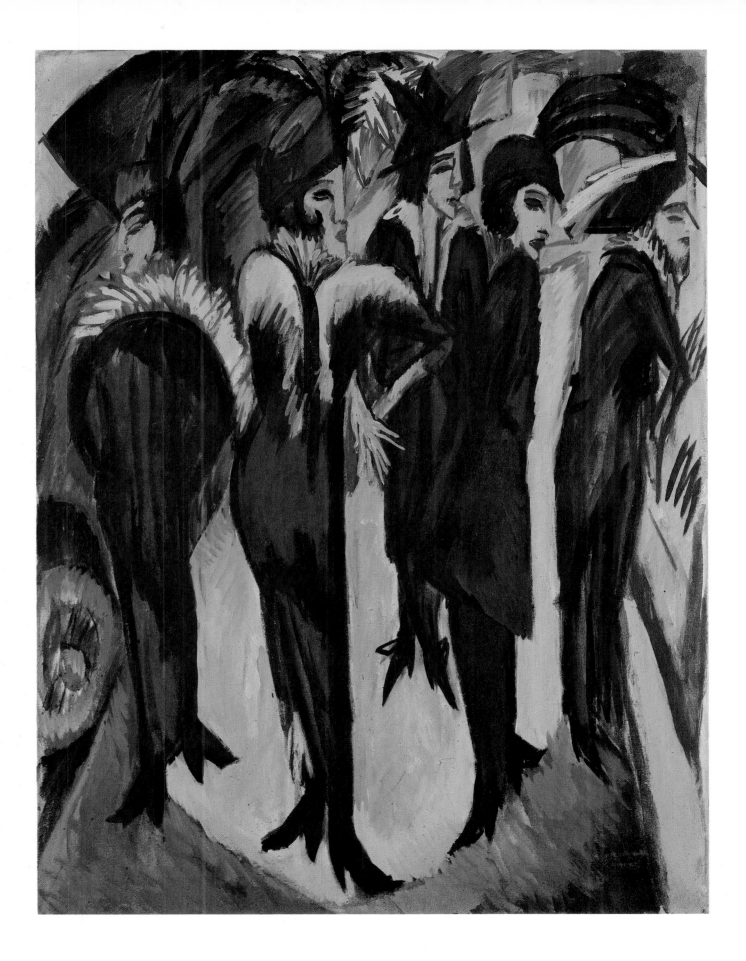

arithmatical exactitude of practical life which has come into being with the money economy, this is what has filled the days of so many men with weighing up, with counting and numerical designations, reducing qualitative to quantitative values.[80]

In *Five Women on the Street* physical proximity and mental distance are combined: although we see back views of the two left-hand figures, their heads are twisted round at ninety-degree angles to their bodies so that they confront us without addressing us directly, and remain psychologically isolated from each other, despite the similarity of dress and type. This expression of their professional sexuality also characterizes the conditions of crowd psychology in the city. As Simmel remarked:

> The mutual reserve and indifference, the spiritual living conditions in large groups, are never more strongly felt to confirm the independence of the individual than in the thickest city crowd. It is here that bodily proximity and crowding first make spiritual distance truly visible; it is apparently only the reverse of this freedom, that one feels on occasion nowhere so lonely and deserted as in the big city crowd.[81]

The depersonalization of the figures goes beyond type and costume; in fact they are manikin-like objects, lit up by the glare of the shop window, a visual equivalent for Döblin's notion of *Verdinglichung*.[82] With reference to a later pastel drawing which treats the same subject, *Figures in front of a Shop Window* (1914) Kirchner wrote about 'the absolute equal value of all appearances for the picture'.[83] In this statement Kirchner echoes Simmel's ideas about the new blasé and money-oriented urban psychology which registers quantity rather than quality so that 'the meaning and value associated with differentiation and therefore with individual things is experienced as irrelevant. They have the same equal, matt grey tone for the onlooker...'[84]

Kirchner's women are caricatures of artificiality, genuine manikins based partly on the iconography of contemporary fashion plates (fig.192). But a tribal rawness replaces the elegant mannerism of Kirchner's source, and the women, although constructed from artifice, are also the focus of powerful 'uncivilized' instincts of sexuality and aggression with their mask-like faces, 'tribal' costumes and spiky primitivist forms. This relates to Worringer's ideas about the alienated, abstracted relation between primitive man and his environment, which undercut traditional eighteenth-century notions concerning the harmonious coexistence of the noble savage and nature. As we have already seen, Worringer's theories related to Simmel's writings where he described man's battle to retain his individuality in the modern urban environment as 'the final transformation of the battle with nature which primitive man fought to preserve his bodily existence'.[85] Gustav le Bon's crowd theory also spoke of the loss of individuality in modern industrial society, maintaining that this wore away the behavioural characteristics of civilization to reveal savage and primitive instincts;[86] Freud too had begun to make connections between the neuroses of modern man and his 'primitive' roots.[87] In all these cases the modern and the 'primitive', instead of being proposed as conceptual alternatives, merge and coincide in a new and disruptive way.

The primitivist rawness of Kirchner's *Five Women*...differentiates it from other Berlin city paintings in an avant-garde idiom like Heinrich Richter-Berlin's painting of prostitutes, *Our Sweet Lady from the Tauentzienstraße* (fig.191). This was inspired by Herwarth Walden's Futurist exhibition in April 1912. Kirchner's own later descriptions of the street, however, were heavily influenced by Futurist aesthetics:

> I developed them from the observation of movement that gives a form which rests on the persistance of light impressions in the eye. The click of moving feet, for example, remains a moment longer in the eye than the heels, which move

190. Plate from the fashion magazine, *Damenmode*, 1913.

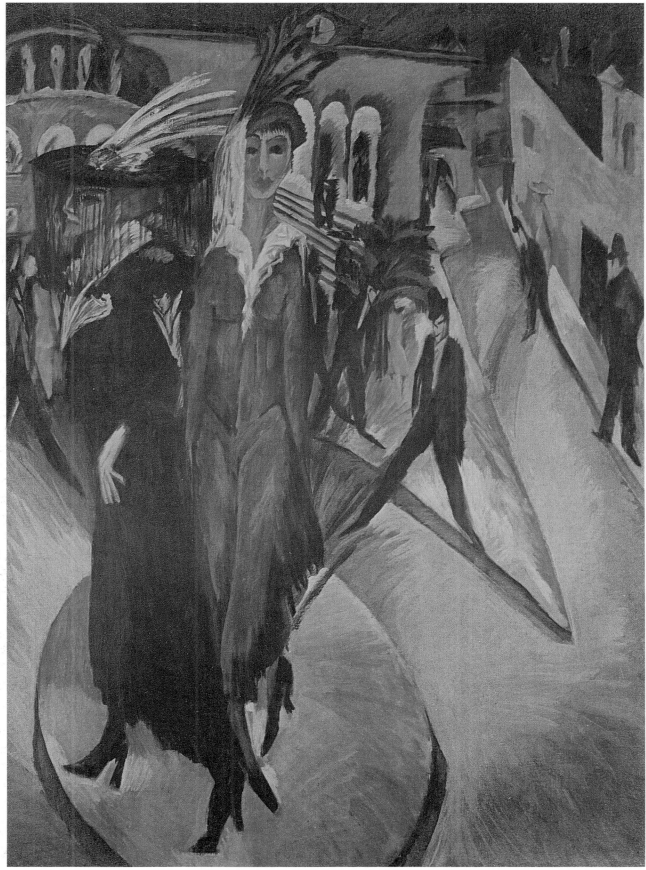

191. Heinrich Richter-Berlin, *Our Sweet Lady from the Tauentzienstraße*, 1913. Oil on canvas, 150 × 80cm. Berlinische Galerie, Berlin.

192. E.L. Kirchner, *Potsdam Square, Berlin*, 1914. Oil on canvas, 200 × 150cm. Private collection.

193. E.L. Kirchner, Sketch for *Potsdam Square*, 1914. Charcoal on hand-made paper, 67.5 × 51.2cm. Private collection.

constantly, so they become bigger in the picture. I myself move about, and single point perspective is cancelled out...[88]

A 1925 entry in his diary continues: 'Kirchner found that the mood lying over a city expressed itself in the form of force lines. In the way men composed into crowds, in the routes they followed, he found a way of capturing the experiences of that time.'[89]

In *Berlin Street Scene* (1913;G.363), *The Street* (1913;G.364), and *Friedrich-straße* (1914;G.367), the repetition of identical male figures and the black 'force lines' radiating from the figures' feet in the latter painting, imply visual acquaintance with Futurist devices for suggesting movement and speed. But just as Döblin

194. E.L. Kirchner, Sketch for *Potsdam Square*, 1914. Pencil, 20.5 × 16.5cm. Private collection.

combined Futurist literary devices with a more critical, finely tuned approach to the subject of city life, so too Kirchner employs these Futurist means to create a mood far from the Italians' celebration of urbanism and industrialization. Only *Friedrich-straße*, with its drove of male figures and predatory prostitutes displaying themselves in their city clothes like the dog with its arched pink backside, recreates the extreme, alienating mood of *Five Women*. The other 1913 paintings are less directly threatening, but their lurid electric colours and jagged geometry create a tense, charged space in which the groups of male and female figures meet and pull apart. The subject of these paintings is not so much a Munch-like confrontation of individual and group interests, as has often been suggested, but rather the substitution of the individual by the crowd, which moves in an impersonal geometric formation, like a dense pack of live manikins. All this comes extremely close to the principles advocated in Döblin's contemporary literary theory. But Kirchner's paintings are not literary or illustrative and they engage in their own visual terms with contemporary discussion about how best to convey the conflicting experiences of modern city life. The real friction and energy of the paintings comes from their combination of rational compositional geometry and powerful gestural brushwork, from their exaggerated colours set against sombre surrounds. In this way Kirchner conveyed both the regulation and the potential wildness of the city crowd, which Simmel described as a complex organism threatening to erupt into chaos if not controlled and disciplined by the impersonal rationality of urban lifestyle, with its punctuality, exactitude and 'fixed non-subjective framework of time'.[90]

The climax of the Berlin street scenes came with *Potsdam Square, Berlin* (fig.192), more than twice the size of the other paintings and in several ways an ambitious, definitive work. A large studio drawing (67.5 × 51.2cm; fig.193), quite different from his first rough sketch of Potsdam Square (fig.194), shows how carefully Kirchner worked out this composition. Like his 1914 cityscape, *Belle-Alliance-Place* (G.371), the painting shows a de Chiricoesque combination of empty arcades and city square, and this mood is echoed by an isolated clock above the entrance to the background station in Potsdam Square.[91] The overt order and geometric rationalization of the scene is combined once again with the suggestion of seething, irrational forces: one prostitute wears a macabre widow's veil over her hat, while the other confronts us with a blank mask-like stare. The architectural geometry, with its arrow-like pavement and circular traffic island, takes on the force of sexual symbolism. This circular traffic island, where the two prostitutes are caught in a frozen movement, performs another rôle. Just like the bath tubs in the studio drawings, it acts like a sculptural plinth, emphasizing the women's artificiality, and the mannerism of the whole scene with its stage-like unreality.

But despite the increasing artifice of the Berlin street scenes, the prostitutes continue to stalk in city landscapes illuminated with lurid 'natural' colours – fluorescent greens and flesh pinks.[92] Forty years previously Menzel had handled the paradoxical interaction of nature and artifice with an ironic lightness of touch: in Kirchner's street scenes, it has become an expressive conflation of opposites pushed to the extremes of caricature.[93] Certainly the Berlin street scenes present an alienating urban alternative to the liberated sexuality of the Moritzburg bathers, but they are closer to Kirchner's contemporary Fehmarn paintings. Just as elements of the city began to invade the countryside isolation of Fehmarn, so too 'nature' reasserts itself under new terms of reference in the city centre. These 'alternative' areas of human experience had been separated by traditional hierarchies, until the value of 'civilization' was called into question in the mid-nineteenth century. In an attempt to fix and stabilize uncertain relations the conservatives, as we have seen, tended to polarize city and country while the modernists, like August Endell, advocated a new aesthetic synthesis. In Kirchner's street scenes a *collision* of city and country, nature and artifice, rather than a synthesis, occurs and primitivism and modernity are no longer held in a delicate balance of contrast and analogy. On the contrary, at the heart of the city, they become one and the same thing.

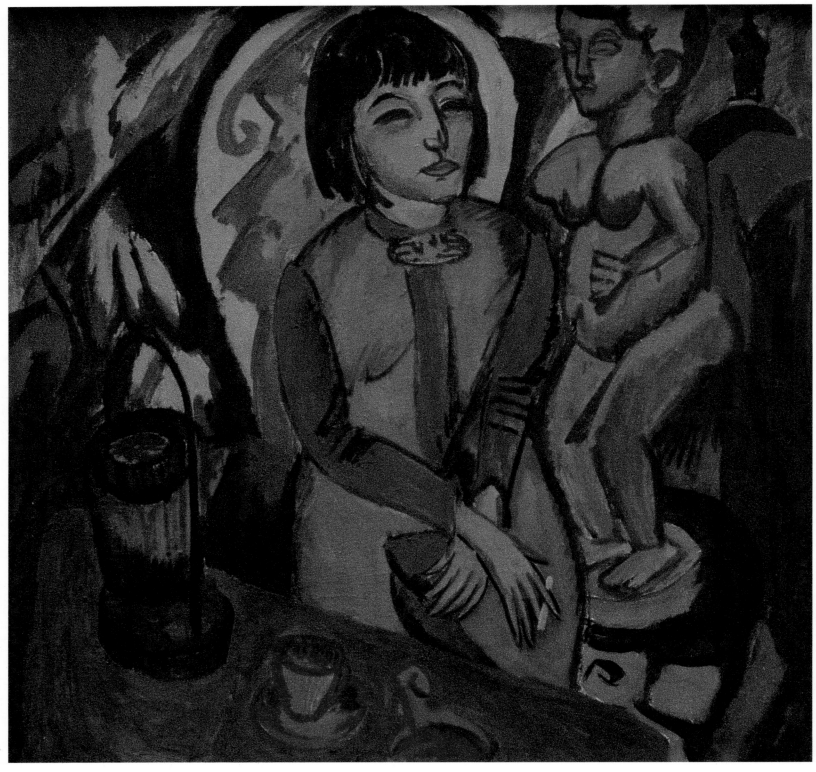

195. E.L. Kirchner, *Seated Woman with Wood Sculpture*, 1912. Oil on canvas, 97 × 97cm. Brücke-Museum, Berlin.

We must look a little more carefully at the rôle women play in this new constellation of relations. When we go back into the studio, we find a number of works where Kirchner continues to hold primitivism and modernity apart by means of an ironic play of contrast and analogy between his sophisticated Berlin girlfriend, Erna, and the primitivist studio ambiance.[94] In the earlier Dresden studio scenes we have often remarked on Kirchner's inclusion of a piquant reference to artifice and

154

196. E.L. Kirchner, *Seated Woman with Headband*, 1912. Pencil on chamois coloured paper, 46 × 31cm. Galleria Henze, Campione d'Italia.

197. 'Frühlings-Moden', *BIZ*, March 1913.

modernity – a hat, a fan, the roller skates in his black crayon *Studio Scene* (1910) – which sets off the primitivist surroundings and marks out the studio as a place where nature and artifice meet in the act of art making. In the Berlin studio, the more fully fledged urban presence of Erna, dressed in the costumes of a modern woman, appears alongside the Africanized MUIM sculpture in Kirchner's drawing *Erna in a Short Jacket next to a Wooden Figure* (1912) and in the related oil painting *Seated Woman With Wood Sculpture* (fig.195). Another drawing *Seated Woman with a Headband* (fig.196), shows Erna juxtaposed to Kirchner's copy of the Ajanta Buddha hanging on the studio wall; in each case visual similarities – the pose and hairstyle here, the mask-like faces of Erna and the wooden sculpture – are played off against the contrast between the modern urban woman and the 'primitive' non-European figures beside her. In Kirchner's 1912 woodcut *Woman Tying her Shoe* (Dube H.206), we find a melancholy urban dancer with provocative black stockings and high-heeled shoes sitting on Kirchner's roughly carved stool supported by a nude figure in African style, against the backdrop of a bather subject. His method of contrast and analogy is a familiar device in the studio scenes, and we have already seen how he builds up his primitivist iconology by employing these means. What is new here is the overt presence and centrality of the modern urban woman, who is both different from and similar to her primitivist ambiance; she thus acts as a kind of interface between the 'primitive' and the modern.

Interestingly, we find Kirchner's methods and subjects recurring in a cruder vein in the popular primitivist imagery of the period. For example, a 1913 illustration in the *BIZ* entitled *Spring Fashions* (fig.197) ironically juxtaposes modern costumes and tribal headdresses. The comparison between women, children and natives in this montage is typical of the use of Darwinian evolutionary principles as a weapon to ridicule women and tribal society and to affirm male superiority by means of the 'objective' mask of the photographic eye. In literary form, an ironic inversion of savagery and civilization also occurs in Hans Paasche's, 'Letters of the Negro Lukanga Mukara; Explorations of the African Lukanga Mukara in darkest Germany', which was first published serially in *Kunstwart*, in 1912–13. Paasche, who was dedicated to the anti-modern reform movement, described his now long-forgotten but originally popular book as an attempt 'to free our people from the abuses of modern life'.[95] He was inspired to write his satire of European society after returning from his honeymoon trip to the Nile and witnessing the negative effects of European colonization. Paasche – like Nolde by 1914 – criticized colonialism and modern society from a conservative viewpoint. He advocated the *Wandervogel* as a source of natural grace and joy which could restore the true values of civilization, represented in his novel by the noble savage, Lukanga Mukara. Lukanga writes home to Africa describing the arbitrary senselessness of his European hosts, the *Wasungu*, ridiculing their money, calculations, factories, clothes and eating habits as foolish, 'primitive' customs contrasting with his own organic wisdom. He describes womens' clothes, in particular, as a kind of scaffolding holding together two quite separate parts of their bodies. Unable to move, women lose their strength and come to be termed the 'weaker' sex: 'then an educated negro experiences something like pity for such ill-treated creatures'.[96] In 1900, a pair of drawings in *Jugend* showed a dignified Red Indian squaw dressed in a manner similar to that advocated by the reform movement next to a powdered and painted 'civilized' urbanite (fig.198), and thus began to formulate in visual terms the ideas later expressed in Paasche's text.

By 1913, cultural relativism could be stretched to this kind of radical inversion of the primitive and the modern. Irony, as we have seen in Menzel's work from the later nineteenth century, was a way of commenting on the shifting, disrupted hierarchies, which had previously controlled and organized the relations between civilization and 'savagery'. At the same time, ironic devices could be used to divert real fears inspired by the collapse of these traditional boundaries. As a distancing device, irony continued to operate in the article on spring fashions, effectively reconfirming rather than challenging the status quo, by reasserting male European superiority.[97]

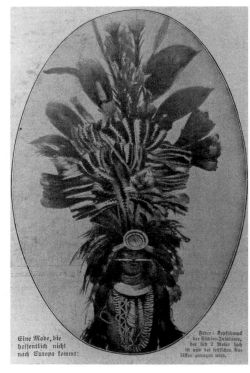

198. Illustration from *Jugend*, 1900.

199. 'A fashion that hopefully won't come to Europe!', *BIZ*, January 1912.

200. 'The 230cm tall black giant Abomah, who is currently performing at the Panoptikum during a walk on Unter den Linden.' *BIZ*, June 1911.

Kirchner's Berlin studio paintings of Erna relate to these popular examples, but the relations they propose are more subtle and problematic, and the visual irony of analogy and contrast is used to question rather than simply to reaffirm the boundaries between the 'primitive' and the modern. In the Berlin street scenes, these fragile, ironic barriers collapse, and the prostitutes become a powerful focus of primitivism *and* modernity, of nature *and* artifice. A similar shift occurs in a second photograph from the *BIZ*, which does not juxtapose tribal and modern headwear, but rather depicts an extravagant tribal headdress *as* an exaggerated European hat, with the comment: 'A fashion which hopefully won't come to Europe!' (fig.199).[98] As the boundaries between the 'primitive' and the modern collapsed in the European imagination, we find women, who were located lower than men on the evolutionary ladder according to the canons of social Darwinism, taking the full brunt of this convergence. This is as true of Kirchner's paintings as it is of the popular examples I refer to. But there is one important difference. In the popular press where women are ironically ridiculed, they are used to shield men from the implications of these shifting, sliding relations between civilization and 'savagery'. In Kirchner's street scenes the opposite is true, and women are depicted as a powerful magnet, an irresistible force drawing men with them, and thus pulling them towards the contradictory heart of modernity.

The Expressionist City and its Heritage

The notion of the city as a battleground between progressive and regressive forces, between nature and civilization, recurs elsewhere in Expressionist art. It is the central theme, for example, in Alfred Kubin's illustrated novel *Die Andere Seite*, (1909; *The Other Side*). Kubin's description of Perle, the city dominated by the forces of death, sleep and ecstasy, until the wind of change and pragmatism blows in with Hercules Bell from America, mixes a dominant expressive mode with ironic devices. For example, the religious cult of organic matter as opposed to technology in Perle, involves the worship of excreta and a horror of metals. During the battle at

156

the end of the book between Klaus Patera, the old ruler of Perle, and Bell, the city itself slips back into the primal mud, so that the triumph of progress and regression go hand in hand. Of course, Bell's victory is compromised as Patera remains lord of death and dreams, and when the narrator awakes, he acknowledges both as forces dividing the world, neither holding absolute sway. 'The real hell', Kubin concludes, 'is when this contradictory play of forces carries on within us.'[99]

The other major painter of Berlin street scenes before 1914, Ludwig Meidner, did not associate himself with Expressionism, but we shall find that his paintings make overt many of the issues simmering beneath the threatening surface of Kirchner's street scenes. As we have seen, Meidner's 1914 essay *Anleitung zum Malen von Großstadtbildern* particularly condemned primitivizing tendencies in Expressionist art, for Meidner considered primitivism to be inadequate – quite wrongly in Kirchner's case – to express the sophisticated nuances of modern city life. Inspired by Futurist aesthetics following the publication of the first Futurist manifesto in *Der Sturm* in March 1912, and by Endell's more local discussion about the aesthetics of city painting, Meidner advocated a modernist engagement with city subjects. Like Endell, Meidner saw the city as the modern *Heimat*, but he directly attacked the Impressionists' depictions of the city as nature, the painting of boulevards as if they were flowerbeds. Meidner rejected both the techniques and approaches of Impressionism, advocating a more exact, penetrating vision and the intellectual advantages of painting from memory rather than *en plein air*. The new city painters were to celebrate the age of engineering, expressed in the geometry of the city which gave a new *raison d'être* to Cubist style. Rather than turn the city into nature, he advocated turning nature into artifice, translating the experiences of city life into a new nervous and expressive geometry. Light, rather than recording weather effects, should be used to create dramatic contrasts and divisions of space.

Meidner's practice as a city painter, however, only partially conformed to the thorough-going urban modernism of his later theories. Before the impact of the Futurist show, Meidner, like Max Beckman, was taking the changing face of the city as his subject. Paintings like *Gasometer in Berlin-Wilmersdorf* (fig.201), propose a compositional schema which recurs in almost all his later city paintings: the city is situated in the background plane and nature in the foreground, like some of Kirchner's 1912 paintings of the Berlin suburbs. This reverses the composition of Menzel's *House under Construction* (1875), where nature is literally in the process of being bricked up behind the picture plane. In Meidner's paintings nature is always nearer to the spectator and the city converges forwards. In his fully fledged modernist city paintings after the impact of the 1912 Futurist exhibition, Meidner was preoccupied by the fate of the individual in the city. *Me and the City* (1913) shows the artist's head (the city was constantly associated with intellect) surrounded by a distorted city panorama. The clump of green trees behind his head forms a kind of halo between Meidner and the man-made city. Meidner's drawing *Street Fight* (1914) makes explicit the struggle for the survival of the fittest, the barbaric evolutionary battle set in the city streets, threatening the security of the sensitive individual.

In the spring of 1912, Meidner, together with the artists Richard Janthur and Jacob Steinhardt, founded an artists' group, Die Pathetiker, referring like Das Neopathetische Kabarett, to the Nietzschean concept of pathos as a more intense experience of life. In the summer and autumn of 1912, many members of the literary avant-garde attended weekly gatherings in Meidner's studio in Berlin-Friedenau, and the influence of apocalyptic city poetry by Jakob von Hoddis and Georg Heym certainly helped to shape Meidner's own apocalyptic vision. Like von Hoddis in his poem 'End of the World' (1911) Meidner shows us a constructed, artificial world literally ripped apart by natural forces – light, wind, fire and flood; often the city seems caught in a whirlwind of destruction. A series of natural disasters during these years, including Halley's comet in 1910, which had always been taken as an augur of disaster, the Messina earthquake in 1909 and the sinking of the Titanic in 1912,

confirmed the general suspicion that natural forces were beyond technological control. Max Beckmann, who admired and supported Meidner's work, and shared his distaste for the decorative, abstracting and primitivist tendencies in Expressionist art, also depicted these disasters as part of the inevitable cycle of human destiny. But while Beckmann continued to work in the traditional genre of history painting translated into a contemporary mode, Meidner pursued a self-conscious 'avant-gardist' direction.

Many of Meidner's apocalyptic subject paintings were titled 'landscape' despite their urban settings. *Apocalyptic Landscape* (1913) depicts a city exploding into fragments and on the reverse side a Beckmannesque nude lying in a splintered landscape. This figure recurs in a second *Apocalyptic Landscape* (fig.202), occupying the foreground space while the natural forces of fire and flood reek havoc on the city behind. Man and the landscape are the tragic victims of the battle between nature and technology and the nude figure is like a felled bather. These compositions acknowledge the futility of dividing city and countryside into watertight categories; the disasters in the one necessarily affect the other. *The Burning City* (1913) repeats the compositional arrangement of a burning urban background and a foreground 'stage' of men on the outskirts of the city. The figures in this case, dressed in earth-brown costumes, seem to be regressing, crawling back into massive crevices in the ground to escape the chaos behind, grimacing with animal-like expressions. Man is no longer the agent of his own disaster as he appeared in Menzel's sharp-eyed critical depictions of social pretensions in the modern world; rather he is the tragic victim of forces beyond his control. Meidner, like Kirchner, relocates social and political realities in a battleground of 'universal' forces, although Kirchner's depictions of sexual confrontation in the street scenes address the reified conditions and economic alienation of the modern world directly. In this sense,

202. Ludwig Meidner, *Apocalyptic Landscape*, c. 1913. Oil on canvas, 80 × 196cm. Staatliche Museen Preußischer Kulturbesitz, Nationalgalerie, Berlin.

Kirchner creates richer, more suggestive images, which are anchored to reality at the same time as they evoke conflicts beneath the surface of experience. These conflicts are explicitly stated in Meidner's paintings and, correspondingly, he polarizes the city and nature, the elements and technology, within the urban arena, rather than conflating these oppositions, as Kirchner does, into single and powerfully contradictory images.

From this survey of the treatment of city versus country in German painting before 1914, paying special attention to Kirchner, it is possible to draw some tentative conclusions and to ask new questions about the heritage of this tradition in the Weimar years. The classic conservative polarization of city versus country, and the classic modernist position of synthesis and reconciliation, both tried to resolve the contradictions of modern historical experience in their times. Between these two extremes there remained a complex area of shifting and conflicting relationships which Menzel, Kirchner and Meidner took in different ways as the subject matter of their art, and which Kirchner expressed primarily through his complex and multivalent notions of the 'primitive'.

I would not suggest that these artists were working with a fully developed sense of the historical contradictions of their times. Menzel's ironic critique of modern civilization was socially specific but functioned only within the wider context of his nostalgic ideal of enlightened monarchy. Meidner addressed not the social and political contradictions of his times, but rather a 'naturalized' battle of forces beyond man's control. Kirchner's work relates to both of these alternatives. On the one hand, his street paintings of Berlin prostitutes do engage with some of the social and psychological effects of urban capitalism. But he also translated these issues into sexual polemics, into a battle of male and female forces, relying very often on clichéd views of femininity which conform to the ethics of sexual politics in Wilhelmine Germany.[100] This combination of alternative modes in Kirchner's work, his tendency to combine historical awareness with his Expressionist sense of 'natural' and 'universal' forces, prepared the ground for the modern tradition of city painting which was inherited by politically engaged artists of the Weimar period, like Otto Dix and George Grosz.

203. Otto Dix, *Prague Street, Dresden*, 1920. Oil on canvas with collage. 101 × 81cm. Galerie der Stadt, Stuttgart.

Dix's *Prague Street* (fig.203) refers back to Kirchner's depictions of figures on a street corner beside a shop window, and demonstrates many of the issues under discussion recurring in a new idiom. The city street has become literally a collection of artificial parts, the bits and pieces left behind after the holocaust and montaged onto the painted surface. At the same time, the 'natural' struggle for the survival of the fittest – and here the battered humans are reduced to the level of animals – has been exaggerated to a pitch of caricature encompassing both ironic and expressive modes. Like Menzel, Dix's criticism is socially specific and used as a weapon to attack bourgeois society. He leaves us in no doubt about the rôle man has played in creating this state of affairs. The pathetic cripple in the foreground still sports his Wilhelmine moustache, and he is juxtaposed to a newspaper slogan, 'Jews Out!'. Recent publications on Dix,[101] have raised the question of whether this should be read as a critical attack on a social and political level, or whether it is just a statement about the inevitable cycles of human nature; the victim of one generation cannot wait to get his hands on the next in line. In my opinion, *Prague Street* is a political painting, and it has the rare quality of conveying today something of its original critical power. But it is significant that it too combines specific social and historical critique with the tendency to visualize the conflicts and contradictions of city life in terms of a battle of 'natural' and universal forces. In this particular instance the two aspects go hand in hand to drive home the political message; but the balance is a delicate one. Dix's decision to locate his critique *both* in history *and* in nature seeks to combine potentially incompatible ingredients, militating both for and against political change. In *Prague Street* the combination works in a mutually reinforcing way, but, in a slightly different combination, they could equally well cancel each other out, and, by fusing in this way, defuse Dix's critical power.

9 Emil Nolde and the Paradox of Primitivism

EMIL NOLDE, member of *die Brücke* from 1906–7, has often been described as the 'natural' primitive of his generation. Born into a north German farming family in 1867, his simple origins and deep, persisting attachment to his native soil have been seen to grant Nolde – according to the laws of social Darwinism – privileged access to more fundamental and primordial levels of existence.[1] This image is fostered both in Nolde's four-volume autobiography, written in the 1930s, and in the secondary literature, which has leant heavily on the artist's own writings. A 1925 entry in Kirchner's diary described Nolde as 'often sickly and too primitive',[2] seeking, it would seem, to distinguish between his own finely tuned, urban-oriented sense of the primitive and Nolde's more crudely wrought vision, rooted in the marsh landscapes and fantastic legends of the north.

Kirchner's distinction is to some extent valid. But when we turn to Nolde's explicit primitivism from 1911–14 in his 'ethnographic' still lifes and his South Seas journey, referring directly to the art and culture of none-European societies, we find that his relationship to the dialogue between modernity and the 'primitive' is more complex and elusive than these black and white distinctions imply. Nolde described his ambition to be 'a man of nature and a man of culture simultaneously, a god and an animal, a child and a giant, naïve and refined'[3] – aspirations which come close to the play of alternative forces that characterized Kirchner's own primitivism before 1914.

In 1919, Gustav Hartlaub also insisted that Nolde's work combined elements of 'barbarism' *and* refinement. He described Nolde's religious paintings as operating in a sphere spanning between a 'European' sense of spirit and humanity and 'a primitive, barbarian Orient'.[4] On a more immediate level, the yearly rythmns of Nolde's lifestyle negotiated the contemporary polarity of city versus country. From 1902 onwards he and Ada Nolde spent the winter months in Berlin and their summers in rural Schleswig-Holstein. In his autobiography Nolde affirmed the impact and importance of this changing, alternating geography, describing Berlin as 'the reverse side of life',[5] and making an interesting comparison between his attraction to city life and his more obvious primitivism:

> This love for the unusual that was simmering in me at the time, has always remained. My heart always beat more strongly, when I could take in artistically a Russian, a Chinese, a South Seas Islander or a gypsy. Even the spoilt city types, creatures of the night, exalted me like foreign beings, and the tendency to depict Jewish types in my later religious pictures certainty had something to do with this impulse.[6]

Before 1914, Nolde's art was deeply characterized by inner tension and conflict, which, I shall argue, was resolved only after the South Seas journey when he evolved

his familiar nordic, mythic commitment to the cycles of nature and landscape. Central to the inner contradictions of Nolde's early work was his engagement with modernity on the one hand, and his deep-seated conservatism on the other, reflected in the fluctuations of his career. In 1937 over one thousand Noldes were confiscated by the Nazis from German museums, and he was featured prominently in their Degenerate Art exhibition, despite the fact that he had joined the Danish section of the National Socialist Party in 1933 or 1934 and continued to try to gain the support of party leaders like Baldur von Schirach after 1940. As William Bradley's study on Nolde's work in the context of volkish ideology points out, he rightly recognized a similarity between his own ideas concerning the rebirth of the German spirit and German art and their translation into Nazi rhetoric. Confusing intellectual ideals and political reality, Nolde failed to see the difference between his own motivations and those of the Nazis.[7]

Nolde's autobiography emphasized these German nationalist affiliations; we must remember, however, that his recollections of the pre-war period were written twenty-five years after the events took place, with the help of diaries and letters. Most important, the first three volumes of the autobiography were written in 1931, 1934 and 1936 respectively, although only the first two were published then. Before it became clear that conservative neo-classical realism was to be the representative style of the Third Reich and the full-scale attack on modernism began, there was considerable support for Expressionism within the Nazi hierarchy, and this provided a propitious climate for stressing the 'Germanic' roots and affiliations of the movement. Nolde's publication of the autobiographical *Jahre der Kämpfe* (*Battle Years*) in 1934, coincided with a series of articles in the magazine *Kunst und Nation* which challenged the conservative aesthetics of Rosenberg's *Kampfbund für deutsche Kultur* (*Battle League for German Culture*).[8]

It is hardly surprising that Nolde himself stressed the 'Germanic' mission of the new art at this date in uncompromising terms, adopting the terminology long used by critics to describe his art, and which, during the years of the Nazi rise to power, became stronger in emphasis. In 1927, for example, Ernst Gosebruch characterized Nolde as 'rustic, full of strength, nordic, rich in imagination, non-European, German'.[9] Before the Degenerate Art exhibition in 1937, Georg Heise and Max Sauerlandt also emphasized the nordic 'Germanic' heritage of Expressionism. Only after 1945 was Expressionism promoted again as Germany's contribution to international modernism.

These events in the 1930s fundamentally influenced post-war writings about Nolde's work. Amongst enthusiasts and supporters, defensive strategies emerged that passed over Nolde's Nazi connections in silence and stressed his hardships during the war years and the heroic modernism of his Unpainted Pictures, which were painted secretly after Nolde was forced into internal exile. More rarely, Nolde has been characterized as an unremitting conservative, steeped in the more sinister aspects of volkish thought. This latter approach led Ettlinger, in his 1968 article on the Expressionists' primitivism, to simplify Nolde's attitudes and practices during the South Seas journey.[10] In both cases, attempts have been made to separate radically modernism and conservative nationalism, as if they were mutually exclusive categories. In so doing both interpretations miss the core of inner contradiction that characterized Nolde's work and personality and which represented in an extreme form the tensions at the heart of the Expressionist movement.

Nolde's Religious Painting and the 1910 Split in the Berlin Secession

In 1910, the split between the 'modernists' and the Expressionist 'avant-gardists' in the Berlin Secession, led to a more specific disagreement between Emil Nolde and the president of the Session, Max Liebermann. He threatened to resign his post

204. Emil Nolde, *Pentecost*, 1909. Oil on canvas, 87 × 107cm. Staatliche Museen Preußischer Kulturbesitz, Nationalgalerie, Berlin.

if Nolde's *Pentecost* (fig.204) was accepted by the jury that year. Nolde's 1934 account of the Secession row in *Jahre der Kämpfe* is the section of his autobiography that refers metaphorically to the Nazi attack on his work and his rejection from Rosenberg's *Kampfbund*. This later rejection made him relive his experience of 1910 when he was expelled from the Berlin Secession with new intensity. It also made him determined to stress the historical 'mistake' of that first repudiation and the long tradition of his battle against 'the Jewish powers that rule all the arts'.[11] Frequently, the political aims of Nolde's autobiography in the 1930s have been ignored in discussions of the Secession affair, and Bradley's use of statements from this chapter in *Jahre der Kämpfe* to justify his arguments about Nolde's volkish affiliations before 1914 lacks historical precision.[12] In the 1956 edition of *Jahre der Kämpfe* we find additions to Nolde's original text as well as omissions in the Secession chapter, and these must have been intended to disguise his anti-semitic comments from the

163

thirties.[13] Nolde's own statements about the instinctive and naïve creativity of the artist have been taken too literally; later commentators on the relationship between his work and writings should pay more attention to Franz Marc's remarks about Nolde's capabilities as a publicist in 1912: 'I am curious about Nolde...has he been lucky with the choice of pictures or did he only send in the two works, more crafty than us.'[14]

Nolde's 1934 account of the events in 1910 is phrased almost exclusively in nationalist terms. Nolde accused the Secession of French influence and commercialism, in contrast to his own Germanic 'inner' and spiritual art, expressed in his 1909 religious paintings. The basis of his argument with Liebermann, Nolde explained, was the clash between the elder artist's internationalist, realist position and his own radical ambitions to renew German art along nationalist lines: 'I wanted recognition of opposing artistic attitudes, a separation between foreign and German viewpoints, between the past and the future.'[15] Peter Paret, relying wholly on Nolde's 1934 description of the affair, used it as a confirmation of his unremitting conservatism:

how illusory it was to equate avant-garde painting at the beginning of the century with social criticism and democratic or even anti-German attitudes. Wilhelmine supporters would object to the style and tone of Nolde's work; but he too had a fantasy about the German spirit... The ideological, rather than aesthetic attack on modernism, which the emperor had launched out of a belief in the affinity between academic art and political loyalty, which [Henry] Thode waged in the name of regenerated German art, and which Vinnen expanded by mobilizing the economic anxieties of the art proletariat, became with Nolde a struggle within the modernist camp as well.[16]

In fact, there was nothing in Nolde's 1910 open letter to *Kunst und Küstler* attacking Liebermann's leadership of the Secession that suggested a radical nationalist stance at this date. Rather Nolde accused Liebermann of a decline in artistic quality and inability to appreciate new developments. A letter in the Seebüll archives, makes clear a degree of impatience on Nolde's part with the extremes of German nationalist art criticism. Discussing the nationalist critic Willy Pastor in July 1910 – after the beginning of the Secession row – Nolde wrote to his friend Hans Fehr:

There is perhaps something of a weak possibility in what he says; but, as you also write, these glorifiers of the Germans [*Germanenverherrlicher*], know how to elucidate and to twist everything as if all that is great and good were German. He has incidentally discovered that Titian, Raphael, Michelangelo and Leonardo da Vinci were all German![17]

Nolde, like Kirchner, Heckel and Schmidt-Rottluff, did not sign the public repudiation of Vinnen's *Protest*. But a letter to Gustav Schiefler dated 1911 which he published in *Jahre der Kämpfe*, contains his comments on the Vinnen affair.[18] In this letter Nolde did affirm his ambition to promote a new German art and condemned the Secession's dependence on French models. But he praised French art for forging new paths and the German museums and exhibition societies that promoted it. He approved fully of Manet, Degas, Cézanne, Gauguin and Van Gogh, while accusing Monet, Renoir, Sisley and Rodin of saccharine tendencies. He concluded:

our nineteenth-century painting won't mean much for the future because it stands almost entirely in the shadow of the great old masters, or is dependent on French Impressionism. Only the French in the past century proved that a great independent new art can come into being alongside the art of the past. If our art is to equal or to outstrip the French then, without consciously willing it, it will be entirely German. In industry and commerce, in science and all, we have become not only

equals but models and if we have self-confidence in art the same will come about, all the best prerequisites are at hand in our nation.[19]

This letter is of particular interest because it proposes the same kind of uneasy compromise we shall find Nolde negotiating in the South Seas when he discusses the acquisition of native art by European museums. On the one hand, he realized that quality in the visual arts transcends national boundaries; but at the same time he was preoccupied with a notion of national identity and German supremacy in cultural and economic spheres. These contemporary comments – in contradistinction to his 1934 writings – do not differ radically from the replies by Osthaus and Niemeyer to Vinnen's *Protest*[20]; in the introduction to the first Folkwang Museum catalogue, published in 1912, Osthaus had made a very similar statement about the necessity for German art and industry to advance hand in hand. Praising the work of Nolde and Christian Rohlfs in his introduction to this volume, Osthaus wrote: 'The collection of modern painting in the Folkwang results from the attempt to foster an artistic life...cultural development in the West (that is the Rhinland) has not kept pace with our commercial success.'[21]

Nolde's position in the context of pre-war Expressionism was not unusual; we have already discussed the various attempts made by the *Brücke* artists immediately before 1914 to reconcile their ambitions for a renewal of German art with their belief in international modernism in projects like the Sonderbund Chapel. Nolde's letter reveals the same fundamental contradictions that gradually enmeshed Osthaus during these years. In Nolde's case, these were sharpened by his inherited respect for 'unspoiled' nature stemming from his conservative upbringing in rural Schleswig-Holstein. Neither Nolde nor Osthaus realized that their commitment to the advance of a 'spiritual' German culture capable of matching the country's achievements in commerce and industry involved a clash of materialistic and non-materialistic ambitions.

These differentiations are necessary, not to excuse Nolde, nor to claim for him greater political respectability; we must try to chart out the route from this pre-1914 position to his far more radically conservative stance in the 1930s. But we must also try to replace the crude polarization of conservatism versus modernism in our discussion of the early years of the century with a more finely wrought account closer to historical reality. Recent research by Manfred Reuther on Nolde's early career has reconstructed his debt to Böcklin, on the one hand, and to German peasant painting on the other. This enabled him to break free from the historicist shackles hampering his imaginative freedom and provided him with a fine art tradition on which to construct his own oeuvre.[22] In many ways, Nolde's religious paintings represented a synthesis of these alternative modes, both of which had 'volkish' associations by the turn of the century:[23] for Max Liebermann they also embodied a revival of literary, nineteenth-century values in a new guise, against which the Secession had fought since its foundation in 1898.[24]

But it is important to remember that Nolde's paintings were equally unpopular among conservative critics, who attacked second rather than first-generation German modernism in 1911. Nolde's combination of conservative themes and avant-garde style rendered his religious painting unacceptable to *both* conservative *and* modernist critics in the debates that rocked the German art world between 1910 and 1912. Had he shown a clear commitment to one side or the other, his work would have found a place within the accepted order of things. Instead, Nolde's attempt to achieve a new and radical synthesis called forth attacks from both directions, and precipitated a crisis which was to effect a deep-rooted rift in German modernism. Ironically, despite Nolde's dislike for 'in between' states, which we must examine in more detail below, his own art provoked – and continues to provoke – controversy, precisely because it transversed boundaries which were felt to be absolute and incontrovertible.

In many ways Nolde's primitivism was the fulcrum of his contradictory commit-

ment to conservative and modernist trends. In his 1919 commentary on Nolde's religious paintings, Gustav Hartlaub pointed out that their 'primitivism' involved a rejection of European standards of beauty in favour of expressive forms and raw direct handling: all culture, all beautiful and educated handwriting, was thrown overboard, and this almost "barbarian" crudity of manual execution makes comprehension so difficult.'[25] On a stylistic level, Nolde's primitivism related to the new generation of 'avant-garde' art, while on a thematic level, it linked him to conservative volkish ideology and to a rehabilitation of nineteenth-century values. In this way, it distinguished him from first generation modernism in Germany without identifying him with the type of artistic *anti-modernism* advocated by Carl Vinnen and his friends. A different yet comparable position was reached by the *Brücke* artists in their 1910 bather paintings at the Moritzburg lakes, which, as we have seen, related to the *subjects* of conservative nudism, at the same time as they undercut the historicist associations of neo-classical aesthetics with their rawly primitivist styles. Artistic primitivism after 1910, which involved both subjects *and* styles, enabled the German Expressionists to differentiate themselves from both modernist and conservative factions, and yet to engage with the struggles and debates between these 'alternative' camps. Because of the complex, mediating position primitivism occupied in these debates, it could be used to reveal and to expose the contraditions of historical experience in the years preceeding the First World War – as it was in Kirchner's street scenes. It could also be used to paper over the cracks and to resolve the conflicts of modern life on an 'ahistorical' aesthetic plane.

Following the Secession row, Nolde's oeuvre did begin to split more radically into the 'alternatives' of primitivism and modernity as he began to work for the first time on a group of modern life subject paintings set in Berlin and depicting cabaret and café life – as if he wanted to reaffirm, on the one hand, his involvement with New Secession 'avant-gardism' and his commitment to the modern movement. At the same time he continued to work on his primitivist religious paintings, and in the autumn of 1911, he began to visit the ethnographic museum in Berlin, making sketches for a series of still-life paintings.

The Berlin Subjects

In his autobiography, Nolde described the foundations of internal opposition and antithesis on which he built his art: 'Duality has achieved a special position in my paintings and graphics – with or against each other: man and woman, joy and pain, God and the Devil. The colours were also set off against each other: cold and warm, light and dark, low and high keys.'[26] During the primitivist phase of his religious paintings this duality was written into the thematic range of his work, as he continued to make his winter visits to Berlin and began to engage with 'modern' subjects offered by the kaleidoscope of city life. Later he described these works not so much in contrast or counterpoint to his primitivist vein but rather in comparative terms; as if the city also offered an arena of the 'wild', the 'other', just as it appeared in Kirchner's Berlin street scenes.[27]

In the 1880s and 1890s Nolde had made caricatures of modern urban types and he was briefly inspired by modern life subjects in *Jugend*. In 1889 he moved to Berlin, seeking a living in furniture and design factories. This was not an encouraging experience as Nolde suffered a period of unemployment and left the city with an attack of tuberculosis, but he had enjoyed visiting the 'music halls and black cabarets in the north'.[28] When Nolde returned to Schleswig-Holstein to recover his health, the locals judged his sickness as an inevitable consequence of the evils and corruption of city life. Similarly, the status of the artist was compared to the floating, 'rootless' world of city entertainment: 'At that time the countryside folk believed

that artists and actors, acrobats and cabaret performers were all one and the same kind, carefree and frivolous like gypsies.'[29] But the anonymity of the city, as Georg Simmel pointed out, could be experienced as alienating *and* liberating, and it freed Nolde from the narrow web of prejudice and suspicion he encountered at home. It also offered an important forum to learn about the international modern movement and to make known his own art.[30]

In 1904, the destructive aspects of city life struck again when Ada, Nolde's wife, collapsed, following her unsuccessful debut in the Berlin cabaret, where she had attempted to alleviate the couple's financial problems. But the Noldes returned for their winter visits, living in rented rooms and small hotels in Berlin-Friedenau, and after 1910 in their permanent Tauentzienstraße studio.[31] Nolde found that the city ambience could stimulate his imagination: in the winter of 1905 his graphic series *Fantasies* was made during the nights, 'when all was quiet and the streets were empty'.[32]

It was during the disruptive winter of 1910 to 1911, in the thick of the Secession row, that Nolde began to draw his subjects from city life, particularly café scenes and urban entertainment. This also characterized the work of New Secession artists like *die Brücke*, Georg Tappert and Heinrich Richter-Berlin. Nolde describes how he and Ada attended masked balls and cabarets in the famous Eispalast:

> where impotent asphalt lions and hectic demi-monde beauties sat in their elegant robes, pale with powder and the smell of death . . . I drew and drew, the light of the rooms, the superficial glamour, all the people, whether bad or good, whether half or fully ruined. I drew this 'other side' of life with its makeup, its sparkling dirt and its corruption.[33]

In 1907 Nolde's lithographs *Tingeltangel 1–4* (Schiefler-Mosel L.25–8), initiated a relationship of confrontation between performers and spectators which he explored more fully in 1910–11. In *Cabaret 2* (*Indian hat*) (fig.205), the woman in the audience and the singer floating on the cabaret stage are locked in an interchangeable relationship, echoing each others' gestures and poses. *Cabaret 1* (1911; Schiefler-Mosel 177) shows the performers knitted into the space of the audience so that the barriers between spectacle and spectators dissolve. In effect, Nolde depicts the artifice of city life as a spectacle in which the characters assume fantastic costumes and rôles. In the drawings and graphics Nolde worked in varied techniques, sometimes using a thinly loaded brush dragged over the surface of the paper and alternating these effects with rich, saturated areas of black and grey. In his engravings, aquatint is often used to convey the smoky, luminous atmosphere of the cabaret halls. In 1911 he began to paint similar motifs, using bright, 'artificial', fluorescent colours which recur in his 'ethnographic' still lifes. In *Gentleman and Lady* (*in a Green Dress*), *Dance II*, and *Party*, Nolde uses an open, flimmering, Ensoresque palette of lemons, oranges, pale blues and greens, very similar to that used in *Mask Still Life I* (1911). *Cabaret Audience* and *In a Night-Bar* are characterized by stronger more intense colours. A favourite motif in the graphics and paintings is a couple at a café table, usually a man and a woman sporting an extravagant hat (Schiefler-Mosel 172–5), recalling Nolde's age-old preoccupation with the subject of figures seated at table. *Slovenes* (fig.206) shows an East European couple, whose faces have assumed mask-like expressions, adding to the theatrical effects of the city. This painting, like *Gentleman and Lady (in the Red Room)* (1911), is an updated version of an Impressionist subject, treated by local Berlin Secessionists as well as by the Expressionist avant-garde. For example, Leo von König's *Café*, shown in the 1910 Secession, showed a similar subject rendered in a more tempered, realist style.[34]

The other main attraction in Berlin for Nolde was the theatre. During the winters of 1910–12, Max Reinhardt reserved seats for the Noldes in his Kammerspiel and Deutsches Theater, so that Nolde could sketch during the productions.[35] Brightly coloured, reductive and freely-drawn watercolours resulted, like *Bassermann as*

205. Emil Nolde, *Cabaret II*, 1911. 19 × 15cm. Etching. Sammlung der Nolde-Stiftung Seebüll.

206. Emil Nolde, *Slovenes*, 1911. Oil on canvas, 80 × 69.5cm. Sammlung der Nolde-Stiftung Seebüll.

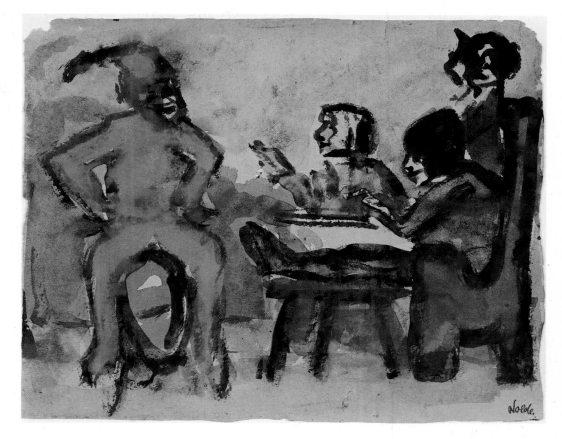

207. Emil Nolde, *Basserman as Mephisto*, 1910/11. Watercolour, 29.7 × 37.7cm. Sammlung der Nolde-Stiftung Seebüll.

Mephisto (fig.207). Nolde's interest, apparently, was in the way the actors' bodies and gestures, and the relationships between figures, could be used to convey expression, regardless of specific narrative content. In effect, the narrative implications are compressed into tableaux vivants, which are lifted out of the sequence and progression of the drama, so that gestures and expressions are prised free from their original meanings and achieve a degree of self-referentiality. During these winters of 1910–12, Max Pechstein also visited Reinhardt's productions and sketched during rehearsals, but his exotic designs for *Genoveva* (see fig.69) were considered too elaborate by Reinhardt, whose preference for simple stage designs is reflected in Nolde's economic drawings. As we shall see, both aspects of Nolde's Berlin imagery, the café and cabaret and the theatre scenes, relate closely to the styles and attitudes in the 'ethnographic' still lifes which he began to paint in 1911.

Nolde and Non-European Art

The earliest evidence of Nolde's response to non-European art is a childhood sketchbook dated 1880. This contains four small, meticulous copies in a linear pencil style, reminiscent of Flaxman and archaeological illustrations (fig.208). Three drawings are copies of illustrations of Egyptian and Assyrian sculptures, and the fourth depicts a Maria by Veit Stoß, prefiguring Nolde's 1913 drawings after Gothic sculptures in the Thaulow-Museum in Kiel.[36] Probably these sculptures from different cultural epochs were copied from a school textbook during a formal drawing lesson. They reflect the current taste for archaeological discovery, a common childhood passion. Of course, these early drawings refer to the subjects rather than the styles of non-European art. Nolde valued and preserved his boyhood drawings in line with his later romantic interest in the art of children as an intuitive and direct form of expression. In his collection, child art by relatives and young

208 (above and following page). Emil Nolde, Sketchbook copies, *c.* 1880. Pencil, each 12.2 × 10.5cm. Sammlung der Nolde-Stiftung Seebüll.

Relief von Damanhur.

Sphinx von Theben.

Portalfigur von Ninive.

admirers featured alongside folk and tribal art.[37] As early as 1908, and in the same spirit, Nolde purchased some of Ernst Josephson's drawings, classed as 'outsider art', from his family in Sweden.[38] But his own childhood drawings are far from the spontaneous, immediate expression of inborn talent with which he later credited these various forms of 'primitive' art. On the contrary, rather than free inspiration, they reveal his painstaking attempts to copy his models as accurately as possible according to inherited traditions of nineteenth-century vision and technique. Ironically, in this sense, his own early drawings are close to the inherited traditions of copying and the repetition of received norms which characterize the production of tribal art;[39] far closer, in fact, than are his later notions of spontanaiety and intuitive creation.

Nolde's boyhood drawings of Assyrian and Egyptian sculptures testify to an early textbook knowledge of classical non-European art. Hans Schröter suggests that Nolde first saw originals in the Louvre during his study trip to Paris in 1900, when he certainly visited the colonial pavilions at the World Fair.[40] Paula Modersohn-Becker, whom Nolde met in Paris, was drawing inspiration from the Assyrian and Egyptian collections in the Louvre; her use of avant-garde style and non-European models to update the 'Germanic' primitivist theme of Worpswede peasants, rooted in the countryside, parallels Nolde's own development in the early years of the century. In *Das Eigene Leben*, Nolde writes:

> The art of the Egyptians and the Assyrians stood before me as something special, like a mystery. I couldn't view them only as 'historical objects', which was the general opinion at that time. I loved these great works although it was as if I shouldn't. But such love sometimes burns strongest... The following decade brought understanding and freedom. I came to know Indian, Chinese and Persian art, the strange primitive artefacts of the Mexicans and primal man. These weren't only 'curiosities' for me (like the corporations named them). No – we raised them to their true status as the strange, austere folk and primitive art of 'natural' peoples. As far as the science of ethnography is concerned we are still today troublesome interferers because we love sensual appearance more than knowledge. Bode still opposed the artistic worth of the original primitives. His eye was buried under a mountain of conventional proficiency and scholarship.[41]

This first full statement in the autobiography, written retrospectively in 1931 and revised in 1949, introduces most of the principles and attitudes Nolde began to develop in his 1912 notes on the *Kunstäußerungen der Naturvöker* (*Artistic Expression of Primitive Peoples*), which reflected many current debates about the fate of tribal artefacts in Western collections.[42] One aspect which does not feature in these 1912 notes, is Nolde's classification of tribal art as a kind of 'folk' art, building on attitudes already implicit in his Flensburg and St Gallen years, and enjoying wide currency at the beginning of the century.[43] In 1909, Nolde would have been able to visit the Berlin winter exhibition given over to International Folk Art at the Deutscher-Lyceum Klub. Here European and American folk art, including modern and historical examples from Schleswig-Holstein, were exhibited alongside artefacts from Egypt, China, Africa, South America and Java.[44] The catalogue introduction to this exhibition describes folk art as evidence of 'a heightened lust for life',[45] predicting the comments Nolde was to make about tribal artefacts in 1912. Although he does not mention folk art in these notes, his response to such artefacts is written into the vocabulary of the still-life paintings. One of the earliest of these, *Still Life (Majolica on a Blue Background)* (1911) depicted two objects from his collection of folk art: a rough flat iron with a horse's head and a sweet, elegant Majolica vase, probably from the Swiss Alps. The different textures, colours and types of object are juxtaposed in a fashion typical of later 1913 still lifes, depicting 'folk' objects from his collection and hand-woven textiles after his own designs alongside non-European artefacts. Nolde's notions of the primitive emerge from the relationships and juxtapositions between these different objects in a fashion similar

to the *Brücke* artists' studio paintings, where their primitivism is demonstrated in the entire *mis-en-scène*, and in the network of contrast and analogy between the various studio props, rather than in the stylistic imitation of specific non-European artefacts.

The central issue in Nolde's 1931 statement about non-European art and in the 1912 notes is the division between the scientific and aesthetic appreciation of these objects. His own artistic evaluation of non-European artefacts related to the opening horizons of cultural relativism, which challenged the absolute values of classical tradition.[46] In *Die Kunstäußerungen der Naturvölker* Nolde writes:

> our museums are growing rapidly, they are becoming gigantic and filled with works of art. But I'm no friend of those collections which suffocate inspiration through sheer size. There will soon be a reaction against all this accumulation. Just a short time ago only a few periods were suitable for museums. But then Coptic, Early Christian, Greek terracottas and vases, Persian and Islamic art were added. Why, however, is Indian, Chinese, and Japanese art still classified under science and ethnology? And why is primitive art ignored altogether?[47]

In the Berlin Ethographic Museum, which Nolde began to visit in 1911, the scientific approach to the collection had been fostered largely by Adolf von Bastian, spiritual founder and director of the museum from 1873 until his death in 1905. When the ethnographic collection was installed in the new museum in Königgrätzer Straße in 1886, Bastian insisted that the main task was to sift and classify the collection in terms of an evolutionary model[48]. To a large extent, however, Bastian's ambitions to achieve laboratory conditions were compromised by the lack of space for the collection. The museum was described by contemporary visitors as little more than a jumble of crowded corridors,[49] and Nolde's visits to the museum would have taken place under chaotic conditions, as much of the collection was in store, awaiting relocation in new premises. His remarks in 1912 about the crowding of museums had an immediate relevance; they also related to a critique of museum conditions, rooted in the arts and crafts movement, which considered the crowded, materialistic displays in modern collections destructive to the 'aura' of individual art works. For example, in his *Entwicklungsgeschichte der modernen Kunst*, Meier-Graefe recalled a visit to a crowded private collection:

> One walked between pictures; one felt capable of walking calmly over them! ...goaded by the idiotic impulse to see as much as possible and the irritating consciousness that it was impossible to grasp anything, every better instinct was stifled by an indifference that quenched all power of appreciation.[50]

The crowded conditions of the Berlin Ethnographic Museum did, by default, encourage discussion about the reclassification of non-European art according to aesthetic rather than scientific criteria. The urgent necessity to rehouse at least part of the collection led to the decision in 1911, warmly supported by Wilhelm Bode, General Director of Museums in Berlin, to separate off the Asian 'cultural peoples' from the tribal artefacts and to organize the former according to aesthetic and qualitative rather than scientific and quantitative criteria, despite fierce resistance from within the museum. Nolde's remarks in 1912 related therefore, to more general levels of debate about the fate of non-European art in the city collections. His later condemnation of Bode as a representative of the scientific approach referred, presumably, to Bode's plans for an aesthetic display of the Asiatic material only, thus highlighting by way of contrast the status of tribal art merely as a scientific curiosity. In 1914, Bode also launched a Vinnen-like attack on the purchase of Expressionist art by young German museum directors, which Max Sauerlandt, director at Halle, fiercely countered.[51] In 1913 Sauerlandt purchased Nolde's *The Last Supper* for 6,000 marks, and his religious art again played a central rôle in the debates around the merits and worth of the avant-garde.

It was Max Sauerlandt, together with Karl Ernst Osthaus, who provided Nolde before 1914 with an alternative and positive model for the display of non-European

art. Two letters written from the South Seas record Nolde's enthusiasm for their approach, which he contrasted with Bode's attitudes. In March 1914, Nolde wrote to Osthaus from Kawieng, New Guinea:

> I know that you intend to order tribal art artistically and I was very happy to see our very beautiful exotic objects treated in this way at the Folkwang museum ...but I can hardly believe that the museum directors of the older generation agree with the younger artists' attitude – and especially in this area (if you ask Bode in Berlin, for example) contradiction is to be expected.[52]

A month later, complaining about the rape of tribal culture by European ethnographic museums, he continued from Rabaül:

> the artistic and ethnographic artefacts of the natives are being subjected here to an evil thieving commercialism...so I am sending Director Sauerlandt at Halle – who recently has intended to organize his native art aesthetically – a copy of this. I'm sending you one too. You have already organized – and certainly were the first to do so – some beautiful exotic objects in your museum artistically.[53]

Nolde would have been familiar with the aesthetic appreciation of non-European art in the Folkwang Museum since 1906, when for a short while he joined the artistic circle Osthaus gathered around the museum.[54] In 1912, when he wrote his notes on 'primitive' art, Nolde had established contact with Max Sauerlandt, and he made a woodcut portrait of his new friend and supporter that year (Schiefler-Mosel H. 122). Sauerlandt had reorganized his ethnographic collection in the context of the fine arts museum at Halle in 1908, and this was a South Seas collection rather than the Oriental and Asiatic objects which dominated Osthaus' display before 1912. In a letter of 1908 Sauerlandt refered to:

> a collection from the German South Seas Islands, bought years ago and finally unpacked. At first, a horror, to put it mildly, then with more careful looking it transformed into pure joy. The pieces are powerful and I would like to display them in absolutely simple, white, laquered cases; not according to geography but rather technical groups, which is perhaps unusual but advisable for several reasons here...[55]

In fact, the organization of tribal objects in technical groupings was an established principle of the 'scientific' approach and commonly featured in European ethnographic museums. What was new in Sauerlandt's arrangement was the inclusion of such material in the fine arts context of the Halle museum and the attention he paid to an aesthetic presentation of the objects. In a much later letter to Nolde, dated 1928, another important principle guiding Sauerlandt's display becomes apparent. He reminded Nolde of his intention to present the tribal objects in the context of the European collection as 'directly belonging, of fundamentally equal value', just as he showed the decorative arts in his collection as art rather than simply as utilitarian objects.[56] The parallel Sauerlandt made between his treatment of tribal and decorative art, according to the expanding principles of cultural relativism advocated by the Viennese school of art history and Alois Riegl's writings, comes close to the policies of the Folkwang Museum. Nolde in his 1912 notes, made clear that he also viewed tribal artefacts as a kind of decorative art, tapping a creative vitality which he saw as an alternative to the outworn and indirect styles of the West. He wrote: 'our age has been to it that a design on paper has to precede every day pot, ornament, useful object, or piece of clothing. The products of primitive people are created with actual material in their hands, between their fingers. Their motivation is their pleasure and love of creating.'[57] In *Jahre der Kämpfe* he continued:

> The elemental feeling, the sheer enjoyment of colour, the ornamentation and carving which 'savages' give to the designs of their weapons and ceremonial and

utilitarian objects are as a rule more beautiful than the mawkish and precious objects which we have in the glass cases of our drawing rooms and our museums of decorative art... There are enough overrefined, pallid, decadent works of art and perhaps that is why artists who are vital and developing, seek guidance from vigorous primitive peoples.[58]

Once again the notions of authenticity and renewal associated with decorative arts reform and *Jugendstil* in the 1890s and given theoretical justification in Georg Simmel's writings about art production, recur with direct reference to tribal artefacts.

As we have seen, the new aesthetic and ahistorical method which justified juxtapositions of art from different temporal and geographical locations could be reapplied in modernist criticism to describe European art as well, and it is precisely this shift that we find occurring in Nolde's comments about museum collections in the period immediately following his intensive engagement with non-European art in the Berlin museum. In a letter of January 1913 he reiterated his suspicions concerning the historical and scholarly classification of works of art, extending his arguments about tribal artefacts to apply to art in general. He wrote:

> The real meaning of a work of art is only it's artistic worth. Different works of art next to each other mutually isolate each other and heighten the impression. It is so comfortable to categorize everything according to its period and subject, you can learn that...it would be so much better if your many, different, fabulous works were displayed only as art in the highest sense.[59]

Nolde's 'Ethnographic' Still Lifes

Nolde's visits to the Berlin Ethnographic Museum gave rise to over 150 drawings before his departure for New Guinea in the autumn of 1913. The drawings were used as preparatory studies for his so-called ethnographic still lifes; probably they were also intended as illustrations for his aborted book on the *Kunstäußerungen der Naturvölker*. Nolde describes the sketches as 'more deeply penetrating the essence than mechanical photos and illustrations'.[60] Just as the tribal objects themselves signified for Nolde a mode of expressive authenticity lacking in the products of the modern age, so too he distinguished between the superficiality of resemblance in mechanized reproductive techniques and the authenticity of his own hand-made drawings.

In the Nolde estate in Seebüll these drawings are collected in a portfolio titled *Drawings for Still Lifes 1911–12*. These also include drawings after pre-Renaissance sculptures from the Thaulow Museum in Kiel, sketches of Egyptian art and of armour and uniforms from the Zeughaus in Berlin. The drawings are grouped according to subjects – figures, heads, masks, exotic figures etc, – but it is possible to re-establish a chronology according to page sizes, style and relationships with dated paintings. The groupings that emerge from a chronological reorganization of the drawings allows us a new insight into Nolde's working methods and helps us to reconstruct his changing and developing attitudes to the tribal artefacts during the course of his museum visits. His early copies of single display cases, which reflect in a relatively straightforward way the geographical divisions of the museum collection, gradually gave way to drawings after single objects or parts of objects from very various parts of the world. Nolde began to orchestrate these in a complex, synthetic way into his still-life paintings.

Nolde's decision to sketch in the ethnographic museum reaffirmed his commitment to contemporary Expressionist practice; both Kirchner and Marc visited the ethnographic collection in 1911.[61] But the drawings also referred back to his early career as an apprentice woodcarver when he had often copied objects in the Flensburg, Berlin and Munich decorative arts museums to improve his drawing style

209. Emil Nolde, *Carved Wooden Horse*, 1882. Pencil, 13.8 × 16.3cm. Sammlung der Nolde-Stiftung Seebüll.

210. Emil Nolde, *Still Life with Wooden Figure*, 1911. Oil on canvas, 77 × 65cm. Dr Max Stern, New York.

and to expand his visual vocabulary.[62] Possibly, feelings of insecurity following the Secession row, prompted Nolde to resume his early practice of sketching artefacts in museum collections, although his choice of 'primitive', non-European objects testifies to a translation of his old historicist mode into new 'avant-garde' terms. His meticulous copying style and illusionistic ambitions of the 1880s gave way in 1911 to a halting, child-like style. But the outline drawings also strike a distant chord of resemblance – they were quite different from the reductive but painterly drawings of other subjects in 1911.[63] As in his early drawings of carvings, candlesticks, inkwells, ivories and vases, the non-European objects were isolated on blank pages rather than contextualized into their surroundings, and despite their simplicity the 'ethnographic' drawings were also fairly accurate copies of the objects rather than imaginative transformations. As we have found so often in the transition from historicism to primitivism, Nolde's drawings referred back critically to the 1880s, but they continued to relate in an ambivalent way to his earliest work and to the magpie attitudes implicit in eclectic historicist methods.

The 1911 drawings reached further back too, recalling Nolde's earliest boyhood still-life drawings in pencil. Two drawings dated 1882, depicting a carved wooden horse (fig.209), and a plaster angel, show Nolde's first attempts to render three-dimensional objects, adding soft, tonal modelling to his linear outline style to convey volume. In artistic terms these drawings are in no way exceptional, but Nolde's choice of objects for these first still lifes predicted to some extent his later 'ethnographic' drawings. Both objects are unsophisticated examples of folk art. Indeed, the 20 pfennig angel, Nolde later recorded, was one of the first pieces of folk art he collected and 'loved like a Greek goddess'.[64] The religious motif of the angel and the appealing awkwardness of the wooden horse were aspects Nolde later valued in tribal art. The absence of a base or plinth to the woodcarving also strands it, isolated against the blank page, in a peculiar no-man's land, half-object, half-alive, and the drawing could easily be understood as an unskilful attempt to render a living horse. In contrast, Nolde's later drawing, *Still Life with a Skull* (1889), made while he was training at the Karlsruhe School of Decorative Art shows a much more conventional arrangement of objects anchored to the surrounding space. Nolde drew a traditional group of vanity symbols, stamped with a brand of historical pathos that typifies art in the period following the unification of Germany.

In the autumn of 1911, Nolde executed forty drawings mostly depicting pots and jewellery from Central and South America from the Berlin Ethnographic Museum.[65] These sketches showed groups of objects on a single sheet as they would have appeared in display cases, and it is from just such a group that Nolde extracted the single Peruvian clay pot that appears in *Still Life with Wooden figure* (fig. 210). The predominence of household and decorative objects in the early sketches links Nolde's activities in the ethnographic collection to his long-standing interest in the decorative arts, but some drawings of masks, figures and animals from Africa, the South Seas and North America also featured in the 1911 series.[66] These appeared as single objects, drawn on separate sheets of paper, and rough shading in coloured crayons replaced written colour notes. There were also more densely coloured drawings, like his sketch of a shrunken head of a Yuruna Indian from Brasil, which features in *Mask Still Life III* (fig.216) and can be seen in a photograph of the American installation in 1886 (fig.217).

One transitional drawing of eight South and Central American heads (fig.214), partly coloured in rough hatching crayon-strokes, was used by Nolde for two other mask still lifes in 1911. A closer look at this group of four *Mask Still Lifes* will illustrate how Nolde worked out the practices which came to characterize the still life series as a whole.

There are in fact no sketches for *Mask Still Life* I (fig.211). It referred to Nolde's encounter with James Ensor's painting during his visit to Belgium in the spring of 1911 rather than to specific ethnographic sources. The thick, matt, oil paint in this still life is applied with a large brush and the bright colours are mixed liberally with

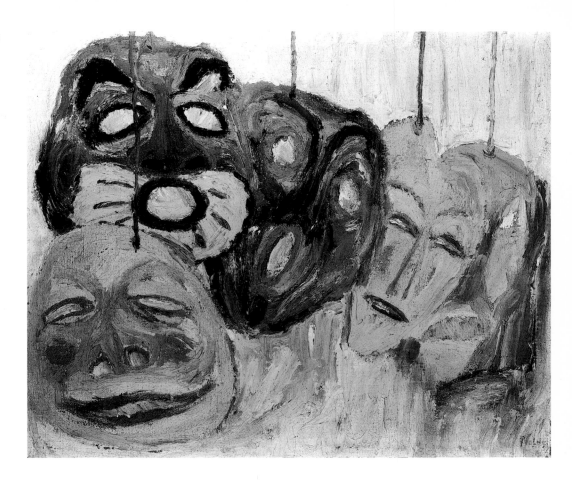

white. Despite the recession from the warm colours on the left towards the cool greens of the right-hand masks, the bright blue background which shines through the holes of eyes and mouths with equal intensity reduces all sense of spatial depth. Nolde's palette and technique were close to Ensor's, but the painting displayed none of the Belgian artist's ironic social comment.[67] Whereas Ensor used masks to reveal the grotesque reality behind the facade of polite society, Nolde's masks were simply hung against the painterly blue background, which isolates them in time and space. In this way he stressed their status as objects, but paradoxically they are objects animated by human emotions – laughing, exclaiming, pensive. Although they refer back to Nolde's long-standing interest in mask-like faces, for example in *Mask of Energy* (1896), or more recently, in *The Last Supper* and *Pentecost* (1909), this is the first painting where the masks occupy a peculiar middle ground between the world of objects and subjective emotions. They are like relics of a theatrical event still embued with the stylized emotions of performance; and it is worth remembering Nolde's current visits to Reinhardt's productions as well as the spirit of Dithyrambus which embues paintings like *Dance around the Golden Calf* (1910) and *Candle Dancers* (1912).

Mask Still Life II (fig.212) and *Mask Still Life IV* (fig.213) depict masks derived from the drawing of eight American heads (fig.214). The layout of this drawing could be influenced by the style of arranging objects 'scientifically' in the Ancient American display (fig.215), and the two identifiable heads are in fact a Mexican Teotihuacan mask 19cm high and a tiny Aztec ormanent *c*. 3cm high.[68] Despite Nolde's faithful if reductive rendering of these objects, the extreme difference in scale between them is evident neither in the drawing nor the paintings, where both were hung as masks. *Mask Still Life IV*, which Nolde exhibited at the Cologne Sonderbund in 1912, refers back to the drawing and 'quotes' the Aztec ornament;

212. Emil Nolde, *Mask Still Life, 2*, 1911. Oil on canvas, 65.5 × 78cm. Sammlung der Nolde-Stiftung Seebüll.

213. Emil Nolde, *Mask Still Life, 4*, 1911. Oil on canvas, 79.5 × 69.5cm. Fischer Fine Art, London.

214. Emil Nolde, *Eight Heads*, 1911. Pencil and coloured crayon. 18.7 × 28.2cm. Sammlung der Nolde-Stiftung Seebüll.

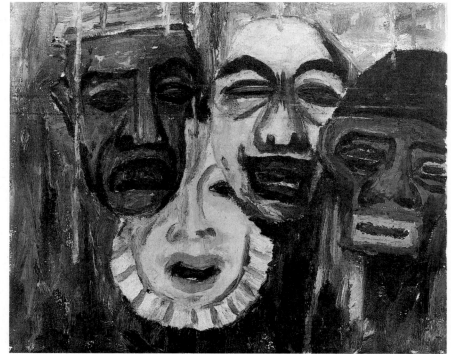

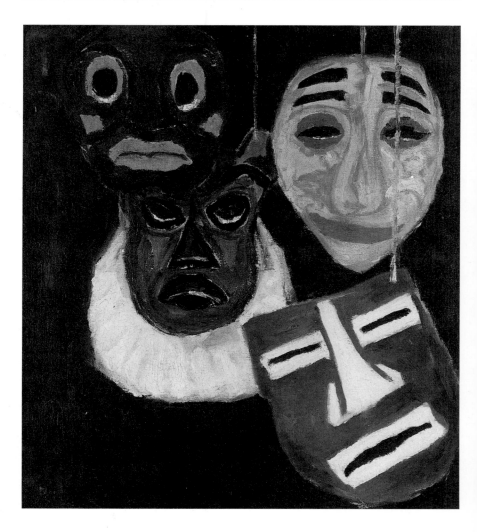

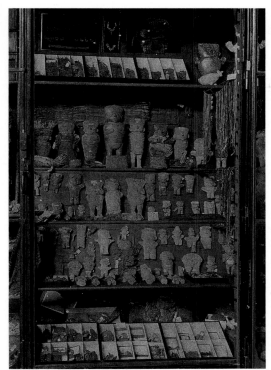

215. Exhibition in the Ancient American collection, Museum für Völkerkunde, Berlin. Before 1914.

216. Emil Nolde, *Mask Still Life, 3*, 1911. Oil on canvas, 74 × 78cm. William Rockhill Nelson Gallery of Art, Kansas City.

217. Display case with Amazon Indian artefacts, in the American exhibition space. Museum für Völkerkunde, Berlin. 1886.

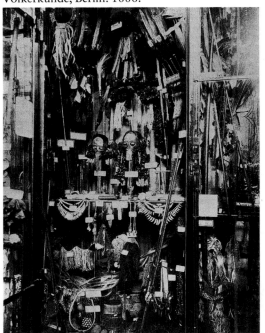

the bottom masks, however, seem to be abstracted from those depicted in *Mask Still Life II*.

In *Mask Still Life III* (fig.216) the objects were also hung as if to represent a single display case, but it is in fact a composite work assembled from several sketches Nolde had made in different parts of the museum with the addition of some 'imaginary' masks. The left-hand head relates to a pencil drawing of a canoe head from the Solomon Islands which would have been displayed in the South Seas section of the museum, while the shrunken head of the Yuruna Indian comes from the South American display (fig.217).[69]

This principle of composite arrangement which Nolde began to evolve by citing individual heads from a single drawing and then using separate drawings is fundamental to the 1912 and 1913 still lifes. In this way Nolde began to extract objects from the scientific and geographical context of the museum displays and to juxtapose them in new, expressive constellations. In *Mask Still Lifes II* and *IV* Nolde also established the practice of pairing paintings and, more generally, the repetition and variation of a single theme, which has its roots in his early career and comes to characterize the still-life series as a whole. Here variation exists on the level of colour combinations, physiognomic expression and, most importantly, Nolde's juggling of the ethnographic fragments into various synthetic combinations. This institutes a kind of self-referential, internally cohesive style of composition within Nolde's own aesthetic construct that counteracts his 'realist' dependence on material objects. Nolde began to orchestrate this practice of internal self-reference in pairs or groups of still-life paintings according to musical principles, in the most general sense, such as repetition, variation and inversion. *Exotic Figures I* (fig.218) and *Exotic Figures*

218. Emil Nolde, *Exotic Figures, I*, 1911. Oil on canvas, 65.5 × 78cm. Galerie Otto Stangl, Munich.

219. Nuwak-chin Mana Hopi doll. Destroyed. Formerly Museum für Völkerkunde, Berlin.

220. Sootuknangwu Hopi doll. Museum für Völkerkunde, Berlin.

II (1911) are inverted versions of each other, as the first shows two Hopi dolls and one 'cat', and the second, one Hopi doll and two stylized feline creatures (fig.221–2).[70]

Most important, the *Mask Still Life* series introduces a peculiar intermediary realm between living and inanimate objects, comparable to the paradoxical space between nature and artifice we found in Kirchner's studio scenes. In fact, Kirchner's *Still Life with Sculptures and Flowers* (fig.221) depicts a similar 'in between realm', where the carved wooden figures around a bowl and the foliage behind look like a miniature Moritzburg scene; and Heckel's *Still Life, Wooden Figure and Bowl* (Vogt 1911/17) also operates simultaneously as a figure composition and as a still life. It is quite wrong to regard these Expressionist still lifes merely as exotic copies of non-European artefacts, as a kind of 'japonaiserie' translated into twentieth-century primitivist terms.[71] True enough, Pechstein's contemporary still lifes like *Blue Anenomies* (fig.222), operate within the conventional boundaries of the genre, depicting the Cameroon pipe-figure as westernized exotica in the shape of a vase, although the carved figure in his *African Sculpture and Tulips* (1914) evinces a more life-like presence.

Pechstein, Kirchner and Schmidt-Rottluff all used still-life painting between 1910 and 1914 as a forum to experiment with the new possibilities of modernist style they encountered in Matisse and the Cubists. Pechstein's *Still Life in Grey* (1913) engages with Cézanne and Cubism, while *Fire Lilies* (1912) clearly refers to Matisse's studio scenes, and shows Pechstein's own studio decorations inspired by *La Danse* (1908). Kirchner's *Still Life with Glass Pitcher* (1912;G.283) and *Still Life with Tulips, Wood-Carvings and Hands* (1912;G.234), show his experiments with the stylistic distortions of Cubism in acid Expressionist colours; the flattening and cropping in the latter painting also owes a debt to Japanese prints, matching an exotic style to the subject of the still life. In all these cases, the non-European objects

221. E.L. Kirchner, *Still Life with Sculptures and Flowers*, 1912. Oil on canvas, 90 × 80.5cm. Museum Grönigen, Netherlands.

222. Max Pechstein, *Blue Anemonies*, 1912. Oil on canvas. Location unknown.

refer to the artists' studio environments and current interests, as well as operating as a sign of their engagement with international modernist style.[72] This holds true for Schmidt-Rottluff's *Still Life with African Figure* (fig.223) and *Still Life with Thistles* (1913), in which he experiments with radical decorative simplification and reduction to intensify expressive effects. Stylistically these works come closest to the reductive, brightly coloured planar compositions of Nolde's still lifes like *Exotic Figures I* and *II*, but they do not evoke the same animated effects.

The 'living' quality of the carved wooden figures in Kirchner's *Still Life with Sculptures and Flowers* (1912) recurs more powerfully in Nolde's 'ethnographic' still lifes, and in both cases this peculiar mediating zone between subjective and objective reality relates to their ambition to depict unalienated objects, carved either by their own hands or by 'spontaneous' native artists. Gabriele Muenter too, in contemporary still lifes like *Still Life with St George* (1911) portrayed 'unalienated' Bavarian folk art, staging it in imaginary figurative scenes.[73] These Expressionist still lifes display the other side of the coin from Kirchner's Berlin prostitutes; as we have discussed, these were transformed into manikin-like objects by the alienating pressures of city life. The still lifes also relate to Simmel's idea that works of art are

223. Karl Schmidt-Rottluff, *Still Life with African Figures*, 1913. Oil on canvas. Wallraf-Richartz Museum, Cologne.

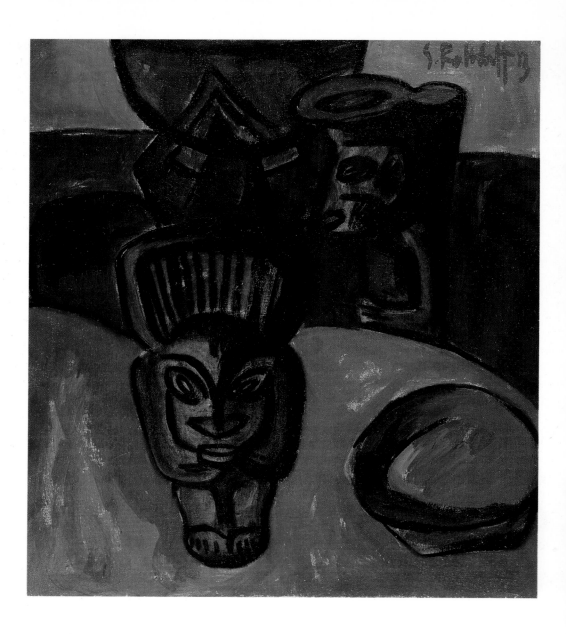

224. Emil Nolde, *Exotic Figures (Monkeys)*, 1912. Oil on canvas, 64.5 × 74cm. Saarland Museum, Saarbrücken.

capable of expressing in objective form the subjective emotions of the artist, a relationship that he considered fractured and splintered by the alienating processes of industrial production.[74] In the *Kunstäußerungen*, Nolde also interpreted the native artefacts as a counter-image to modern products, resulting from a direct, unmediated relationship between the creative fingers of the native artisan and his materials: 'The products of primitive people are created with the actual material in their hands, between their fingers. Their motivation is their pleasure and love of creating.'[75]

The large number of 'ethnographic' sketches which Nolde made in 1912 depict a wider range of geographical types, adding Indian, Javanese, Korean, and Egyptian objects to the tribal examples. There are also sketches from Nolde's own collection of folk art and of his stone fertility goddess, Astarte, which appears in the still life *Figure and Dog* (1912).[76] These drawings in coloured crayon and pencil have a distinctly child-like quality. The drawings themselves are exactly contemporary to the first public statements of interest in child art by Paul Klee and the artists of the *Blaue Reiter*.[77] Presumably his understanding of tribal art as 'expressive' objects, encouraged him to adopt a child-like style, associated with authenticity and spont-

180

anaiety. Nolde described children's drawings as revealing 'unbelievable talent and full of sparkling life'[78] and spoke of the necessity for mature artists to retain a child-like vision: 'Alongside all the self-confidence I'd achieved with knowledge I wanted very much to retain my child-likeness, because if this is missing in an artist the most beautiful, full resonance is missing too.'[79]

Nolde's notion of the primitive still relied on evolutionary criteria which located tribal society on a simpler level of experience. Dissatisfaction with modern civilization involved an inversion rather than a rethinking of evolutionary criteria and this may be said to have reinforced rather than corrected misunderstanding of tribal societies by presenting prejudice in a new and positive guise. An untypical still-life painting *Exotic Figures (Monkeys)* (1912;fig.226), which shows negro figures in stages of 'regression' becoming increasingly similar to a monkey perched on a pole, shows the extent to which conventional evolutionary values operated in Nolde's paintings, although this is probably meant as a positive celebration of animal 'vitality'. In a very similar way, the cultural relativism of the *Blaue Reiter Almanach*, – with its juxtaposed illustrations of folk art, non-European art, child art, El Greco, Gothic art, and international modernism – is superficial, as its wide-ranging notion of the primitive is still defined in antithesis to the norm of Western realism, which is now seen in negative rather than positive terms.

In the 'ethnographic' still lifes, Nolde's method of juxtaposing fragments into new and surprising constellations relies on formal and expressive criteria. This is also a feature in the synthetic method of the *Almanach* and in the *Kunstäußerungen*, where Nolde makes a link between northern Gothic and tribal art, very much in the tradition of Worringer, *die Brücke* and the *Blaue Reiter*. The winter of 1911–12 saw the highpoint of contact between the various camps of the Expressionist avant-garde, and Nolde's 1912 notes were almost certainly his own answer to the issues currently raised in these circles.[80] But rather than draw the conclusions of the *Blaue Reiter*, which led them away from 'materialist' realism to modernist abstraction, Nolde's still lifes continued to operate in a complex zone which engages with both representational and abstracting modes.

In 1912, Nolde began to flatten and simplify his compositions and forms in a more radical way. When we compare the sketches for *Man, Woman and Cat* (figs.229–30) and its variant pair *Man, Fish and Woman* (fig.225–6) with the paintings, we see how he also simplified and intensified the colours in the paintings. In the former work the background displays a painterly, textural handling in contrast to the flat, matt painting of the ethnographic figures. Underneath the brown skin and dark blue hat of the female figure flecks of yellow paint shine through, adding an intense luminosity to the colour. The sketch of the female figure for *Man, Fish and Woman* is particularly fine and delicate, conveying volume through effects of light and shadow. The sketch for the male figure (fig.226) is more crudely handled, and this flat, reductive, child-like style is repeated in the painting with its dark-brown contours and flat areas of blue, ochre, red, green, white and brown. The male figure is very exactly copied from the drawing, as we see, for example, in the position of his eyes and ears, but the sex of the female figure, which is very obvious in the drawing, is omitted in the painted work.

Nolde's dislocation and relocation of the ethnographic objects went a stage further in these paintings, as he began to sketch only figurative fragments from his ethnographic sources. For example, the male figure in *Man, Woman and Cat* was taken from a Cameroon throne (fig.231), and the cat from the top panel of a carved Nigerian door (figs.227–8).[81] This method of double decontextualization results in a proto-Surrealist effect of *dépaysement* in the still lifes of this type. Nolde stages the fragments into increasingly theatrical encounters lifted out of time and place. Moreover, the subject matter of these two paintings sets up an opposition of 'types' rather than specific or particular characters. Like the protagonists in contemporary Expressionist drama – such as Oskar Kokoschka's *Mörder, Hoffnung der Frauen* (1909) – these have mythic implications. In Nolde's still lifes the 'mythic' opposition

226. Emil Nolde, sketch for male figure in *Man, Fish and Woman*, 1912. Pencil, 27.8 × 12.4cm. Sammlung der Nolde-Stiftung Seebüll.

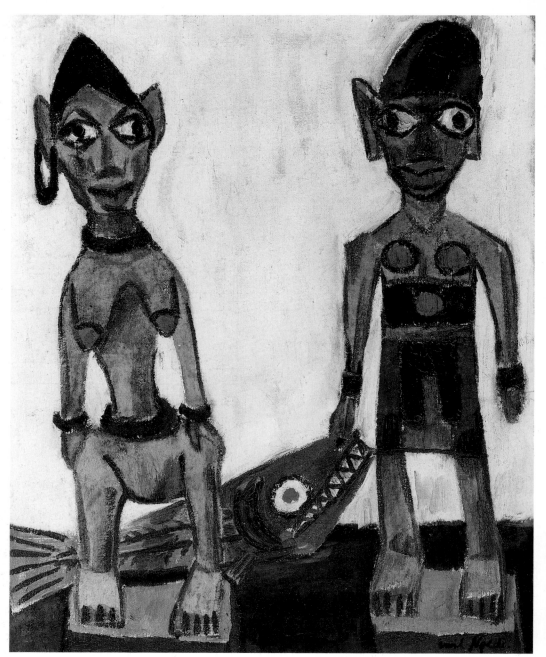

225. Emil Nolde, *Man, Fish and Woman*, 1912. Oil on canvas, 71.3 × 57.5cm. Sammlung der Nolde-Stiftung Seebüll.

227. Wooden carved door, Nupe Nigeria. H. 189cm. Museum für Völkerkunde, Berlin.

228. Emil Nolde, sketch for *Cat*, 1912. Pencil, 21.4 × 27.8cm. Sammlung der Nolde-Stiftung Seebüll.

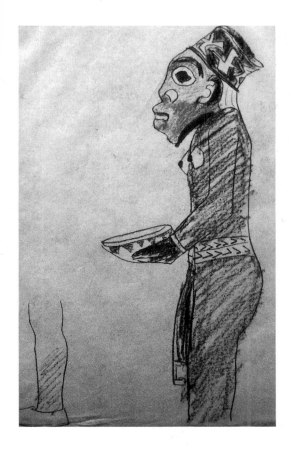

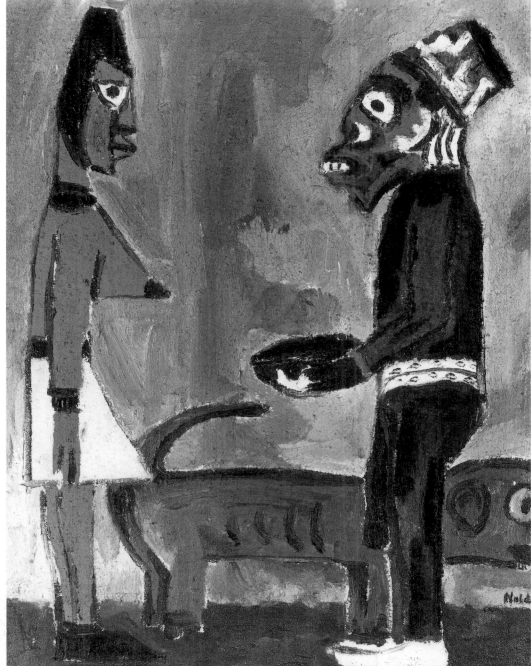

229. Emil Nolde, *Man, Woman and Cat*, 1912. Oil on canvas, 67 × 52.8cm. Sammlung der Nolde-Stiftung Seebüll.

230. Emil Nolde, sketch for male figure in *Man, Woman and Cat*, 1912. Pencil and coloured crayon, 27 × 21.8cm. Sammlung der Nolde-Stiftung Seebüll.

231. Throne of Sultan Njoya, Bamun Cameroon. Wood and coloured glass beads, h.175cm. Museum für Völkerkunde, Berlin.

232. Emil Nolde, *Figure and Chickens*, 1912. Oil on canvas, 50 × 60cm. Private collection.

233. Emil Nolde, *Still Life, Exotic Figure, Mask and Rider*, 1913. Oil on canvas, 73.5 × 89cm. Private collection.

234. Emil Nolde, *Still Life, Rider and Woman's Head*, 1913. Oil on canvas, 63 × 87cm. Location unknown.

of 'man' and 'woman' is mediated by animals with sexual connotations like the cat and the fish. Elsewhere the theatrical effects rely on exaggerated gesture and expression, reminiscent of Nolde's sketches of Reinhardt's productions pushed to new extremes. The extremity and exaggeration of gesture and expression in works like *Figure and Chickens* (fig.232), or *Figure and Bird* (1912) go beyond all narrative determinations and become a sort of autonomous rhetoric of gesture for its own sake. This is partly because the original significance of pose and gesture was lost when the tribal pieces were cut adrift from their own historical contexts, so that from the Western artist's point of view they appeared redolent with unspecific, but powerfully expressive significance. The cumulative effect of this rupture between gesture and meaning in Nolde's still lifes is an extraordinary tension between the apparent significance of the theatrical groupings and a rhetoric of gesture pushed to extreme non-referentiality.

In 1913, the range of material in Nolde's sketches and still-life paintings once again expanded. Forty-four drawings exist on a new paper size, none of which relate to pre-1913 paintings.[82] Amongst these are a series of sketches after medieval sculptures in the Thaulow Museum in Kiel, and a group of Egyptian, Etruscan and Tanagran heads, which Nolde coloured densely and brightly using waxy crayons. In *Jahre der Kämpfe* he wrote:

> When the winter came round again I followed an inner impulse to go to the Egyptian and Coptic sections of the museums. I visited the Tanagra and Romanesque and Gothic figures – always drawing these rich forms and colours...in my later, often freely painted still lifes, some of these depicted objects turn up again.[83]

In effect, Nolde's interest in tribal art was eclipsed by these new areas of interest, although he did re-use some of the 1912 drawings after tribal objects in his 1913 still lifes. In the paintings, both categories of objects were supplemented by an increasing number of figures and objects from Nolde's own collection of 'folk' art and textiles woven by Ada Nolde after his own designs. Like other members of the Expressionist avant-garde, Nolde and his wife were encouraged by Osthaus to resume craft activities at this date, and Nolde made a number of ceramic and textile designs; he even became involved in a mosaic design for the firm of Puhl and Wagner in Berlin.[84] The 1913 still lifes reveal a more complex and varied orchestration of objects, which are combined in relationships of analogy and contrast – between different types of objects, textures, colours and poses. *Still Life, Exotic Figure, Mask and Rider* (fig.233) juxtaposes a grimacing mask from a 1912 drawing and painting, with the North-West coast Indian figure with splayed legs from *Figure and Bird* (1912). Nolde added to the composition a glazed ironware figure of a rider. Despite the shadows cast on the background wall, the flat, planar style is affirmed by the staring eyes and mouths of the two mask-like faces, and the exaggerated scale of the background mask. Although the colours of the foreground figure are repeated in the ironware rider, there is a marked contrast between the static, frontal poses of the ethnographic objects and the asymmetrical, profile view of the rider, moving sideways. Thus, a network of relationships emerges on the level of form and content which convey Nolde's notions of the primitive – just like the relationships of contrast and analogy between different aspects of the 'primitive' in studio scenes by *die Brücke*. In the *Blaue Reiter Almanach*, a similar method of juxtaposition was used to construct an iconology of the 'primitive', which counteracts the straightforward narrative sequence of the book.

In these 1913 paintings different theatrical effects occur. *Still Life Exotic Figure* presents the grotesque mask in the position occupied by the Egyptian and Tanagran heads in *Still Life, Rider and Woman's Head* (fig.234), *Still Life (Woven Material, Head and Sculpture)* (fig.235), and *Still Life (Cow, Japanese Figure and Head)*. In all cases, these heads seem to occupy the position of a narrator, or a chorus in a classical drama, whose expressions are played off against the *tableaux vivants* of the still-life

184

235. Emil Nolde, *Still Life, Woven Material, Head and Sculpture*, 1913. Oil on canvas, 76.5 × 71cm. Location unknown.

236. Emil Nolde, *Church Figures, II*. Oil on canvas, 77.5 × 64.5cm. Sammlung Sprengel, Hannover.

scenes. Invariably, they stare out towards the spectator, but in the still life *Woven material, Head and Sculpture* the grinning head also acts as a voyeur, looming above the reclining female nude.

The three still lifes referring to the sketches of medieval sculptures display various compositional styles. *Church Figures* I (1913,) relates to the complex figurative interractions operating in other compositions of this year, while the *Madonna Still Life* and *Church Figures II* (*Man and Woman*) show simpler arrangements. The madonna is posed alongside flowers, which is rare in the pre-1914 still lifes, but a recurrent feature after 1915. *Church Figures II* (fig.236) juxtaposes male and female figures frontally, in the style of *Man, Woman and Fish* (fig. 225). The quieter mood of these pious objects, with their gestures of prayer and blessing, means they avoid the extreme gestural exaggerations we find in the 1912 still lifes, but they occupy the same peculiar intermediary realm between figures and objects, recalling more directly than Nolde's religious paintings, his figure style in *Free Spirit* (1906).

The Dialogue between Modernity and Tradition

In *Reisen, Achtung, Befreiung* 'Travels, Attention, Liberation', the fourth volume of his autobiography, Nolde described his continuing practice of still-life painting in 1919 as 'harmless, simple pictures' in contrast to his fantastic imaginative works.[85] Usually, commentaries on the still lifes class them with other naturalistic aspects of Nolde's oeuvre,[86] although Max Sauerlandt points out that their expressive intensity is comparable to the effects Nolde achieved in his religious paintings,[87] and Martin Urban remarks on stylistic parallels between the still lifes and *The Life of Christ* (1911–12), such as flattened patterning and exaggerated gestures.[88] In fact, the thematic range of Nolde's oeuvre following the Secession row in 1910 suggests that the still lifes occupy a more central and pivotal position. At this time Nolde's activities had polarized radically into two types of painting: the modern life Berlin subjects on the one hand, and the 'spiritual' counter-images to the modern world he presented in his religious paintings. In his autobiography, Nolde mentions both types in relation to his search for 'foreign, primal and racial origins'[89]. His decision in 1911 to engage with the current avant-garde enthusiasm for non-European art set him apart from the Secessionist and traditionalist attacks on his work, and affirmed his relationship with the Expressionist generation. But he also used this first overtly primitivist phase to mediate between the two main aspects of his current work dealing with modernity and its opposite, as if to try to resolve an internal division in his oeuvre.

In several ways, the 'ethnographic' still lifes relate to his modern, historical Berlin scenes. The confrontations between men and women, stated most blatantly in his 1912 still lifes, pick up on the male/female oppositions in the Berlin café scenes like *Slovenes* (see fig.206), where bottles and glasses occupy the same position as the ethnographic animals. Also, there is a similar play between artifice and nature, revolving around performance in the Berlin scenes and the rhetoric of gesture and costume. In the still lifes, as discussed above, this has to do with a crossing of boundaries between the inanimate and the animate to produce 'living' still lifes. Most important, the theatrical effects, which Nolde explored in his sketches of Max Reinhardt's productions, recur in the still-life series, and undermine in a powerful way the narrative continuity and coherence of the scenes he depicts. It is this aspect of the still lifes which links them in a fundamental way to Nolde's contemporary religious paintings. Of course, there are more obvious similarities; the non-European and medieval figures in the museums are themselves objects with religious significance and Nolde translated this into his notion of expressive authenticity. In his triptych *Legend-St Mary of Egypt* (1912), the figures and the lion in the third panel relate closely to his ethnographic drawings, just as the influence of Grünewald in *The Life*

of Christ relates to Nolde's inclusion of pre-Renaissance German styles in his pantheon of the 'primitive'. In the *Kunstäußerungen* he writes:

> much has changed since then. We cannot stand Raphael and we are indifferent to the statues of the so-called Greek Golden Age. Our ideals are no longer those of our predecessors... We love and respect those modest people who worked in their shops, whose lives are almost completely unknown to us, whose names are unrecorded but who made the simple and grand sculptures of Naumburg, Magdeburg, and Bamberg.[90]

But it was Nolde's reapplication of these theatrical effects and the exaggerated gestural code he had worked out in the still lifes, to the narrative sequence of his nine-part polyptych *The Life of Christ*, which had the most far-reaching effects. The repetition and variation of gesture playing across the entire surface of the paintings introduces an element of synchronicity and simultaneity – rather of atemporality – which work against the diachronic unfolding of the story of Christ's life. There is perhaps a discernible parallel between this pictorial procedure in *The Life of Christ* and the still lifes and certain aspects of Kafka's contemporary prose – particularly those referred to by Walter Benjamin in his essay 'America,' as 'gestic theatre'. This description is worth quoting in full because it provides the kind of language necessary to evoke the rich and paradoxical qualities of the still lifes:

> Only then will one recognize with certainty that Kafka's entire work constitutes a code of gestures which surely had no definite symbolic meaning for the author from the outset. Rather, the author tried to derive such a meaning from them in ever-changing contexts and experimental groupings... each gesture is an event – one might even say a drama – in itself. The stage on which this drama takes place is the World theatre which opens up towards heaven. On the other hand this heaven is only the background, to explore it according to its own laws would be like framing the painted backdrop of the stage and hanging it in a picture gallery. Like El Greco Kafka tears open the sky behind every gesture; but as with El Greco – who was the patron saint of the Expressionists – the gesture remains the decisive thing, the centre of the event...[91]

Into his framework of narrative realism, Kafka threads what Silvio Vietta has described as absolute metaphor; one could also call it 'absolute symbol' in the sense that it defies all rational analysis and works – like Nolde's pictorial equivalents – against the weave of the narrative.[92] It is precisely this self-referential code of gestures and forms that separates his paintings from the nineteenth-century precedents he had admired like Arnold Böcklin. Like Nolde, Böcklin retained in his work a precarious balance between painterly realism and symbolic intent. But Böcklin's subjects operate in a conventional literary mode, separating his work fundamentally from the modernist disassociation at work in Nolde's 1912 paintings. In *The Life of Christ*, like the *Blaue Reiter Almanach* and Gauguin's monumental *D'Où venons nous?*, narrative sequence is undermined by modernist strategies like the juxtaposition of text and image, the expressive repetition of gestures, forms and colours, and, in Gauguin's painting, an inversion of narrative logic, so that we 'read' the painting from right to left. In each case, narrative sequence is not totally cancelled out, but it is disrupted and dislodged by such *anti-narrative* devices as these.

The question of the fate of narrative became central in the 1930s debate about Expressionism between Lukács and Bloch. For Lukács, the modernists' attack on narrative sequence, like the plundering of non-European cultures, was an attack on objective reality in favour of a subjective, in-turned vision. Most important, it was an attack on history itself; the 'dynamic and developmental' sequence of narrative realism was challenged by the 'static and sensational' emphasis of modernist fiction whereby man stands isolated and ahistorically confined within the limits of his own experience. For Lukács it was Kafka who epitomized this direction in modern

186

fiction: in Kafka 'techniques elsewhere of merely formal significance are used...to evoke a *primitive* (my emphasis) awe in the presence of an utterly strange and hostile reality. Kafka's *Angst* is the experience par excellence of modernism.'[93]

Whether or not one accepts the value judgements surfacing in Luckács' analysis, his notion of the modernists' attack on history is crucial to our understanding of the Expressionists' primitivism. The formulation of a timeless, ahistorical, mythical counterimage to the onslaught of historical change is part of this attack and this is written, as I have suggested, into the frozen, theatrical effects of Nolde's still-life paintings. But primitivism also involved a radical and revolutionary challenge to the values of the past, sweeping away the cobwebs of history. In a letter from Franz Marc to August Macke, dated 14 January 1912, reporting the revelation he had experienced in the Berlin Ethnographical Museum, this revolutionary quest for an *alternative* to history is clearly stated. Echoing Nietzsche's attack on historicism in his 1874 essay, 'On The Advantages and Disadvantages of History for Life' Marc writes:

> I find it natural that we should look for the rebirth of our own artistic conscious-ness in this dawn of artistic intelligence rather than in cultures with thousands of years of history like the Japanese or the Italian Renaissance...at last I believe I've grasped what it involves if we want to call ourselves artists today. We must become ascetics...we must courageously relinquish everything that was dear and necessary to us as good middle Europeans. Our ideas and ideals must wear a hair shirt, we should nourish them with locusts and wild honey and not with history, in order to escape the exhaustion of our European bad taste.[94]

The relation of Nolde's still-life paintings to both his religious, idealistic counter-images to modernity *and* to his modern-life subject paintings uncovers a deep-rooted paradox between the concepts of primitivism and modernity. On the one hand, primitivism negotiates a counterimage to the dialectics of historical change in the modern period. But at the same time it postulates a revolutionary attitude that makes possible the experience of the 'modernness' of modernity – an attitude pushed by the Expressionists to extremes unimaginable in first-generation Secessionist modernism, which continued to foster the standards and values of European taste. As Paul de Man writes:

> In order to renew one's experience of the present it is necessary to sever it from the past and to view the world with the freshness of perception that results from a slate wiped clear, from the absence of a past that has not yet come to tarnish the immediacy of perception.[95]

It is this paradoxical relation between the primitive and the modern that occurs in the earliest texts about modernity like Baudelaire's *Le Peintre de la vie moderne*, with its play on the notions of the man-child, the sophisticated naïve. But whereas Baudelaire envisaged a painterly celebration of the modern world, the complex historical situation in Germany in the years leading up to The First World War, where the historical phenomena of urbanization and industrialization clashed with the creaking nineteenth-century machinery of state and government, and national achievements in commerce and industry clashed with the ideology of conservative nationalism seeking 'roots' in rural tradition, artists and writers found themselves in a very different situation to nineteenth-century Paris. In the paintings of the Expressionist 'avant-garde', an ambivalent and multi-faceted approach to the sub-ject of modernity emerged. This was best expressed in their primitivism because, on the level of cultural ideology, it proposed both an alternative to and an engage-ment with modernity. Involving, on the one hand, a search for an authentic, holistic area of cultural experience beyond the contradictions of historical change, and, on the other hand, a Nietzschean engagement with the potential of present time, Expressionist primitivism bridged the gap between the 'conservative' and 'revolu-tionary' aspects of modernist avant-gardism. At the same time, and particularly

after the split in German modernism following the Secession row in 1910, it could be used as a mark of separate identity, and as an arena where many modernist principles – such as the cults of spontaneity, authenticity and aesthetic self-reference – could be worked out under new terms of reference.

In the particular case of the 'ethnographic' still lifes, it is likely that Nolde intended them – at least unconsciously – to resolve the crisis between modernity and tradition which had split the German art world in 1910 and driven a rift too within his own oeuvre. In practice the paintings reveal rather than resolve and conceal the contradictory ingredients of the 'avant-garde' position. Their alternative modes of Western and non-Western representation, the combination of realist and modernist aesthetics, and their Janus-faced relation to his modern life paintings on the one hand and the religious works on the other, make them operate in a space which, as Bloch later claimed, shows up 'the real fissures in surface inter-relations'.[96]

But one important question remains to be asked. Could primitivism be used by the Expressionist avant-garde as a truly critical force? Or was it doomed to failure because, as Lukács claimed, it was built on the foundations of an imperialistic and appropriative misunderstanding of non-European societies:

> What the Expressionists intended was undoubtedly the very opposite of atavistic. But since they were unable to free themselves intellectually from an imperialist parasitism, and since they colluded in the ideological decay of the imperialist bourgoisie without offering either criticism or resistance, acting indeed on occasion as its vanguard, their creative method could without distortion be pressed into the service of that synthesis of decadence and atavism which is the demagogy of Facism.[97]

To look into this central and pressing question, it is necessary to investigate the Expressionists' visual and written representations of non-European peoples. Let us turn finally to the notions of race and nationalism which surface in the South Seas journeys made by Max Pechstein and Emil Nolde immediately preceding the outbreak of the First World War.

THE POLITICS OF
PRIMITIVISM

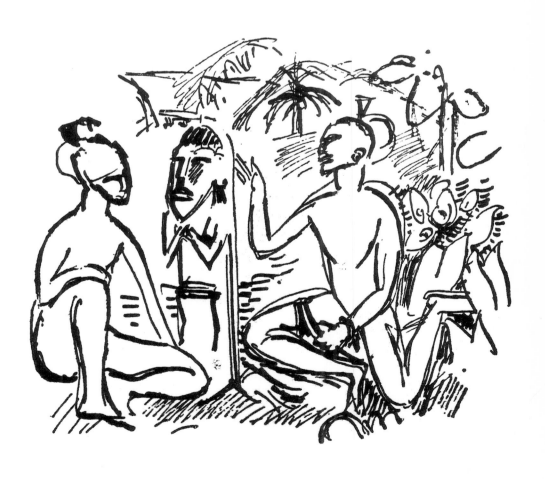

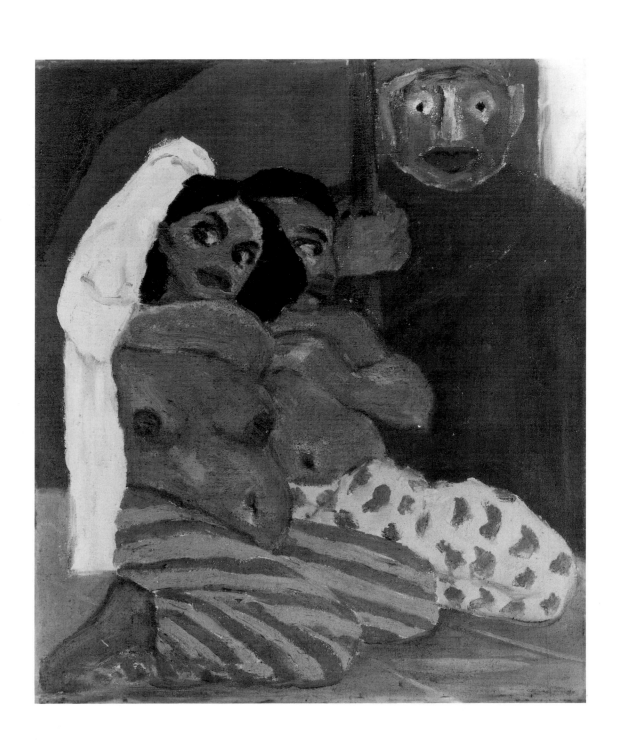

10 A South Seas Odyssey: Max Pechstein's Visionary Ideals

My old wish came true – to leave Europe and to seek out the Elysian fields in Palau.

Max Pechstein[1]

THE SWAY that Italy held over German artists' imaginations meant that they had made very few journeys outside the boundaries of Europe before 1913. Exoticism in France and Britain had deep roots in the first half of the nineteenth century when North Africa and the Middle East attracted many travelling artists.[2] In contrast, the German Romantics still followed the trail to Italy. If we search for the roots of primitivist consciousness in late nineteenth-century German art we find them in the development of a Dionysian classicism by Arnold Böcklin and his followers, still inspired by the romance of Italy, rather than in a response to exotic civilizations. 'Japonisme', as a stylistic influence, infiltrated the *Jugendstil* rather than high-art milieu, and it also appeared in some of Max Klinger's graphic cycles.[3] Emil Orlik made a trip to Japan in his youth and both he and Menzel painted works influenced by the popular enthusiasm for Japanese decorations. But these are isolated instances. It was the Expressionist generation that first voiced the desire to expand their horizons beyond Europe. Even so, Heckel, Pechstein and Nolde all travelled first to Italy.[4] A letter from the artist Wilhelm Morgner to Tappert in 1912, shows how vague and wandering notions of wider travels could be, how difficult it was to fix the broad associations of the primitive in a precise geographical location. He wrote; 'I've decided to go and join the wild men. Exactly where, I'm not quite sure as yet. First Brasil, then the South Seas Islands, then India . . . an impulse towards the sun is pushing me on.'[5]

In the end, the preference Pechstein and Nolde showed for the South Seas is explained by the possibilities of the German colonial empire combined with the influence and precedent of Gauguin. Both artists were aware of Gauguin's South Seas paintings and had quoted them in their own, significantly quite different works. In Pechstein's *The Yellow Cloth* (see fig.71) we find his reference to Gauguin's *Te Nave Nave Fenua* (1893) exaggerating the romantic and exotic effects.[6] Nolde, on the other hand, used the composition of the Folkwang Museum's *Contes Barbares* (1902) in his more brutal and disturbing 1912 canvas, *Nudes and Eunuch* (fig.237). Here a castrated warrior, guarding two tempting nudes, has taken the place of Gauguin's 'too knowing' European, Meier de Haan. In 1908, Gauguin's account of his journey in *Noa Noa* was published in *Kunst und Künstler*[7] which, as Osborn pointed out, made clear the breadth and significance of the South Seas enterprise, as a life project rather than simply as an artistic stimulus:

his painterly work always remained tied to Paris. Good taste, self-consciousness, even a trace of sentimentality in a refined and reduced form, can still be seen. But whoever reads *Noa-Noa* knows how Gauguin the man grew larger than his work. He is still to be credited with having carved out a new route to great goals.[8]

(*Preceding page*) Detail of fig.245.

237 Emil Nolde, *Nudes and Eunuch*, 1912. Oil on canvas, 88 × 74cm. Indiana University Art Museum, Bloomington.

As we shall see, it was Pechstein who continued to make direct reference to Gauguin during his South Seas journey, and often to the more superficial aspects of the French artist's refined exoticism. Nolde, in an indirect way, excavated some of the more troubling and problematic implications of Gauguin's oeuvre.[9]

The reluctance of German nineteenth-century artists to leave the shores of Europe was certainly influenced by the late expansion of the German colonial empire. In contrast to Britain and France, the industrial revolution in Germany preceded the commercial revolution and search for world markets. Although the wave of nationalist fervour following the Congress of Vienna in 1815 produced the first popular demand for colonial expansion, it was only after the 1871 unification that the boom in commodity production, resulting from the input of French indemnities and a new sense of national consciousness, prompted Bismarck to proceed cautiously with laying the foundations of the German colonial empire. During the 1870s and 1880s, trading companies, missions and scientific expeditions were encouraged to secure German influence in preparation for colonial takeover, and in 1884 the empire was inaugurated with the German annexation of South West Africa. In 1885, Germany secured its first South Seas colonies and in 1886 extended its interests in Africa.[10]

The entry of Germany into the world market at this late stage had several consequences. Inevitably, Bismarck's policy of non-aggression and negotiation with other European powers was short-lived, and after 1897 Wilhelm II pursued an aggressive colonial policy, expanding German interests on a world-wide basis. These expansionist policies were accompanied increasingly by aggressive nationalist justifications fostered by the colonial organizations. In 1882 the Colonial Association was founded to unite previously splintered support groups, and in 1887 this merged with The Society for German Colonies to form the monolithic Colonial Society. Finally, in 1890, the foundation of the Pan-German movement, 'to arouse patriotic self-consciousness at home...and, above all, to carry forward the German colonial movement to tangible results', provided a radical conservative spearhead consistently opposed to all attempts at colonial reform.[11]

But the delay in German colonization provoked not only conservative nationalist support. A strong and unprecedented critical position was adopted by the Socialists and the *Deutsche Freisinnige Partei* in the 1880s. They stressed the dangers of European competition and objected to the blatant capitalist basis of colonialism. In the *Communist Manifesto* (1845), Karl Marx had pointed to the tendency of bourgeois capitalist society to impose its own image on non-Western lands:

> The bourgeoisie, by the rapid improvement of all instruments of production, by the immensely facilitated means of communication, draws all, even the most barbarian nations into civilization... It compels all nations, on pain of extinction, to adopt the bourgeois mode of production, it compels them to introduce what it calls civilization into their midst, i.e., to become bourgeois themselves. In one word, it creates a world after its own image.[12]

By the mid-nineteenth century persisting ideals of the 'new land', untainted by Western civilization and history which we find, for example in Goethe's *Wilhelm Meister's Wanderjahre*,[13] had begun to be countered by a critical awareness that the reality of Western contact could make these 'ideal' communities look like grotesque caricatures of Western modernization. This 'double-take' on non-European society – which reflected schizophrenic attitudes to modernity itself – was an important prerequisite for the course that artistic primitivism took in Germany.

After 1900, the Centre Party and the Catholics joined the forces of opposition to colonialism, and in 1907 combined objections to imperialist policy overseas provoked a serious governmental crisis. Corruption and inefficiency in the administration and a series of expensive punitive missions to subdue native uprisings – culminating in the Herero revolt in South West Africa in 1906 – provided fuel for August Bebel's thoroughgoing attack on imperial policy. Bebel exposed extremely poor trade figures which showed Togoland to be the only self-supporting German

238. Richard Janthur, *The European*, 1912. Oil on canvas. Location unknown.

239. 'The New African Idol,' *Jugend*, 1896.

colony, while the rest required huge imperial grants. When the Reichstag refused supplementary funds to continue the fight in South West Africa, Chancellor von Bülow dissolved parliament. The 1907 election campaign was fought mainly on patriotic grounds, and the resulting governmental victory provided overwhelming support for the *Weltpolitik* of Wilhelm 11. After 1907, criticism of the imperial colonial policy was effectively silenced, and the wide-ranging reform programme formulated in response to the 1906 crisis tended to persuade even the Socialists of the possibilities of an educative and humane colonialism. Although they continued to address critical attention to specific issues, their general policy was far less radical. In the *Kolonial Rundschau* (1911), the modified socialist position was described in the following terms: 'to back reforms which improve the lot of the natives...to stop all attacks on native rights, their exploitation and enslavement, and...to employ all available means to encourage their education and independence'.[14]

Without doubt the reforms in colonial administration, native land rights, education and hygiene after 1907 smoothed the way for majority support of imperial *Weltpolitik*. But it must also be said that the new policies reflected a certain anomoly in German colonialism which we shall find illustrated in the particular case of New Guinea. The imperial administration found itself balancing between two extremes: the fierce, uncompromising nationalism of the Pan-Germans and the anti-colonialism of the Socialists. Aiming to accommodate all sides it was often in danger of falling between two stools.

To explore how these issues passed down into popular consciousness, it is useful to look at the critical voice raised in the bourgeois satirical journals. The foundation of *Jugend* in 1896 coincided with the acceleration in Wilhelm II's colonial policy; that year we find a satirical cartoon entitled *New African Idols* (fig.239) showing Africans worshipping in front of two totems which are hybrids of oriental decorative forms and grimacing European heads. The text comments ironically on the 'civilizing' processes of colonialism:

> Oh you great, good white god! We thank you from the depths of our souls for making some of your culture available to us stupid, immoral blacks...you are gentle and good, and if you turn fire and sword against us, you do so certainly with a heavy heart, only for civilizations sake, you have cured our silly assumption that the land we live in belongs to us, that our women and children are our own; you have persuaded us to give up cannibalism and take up drinking schnapps... Great, good, white god. Just send us lots more like you so that we will be up to our necks in culture, and become as just, gentle and good as you – that is if any of us are still around![14]

Despite the ironic critique of Western civilization, it is interesting to see that the satirical form here also makes use of European prejudices and preconceptions about non-European peoples. The reference to cannibalism – which we find recurring as one of the generic characteristics of the native – and the naïve paganism of the African prayer – although ironically presented – nevertheless reinforce notions of Western superiority. At one and the same time the reader can enjoy laughing at himself and see his prejudices reconfirmed. A closer look at the representation of colonial issues in another bourgeois journal, *Fliegende Blätter*, shows that despite the generic and archetypal images of natives and colonizers (for example, there is very little distinction made between different continents), the cartoons responded to shifts in colonial policy.[15]

At the turn of the century there were persistent references to native resistance, either to colonial control or to the forces of civilization. In 1900, for example, one cartoon depicted the ring on a native's nose stuck on an alligator's tooth as he tries to swallow him.[16] A year later, the underlying interests of philanthropy were laid bare when we find the same alligators knitting socks for a group of naked warriors.[17] Between 1903 and 1904 a series of cartoons by E. Reinicke slightly shifted the emphasis from the difficulties and means of conquoring the natives

to the difficulties of civilizing them. *A Station in Darkest Africa* shows a group of natives, half in European dress, waiting to board a train. Because the station has run out of tickets, the native conductors are using their clippers to punch holes in the travellers' ears before they depart.[18] *Country Customs* depicts a European teacher instructing a group of small native children to sit on a bench before the class begins. Obediently they procede to squat in native posture on the bench rather than the floor.[19]

After 1904, we find a series of images in *Fliegende Blätter* relating to the powers of commercial control over native communities. Partly these concern the quick business instinct of the native, and in this sense, of course, images of race coincide with contemporary representations of Jewish ethnicity. *Practical Use of Nose Rings* shows the native trader with a set of scales hanging from the ring on his nose, on which he is weighing salami to sell to his fellow villagers.[20] A 1905 cartoon shows a group of native warriors in a beer hall. In place of their traditional warpaint, a waitress is chalking up on their backs the number of litres each has drunk – and must pay for. In the foreground we find a leopard, tamed like a cat and licking up beer slops from a dripping barrel.[21]

All these cartoons respond to issues discussed in the colonial debates during the first years of the century: the trading rights of the natives, commercial exploitation, the importation of alcohol into the colonies. Translated into images of humour, the critical viewpoint is dislodged and tends to drift across the issues, unfixed and attaching itself to whichever victim provokes the most laughs. Of course, this is an aspect of bourgeois satirical style, which encompasses both critical attack and a reaffirmation of the status quo. The subject of modern art in *Fliegende Blätter* is approached in the same ambivalent critical style, and between 1912 and 1914 the Berlin Futurist exhibition in particular provided an opportunity to attack both the philistinism of bourgeois taste and the childish arbitrariness of avant-garde style.[22]

As for the colonial question, we find that it only rarely appears in the pages of *Fliegende Blätter* after 1907. Until 1910, only two cartoons attempted to satirize imperial policy, and then in 1911 two images with a new and pessimistic mood responded, apparently, to the widespread criticism at home of Germany's entry into the Congo, where sleeping sickness was proving to be an insurmountable problem. *Straight through Africa* shows a European car driving by mistake onto the back of a sleeping elephant which helps a group of lurking cannibals to capture the drivers.[23] Two months later, *Herr Professer Forschmeier Exposing himself to Danger in Darkest Africa*, shows a German scientist being swallowed up by a hungry alligator while his scientific instruments – the tools of progress – lie impotently at the side of a pond.[24] Whereas in 1900 it was the German colonizer who was represented as the alligator, now it is the colony. The image has come full-circle and a new cultural pessimism enters the vocabulary of colonial satire. Between 1911 and 1913 the satirists are once again silent, and colonialism apparently became an unfit subject for their critical pen. It is precisely at this date, following the split with first generation modernism, that a new cultural pessimism entered the vocabulary of fine art avant-gardism, for example in the city Expressionism of Kirchner and Meidner.

It would seem that fine art discourse in the years leading up to 1914 did assume a new critical rôle. But, as we shall see, the critical ambivalence about colonialism that we find in the bourgeois satirical journals, resurfaces in a different guise and form in the work of Pechstein and Nolde. Both sets of images, in their different ways, were representative of the internal contradictions of the imperial system in action.

Pechstein's Primitivist Aesthetic

Pechstein's primitivism, like Nolde's, was rooted in a set of European experiences and it developed within the context of the Expressionist movement several years

194

before his departure for the South Seas. Whereas Nolde's work was provoking controversy in 1913, Pechstein was on a rising star. His genial and essentially French-oriented version of Expressionist style made him the most popular of the new generation. A crude characterization of their respective positions seems to span across the opposing possibilities of Expressionism – with Pechstein representing the progressive internationalist trend and Nolde the 'conservative' Germanic revival. The artists' own memoirs, written from the point of view of Pechstein's subsequent political shift to the left and Nolde's to the right, reaffirm this contrast.[25] But a more detailed study of the pre-war years suggests that Pechstein's primitivism, like Nolde's, involved a complex synthesis of alternative modes, and that the difference between them was a matter of emphasis rather than absolute disparity.

After his move to Berlin in 1908, Pechstein's primitivism began to develop in two directions. Histories of Expressionism have emphasized his fine art activity and his development of a Western exoticism referring to Delacroix and Gauguin in paintings like *The Yellow Cloth* (see fig.71) and *Two Women in a Room* (1909).[26] But in his decorative projects, and particularly his stained glass, Pechstein also contributed to the formulation of a new 'Gothic' style which was understood as a type of indigenous, national primitivism. Like his *Brücke* associates Kirchner and Heckel, Pechstein located his images of the primitive in both urban and countryside settings, negotiating the dichotomy between modernity and nature so central to Expressionist primitivism. During the 1910 Moritzburg summer, he developed a primitivist Palau style which involved a shift away from a post-naturalist idiom to a more conceptual, symbolic mode. For example, his famous archer design for the first New Secession poster in May 1910 (see fig.152), began as a life study and ended as a symbolic and generic image of a primitivist female warrior, replete with Nietzschean associations. (see figs.151–2).

But a second aspect of Pechstein's countryside imagery presented a 'primitive' type that came closer to Nolde's rural peasant paintings. In 1909, Pechstein had sought out a more remote alternative to the whirl of Berlin city life in the fishing village of Nidden, in East Prussia. In his memoirs Pechstein stresses the isolation and inaccessibility of Nidden: when he missed the weekly ferry he had to travel with the local fishermen, a journey he undertook in the spirit of an overseas explorer: 'I was as full of hope and expectation as an explorer, on route to the New World.'[27]

Osborn's description of the summer stressed the 'primitive' status of the Nidden fishermen: 'a forgotten human settlement, whose inhabitants have maintained their life and work, the flow of time, in a state just as unaltered as the ocean . . . Pechstein identified with these primitive, unvoluble and serious companions'.[28]

Able both to identify with and to preserve a certain 'artistic' distance from the local fisherman, Osborn claimed, Pechstein was ideally suited to extract the poetry from their hardworking lives. Here we see operating once again the unconscious prejudices of social Darwinism which recur so frequently in the Nolde literature. The notion of an ahistorical and therefore 'natural' peasant community which, unlike proletarian workers, could be idealized as an unchanging and stable social force by conservative thinkers, also features in Nolde's early work. Pechstein's memoirs frequently draw on passages of Osborn's book and, thus mediated by the authority of the artist's voice, recur in more recent commentaries.[29] Pechstein's memoirs also make a connection between his working-class origins and the 'primitive' lifestyle of the Nidden fishermen in terms of his familiarity with manual labour, and the close relationship between man and nature to which he himself aspired and which he believed the fishermen to have achieved. Describing the first Nidden summer, he stressed his primary experience of nature: 'and so I experienced for the first time the eternal rhythm of the sea that intoxicated me so'.[30]

Discussions of Gauguin's Brittany and South Seas works, have acknowledged a division into 'hard and soft primitivism'[31] that recurs in Pechstein's visual and literary representations of Nidden and Palau. In Nidden he stressed man's elementary battle with the forces of nature and in Palau, his harmonious unity with

240. Max Pechstein, *Fishermen in Boat*, 1909.
Oil on canvas, 75 × 100cm. Private collection.

nature. Pechstein's memoirs describe the Nidden villagers as, 'fighting against the elements' just as they appear in *Fishermen in a Boat* (fig.240), riding a stormy sea. He translated the real historical struggles of the fishermen to earn their living into Expressionist terms: that is, into a battle with natural and elemental forces beyond historical determination.[32]

Pechstein described his return from the 1909 Nidden summer to Berlin in terms of a catalogue of primitivist associations:

I was a pretty sight. Red-brown, dark brown like an Indian, with a crude boatman's beard... I must have looked like a medieval warrior... I got through this first night in civilization with joy and pain but with more pain than joy.[33]

His identification with the Nidden fisherman relates to the Expressionist ambition to challenge the self-contained institution of art by opening it up to the practice of life. This was an important aspect of the South Seas trips too. In his memoirs Pechstein writes: 'My art, my work as fisherman's mate and the pleasure I took in this aren't to be separated...they were one and the same thing'.[34] Peter Bürger views this challenge which always related to the practices of primitivism in Expressionism, as a prerequisite for the evolution of a critical avant-garde, but once again it took place in an 'outsider' location rather than within society.[35] In Pechstein's case, a rupture between theory and practice began to emerge as the artistic fruits of this challenge were increasingly accepted by the art world. In this sense he stands in stark contrast to Nolde, whose paintings were far less easily accommodated to standards of prevailing taste.

When Pechstein returned to Nidden in the summers of 1911 and 1912, an important stylistic and thematic change occurred in his work. Although he continued to paint the village and its surroundings, his paintings of fishermen were superseded by numerous representations of his wife and model, Lotte, bathing nude in the dunes and sea. The experience of Moritzburg pervades these new canvases, although in his memoirs Pechstein insists that Nidden offered more satisfying opportunities than Moritzburg because the fishermen models were 'flesh

196

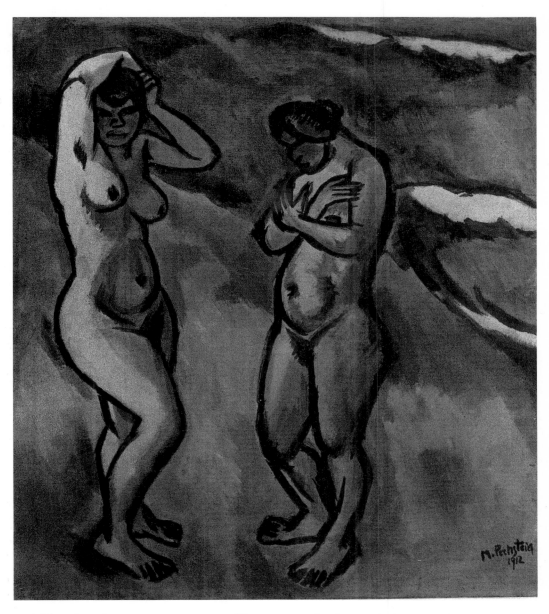

and blood and creative art in one'.[36] Increasingly, he tended to see the community in Nidden in aesthetic terms, as a work of art, rather than to rethink his artistic practice in terms of life experience.

The nude bathing subjects provided him with a new means of identifying the figure and nature, further removed from the 'civilized' trappings of dress and labour. Osborn described the nude women as fragments of nature, who 'grow like newly born creatures out of the sand and dunes',[37] anticipating Pechstein's use of Botticelli's *Birth of Venus* in his 1913 stained glass designs.[38] Pechstein attempted to articulate the space and rhythms of the landscape with the gestures and contours of the bathers' bodies, fusing the two in hot, glowing colour combinations. Cézanne and Matisse are the main stylistic influences: *Morning* (1911) refers to Matisse's *Blue Nude (Souvenir of Biskra)* (1907), while the 1912 canvases, *Three Bathers on the Coast, Two Nudes on the Beach* (fig.241), and *In the Dunes*, all echo Matisse's post-1909 bathers.[39] But there is a more general neo-Romantic mood in Pechstein's bathers, recalling Hans von Marées rather than the French avant-garde.[40] Increasingly, Pechstein moved away from straight renditions of nature to more synthetic, imaginary compositions. His sketches reveal that the source for the

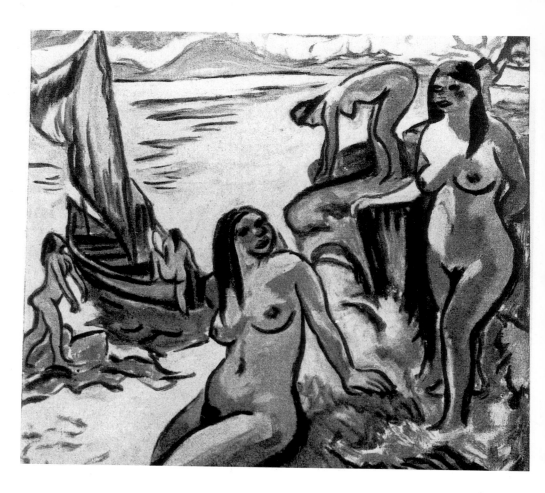

242. Max Pechstein, *Women with a Boat*, 1911. Oil on canvas. Location unknown.

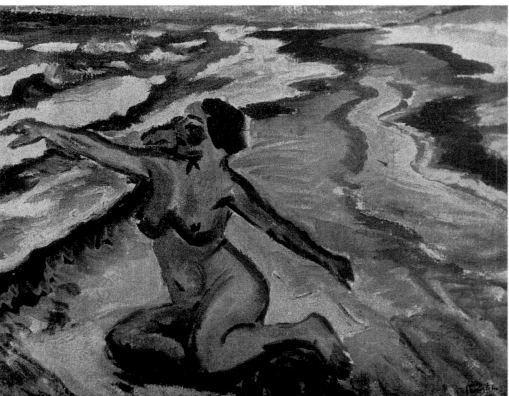

243. Max Pechstein, *On the Open Sea*, 1912. Oil on canvas. Location unknown.

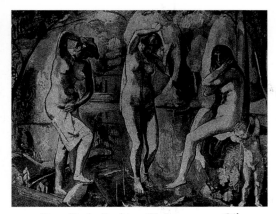

244. Kurt Tuch, *Bathing Women*, 1910. Oil on canvas. Location unknown.

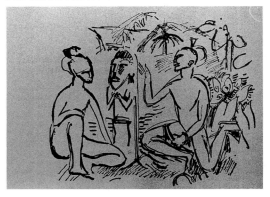

245. Max Pechstein, *The Carver of Idols*, 1914. Pen and ink. Location unknown.

compositions were life studies of Lotte moving around the coastal area. But these drawings are synthesized into group bather compositions in various poses like *Women with a Boat* (fig.242), which are repetitions and variations on a single figure and theme. Precedents for this method could be found in both modernist *and* academic art: Derain's *Les Baigneuses* (1907), or paintings like Kurt Tuch's *Bathing Women* (fig.244) which superficially 'modernizes' the academic studio nude by grafting on Secession style. In contrast to this frozen academic treatment of the subject, Pechstein's bathers avoid traditional poses by moving, dancing and bending through the dunes and waves, animated by a free and expansive spirit reminiscent of the new dance movement (fig.243). In this sense he presents us with unconventionally active images of female nudity. But at the same time these buxom nudes fulfil male fantasies about the earth mother more convincingly than primitivist females by Heckel and Kirchner. To this extent they totter even more precariously on the brink between nonconformity and a reaffirmation of sexual orthodoxy.[41]

Pechstein's shift away from nature to a more imaginative approach in the Nidden bathers was an important step in the direction of the Palau scenes. His relocation of the bather theme in the remote Nidden landscape, where he had discovered a 'rooted' rural community in 1909, also provided a synthesis of countryside modes. This was a powerful and direct precedent for his visualization of the South Seas. As Werner Timm remarks: 'One should view these journeys as a whole, as expeditions to the same interior goal. To discover a landscape that corresponded to his creed "to grasp man and nature as one".'[42]

The South Seas

Pechstein, like Nolde, spent the Second World War in 'internal exile'. Returning from Pomerania to Berlin in 1945, he found his studio bombed out and raided in the midst of a cityscape of ruins. All he had left, Reidemeister suggests, was his memories, which he wrote down in 1945–6. Published posthumously in 1960 with a selection of drawings, these memoirs now provide our main body of information about the Palau journey, the ethnographic details having been overseen and 'corrected' by Gerd Koch, a South Seas specialist at the Berlin Ethnographic Museum.[43] Like Nolde, Pechstein brought back with him a body of drawings from the South Seas, but the chaotic circumstances of their return to Germany during the 1914–18 war meant that paintings went missing (although a group of Nolde's works later resurfaced in England).[44] Both artists, on their return to Germany, set about 'remaking' their South Seas paintings. All in all we are dealing here with complex layers of historical experience; in each case a certain distance is inscribed between experience and memory, a space in which nostalgia can flourish and grow.

Leaving aside the added complication of time lapse, we should be wary of interpretations seeking to identify the artists' accounts of their journeys with ethnographic fact. In the catalogue for the 1984 MoMA Primitivism exhibition, Donald Gordon, paying scant attention to the South Seas journeys, did precisely this. Following Pechstein's memoirs too literally, Gordon claims that he 'resided...in the as yet unspoiled island of Palau'. A 1917 painting, *The Carver of Idols*, is described by Gordon as 'a virtually ethnographic document, in which we see a native, adz in hand, studying the features of another native before completing his larger-than-life sculpture' (fig.245).[45] In fact, no such 'orientalized' wooden sculpture nor methods of native production are known to have existed in Palau. Such mistakes have long since been ironed out of Gauguin scholarship, where a less naïve approach to the artist's writings has been coupled with a more thorough investigation of modes and types of native art available to Gauguin in Tahiti and the Marquesas Islands.[46] This present account of the Expressionists' South Seas journeys will make comparative reference, where possible, to contemporary ethnographic documents. But my aim is not to show, by reference to some larger body of 'objective fact', that the artists' memoirs are in some obvious sense false or distorted. Ethnographic reports, such as

those concerning the German South Seas colonies of New Guinea and Palau, are not objective accounts, but rather a second type of historical document in which values and attitudes are embedded indicating the colonial situation and imperialist power relations. By comparing these attitudes to those of the Expressionists, by exploring the differences and similarities, we are better able to situate their South Seas experiences more precisely in relation to the historical and political circumstances of imperialism.

Palau, situated in Western Micronesia, had been a German colony since 1899, when it was ceded by Spain. Pechstein's journey there began in April 1914 after a winter of protracted preparations. His official certificate of departure from the Berlin authorities forecasted an absence of over two years, and the financial backing for the trip was provided by the art dealer Wolfgang Gurlitt, with whom Pechstein signed a contract promising exclusive exhibiting rights.[47] Unlike Nolde, Pechstein did not travel overland, although he planned to do so on a future occasion. Instead, he took a six week boat trip together with his wife via Genoa, Port Said, Ceylon, India, China and the Philippines. In 1903 a second class ticket for this journey cost 1,200 marks; Pechstein's paintings by 1911 were selling for between 1,000 and 2,000 marks.[48]

In China, Pechstein was impressed by the simple, everyday, 'hand-made' goods – the sunshades, paper lamps and bamboo stools – which, although often made for tourist consumption, seemed to answer the Expressionist demand for authenticity.[49] He travelled in a steamer to Manila where he was able to buy his last supplies and petrol. This is where he first encountered the effects of European infiltration, and he recorded the contrast between the European and American hotels, clubs, houses and gardens and the small round huts occupied by Philippinos, in neutral terms in his memoirs.[50] In Hongkong, he claims to have met the general administrator of the German South Seas colonies (Dr Hahl), who sought to make him aware of the problems involved in European contact. Anxious as Hahl was to preserve the integrity of native customs, Pechstein suggests, he was worried about the arrival of an artist who might corrupt the 'innocent' Palau natives with his 'European nonsense'. Pechstein hurried to assure him of his contrary intentions, inspired by 'feelings of respect for the undesecrated unity of nature and man I was expecting to find'.[51] Departing from Manila, Pechstein 'took his leave of European civilization'. The journey on a Japanese boat to Palau was interrupted by a typhoon, which Pechstein describes as a baptism of fire separating his old and new lives.[52]

To this extent, his arrival in Angaur, the southernmost island of the Palau group, was disappointing. He found an established European colony around the German South Seas Association whom Pechstein describes as, 'certainly the only ones who had extracted money from the Palau islands'.[53] This time Pechstein assumes a more critical stance, attacking – like the socialist press – European money-grubbing and the financial exploitation of the colonies:

> On Angaur, several European employees were perched in their nicely furnished homes, with a mess and a European brimborium, which the tooth of time had already nibbled away, and houses for the coloured workers. They had aquired men from Yap, Nauru, all the possible South Seas Islands. They were made to serve two years, to excavate the open phosphorus mines and to wash the mineral which was then taken as dung to the outside world on phosphorus boats... Only one Palau village still existed on the island, a peaceful oasis in this world of greed for money and European commerce.[54]

Moving on from Angaur as soon as the opportunity arose, Pechstein travelled to the main Palau island of Baobeltaob, where the German administration was housed at Melekéiok (fig.246). At this point Pechstein's memoirs switch from a descriptive into a romantic gear and this persists until his departure from the islands. He felt himself finally free of the shackles of European civilization and to have reached 'the paradise' for which he had been longing.[55] The German administrator, Winkler,

246. Diagram of the Palau Islands, 1914.

and the resident barber/surgeon, who were both married to native women, greeted his boat in their grass shirts and invited the weary travellers to step out onto steps carved from the coral reef and enter their island paradise.

Pechstein's description of the Palau islanders follows the idealistic model of Rousseau's noble savage: he consistently emphasizes the cleanliness, dignity, humanity and gentle childishness of the natives. Most important, he represents them living in concert with nature, enjoying an effortless round of fishing, hunting, feasting, dancing and sleeping. One excerpt from his memoirs should serve to give the flavour of this account:

> I was surrounded by an unsurpassable natural lushness. Incomparably fertile growth extended everywhere, plants never before seen, palms and bread fruits rose up, bamboos and sugar beet. In this verdure huge colourful butterflies fluttered about – you could almost say that they took the place of flowers. The eternal ocean shimmered with unbelievable colours. The glowing sun threw out beams of light which Europeans would never suppose to exist. In such nature, out of such nature, the brown natives grow. Slim, bronzed beings in their godly nudity. The women wearing only little skirts, made of palm leaves or grass, around their hips.[56]

His descriptive language recalls nineteenth-century accounts of Polynesia, particularly Tahiti, such as we find in the ship journals of Antoine-Louis de Bougainville and in Pierre Loti's novels, both of whom influenced Gauguin's vision of the South Seas.[57] In 1911 a German translation of Laurids Bruun's romantic diaries, *Van Santens glückliche Zeit* (*Van Santens Happy Hours*) appeared, telling the tale of a 'European drop-out'. In fact, the Palau Islands were the subject of one of the last eighteenth-century hymns to the noble savage, at a time when the concept came under increasing attack from the evangelical quarter and reports of native aggression filtered back to Europe. George Keates' *Account of the Pelew Islands* (*1788*) which, in its popular version, *The Interesting and Affecting History of Prince Lee Boo*, ran through twenty editions from 1789 to 1850, was a romantic tale woven around the true story of Captain Wilson's friendly encounter with the Palau Islanders after the shipwreck of his boat *Antelope* in 1783. The chieftan Abba Thule and his son Lee Boo, who was sent back to Europe to be educated, were praised by Keates not so much for their physical beauty and freedom from social constraints, but rather for their good sense and good hearts, spiritual qualities which were a new departure in the image of the noble savage, and which Pechstein also emphasizes in his account. The romantic engraving of Ludee, one of Abba Thule's wives, which appeared alongside scientific drawings of Palau artefacts in Keates' book, also provides a precedent for the sentimental eroticism that characterizes Pechstein's drawings of female natives – and most other depictions of South Seas women since the eighteenth century.[58]

The friendly, gentle and 'noble' characteristics of the Palau Islanders had also been praised by Carl Semper, following his field work there in 1861–2, when he secured the famous Palau beams for the Dresden museum. His chief aid, 'Math' or Arakaluk, fostered a pro-German feeling which was of considerable importance during the takeover of the islands in 1899.[59] In contrast to the Melanesian population of New Guinea, who were traditionally associated with the 'hard' and fierce savagery so convincingly represented in Nolde's paintings, the Polynesian people of Palau were associated with the image of 'soft' and exotic South Seas Islanders. Thus, Pechstein's description of Palau engages both with an established myth and with a certain reality – the pliable Polynesian population was considered a distinct political advantage by the imperial administration seeking to establish control over the islands.[60]

In fact, the general feeling and some details of Pechstein's memoirs of Palau do not differ radically from the official information we find in colonial reports. The island landscape is generally praised for its rich, fertile beauty, although it had not yet yielded the mineral deposits which had been anticipated in 1900. Pechstein's

247. Max Pechstein, *Women Dancing, Palau*,
1914. Pencil and pen and ink. Location unknown.

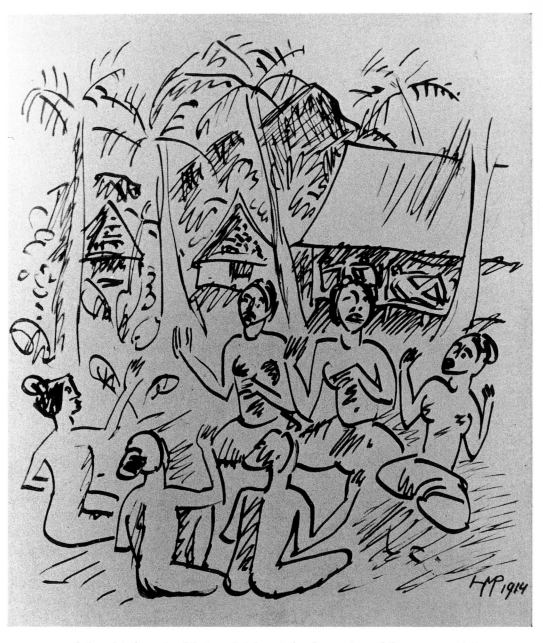

accounts of the chieftan Araklai on Malegojok, the rarity of firearms and European
clothing, the dancing style (captured in one of the South Seas sketches, fig.247),
conform more or less precisely – leaving a little space for poetic licence – to
information in contemporary journals like the *Deutsches Kolonialblatt*. Where
Pechstein's account differs from both official information and from late nineteenth-
century fictional accounts of the South Pacific by Hermann Melville and Robert
Louis Stevenson, is in his insistence on the *intactness* of his native paradise, in his
disregard for the phenomena of change and loss. His image of Palau in its pristine
conditon was more useful to him as a critical counter-image to European civilization
than the reality of Palau under the impact of colonial rule, and his journey and
experiences there were used primarily to lend validity to his own fiction.[61]
 This lies at the problematic heart of Pechstein's visual and literary representations
of Palau: the necessity of preserving his image and ideal of the 'other' against all
odds, in order to effect a general critique of the values of European society, blinded
him to a critical evaluation of colonial rule.

It must be said that Pechstein's general approbation of the colonial system was shared, as we have seen, by the Socialists after 1907 and his comments on the German administration of Palau refer also to the reforms instituted after that date. In his memoirs we read:

Thanks to the German administration everything was preserved in its pristine condition. There was nothing European around beside the two officials and the mission stationed on Babeltaob. The medical and hygeinic care of the natures was just as important here as the attempt to make Christians of the Palau Islanders.[62]

The official position regarding the 'preservation' of native customs, is aptly summarized in a report of a 1906 expedition by Sonsol and Tobi to the Palau Islands in the *Deutsches Kolonialblatt*: 'nobody will disturb your old customs – in as far as they are good ones'.[63] The decision as to whether native customs were to be preserved or discouraged depended, of course, on whether or not they were considered 'good' for European interests. Proudly, colonial reports describe administrative reforms of customs less advantageous to German interests as part of a general programme of moral improvement, and often these passages directly conflict with Pechstein's account. For example, with regard to the natives' religious beliefs, we learn in a 1905 report that 'the administration still has to reckon' with the Kalids, local witchdoctors and sorcerers, 'whose superstitions exert an influence on the population which should not be underestimated'.[64] In 1906, station-leader Winkler, who is highly praised in Pechstein's autobiography for his respect for the integrity of native society, led a punitive raid in northern Baobeltaob against the Kalids who, it seems, provoked political rather than religious objections:

The Kalids – local spiritual leaders, magicians and witch doctors who were concerned about their weakening influence – tried to sow seeds of unrest. Bravely, and despite warnings from friendly chiefs, station-leader Winkler went immediately with his small police unit to Arekolong, destroying the Kalid house he had prohibited, and taking the six trouble-makers prisoner. S.M.S. 'Condor' brought them to Yap and from then to Saipan where they might be employed in useful construction work or on the plantations and hopefully lose their magical delusions before long.[65]

The real fate of the famous Palau club houses with carved and painted beams, first discovered by *die Brücke* in the Dresden Ethnographic Museum, is another case in point. Pechstein's memoirs describe his delight in seeing the houses as part of the living texture of native life:

Wooden houses with tall, pointed gables house the natives. On these houses I now saw in the flesh, in their everyday use for which they were made, the carved and painted beams which first inspired me in Dresden and filled me with the desire to visit them in their original setting.[66]

Pechstein interpreted the Palau carvings as evidence of a primary desire for beauty, and then introduced a more abrasive note into his harmonious and sensual island paradise by suggesting, like Worringer, that the natives carved to conquer their fear of nature: 'I see the carved idols, in which trembling piety and awe before the uncontrollable forces of nature have marked their way of seeing, their fear and their subjection to unavoidable fate.'[67] In fact, the production of mens' club houses had virtually ceased after 1907, when one of the last to be made was purchased for the ethnographic museum in Berlin. Again, colonial reports make clear that political reasons lay behind the 'discouragement' of this native custom. Moral objections to native 'laziness' and 'prostitution' in the club houses barely concealed real anxieties about the decline in population, which had been flourishing at the time of German takeover in 1899. In 1907, a researcher concluded:

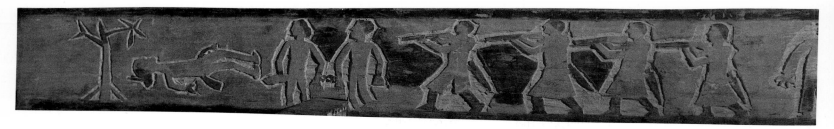

248. Palau beams, showing recent historical events, c.1907. Museum für Völkerkunde, Berlin.

You have no family life. Until recently the men lived in club houses and it was there that your young girls were ruined. Now that is forbidden for the well-being of you and your folk. The folk of Palau should become strong again numerically. You should not give your children to strangers, they should stay with their parents. You should lead a good family life and then your women will become fertile again.[68]

Such measures were well established by the time of Pechstein's arrival in Palau in 1914: already in 1906 the club houses were being used to house the local police force.[69] But Pechstein's *Palau Triptych* (1917), painted on his return to Europe, depicts his own semi-religious evocation of traditional native life: fishing, feasting and bathing, alongside the carved houses.[70] Although his 1914 drawings are usually translated quite directly into these retrospective paintings, in this case the baby is added to the arms of the loving couple in the left-hand panel, reaffirming the Western ideal of family life which had proven politically as well as morally viable in the administration of Palau.

More than anything, this work depicts an exotic synthesis of Pechstein's own Moritzburg and Nidden experiences of bathing and fishing, although the subject and style of the painting, in a somewhat facile way, refer back to the Palau beams. Even in these terms, Pechstein's depiction of island life is 'outdated'. In the Palau club house in the Berlin Ethnographic Museum, for example, on display during the first decade of the century, traditional mythological subjects relating to fishing and hunting scenes appeared alongside carved depictions of more recent events: the beams also show Europeans shooting at a native community, a European mission, and even a European photographer (fig.248).[71] Such subjects, which reflected the changing historical reality of Palau under the impact of colonial rule, had no place in Pechstein's mythology of the island. His desire for an ahistorical *primitive* ideal, to act as a counter-image to the ruptures of historical change at home, precluded a response to the altering circumstances of the natives. Having no use for their history, he simply ignored it.

One of the most important features of Palau for Pechstein, was the ideal of brotherhood and community, and the anti-capitalist organization of society he claimed to have found there. In Pechstein's description of native life, as Osborn commented, 'life and labour do not exist side by side like foreign or opposing elements. They are one entity and flow into each other.'[72] Pechstein constantly stressed communal village participation in working projects, which were always celebrated by feasting and dancing. He records his refusal of a gift of pearls from a native: 'Because I didn't know what to do with it, I didn't take it. Because I wasn't interested in possessing things that are only valuable for Europeans. I didn't need money any more to live. Also I hoped not to have to go back to Europe since I had found this paradise.'[73] This passage relates to Pechstein's subsequent political stance in the 1920s, although it has its roots, obviously, in an Expressionist consciousness. As we have seen, the main socialist objections to imperial policy were aimed at capitalist exploitation of the colonies. There is, of course, evidence to contradict Pechstein's idealistic description of community relations in colonial reports which, like the bourgeois satirical journals, often stress the sharp business instincts of the natives. Certainly, in comparison to New Guinea, Palau was relatively unexploited commercially, although private trading companies had long since established them-

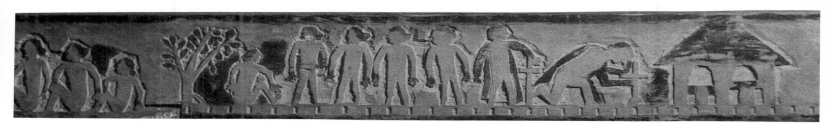

selves on the islands. The absence of expected mineral reserves meant that small-scale kopra production, pearl farming and coffee and cocoa plantations were the main areas of commercial activity. Native land rights were well protected and Pechstein had to buy the small island he planned to settle on before the Japanese claimed Palau in 1914.[74] But the notion of a 'natural' community spirit, so central to Pechstein's account, seems to have little basis in fact. A 1902 report in the *Deutsches Kolonialblatt*, suggested that:

> The reason for the sparse production in this group of islands, which are much more fertile than Yap, is the deep-rooted state of misfortune whereby the rich can exploit the poor. A marked plutocracy rules in Palau. Everywhere I got the same answer to my enquiries from the average Palau man. Why should I bother to plant or fish more? If I get more than I need, more powerful men take it away from me.[75]

There is a certain bitter irony in the fact that the German authorities in Palau discouraged the plutrocratic system in order to assure higher production levels for European export.

Pechstein's description of financial and social relations in Palau relate, once again, not to an experienced reality, but rather to a set of aspirations intimately bound up with his membership of *die Brücke* and the 'alternative' strategies the group had formulated in response to the conditions of their times. These aspirations had run aground with Pechstein's departure from *die Brücke* in 1912. The contract Pechstein made with Gurlitt in order to finance his South Seas odyssey was precisely the type of arrangement the *Brücke* community had sought to avoid. Even Pech-

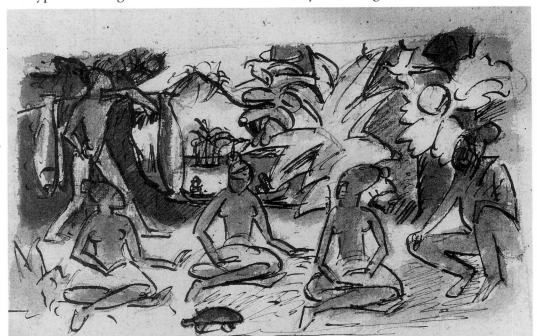

249. Max Pechstein, *Four Women Seated in front of a Tortoise Palau*, 1914. Pencil, pen and ink, watercolour, 12.7 × 16.3cm. Staatliche Kunstsammlungen Dresden, Kupferstichkabinett.

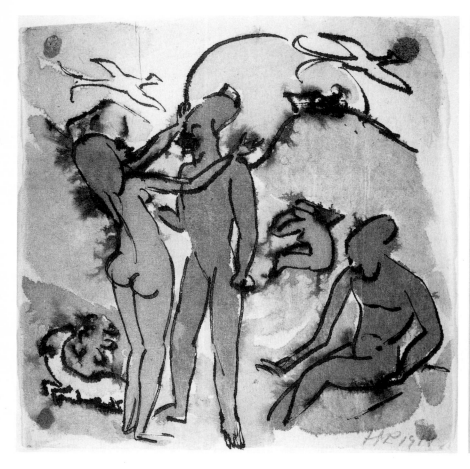

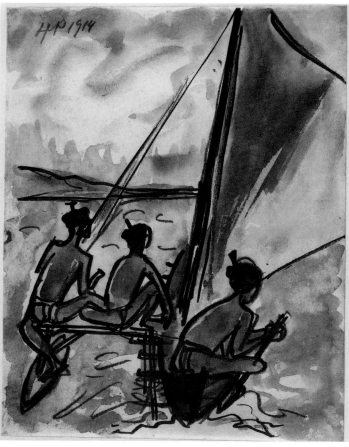

250. Max Pechstein, *Bathing Scene with Navigating Birds*, Palau, 1914. Watercolour, 17 × 16.5cm. Brücke-Museum, Berlin.

251. Max Pechstein, *In the Scouting Boat*, Palau, 1914. Pencil, watercolour, pen and ink, 16.3 × 12.5cm. Staatliche Kunstsammlungen Dresden, Kupferstichkabinett.

253. (*facing page top*) Max Pechstein, *Fishermen, Palau*, 1914. Pencil, pen and ink. Location unknown.

252. Max Pechstein, *Colombo, Ceylon*, 1914. Pen and ink. Location unknown.

stein's description of the native Arclay working on his sculpture – an action he initially baulks at, and which does indeed disrupt the 'authentic' one-to-one relationship between producer and product – harks back to the early *Brücke* days and their short-lived communal sketchbook, *Odi Profanum*. The strength and persistance of Pechstein's myth of Palau must be seen in direct relation to the loss of a real platform for his critical and reformative ideals in 1912. Describing his Palau paintings in 1949, Pechstein suggested: 'I think they arose out of a certain nostalgia for something that couldn't be recovered.'[76] The Palau experience was more than anything for Pechstein an attempt to resolve a contradiction, to fill a gap, between the theory and practice of his critical ideals. His own sense of loss at this stage eclipsed any response he may have had to the historical changes imposed by colonial rule on his native friends. It is for this reason, rather than simple naïvety – although this is not to be totally discounted – that Pechstein's Palau works tend to be one-dimensional, unconvincing images.

Gauguin's South Seas paintings provided an important precedent for the visual idealization of native life, but Pechstein, we should remember, insisted on the primacy of experience, validated by his diaries and sketches. Romantic images of cavorting natives, like *Bathing Scene with Navigating Birds* (fig.250), where Pechstein uses a surprisingly Nolde-like technique, laying in washes of watercolour on damp paper into which the black ink bleeds, were apparently made direct from nature. Drawings such as *In the Scouting Boat* (fig.251) stand in closer relation to experienced reality. This rough pencil sketch, which has been reworked in pen, ink and watercolour, shows a convincing representation of a Palau boat, like the one Semper had collected for the Dresden museum, and the posture of the native sailors is also well observed. But many of the Palau scenes are visualized

206

254. Max Pechstein, *Dancers, c.* 1910. Pen and ink, watercolour, 16.5 × 17.6cm. Staatliche Museen zu Berlin, Kupferstichkabinett.

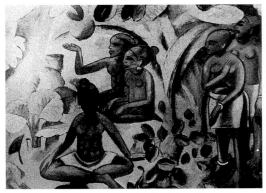

255. Max Pechstein, *At the Bathing Ground, Palau,* 1917. Oil on canvas. Location unknown.

256. Max Pechstein, *A Mosaic for the art dealer Fritz Gurlitt: The Expulsion from Paradise,* 1917 (detail). Destroyed.

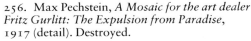

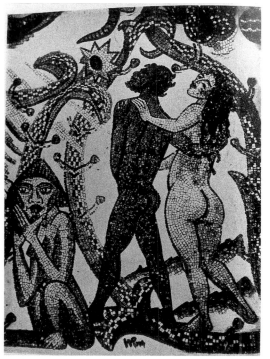

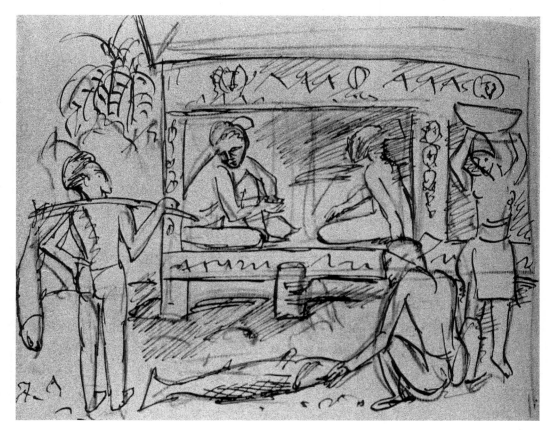

in terms remarkably close to the drawings of exotic cabaret acts by Pechstein and the other *Brücke* artists, for example, figs.247 and 252, although the former is an accurate rendition of a native dance. Sometimes the scenes are compressed into box-like spaces (fig.253) with theatrical associations, and are particularly reminiscent of Pechstein's earlier drawings of exotic performers. It is this tendency to 'stage' his compositions, even when sketching directly from nature, that distances the drawings from reality and recasts Palau life as a kind of spectacle. Fig.254, a pencil sketch on rough hand-made paper, like the drawing of native sailors, has been worked over subsequently with watercolour and pen and ink, suggesting that Pechstein returned to these drawings in the studio and reworked his initial sketches. But no radical changes to the motif itself are evident.[77]

Sometimes it seems that Pechstein actually saw the Palau islanders in exotic Gauguinesque terms. For example, his drawing of native carvers (fig.245) shows them working on an idol far closer to Gauguin's exotic Tikis (e.g. *There is the Marae,* 1892) than the wooden figures they traditionally carved to decorate the gables of their club houses. As this practice was virtually unknown in 1914, Pechstein apparently invented a Gauguinesque scene, or elaborated imaginatively on some experienced event, which he then reproduced in his painting *The Carver of Idols* (1917). The romantic nature of Pechstein's 'on the spot' sketches explains why they could be translated so directly into his nostalgic retrospective paintings of Palau life.[78] A single and relatively naturalistic landscape is the only oil painting known to survive from the trip itself.

Despite Osborn's claims to the contrary, many of the 1917 paintings refer to Gauguin.[79] The evocative space, mood and figure style of *At The Bathing Ground* (fig.255), come close to Gauguin's exotic effects, while Pechstein's mosaic decoration for Gurlitt, *Expulsion from Eden* (fig.256), which refers metaphorically to his own untimely expulsion from Palau in 1914, recalls the composition and

257. Max Pechstein, *Anchell, Palau*,
1917. Oil on canvas. Location unknown.

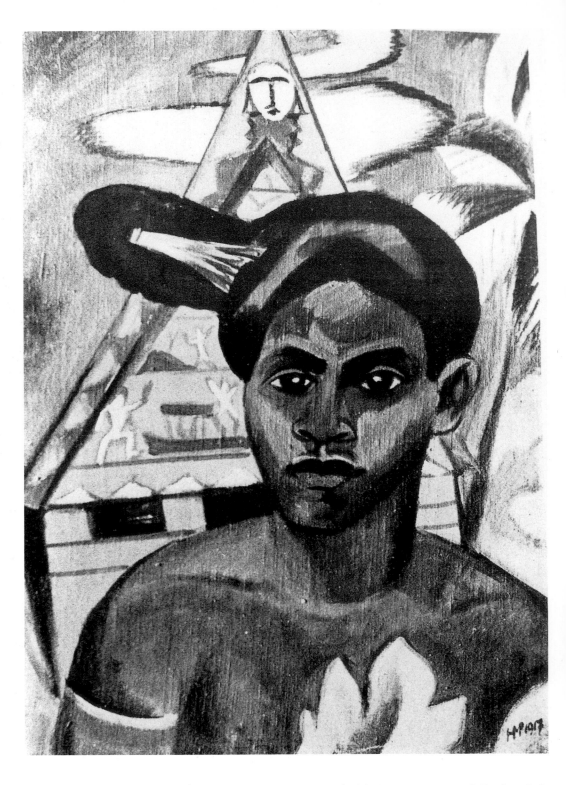

some figurative details of Gauguin's monumental *D'où venons-nous?* Pechstein's portrait of *Anchell*, his native boy (fig.257), is a richer, more successful painting recalling Gauguin's *Les Ancêtres de Tehamana* (fig.258). Gauguin's portrait of his young native mistress in a missionary dress, juxtaposed to a background of Easter Island pictograms and a voluptuous Hindu-like nude carving (representing Gauguin's imaginary exotic Eve), reflects his awareness of the fissure between imagination and experience, between myth and history, in the changing colonial environment

258. Paul Gauguin, *Marahi Metua no Tehamana. Les ancêtres de Tehamana*, 1893. Oil on canvas, 76.3 × 54.3cm. Art Institute of Chicago.

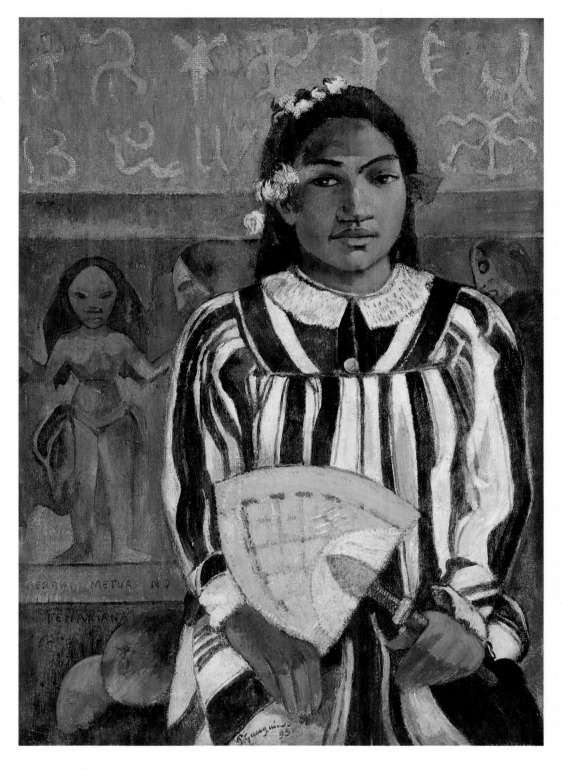

of Tahiti.[80] By way of contrast, Pechstein, quite typically, provides us with a synthesis of these different levels of experience. Possibly the melancholy and pensive expression on the boy's face rendered like a girl's, suggests an awareness of his vanishing culture, signified by the Palau club house behind him. But if we compare this painting to Kirchner's similar composition, *Fränzi in front of a Carved Stool* (see fig.98), we find that it is relatively shallow in terms of its associations and potential meanings. Whereas Kirchner sets up a rich network of contrast and analogy between

259. Max Pechstein, *In the Bordel, Palau*, 1917. Oil on canvas. Location unknown.

the carved primitivist chair and the seated girl, Pechstein's image presents a single, direct analogy between the Palau boy-girl and the house behind – he is indeed a living version of the female gable sculptures which traditionally decorated the mens' club houses (see fig.119).

In the Bordel, Palau (fig.259) shows an imaginary rendition of life inside the mens' club houses where the villagers experienced their sexual initiation. The cameroon stool, which features first in Pechstein's 1913 *Grey Still Life*, could be read as a sign that this primitivist space is an imaginary, synthetic arena into which Pechstein is free to project his fantasies, rather than a factual or historical location. Osborn saw the references to Indian, Egyptian and Far Eastern art which occur in the 1917 Palau paintings (often via Gauguin), as a sign of Pechstein's freedom from 'irrelevant' ethnographic detail:

> The pictures are thus all the less in danger of descending somehow or other into interesting realistic detail. They rise all the more majestically above the level of reality to become symbolic representations of primal life, painterly confessions. All the more purely the subject dissolves in an artistic construction of colours and lines.[81]

The remaining anomaly of Pechstein's actual physical journey to Palau testifies more than anything to the fine line in Expressionist practice between their aspiration to transform art into life and their tendency to transform, on the contrary, life into art. This is an important point because it is the crux of Peter Bürger's differentiation between the avant-garde and modernism. The transformation of art into life praxis is for him characteristic of a revolutionary avant-garde, attacking the institution of art and so challenging the modernists' retreat from life into aesthetic isolation.[82] Pechstein's South Seas journey, as Osborn accurately observed, ended as a modernist venture, a transformation of experience into art, even if it began under the impetus of the opposite, avant-gardist intention to extend the boundaries of art into life. As so often in Expressionist primitivism, Pechstein's South Seas journey operates in the contradictory space between these two alternatives, between revolution

210

and reconciliation. But finally the South Seas odyssey comes down on the side of modernist aestheticism: Pechstein rendered historical experience, including his own journey, as art.

One further episode is worthy of mention. In October 1914, Pechstein's idyll was ruptured by the arrival of Japanese troops in Palau, and after a period of internment in Nagasaki he travelled to America via Manila, Shanghai and Honolulu. As soon as he left the islands his critical faculties returned, and his comments about Honolulu in particular condemn, interestingly, both the influx of Western civilization and the attempts of Europeans to 'go native' in the style of Gustav Landauer.[83] The hardships of Pechstein's journey back to Germany, where he volunteered for active service, are not to be made light of; he finally worked his passage as a stoker on an Dutch ship. It was here that Pechstein encountered proletarian labour face to face, and he described the appalling conditions on board and meagre wages in an article he wrote for the *Vossische Zeitung* on his return as 'a slave's existence,' adding that in America 'only coloured or broken or highly dubious peoples usually allow themselves to be paid these wages'.[84]

Amongst these coloured workers, Pechstein felt himself far less at ease than in Palau, having lost temporarily his own position of dominance and power. He found it necessary to hide his possessions and the secret of his nationality, as rewards were offered for the surrender of German nationals working their passage home. He described his fellow workers in the following terms: 'Their manners were certainly very primal, but not so easy to imitate. I had to forget various unsuitable prejudices and habits like the use of a handkerchief, in whose place the finger was considered the right thing here. . .'[85] Once again, and of course understandably, the 'primitive' in immediate proximity was far less acceptable than the image, the ideal, that can be kept at arms length and admired from a distance. Pechstein's experiences of social injustice during the war years were one of a complex of factors that guided him towards political action in the post-war, left-wing artists' organizations, primarily in the *Novembergruppe*. But the visionary political ideals he evolved with his artist friends in this organization related more closely to his idealistic and imaginary notions of Palau society than they did to his experiences in the intervening period. Aboard his Dutch ship, in the engine room, Pechstein survived the ordeals of physical labour by imagining, 'a row of images, which contrasted as strongly as possible with my actual surroundings: a forest glade, a meadow lit by the sun, and other such things'.[86] This habit of correlative thinking in an escapist mode had its time and its place; it helped Pechstein to sustain his determination to return home. But it proved a flimsy basis on which to build a platform for effective political action. In 1933, Pechstein's failure to grasp the realities of the colonial situation of 1914, became associated with another political lapse. In a letter he wrote to the artist Arthur Kampf defending himself against Nazi attacks, he described his Palau drawings as 'an expression of a pure, ideal attitude to the old German colonial power'.[87]

11 Emil Nolde's Critique of Colonialism

You build wagons so that you can carry coal, and you carry coal in order to build wagons. Business, traffic, smoke, noise and progress – what the Wasungu call 'culture' – is then underway.[1]

EMIL NOLDE'S journey to New Guinea differs from Max Pechstein's to Palau in several important ways, relating both to the artists and to the different characteristics and associations of their South Seas Islands. Nolde's journey from the outset was seen as an interlude, an episode with temporal boundaries, and he planned to return to Europe after one year. He accompanied an official expedition to German New Guinea, which was a major centre of imperial commercial activity and whose large population was known for its fierce resistance to European domination rather than 'peaceful' cooperation. Nolde, as we shall see, was a harsh critic of European colonization and he did not, like Pechstein, turn a blind eye to the changes wrought by imperial rule on native society. But, like Pechstein, his image of that society was in many ways idealized, engaging with the tradition of the romantic rather than the noble savage. His awareness of the fissure between the ideal and reality was, like Gauguin's, more acute than Pechstein's. and to this extent his vision of the South Seas was richer and more complex. But he too fantasized about a timeless, and therefore 'primitive' and ahistorical, native lifestyle as a counter-image to the negative effects of European civilization. In this the conservative and left-wing branches of Expressionism coincide. For Nolde, the natives of New Guinea had a history, but it was a history solely dependent upon European contact: left to themselves, he supposed, they would have remained timeless and eternal like surrounding nature.

Nolde, like Pechstein, approached his South Seas adventure in the light of previous European experiences, and with a primitivist consciousness which, as we have seen, spanned between the 'volkish' conservative implications of the term and the rebellious anti-historicism of the avant-garde. His earliest encounter with non-European art in the flesh was almost certainly in the context of the 1900 World Fair in Paris. There was much here to stimulate later travel plans: the vast colonial exhibition at the Trocadéro included native villages, palaces, temples, bazaars and thatched huts.[2] Japanese, Chinese and Russian pavilions were featured, the latter presenting a display about the Trans-Siberian railway. There were theatres, panoramas and native dancers to bring alive the spirit of far-off lands, and sections devoted to Oceania and the German colonies in Africa. Nolde recorded his visit to the World Fair, and recalled in his autobiography how he and his St Gallen friend, Hans Fehr, first began to dream in Paris of a journey to the antipodes.[3] The native art Nolde could have seen here (there was for example a large selection of 'objects

260. Emil Nolde, *The Missionary*, 1912. Oil on canvas, 79 × 65.5 cm. Private collection.

and fetishes' in the Dahomey pavilion[4]), was presented in the context of popular colonial propaganda rather than in the scientific environment of the ethnographic museum. In fact, the whole event provided an opportunity to dress up imperial ambitions in a popular and adventurous guise: the sections on administrative, political, commercial and educational programmes were absorbed into the wider spectacle. But Nolde, during the early years of the century, seems to have developed a critical attitude to colonialism. In the 1907 elections, he supported the Social Democrats' attack on imperial policy, and his correspondence with Ada at this time shows real disappointment at the defeat of the Socialists.[5]

By 1912, Nolde had apparently evolved a particularly negative opinion of missionary activity in native communities. As a boy he considered becoming a missionary,[6] but his complex religious musings around 1909 involved doubts about the absolute validity of Christianity.[7] His 1912 still-life painting *The Missionary* (fig.260) is usually interpreted as a condemnation of missionary activity in that the grotesquely masked Man of God is trying to divert the Yoruba native woman and her child from their own religious practices, symbolized by the East African mask behind.[8] This still life is unusual, partly because the missionary's mask is used in true Ensoresque fashion to reveal grotesque intentions behind the facade of his humanism. The symbolic narrative Nolde constructs by placing the tribal artefacts in a theatrical confrontation encourages a more specific reading than his usual non-narrative groupings. Nolde's celebration of the pagan and intuitive roots of religious emotion in paintings like *Dance around the Golden Calf* (1910) and *Candle Dancers* (1912) goes some way towards explaining his attack on the 'civilizing' dogmas of world Christianity. But there is a certain irony in his singling out missionary activity for particular criticism. For Nolde's own subsequent image of South Seas natives as fierce, awesome beings, relates to missionary depictions of 'ignoble' savagery, which countered the prevalent notion of the noble savage at the end of the eighteenth century, and, by the mid-nineteenth century, had passed down into popular consciousness. Nolde's autobiography recorded his boyhood enthusiasm for Stanley and Livingstone, and it was in boys' adventure stories that the ferocious savage — with glaring eyes, arched brows and bared teeth, as he appears for example in *The Death of Cook*, from an 1874 edition of Cook's Travels (fig.261) — became a popular feature. Missionary influence on popular publications also encouraged illustrations of native art which exaggerated grotesque aspects, just as Nolde does himself in his missionary figure.[9] To this extent the painting and Nolde's subsequent attitudes to South Seas natives, are more complex than usually supposed. Typically, we find that his critical commentary also contains affirmative references to the values and codes inscribed in the institution under attack.

Nolde's *The Missionary* has also been interpreted as an early visual example of his theories of racial purity. Manfred Schneckenburger suggests that Nolde's choice of a Korean road god for the missionary figure relates to the fact that the demon stems from a mixed racial culture.[10] If this theory is accepted, the complexity of the painting grows because Nolde's attack on cultural imperialism would in this case be phrased in terms relating first and foremost to his conservative and 'proto-fascist' notions of racial purity. Ettlinger suggested that it was solely on racial grounds that Nolde objects to colonialism because of his desire to preserve racial difference in a pure, unsullied state: 'To Nolde the primitive was a paragon of pure race, drawing strength for his art from blood and soil. His was a last and false step in a regression to that innocence which had haunted the imagination of artists' since the nineteenth century.'[11] Ettlinger's argument refers primarily to comments in the 1934 edition of *Jahre der Kämpfe*, which contains Nolde's most virulent racist statements, and, in the retrospective chronology of the autobiography, suggests that his attitudes to race were formulated before his departure for the South Seas. These views were condoned by the historical moment and relate both to Nolde' attempt to defend the 'Germanic' integrity of his art in 1934 and to his sympathy for aspects of Nazi ideology, which, as Robert Pois points out 'represented the aspirations and the hatreds of all of

261. *The Death of Cook*, engraving from Cook's *Voyages* (ed. John Barrow 1874).

those who were unable to assimilate modernity or deal with the immense problems created by urbanization and mechnanization'.[12] As we have seen, Nolde's blatant anti-semitic remarks, for example his comments on British Jews,[13] were removed or modified in the posthumous editions of *Jahre der Kämpfe*. But his more general statements about racial 'integrity' remain. For example, his insistence that race should be taken into account in our judgement of art:

> ...it may well be that seen from a broader perspective no one race is any better or any worse than another. Before God they are all equal – but they are different, very different in their stage of development, in their life, their customs, appearance, smell and colour. And it is certainly not in Nature's scheme that they should mix with one another. Races *en masse* don't like each other, at best they achieve mutual respect. Assyrians, Egyptians, Greeks, Chinese, Hindus – their works of art are all gloriously different; those of the old Italians, Germans, Spanish and French too. Mixtures alone are hermaphrodite.[14]

But is it not historically dubious – rather than entirely false – to explain Nolde's pre-1914 works in terms of these defensive statements from the 1930s, written when he was a member of the Nazi party? As Georg Mosse and Uriel Tal point out, racial, rather than religious anti-semitism which favoured assimilation, was a rare phenomenon before 1914, although it had its roots in the 1870s.[15] Examples can be found in literature, for example in Arthur Disler's notorious *Die Sünde wieder das Blut* (1912; *Sins Against the Blood*). Carl Hauptmann, Nolde's friend,[16] wrote *Israel Friedmann* in 1913, in which mixed race is blamed for a lack of solidity of character and steady application to work. Nolde's triptych *St Mary of Egypt* (1912) depicts the famous conversion of a Jewish prostitute to 'spiritual' Christianity, and Bradley is wrong to try to identify Nolde's work completely with Langbehn's hard-line view, which sought to separate a 'Germanic' Christianity entirely from its Judaic roots.[17] But Nolde's later comments concerning his religious paintings do suggest a confused engagement with the discussions about race which characterized religious revivalism in radical conservative circles before 1914.

In *The Life of Christ* (1912) Nolde sustained a contrast between the red-blonde figure of Christ and the dark-haired Jewish characters who populate the stage of his life. As a baby in Mary's arms he is little more than a blond ball of light which gathers force and momentum to climax in the transfiguration scene, bottom right of the central crucifixion. In his 1934 autobiography, Nolde explained the rejection of this polyptych by the Catholic Church at the World Exhibition in Brussels in 1912 as a reaction against his unconventional representation of Jewish types: 'Christ and the Apostles too, exactly how they were, the Apostles as simple Jewish country folk and fishermen'. Nolde proposed his own solution as a kind of 'ethnographic' accuracy, intended to stem the tide of cultural relativism which results from multiple ethno-centricities: 'Where does that lead to? If we want to see biblical figures represented as Arians, shouldn't the Chinese Christians be allowed to show them as Chinese, the negroes to show them as blacks?'[18] As if bewildered by the open floodgates of cultural relativism which, as we have seen, Nolde was beginning to explore in his responses to non-European art in 1911 and 1912, he searched once again for absolute certainties, for a kind of bottom line on which to rest his convictions. This search for absolute values in the shifting, relativist, modern age made Nolde increasingly suspicious of what he termed, 'mixture...in between paths that I despised'.[19] In his 1934 text, he came to identify art with this 'bottom line', visualizing aesthetic experience in a classic modernist vein as a kind of absolute, eternal truth beyond the vicissitudes of historical change, and thus offering a way out of a bewildering web of conflicting sentiments: 'Not a soul today still believes in the religions of the Assyrians, the Egyptians, the Greeks. These races are used up, mixed, spoilt. Only their art, where it was beautiful, stands proud and exalted beyond the call of time.'[20]

Our task as historians is not to try to resolve the contradictions in Nolde's

262. 'The Black and White Monarchs', *BIZ*, April 1911.

thought, which we shall find recurring in his statements about native peoples. Rather we must explore the extent to which such confusion helps us to understand Nolde's art and the issues of his times. The danger of reading back statements from the 1930s into his pre-1914 activities must be avoided when possible, because by that time the same issues were less finely cut and the contradictions more coarsely grained. Apparently sophisticated analyses of individual works, like the 'mixed race' theory concerning the Korean road god in *The Missionary*, may for this very reason be cruder than the simple explanation that Nolde found the grotesque appearance of the demon suitable for his painting.[21]

In Nolde's 1912 notes, *Die Kunstäußerungen der Naturvölker*, there is no overt mention of racist issues. The distinction he makes between northern and southern art, which Pois reads as a sign of nascent racism,[22] is closer to Worringer's anti-materialistic interpretation of the 'Gothic' than it is to Vinnen's obsession with national identity: worldly artists on the merry-go-round of their times, 'creating art for "Popes and Palaces", are contrasted by Nolde to the anonymous, "spiritual" sculptors of Naumberg, Magdeburg and Bamberg.'[23] But in Nolde's 1934 additions to these notes, racial issues feature prominently. By then he spoke of the southern threat to northern identity. He also condemned superficial imitation of tribal art and travel for travel's sake, and continued:

> Every strong artist, wherever he may be working, gives his art the stamp of his own personality and race. What a talented Japanese paints is Japanese art, what a German artist with a strong character creates will be German art, whether it was done near to home or in the farthest reaches of the world. What weaklings do, swaying this way and that, results in a shallow mixture.[24]

The cult of racial purity was propounded in 1934 as a reason for Nolde's interest in the South Seas natives and for his ambition, 'to become acquainted with some original people and nature absolutely untouched by civilization...the original strength of these children of nature carries the seed of the future, only shallow decadence will die out.'[25] Nolde praised the 'manly' purity of native art, which 'has nothing to do with women or children', and concluded: 'My joy was the absolute, pure and strong, wherever I could find it – from the most primitive tribal and folk art to the highest vehicles of free and most developed beauty. I didn't like double-sidedness – be it Chinese-Greek, exotic-Arian, Japanese-European or French-German. All this is plain cultural decadence.'[26]

Nolde's sinister affirmative denial of the evolutionary code here, in order to justify his interest in tribal art, goes beyond any comparative strategies in *Brücke* art. Whereas *die Brücke* inverted the values of evolutionary thought without upsetting the traditional link between natives, women and children, Nolde reaffirmed the values of social Darwinism at the same time as he lifted 'primitive' art, by implication, from its inferior rung on the ladder onto the level of German cultural achievement. Is this less or more revolutionary? Less or more disruptive of nineteenth-century values? The answer is surely yes – and no. In his very act of conforming to the racist precepts of Nazi ideology, Nolde's positive evaluation of non-European art directly contradicted their cultural policies. Our task now is to enquire whether such views shaped or – at least in part – were structured by his South Seas experiences.

Emil and Ada Nolde set out for German New Guinea in October 1914. During the previous months Nolde had been reading Norse sagas and his autobiography compares the 'heroic' spirit of his own journey to ancient Norse expeditions in search of unknown lands, seas and peoples.[27] In fact, the Noldes accompanied a medical-demographic expedition sent by the Imperial Colonial Office to the Bismarck Archipelago to investigate health conditions and population decline. Nolde and Hans Fehr both suggest that Nolde was employed as an official draughtsman to record racial characteristics for the demographic section of the expedition,[28] but this is most unlikely. By 1910, ethnographic reports almost exclusively used

263. Fritz Nansen, 'Hair-styles of the Fulbe Women', *Koloniale Rundschau*, 1911.

264. Emil Nolde, *Portrait (Dr Leber)*, 1912. Woodcut, 26.5 × 19.5cm. Sammlung der Nolde-Stiftung Seebüll.

photographic illustrations, and any rare exceptions to this rule, such as Fritz Nansen's illustrations of native hairstyles in the 1911 *Kolonial Rundschau* (fig.263), or those in Alfred Wünsche's school textbook *Die deutsche Kolonien* (1912), were in a diagramatic or conservative illustrative style. Certainly Nolde had to finance his own trip, partly with money raised from the sale of his 1904 painting *Farmers* to the Berlin banker Arnthal (whose niece Gertrude accompanied the expedition as a nurse), and partly with bank loans.[29] In 1914 Nolde returned to Germany with debts amounting to 10,000 marks.[30] During the war Osthaus arranged an exhibition of the South Seas watercolours in the Folkwang Museum, and fifty drawings of native heads were purchased by a small group of supporters – including the former governor in German New Guinea, Alfred Hahl – and donated to the Colonial Office which was abolished in 1918. This is as 'official' as the drawings ever got.[31]

The Noldes' companions on the expedition, aside from Gertrude Arnthal, included Professor Külz, a doctor of tropical medicine working previously in the African colonies, and Professor Leber from the University of Göttingen who had already made field trips to Samoa. Archive records in Potsdam make clear that Leber arranged for Nolde' passage and guaranteed the necessary loans.[32] He is described in the autobiography as a supporter of Nolde's art,[33] and in 1912 Nolde executed a woodcut portrait of Leber (fig.264).

The expedition travelled overland to New Guinea via Russia, Korea, Japan and China. During his journey Nolde sketched and enjoyed purchasing items for his own collection of 'authentic' objects.[34] Nolde's letters home during the journey show him to have been very much occupied with the issues we have seen operating in his 'ethnographic' still lifes. Primarily he responded to the 'authenticity' of exotic goods in contrast to mass-produced European objects, which he witnessed overunning the native markets. In November 1913 he reported:

> Dear friend. . .it is disturbing to see how whole countries here are swamped by the worst European consumer goods, from petrol lamps to the commonest cottons, coloured with most artificial plastic colours. The best, good raw materials go to Europe and come back as the cheapest-made goods which displace the excellent local products. Our good Germany contributes its own good part to this ghastly situation – but the import and export figures at home are rising fast, and profits collect in Berlin, Hamburg and in the industrial provinces.[35]

It is in these terms, rather than according to a philosophy of racial purity, that Nolde criticized colonial activity in 1913. That is to say in anti-capitalist terms, set, like the socialist minority, against material exploitation of the colonies – and thus in the spirit of his 1907 vote. In a second letter, dated December 1913, he continues:

> Foreign cultural states operate in China exactly like the usurer with his debtor. Every effort is made to lend China money in order to get land, concessions, mines, customs rates, railway constructions etc from China. First just as a guarantee, then the rope is tightened and they become possessions. Many greedy hands are reaching their greedy fingers ever deeper into the country.[36]

Only in 1936, when Nolde added his comments to these early letters in *Welt und Heimat*, do references to racial difference appear. In 1913, when he accused Japan of exploiting China, he actually described Japan as 'the Germany of the East'[37], as indeed it was in terms of its dramatic modernization and speedy economic and industrial growth at the beginning of the century. By 1936, this comparison was dropped in favour of a distinction between the superficial 'civilization' of Japan, drawing its technology from Europe and its culture from China, and the strange, foreign 'culture' of China, 'its great culture and art, it's poetry and huge, deep ancient wisdom'.[38] Thus Nolde introduced volkish differentiations in place of the political and historical analogies of 1913.

We must also precede cautiously in applying Nolde's 1930s statements blindly to earlier visual representations of his journey. In his 1934 additions to the

265. Emil Nolde, *Javanese Dancers*, 1913.
Watercolour, 31.1 × 25.7cm. Sammlung der
Nolde-Stiftung Seebüll.

Kunstäußerungen...in *Jahre der Kämpfe*, he claimed in the light of his philosophy
of racial difference, that no direct influence of non-European art is to be found in his
own, indelibly 'Germanic' oeuvre – a judgement frequently repeated in the second-
ary literature. However, an important stylistic shift did occur during the journey to
New Guinea and this must also make us wary about the relevance of Nolde's later
racial analysis of his own art. Nolde's drawings of Russians and Siberians on railway
platforms prefigure the study of type and the experimental groupings of figures
which characterize his drawings of South Seas natives. But stylistically they are quite
different, executed in a tight, scribbling pen-and-ink line, reminiscent of Alfred
Kubin's drawings, sometimes over watercolour washes. It was in the East that
Nolde's characteristic South Seas drawing style emerged, featuring vivid washes of
colour and sweeping, reductive contours in brush and ink, such as we see in his
sketches of Japanese and Chinese boats. To some extent, these drawings remake
the Hamburg Harbour scenes of 1910 in an Eastern mode, and characteristically
Nolde achieves an extraordinary range of variation with very limited means. But it
would also seem that oriental calligraphy had some influence on this free, fluid
and reductive drawing style which, as we shall see, was used by Nolde to achieve
hieroglyphic effects. His drawings of Japanese actors were often made on local
papers decorated with Japanese characters, and his watercolour sketch of a dancer in
green and violet (fig.265), makes the influence of oriental calligraphy very obvious.
Usually this influence is less direct, more subtle; and certainly Nolde's 1913
drawings relate to his drawing style before the South Seas journey, for example, in
the Berlin scenes. But to discount Oriental influence entirely is to read his later
comments too literally. The stylistic influence of tribal artefacts on his broad and
planar painting style had already taken effect by 1912, and this was simply extended
to his South Seas subjects.

Like Pechstein, Nolde travelled via Manila to the South Seas islands, pausing
briefly on Yap, south of Palau, and landing eventually in Friedrich-Wilhelmshafen,
the administrative centre of German New Guinea. He, too, was repelled by the
rampant Europeanization: 'There were only official German buildings', he wrote
in his autobiography, 'cultivated and European'.[39] But there were also important
differences from Pechstein's experiences, which militated against the formulation
of a second romantic idyll of the South Seas. Most important, New Guinea, unlike
Palau, had no traditional mythology of noble savagery inherited from the eighteenth
century. European penetration of the Bismarck Archipelago dated only from the
1870s, and in contrast to the small island population of Palau, numbering about
4,000 in 1906, there were 40,000 natives living in the Gazelle Peninsula where
Nolde's expedition was headed.[40] The area was known for its grand landscape
features with high mountain ranges – in the European tradition of the sublime –
rather than its welcoming coves hewn out of the coral reefs. In 1884 German New
Guinea had been ceded from Britain and it was first developed as an important
trading centre by the German New Guinea Company. In 1899, the imperial
government assumed full administrative responsibility for the protectorate, but the
clashes with the native population which had marked the 1890s continued in areas
where the New Guinea tribesmen fought outside interference in their traditional
power structures until 1914. By 1913, the European population in the area num-
bered more than 1,000 with about 350 traders and planters, including a strong
Pan-Germanic faction. The Gazelle Peninsula was a prosperous area with private
and government copra plantations. The local Tolai tribe resisted being pushed into
the European plantations, however, and preferred on the whole to pay the head
tax, imposed in 1903 and doubled in 1910, with profits made from the sale of
privately cultivated copra. After the turn of the century the natives enjoyed an
increasing per capita income and the demand for Western consumer goods – clothes,
cigarettes, tinned foods – increased steadily before 1914.[41]

The image of the Melanesian New Guinea native that filtered back to Europe was
not as favourable as that of his Micronesian neighbours. In fact, a distinction was

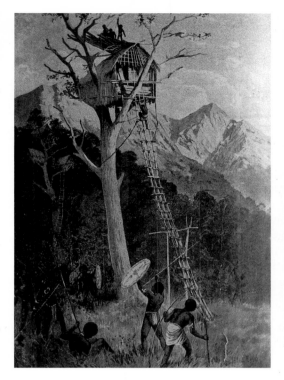

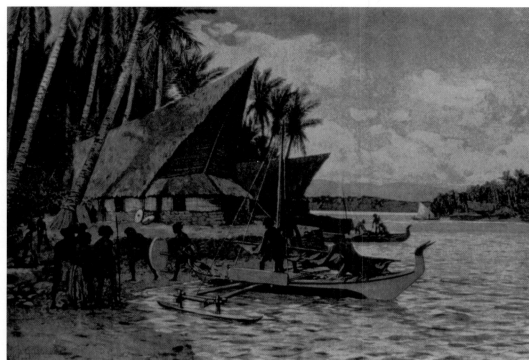

266. 'Treehouse in Kaiser Wilhelm's Territory', New-Guinea,' illustration in Alwin Wünsche's, *Die deutschen Kolonien*, 1912.

267. 'On Yap, one of the Caroline islands', illustration in Alwin Wünsche's *Die deutschen Kolonien*, 1912.

made between the 'light' and 'dark' skinned populations of the German South Seas islands, reflecting European preferences.[42] The New Guinea tribes, although mixed in racial features, were thought to be closely related to the 'negroid' population of Australia, and they were described as unattractive beings with broad noses, small eyes and excessive amounts of negroid hair. In contrast, the Polynesian populations of Palau and Samoa were tall and well-proportioned with long wavy black hair: 'In general, the Polynesians are a beautiful people, the female sex in particular often displays regular, lovely features... The Polynesians have friendly, peaceful, obliging ways and lively temperaments.'[43] These distinctions were also reflected in visual representations of native life. In Alwin Wünsche's *Die Deutsche Kolonien* (1912; *The German Colonies*), the New Guinea tribesmen are depicted as frightening cannibals, as warriors fighting both amongst themselves and against Europeans (fig.266). In contrast the illustrations of Palau, Yap and Samoa show peaceful village scenes (fig.267).

Interestingly, however, Nolde's direct renditions of native life in his numerous South Seas drawings mostly fail to pick up on these traditional characterizations in any obvious way. With the expedition he travelled on to Rabaul, the administrative centre of the Gazelle Peninsula, and he remained there for a month to acclimatize before journeying with Professor Külz to outlying villages where medical inspections were performed. It was during this period that he began to draw in watercolour, pencil and pastel, and to record the comings and goings of native life.[44]

The largest and best-known group of drawings – and the richest fruits of Nolde's journey – are the watercolours of native heads, fifteen of which were eventually purchased for the colonial office. Although these heads are in no way conventional demographic records, they do employ some of the conventions of contemporary ethnographic photography and to this extent they pay court to the 'official' context of Nolde's journey. The full-face and profile 'mugshot' poses we find in Nolde's drawings were familiar in ethnographic photos and reminiscent, of course, of criminal records. Just as his drawings in the Berlin Ethnographic Museum were meant to challenge the mechanical photographic eye with the expressive authenticity

268. Emil Nolde, '*Johann Anton Schäfer*' (*Appenzeller*), 1892. Pencil. Location unknown.

269. Emil Nolde, *An Aborigine with Headscarf*, 1913/14. Watercolour, 50.9 × 38.5cm. Sammlung der Nolde-Stiftung Seebüll.

of the hand-made sketch, so too, Nolde makes clear in his autobiography, the South Seas drawings were to surpass the possibilities of photographic records: 'mechanical photographs cannot compete with artistic conception'.[45] In this sense they contrast with the painstaking exactitude of his *Appenzeller Types* (fig.268), which were described in J.B. Grütter's accompanying 'volkish' text as, 'photographically true to nature'. These works are nevertheless a thematic prototype for the South Seas natives.[46]

Nolde's early drawings of 'Swiss Primal Types' were the first of a series of attempts to 'preserve' and record populations threatened by the onslaught of modernity. The Swiss interlude in the 1890s provided Nolde with his first opportunity to project or exteriorize attitudes originally associated with his native Schleswig-Holstein onto an outer or 'other' reality. By 1913 this tight descriptive style had given way to a much richer, more expressive handling, and the treatment of the South Seas native heads comes much closer to his 1909 watercolour drawings of the Apostles; in many ways they represent a synthesis of these two earlier modes. At their best the South Seas drawings strike a delicate balance between observation and expression, between individual and type, which differentiates them starkly from Pechstein's contemporary caricatures of native life.

As in his sketches of boats, Nolde used a reductive but infinitely variable pictorial schema for his native heads – washes of watercolour with black brush and ink signs for eyes, nose and mouth isolated against a blank page. His attention to ethnographic detail is in no way negligible: different types of facial decoration, scarification, hairstyle, jewellery and costume are shown. One drawing, for example, depicts different methods of tying a native headscarf (fig.269). But variation in the series as a whole has as much to do with the set of a head, the direction of a glance, the patterns of falling light and shade, which convey a freshness and directness of observation within the framework of a repetitive and typical facial schema (fig.270). This attention to mood and expression, often conveying something of the wary attention of his native models, together with his bold stylistic means, distinguishes the drawings from conventional ethnographic illustrations. Often it would seem that Nolde sketches a head not because of any particular ethnographic or 'racial' feature he aims to record, but rather for its expressive and painterly possibilities. The bone structure of a native face, for example, is shown creating a pattern of light and shadow which rhymes with his silhouette, rather than as an illustration of a facial type.

None of Nolde's heads are simply black but are rather a rainbow of colours. The colours are often based on fact as the body decoration of the natives described by Ada Nolde in a letter to Hans Fehr in 1914,[47] is also mentioned in ethnographic surveys.[48] But Nolde uses colour primarily to create effects of light and shade. This is also suggested by transparent and opaque veils of watercolour. His portrait of one of the house boys *Tullie* depicts a purple skin with blue highlights, rendered transparent on the right side of the face to suggest a falling shaft of light. Touches of complementary yellow are then added to the corner of his eyes, to his necklace and to the red flowers in his hair to enrich the contrasting effects of light and dark. Elsewhere we find a rich orchestration of reds, blues and oranges, or a delicate balance of mole-coloured skin with blue. This drawing shows the effects that Nolde achieved by painting on damp paper: the yellow headband bleeds into the native's hair, and a touch of complementary blue is added where the yellow band meets his red scarf. Colour is all important for these South Seas sketches and in his pencil drawings Nolde often adds colour notes, as he did in his 1911 'ethnographic' sketches.

One interesting feature is that Nolde only rarely showed the natives with weapons or as an obviously fierce and dangerous presence.[49] In the village scenes which form a second series of watercolours (fig.271), we find casual groups of natives, some in European dress, going about peaceful everyday activities – dancing, fishing, making fires or preparing their meals. The 'madonna' motif of mother and child is also a frequent one (fig.272). Although the subjects of these sketches are close to Pechstein,

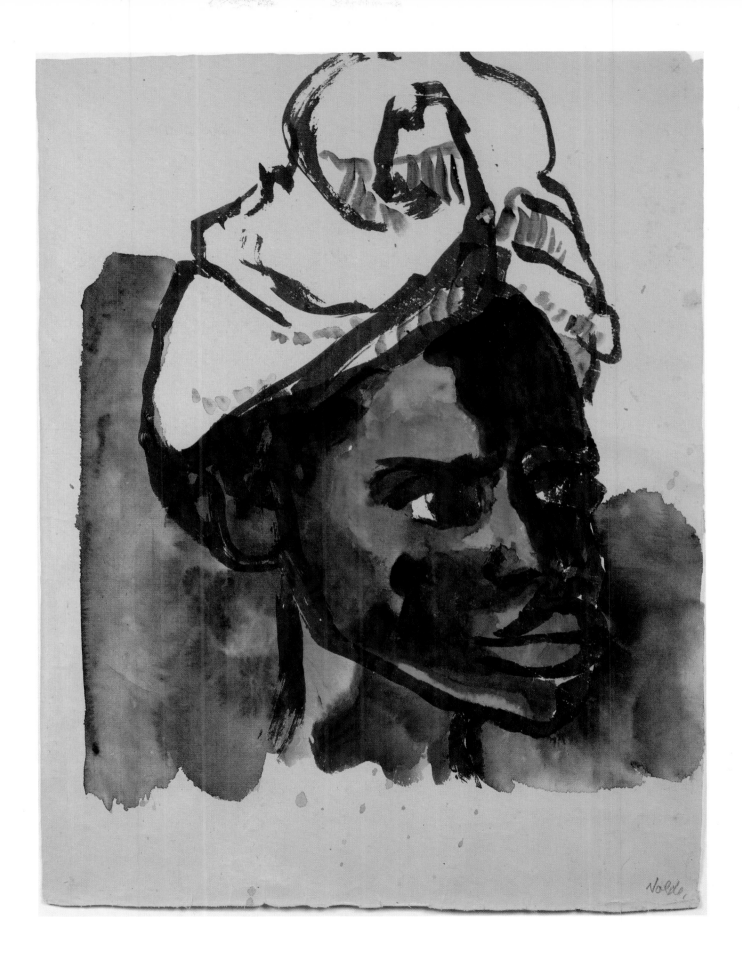

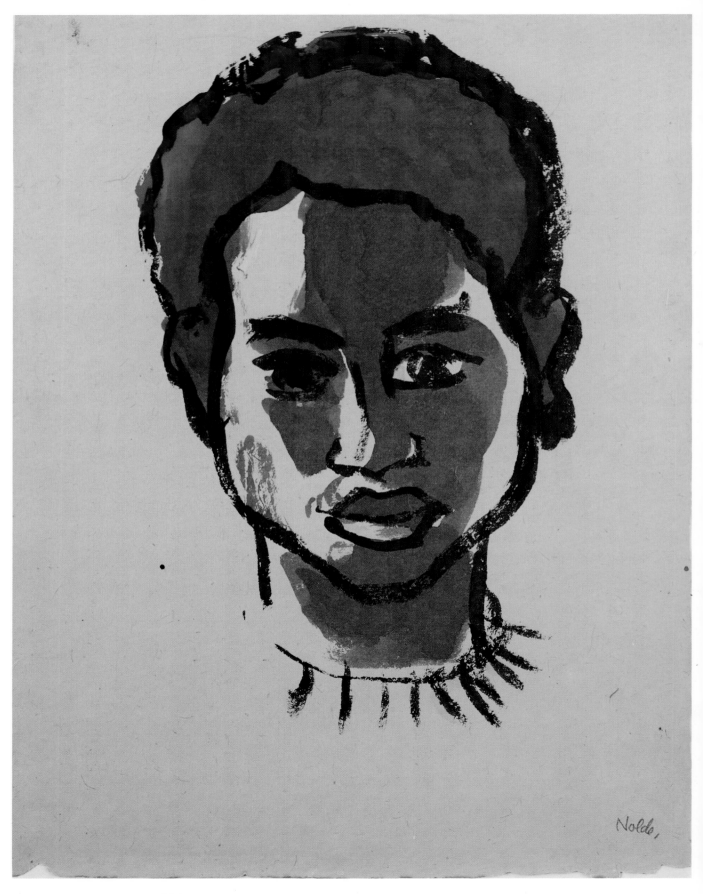

270. Emil Nolde, *An Aborigine*, 1914. Watercolour, 50.2 × 38cm. Sammlung der Nolde-Stiftung Seebüll.

271. Emil Nolde, *An Aborigine in the Village*, 1913/14. Watercolour, 34.5 × 47.6cm. Sammlung der Nolde-Stiftung Seebüll.

272. Emil Nolde, *Aboriginal Woman with Child*, 1914. Watercolour, 52.8 × 39.2cm. Sammlung der Nolde-Stiftung Seebüll.

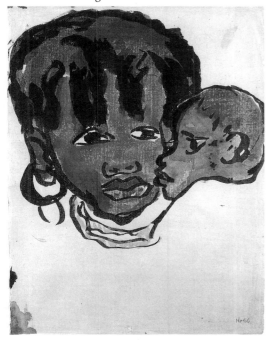

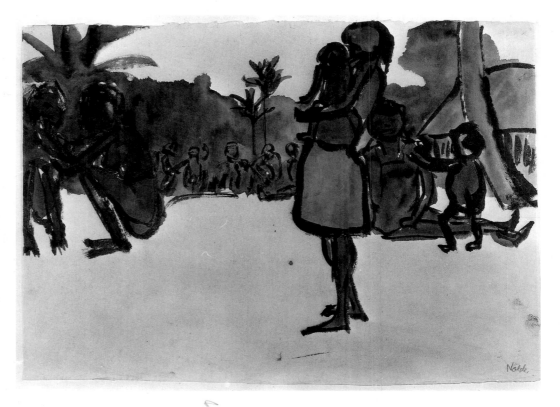

273. Max Pechstein, *Portrait of a South Sea Islander*, 1914. Watercolour, 16.3 × 12.7cm. Staatliche Kunstsammlungen Dresden, Kupferstichkabinett.

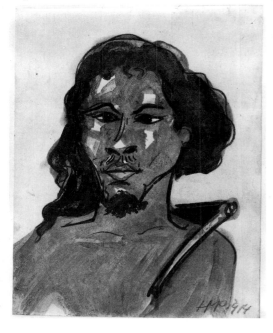

Nolde does not transform them into an idyll. Visually the drawings are indeed beautiful, but the distant viewpoints, the incidental groupings, the freshness and immediacy of observation, avoid idyllic effects. In his fishing scenes, for example, Nolde renders schematically the exact structure of the native boats, rather than the generic shapes we usually find in Pechstein's work. Occasionally Pechstein's more freshly observed subjects come closer to Nolde, as for example his more delicate but sensitively observed, drawing of native heads (figs.273–4). Nolde's landscape backgrounds are cursory, often conveyed by the schematic contours of a palm tree. Only in the case of the native heads, where background landscapes are very rare, does this introduce a romantic effect, lessening the stark, confrontational impact of the drawings. In his full-length and group scenes Nolde concentrates on effects of movement and space rather than light and shade. For example, the sweep of his brush on damp paper is used to suggest the movements of a dancer, or the crouching position of a native boy is expressed through the cramped composition of a drawing, crowded against the edges of the sketchbook page.[50] All in all, the fine edge of observation in the group scenes eclipses Nolde's engagement with types, which still plays an important role in the drawings of heads.

Apart from these large watercolours which function as finished works in their own right, Nolde also made tiny pencil and pastel sketches, (*c*.8.5 × 13.5cm), often as preparatory studies for paintings. His simple outline drawings in pencil, reminiscent of the 1911 'ethnographic' sketches, show no details of dress or decoration. Mostly they are quick records of pose and posture, with natives standing, squatting, talking, carrying their babies; a similar interest in the body as an expressive vehicle emerges to that which featured in Nolde's Berlin theatre scenes. Nolde recorded, for example, a native performing the Duc-Duc dance (figs.275–6). Sketches of exotic plants and vegetation, often in close-up, also occur, sometimes with scribbled colour notes or details of size (e.g. 'tropical blooms, meadow with many flowers half a metre high'). Nolde's paintings, as we shall see, are not so much abstracted from these sketches, but rather fixed and absolute versions of fleeting and varying possibilities. The changing poses and groupings are reflected in Nolde's own shifting viewpoint as

223

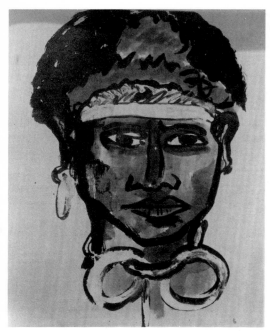

274. Emil Nolde, *Head of an Aboriginal with Earings and Necklace*, 1914. Watercolour, 50.5 × 37.5cm. Staatliche Kunstsammlungen Dresden, Kupferstichkabinett.

277. Emil Nolde, *Trophies of the Savages*, 1914. Oil on canvas, 73 × 88.5cm. Sammlung der Nolde-Stiftung Seebüll.

275. Emil Nolde, *Duk-Duk Dance*, 1913/14. Pencil, Sammlung der Nolde-Stiftung Seebüll.

276. Photograph of the Duk-Duk dance, Gazelle Peninsula, New Guinea. Before 1911.

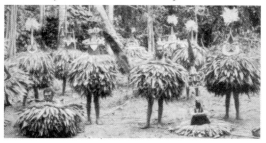

he moved around the figures, sketching them from in front, above, behind. His landscape paintings too are based not on the large watercolour drawings but rather small crayon and pastel sketches.[51] In this series, colour and line, which function as separate abstract and figurative layers in the watercolours, coalesce. The abstract, suggestive colour combinations subdue the figurative associations of line, and the sketches of beaches, rocks, cloud formations and seascapes become extremely abstract variations on a kind of generic landscape that Nolde locates at the meeting point of sky and sea. But still the shapes and colours remain tied to effects of light, weather and time of day; they never cut entirely loose from reality.

But does Nolde's sensitivity to the particularity of experience, the balance of individual and type, really mean that he approached the natives in an open and enquiring spirit, free from the kind of preconceptions we found operating in Pechstein's case? Surely not. What it does mean is that the relationship between image and reality, between myth and history is richer and more multifold. Accordingly, Nolde's vision of the natives themselves is more complex and elusive. Often this is written into the texture of the images in a strangely ambivalent way, for example in the series of native heads. Nolde's drawings, as we have observed, make little or no direct reference to the fierceness or hostility of the natives and yet this is one of the visual effects of the heads that distinguishes them from the more casual, peaceful village scenes and from Pechstein's images. It is worth trying to pinpoint, more closely, how this happens.

In his memoirs, Nolde makes clear that he was aware of the more sinister, hostile associations of New Guinea natives represented in European newspapers and popular books and confirmed by some of his own experiences. He refers particularly to the hostile mood of the natives on the Admiralty Isle of Manus, where he claims to have sketched while Ada covered him with a revolver.[52] In Friedrich-Wilhelmshafen a row of decorated human skulls in a shop window provided the subject for his own

gruesome painting *Trophies of the Savages* (fig.277). In fact, the subject of severed heads provokes more complex historical associations than we might at first suspect. During his visits to native villages with Professor Külz, where they enjoyed, Nolde remarked, a peaceful and cooperative reception, the memory of a recent punitive raid in the area put the natives somewhat on edge. The loss of a previous expedition had caused a sensation in the German press, Nolde claimed, and provoked fears that their own group would be attacked by 'South Seas cannibals'.[53]

In fact, the last serious, full-scale military clash involved the Baining tribe, who had slaughtered a Catholic mission at the beginning of the century. Repercussions and revived hostilities continued spasmodically until 1914, erupting more seriously in 1905 and 1911, although by this time 200 Baining men were working in government projects or for private plantations. The events are memorable primarily for the scandal provoked by Alfred Hahl, the German governor, when he sent back three native heads procured in the original punitive raid, to the University of Freiburg for 'scientific investigation'. As we might imagine, the socialist press was reluctant to drop this affair.[54]

A close personal encounter with native 'cannibals' seems to have provided the original inspiration for Nolde's watercolours. In his memoirs Nolde speaks of the dangerous conditions under which the drawings were made, referring presumably to a particular instance when, on his arrival in Rabaul, he encountered a group of natives 'direct from the primal forest'.[55] They had been seized from their villages for government service: 'They were wild, with their powerful hair, with their jewellery made from mussels and bone on their arms, around their necks, or hanging from their ears; some of them had bent, white bones through their noses. They were cannibals, these people. A sinister concept for us Europeans...'[56] Returning the next day to begin his watercolour series, Nolde claimed he narrowly escaped attack because the natives believed his possession of their image would put them in his power.[57]

It is the stark confrontational format of the watercolour heads, the strong features and colours which convey something of the mood Nolde describes in his autobiography: 'When one of their eyes lit on me from a corner, it was unsettling, and when they looked at you directly, it was so wild and despising, like the look of black panthers or leopards. They had been captured. They were worked up. They came direct from the bush, the primal forest...'[58]

Most important, Nolde's drawings of the native heads show them severed from their bodies, like trophies. Just as his mask still lifes in 1911 depicted living, grimacing objects, so too these severed heads are powerfully alive. The range of associations this provokes is significant. On the one hand it suggests an oblique reference to their own cannibal traditions; on the other, a different kind of 'head hunting', more closely related to Alfred Hahl's controversial treatment of the Baining heads. This has to do with the power of the white man to collect the natives' images as trophies, indirectly confirming the latter's own fears about the power of images. Nolde was quite clear in his opposition to the 'castrating' effects of colonialism on the dignity and integrity of native life:

> They were dragged away from their villages, from their women and children. This crude and extreme colonialism is a brutal business...if a history of colonialism could be written from the point of view of the coloured natives, then we white Europeans should crawl away in shame. But it won't happen. The only children of nature who will resist the destructive exploitation of the whites, apart from the Chinese and Indians, are certainly the robust Africans.[59]

What he was not so clear about – how could he be? – were the layers of ambivalence beginning to emerge in his own images, and relating to his contradictory position in New Guinea as a critical observer attached to an official govern-

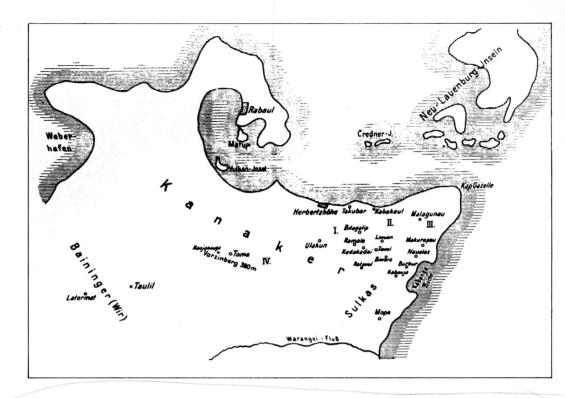

278. Diagram of the area covered during the first phase of the Leber-Külz expedition, *Deutsches Kolonialblatt*, September 1914.

ment expedition. What began to show up in his drawings of native heads were the weaknesses in a theory of cultural relativism that took no account of historical power relations.

Alongside Nolde's memoirs of his journey, recorded in *Welt und Heimat*, a second 'official' report exists, published in the *Deutsches Kolonialblatt* in September 1914.[60] Written by Professor Külz, the report confirms the general factual basis of Nolde's account, but only covers the first phase of the expedition in the Gazelle Peninsula (fig.278). At this time Nolde suffered an attack of dysentery at the foot of the Varzin Mountains and was forced to retreat to the hospital in Herbertshöhe. The second phase of Nolde's journey, when he accompanied Dr Leber to New Hannover and the more unruly island of Manus in the Admiralty Isles, is not described. This second document of the expedition nevertheless provides a valuable opportunity to compare Nolde's attitudes to the official line and affords us an insight into other important aspects of his descriptive ideal of New Guinea life.

During this early phase of the expedition the Noldes travelled with Külz and Arnthal (whose death from sunstroke Nolde described), while Leber, who had injured his shoulder in a riding accident, remained in Rabaul. Working inland towards the Baining tribe, the investigative spirit of the expedition may well have inspired the fresh and observant approach we find in Nolde's drawings of village life. In fact Külz's report, like Nolde's drawings, treads a delicate line between observed fact – expressed in charts, tables, diagrams – and underlying ideological suppositions related, in this case, to his official capacity in New Guinea.

Külz presents us with a detailed picture of the expedition, fleshed out by fine differentiations missing in Nolde's account. For example, there were, according to Külz, important differences between the four tribes under inspection which Nolde does not register, although he mentions the heterogeneous character of the population.[61] The Kanaks or Livuan, numbering 30,752 in 1910, was the largest and best organized tribal group with a population density comparable to that of Prussia. The child mortality in this tribe was low, the fertility of the women good, and the occurrence of serious illnesses like tuberculosis and venereal diseases rare. Külz does not relate these facts to an absence of Western contact – their shabby

European clothes contrasting with their well-kept villages spoke against this. Rather he sees it as proof of a successful and humane government administration. He writes:

> Neither signs of degeneration nor lack or discipline nor evidence of a general population decline, are to be found in this tribe. On the contrary, it is certainly to be expected that a new head count will reveal a not inconsiderable population increase. The example of the Kanaks shows that contact with European culture does not necessarily lead to the decline of a primitive folk, when, as the administration has consciously encouraged in this case, such contact is established in a moderate, careful way.[62]

Külz was not blind, on the other hand, to the negative effects of irresponsible European contact. A second tribal group, the Sulka, had suffered from an increasing mortality rate over the past five years; this Külz attributed to unwise government land policy, which had moved the tribe from its ancient homeland and forced them into the plantations. Since October 1913, moreover, Pan-German pressure groups amongst the planters had forced the government administration to lift the prohibition to enrol women. General fear and uncertainty created an atmosphere in which the villages fell apart: the fields were neglected and huts left unrepaired.[63] In contrast, the fate of the Taulil tribe was felt to be outside government control. Threatened from the Kanaks on one side and the Bainings – who practised cannibalism and slavery on Taulil women and children – on the other, many Taulil fled to the plantations with no plans to return. Külz refers this process to the larger and universal law of the survival of the fittest, invoking a Darwinian justification: 'the growth of large tribes by means of the absorption of smaller one...this has nothing to do with "racial weakness", with disease or with hunger and the like. Rather it involves the triumph of the stronger over the weaker.'[64] Külz understood this Darwinian process not in racial terms, but rather as an inevitable consequence of historical power relations.

Nolde acknowledged the humane and correct behaviour of the German administration in New Guinea, despite his general objections to colonialism, 'errors of human judgement or bureaucratic narrowness of vision may have led to mistakes being made, but they weren't too important'.[65] But the 'well meaning' foundation of schools and hospitals was, in his opinion, irrelevant to the real needs and desires of the natives. He ignores Külz's theory about the positive impact of colonial administration on the Kanak tribe, and groups the natives more generally as a heroic and suffering people. For example, his explanation of the population decline looked towards their tragic resistance to European rule:

> on a small island in this region no child had been born for fifteen years. The natives wanted to die out. Rather this than work for strangers – their own fertile, beautiful island had been taken from them by the whites. They had been banished to a hidious, small neighbouring island, and in order to survive they had to work on the foreigners' coconut plantations on their homeland.[66]

Nolde, as we see, embroiders around given facts rather than simply inventing. The combination of native features he comes up with – involving a wild and tragic dignity – conforms to what Bernard Smith describes as the romantic as opposed to the noble savage, which was an updating of the eighteenth-century concept in response to real experience of native societies.[67] In Byron's *Island* and Melville's *Moby Dick*, we find new European preoccupations projected into the image of the Pacific Islanders: freedom, devotion to race or nation, strong temperament and emotional depth – all of which were part of Nolde's vision too. The missionary image of the ferocious savage was transformed by the Romantics into a vision of physical prowess and wild dignity – such as we see in Jacques Arago's *The Savage of New Holland Coming from Battle* (fig.279), or in Max Slevogt's *The Conqueror* (see

279. Jacques Arago, *Savage of New Holland Coming from Battle*, 1823. Engraving.

280. Emil Nolde, *New-Guinea Natives*, 1915. Oil on canvas, 73 × 100.5cm. Sammlung der Nolde-Stiftung Seebüll.

fig.63). In Nolde's retrospective paintings of 1914 and 1915, such as *New Guinea Natives* (fig.280) and *Manus Men*, we find similar effects. Although the seeds of the romantic savage are to be found in his native heads, the mixture of qualities there balanced by observation is more finely wrought and complex. In the paintings, where he combines different heads into synthetic compositions, just as in 1911 he had begun to combine separate non-European artefacts in his still lifes, the wild and romantic features are exaggerated.

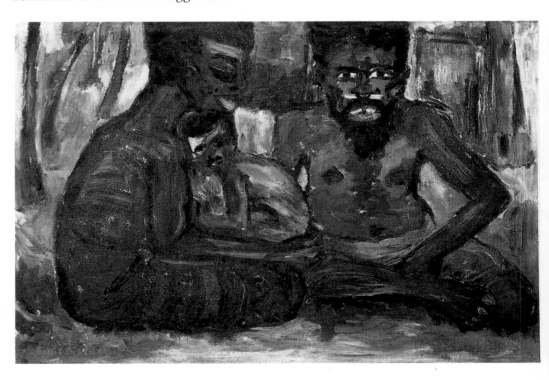

281. Emil Nolde, *New-Guinea Family*, 1914. Oil on canvas, 71 × 104.5cm. Sammlung der Nolde-Stiftung Seebüll.

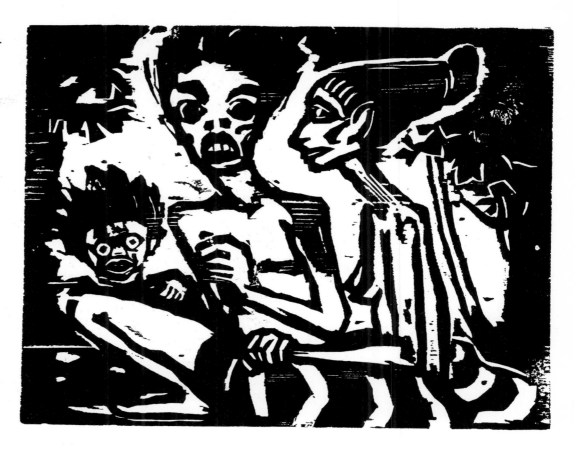

282. Emil Nolde, *Family*, 1917. Woodcut, 23.2 × 32.2cm. Sammlung der Nolde-Stiftung Seebüll.

His family scenes of 1914, *New Guinea Family* (fig.281) and *Man Woman and Child* and *Papuan Family* (1915) could also be related to his still-life combinations of male and female figures. In the first of these paintings, the basic constituents – hut, land and family – show the simple and vulnerable elements of native life rendered in a bright, luminous palette. The male natives play a protective rôle in these paintings, although in the 1914 drawings the mothers usually appear alone with their children. The composition of *Man Woman and Child* is taken from a single drawing, but *Papuan Family* combines two separate sketches.[68] Family life, as we have seen in our discussion of the Palau club houses, was fostered by the colonial administration, and once again Nolde's paintings refer both to a reality and an ideal. Unconsciously, they both sympathize with the plight of the native and reconfirm colonial values. While his paintings of male natives stress the wild and savage, these works show the natives in a dignified and sympathetic light, thus engaging with a second facet of the 'romantic savage'. In his 1917 woodcut *Family* (fig.282) Nolde combines both aspects with a new type of grotesque exaggeration of gesture and expression, comparable to his 1912 still lifes. In this image the native models have become, once again, caricatures.[69]

In contrast to Professor Külz, Nolde's general distrust of progress led him to reject Darwinian explanations about the triumph of the stronger over the weaker in his 1936 comments about his South Seas journey. Even at this date he viewed such explanations as a false justification of colonial rule. He wrote: 'The rights of the stronger – as they exist as a natural law in plant and animal life – can perhaps comfort us men with our animal protection societies, our humanitarian teachings and Christian beliefs. If it can comfort us. One thing alone is sure: we white Europeans are the bane of coloured natives.'[70] As an alternative to the linear evolutionary mode, Nolde subscribed to a cyclical philosophy of history, which he began to evolve at the end of his South Seas journey. In March 1914, Nolde began the following letter with a virulent attack on colonialism:

229

with an impulse to change, with their best knowledge and aims, and with modest success, the pious, white missionaries attempt to weaken and bury the cults, the self-confidence and will of the primal peoples. They work with the energy of mild fanatics, until one harmless victim after another falls their way. They sacrifice their own lives to a martyr's death, and then the soldiers arrive with apparent justification to avenge them. The first, great door is opened in this way for adventurers, for dubious European rubbish carrying venerial diseases, and for greedy salesmen. The colony is secured.

He continued:

An original segment of being is lost with the disappearance of the original state of these children of nature. But the development of mankind continues, and only when a secondary flowering of the folk has begun, does a cultural decline begin too... On our planet we men can stay still a little in our own being, sometimes even speed up, but in general forwards development and decline of individual peoples and the whole of mankind follows its own regular pace.[71]

The beginnings of Nolde's cultural pessimism, his sense of an inevitable cycle of growth and decay in human destiny,[72] results from his sense of a contradictory historical process. As 'civilization' advances, 'culture' regresses; and where these contradictory historical movements meet, they short-circuit, creating, as we shall see, a timeless 'primitive' zone. The revolutionary potential of the 'primitive', the 'primal strength' which Nolde still refers to in the 1930s as 'capable of future germination',[73] is thus counteracted by a more conservative notion of cyclic growth and decay, contradicting the forward movement of history and increasingly dominating Nolde's artistic philosophy. Once again, this is a romantic notion, and although comparable, different in emphasis to Pechstein's ahistorical 'primitive' ideal which was more in line with the concept of the noble savage. As Smith remarks: 'The main distinction between the noble and romantic savage was that the former was self-sufficient in his natural state... [he] expressed the classical desire for a state of natural perfection. The romantic savage expressed the ideal of life as a voyage, a continuous movement towards an ever-receding goal.'[74]

Although the historical trajectory remains an ideal, there is in fact no movement forwards. Any movement is caught in the dilemma between aspirations about the future and nostalgia about the past.

Nolde arrived at this position towards the end of his South Seas journey, by extracting a philosophical contradiction from the real historical dilemmas he encountered there. Gradually in the course of his stay, his sense of colonial interference and 'loss' focused on the predicament of native art. As we have seen in our discussion of his still-life paintings, tribal art, like folk and medieval art, represented for Nolde a mode of authenticity that assumed a whole and organic relationship between art and life, between material and spirit, between subjective and objective reality, which he mourned the loss of in his own times. In his travel memoirs he praised the tasteful decoration of utility objects and the rôle that cult and dance still played in native life.[75] But he describes this as a vanishing reality. The natives had begun to produce tourist carvings, destined for Europe and America,[76] and their own religious iconography gave way to Christian dogma; on the mainland Nolde found a carving of Christ with Papuan features – precisely the kind of pitfall he had tried to avoid in *The Life of Christ*.

In April 1914, in response to this situation, Nolde sent letters to Max Sauerlandt and Osthaus. He could trust their aesthetic appreciation of tribal art and complained of the rape of that art by colonial powers. He enclosed, moveover, a letter intended for the Colonial Office and composed jointly by himself and the local government administrator, Alfred Stübel. In this missive, Nolde concentrated not so much on the removal of tribal art from its native setting, but rather on the loss to *Germany*

provoked by foreign competition for native artefacts. America, Japan and Sweden, Nolde complained were carrying off treasures that had their rightful place in German museums:

> I find it a pity that many irreplaceable pieces are lost to Germany in this way. At home the new conviction that these products of the so-called children of nature have artistic worth, alongside scientific interest, makes it all the more important to realize that these objects are the last trace of a primal art which is scarcely to be found today. In my opinion it is a question of honour for the German Empire, that they preserve the rest of this art, and preserve it for Germany. I hope that the Colonial Office will give credence to the growing interest for native South Seas art in artistic circles at home and take protective measures.[77]

It is possible to read between the lines of this letter the ambitions of a petty government official seeking approval, and hiding behind the naïve facade of the 'disinterested' artist. But the conflicting sympathies provoked by Nolde's South Seas experiences are implicit in other aspects of his work too. In his watercolours of native heads the difficulty of situating his own position in this network of conflicting emotions resulted in a series of powerfully ambivalent visual 'trophies'. Stephen Bronner's conclusion that 'Nolde's critique of imperialism is carried out from the standpoint of an imperialist mentality',[78] is just a little too simple. Rather it would seem that the progressive and regressive aspects of Nolde's primitivism, still held in a fine balance in his ethnographic still lifes, developed into an untenable contradiction under the real pressures of historical experience. His objections to imperialism on the one hand and his nationalist enthusiasms on the other could no longer be resolved under the mantle of an open ended cultural relativism. Nolde, in the end, had to take sides. In the light of his conservative background and upbringing, the side he took is not wholly surprising.

But the original internal paradox of Nolde's primitivism remained significant with regard to his ambiguous position in Nazi Germany. His autobiographical writings, which fail on all sides to strike the right note, which mix anti-semitic ranting with attacks on cultural imperialism, are more a testament to that paradox than a statement of Nazi solidarity – even if he intended just this. In 1914, his split loyalties and sense of historical dilemma related to a more general historical crisis which we find surfacing too in the actions of the governor of German New Guinea, Alfred Hahl. Hahl was a dynamic administrator with capitalist beliefs during his thirteen years of office from 1901 to 1914, but was constantly torn by the reformative plans of the central colonial administration on the one hand, and the radical exploitative ambitions of the powerful Pan-Germanic clique of New Guinea planters on the other. Hahl fought against excessive recruitment for European plantations and guaranteed native reserves on the understanding that they should be cultivated to ensure native *and* government profits. In 1913 he was forced to renew the recruitment drive against his better judgement, and outbreaks of violence occurred in New Ireland and Aitape on the mainland. Hahl insisted that prosperity lay in Germany's ability to tap the reserves of native labour by creating an orderly and reliable administrative framework. But he was increasingly pressurized into enforcing more radical capitalist policies. His own resolution to this practical dilemma was found in a firm and unflinching cultural nationalism. In his speech of departure from New Guinea in April 1914, he was adamant that native life and thought had to be assimilated to that of the German people if the empire's national integrity was not be subverted.[79]

Nolde's immediate solution to the historical problems with which he was faced was twofold. Firstly, he retreated into a timeless and eternal concept of the 'primitive', expressed primarily in his landscape paintings. *Nusa Lik* (fig.283) and *Crocus Blossom*, both painted in 1914 and based on pastel sketches,[80] refer to 'worldy' landscapes, situated by the boats and small native figures. The plantation

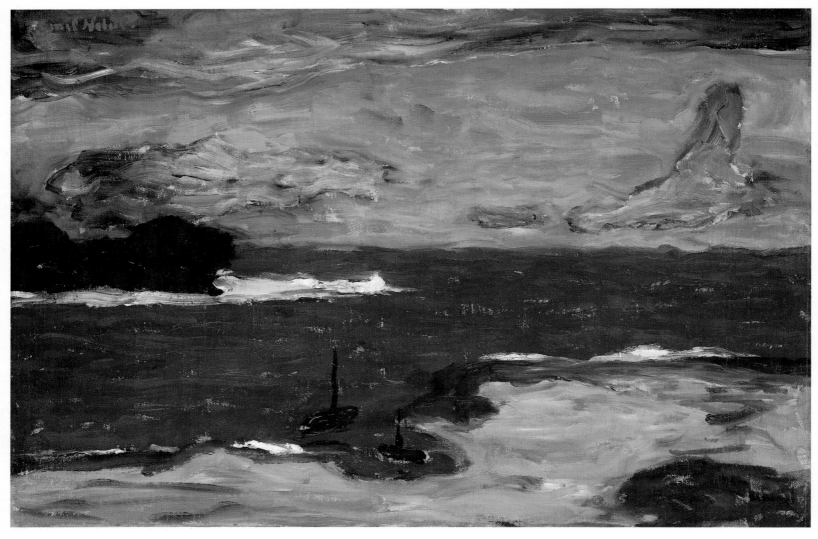

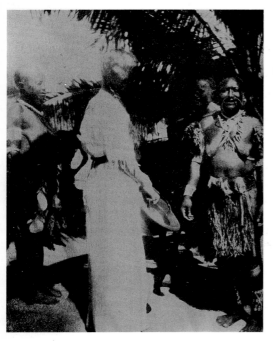

featured in the latter painting provides Nolde simply with an exciting, colourful landscape motif. Of more lasting importance was his *Tropical Sun* (fig.285).[81] This depicts a confrontation of the elements: sky and sea. Reminiscent of Nolde's early watercolour *Sunrise* (1895), this landscape format had also been used for his 1910 series of *Autumn Seas*. Tranferred to a northern landscape setting, whose timelessness is expressed in the flattening of the spatial plane, this elemental landscape was to be repeated endlessly after 1915, together with other landscape subjects, the tides and the seasons, suggesting the cyclic rythms of nature. In his 1934 additions to the *Kunstäußerungen*, Nolde wrote: 'Everything primal and original always captured my attention. The huge, tossing sea is still in an original state, the wind, the sun, the starry sky are certainly the same as they were fifty thousand years ago...'[82]

Secondly, Nolde resorted to a cruder and more radical polarization of 'primitive' and European society. This involved him in an imaginary vision far removed from the sensitive particularity of his South Seas sketches, and comparable in many ways to Pechstein's written evocations of Palau. In 1914, both Emil and Ada Nolde wrote letters to Hans Fehr describing their visits to native villages with Professor Külz (fig.284). Ada writes in a clear, unaffected prose style:

> The houses and the people are all 'dirty too much', as one says here...the women are not beautiful, they have hair cut very short and are horribly dressed by the missionaries. Most look overworked. There is much disease among the people. Some have no noses, some no toes, they simply drop off. Until now the birth rate

285. Emil Nolde, *Tropical Sunset*, 1914. Oil on canvas, 71 × 104.5cm. Sammlung der Nolde-Stiftung Seebüll.

is high, but the mortality figures are high too. In other areas no more children are born, on one island the youngest son is fifteen years old.[83]

Already we have seen Nolde referring to this letter in his interpretation of depopulation as a heroic resistance on the part of the natives to European rule. In May 1914, from the steamship *Manila* on the journey homewards he began to succumb to the temptations of a retrospective ideal:

> The natives are a magnificent folk, in as far as they haven't been spoilt by whites. We have sometimes had a chance to meet absolutely primal people in their villages. That was fabulous. Powerful figures with heavy hair growth and ears and noses full of heavy jewellery... The red-brown people, men and women, almost without clothes and wearing only jewellery, walk on white beaches between the fertile palm or banana trees, or among the red-yellow bushes around their settlements – an unusual harmony. When I think of our German houses, full of the lowest collections of cheap bits and pieces and factory goods, or our bodies crippled by clothes and polished shoes like pictures in a fashion magazine!... The natives in the European settlements are unbearable, mendacious, contaminated, and hung with the poorest rags and glitter... But don't say anything! – Psst! – No white man is allowed to see. If you see, close your eyes nicely, 'economic use' overpowers all considerations.[84]

283. Emil Nolde, *Nusa Lik*, 1914. Oil on canvas, 70 × 104cm. Museum Folkwang, Essen.

284. Ada Nolde with New Guinea natives. Photo archive, Stiftung Seebüll.

On the journey home, Nolde's critique of imperialism still attacked the exploita-

tive commercial basis of colonialism. But the emphasis of this attack had changed: it now related first and foremost to Nolde's *anti-modern* philosophy, to his distaste for the superficiality and artificiality of modern society, which he saw as the antithesis to his idealistic notions of 'noble' and 'natural' savagery. His comments now bring to mind Paasche's satirical attack on modern life from the point of view of the conservative wing of the *Wandervogel*. This had always been one aspect of Nolde's primitivism, and from now on it became dominant on an ideological rather than a formal, artistic level.

Whereas Pechstein's memories and visual representations of Palau polarized the primitive and the modern into simple black-and-white alternatives, Nolde's awareness of a more complex interraction had given rise to a grey and contradictory area. It was precisely this area of interchange, of sliding and conflating bounderies, which Kirchner, as we have seen in our discussion of the city versus country theme, chose as the subject of his art after 1910. Nolde, it seems, took fright during the course of his South Seas journey at the complexity of these relations, which he identified increasingly with a 'mixed' and confusing conflation of categories more comfortably regarded as unproblematic alternatives. The polarization of the primitive and the modern could be used as a critical antithesis to oppose the negative effects of modernization. But it was also a means of separating 'them' and 'us', and as such a strategy that had emerged first of all in the Romantic era. It guaranteed a safe distance from which to admire both the 'other' and, by implication, ourselves. The 'in between space' separating these alternatives was a complex historical zone, the area in which power relations operated and in which the contradictions of modernity itself became visible. It was a mobile and vagrant space in which Expressionism, with its political affiliations to the left *and* to the right, was entirely at home. It could be used as a means of access to, or as an escape from, historical experience. If it became too frightening, it could even take on the shape of an 'impure' race which had to be eradicated from the face of the earth to ensure German superiority. If this had remained an idea, a project for art, it would have been bad enough. The great tragedy and the great horror of modern German history is that it was translated into life.

All translations are by the author unless otherwise stated.

INTRODUCTION

1. P.L. Berger, *Facing Up to Modernity*, N.Y. 1977, p.101.
2. Charles Baudelaire, *Le Peintre de la vie moderne*, Paris 1863, transl. *The Painter of Modern Life* in *Selected Writings on Art and Artists*, by P.E. Charnet, Cambridge 1972, p.399.
3. Kirk Varnedoe, 'Gauguin', in *Primitivism in 20th Century Art*, N.Y. 1984, vol. 1 p.185.
4. Ibid. p.202.
5. Ernst Bloch, 'Diskussion über Expressionismus', *Das Wort*, Moscow 1938, reprinted in *Erbschaft dieser Zeit*, Frankfurt 1962, pp.264–75. Georg Lukács, 'Es geht um den Realismus', *Das Wort*, 1938, reprinted in *Essays über Realismus*, Neuwied 1971, pp.313–43. Both essays are translated by Ronald Taylor in *Aesthetics and Politics*, New Left Books, London, pp.16–59.
6. Taylor, *Aesthetics and Politics*, p.19.
7. Ibid. p.26.
8. Ibid. p.53.
9. Ibid. p.54.
10. Peter Bürger, *Theorie der Avantgarde*, Frankfurt-am-Main, 1974, transl. *Theory of the Avant-garde*, Manchester 1984, p.50.
11. Ibid. p.22.
12. Jochen Schulte-Sasse, 'Theory of Modernism versus Theory of the avant-garde', introduction to Bürger, *Theory of the Avant-garde*.
13. 'Modernist Primitivism, An Introduction', p.41. The first article to point out the flaws in the concept of the MoMA exhibition was Michael Peppiatt's 'Sujet Tabou, Exposition Risquée, *Connaissance des Arts*, Paris no. 391, Sep. 1984. Thereafter, a fierce debate about the merits of the show developed between Thomas McEvilley and the organizers at MoMA in *Art Forum* Nov. 1984, Feb. 1985 and May 1985.
14. Bürger, *Theory of the Avant-garde*, p.xxx.
15. 'Hier (Dresden), ist das Völkerkundemuseum wieder auf, nur ein kleiner Teil aber doch eine Erholung und Genuß. Die famosen Bronzen aus Benin, einige Sachen der Pueblos aus Mexiko sind noch ausgestellt und einige Negerplastiken...Ein Cirkus ist wieder da und in den Zoologischen kommen Samoaner, Neger usw, diesen Sommer!' Letter from Kirchner to Heckel, dated 31 Mar. 1910, postmark Dresden (Altonaer Museum Archives, Hamburg). Kirchner's letter refers to the *Zirkus Angelo*, on Münchner Platz in the southern suburbs of Dresden. In the *Dresdener Neueste Nachrichten* 31 Mar. 1910 and the *Dresdener Anzeiger* 1 April 1910, details of Marquardt's *Völkerschauen* displaying an African village and a group of Samoan natives are given. Kirchner must have been referring to the first of these newspaper advertisements. For more details see chapter 3, p.30. Also, Ann Marie Dube-Heynig, *E.L. Kirchner, Postkarten und Briefe an Erich Heckel im Altonaer Museum Hamburg*, Cologne 1984, p.237.

CHAPTER 1. TURNING AWAY FROM HISTORY: THE *JUGENDSTIL* RENEWAL

1. Lucius Grisebach ed., *E.L. Kirchner's Davoser Tagebuch*, Cologne 1968, p.78. This is Kirchner's diary, written between 1919 and 1928.
2. This is supported by the artists' own statements. For example the letters from Erich Heckel and Karl Schmidt-Rottluff to Gustav Vriesen, originally published in *Die Schanze*, 1951, and reprinted in L.G. Buchheim, *Die Künstlergemeinschaft Brücke*, Feldafing 1956, pp.66–7. Both these letters were written in 1946, and Heckel in particular speaks of the relationship to Munch and their, 'common roots in the *Jugendstil* movement...some years later we opposed this style, rejecting it more firmly than Munch, or, in our own ranks, Kirchner, who worked with Obrist in Munich for one or two semesters' (p.67). See also Peter Selz, *German Expressionist Painting*, Berkeley 1957, pp.63–4. We should bear in mind that almost all later statements by the *Brücke* artists underplayed the formative influences on their art. Also a distinction should be made between their roots in *Jugendstil*, and their continuing and transforming commitment to the decorative arts.
3. The most important recent study is Georg Reinhardt's, *Die Frühe Brücke. Beiträge zur Geschichte und zum Werk der Dresdener Künstlergruppe Brücke der Jahre 1905–1908*, Brücke-Archiv, vol. IX–X, Berlin 1977/8. The advertisements in *Jugend* provide a good example of how the new style passed down onto a popular level.
4. 'Die anfänglichen stilistischen Zusammenhänge Kirchners, Noldes, Pechsteins und der Münchener Maler mit dem *Jugendstil* bedeuten jedoch wenig, denn sie haben sie bald überwunden, und allem dekorativen Beiwerk galt ihre Verachtung. Von einer neuen Kunst hatten sie eigene Vorstellung, sie waren eine neue Generation, die andere, noch nicht bekannte Wege beschritt. Sie waren aus dem Goldrahmen gestiegen...' *Plastik und Kunsthandwerk von Malern des deutschen Expressionismus*, exhib. cat., Schleswig-Holsteinisches Landesmuseum, Schleswig 28 Aug.–2 Oct. 1960, pp.15–16.
5. *Pan V*, vol. 4, 1899/1900, pp.261–70.
6. Joseph Mascheck, 'Primitive Authenticity and German Expressionism' in *RES 4*, Autumn 1982, pp.110 ff.
7. Alois Riegl, *Stilfragen. Grundlegungen zu einer Geschichte der Ornamentik*, Berlin 1893, and *Spätrömische Kunstindustrie nach den Funden in Osterreich-Ungarn*, Vienna 1901.
8. '...wir werden finden daß die Karikatur gewißermaßen die Form ist, von der alle objektive Kunst ausgeht. Ein einziger Blick in die ethnographischen Museen belegt diesen Satz...ganz so verfährt das Kind, ganz so der unzivilisierte Wilde. Das Kind...macht seine ersten Zeichenversuche genau wie der erste Menschheitskünstler, es holt die unterscheidenden Merkmale heraus...es unterscheidet, es charakterisiert, es karikiert.' Edward Fuchs, 'Vom Altertum bis zur Neuzeit' in *Die Karrikatur der europäischen Völker*, Berlin 1901, p.4.
9. Kirchner was influenced by the *Simplicissimus* caricaturists Olaf Gulbransson and Hans

Dunnebier,...and by the *Jugend* illustrator Marcus Behmer. See Reinhardt, *Die Frühe Brücke*, pp.102–3. In *Studio* too, we find reductive and abstracted black-and-white woodcut caricatures by Joseph Simson, vol. XXXV, 1905, pp.20ff.

10. For example, August Endell's 1903 statement, 'We stand at the threshold of an altogether new art, an art with forms which signify nothing and represent nothing and which stir us deeply and powerfully as only musical notes can do' (quoted by Selz, *German Expressionist Painting*, pp.55–6). See also Fritz Schmalenbach, *Jugendstil. Ein Beitrag zur Theorie und Geschichte der Flächenkunst*, Würzburg 1935, pp.31–2.

11. 'Wir haben gesehen, daß wir wenig Veranlassung haben die Architektur und das Kunsthandwerk dieser letzterwähnten Zeiten sehnsüchtig und wie hypnotisiert zu bewundern, auch trotzdem vieles daran schön ist. Viel eher noch könnten wir solchen Völkern nachsinnen die verhältnismäßig Ursprüngliches schufen, wie z.B. die ersten Griechen und die Gotiker, oder noch weiter zurück, etwa die alten Wikinger, ja sogar die Wilden der Südseeinseln. Doch auch das ist um keinen Preis zu erstreben, daß wir nun diese Stile uns zu eigen machen sollten. Nein, sondern nur so sollen wir schaffen wie sie schufen, unbewußt, wahr, einfach, wie es ihnen natürlich kam, ohne tausend Anregungen und Ablenkungen.' Hermann Obrist, *Neue Möglichkeiten*, Leipzig 1903, p.96.

12. Also by the generation emerging out of *Jugendstil*, for example, early work by Peter Behrens.

13. Nicolas Pevsner, 'Möglichkeiten und Aspekte des Historismus. Versuch einer Frühgeschichte und Typologie des Historismus', in *Historismus und bildender Kunst. Studien zur Kunst des 19. Jahrhunderts*, vol. I, Munich 1965, p.13.

14. Fritz Bleyl, 'Erinnerungen', in 'Fritz Bleyl, Gründungsmitglied der Brücke', *Kunst in Hessen und am Mittelrhein*, vol. VIII, 1968, p.95.

15. Ibid.

16. 'Vom Symbol des Heiligsten, das in der Kirche Ehrfurcht verbreitete, das über den Menschen stand wie die Gottheit selbst, zu dem sich die Blicke des Trostbedürftigen flehend erhoben und das dem leichtsinnigen Menschenkind die erhabene Würde des Ortes mit überzeugender Eindringlichkeit vorstellte, von diesem Göttlichen ist das Bild zu dem Füllsel des allerflüchtigsten, allernichtigsten Moment der Zerstreuung geworden. Die Kirche hat sich in die Jahrmarktsbude verwandelt, und aus den Betern sind frivole Schwätzer geworden.' Julius Meier-Graefe, 'Einleitung – Die Träger der Kunst früher und heute', in *Die Entwicklungsgeschichte der modernen Kunst*, Munich 1904 (reprinted 1966), p.751, Transl. *Modern Art*, 1908, p.11.

17. Kenworth Moffett, *Meier-Graefe as an Art Critic*, Munich 1973, p.15. For a fuller explanation of these distinctions see also Richard Hamann and Jost Hermand, *Stilkunst um 1900*, Berlin 1967, chapter 2. In the series *Epochen deutscher Kultur von 1870 bis zur Gegenwart*, vol. IV.

18. Georg Simmel, *Philosophie des Geldes*, Leipzig 1900, p.294. Transl. *Philosophy of Money*, 1978, p.206.

19. Ibid. p.488; transl. p.206.

20. Ibid. p.293; transl. p.164.

21. Ibid. pp.495–6; transl. p.213.

22. For an account of the popularity of Simmel's lectures and ideas, see David Frisby, *Sociological Impressionism – A Reassessment of Georg Simmel's Social Theory*, London 1981, p.17. The broad resonance of Simmel's ideas reached down to the daily press too. For example, an article by Ad. Leuchtenberg on Simmel's ideas about sexual difference, 'Persönlichkeit und Sexualbeziehung', appeared in the *Dresdener Neueste Nachrichten*, no. 168, 24 Jun. 1909, p.1.

23. Frisby, *Sociological Impressionism*, chapters 1 and 3, pp.1–33, 68–102.

24. Ettlinger, 'German Expressionism', Martensen-Larson, 'Primitive Kunst' Gordon 'German Expressionism' in *Primitivism in 20th Century Art*, vol. II.

25. A full list of books in Kirchner's library can be found in *E.L. Kirchner, Dokumente*, edited by Karl-Heinz Gabler, Aschaffenburg 1980, pp.353ff. This is a copy of the auction lists from the Galerie Jürg Stuker in Bern, Auction xxiv on 15 Mar. 1951. As Gabler points out, the catalogue entries on this list are very summary and often the date of an edition is not given. Some books and, above all, periodicals were lost when the Kirchner household was broken up following Erna Kirchner's death in 1945. The list gives us an idea, nevertheless, of the impressive range of material in Kirchner's library. Out of the 590 items on the auction list, 65 books relate to Kirchner's interest in travel, ethnography and non-European art. Out of 222 art books, 32 are about non-European art.

26. Postcard from Erich Heckel to Cuno Amiet dated 28 Feb. 1907 (Brücke Museum Archives). Heckel began to correspond with Osthaus in December 1906. In a letter dated 3 Dec. 1906, he approached Osthaus with the offer of a *Brücke* exhibition: 'The modern and, for us, exemplary organization and genuinely artistic direction of the Folkwang Museum, has made us wish to present an exhibition of our works in these beautiful rooms.' ('Die moderne und für uns mustergültige Einrichtung und echt künstlerische Leitung des Folkwangmuseums hat in uns den Wunsch sich regen lassen, in diesen schönen Räumen eine Ausstellung unserer Werke veranstalten zu lassen.') Quoted in *Erich Heckel und Sein Kreis, Dokumente, Fotos etc*, edited by Karlheinz Gabler, Stuttgart 1983, p.50.

27. *Dekorative Kunst*, Jg.3, 1899/1900, pp.139–42, 223–5.

28. Dr Heinrich W. Nettmann writes: 'Under the influence of Van de Velde, Osthaus dropped the idea of setting up a Museum of Natural History and created in his Folkwang Museum a collection of modern French and German art alongside outstanding examples of utensils and objects of daily use from antique times and art from other cultures. This was intended to make life more worth living for people in our times. At the same time it should inspire the artists and craftsmen to learn from the example of these works of art.' ('Die Idee der Errichtung eines naturwissenschaftlichen Museums fallen und schuf in seinem Folkwang-Museum eine Sammelstätte moderner französischer und deutscher Kunst neben hervorragenden Beispielen von Geräten und Gebrauchsgegenständen aus der Antike und der Kunst anderer Kulturen. Er ging dabei von der Idee aus, daß das Zeigen schöner Bilder und Plastiken, von formvollendeten Gebrauchsgegenständen aus alten Kulturen, den Menschen unserer Zeit das Leben lebenswerter machte. Zugleich sollte es den Künstler und Handwerker anregen von diesen.') In 'Osthaus wollte die Gesellschaft veredeln in ihr den Sinn für das Schöne im Leben aufschließen', *Kunst und Wirtschaft – Südwestfälische Wirtschaft*, April 1971, pp.1–3.

29. *Museum Folkwang*, vol. 1, 'Moderne Kunst, Plastik, Malerei, Graphik', Bearbeitet von Dr Kurt Freyer, Hagen 1912, p.5.

30. 'Wir hatten schon gesehen, daß zumal die Abteilung des alten Kunstgewerbes auf das heutige Kunstschaffen vorbildlich wirken soll. Daher ist bei den einzelnen Gegenständen nicht so sehr die Seltenheit und wissenschaftliche Bedeutung betont obgleich auch diese bei vielen nicht gering ist, sondern ihr künstlerischer Anregungswert. Das erste Gesetz dieser Sammlung ist Qualität. Unter Beobachtung dieses Gesetzes wird die Kunst aller Zeiten und aller Weltgegenden in ausgewählten Werken zur Anschauung gebracht.' Paul Vogt, *Das Museum Folkwang in Hagen 1902–1927*, Cologne 1965, pp.33–4.

31. Part 2 of the exhibition catalogue *Sonderbund Westdeutscher Künstler*, Cologne 1912, 'Die Gilde Westdeutscher Bund für Angewandte Kunst', introduction p.80.

32. E.L. Kirchner, letter to Gustav Schiefler dated June 1912 (Schiefler Archive, Hamburg).

33. Kirchner exhibited a necklace and two hand-made coat buttons and Schmidt-Rottluff showed two belt fasteners. The working committee of the Guild included Josef Feinhals, Dr Ernst Gosebruch, Professor Wilhelm Kreis, Dr Friedrich Plietzsch and Karl Ernst Osthaus. All these figures were supporters and associates of *die Brücke*.

34. Schleswig-Holsteinisches Landesmuseum, *Plastik und Kunsthandwerk*. A letter from Kirchner to Heckel dated spring 1910 records that he was making a bracelet for Emy Frisch (Dube-Heynig, pp.238–9). The poster Kirchner and Heckel designed for the *Brücke* exhibition at *Der Neue Kunstsalon* Munich in 1912 (Annemarie and Wolf-Dieter Dube: *E.L. Kirchner. Das graphische Werk*, 2 vols. München 1967 – from now on Dube – H. 71), advertises their fine and decorative art practice: '*Gemälde, Plastik, Grafik, Kunstgewerbe der Neuen Kunst*'. A selection of Schmidt-Rottluff's extensive decorative work was exhibited at his centennial exhibition, Schleswig-Holsteinisches Landesmuseum, summer 1984.

35. *Moderner Unterricht in Malerei.*

36. Advertisements in the catalogue of the *Größe Berliner Kunstausstellung*, 1909 and 1910. The graphic style of these two advertisements is quite different, the second relating to more progressive *Jugendstil* typography.

37. Undated letter from Kirchner to Frau Schiefler before 15 Nov. 1911, when he acknowledges her good luck wishes for MUIM (Schiefler Archives, Hamburg). See also Max Pechstein, *Erinnerungen*, Wiesbaden 1960, p.46.

38. Kirchner attended the Debschitz-Obrist School in the winter semester of 1903–4. The school was founded in 1902 on the model of Charles Rennie Mackintosh's Glasgow Art School, focusing on cooperative ateliers where teacher and pupils worked together. Obrist's essay, 'Eine Methode des Kunstunterrichts', in *Der Kunst*, vol. VII, 1904, pp.288ff. speaks of their ambition to encourage: 'the free individual creative development of each talent, guided by experienced direction' ... 'freie individuelle schöpferische Entwicklung jeden Talentes unter erfahrener Leitung'). Ideally the students' designs were to be realized in industry, and they followed similar ideals to Osthaus, aiming to develop the *Jugendstil* notion of an ideal unity between art and life on a more practical basis. In the summer study trips were made to the Alps.

39. '...Moderner Unterricht in Malerei, Graphik, Plastik, Teppich, Glas-Metallarbeit, Malerei in Verbindung mit Architektur. Unterricht mit neuen Mitteln auf neue Art. Skizzieren nach dem Leben verbunden mit Komposition... Im Sommer Freilicht an der See. Fördernde Korrektur aus der Eigenart des Einzelnen heraus. Das neuzeitliche Leben ist der Ausgangspunkt des Schaffens. Die Konversation gibt Einblick in die neuen Kunstbestrebungen. Anleitung zum Verständnis und Anregung durch

Anschavung und Erleben (auch für Nichtausübende) *Die Werkstatt der Kunst*, vol. VII, 13 Nov. 1911. Other adverts for MUIM appeared in *Der Sturm* March and May 1912 and in Karl Kraus' *Der Fackel*.

40. Letter from Heckel to Schiefler dated 16 Jul. 1914: 'a city like Hamburg without dreadful academic tradition is more suited for the creation of schools of fine art and craft.' ('eine Stadt wie Hamburg ohne die schlimme Schultradition ist zur Schaffung neuer Malerhandwerkschulen geeigneter') (Schiefler Archives, Hamburg). These opinions are related to wider reforms in art education at the beginning of the century. An article in *Kunstwart*, 19 Jun. 1904. advocates a new contact between art and life. In 1909, an art education conference in Dresden concentrated on the relation of art and industry, and we find the seeds of the Bauhaus paradox in these years, i.e. the simultaneous promotion of handwork on the one hand and industrial design on the other. See *Kunstschule-Reform 1900–1933*, exhib. cat. Bauhaus-Archiv, Berlin 1977.

41. John Griffiths, *The Paintings in the Buddhist Cave-Temples of Ajanta, Khandesh India*, London 1896, Cave X, plate 42. Kirchner's drawing in pencil and watercolour (34.5 × 17.5, 34.5 × 13cm) is now in the Bündner Kunstmuseum, Chur. The drawing has previously been wrongly described as a copy of a Kuniyoshi print, see *Ernst Ludwig Kirchner und seine Schüler im Bündner Kunstmuseum Chur*, exhib. cat. Feb.–Apr. 1980. M. Gersprach's illustrated book, *Les Tapisseries coptes* (first edition 1890, Kirchner's edition undated in the auction list), was in Kirchner's library. The drawings he attached to the pages of this book were certainly made later during his Swiss years (1917–36) when he was designing textiles to be executed by Lise Gujer in Davos. But the MUIM Institute table cloth is the first sign of this later important influence on Kirchner's decorative work.

42. André Warnod's review 'L'Art Nègre' in *Comoedia*, 2 Jan. 1912, suggested that tribal art might soon replace Greek art in training young artists. Other items of decoration in the MUIM studio include a reproduction of Picasso's *The Friends*, 1904, and an erotic relief in clay by Kirchner.

43. Osthaus began to purchase duplicates from the Hamburg Art and Crafts Museum after 1902. He bought a Buddha from the Louvre in 1904, and in 1909 he made purchases too from the Museum for Decorative Arts in Cologne. He built up an international network of contacts with dealers in non-European, specifically Far Eastern art at the beginning of the century. In 1906 he purchased Oriental and Syrian objects from Samuel Bing in Paris; in Amsterdam he made purchases from the firm Van Veen and Co., importers of Japanese and Chinese 'curiosities'. In Berlin he was in touch with Rex and Co. (Japanese and Chinese goods), and in Hamburg Koltzmann and Saenger provided Oriental goods. Often dealers in European art would also offer Osthaus Japanese prints etc. (correspondence in Karl Ernst Osthaus Museum archives, Hagen).

44. Jean-Louis Paudrat's, 'From Africa', in *Primitivism in 20th Century Art*, p.144, claims that Osthaus' connections with the Paris dealers in tribal art came via Carl Einstein and Hans Purrmann. Correspondence in the Osthaus archives does not support this thesis. In August 1912, Karl Brummer sought out Osthaus in Paris, via the Oriental specialist Karl With, and in September they corresponded about a selection of objects, including a Mexican mask and an Alexandrian athlete in terracotta. Osthaus purchased a trunk of objects, and in October Brummer

offered to send a second selection to Hagen for Osthaus to chose from (correspondence in Osthaus archives 24 Aug. 1912–10 Oct. 1912.) In September 1912, Paul Guillaume too approached Osthaus when he learnt from Archipenko that the Hagen collector wished to acquire some 'negro' sculptures. He sent Osthaus photos of ten objects offerering a wholesale price of 1,200 francs. Typically, Osthaus wrote back that he may be prepared to buy one or two pieces for a reasonable price. (correspondence Osthaus archives 9 Sep.–19 Oct. 1912.) The most important purchase of African sculpture was from J.F.G. Umlauff in 1914. Umlauff's Ethnographic Institut in Hamburg was both a private museum and a commercial gallery. Osthaus was put in touch with Umlauff by August Macke, who had collected the ethnographic material for the *Blaue Reiter Almanach* in 1911/12, and began his own collection in 1912. In 1913, Umlauff offered Osthaus, first of all, Far Eastern goods (from China and Tibet), and then, in February 1914, a major collection of African pieces from a Frobenius expedition to West Africa, which entered the Folkwang in April 1914. In March, Umlauff offered ten pieces for 3,500 marks, and, in April, he agreed to a price of 3,000 marks cash for eleven pieces. From May to July 1914, an exhibition of new acquisitions at the Folkwang Museum included the Frobenius collection, (correspondence Osthaus archives, 9 May 1913–10 Apr. 1915).

45. Undated manuscript – a guide by Osthaus to the Folkwang collection *c*.1911. See Vogt, *Museum Folkwang*, pp.30–4.

CHAPTER 2. THE EXPRESSIONISTS' REDEFINITION OF *JUGENDSTIL*

1. Bleyl, 'Erinnerungen' p.93.
2. Fritz Schumacher, 'Aus der Vorgeschichte der Brücke', *Der Kreis*, vol. IX, Jan. 1932, p.10.
3. Ibid, p.8.
4. Bleyl, 'Erinnerungen', p.95.
5. E.L. Kirchner, *Chronik der Brücke*, 1913. Reprinted in *Ernst Ludwig Kirchner 1880–1938*, exhib.cat. Nationalgalerie Berlin, Nov. 1979–Jan. 1980, p.66. (Hereafter *ELK*)
6. See Dr Ernst Zimmerman, 'Typisches und Neues in der Raumkunst auf der 3. Deutschen Kunstgewerbe-Ausstellung in Dresden', exhib.cat. 3. *Deutsche Kunstgewerbe-Ausstellung Dresden 1906, Architektur, Wohnungs-Kunst und Kunstgewerbe, Einzel-Erzeugnisse*, Darmstadt 1906, pp.747ff.
7. The *Blaue Reiter Almanach*, Munich May 1912, which includes Kandinsky's play *Der gelbe Klang* (*The Yellow Sound*), is the fullest realization of these ambitions.
8. Schumacher, 'Vorgeschichte der Brücke', p.11.
9. *Kunstwart*, August 1906, pp.458ff.
10. Pechstein, *Erinnerungen*, p.22.
11. 'Eine Neuerung hinsichtlich der Wandbehandlung hat eigentlich nur Peter Behrens versucht. Von minderer Bedeutung ist hierbei, daß er in seinem großen Musiksaal zu denkbar einfachsten und primitivsten Wandmalerei zurückgekehrt ist, zumal jene hier angewandte rein geometrische Ornamentik doch gar zu wenig von jener göttlichen Gabe zeugt, die man im gewöhnlichen Leben Phantasie zu nennen pflegt. Der wirkliche Künstler jedoch wird in ihr ein neues Hilfsmittel zu freier künstlerischer Gestaltung erblicken... Zimmerman', 'Typisches und Neues', p.755.
12. Bleyl, 'Erinnerungen', p.96.
13. For the early history of *die Brücke*, and a descrip-

tion of their exhibiting activities before the Seifert factory event see Reinhardt, *Die Frühe Brücke*, pp.56ff.
14. Bleyl, 'Erinnerungen', p.94.
15. Ettlinger, 'German Expressionism', p.95. He refers to the article by C. Praetorius, 'The Art of New Guinea', *Studio*, vol. XXX, 1903, pp.51ff.
16. Reinhardt, *Die Frühe Brücke*, p.83.
17. See chapter 1, note 38.
18. Bleyl, 'Erinnerungen', p.94. Bleyl also mentions '*H. Knackfüßchen's Künstlermonographien*' as a source for their knowledge of '*Weltkunst*'. He refers to Fr. Perzynski's book *Hokusai*, Leipzig 1904, Künstler-Monographien, vol. LXVIII, edited by H. Knackfuß. This was the only book in the series on non-European art. It contains 97 illustrations with 6 colour plates. In the *Studio* there was a rush of articles on non-European art in 1903 and 1904; for example: 'Japanese Flower Painting', *The Studio*, vol. XXXI, 1904, pp.191ff, 'Tibetan Art', by Mrs. Le Mesurier, ibid, pp.294ff, 'Primitive Art as exemplified in Tobacco pipes', ibid, vol. XXXIII, 1904, (15 illustrations); 'Art in the Solomon Islands', by C. Praetorius, ibid, vol. XXXIV, 1905, pp.118ff. Before and after this date articles appear much less frequently. This would support the hypothesis that Kirchner first sought out non-European art in the Dresden ethnographic collection in 1904, inspired by discussion in the decorative arts movement. There were also articles on folk art, for example, 'Austro-Hungarian Peasant Furniture,' In *Studio*, vol. XXXIX, 1906, pp.224ff. *Kunstwart* contained monthly articles reviewing newly published ethnographic and travel literature in the years 1903–6.
19. The *Studio*, as above. *Studio* also published illustrations of Western paintings drawing stimuli from non-European societies in a romantic vein. For example, George Henry, *The Samisen Player*, vol. XXXI, 1904, p.11. Anders Zorn, *An Algerian Interior*, vol. XXXI, 1904, p.105. Irving Coase, *Roasting Corn*, vol. XXXV, 1905, p.143. This painting depicts a romantic Red Indian scene, possibly inspired by Karl May's Winnetou novels.
20. 'Eines Tages erschien er (Kirchner) in meinem Amtzimmer, breitete eine Mappe mit den farbigen Zeichnungen zu einem ganz extravagantem modernen Innenraum vor mir aus und eröffnet mir, das sei seine Doktorarbeit. Er bäte mich nun das weitere zu veranlassen damit er diesen Titel bekäme. Ich musste ihm auseinandersetzen, daß nicht ein künstlerischer Entwurf, sondern eine wissentschaftliche Arbeit die Vorbedingung zum Doktorexamen sei, was ihn, glaube ich, sehr empörte. Er ließ durchblicken, daß die zivilisierte Welt nichts als Entäuschungen böte und nur noch bei primitiven Menschen einige Erholung zu treffen sei. Ich erinnere an Gauguin. Er nahm das so ernsthaft auf, daß ich bei seinem Fortgang einen Aufbruch aus Europa mit Sicherheit erwartete.' Schumacher, *Vorgeschichte der Brücke*, p.10.
21. An advert in the *Dresdener Anzeiger*, 2 Feb. 1910 states that entry to the museum was free. For details of the *Brücke* artists earliest lodgings in the American quarter in Dresden close to the old Technical University see Bernd Hünlich, 'Wohnstätten und Lebensumstände der vier *Brücke*- Gründer in Dresden, zum 80. Gründungstag der Künstlergruppe am 7. Juni', *Dresdener Kunstblätter*, no. 3, 1985, pp.8off.
22. Reinhardt, *Die Frühe Brücke*, p.23. Originally published in Leopold Reidemeister, *Künstler der Brücke, Gemälde der Dresdener Jahre 1905–11*, exhib.cat. Brücke Museum, Berlin 1973, p.5.

23. Emil Nolde, *Jahre der Kämpfe*, Berlin 1934, pp.90–1. (Hereafter *JDK*.)

24. Heckel to Cuno Amiet, 6 Sep. 1906 (Brücke Museum Archives).

25. Heckel to Amiet, 12 Oct. 1906 (Brücke Museum Archives).

26. Schmidt-Rottluff to Amiet 24 Dec. 1908 (Brücke Museum Archives).

27. Meier-Graefe, 'Einleitung', *Die Entwicklungsgeschichte*, pp.636–45.

28. J. Fineberg, introduction to the facsimile edition of *Les Tendances Nouvelles*, 4 vols, N.Y. 1980, pp.v ff.: 'The Parisian review, *Les Tendances nouvelles* emerged in May 1904 as part of an ambitious enterprise, consisting not only of a periodical, but of a gallery, an exhibition society and an international artists' cooperative with explicitly Utopian ideals.'

29. Letter from Nietzsche to Erwin Rohde 15 Dec. 1870. See *Friederich Nietzsche, Briefe April 1869 – Mai 1872, Kritische Gesamtausgabe*, ed. Giorgio Colli and Mazzino Montinari, vol. I, Berlin and New York 1977, pp.165ff.

30. August Strindberg, *The Cloister*, ed. C.C. Bjurström, transl. with commentary and notes by Mary Sandbach, London 1969, p.131.

31. Reinhardt, *Die Frühe Brücke* p.18. In a letter to Ernst Beyersdorff dated Berlin 13 May 1913, Schmidt-Rottluff wrote, 'I am pleased to hear that you're reading Strindberg, I admire this unusual genius very much.'

32. '...In älteren Kulturen arbeitet der Künstler für einen kleinen Kreis von Menschen, die traditionell die Kunst pflegten und das Verständnis für sie geschult hatten; heute arbeitet er für eine breite, unbestimmte Masse, in der vielleicht ein allgemeines Empfinden schlummert, aber der entscheidende Sinn für die Qualität der subjektiven und objektiven Leistung unmöglich entwickelt sein kann. Diese unglückliche Situation spiegelt sich letzten Endes auch in der wirtschaftlichen Lage der Kunst. Noch nie standen sich Künstlerschaft und Publikum so fremd gegenüber wie Heute – und noch nie trug die Durchschnittskunst so sehr ein Stempel einer Massenproduktion.' Georg Swarzenski, 'Künstler und Kunstpreise' *Deutsche Kunst und Dekoration*, 1911/12, pp.370–82.

33. Dr A. Halbe, Munich, 'Gedänken und Vorschläge zur Durchführung einer wirtschaftlichen Organization der Künstlerschaft', *Werkstatt der Kunst*, vol. XXXVIII, 1913, pp.523–5.

34. Lists of the non-active members of *die Brücke* can be found in Hans Bolliger and E.W. Kornfeld, *Ausstellung Künstlergruppe Brücke Jahresmappen 1906–1912*, exhib.cat. Kornfeld und Klipstein Bern, 19–27 Oct. 1958. See also, *Maler suchen Freunde. Jahresmappen, Plakate und andere werbende Graphik der Künstlergruppe Brücke*, exhib. cat. Wallraf-Richartz Museum, Cologne 26 May – 25 Jul. 1971.

35. Letter from Schmidt-Rottluff to Nolde. See chapter 2 note 23 above.

36. Pechstein, *Erinnerungen* p.23.

37. Reinhardt, *Die Frühe Brücke*, p.83.

38. *Ver Sacrum*, vol. I, 1898, pp.52ff. See Reinhardt, *Die Frühe Brücke*, p.87.

39. ed. Giorgio Colli and Mazzino Montinari, *Nietzsche Werke – Kritische Gesamtausgabe*, Berlin 1968, vol. VI, 'Also Sprak Zarathustra', 1883–5, *Von der drei Verwandlungen*, p.27. Transl., *Thus Spoke Zarathustra*, London 1961, p.55.

40. See in particular Reinhardt, *Die Frühe Brucke*, pp.28ff.

41. 'Der Mensch ist ein Seil, geknüpft zwischen Tier und Übermensch – ein Seil über einem Abgrunde. Ein gefährliches Hinüber, ein gefährliches Auf-dem-Wege, ein gefährliches Zurückblicken, ein gefährliches Schaudern und Stehenbleiben. Was groß ist am Menschen, das ist, daß er eine *Brücke* und kein Zweck ist: was geliebt werden kann am Menschen, das ist, daß er ein *Übergang* und ein Untergang ist.' *Zarathustra*, p.11; transl., p.44.

42. Interview with Erich Heckel by Hans Köhn in *Das Kunstwerk*, XII, vol. III, 1958/9, pp.24ff: 'Schmidt-Rottluff said we could call ourselves *Brücke* – that is a multi-levelled word and it would not involve a programme but, in a certain sense, would lead one from one shore to the other. It was clear to us what we had to leave behind – where we hoped to arrive was a lot less clear.' In his *Davoser Tagebuch*, p.74, Kirchner too recorded that Schmidt-Rottluff had invented the name. Bleyl, 'Errinerungen', p.96, attributed the invention to Heckel.

43. Reinhardt, *Die Frühe Brucke*, p.24.

44. 'Als Zarathustra aber allein war, sprach er also zu seinem Herzen. Die Frühe alte Heilige hat in seinem Walde noch nichts davon gehört, daß Gott todt ist!... Alle Wesen bisher schufen etwas über sich hinaus: und ihr wollt die Ebbe dieser grossen Fluth sein und lieber noch zum Thiere zurückgehen, als den Menschen überwinden?... Einst wart ihr Affen, und auch jetzt noch ist der Mensch mehr Affe, als irgend ein Affe.' *Zarathustra* (Preface 2–3) p.8, transl. pp.41–2.

45. Many examples of this type of article can be cited in the Dresden and Berlin press. For example, 'Die Zukunft Indiens', *Dresdener Illustrierte Neueste*, 8 May 1909, 'Das moderne Japan', *BIZ 39*, 25 Sep.1910.

46. *Dresdener Anzeiger*, 116, 28 Apr. 1910, p.6. Photo in *BIZ 22*, 29 May 1910, p.423.

47. *Dresdener Anzeiger*, 245, 5 Sep.1910, p.2.

48. See, for example, the articles, 'Vom Kannibalismus zum Parliamentarismus. Die Entwicklung Neuselands in den letzten 50 Jahren', *BIZ 9*, 26 Feb. 1911. 'Der Aufstieg der farbigen Rassen. Neger und Indianer in hervorragenden Stellungen in Amerika', *BIZ 5*, 2 Feb. 1913. 'Civilization' is seen as a positive force in these instances, from the point of view of a colonial power. But, in the case of Brant-Sero, much was made of his 'natural' wisdom, which survived the material changes in his society: 'for him Nature is an open book. He remains in constant communion with nature, his receptive powers are always sharp. Great imaginative powers accompany him through life' ('ihm ist die Natur ein offenes Buch. Er bleibt in unaufhörlicher Gemeinschaft mit der Natur, seine Wahrnehmungskraft ist stets scharf. Große Macht der Phantasie begleitet ihn durch sein Leben' (*Dresdener Anzeiger*, 116). In this sense he could readily be idealized by modern society.

49. *BIZ 13*, 31 Mar. 1912, p.266.

50. Reinhardt, *Die Frühe Brücke*, p.26. See also L. Reidemeister, *Künstlergruppe Brücke, Fragment eines Stammbuches*, Berlin 1975.

51. *Zarathustra* (Preface 3–4) p.11; transl., p.44. Reinhardt *Die Frühe Brücke*, p.30.

52. Wilhem F. Arntz, 'Die Künstlergruppe Brücke 1905–1913', in *Paula Modersohn-Becker und die Maler der Brücke*, exhib.cat., Bern 1948, p.7.

53. Kirchner to Heckel 22 May 1910 (Altonaer Museum Archive, Hamburg). See Dube-Heynig, p.245.

54. Lucius Grisebach, 'Kirchner und Cranach', in *E.L. Kirchner Aquarelle, Zeichnungen und Druckgraphik aus dem Besitz des Städel Frankfurt am Main*, exhib. cat, Wissenschaftszentrum Bonn- Bad Godesberg, 18 Apr.–1 Jun. 1980, p.39.

55. Schulte-Sasse, 'Modernism versus Theory', p.35.

CHAPTER 3. THE *BRÜCKE* STUDIOS: A TESTING GROUND FOR PRIMITIVISM

1. Donald Gordon, 'Kirchner in Dresden', *Art Bulletin*, vol. XLVIII, 1966, pp.335–66. Here pp.354–5: 'there is in fact no evidence to indicate Kirchner's creative interest in non-Western sculptural sources before the year 1909. And even in that year Kirchner's concern for primitive art is directed as much towards the creation of studio draperies and furniture.'

2. Ibid, p.355.

3. Mark Roskill, *Van Gogh, Gauguin and the Impressionist Circle*, London 1970. See in particular chapter 3, 'The Japanese Print and French Painting in the 1880s', pp.57ff: 'The term "Japonaiserie" is the equivalent, for Japan, of the better known term "Chinoiserie". It means an interest in Japanese motifs because of their decorative, exotic or fantastic qualities. The kind of response which it aims to elicit is purely and simply a matter of imaginative or wishful association. "Japonism", on the other hand, means the incorporation into Western art of devices of structure and presentation which match those found in actual Japanese works.'

4. 'Was heißt überhaupt 'dekorative'? Je mehr die Kunst fortschreitet, je mehr fällt diese Unterscheidung und damit die Verächtlichmachung gewisser Kunstwerke, die praktischen Zwecken dienten. Es geht heute fast ins Gegenteil über, nämlich daß man die (Notwendigkeit) und die (Berechtigung) dekorativer Kunst leugnet. Die Primitiven aller Völker aber kannten überhaupt nur diese Kunstarten, da ihnen der Platz zu anderen fehlt, das Haus, der Raum.' *Davoser Tagebuch*, p.180.

5. See, for example, Erika Billeter, 'Ernst Ludwig Kirchner: Kunst als Lebensentwurf', *ELK*, pp.16ff.

6. Bleyl, 'Erinnerungen', p.93.

7. See Bernd Hünlich, 'Heckel und Kirchner auf der Berlinerstrasse in Dresden,' *Dresdener Kunstblätter*, Staatliche Kunstsammlungen Dresden, 27, 1983, vol. IV. In an interview with Bernd Hünlich 30 Mar. 1987, he showed me the Berlinerstraße premises and expressed some doubt about Heckel's attic rooms in no. 65. His parents lived on the first floor of the large house belonging to the railway.

8. Reinhardt, *Die Frühe Brücke*, p.35.

9. *Das Kunstwerk*, 1958/9 p.24ff.

10. Buchheim, *Die Künstlergemeinschaft*, p.65.

11. Hans Bolliger and Georg Reinhardt, 'Ernst Ludwig Kirchner eine biographische Text-Bild-Dokumentation', *ELK*, pp.54–5.

12. Bleyl, 'Erinnerungen', p.99.

13. Bolliger-Reinhardt, '*ELK*', p.51. Köhler-Haußen's report, 'Etwas von Dresdener Kunst' was originally published in the *Dresdener Jahrbuch*, 1908.

14. 'Er hatte sich in einer Vorstadtstraße Dresdens, der Not gehorchend, ein seltsames Atelier gemietet: einen engen Krämerladen, der sich mit einer großen Scheibe nach der Straße öffnete und neben dem ein kleines Gemach als Schlafraum diente. Diese Räume waren phantastisch ausgestattet mit bunten Stoffen, die er selbst in Batiktechnik gemustert hatte, mit allerlei exotischem Gerät und mit Holzschnitzereien seiner eigenen Hand: eine primitive, aus der Not geborene aber doch von stark ausgeprägtem eigenem Geschmack getragene Umgebung. Er hauste hier in einer nach bürgerlichen Begriffen ungeregelten Lebensweise, materiell einfach, aber in seinem künstlerischen Empfinden anspruchsvoll. Er

arbeitete fieberhaft, ohne sich an die Tageszeiten zu kehren...Jedem, der mit ihm in Berührung kam, mußte dieses gänzliche Aufgehen in seinem Tätig-keitsdrange die stärkste Anteilnahme erwecken und einen Begriff von wahrer Künstlerschaft geben.' Gerhard Schack, ed. *Postkarten an Gustav Schiefler*, Hamburg 1976, p.80.

15. ELK, p.66.

16. Letter in Altonaer Museum Archives. Photo re-printed in Karlheinz Gabler ed. *Erich Heckel und sein Kreis – Dokumente Fotos Briefe Schriften*, Stuttgart and Zurich 1983, p.60.

17. Heckel to Amiet 30 Jan. 1908 (Brücke Museum Archives). Matisse's text first appeared in *La Grand Revue*, December 1908, pp.731–45, and it was translated into German in *Kunst und Künstler*, December 1909, pp.333ff. Unfortunately the letters Amiet sent to the *Brücke* artists have not survived. See, *Cuno Amiet und die Maler der Brücke*, exhib. cat., Kunsthaus Zurich, May–August 1979.

18. Zimmerman, 'Typisches und Neues', p.747.

19. 'Gauguin bewundere ich sehr – ich habe ja von ihm einige wunderschöne Bilder – Folkwang Museum – gesehen. Kennen Sie die indischen Freskomalereien in buddhistischen Grabtempeln? Es existiert eine sehr...Ausgabe mit Fotographien wiedergegeben von Griffith...Ich habe es vor nicht langer Zeit in einer Bibliothek hier entdeckt. Es sind sehr gute Werke'. Heckel to Amiet 30 Jan. 1908 (Brücke Museum Archives). Heckel refers to J. Griffith, *The Paintings of the Buddhist Cave Temples of Ajanta Khandesh India*, London 1896/7. Kirchner sketched the same group of figures in spring 1911.

20. Heckel to Amiet 27 Apr. 1909 (Brücke Museum Archives).

21. Gordon, 'Kirchner in Dresden', p.357.

22. *Kunst und Künstler*, 1908, p.153. This reproduc-tion was in black and white, and Kirchner must have been familiar with the colours of the painting.

23. Gordon, 'Kirchner in Dresden' p.356, note 124. Gordon also suggests that Gauguin's *Ta Matete* (1892), influenced Kirchner's lithograph *Bathing Bohemians* (1911), but I find this a less convincing comparison. This extensive exhibition of Gauguin's work was reviewed in the *Dresdener Anzeiger*, 256 (16 Sep. 1910) and *Dresdener Neueste Nachrich-ten*, 247 (11 Sep. 1910). The latter review states that the exhibition was identical to that shown in Munich in August 1910, for which a catalogue survives. Nevertheless, the German titles in this catalogue hinder a positive identification of the paintings. Gauguin's *Manao Tupapau* (1892), was definitely included in the exhibition under the title, *The Evil Spirit*. Klaus Lankheit suggests that Franz Marc based his *Reclining Nude with Flowers* (1910) on this Gauguin painting (*Franz Marc, sein Leben und seine Kunst*, Cologne 1976, figs. 20 and 21). Donald Gordon's suggestion that Marc's *Reclining Dog* (1911) is a further variation on Gauguin's composition is somewhat far-fetched ('Content by Contradiction', *Art in America*, December 1982, pp.76ff).

24. See Gordon, 'Kirchner in Dresden' appendix one for details of Kirchner's Ajanta drawings. Dube-Heynig (p.276) suggests that Kirchner began to sketch from the book in spring 1911, rather than autumn 1910.

25. Kirchner to Heckel, 31 Mar. 1910 (Altonaer Museum Archives). Dube-Heynig, pp.235/6.

26. *Ernst Ludwig Kirchner*, exhib.cat. Galerie Wolf-gang Ketterer, Munich 6 Sep.–26 Oct. 1985, pp.162–3. See also Donald A Rosenthal, 'Two Motifs from Early Africa in Works by Ernst Ludwig Kirchner', *Abhandlungen und Berichte des Staat-lichen Museums für Völkerkunde Dresden*, vol.

XXXV, 1976 pp.169–71, and Gordon, 'German Ex-pressionism' p.375.

27. Kirchner to Heckel (Altonaer Museum Archives). Dube-Heynig, pp.249/50 suggests a date of June 1910.

28. Kirchner to Heckel, 20 Jun. 1910 (Altonaer Museum Archives). Dube-Heynig, p.255.

29. Kirchner to Heckel, 5 Jan. 1911 (Altonaer Museum Archives). Dube-Heynig p.259. The eskimo bone carvings are from the Berlin Ethnographic Museum inventory nos. Sammlung Jacobsen IVA 3243 (853) and IVA 5858.

30. Kirchner to Heckel, 26 Jun 1912 (Altonaer Museum Archives). Dube-Heynig, p.233. I have not been able to find an exact source for this drawing, although the figure is similar to a Cameroon figure without an accession number in the Berlin collec-tion. See Kurt Krieger, *Westafrikanische Plastik 1*, Museum für Völkerkunde Berlin 1978, cat.no. 145, fig. 31.

31. Postcard from Kirchner to Heckel, 6 Sep. 1909 (Altonaer Museum Archives). Dube-Heynig p.217. Dube-Heynig now suggests this woodcut 1909. Perhaps the romance for a 'primitive' life style was inspired by the Sudanese show in the zoological gardens that spring (see note 35). Also at the Galerie Emil Richter in June 1909 an exhibition 'Landscapes and Animal Paintings From our African Colonies' by Wilhelm Kühnert-Berlin overlapped with the beginning of the *Brücke* show there (*Dresdener Neueste Nachrichten*, 13 Jun. 1909, p.2).

32. Frank Tiesler, 'Hausbalken von den Palau-Inseln', *Kleine Beiträge aus dem Staatlichen Museum für Völkerkunde Dresden*, no. 4, 1981, p.3ff.

33. A collection of Marshall Islands and Caroline Is-lands objects entered the Museum in 1892, and a collection from the Gilbert Islands was acquired in 1906. An early collection from the Sepik River region in New Guinea was aquired for the museum in 1909. An excellent selection of New Ireland sculpture was in the museum by 1897, including an elaborate *Festschnittwerk Seelenboot* (Parkinson 1897). Sculpture from Easter Island (Weißer 1882, Webster 1896, Pöhl 1881). The Palau collection, acquired from Semper in 1881, included a ship as well as the beams, and numerous smaller objects. There was no gable figure in Dresden comparable to that in the Berlin Ethnographic Museum in Dresden.

34. Postcard from Erich to Manfred Heckel, 11 Aug. 1910 (Altonaer Museum Archives). This postcard depicts two boomerang throwers. Heckel to Rosa Schapire, 2 Oct. 1909 (Altonaer Museum Archives) shows an archer motif. Karl May's Red Indian adventure stories about Winnetou reached a peak of popular acclaim in 1911. May lived and worked in Radebeul near the Moritzburg lakes. In 1909 Max Slevogt illustrated May's *Lederstrumpfs Erzählungen* with a series of lithographs.

35. In the *Dresdener Rundschau 1*. May 1909, p.10 we read: 'with the arrival of Marquardt's Sudanese troop the things worth seeing at our zoological gardens have been enriched by an interesting ethnographic show. The great interest which the little exotic people excite is to be seen in the numer-ous visitors at the first show, despite the wet weath-er. This offered the spectators in an edited form a vivid picture of the customs, activities and genuine artistic talent of the Sudanese. A simultaneous exhibition of ethnographic objects is well worth a visit ('mit dem Einzug der Marquardtschen Sudanesentruppe werden die Sehenswürdigkeiten unseres zoologischen Gartens um eine interessante Völkerkundliche Schaustellung bereichert. Wie groß das Interesse ist, das man dem exotischen

Völklein allgemein entgegenbringt, bewies der trotz des regnerischen Wetters recht zahlreiche Besuch der Eröffnungsvorstellung, die den Zuschauer in gedrängter Form ein anschauliches Bild von den Sitten, Gebräuchen und Kunstfertigkeiten der Sudanesen entrollte. Mit der Schaustellung ist eine gleichfalls sehr besuchenswerte ethnographische Ausstellung verbunden'). A photograph of the Sudanese natives appeared in the *Dresdener Salonblatt*, Jg. 4, 1909 no.20. The attractions at the Samoan show in September included 'Prince Tamasese with Family...Houses and Boats ...Weapons and Instruments. Performances on Water and Land... The Sensational Water Slide.' In the evenings slide shows about Samoa were given and a feast with 'roast pig' was staged which proved to extremely popular (*Dresdener Anzeiger* 1, Oct. 1910, p.12 and 5 Oct. 1910, p.2. In the *Dresdener Neueste Nachrichten*, 8 Sep. 1910, p.3. we read of a crowd which broke into the enclosure where the Samoan natives were performing. Again, the report speaks of the valuable ethnographic ob-jects displayed on the sight.

36. Dube-Heynig, p.244. In a letter from Kirchner to Botho Graef, dated 21 Sep. 1916, he described his earliest experiences in Frankfurt am Main, men-tioning his memories of 'foreign people at the Zoo'. He also claims in this letter to have discovered the ethnographic collection in Dresden before his study trip to Munich. (Reprinted in *Gabler, E.L.K. Dokumente*, p.20). Quite probably Kirchner's memories of Frankfurt were inexact. He was six years old at the time.

37. Karlheinz Gabler, *Ernst Ludwig Kirchner, Zeich-nungen, Pastelle, Aquarelle*, Aschaffenburg 1980, pp.88–9.

38. *Dresdener Salonblatt*, no. 34, 20 Aug. 1910, p.1008. This exhibition included Oceanic, African and Chinese art.

39. Altonaer Museum Archives, Dube-Heynig, pp.56/7.

40. Information from Dr Frank Tiesler, 20 Mar. 1987.

41. Photographs in *E.L.K. Dokumente*, pp.65, 66, 69, 71. See also Hünlich, 'Heckel und Kirchner', 1983.

42. An undated letter Kirchner to Frau Schiefler (Schiefler Archive Hamburg) records that he brought the divan from Dresden.

43. Kirchner's coloured lithograph, *Picknik der Baden-den*, 1909 (Dube L. 119), shows a very similar style.

44. Gordon, 'Kirchner in Dresden', p.347. In reviews of the exhibition sixteen works are mentioned by Marquet, Van Dongen, Vlaminck, Puy, Guerin, and Friesz. It is hard to identify exactly the paintings on view, but Gordon makes some convincing sugges-tions. Gordon remarks on an important stylistic shift in Kirchner's work, under the influence of this Fauve show. As we shall see in chapter 6, the subjects of Van Dongen's paintings in particular were also influential.

45. Dube-Heynig, p.229.

46. Ibid, fig.246, p.228.

47. The Indonesian collection was aquired by Arthur Baessler at the turn of the century. It included more than 160 Wayang-Figures for a complete shadow puppet show.

48. This photograph of Ernst von Wolzogen's Buntes Theater, 1901–2, portrays a Javanese puppet show in action. Illustrated in R.O.W. Rösler, *Kabarett-geschichte*, East Berlin 1977, p.38. Pechstein's post-card to Heckel dated 19 Jan. 1910 (Altonaer Museum Archives), depicting 'head of a woman and an exotic sculpture', shows a shadow puppet behind an urban woman's head. The style is very similar to the curtain rondels.

49. *BIZ*, 46, 13 Nov. 1910.

50. *Davoser Tagebuch*, p.85.

51. Martensen-Larsen, 'Primitive Kunst', pp.93ff. These photographs are reproduced in *E.L.K. Dokumente*, pp.69, 65.

52. Dube-Heynig, p.284. Heckel's *Seated Children* (Vogt 1910/10) is obviously very closely related to this photograph of the studio. Probably it was painted on the same day that the photograph was taken.

53. Karlheinz Gabler, 'Die Gemälde Ernst Ludwig Kirchners', exhib.cat. *Ernst Ludwig Kirchner*, Düsseldorf Kunsthalle, Sep.–Oct. 1960. No record of the colours used survives, and Gabler draws this conclusion from the paintings and graphics depicting the studio space. In fact the bright colours of the *Brücke* paintings come closer to the Palau beams in the Berlin Ethnographic Museum than the softer more muted colours of the Dresden beams, where pure vegetable dyes are used.

54. Heckel to Kirchner, 3 Jan. 1911 (Altonaer Museum Archives).

55. Heckel to Maschka Mueller, 9 Jan. 1911, 2 Feb. 1911 and 25 Feb. 1911 (Altonaer Museum Archives).

56. Heckel to Sidi Riha, 7 Nov. 1911 (Altonaer Museum Archives). Heckel moved to Berlin in November 1911.

57. Berndt Hünlich's attempts to discover the exact identity of Sam and Milli have not – as yet – proved fruitful. Gabler's information about Dresden is not altogether reliable, but he suggests that they came from the circus. A photograph in the *Dresdener Illustrierte Neueste*, 22 Jan 1910 depicts a boxer Sam Macrea. This is a possible but not firm identity for Sam at least.

58. Dr Rosa Schapire, *Monatshefte der Kunstwissenschaftlichen Literatur*, vol.II, Hamburg 1906, pp.92–3. She also reviewed Conrado Ricci's *Kinderkunst*, 1906 in ibid. vol.III, 1907, p.113.

59. The most obvious example of this is the postcard drawing from Kirchner and his Dresden girlfriend Doris (Dodo) to Heckel, 2, Nov. 1910, (fig.48) (Altonaer Museum Archives). The mask-like face with scribbled 'Ajanta' contours and awkward child-like style would seem to refer to a combination of Kirchner's current primitivist interests. But Dube-Heynig suggests that this is a postcard drawing by Doris, not Kirchner, hence the awkward style, and that the contours refer to Kirchner's own corrections (p.276). The unusual style here supports her theory and should warn us against springing to too hasty conclusions.

60. Will Grohmann, *Ernst Ludwig Kirchner*, Munich 1958, p.32.

61. Heckel postcard to Rosa Schapire, 18 Feb. 1910 (Tel Aviv Musueum), depicts two nude young girls with bows and arrows: 'Two Sisters who I discovered recently here'.

62. *Blaue Reiter Almanach*, 1967 (1912), pp.59, 134–5.

63. Altonaer Museum Archives, Dube-Heynig, p.238.

64. See Kirchner's *Seated Franzi* (1910/20; G.123) and *Franzi*, 1911; G.174.

65. *Symboles et réalités, le peinture allemande 1848–1905*, exhib.cat. Musée du Petit Palais Paris, 12 Oct. 1984–13 Jan. 1985, cat.no.46, p.159.

66. Heckel's Tanzanian mask appears in his *Still Life with Blue Vase* (Vogt 1910/3) and *Still Life with Mask* (Vogt 1912/48). The mask is in the Heckel estate in Hemmenhofen.

67. Dube-Heynig, p.260.

68. In a surviving photograph (Gabler, 1983 p.79) we see Sidi trying to imitate the dancing style of Nelly, their negress friend. The scene takes place in front of another African textile.

69. Reinhardt, *Die Frühe Brücke*, p.147.

70. See Christina Farese-Sperken, 'La Danse di Matisse e l'arte tedesca', *Arte Illustrate* LII, 1973, pp.143–7. This article makes no mention of Otto Mueller and Cuno Amiet. Dominik Bartmann has also pointed to a quotation of Matisse's *La Danse* by August Macke on a 1912 ceramic, 'Elemente von Tradition und Avantgarde in Mackes Kunsthandwerklichen Arbeit', *August Macke Gemälde, Aquarelle, Zeichnungen,* exhib.cat. Westfälisches Landesmuseum für Kunst und Kulturgeschichte, Münster, 7 Dec. 1986–8 Feb. 1987.

71. Preface to the 3rd New Secession exhib.cat., spring 1911, which discusses the artists' ambitions to create colour decorations, to use line and colour 'to characterize the expression of a feeling': 'A decoration, derived from Impressionist colour, this is the programme of young artists in all countries. That is to say they derive their laws no longer from the object, which the Impressionists aimed to capture the impression of with the means of pure painting, rather they think of the wall, for the wall and certainly in colours. They no longer want to render nature in every transitory appearance, but rather condense the personal sensations of an object, to reduce it to a characteristic expression, so that the expression is strong enough to operate in a wall painting, in a coloured decoration. They place coloured planes next to each other, so that each quite unpredictable equivalence of colour quantities dissolves the stiff scientific laws of colour qualities with a new scope for personal freedom of movement. These colored planes do not destroy the underlying design of the objects represented, on the contrary, line is consciously used again as a factor, not to express or to constrict form but rather to contain form, to signify a mood, and to raise the figurative life to the surface.' ('Eine Dekoration, gewonnen aus den Farbenanschauungen des Impressionismus: Das ist das Programm der jungen Künstler aller Länder; d.h. sie empfangen ihre Gesetze nicht mehr vom Objekt, dessen Eindruck mit den Mitteln reiner Malerei zu erreichen, Wille der Impressionisten war, sondern sie denken an die Wand, für die Wand, und zwar in Farben. Sie wollen nicht mehr die Natur in jeden ihren flüchtigen Erscheinungsformen wiedergeben, sondern die persönlichen Empfindungen von einem Objekt derartig verdichten, zu einem charakteristischen Ausdruck zusammenpressen, daß der Ausdruck stark genug ist, um für ein Wandgemälde auszureichen. Für eine farbige Dekoration. Man setzt Farbflächen gegeneinander so, daß jene ganz unberechenbaren Gleichgewichtsgesetze von Farbquantitäten mit einem neuen Spielraum persönlicher Bewegungsfreiheit die starren wissenschaftlichen Gesetze der Farbqualitäten ablösen. Diese Farbflächen vernichten nicht die Grundlinien der dargestellten Gegenstände, vielmehr wird die Linie bewußt als Faktor wieder angewandt, nicht formausdrückend, formbildend, sondern formumschreibend, einen Empfindungsausdruck bezeichnend und das figürliche Leben an die Fläche heftend.') (Reprinted in W.D. Dube, *Der Expressionismus in Wort und Bild,* Stuttgart and Geneva, 1983, pp.63–4). As Marit Werenskiold points out, the same themes were treated by Roger Fry in 1910 in his preface to the 1st Post-Impressionist exhibition and an unsigned article in *The Times*, 11 Jul. 1910, *The Concept of Expressionism, Origin and Metamorphoses*, Oslo 1984, pp.18ff, 215ff. Werenskiold insists on a direct influence of Fry's writings on Herwath Walden and the New Secession. I favour a more flexible approach to the question of the origin of the term Expressionism. In 1911 theoretical influences from France and England coincided with more local, indigenous discussion about expression and decoration in Germany. A similar position is adopted by Geoffrey Perkins, in *Contemporary Theory of Expressionism*, Bern and Frankfurt am Main, 1974, and by Ron Manheim in his essay, 'Zur Entstehung eines kunsthistorischen Stil- und Periodenbegriffes', *Zeitschrift für Kunstgeschichte*, no.1, 1986, pp.73ff.

72. Alfred Hentzen, 'Kunsthandwerkliche Arbeiten der deutschen Expressionisten und ihrer Nachfolger', *Festschrift für Erich Meyer, zum 60. Geburtstag*, Hamburg 1957, pp.319ff.

73. Undated letter from Kirchner to Frau Schiefler, end 1911 (Schiefler Archives).

74. Kirchner to Gustav Schiefler, 28 Feb. 1912 (Schiefler Archive).

75. Schleswig-Holsteinisches, Landesmuseum, cat. no.83.

76. There were two wings to the revival of folk art in Dresden in the early years of the century led by Karl Reuschel (1872–1924) at the Technische Hochschule and Oskar Seyffert (1862–1940), professor at the Staatlichen Akademie für Kunstgewerbe in Dresden from 1889–1927. An article by Seyffert 'Volkskunst – Kunst fürs Volk' in the *Dresdener Salonblatt*, no.3 1910, pp.60ff. expressed his extremely conservative and chauvinist views about the conservation of German 'volk' culture.

77. Dietrich von Beulitz 'The Perls House by Ludwig Mies Van der Rohe', ed. Doug Clelland, *Berlin an Architectural History*, Architectural Design Profile, vol.LIII, no.11/12, London 1983, pp.63ff.

78. Pechstein's Nidden paintings are discussed in detail in Chapter 11. In his niche design for a fountain in the Hans Kühne room at the 1906 exhibition a clear example of this early figure style can be seen. Exhib.cat. 1906, p.658.

79. 'Auch für ihn stand die Kunst als ein untrennbares Ganzes da, möchte sie bauen, meisseln, oder malen...möchte der bescheidenste Gegenstand des täglichen Gebrauchs ihr Organ sein. Auch er hatte, wie die Renaissance-Meister, gleichsam ein ganzes Leben im Auge, in welchem die Macht der freien, grossen Persönlichkeit herrschte und in der Schönheit alles in Einklang hielt.' Friedrich Plietzsch, *Schinkel's Ausstattungen von Innenräumen*, Mannheim 1911, p.9.

80. In this instance a comparison with Freud's writings on sexuality is relevant, although I am not necessarily suggesting a direct influence. On the one hand Freud's theories of child sexuality confronted and undermined bourgeois taboos. But the techniques of psycho-analysis, as often pointed out, were aimed at sustaining bourgeois notions of 'normality', at stamping out deviancy.

81. See in particular Kirchner's lithograph series of Milli and Sam in erotic postures, Dube 185–90, 1911.

82. Robert Stiassny, *Hans Makart und seine bleibende Bedeutung*, Leipzig 1886. Excerpt in *Makart*, exhib.cat. Staatliche Kunsthalle Baden-Baden, June–Sep. 1972, pp.205–10.

CHAPTER 4. PRIMITIVISM IN PUBLIC PLACES

1. Marit Werenskiold, chapter 2, pp.35–55. Paul Fechter's *Expressionismus*, Munich 1914, was negatively reviewed by Rosa Schapire in *Beiblatt der Zeitschrift für Bücherfreunde*, N.F.6, 1914, pp.243–4.

2. See chapter 3, note 71.

3. For a detailed discussion of these events see Peter Paret, *Die Berliner Secession. Moderne Kunst und*

ihre Feinde im kaiserlichen Deutschland, N.Y. and London 1981, pp.287ff.

4. See chapter 3, note 71.

5. A.L. Mayer, *El Greco*, Leipzig 1911, J. Meier-Graefe, W. Weisbach, *Die Spanische Reise*, Berlin 1910, H. Kehrer, *Die Kunst des Greco*, Munich 1914.

6. A.L. Mayer, *Die Kunst für Alle*, May 1914, pp.358ff.

7. Rosa Schapire reviewed *Umělécky Měsíčnek* (U.M.) in *Beiblatt der Zeitschrift für Bücherfreunde*, N.F.5, 1913. She wrote of the need for a similar journal in Germany. At least one tribal object was illustrated in both the Czech publication and the *Blaue Reiter Almanach* (BRA) i.e. the Easter Island figure seen in profile in the BRA (p.54), and full-face in U.M. no. 1, 1911/12, p.320. In U.M. no. 2, 1912/13, Joseph Brummer's famous Fang head was illustrated opposite Picasso's 1909 bronze *Head*. This Fang piece also featured in Carl Einstein's *Negerplastik* (1915). In the third and fourth exhibitions of the Skupina group in Prague, May–June 1913 and Jan.–Mar. 1914, African sculptures were included. In 1910 and 1911 the Skupina artist Josef Capek had visited the Trocadéro in Paris and taken photographs. The 1911 Oriental exhibition held at the House of Artists from April–May 1911 in Budapest, under the aegis of Josef Rippl-Ronai and Karoly Kernstock, included Indian miniatures, Japanese prints, Chinese, Tibetan, Cambodian and Indian sculpture, Oceanic and African sculpture (Paudrat 'From Africa', p.148). This Middle European activity relates very directly to contemporary projects in Germany.

8. See the postcard from Kirchner, the Muellers, Willi Novak and Bohumil Kubista, to Heckel, 3 Aug. 1911 (Altonaer Museum Hamburg). This card shows a sketch by Kubista who exhibited with *die Brücke* in the fourth and fifth New Secession shows in Nov. 1911, Jan. 1912 and Mar. 1912. In Sept.–Nov. 1912, Kirchner, Heckel, Mueller and Schmidt-Rottluff took part in the second exhibition of the Group of Artists in Prague. In Jan. 1912, Heckel, Kirchner, Mueller and Pechstein contributed to the second Karo Bube exhibition in Moscow; in April–May 1912, Heckel, Kirchner, Pechstein and Schmidt-Rottluff contributed to the exhibition 'A Mühéshaz Nemetközi Postimpresszioninsta Kiállitásához' in Budapest.

9. E. Roters, *Avant-garde Osteuropa 1910–1930*, exhib. cat. Akademie der Künste Berlin, Oct.–Nov. 1967.

10. Pechstein, *Erinnerungen* p.24.

11. Max Osborn, *Max Pechstein*, Berlin 1922, p.70.

12. Günter Krüger, 'Die Brückes Glasmalerei', *Brücke-Archiv 1*, Berlin 1967, pp.19ff.

13. The pose of the right-hand figure in *The Yellow Cloth* and in the stained glass window refers to Gauguin's *Te Nave Nave Fenua, Terre Délicieuse*, (1893). This pose was taken by Gauguin from the Borubudur frieze in Java, copies of which were in the Berlin Ethnographic Museum by 1905. See, *Führer durch das Museum für Völkerkunde*, 'Die indische Sammlung', Berlin 1905. There is a general response too on Pechstein's part to Delacroix's exotic harem scenes. An exhibition of Delacroix's work was mounted in Berlin in 1907 at Paul Cassirer's gallery.

14. In 1911 Reinhardt did put on a production of Turandot's 'A Chinese Fairytale' with exotic costumes and décor. *BIZ* 46, 12 Nov. 1911.

15. Pechstein, *Erinnerungen*, p.47.

16. *Zeitschrift für alte und neue Glasmalerei*, 1912, pp.126ff.

17. Gottfried Heinersdorff, *Die Glasmalerei*, Berlin 1913, p.52.

18. Ibid, p.48.

19. Ibid, p.51.

20. Ibid, p.54.

21. Ibid.

22. Ibid, p.55.

23. *Zeitschrift für alte und neue Glasmalerei*, 1913, pp.39–41.

24. '...handwerklich...wie die Gottesbilder, die die Besten der Malergilden anonym für die Kirchen und Kapellen auf die weißen Kalkwände oder die hölzernen Altartafeln bannten...um Wände malerisch zu bezwingen, sind (Pechstein and the Expressionist generation) in die Werkstätten des Handwerks eingedrungen und haben den Schmelz ihrer Glasfenster oder Keramiken selbst überwacht, um verloren gegangene Techniken auf dem Wege des Experimentes zurückzuerobern.' Georg Biermann, *Max Pechstein*, Junge Kunst, vol.I, 1920 (1st ed. 1919) p.6.

25. An excellent, detailed account of this project can be found in G. Krüger, 'Die Jahreszeiten, ein Glasfenster-Zyklus von Max Pechstein', *Zeitschrift des Deutschen Vereins für Kunstwissenschaft*, vol.XIX, 1965 vol.1/3, pp.77ff.' See in particular pp.82ff.

26. Ibid, p.85.

27. See Paret, *Die Berliner Secession*, pp.17ff.

28. This aspect of cultural conservatism is not given detailed attention in Paret's book. See rather Georg Mosse, *The Crisis of German Ideology*, London 1966, and Fritz Stern, *The Politics of Cultural Despair*, Berkeley and Los Angeles, 1961.

29. Carl Vinnen's *Protest Deutscher Künstler*, Jena (1911) was not only signed by conservative artists and critics. Significant exceptions include Georg Biermann, Käthe Kollwitz, and five other members of the Berlin Secession. The fact that Wilhelm Trübner signed both the *Protest* and the *Antwort* is indicative of the complex cultural situation these documents addressed, as well as the uncertainty of his own position.

30. Foreword to the *Protest*, p.3.

31. Ibid, p.16.

32. *Die Antwort auf den Protest Deutscher Künstler*, Munich 1911, p.153.

33. 'unsere Aufgabe hingegen ist stets die der Naumburger Skulpturen, Holbeins und Leibls, die ästhetische Abstraktion mit Individualismus der Naturwahrheit zusammenzuschließen...längst ehe die neue Malform in der literarische Diskussion trat, ist in Deutschland eine Malerei heraufgekommen, der französischen verwandt und doch wieder verschieden und national'. Ibid, p.17.

34. Ibid, p.103.

35. Ibid, pp.95–6. Worringer is presumably referring to the fact that German neo-romantic symbolism, such as we find in the work of Max Klinger and Arnold Böcklin clothed the 'idea' in illusionistic, realist form. There is a clear relation between Worringer's train of thought and French Symbolist aesthetics in the 1890s, particularly Albert Aurier's 'Le Symbolisme en Peinture; Paul Gauguin' (*Mercure de France 2*, Paris 1891, pp.159–264), and Maurice Denis, 'Définition du néo-Traditionnisme', (*Art et Critique*, Paris 23 Aug. and 30 Aug. 1890).

36. W. Kandinsky's essay, '*Über die geistige in der Kunst*', Munich 1911, p.5, makes a very similar point about the temporary necessity of overt primitivist forms.

37. '...um dessentwillen wir das Gegenwärtige pflegen ...Denn diese moderne Primitivität, sie soll ja kein endgültiges Stadium sein. Der Pendelschlag bleibt nicht am äußersten Punkte stehen. Diese Primitivität soll vielmehr ein Übergang, ein großes, langes Atemholen sein, bevor das neue und ent-scheidende Wort der Zukunft ausgesprochen wird.' *Antwort*, p.97.

38. '...daß wir das Stichwort immer erst von draußen empfingen...uns immer erst aufgehen und verlieren mußten, um unser eigentliches Selbst zu finden, das ist von Dürer bis Marées die Tragik und die Größe der deutschen Kunst und es heißt unserere eigentliche nationale Tradition verleugnen, wenn unsere Kunst von der Auseinandersetzung mit anderen Kunstwelten abschneiden will. Denn sie gab der deutschen Kunst ihre eigentliche Dynamik.' Ibid, p.98.

39. Masheck p.96.

40. In October 1903 Kirchner made a study trip to Nürnberg where he saw original Dürer woodcuts in the Germanisches Museum. In his *Chronik der Brücke*, 1913 and *Lebensgeschichte*, 1937, Kirchner emphasized the early impact of Dürer and of a Rembrandt drawing, identified by Bolliger and Reinhardt as Benesch 11 Nr.405 (*ELK*, p.48).

41. Probably Kirchner's design for a magazine cover, *Zeit im Bild* (Dube H.196, 1912), relates to this project.

42. Correspondence in the Osthaus Archive Hagen: 25 Mar. 1911 Niemeyer was meeting Pechstein, Walter Botticher and Emil Nolde to discuss his plans. A letter from Pechstein to Heckel dated 21 Sep. 1911 states that he was still looking for a suitable space for a joint exhibition of the German and Czech avant-gardes. Reinhardt, *Die Frühe Brücke* p.154, suggests that the union was also to include literary associates and members of the group of avant-garde writers who frequented the Neue Club.

43. Bolliger, *Frühe Brücke* p.27. Reinhardt, *Die Kunst lergruppe Brücke Jahresmappen*, pp.99–100, places great emphasis on the international ambitions of *die Brücke* from 1906, and their attempts to forge a network of international links by means of invitations to join the group and group exhibitions.

44. '...die in vielig sinnlicher Farben rot und grün und blau dem ganzen eine mystische Weihe geben. Das ganze ist Modern-Gothik. Auf die 13m hohe Rückwand malte ich eine 4m große Madonna, es ist eine feine Sache, eine Madonna zu malen. Die Seitenwände erhielten erst 6 Darstellungen von Wundern des alten und neuen Testaments...von uns aber in Ornamentik umgestaltet werden auf Wunsch der Geistlichkeit. Die Farben der Kapelle sind violettes pinceau rot und ein scharfes grün mit blau.' Undated letter from Kirchner to Schiefler (Schiefler archive Hamburg).

45. Billeter, 'Ernst Ludwig Kirchner', p.23. The *Brücke* artists' technical experiments are partly described in the Amiet correspondence: letters from Heckel to Amiet dated 17 May 1907 and 22 May 1907 respectively, describe his use of rice water for watercolours, his use of photographic paper for drawings and of photographic tools to hand print his woodcuts.

46. Leopold Reidemeister, 'Die vier Evangelisten von Karl Schmidt-Rottluff und die Sonderbundausstellung in Köln', 1912 Brücke Archiv 8, 1975–6, pp.13–26. In a letter to Ernst Beyersdorff dated 15 Nov. 1912, Schmidt-Rottluff described Picasso as an artist 'who the best minds of our time take seriously'. (See G. Wietek, *Maler der Brücke in Dangast 1907–1912*, exhib.cat. Oldenburg 1957.)

47. Gordon, 'German Expressionism', pp.384–5. In fact, there were some Cameroon Anyang alligator skin heads in the Dresden Ethnographic Museum by 1912, (inv.no.29859), although Gordon failed to record this information. But the visual sources remains unconvincing.

48. Catalogue introduction to the Cologne Sonder-

49. Ibid.
50. 1914 Werkbund catalogue (reprint Cologne 1981) p.2.
51. Ibid.
52. Ibid.
53. Gabler, *E.L. K. Dokumente*, p.136. Gabler's claim that Feinhals' exhibition was in the colonial section of the Werkbund is not correct.
54. Gabler, 'Die Gemälde Ernst Ludwig Kirchner', exhib. cat. *Ernst Ludwig Kirchner*.
55. Publications in Kirchner's library about North Indian art date from the 1920s. For example: Leonhard Adam, *Nordwestamerikanische Indianerkunst*, Ernst Fuhrmann, *Tlinkit und Haida. Kulturen der Erde, Indianerstämme von Nordamerika*. But there were good collections of north-west coast art in the Dresden and Berlin ethnographic museums by 1910.
56. The mosque appears on the left-hand side of Kirchner's drawing *Landscape near Dresden* (1911), Ketterer 1985, no.48.
57. 'Die Welt... war von der Theorie des Kampfes ums Dasein beherrscht. Glaubenssatz war die Notwendigkeit der freieren Konkurrenz, des Kampfes aller gegen alle. Er wurde ausgetragen Mann gegen Mann, Konzern gegen Konzern, Volk gegen Volk...die Maschine verdrängte das Werkzeug...Jede Handlung beruhte auf exaktester Berechnung des Nutzens. Das freie Schaffen verlor seine Geltung...So trat der Künstler ab vom Schauplatz der Produktion. An seine Stelle trat der Musterzeichner, dem der Formenschatz von fünf Jahrtausend zur Ausbeutung zur Verfügung stand. Die Maschine bestimmte das Weitere. Der Kaufmann herrschte über alles, so entseelte sich langsam die Welt. Wert um Wert ging verloren bis schließlich der nackte Nutzen als einziger Götze auf dem Throne saß.' Karl Ernst Osthaus, 'Ex Ungue Leonem' in *Genius*, vol.I, 1919, pp.91–2.
58. Ibid, p.92. Osthaus' feelings of disillusion were shared by other commentators on the cultural scene in 1914. For example, a review of the Werkbund exhibition by Walter Curt Behrendt in *Kunst und Künstler*, vol.XII, 1914, pp.615–16, claimed that the promise of the 1906 Dresden decorative arts exhibition had not been fulfilled, and complained about a revival of historicist taste. The real talents at the Werkbund, he continued, were swallowed up by clashing commercial interests which had come to play a central rôle in cultural affairs.
59. Osthaus, 'Ex Ungue Leonem', p.94.
60. 'Diese große Halle mit dem Minnebrunnen wirkte in dem gedämpften Licht, das durch die farbigen Glasfenster Van der Veldes hineinfiel, sehr feierlich. Es wirkte fast wie eine Kunst-Kathedrale. Dieser Eindruck blieb auch, wenn man durch das ganze Museum ging. Es waren wenig Besucher dort...das Publikum in der Stadt Hagen interessierte sich relativ wenig.' Nettmann, 'Osthaus wollte die Gesellschaft', p.7.

CHAPTER 5. EXPRESSIONIST WOOD CARVING: IDEALS OF AUTHENTICITY

1. See chapter 2, note 18. Also Reinhardt *Die Frühe Brücke*, pp.59–63, 86–7. The influence of Hiroshige's *Sunrise*, c.1831, on Schmidt-Rottluff's woodcut *Beneath the Railwaybridge* (1905), seems to have come via Axel Gallén-Kallela, who joined *die Brücke* in March 1907. See Reinhardt, *Die Frühe Brücke*, pp.123–5 and G. Wietek, 'Der finnische Maler Axel Gallén-Kallela als Mitglied der Brücke', in *Brücke-Archiv*, vol.2/3, 1968/9,

pp.3–24. Robert Sterl, the local Dresden naturalist, who taught Schmidt-Rottluff the technique of lithography, also made quite daring 'Japanese' compositions, for example *The Excavator* (undated). Max Klinger's graphic cycles, which Kirchner could have seen exhibited in the Munich Kunstverein in March 1904, also show the influence of Japanese prints, e.g., *Bear and Elf*, Opus IV, Blatt 1, 1880, and *Desires*, Opus VI, Blatt 3 (*Paraphrase über den Fund eines Handschuhs*, 1881). The fifth Phalanx exhibition in Munich that winter showed the work of Felix Vallotton, and it is indeed hard to separate the impact of Japanese prints from a more general *Jugendstil* influence on the *Brücke* artists' early woodcuts.
2. See chapter 3, pp.32ff.
3. Heckel to Amiet 24 Sep. 1906 (Brücke Museum Archive). Francine Legrand, discussing the exhibition of Minne's sculptures at *Les Vingt* in 1890 writes that they may be related to, 'the fetishes of savage tribes' (*Le Symbolisme en Belgique*, Brussels 1971, p.142). In my opinion, Minne's work shows no relation at all to tribal sculpture.
4. Heckel to Amiet 27 Jan. 1907 (Brücke Museum Archive).
5. Ed. Stephanie Barron, *German Expressionist Sculpture*, exhib.cat. Los Angeles County Museum of Art, Oct. 1983 – Jan. 1984. Translated into German as *Skulptur des Expressionismus* exhib. cat., Josef-Haubrich Kunsthalle, Cologne, July–Aug. 1984, p.152.
6. Ibid.
7. Ibid, p.87.
8. Gordon 'Kirchner in Dresden', p.354, notes 118 and 119. Gordon is referring to an interview with Heckel in April 1954.
9. Buchheim, *Die Künstler–gemeinschaft Brücke*, pp.66–7. Nostalgia for the hand-made in the machine world is described as one of the main reasons for interest in tribal art by N.H. Graburn, 'Introduction. The Arts of the Fourth World', *Ethnic and Tourist Arts, Cultural Expressions from the Fourth World*, London 1976, p.19. See also, Edmund Carpenter, 'Do you have the same thing in green? Or Eskimos in New Guinea,' Ontario 1971.
10. This issue is discussed in more detail in chapter 10 pp.192–3.
11. Max Sauerlandt, 'Die Holzbildwerke von Kirchner, Heckel, Schmidt-Rottluff im Hamburgischen Museum für Kunst und Gewerbe', *Museum für Gegenwart: Zeitschrift der deutschen Museen für neuere Kunst*, no.1, 1930–1, pp.101ff. Here p.107.
12. Gordon, 'Kirchner in Dresden', p.354, note 115.
13. Martensen-Larsen, 'Primitive Kunst', p.92.
14. Eds. Günther Guhr and Peter Neumann, *Ethnographischen Mosaik – Aus den Sammlungen des Staatlichen Museums für Völkerkunde Dresden*, Berlin 1982, pp.65ff. Research in the archives of the Dresden Ethographic Museum makes it is possible to confirm that at least six major collections of Cameroon material entered the museum between 1908 and 1913: Kolscher 1908, Kettner 1908, Rothe 1909, Lessel 1909, Gütschow 1910, Lems 1913.
15. Gordon, 'Kirchner in Dresden', pp.354–5, note 116. This interview with Schmidt-Rottluff took place on 12 June 1954.
16. Altonaer Museum Archives. The message on the card does not make any mention of African art, but refers rather to 'Van Gogh, Gauguin, Vermeer'.
17. Interview with Dr Wolf Löhse, curator of African art at the Hamburg Ethnographic Museum, 12 August 1983.
18. I draw this conclusion from Umlauff's correspon-

dence with Karl Ernst Osthaus (Osthaus Archives, Hagen). A letter of 20 Apr. 1914 presents a price list for Osthaus with a selection of pieces from a Frobenius expedition. The prices partly relate to the size of the objects for sale, but not to the intrinsic worth of the materials; for example, a *großes geschnitztes Brett* is listed for 900 marks, and an 'Elfenbein Kopf' for 250. The selection, which Umlauff describes as 'sehr alte schöne Yoruba Negerkunst Holz und Elfenbein' (24 Feb. 1914) must also be priced according to the *quality* of the objects – relating to their age, their rarity, their size and the standard of wood carving. Osthaus, of course, was selecting according to aesthetic criteria, and Umlauff may be responding to the taste of his client.
19. Selz too suggests that Schmidt-Rottluff began his collection of African art which includes several Cameroon pipe figures, before 1914 (*German Expressionist Painting*, p.289). Mostly his African collection, which is now stored in the Brücke Museum, was acquired after 1945.
20. Kurt Glaser, 'Neue Galerien in Berlin', *Kunst und Künstler*, Dec. 1913.
21. Selz, *German Expressionist Painting*, p.83. This letter from Schmidt-Rottluff to Selz, dated 11 Jul. 1952, states that his interest in African art developed later, 'because at this time I didn't really understand African art, and as a painter I'd realized that nature doesn't have contours or sculptural forms – just colours' ('weil ich zu diesem Zeitpunkt für die afrikanische Kunst nicht viel Verständnis gehabt habe, und als Maler erkannt habe, daß die Natur keine Kontur, keine plastische Form kenne, nur Farbe').
22. In Karlheinz Gabler's private photo archives in Frankfurt, an early Schmidt-Rottluff carved mask featured, strongly influenced by East African styles, which Gabler dated 1911. I have not been able to find any other trace of this piece.
23. Martensen-Larsen, 'Primitive Kunst', p.110.
24. *Male Head* (1917), refers directly to plate 4 in *Negerplastik*. *Lithuanian Girl* (1917), refers likewise to plate 5, a wooden cup from the Belgian Congo. *Blue-Red Head* (1917) refers to Einstein's photograph of a Luba figure from East Zaire; while *The Cry* and *Red Head* are based on Fang heads, several of which were illustrated by Einstein, including the famous Brummer Head. *Standing Figure* (1918), and *Looking Backwards* (c. 1920), relate more generally to illustrations of Baule figures.
25. Rosa Schapire reviewed Einstein's book very favourably in *Beiblatt der Zeitschrift für Bücherfreunde*, N.F.6, 1915, pp.500–1. She connected his aesthetic appreciation of African art to the innovations of the Expressionists.
26. Einstein, *Negerplastik*, 1915. Reprinted in R.P. Baacke ed. *Carl Einstein Werke*, vol.I, 1908–18, Berlin 1980, pp.336, 363.
27. Gordon, 'German Expressionism', p.399.
28. Rhys Williams, Lecture at the University of East Anglia, spring 1984.
29. Einstein, *Negerplastik*, p.1.
30. '...in formalem Realismus, worunter nicht ein nachahmender Naturalismus verstanden wird, ist die Transzendenz gegeben... Das Kunstwerk wird nicht als willkürliche und künstliche Schöpfung angesehen werden, vielmehr als mythische Realität, die an Kraft die natürliche übertrifft... Das religiöse Negerkunstwerk ist kategorisch und besitzt ein prägnantes Sein, das jede Einschränkung ausschließt.' Ibid, p.xv.
31. 'Ich bin verschiedentlich zu einer Steigerung der Formen gekommen, die zwar den naturwissen-

schaftlich gefundenen Proportionen widerspricht, die aber in ihren geistigen Beziehungen ausgeglichen und proportioniert ist. Köpfe habe ich oft im Verhältnis zu den anderen Körperformen ins Ungeheure gesteigert als einen Sammelpunkt aller Psyche, allen Ausdrucks... Es ist nicht anders mit den Brüsten. Sie sind ein erotisches Moment. Aber ich möchte es loslösen von der Flüchtigkeit des Erlebnisses, gewissermaßen eine Beziehung herstellen zwischen dem kosmischen und dem irdischen Augenblick. Vielleicht kann man sagen, es ist eine ins Transzendentale gesteigerte Erotik. Das klingt in unserer mit Zynischem durchsetzten Zeit etwas mystisch, aber was uns so im Laufe der Zeit und Kunst der Vergangenheit übriggeblieben ist – Ägypten, Michelangelo – was ihnen ihre Unvergänglichkeit verleiht: es ist das Erleben transzendentaler Dinge im Irdischen.' Gerard Wietek, *Schmidt-Rottluff Graphik*, Munich 1971, pp.100–1. No exact date for this letter is given. In his more recent publication, *Schmidt-Rottluff in Hamburg und Schleswig-Holstein*, Neumünster 1984, Wietek publishes this same undated letter and suggests an approximate date of 1913. If this is correct, Schmidt-Rottluff's statement precedes Einstein's text. This underlines my point that the relationship is a question of shared ideals and ideas growing out of their roots in Expressionism.

32. The other books on non-European art in the remains of Schmidt-Rottluff's library, now in the Brücke Museum, are mostly presents from the post-war period, i.e., after 1945.

33. See in particular Einstein's *Bebuquin oder die Dilettanten des Wunders*, written 1906/9 and published in *Die Aktion*, 1912. This is one of the first texts of literary Expressionism.

34. Franz Marc, 'Die Neue Malerei', *Pan 2*, March 1912, pp.499–502.

35. See figs.8 and 38. Karlheinz Gabler, who was compiling a photo archive of Expressionist sculpture before his death, suggested to me that Kirchner visited the ethnographic museum in Munich in 1903/4 and that an Aztec piece there was the model for his earliest stone sculpture (interview September 1983).

36. The sculpture appears in the 1910 woodcut Kirchner carved for the cover of the Galerie Arnold exhibition in September, and for the poster (Schleswig-Holsteinisches Landesmuseum, cat.no. 53). Dube (H.708), describes this woodcut as a vignette, and dates it 1911.

37. In *ELK*, cat.no.263, this sculpture was dated 1917. The Städel in Frankfurt has now accepted the 1912 date.

38. The same type of stool recurs in Pechstein's *Grey Still Life* (1913) and in his imaginative composition *In the Bordell Palau* (1917) (fig.259), possibly referring to a genuine Cameroon object in his collection by 1913. But Kirchner's stool does not recur in any other works, and in this instance he probably cites an object he saw in the ethnographic museum rather than one he had carved. A very similar stool (fig.97), Bafum Cameroon Grasslands, inv.no.29862 (Rothe 1912) is found in the Dresden Ethnographic Museum.

39. Altonaer Museum Hamburg, Dube-Heynig, p.261.

40. Chemical tests on the wood of Kirchner's leopard stool, now in the Bündner Kunstmuseum in Chur, show it to be an original African piece. I would like to thank Bernd Hünlich for this information, who possesses the relevant correspondence and suggested that the tests be made. A wooden female figure carrying a bowl on her head from the Cameroon grasslands entered the Dresden museum in 1909 (Rothe, inv.no.24228), and a leopard bowl

from the Duala coastal area of Cameroon was acquired by the museum in 1910 (Rohrbach inv.no.24515). This could have inspired Kirchner to acquire his own leopard stool, which was certainly in his collection by 1914, when the photo of the Körnerstraße atelier was taken. Berndt Hünlich also drew my attention to a Baluba figurative stool in the Dresden museum (inv.no.46691), which comes very close to the one depicted in Kirchner's woodcut, *Three Nudes*, 1910. The inventory number suggests that this was a later purchase.

41. Photograph in the Schmidt-Rottluff centennial exhibition, Schloß Gottorf 1984.

42. Altonaer Museum Hamburg. Dube-Heynig p.178. Kirchner's message speaks of a 'maple-tree sculpture...unfortunately the centre is rotten'. This sculpture also features in several Heckel drawings. See too Martensen-Larsen, Primitive, Kunst, p.101.

43. Kirchner to Gustav Schiefler, 27 Jun. 1911 (Schiefler Archive Hamburg). Barron, p.109.

44. Kirchner to Heckel, 30 Jun. 1910 (Altonaer Museum Hamburg). Dube-Heynig, pp.148–9. Gordon, 'Kirchner in Dresden', p.353, first suggested the relationship between Kirchner's *Marcella*, (1910;G.113), and Munch's *Puberty* (1894).

45. Roman Norbert Ketterer unter Mitwirkung von Wolfgang Hentzen, *E.L. Kirchner Zeichnungen und Pastelle*, Zurich 1979, p.33.

46. See note 43 above.

47. Drawing in the Bündner Kunstmuseum, Chur, Barron, p.109.

48. Postcard with photo from Kirchner to Schiefler dated 23 Jul. 1913. Reproduced in Barron, p.118, fig.12.

49. *Davoser Tagebuch*, p.219. Originally, L. De Marsalle, 'Über die plastischen Arbeiten von E.L. Kirchner', *Die Cicerone*, XVII, no.14, 1925, pp.695–701. Kirchner's earlier comments about hand printing are also relevant in this context: 'hand printing makes possible the execution of all three techniques in the studio and so places the final technical subtleties in the hands of the maker,' ('der Handruck ermöglicht die Ausführung aller drei Techniken im Atelier und legt so die letzten technischen Feinheiten in die Hände des Schaffenden'). *Über die Grafik* (1913). Text planned for the *Chronik der Brücke*.

50. '...wenn man sich vergegenwärtigt, daß bei dieser alten Arbeitsmethode eigentlich nur das Tonmodell vom Künstler stammt, das Endresultat und alle Arbeit dafür aber von anderen Händen geschafft wird, so begreift man leicht die trübe Einförmigkeit unserer Plastikausstellungen, und man fragt sich oft beim Anschauen, was wohl bei diesen Kunstwerken eigentlich noch vom Künstler stammt.' *Davoser Tagebuch*, p.219.

51. Graburn, *Ethnic and Tourist Arts*, p.21 points out that another great attraction of tribal and folk art is its anonymity.

52. *Davoser Tagebuch*, p.220.

53. Ibid.

54. Ibid, pp.220–1.

55. Kirchner makes several somewhat contradictory statements about the difference between French and German art in the *Davoser Tagebuch*. For example, in 1925 (p.94) he wrote: 'the German artist creates imaginatively and spiritually, in contrast to artists coming from a romance tradition, who copy what they see... Germans paint the 'what', and Frenchmen the 'how'; ('Der deutsche Künstler schafft aus der Phantasies aus dem Geiste, im Gegensatz zum Künstler romanischen Stammes, der aus der Anschauung gestaltet... Der deutsche malt das

'was' der franzose das 'wie'.)

In 1928 (p.178), he rejected the distinction between French visual tradition as opposed to the intellectual and spiritual qualities of the Germans: 'Every work of art comes from the spirit, and among the French a great number of masters, like Puvis, Odilon Redon, Cézanne etc, create pure imaginative works that are just as spiritual as our Hodlers, Noldes, Klees etc.'; ('Jedes Kunstwerk kommt aus dem Geiste, und wir haben unter den Franzosen eine ganze Reihe großer Meister, wie Puvis, Odilon Redon, Cézanne usw., die reine Phantasie schufen, genau so geistig wie unsere Hodler, Nolde, Klee usw.')

In a letter dated 25 Dec. 1933 to his brother Ulrich (Gabler 1980, p.330), Kirchner rejected the notion of 'pure race', at the beginning of the era of Nazi persecution of modernist artists: 'There are hardly any pure races in Europe these days. We too, alongside our Prussian blood, have French blood in our veins – perhaps this explains our human differences (as brothers). All these questions are very complicated and difficult and are not decided by a law or a stroke of the pen.' ('Reine Rassen gibt es in Europa kaum mehr. Auch wir haben neben preußischen, slavisches und französisches Blut in unseren Adern, daher wahrscheinlich unsere menschliche Verschiedenheit (unter uns Brüdern). Alle diese Fragen sind sehr kompliziert und schwierig und nicht mit Gesetzen oder einem Federstrich zu lösen.') On 21 Sep. 1935 he continued this correspondence with his brother, reaffirming his sense of 'German' identity in the face of Nazi persecution: 'I find it all the sadder when I must read in NZ pamphlets that my art is bolshevist...because my heart is German and my art too, and I've always felt myself to be the representative of new German art, and behaved accordingly.' ('Umso trauriger trifft es mich, wenn ich heute in NS Blättern lesen muß, daß meine Arbeit bolschewistisch sei... Aber mein Herz ist deutsch und meine Kunst auch und ich fühle mich eben als Vertreter neuer deutscher Kunst und handle danach.')

56. Einstein's *Negerplastik* was in Kirchner's library and the possibility of a direct influence on the artist's own aesthetic writings is not to be ruled out.

57. '...ist soweit ich es kenne der einzige Plastiker unserer Tage, dessen Formen sich nicht auf die Antike zurückführen lassen. Er formt, wie in seiner Malerei, direkt sein Erlebnis aus den Gestalten des heutigen Lebens...diese Arbeiten...sind ebenso weit von den Griechen wie von den Negern entfernt, weil sie unmittelbar geboren sind aus der Anschauung des heutigen Lebens.' *Davoser Tegebuch*, pp.218–19.

58. Also in his essay 'Über Kirchners Graphik' (L. de Marsalle) in *Genius*, 1919, vol. 1, no. 2, pp. 351–63: 'Just as the natives carved figures from hard wood with unending patience, to embody their vision, so the artist creates what are probably his purest and strongest works as a result of difficult and complicated technical processes... By the sweat of your brow might you eat your bread'; ('Wie die Wilde mit unendlicher Geduld aus dem harten Holz die Figur schnitzt, die Verkörperung seines Sehens, so schafft der Künstler in mühsamer komplizierter technischer Arbeit seine vielleicht reinsten und stärksten Arbeiten...im Schweiße Deines Angesichts sollst Du Dein Brot Essen,') (p.363). It is interesting to see how Kirchner associates a protestant ethic of hard work with 'primitive' carvers. This is a classic example of what Bernard Smith has termed 'hard primitivism'. See Bernard Smith, *European Vision and the South Pacific*, 2nd ed., New Haven and London, 1985, chapter 2, pp.8f.

59. Letter to Schiefler, 28 March 1916 (Schiefler Archive, Hamburg).

CHAPTER 6. URBAN EXOTICISM IN THE CABARET AND CIRCUS

1. 'Anlehnugsbedürfnis an alte primitive Stile, die in ihrer Zeit organisch aus einer gemeinsamen Religion und einem gemeinsamen mystischen Volksbewußtsein herausgewachsen sind. Schwächlich weil er (Gauguin) nicht fähig war, aus unserer Zeit heraus mit all ihren Unklarheiten und Zerissenheiten, Typen zu bilden, die uns Heutigen das sein könnten, was denen damals ihre Götter und Helden gewesen sind. Matisse ist ein noch trauriger Vertreter dieser Völkerkunde-Museumskunst, Abteilung Asien.' Max Beckmann, 'Gedanken über zeitgemäße und unzeitgemäße Kunst', *Pan 2*, March 1912, pp.499ff.

2. 'Leider verwirrt heute allerlei Atavistisches die Köpfe. Das Stammeln primitiver Völker beschäftigt auch einen Teil der deutschen Maler-Jugend und nichts scheint wichtiger zu sein, als Buschmannmalerei und Aztekenplastik... Aber seien wir ehrlich! Gestehen wir uns nur ein, daß wir keine Neger oder Christen des frühen Mittelalters sind!... Wozu die Manieren und Anschauungen vergangener Zeit nachahmen, das Unvermögen als das Richtige proklamieren?! Sind diese rohen, mesquinen Figuren, die wir jetzt in allen Austellungen sehen, ein Ausdruck unserer komplizierten Seele?!' Ludwig Meidner, 'Anleitung zum Malen von Großstadtbildern', *Kunst und Künstler*, XII, 1914, pp.299ff.

3. *Davoser Tagebuch*, p.73.

4. 'Unsere Seele...birgt in sich Keime der Verzweiflung des Nichtglaubens, des Ziel- und Zwecklosen... Dieser Zweifel und die noch drückenderen Leiden der materialistischen Philosophie unterscheiden stark unsere Seele von der der 'Primitiven'. In unserer Seele ist ein Sprung und sie klingt, wenn man es erreicht sie zu berühren, wie eine kostbare, in den Tiefen der Erde wiedergefundene, Vase, die einen Sprung hat. Deswegen kann der Zug ins Primitive, wie wir ihn momentan erleben, in der gegenwärtigen, ziemlich entliehenen Form nur von kurzer Dauer sein!' Kandinsky, *Über das geistige in der Kunst*, 1912 pp.4–5; transl. *On the Spiritual in Art*, pp.1–2. Kandinsky uses an evolutionary metaphor to illustrate his arguments. Imitative primitivism is described as 'mere aping'. He continued; 'Externally the monkey completely resembles a human being; he will sit holding a book infront of his nose, and turn over the pages with a thoughtful aspect, but his actions have for him no real meaning.' ('Äußerlich sind die Bewegungen des Affen den Menschen vollständig gleich. Der Affe sitzt und hält ein Buch vor die Nase, blättert darin und macht ein bedenkliches Gesicht, aber der innere Sinn dieser Bewegungen fehlt vollständig.') Typically, Kandinsky inverts the evolutionary code in this passage at the same time as he reconfirms a hierarchy of evolutionary values. Modern man is now classed as the 'primitive', the ape on the evolutionary ladder, while 'primitive' non-European man is elevated, on account of his spirituality, to a superior position. Kandinsky's text, like Mondrian's near contemporary *Evolution Triptych* (1910–11), then goes on to describe the progress of the spirit, which is proclaimed by art and artists in modern society as a new evolutionary phenomenon, capable of winning back ground for modern man. Both Kandinsky and Mondrian were influenced by Theosophist writings.

5. Gordon, 'German Expressionism', p.376. Gordon's

suggestion that a Cameroon Buffalo Helmet was also a source for Marc's Donkey Frieze (1911), is not visually convincing. The comparison with an Egyptian relief of c.2700–2600 BC in the Rijksmuseum Leiden, was first made by Klaus Lankheit in *Franz Marc, 1880–1916*, exhib.cat. 27 Aug.–26 Oct. 1980, Städtische Galerie im Lenbachhaus, München, p.156.

6. The *Blaue Reiter Almanach*, pp.57.

7. A postcard from Schmidt-Rottluff to Amiet dated 8 Jan. 1909 mentions a proposed invitation to Van Dongen: 'Do you know Van Dongen from Paris? We intend to make him a member. We're also thinking about H. Matisse and E. Munch. What do you think?' (Brücke Museum Archives). A letter from Heckel to Rosa Schapire dated 15 Jan. 1909, confirmed Van Dongen's acceptance of the invitation, although no evidence of future contact with *die Brücke* has been discovered. See Reinhardt, *Die Frühe Brücke*, pp.144ff. The invitation to exhibit at the Indépendants could also have come to *die Brücke* via Axel Gallén Kallella or Cuno Amiet. A letter from Heckel to Amiet dated 14 Apr. 1907, says that Kallella is going to Paris, and suggests they all meet up there. A second letter dated 27 Apr. 1909 asks Amiet to approach Matisse on behalf of *die Brücke*.

8. Reinhardt, *Die Frühe Brücke*, pp.144ff.

9. Paul Fechter, 'Die Berliner Secession', *Dresdener Neueste Nachrichten*, 166, 22 Jun. 1909, p.1.

10. Osborn, *Pechstein*, p.98.

11. Baudelaire, *The Painter of Modern Life*, p.430. He describes prostitutes in music halls in the following terms: 'she moves towards us, glides, dances, sways...her eyes flash from under her hat like a portrait in its frame. She is a perfect image of savagery in the midst of civilization...' This very typical connection between women and the 'primitive' at the heart of modern civilization is repeated in the *Brücke* paintings and in Osborn's text.

12. Gordon convincingly suggests that Van Dongen's *Mistingett and Max Dearly in the Chaloupée Waltz*, influenced Kirchner's lithograph *Dancer with a Bent Back*, 'Kirchner in Dresden', p.347.

13. R.O. Rösler, *Kabarettgeschichte*, Berlin 1977, p.28.

14. Altonaer Museum Archives. Dube-Heynig, p.164.

15. *Dresdener Rundschau*, 15, 15 Apr. 1905 p.1, *Dresdener Salonblatt*, 14, Apr. 1910, p.400.

16. *Dresdener Rundschau*, 15, 15 Apr. 1905; 16, 22 Apr. 1905: 'A visit to the zoological gardens over the holiday is highly recommended...Hagenbeck's Indians are giving daily performances in the park which are well attended for their originality.' ('Ein Besuch des zoologischen Gartens ist für die Festtage dringend zu empfehlen... Auf der Völkerwiese geben täglich Hagenbecks "Indier" Vorstellungen, die infolge ihrer Eigenart zahlreich besucht werden.')

17. *Dresdener Salonblatt*, Jg. 5, no. 14, p.400, 2 Apr. 1910. See too Marja Keyser, 'Hochverehrtes Publikum. Ein Streifzug durch die Zircusgeschichte', in *Zirkus, Circus, Cirque*, exhib. cat. Nationalgalerie Berlin 1978. Various circuses made guest appearances in Dresden during the *Brücke* years: the Circus Henry in 1905, the Circus Angelo in 1905 and 1910, the Circus Schumann in 1908. But few exotic acts are recorded in the daily press reports of these events. The main source for this type of show was undoubtedly the zoological gardens. Other *Brücke* motifs, for example the tight-rope walkers, certainly refer to circus performances.

18. *Dresdener Rundschau*, 5, 4 Feb. 1905, pp.9–10, 11. Cinema also overlapped with the cabaret during these early years, and at the Vittoria-Salon bicycle and motor-bike riders also appeared.

19. Ibid, 36, 9 Sep. 1905, p.10.

20. Ibid, 9, 29 Feb. 1908: '*Sandi, Suvil and Amat from Java*'.

21. *BIZ* 2, 9 Jan. 1910, p.28. *BIZ* 5, 30 Sep. 1910, pp.73–5. *Dresdener Illustrierte Neueste*, 1 Jan. 1910: 'The Indian temple-dancer princess Makara with her snakes'.

22. *BIZ* 7, 13 Feb. 1910, p.112.

23. *BIZ* 20, 19 May 1912, p.460. *BIZ* 27, 7 July 1912, p.622. *BIZ* 33, 18 Aug. 1912, p.756.

24. *Kunst und Künstler*, 1908, p.409. In the 1890s *Jugend* too published illustrations of exotic cabaret acts. For example, Otto Eckmann's 'Oriental' dance scene in *Jugend*, Nr. 3. 1899.

25. *Dresdener Illustrierte Neueste*, 16, 17 Apr. 1909.

26. *BIZ*, 27, 7 Jul. 1912, p.622.

27. Emil Nolde, *Das Eigene Leben*, Berlin 1931, p.68. (Hereafter *DEL*.) This refers to his residence in Berlin from 1889–91. See Chapter 9, pp.166–7.

28. Berndt Hünlich, 'Heckel und Kirchner im Dresdener Flora-Variété', *Dresdener Kunstblätter*, 1986 no. 3, pp.83–91.

29. *Dresdener Rundschau*, 34, 26 Aug. 1905, p.12; 25 Nov. 1905, p.15.

30. Gordon suggests that a combination of Palau and Ajanta also features in Kirchner's 1911 sculpture, *Dancing Woman*, 'German Expressionism', p.386.

31. See also Kirchner's *Four Dancers*, 1911 (Dube L168). Here we see exotic Ajanta-like decorations in the background.

32. 'Die Renaissance aller Künste und des ganzen Lebens vom Tingeltangel her!... Was ist die Kunst jetzt? Eine bunte, ein bißchen glitzernde, Spinnwebe im Winkel des Lebens. Wir wollen sie wie ein goldenes Netz über das ganze Volk, das ganze Leben werfen. Denn zu uns, ins Tingeltangel, werden alle kommen, die Theater und Museen ebenso ängstlich fliehen wie die Kirche...wir werden eine neue Kultur herbeitanzen!' Otto Julius Bierbaum, *Stilpe. Roman aus der Froschperspektive*, 1897, 24th and 25th ed. Berlin 1927, pp.357, 359.

33. Julius Otto Bierbaum ed., *Deutsche Chansons*, Berlin and Leipzig 1900, pp.ixff. Rösler, *Kabarettgeschichte*, p.33. An association between *Jugendstil* and cabaret was often made on a popular level at the turn of the century. For example a cartoon in *Fliegende Blätter*, 1902. Nr.2952, p.85 shows a sophisticated *Jugendstil* interior with a child's music box in the shape of the *Überbrettl* (see note 35 below). Interestingly what is being addressed here is the world-weary sophistication of the 'youthful' style which had passed over into high fashion.

34. Carl Einstein, 'Brief an die Tanzerin Napierkowska', *La Phalange*, Jan. 1912, pp.73–6.

35. Bierbaum's ideas for a literary cabaret were put into practice by Ernst von Wolzogen in 1901 when he opened his *Überbrettl* (super-cabaret) in Berlin, the name of which referred to his ambitions to rise above the level of Tingeltangel while retaining the potential of the popular cabaret to transverse the boundaries between art and life. It also referred, of course, to Nietzsche's *Übermensch*. The programme of the *Überbrettl* included songs from the *Deutsche Chansons*, recitations, short dramas, shadow puppet plays and pantomimes. A photograph c. 1901 shows the use of Javanese shadow puppets in a cabaret performance. When the cabaret was transformed into the Buntes Theater at the end of 1901 and moved to the new building designed by August Endell in the Köpernickerstraße the erotic emphasis of the programme eclipsed the satirical overtones. A more consistent anti-bourgeois, satirical tone was pursued by the Elf Scharfrichter in Munich, who used carnival-like masks in their per-

formances. But as we shall find in our discussion of bourgeois satirical humour more generally (Chapter 10, pp.193–194) the cabaret more than anything provided a cultural outlet for anti-establishment sentiments.

36. *Zarathustra*, Leipzig 1923, pp.327–8; transl. pp.301–2.

37. Martin Beradt, 'Tagebuch eines Dekadenten', *Hyperion*, vol. II, 1909. See *ELK*, p.56.

38. Published in the *BIZ*, in October and December 1911. In *Dresdener Salonblatt* Jg. 5, 1910 no. 12, pp.348ff. we find a story 'Im Zirkus' by Hans Bethge, who writes: 'If I was a painter I would have a great desire to bring the painterly excitement of the circus to my canvases.'

39. However, the tightrope walker appears elsewhere in literature: in 1937 Kirchner illustrated the tightrope walker scene in Goethe's *Wilhelm Meister*. J. McCullagh, in her article, 'The Tightrope Walker: an Expressionist Image,' *Art Bulletin*, vol. LXVI December 1984, pp.633–44, supports this thesis concerning Nietzsche's influence.

40. For example, *Japanese Acrobats* (1912; Dube H194) and *Somersaulting Acrobatic Dancer* (1913; Dube H216).

41. See also Heckel's *Green Dancer* (Vogt 1912/20). Here the mood is complicted by the male voyeur watching the dancer.

42. Tilla Durieux, p.154.

43. *BIZ* 37, 10 Sep. 1911, p.721.

44. *BIZ* 49, 3 Dec. 1911, p.1018.

45. *Dresdener Anzeiger* 174, 25 Jun. 1909, p.2.

46. Osborn, *Pechstein*, p.72.

CHAPTER 7. THE *BRÜCKE* BATHERS: BACK TO NATURE

1. *Barbizon Revisited*, exhib. cat. Boston Museum of Fine Art, 1962.

2. Wilhelm Riehl, *Land und Leute*, 1857–62. See also Norbert Elias, *Über den Prozeß der Zivilisation*, 1936, vol.1, chapter 1, 'Zur soziogenese der Begriffe Zivilisation und Kultur'. Elias traces this distinction back to Kant's *Ideen zu einer allgemeinen Geschichte in Weltbürgerlicher Absicht*, 1784, and argues that the concept of 'culture' was evolved in the nineteenth century to provide an identity for the emerging German bourgeoisie. Civilization was associated with 'Superficiality, ceremony, polite conversation', culture with 'inwardness, depth of feeling, absorption in literature, development of the individual personality.' See also A.L. Kroeber and Clyde Kluckhorn, *Culture a Critical Review of Concepts and Definitions*, N.Y. undated, chapter 4. Also R. Hamann and Jost Hermand, *Stilkunst um 1900*, vol. 4, Berlin 1969, p.102.

3. F. Stern *The Politics of Cultural Despair*, Berkeley and Los Angeles, 1961, (chapter 2, 'Julius Langbehn and German Irrationalism'), describes Langbehn's ideas as 'an aspiration towards a form of primitivism which after the destruction of the existing society, aimed at the release of man's elemental passions and the creation of a new German society based on art, genius and power. To worship art in Langbehn's manner', he continues. 'was to go primitive, to return to some new form of tribal fetishism.' Peter Gay, in *Freud, Jews and other Germans. Masters and Victims in Modernist Culture*. Oxford 1978, p.178, describes the city versus country dichotomy: 'The Berlin-Jewish spirit thus emerges as a distinct political and intellectual force in the great debates between modernism and tribal-volkish primitivism.'

4. Meier-Graefe's attack, *Der Fall Böcklin und die Lehre von den Einheiten*, 1905, provoked a fierce volkish defence by Henry Thode, professor of Art History at Heidelberg University and Wagner's son-in-law. He upheld Böcklin and Hans-Thoma as Germanic spiritual leaders capable of freeing the German people from artificiality and materialism, returning them to 'a mystic and medieval oneness with heaven, earth, clouds and sea', (Paret, *Die Berliner Sezession*, p.174).

5. Another important influence on Liebermann's early peasant painting was the Hungarian painter Munkácsy. See *Liebermann in seiner Zeit*, exhib. cat. Nationalgalerie Berlin, 1979, pp.25–34.

6. Gillian Perry, *Paula Modersohn-Becker, her Life and Works*, N.Y. and London 1979, pp.89ff. Schmidt-Rottluff visited Worpswede to attend the 'Nordwestdeutsche Künstlerbund' just before Paula Modersohn-Becker's death in November 1907. In a letter dateed 1909, he described the painting there as provincial, 'a wholly temporary phenomenon in German art' (Wietek, *Schmidt-Rottluff Graphik*, Munich 1971, p.58). It is unlikely that he saw any of Modersohn-Becker's recent work, which her husband discovered in her atelier after her death.

7. 'Manchmal, wenn mich ein neugieriges Verlangen nach solchen abenteuerlichen Dingen anwandelte, habe ich den Reisenden beneidet, der solche Wunder mit andern Wundern in lebendiger alltäglicher Verbindung sieht. Aber auch er wird ein anderer Mensch. *Es wandelt niemand ungestraft unter Palmen* (cited by Menzel) und die Gewinnungen ändern sich gewiß in einem Lande, wo Elefanten und Tiger zu Hause sind.' Transl. *Elective Affinities*, London 1980, p.215. *Menzel der Beobachter*, exhib. cat. Hamburg Kunsthalle May-July 1982, cat. no.67.

8. H. Schaafhausen, 'Les Questions anthropologiques de nôtre temps', *Revue Scientifique*, 1866, pp.769–76. See Poliakov, p.278.

9. Poliakov, p.161.

10. Baudelaire, *The Painter of Modern Life*, p.430. He speaks of the prostitute in particular as an animal in the midst of civilization.

11. *Dresdener Neueste Nachrichten*, 244, 8 Sep. 1910, p.3. A second report of Moritz appears in *Dresdener Anzeiger*, 163, 14 Sep. 1909.

12. *Fliegende Blätter*, Nr. 3042, 1903, p.229.

13. The graphic portfolios of Kirchner's (1910), Heckel's (1911) and Pechstein's (1912) work, juxtapose country and city scenes. The 1910 Kirchner portfolio contained *Bathers Throwing Reeds* (Dube H.160), *Dancer with her Dress Raised* (Dube H.141), and *Three Bathers at Moritzburg* (Dube R.69). The Heckel 1910 portfolio contained *Standing Child* (Dube H.204), *Scene in the wood* (Dube L.153), and *Street in the Harbour* (Dube L.153) Pechstein's portfolio contained *Russian Ballet 1* (1912, Fechter R.65), *Dancers and Bathers at the Pond in the Woods* col. litho, and *Fisherman's Head VII*, (1911; Fechter H.79).

14. *ELK*, p.12.

15. Ibid, p.65 (*Chronik der Brücke*).

16. Ibid, p.49. The artistic fruits of this trip include Fritz Bleyl's watercolour *Open Air Nude* (1904) and Heckel's *Bathing Boy at the Waterside* (1904). See *Die Brücke im Aufbruch*, exhib. cat. Brücke Museum Berlin, 7 Jun. – 13 Jul. 1980, cat. nos 1 and 46. In his memoirs Bleyl records that he and Kirchner worked together before the foundation of *die Brücke* along the banks of the Elbe and 'also occasionally in the vicinity of Moritzburg'. (Bleyl, 'Erinerungen' p.94).

17. *Liebermann in seiner Zeit*, exhib., cat.no.72. See also *At the Swimming Pool* (1875–7) cat.no.30. Menzel's *Boys Bathing in the Saale near Kösen*

(1865) provides a precedent for these works. There was also a local naturalist school in Dresden, known as the *Goppeln Landscape school*, including Robert Sterl, Paul Baum, Carl Bantzer and Hans Unger, painting outdoors in Göppeln since 1893. Sterl apparently taught Schmidt-Rottluff the technique of lithography (Reinhardt, *Die Frühe Brücke*, p.38). Pechstein's memoirs pp.23–4, speak of the summer of 1907 spent with Kirchner in Göppeln painting nudes in the open air. His woodcuts *Bathers* (Fechter H.19), *At the Waterside* (Fechter H.20) and the pen and ink drawing *In Shadow*, 1907 all refer to this early experience. This last nude in particular has a somewhat coy, academic air, and is comparable to contemporary treatments of the same theme by academic artists, drawing on the inspiration of Böcklin. For example, Paul Paede's *Nude* exhibited in the 1908 Große Berliner Kunstausstellung.

18. Other sources for the city versus country theme include Walt Whitman and articles in *Kunstwart*, e.g. Paul Schulze-Naumberg, 'Die Großstadtkrankheit', March 1906, and an anonymous article, 'Zur Körper-Kultur', July 1906, pp.437–9. Bleyl, 'Erinnerungen' p.94, records their knowledge of these two literary sources.

19. *Der Mensch*, Jg. 13, 1906, Nr. 52, quoted in Frecot, Geist, Kerbs ed. *Fidus 1868–1958, zur aesthetischen Praxis bürgerlicher Fluchtbewegungen*, Munich 1972, p.55.

20. Walter Eberding, '35 Jahre Obstbausiedlung Eden', *Biologische Heilkunst*, 1928 Nr.17. See Frecot et. al., *Fidus 1868–1958*, p.37. From 1901 Julius Sponheimer published a magazine from Eden entitled *Hinaus aufs Land!* ('Out onto the Land.')

21. *Monte Verità Berg der Wahrheit*, exhib. cat. Akademie der Künste Berlin, March-May 1979.

22. *Dresdener Salonblatt*, 4, 1910, p.1189.

23. *Dresdener Rundschau*, 31, 5 Aug. 1905, p.6.

24. Heinrich Pudor, 'Nackende Menschen, Jauschzen der Zukunft', *Dresdener Wochenblätter*, 1893, pp.23ff.

25. Ibid, p.40. See too Richard Ungewitter, *Die Nacktheit in entwicklungsgeschichtlicher, gesundheitlicher, moralischer und künstlerischer Beleuchtung*, vols. 1 and 2, Stuttgart 1907 and 1913, which sold 99,000 copies before 1930. In the 1880s the artist Wilhelm Diefenbach (b.1851) was practising nude bathing with art students and local children in Höllriegelskreuth near Munich. He was imprisoned on charges of indecency.

26. In 1893 the *Lichtgebet* appeared in the periodical *Sphinx*, and in 1897 it was used to illustrate a poem by J. Loewenberg in *Jugend*, No.29, p.489. In 1905 it was reprinted in *Deutsche Kultur*. In 1906 a special edition of 10,000 copies was published entitled *Betender Knabe* (Praying Boy). In 1901 the motif appeared on a poster advertising the new *Licht-Luft Sportbad* for men in Berlin. Some of Pechstein's early work like his drawing *Branch of Mistletoe* (1905) (Reinhardt, *Die Frühe Brücke*, p.43) comes stylistically close to Fidus.

27. See Walter Laqueur, *Young Germany*, London 1962, where he describes the broad range of political affiliations and viewpoints that infiltrated the Youth Movement and *Wandervogel*. See too Harry Pross, 'Youth Movements in Germany' in *German Art in the 20th Century*, exhib.cat. Royal Academy 1985, pp.83–91. Also Charles S. Kessler, 'Sun Worship and Anxiety', *Magazine of Art*, November 1952.

28. Frecot et. al., *Fidus 1868–1958* p.15.

29. Thomas Kempas, Rolf Wedewer, *Landschaft – Gegenpol oder Fluchtraum?*, exhib.cat. Städtisches Museum Leverkusen, 27 Sep.–10 Nov. 1974, fore-

word pp.6–7.

30. Gordon, 'German Expressionism', p.371, p.401, notes 21–3. Gordon argues that the choice of the 'neutral title' for their group '*Künstlergruppe Brücke*' in favour of the more volkish term '*Gemeinschaft*' is proof of their 'progressive' aspirations. Gordon refers to the distinction formulated in F. Toennies, *Gemeinschaft und Gesellschaft*, 1887, a distinction comparable to that between '*Kultur und Zivilisation*'. He also describes the 1906 *Programm der Brücke* as a hymn to the future. Gordon is not wrong. But he follows the general trend in the Primitivism catalogue to insist on the progressive modernist aspects of his subject at the expense of more complex layers of cultural associations.

31. William Bradley, *Emil Nolde in the Context of North German Painting and Volkish Ideology*, PhD. 1981, Northwestern University, p.58. The original German is not given and the page reference is inexact.

32. See note 26 above. Kirchner – like Fidus and Schneider – was doubtlessly inspired by his reading of *Zarathustra*: 'and one morning he rose with the dawn, stepped before the sun, and spoke to it thus: Great Star! What would your happiness be, if you had not those for whom you shine! You have come up here to my cave for ten years: you would have grown weary of your light and of this journey, without me, my eagle and my serpent' p.39; ('und eines Morgens stand er mit der Morgenröthe auf, trat vor die Sonne hin und sprach zu ihr also: "Du großes Gestirn! Was wäre Dein Glück, wenn Du nicht die hättest, welchen Du leuchtest! Zehn Jahre kammst Du hier auf zu meiner Höhle: du würdest Deines Lichtes und dieses Weges satt geworden sein ohne mich, meinen Adler und meine Schlange' p.5). Nietzsche's influence was the major point of coincidence between *die Brücke* and the nudist movement. Kirchner's *Moonlight Glimmer*, 1904 (Dube H10) shows a group of nude figures cavorting through a wood. An earlier drawing by Nolde, *Sun worshiper* (1901) also quotes the *Lichtgebet* motif.

33. See Paul Rees, 'Edith Buckley, Ada Nolde and *die Brücke*. Bathing, Health and Art in Dresden 1906–1911', *German Expressionism in the U.K. and Ireland*, ed. Brian Keith Smith, University of Bristol 1985.

34. In 1909 and 1911 Kirchner and Heckel worked together in Moritzburg. In 1910 Pechstein joined them there.

35. This mistake was perpetuated by Leopold Reidemeister in *Künstler der Brücke an der Moritzburger Seen 1909–1911*, exhib.cat. Brücke-Museum Berlin, Oct.–Dec. 1970. In 1909 Kirchner and Heckel were definitely at the lower and upper forest ponds in Boxdorf, as Kirchner's postcard to Heckel dated 6 Sep.1909, with the 'Palau' bathers motif states: 'we are in Boxdorf – there too quite nice landscapes' Confusion has arisen partly because Kirchner refers to the water being drained in the ponds (postcard to Heckel 20 Oct. 1909, 'Greetings from the ponds which are unfortunately drained.') In the artificial Moritzburg lakes, this is done in late summer to facilitate carp fishing. But in Boxdorf the lower pond is also drained for carp fishing in the autumn.

36. Kirchner's postcard dated 9 Sep.1909 (*E.L. Kirchner. Die Handzeichnungen Aquarelle und Pastelle in eigenem Besitz*, exhib.cat. Brücke Museum 16 Sep. 1978–15 Feb. 1979, cat.18) relates directly to his painting *Girl Bathing*, (1909;G.86), and to Heckel's *Bathers at the Pond* (Vogt 1908/4). Kirchner's *Three Nudes in the Wood* (G.44;1908/20) and Heckel's *Three Women* (Vogt 1908/5) show

the same group of models around a tree; this time Heckel is slightly closer to the motif. These relations suggest mistaken dating in the catalogues raisonnés.

37. The large scale of the figure in relation to the landscape in G.140 is frequent in Kirchner's 1909 paintings and unusual in 1910. I would suggest that this work too was painted in 1909.

38. Kirchner's lithograph *Group of Bathers* 1909, (Dube L118) is related to G.93. Literary themes were not unknown in Kirchner's work at this date. On the reverse of *Reclining Blue Nude* for example, he painted a nude surpised by male figures, intitled *Shame, Allegory* (G.87v, 1909).

39. Frecot et. al. *Fidus 1868–1958*, p.51.

40. An advertisement for Bilz' public 'Sun-and-air sports bath' in the *Dresdener Neueste Nachrichten*, 13 Jun. 1909, p.2 reads: 'In the midst of extensive pine forests and countryside woods, all kinds of relaxation and enjoyment is to be found for nervous, lead-poisoned city dwellers. In three separate sectors for men, women and families, covering 300,000 sq. metres, there is the chance to take the air and practice all kinds of sports. Nude gymnastics are a speciality, which gave the classical people of ancient times their strength, beauty and agility.' ('Inmitten von weiten Nadel-und Landwäldern gelegen, bietet es für den nervösen und bleichflüchtigen Großstadtbewohner Erholung und Freuden aller Art in reinster Waldluft. In drei getrennten, circa 300,000 Quadratmeter umfassenden Abteilungen für Herren, Damen und Familien ist Tausenden gleichzeitig Gelegenheit zum Luftbaden und zur Ausübung jeden Sports, besonders der Nacktgymnastik geboten, der die klassischen Völker des Altertums ihre Kraft, Schönheit und Gewandheit verdankten.') Laquer *Young Germany*, (pp.58, 64) describes the appeal for sexual abstinence in the Youth Movement, e.g. Hermann Popert's *Helmut Harringa*, 1910 and the stirrings of a more liberal attitude to mixing the sexes before 1914, e.g. in the 'Anfang group' 1913–14. Gustav Wyneken observed in 1915 that the Youth Movement needed a new erotic orientation and Hans Blüher published his biased history of the movement, *Die deutsche Wandervogelbewegung als erotisches Phaenomen* at the time. Laquer points out that this involved more erotic mysticism than heterosexual contact.

41. Both Kirchner and Schmidt-Rottluff attended the Cézanne exhibition at Paul Cassirer's gallery in Berlin in Novemeber 1909. A card from Schmidt-Rottluff to Heckel dated 23 Nov. 1909 shows his sketch after Cézanne's *St Henri of L'Estaque* (1900), and Kirchner's card dated 21 Oct. 1909 shows his sketch after Cézanne's *Seated Man with a Newspaper* (1898) (Venturi 1936, No. 697). A second card from Kirchner to Heckel dated 25 Nov. 1909 depicts a sketch from a Cézanne bather composition (Venturi 1936, No. 724, now in Baltimore). This painting was illustrated in an article by Maurice Denis in *Kunstbladet*, Kopenhagen 1909/10. The message on the card stresses that this painting was *not* to be seen at Cassirers. See Dube-Heynig, p.225. Reinhardt, *Die Frühe Brücke*, pp.90–1 suggests that the pose of the crouching bather seen from behind was taken from the Palau beams rather than Cézanne, and Frank Tießler also makes this association with reference to a 1910 Heckel lithograph, (pp.6–7). Indeed, a very similar motif recurs in the Ajanta wallpaintgings (cave 1, plate 18, later sketched by Kirchner), already known to Heckel at this date. But the group bathing scene definitely refers to Kirchner's new interest in Cézanne.

42. This applies particularly to the genesis of Picasso's

Les Demoiselles d'Avignon in 1907. Also to André Derain's *Les Baigneuses* (1907) and Matisse's *Nu Bleu. Souvenir de Biskra* (1907). Cézanne could be used both to refer to and to challenge the classical tradition. In Kirchner's 1928 remarks about French and German art, when he rejects the traditional distinction between sensuality and spirit, he also suggested that the French continued to cite classical mythology whereas the Germans referred to Norse sagas. Both races were united, however, by the 'the drive to discover mystical novelty in the study of exotic art', which inspired many modern artists – and not only in formal terms' (*Davoser Tagebuch* p.178).

43. Dube-Heynig, p.18. Heckel's *Bathers in the Reeds* (Vogt 1909/13) also shows traces of the Palau style which features in studio scenes that autumn. It predicts Kirchner's 1910 bather compositions, and significantly, Heckel is once again slightly ahead of Kirchner. The painting is executed quickly on the spot, using two blues, two greens, two oranges. White spaces were left for the figures in the blue water but the red/orange figure to the left was added later, on top of the dry blue oil paint, presumably to provide a foreground emphasis.

44. Despite the rejection of Böcklinesque neoromanticism, another important influence on the *Brücke* bathers was the 1909 Berlin retrospective of Hans von Marées. A postcard from Pechstein to Heckel in Rome dated 10 Mar. 1909 records that Schmidt-Rottluff and Rosa Schapire visited the Marées exhibition. Marées influence is evident in Pechstein's and Schmidt-Luff's bather compositions, not in those by Heckel and Kirchner. In *Exoten, Sculpturen, Märchen*, 1920, p.10, William Hausenstein described Marées and Cézanne as two major representatives of 'African' aesthetics in Western art, because of their simplifications and non-literary forms. But by the 1930s Marées was acccepted by the Nazis as a neo-classicist. In the summer of 1908 recent Munch paintings were shown in Berlin at Cassirers, and fifteen recent paintings were shown at the Berlin Secession that year. In 1907 Munch too had begun to paint male bather subjects.

45. G.95 is dated 1909 by Gordon and 1910 in *ELK*, cat. no.94. For stylistic reasons and the appearance of Fränzi or Marcella as the left-hand bather, 1910 seems a more convincing date. In September 1910 this painting was included in the Galerie Arnold exhibition in Dresden. G.142, 144 and 146 also display the 1910 Palau style.

46. The Palau style also features in 1910 bathers by Heckel and Pechstein. e.g. Heckel's *Children in the Open Air* (Vogt 1909/19 – which I would date 1910), *Forest Pond* (Vogt 1910/11), and *Bathers at the Forest Pond* (Vogt 1910/19). Pechstein's *The Yellow and Black Tricot*, 1910 and *At the Lakeside*, 1910 also show his response to the Palau beams. Pechstein sometimes makes reference this year to modern, civilized trappings, like Kirchner in 1909. e.g. swimming costumes, hammocks (*In the Woods near Moritzburg* 1910, and the horse market, *Horse Market*, 1910). Heckel's non-active members card in 1910 is a direct pastiche of the Palau beams. Kirchner's list of non-active members in 1910 (Dube H. 704), and Heckel's cover design for the 1910 portfolio of Kirchner's graphics (Dube H. 181) also use the Palau style to depict primitivist archers.

47. Reinhardt, *Die Frühe Brücke*, p.174.

48. Ibid, p.90. He quotes from Eberhard Roters, 'O das wir unsere Urahnen wären', in the exhib. cat. *Landschaft-Gegenpol oder Fluchtraum*, Leverkusen/Berlin 1974/5, p.39.

49. Dr Hoffman at the Karl May Museum in Radebeul

informs me that primitivist fancy dress balls also took place at Bilz' *Licht-Luft Sportbad* (interview 27 Mar. 1987).

50. '...der Mensch als Gattung stellt keinen Fortschritt im Vergleich zu irgend einem andern Tier dar. Die gesamte Tier- und Pflanzenwelt entwickelt sich nicht vom Niederen zum Höheren sondern alles zugleich, und übereinander und durcheinander und gegeneinander...die Domestikation (die Kultur) des Menschen geht nicht tief... wo sie tief geht, ist sie sofort Degenerenz (Typus: der Christi). Der "wilde" Mensch (oder moralisch ausgedrückt: der böse Mensch) ist eine Rückkehr zur Natur – und in gewissem Sinne, seine Wiederherstellung, seine Heilung von der "Kultur".' Friedrich Nietzsche, *Der Wille zur Macht*, Stuttgart 1964, pp.461ff.

51. *Unzeitgemäße Betrachtungen*, 1872–4, *Thoughts Out of Season*, London 1909, vol. 2 pp.83–4. Poliakov, p.300.

52. 'Daß der Expressionismus zunächst mitunter ziemlich ungebärdig, ja beserkerhaft verfahren muß, entschuldigt der Zustand, den er vorfindet. Es ist ja wirklich fast der Zustand des Urmenschen. Die heute wissen gar nicht, wie recht sie haben, wenn sie spotten meinen, daß diese Bilder 'wie von Wilden' gemacht sind. Die bürgerliche Herrschaft hat aus uns Wilde gemacht. Andere Barbaren, als die Robertus einst fürchtete, drohen ihr. Wir selber alle, um die Zukunft der Menschheit vor ihr zu retten, müssen Barbaren sein. Wie der Urmensch sich aus Furcht vor der Natur in sich verkriecht, so flüchten wir in uns, vor einer Zivilisation zurück, die die Seele des Menschen verschlingt.' Hermann Bahr, *Expressionismus*, Munich 1919, pp.115–17 (written 1914, first published 1916).

53. Nietzsche, *Werke...*, 1972, p.248; transl. *Untimely Meditations*, p.63.

54. Ibid. See also p.326: 'with the word "unhistorical" I designate the art and power of forgetting and of enclosing oneself within a bounded horizon; call "suprahistorical" the powers which lead the eye away from becoming towards that which bestows upon existence the character of the eternal and stable, towards art and religion.' ('Mit dem Worte "das Unhistorische" bezeichne ich die Kunst und Kraft vergessen zu können und sich in einen begrenzten Horizont einzuschliessen; "überhistorisch" nenne ich die Mächte, die den Blick von dem Werden ablenken, hin zu dem, was dem Dasein den Charakter des Ewigen und Gleichbedeutenden gibt, zu Kunst und Religion.') See too Baudelaire, *The Painter of Modern Life*, p.392.

55. Heinrich Scham (Pudor) *Jungbrunnen, Offenbarungen der Natur*, Leipzig 1894, p.15.

56. Archive illustrations of these posters are included in Bernd Hünlich, 'Heckel and Kirchners verschollene Plakatenentwürfe für die Internationale Hygiene-Ausstellung Dresden 1911', *Dresdener Kunstblätter*, 1984, no. 5, pp.145ff. A report on the competition appears in the *Dresdener Salonblatt*, no. 23, 1910, p.695, where the entries are generally criticized for lack of imagination.

57. 'Das zeigen die nun folgenden bildlichen und plastischen Darstellungen über die Leibesübungen bei den alten Etruskern, Ägyptern, Hellenen und Römern. Bei den Römern entarteten die Leibesübungen später vielfach zu rohen Schaustellungen und weiterhin im Mittelalter wurden sie teilweise sogar unter dem Einfluß der auf das rein geistige gerichteten Bestrebungen ganz vernachlässigt.' *Katalog der internationalen Hygiene-Ausstellung*, Dresden 1911, p.386.

58. 'Wir hatten Glück auch mit dem Wetter, kein verregneter Tag. Zwischendurch fand manchmal in Moritzburg ein Pferdemarkt statt...sonst zogen wir Malersleute frühmorgens mit unseren Geräten

schwer bepackt los, hinter uns die Modelle mit Taschen voller Fressalien und Getränke. Wir lebten in absoluter Harmonie, arbeiteten und badeten. Fehlte als Gegenpol ein männliches Modell, so sprang einer von uns dreien in die Bresche...' Pechstein, *Erinnerungen*, p.42.

59. *Expressionisten. Sammlung Buchheim*, exhib. cat. Kölnische Stadtmuseum, 2 Apr. – 31 May 1981, no.96.

60. In the summer of 1911 Kirchner painted with Otto Müeller in Mnischek, Bohemia, before travelling to Prague, and Heckel worked at the artists' colony in Prerow. In August they joined up in Moritzburg. In 1912 Heckel painted at Stralsund, Hiddensee and then joined Kirchner on Fehmarn. In 1913 Heckel visited Osterholz on the Flensburger Förde while Kirchner returned to Fehmarn in 1913 and 1914.

61. A.M. Dube-Heynig, *E.L. Kirchner. Graphik*, Munich 1961, p.51, suggests that this practice provided Kirchner with a means of conceptualizing nature without resorting to two dimensional decoration.

62. A photograph of Erna, which Kirchner used for *Bather Between Rocks* (G.256), is in the Kirchner estate in Campione (Gordon, 'Kirchner in Dresden' p.86). Grohmann, 1958, p.64, says that *Brown Nude At The Window* and *The Toilette; Woman Before a Mirror* were executed after Kirchner's return to Berlin in 1912.

63. In 1912 and 1913 Heckel's paintings follow a related and yet different path. Initially in paintings like *Scene at the Sea (Bathing Women)* (Vogt 1912–8), Heckel continued the celebratory spirit of Moritzburg, sometimes combining references to Palau and Ajanta. In this case the forms of the figures recall Ajanta and their compositional articulation Palau. In 1913 the influence of international modernism, which also makes itself strongly felt in Pechstein's contemporary paintings is evident in the splintered forms of *Day of Glass*, and Bathers (Vogt 1913–9). The small fragmented forms and hieroglyphic figures in the latter painting also seem to owe some formal influence to South African cave painting. In *Day of Glass* and the Münster composition *Bathing Women* (Vogt 1913–12), the figures closely resemble Heckel's wooden sculptures. But in his case it seems that this development had more to do with the influence of Futurism and Rayonism, than with the practices of self-reference and interchange between nature and artifice, so deeply written into the textures of Kirchner's oeuvre.

64. Letter dated 31 Dec. 1912 (Schiefler Archive Hamburg).

65. For a description of the geography of the island see Horst Rohde, *Das Fehmarnhaus und sein Dorf*, Neumünster 1984.

66. Dr Kurt Düring, 'Das Siedlungsbild der Insel Fehmarn 1937', *Forschungen zur deutschen Landes- und Volkskunde*, vol. XXXII, pp.7–135, here 102. Ingolf Junghaus, 'Eine Insel ohne Märchen', *Merian*, Jg. 9, vol. VIII, 1956, pp.42–7, points out that despite the growing tourist industry in the 1950s, the islanders still spoke of a journey to the mainland as, 'journey to Europe' (p.42).

67. *BIZ*, 1911, 1912.

68. Düring, 'Das Siedlungsbild', p.124.

CHAPTER 8. THE LURE OF THE METROPOLIS

1. 'Bismarck, der so oft recht hat, hat auch recht in seiner Abneigung gegen die Millionen-Städte. Sie Schreiben selbst: "Bei weniger 'Carrière machen' hätten wir mehr Wahrheit in der Welt!" Gewiß. Und nicht bloß mehr Wahrheit, auch mehr Einfach-

heit und Natürlichkeit, mehr Ehre, mehr Menschenliebe, ja auch mehr Wissen, Gründlichkeit, Tüchtigkeit überhaupt. Und was heißt 'Carrière machen' anders also in Berlin leben, und was heißt in Berlin leben anders als 'Carrière machen'. Einige wenige Personen brauchen ihrem Beruf nach die große Stadt, das ist zuzugeben, aber sie sind doch verloren, speziell für ihren Beruf verloren, wenn sie nicht die schwere Kunst verstehen, in der Stadt zu leben und wiederum auch nicht zu leben.' Letter from Theodore Fontane to Georg Friedlaender 21 Dec. 1884. In *Theodore Fontane Briefe*, ed. Kurt Schreinert, Heidelberg 1954, p.3.

2. B.R. Mitchell, *European Historical Statistics 1750–1970*, London 1975. Berlin had the same size population in 1800 as Lisbon, i.e. 172–180,000. In 1910 Lisbon had grown to 435,000 and Berlin to 2,071,000 people.

3. August Endell, *Die Schönheit der großen Stadt*, Stuttgart 1908, p.9.

4. Walter Leistikow on the contrary, painted the outlying areas of Wannsee and Nicolassee in the 1890s, avoiding all references to encroaching civilization. His paintings come close to contemporary Scandinavian landscape painting by L.A. Ring or Kitty Kieland. Examples of city Impressionist paintings by the Berlin Secession artists include Max Liebermann's *Restaurant De Oude Vink in Leiden* (1905); Max Slevogt's *Trotting Race* (1907) and Konrad von Kardorff, *Königin Augustas Straße in the Tiergarten* (1910) (fig. 173)

5. Endell, *Schönheit*, pp.87–8.

6. See chapter 4, p.57.

7. Endell, *Schönheit*, p.16.

8. Ibid, p.20.

9. Gustav le Bon, *Psychologie des Foules*, Paris 1895, translated into German in the same year under the title *Massenpsychologie*, and reviewed by Georg Simmel in *Die Zeit*, Nr. 5, 23 Nov. 1895.

10. *BIZ* 33, 17 Aug. 1913, p.655.

11. *BIZ* 2, 12 Jan. 1913, p.69.

12. Dr Werner Hegemann, 'Soll Berlin Wolkenkrätzer bauen?', *BIZ* 4, 26 Jan. 1913.

13. Henry F. Urban, 'Im Wolkenkratzer', *BIZ* 7, 16 Feb. 1913, p.141. America played an important rôle in the discussion about modernization in Germany. 'Americanization' was the term used to signify modern materialism, mechanization, commercialism and mass society. It was also described as a nation with no sense of history, no bond with its soil; in short a nation that was not a *Volk*.

14. *BIZ* 27, 6 Jul. 1913, p.536.

15. 'Die Stadt der Zukunft', *BIZ* 50, 15 Dec. 1912, pp.1233–4.

16. 'Die Sehnsucht des Großstädters', *BIZ*, July 1914.

17. 'Die Schönste Park der Welt', *BIZ* 25, 23 Jun. 1912, p.577. The Tiergarten is described as, 'designed more for a hermit than a cosmopolitan. There were also moves to establish bathing resorts in the city parks. See *BIZ* 18, 1 May 1910, p.329, and *BIZ* 23, 8 Jun. 1913, p.456.

18. There are also *Brücke* paintings of the Tiergarten. For example Kirchner's *Tiergarten Berlin Zoo* (1911; G.241) shows lush green trees and small city figures sitting on a park bench. Heckel's *Winter Canal in the Tiergarten* (Vogt 1913/42) translates the motif into very abstract terms.

19. Hünlich, 'Wohnstätten und Lebensumstände', p.89. Another extended essay, 'Dresdener Motive in Werken der Künstlergemeinschaft Brücke. Ein Beitrag zur topographisch-kritischen Bestandsaufnahme', *Jahrbuch der Staatlichen Kunstsammlungen Dresden*, 1981, pp.67ff, gives a full picture of the relationships between *Brücke* motifs and the original Dresden sites. This admirable achievement tells us much that is new about

Kirchner's pictorial methods. Generally it is in his coloured works rather than drawings that departs from a given motif, and even then Kirchner's chosen palette often has its roots in a detail of a given scene. Bernd Hünlich kindly took me on a tour of the Friedrichstadt in March 1987, pointing out more, as yet unpublished, relations between *Brücke* images and the topography of the area they lived in.

20. Reinhardt, *Die Frühe Brücke*, p.113 suggests that Kirchner was inspired to paint *Street* after a stopover in Berlin on his way back from Fehmarn in 1908, but he presents no evidence to support this theory. Kirchner's later but related drawing of a street scene on a postcard to Heckel dated 4 Apr. 1910 (Altonaer Museum, Dube-Heynig, p.87), has a Dresden postmark.

21. Ibid. Reinhardt questions the possibility of Kirchner's knowledge of Munch's *Karl Johann Straße*, which Procházka would have seen in the large 1905 Munch exhibition in Prague. Reinhardt suggests Felix Vallotton's *L'Etranger* (1894) and Toulouse Lautrec's *Danse au Moulin-Rouge* (1890) as alternative sources for the composition, but neither are visually convincing. The connection with Munch's painting was first suggested by Eberhard Roters in 'Beiträge zur Geschichte der Künstlergruppe Brücke', *Jahrbuch der Berliner Museen*, 11, 1960, pp.172–210. Gordon, 'Kirchner in Dresen', p.345 makes the connection too.

22. Heckel to Amiet 9 Jun. 1907 (Brücke Museum Archives): 'I was in Berlin, saw very good Cézanne and the first Van Gogh drawing. One Gauguin and a very fine Degas I'm still dreaming of them.' For the sequence of *Brücke* visits to Berlin see L. Reidemeister, *Künstler der Brücke in Berlin 1908–1914*, exhib.cat. Brücke Museum Berlin, September–November 1972.

23. Kirchner, for example, showed a drawing *Travelling Across the Elbe* in the 1906 black-and-white exhibition of the Berlin Secession. In 1908, he showed one drawing, *Cows*, one lithograph, *Boat* and two engravings, *Woman on the Beach* and *Windmill*. In 1909 he showed an engraving *Bathing Girls* and a lithograph *Circus Rider*.

24. Heckel to Amiet, 6 Oct. 1910 (Brücke Museum Archives): 'Now the pictures are in Weimar, in January they'll be in Leipzig, in April in Berlin at Gurlitt's.' In the same letter he wrote of his financial problems and the plan to raise the yearly members fee to 20 marks as 12 marks was proving inadequate. A card from Kirchner and Heckel to Otto Mueller dated 22 Mar. 1911 (Altonaer Museum Hamburg) reads: 'Unfortunately the April exhibition has finally been cancelled. Only managed to get a promise for a later exhibition at Gurlitt's.' A letter from Heckel to Amiet in February 1912 confirmed that the Gurlitt exhibition was to take place in April that year, and the plans to raise the yearly membership fee: 'I'm living in Berlin now in order to survive financially.' In May 1912 Heckel continues in a further letter to Amiet, 'Our exhibition here was well attended and has excited much favourable criticism.' The *Chronik der Brücke* was first mentioned in this letter, suggesting that the idea was to capitalize on their recent success and good publicity.

25. Undated letter from Schmidt-Rottluff to Amiet winter 1908/9. Nölken was named as a member in this letter (Brücke Museum Archives).

26. Richard Stiller, 'Die Ausstellung der K-G Brücke bei Arnold', *Dresdener Anzeiger* 249, 9 Sep. 1910, pp.3–4. Paul Fechter, 'Die Ausstellung der Brücke', *Dresdener Neueste Nachrichten*, 249, 13

Sep. 1910, p.1. Both critics had reviewed the 1909 Galerie Richter show in positive terms. Their change of tone in 1910 is an interesting phenomenon, coinciding precisely with the first consistent formulations of the *Brücke* artists' primitivism. Stiller charges *die Brücke* with a lack of *German* identity, which renders their claims to represent the new German art ridiculous, in his opinion. He also complains about 'their regression into childishly crude clumsiness'. Fechter's review revolves around the issue of whether the artists' attempt to render their own times, 'an attempt to render the contemporary, the present in a form freed from tradition', is successful or not. He considers that their recent paintings have not fulfilled this ambition. It is possible to interpret Fechter's uncertainty about their work in 1910 as a sensed but not yet precisely formulated discomfort about the suitability of their primitivist style for the task of rendering 'the idiosyncratic rhythm of our times'.

27. Eduard Plietzsch, *Heiter ist die Kunst*, p.61. He claims that Pechstein knew a wide circle of painters, musicians, tradesmen, actors, bankers, politicians, poets, sculptors etc.

28. The first quotation is from an undated letter from Kirchner to Heckel without a postmark. Probably December 1909 from Dresden (Dube-Heynig, p.229). The second comment comes from a letter from Kirchner to Frau Schiefler dated 15 Nov. 1911: 'I hope we shall create a new tradition and persuade many new friends of the value of our work' (Schiefler Archives Hamburg).

29. Letter from Kirchner to Schiefler dated 28 Dec. 1912 (Schiefler Archives Hamburg).

30. Schmidt-Rottluff to Ernst Beyersdorff, 21 Jul. 1913, quoted in G. Wietek, *Bilder aus Nidden 1913*, Stuttgart 1963, Reclam Werkmonographien zur Bildenden Kunst, Nr. 91.

31. A letter from Pechstein to Heckel dated 18 Oct. 1911 hints at the internal troubles in the group: 'Schmidt-Rottluff is here and he's trying to make trouble' (Altonaer Museum Hamburg). An undated letter from Kirchner to the Schieflers (early Spring 1912) reports his regrets that he is unable to take part in the first *Sturm* exhibition in Herwath Walden's new gallery where Munch, Kokoschka and Hodler are to be shown. The reason he gives is the forthcoming *Brücke* exhibition at the Fritz Gurlitt gallery: 'the art dealers don't permit another show so soon before' (Schiefler Archives Hamburg). This throws new light on Walden's decision not to exhibit *Brücke* paintings which has provoked much speculation in the past. In *Der Sturm*, 27 May 1911 a bad review of *die Brücke* at the New Secession appeared: 'The name *Brücke* probably indicates that their art involves a union of German and French styles. The paintings are not to be excelled for the hopelessness of their draftsmanship and mean no more than the shrilly coloured scribblings of a group of cannibals.' But Walden showed enthusiasm for *Brücke* graphics publishing, for example, ten Kirchner woodcuts in *Der Sturm* from July 1911 to March 1912. In December 1911 *die Brücke* left the New Secession and were making plans with Niemeyer and Osthaus for the foundation of their *Künstlerbund*. A letter from Marc to Macke dated 19 Apr. 1913 recorded his disappointment that Heckel had refused to join the *Erst deutsche Herbstsalon* because he was afraid to compromise himself in the *Sturm* circles, and that Schmidt-Rottluff had decided all his energies should be concentrated on the 1912 Cologne Sonderbund exhibition (*Briefwechsel August Macke, Franz Marc 1910–1914*,

Cologne 1964, p.158). Eventually Pechstein helped Paul Cassirer and Liebermann to organize a rival Secession Autumn Exhibition. Increasingly critics like Paul Fechter, Max Osborn and Curt Glaser who continued to write scathingly about Cubism and the *Blaue Reiter* began to respond positively to *die Brücke* after 1912. In December 1914 in *Die Kunst für Alle* Glaser praised Heckel's exhibition at J.B. Neumann's gallery and in January 1914 he spoke of the *Brücke* artists at the old Secession as 'the strongest talents among the younger artists'. After the foundation of *die Freie Secession*, the *Brücke* artists exhibited paintings which Paul Cassirer first agreed to purchase (Nolde, *Jahre der Kämpfe*, 1934, p.202).

32. Preparatory stages of the *Chronik der Brücke*, are now in the possession of the Staatliche Graphische Sammlung, Munich. This includes a cover with four woodcut portraits of the *Brücke* artists by Kirchner (Dube H. 710), the woodcut text, carved by Kirchner (Dube H. 696), a table of contents, a list of members, photographs of their 1909 Galerie Richter exhibition; photographs of *Brücke* paintings; three texts by Kirchner, 'Über die Malerei', 'Über die Graphik,' 'Die Freunde der Brücke'.

33. The first Futurist exhibition at Walden's *Der Sturm* gallery was held from 12 April to 31 May 1912. Boccioni and Marinetti distributed several thousand pamphlets on the streets to publicize the event. The exhibition was a sell-out, 28 paintings were bought by the Berlin banker Dr Borchardt for 11,650 marks. See Dorothea Eimert, *Der Einfluß des Futurismus auf die deutsche Malerei*, Cologne 1974.

34. Günter Krüger, *Pechsteins Jahreszeiten*, p.92.

35. In 1885 Arno Holz' *Buch der Zeit* (*Book of the Times*) was subtitled *Großstadt* (*Big City*). In 1905 a collection of city poems by Ernst Schur, *Die Steinerne Stadt* (*The Stone City*) appeared. Bleyl (*Erinnerungen*, p.96) recorded that *die Brücke* read Arno Holz in the early Dresden years. Other relevant literary contacts included Gerhard Hauptmann, who was related to Otto Mueller. (A postcard from Kirchner to Heckel dated 11 Jan. 1911 (Dube-Heynig, p.166) was signed by Hauptmann too.) Schmidt-Rottluff was in contact with Alfred Mombert, a Jewish 'Kosmiker' fiercely opposed to contemporary materialism (see Schmidt-Rottluff's woodcut *An Mombert*, 1912, Schapire H77). A local visual tradition of industrial urban subjects existed too. For example in the 1912 black-and-white exhibition of the Berlin Secession, 24 drawings by Hans Baluschek entitled *The Way of Machines* were exhibited which were negatively reviewed in *Die Kunst für Alle*.

36. Karl Ludwig Schneider, 'Themen und Tendenzen der Expressionistischen Lyrik. Anmerkung zum Anti-traditionalismus bei den Dichtern des Neuen Clubs', in *Zerbrochene Formen. Wort und Bild in Expressionismus*, Hamburg 1967, p.44.

37. Kurt Hiller, *Die Weisheit der Langeweilen*, Leipzig 1913, p.119.

38. From June 1910 the Neuer Club organized literary evenings in the Neopathetische Cabaret. Kirchner made a drawing, *Young Poet Guttmann* 1911 and a painting *Portrait of Guttmann* (1911; G.215). Schmidt-Rottluff painted two portraits in 1911 and 1913, and a woodcut *Portrait of Guttmann* (1914; Schapire H137).

39. In November – December 1911 Schmidt-Rotluff designed two programmes. In 1912 Heckel made a woodcut advertising a 'Pantomime von W.S. Guttmann getanzt von Sidi Riha' (Dube H. 232).

40. The carved head in this painting recurs as a kind of voyeuristic presence in *Nude with Mirror and Man* 1912 (G.225). Here and in a second painting, *Nude with Two Mirrored Figures* (1912;G.226), Kirchner uses the mirror simultaneously to distance and to involve the spectator. Very similar carved wooden heads from the Cameroons (Ossindinge) were to be found in the Dresden Ethnographic Museum after 1908 (collection Otto Kolscher).

41. See for example Heckel's paintings referring to Dostoyevsky: *Two Men at Table (The Idiot)* (Vogt 1912/2), *Deadman (The Idiot)* (Vogt 1912/13) and *Prisoners in a Steam Bath (The House of the Dead)* (Vogt 1912/15).

42. Unpublished manuscript in the Loewenson estate. Cited in K.L. Schneider and G. Burckhardt ed. *Georg Heym, Dokumente zu seinem Leben und Werk*, vol. IV, Munich 1968.

43. The young poets in the circles of the New Club and Neopathetische Kabarett came from the Friedrich-Wilhems Universität where Simmel was Privatdozent from 1885–1914. He was the most popular lecturer of his day.

44. 'Eine Ambivalenz des Erlebens zeichnet sich ab, bei der rasche Übergange vom Rausch zum Entsetzen ohne weiteres möglich sind und keinen Bruch darstellen. So besteht auch zwischen der positiven Darstellung des Weltstädtischen bei Ernst Blass und der Dämonisierung der Stadt bei Heym keinesweges ein prinzipieller Unterschied des Erlebens. Es händelt sich lediglich um zwei verschiedene Aspekte des gleichen Grunderlebnisse." 'Themen und Tendenzen der Expressionistichen Lyrik' Karl Ludwig Schneider, 1967, p.51.

45. Georg Heym, *Dichtungen*, Stuttgart 1965, pp.3–4. Originally published in Heym's *Der Ewige Tag*, April 1911.

46. Three woodcuts were made by Kirchner as illustrations and mentioned in a letter to Gustav Schiefler dated 19 Dec. 1913 as images for Döblin's 'brothel story' (Schiefler Archive Hamburg).

47. Döblin's first literary manuscript dated 6 Oct. 1896 was entitled *Modern. Ein Bild aus der Gegenwart* (*Modern. A Picture of the Present*). This combined a naturalistic description of milieu, dialogue in Berlin dialect and a social critical essay about the womens' movement.

48. For example, 'Die Tänzerin und ihr Leib' (*The Dancer and her Body*) *Der Sturm* nr. 2, 10 Mar. 1910 and 'Zirkus Pantomime' (*Circus Pantomime*) *Der Sturm*, 3, 24 Mar. 1910.

49. Alfred Döblin, 'Die Bilder der Futuristen', *Der Sturm*, Jg. 3 110, May 1912 pp.41f. and 'Futuristische Worttechnik', an open letter to Marinetti in *Der Sturm*, Jg. 3, 150/151 March 1913, pp.280–2.

50. 'La Pittura futurista manifesto tecnico', *Archivi del Futurismo*, ed. Maria D. Gambillo and Teresa Fiori, Rome, undated, vol. 1, p.65. (Engl. transl: 'Futurist Painting; Technical, Manifesto, in *Futunst Manifestos*, ed. by Umbro Apollonio, London 1973, p.30.)

51. Rosa Trillo Clough *Futurism, the Story of a Modern Art Movement. A New Appraisal.*, N.Y. 1961, pp.33–4.

52. Alfred Döblin, 'An Romanautoren und ihre Kritiker', *Der Sturm*, Jg. 4, 158/159 May 1913, pp.17ff.

53. Ibid, p.41.

54. Letter from Simmel to Count Hermann Keyserling 18 May 1918, quoted in Frisby, p.145.

55. 'Dieser himmlische Taubenflug der Aeroplane. Diese schlüpfenden Kamine unter dem Boden. Dieses Blitzen von Worten über hundert Meilen: Wem dient es?

 Die Menschen auf dem Trottoir kenne ich doch. Ihre Telefunken sind neu. Die Grimassen der Habgier, die feindliche Sattheit des bläulich rasierten Kinns, die dünne Schnüffelnase der Geilheit, die Roheit, an deren Geleeblut das Herz sich klein puppert, der wässerige Hundeblick der Ehrsucht, ihre Kehlen haben die Jahrhunderte durchkläfft und sie angefüllt mit – Fortschritt.

 O, ich kenne das. Ich, vom Wind gestriegelt. Daß ich nicht vergesse-. Im Leben dieser Erde sind zweitausend Jahre ein Jahr.' Alfred Döblin, *Die drei Sprünge des Wang-lun*, Berlin 1915. Quoted in *Alfred Doeblin 1878–1978*, exhib.cat. Deutscher Literatur-Archiv im Schiller-Nationalmuseum Marbach am Neckar, Jun.–Dec. 1978, p.132.

56. Ibid.

57. See Keith Hartley, *The City as seen by Artists in Berlin 1911–1914*, unpublished M.A. report, Courtauld Institute of Art, London University, 1975, section 2, fn. 61–2. The Van Gogh exhibition ran from 25 Oct. – 20 Nov. 1910. German titles are given in the catalogue, and Hartley suggests Van Gogh's *Factory at Asnières* (F. 317) or (F. 318) as a direct influence on Meidner's *Gasometer in Berlin-Schönberg*, a 1912 drawing.

58. Gordon compares this painting to Van Gogh's *Railway Bridge Avenue Montamjour*. The composition comes close to Van Gogh's *Park at Arles*, 1888. See E.L.K., p.142. But Berndt Hünlich pointed out to me that the dip in the road beneath the railway bridge, which still exists today, largely accounts for the spatial distortion in Kirchner's painting.

59. Grohmann, *Kirchner*, p.54.

60. Gordon, 'Kirchner in Dresden', p.98.

61. Ibid, p.90.

62. *Davoser Tagebuch*, p.142. April 1927, Kirchner's description is similar to statements by Kurt Hiller and Georg Simmel. For example Simmel writes of 'an intensified nervous life' in his essay 'Die Großstadt und das Geistesleben', *Jahrbuch der Gehe-Stiftung zu Dresden*, 1903, p.188.

63. Louis de Marsalle (E.L. Kirchner), 'Zeichnungen von E.L. Kirchner', *Genius*, vol. II, no. 2, 1920, p.221.

64. Ibid.

65. 'Das Werk entsteht im Impuls, in der Ekstase, und selbst wenn der Eindruck lange im Künstler ruht, so ist doch seine Niederschrift rasch und plötzlich...

 Ich lernte den ersten Wurf schätzen, so daß die ersten Skizzen und Zeichnungen für mich den größten Wert hatten. Was habe ich mich oft geschunden, das bewußt zu vollenden auf der Leinwand, was ich ohne Mühe in Trance auf der Skizze ohne weiteres hingeworfen hatte und was so vollendet und ruhig war, daß es fertig erschien... Seine (Kirchner's) Zeichnungen sind in der tat Notizen, die er sehr rasch hinwirft, so wie man etwas aufschreibt.' Kirchner's 'Aufsatz Zehnder', *Davoser Tagebuch*, pp.156–8.

66. Letter from Schmidt-Rottluff to Ida Dehmel in 1911 describing his experience of Dehmel's poetry. Reinhardt, *Die Frühe Brücke*, p.159.

67. Charles Baudelaire, *Oeuvres Complètes*, Paris 1937, vol. II, p.334. Translation from Walter Benjamin, *Charles Baudelaire: A Lyric Poet in the Era of High Capitalism*, transl. by Harry Zohn, NLB London 1973, p.68.

68. Paul de Man, *Blindness and Insight: Essays in the Rhetoric of Contemporary Criticism*, N.Y. 1971. See in particular chapter 8, 'Literary History and Literary Modernity'.

69. This format is frequently used for contemporary drawings of studio scenes too, for example, *Sitting Dancer Erna* (1913) (Gabler, p.151), *Seated Nude in a Blue Chair* (1913) (ibid. p.155), *Domestic Scene*, (1913) (ibid. p.157), and *Conversation* (1913) (ibid. p.159). No previous attempts have been made to specify more exactly the chronology of the Berlin street drawings nor the difference between on-the-spot sketches and studio drawings.

70. *Davoser Tagebuch*, p.157. Aufsatz Zehnder.

71. For example, *Five Prostitutes* (1914;Dube H. 240 11) relates to *Five Women on the Street* (1913); *Women on Potsdam Square* (1914;Dube H239 a1v) relates to *Potsdam Square* 1914. Both show the original painted compositions inverted due to later printing.

72. 'Ich habe gerade das Foto des Straßenbildes (G. 363)...vor mir. Wieviel echte Zeichnung ist nötig, so ein Bild zu machen! Wie stehen diese Figuren zusammen und bilden die ganze Straße mit nichts sonst als zwei Hauseingängen. Wie die Bewegung der Passanten in dem Rhombus der Köpfe, das sich zwei mal wiederholt, gefasst. So wird aus geometrischer Grundform Leben und Bewegung. Sie ruht auf festen Gesetzen, die aber gerade hier bei diesem Bild neu, d.h. vom Künstler aus dem Naturerlebnis abgeleitet sind. Es ist ja die Aufgabe des Malers, den plastischen Reichtum der Natur zu sichten und zu ordnen und so neu zu gestalten, dass das, was gemeint ist, klar und rein hervortritt. Gerade dieses Bild wäre interessant einmal neben einem Dürerschen zu sehen....ist unumgänglich nötig zum Schaffen, sie ist die Quelle, der Anfang, sie begleitet die Arbeit und vollendet sie, aber daneben steht als aufbauende Kraft, die den Pinsel dirigiert und die Farbe mischt, Form gibt, eben das Gehirn. Anders geht es nicht, sonst würde ja ein Chaos und kein Bild fertig.' Kirchner to Carl Hagemann, Davos, 27 Feb. 1937. Quoted in E.L.K., p.68.

73. Gordon, 'Kirchner in Dresden', suggests the following chronology for the painted street scenes: G.362–4, 1913; G.365–70, 1914; G.427, 1915.

74. The drawings are reproduced in E.L.K. p.188 (cat. no. 176), and *E.L.K. Zeichnungen*, 1980, p.381 (cat. no. 57).

75. Reproduced as *Street Scene* in Ketterer, *Kirchner*, no.38.

76. Max Klinger, *A Love*, Opus X, 1887, *A Life*, Opus VIII, 1884. We also find contemporary 'documentary' accounts of the brutal realities of prostitutes' lives: for example, the ten life stories in H. Oswald ed. *Gesammelte Großstadt Dokumente (Collected Big City Documents)* vol. 1 'Das erotische Berlin', 1910. Dr Wilhem Hammer, a police doctor, wrote about the life of Christine Leichtfuß, an illegitimate child who earnt about 7–8 marks weekly as an apprentice to a Berlin firm. Dissatisfied with her low wages she became a waitress in one bar after another in north-west Berlin where she earned between 13 pfennigs and 16 marks daily. At the age of 15 and 16 years she underwent two cures for syphillis and her one child was born dead. She was of average size and had smoked since she was 13 years old. Working as a prostitute she could earn 10–25 marks daily serving 1–3 men. This account is presented in documentary guise, but Christine's name (light foot) obviously points to the author's combination of social comment and moral tale. Since 1908 prostitutes appeared in Pechstein's work too, e.g. his lithograph series, Fechter 16, 17, 18, 22, 24. Kirchner's *Bordell* (Gabler, p.144) possibly relates

to his illustrations for Döblin's *Comtess Mizzi* and to the oil painting G. 287. Gabler suggests that the drawing results from Kirchner rethinking this 'unsatisfactory' painting. The two foreground figures in the drawing also relate to Kirchner's *Paar im Zimmer* (1912,G.285). His *Prostitute's Head with a Feather Hat* (1909;Dube L.137) looks more like a portrait of Dodo. *The Murder* (1914) shows him treating the theme of the sex crime which also appears in contemporary works by Max Beckmann and Ludwig Meidner.

77. Kirchner to Schiefler, 28 Mar. 1916, in *E.L.K. Dokumente*, p.160.
78. Rosalynd Deutsch 'Alienation in Berlin. Kirchner's Street Scenes', *Art in America*, January 1983, pp.65–72. Deutsch rightly argues that the mechanization and objectification of human relations in Kirchner's street scenes relates to Simmel's notions about the rule of the money economy in urban society. She suggests that Kirchner tried to overcome alienation by means of his subjective, expressive brushstroke, referring to one of Kirchner's statements in the catalogue to Ludwig Schames' 1918 exhibition of his works: 'My work results from the longings of a lonely state. I was always alone; the more I mixed with men, the more I felt my loneliness.' Deutsch's argument is, on the whole, convincing, but she herself points out the danger of applying Kirchner's later statements too literally to an analysis of his pre-1914 works. I prefer to interpret the gestural brushwork as the technical, stylistic expression of spontaneity, of 'ahistorical modernity', clashing with the geometric rationality of the compositions, which expresses the 'objective', alienating face of modern life, i.e. as part of his multilayered and complex vision of modernity as a contradictory field of experience. In other words, the street scenes embody a clash of subjective and objective realities which Simmel described as the extreme and interdependent alternatives of modern experience. As we shall see, in a discussion of Emil Nolde's still-life paintings, Expressionist primitivism more typically involved the aspiration to heal or 'bridge' the gulf separating subjective and objective experience in the modern world. Instead of proposing an idealistic synthesis, Kirchner's primitivism in the street scenes engages with this rift.
79. Lothar Brieger and Hans Steiner ed. *Zirkus Berlin*, Berlin 1919, p.94: 'The Berlin woman is not styleless, but she has departed from the traditional path of development in order to come into line with the entire mode of the city which follows new paths without a care and vigorously searches for new foundations.' See too Simmel's essay 'Die Mode', in *Philosophischen Kultur, Gesammelte Essais*, Leipzig 1911, which describes the contradiction between the attempt to proclaim individuality in dress and the simultaneous reaffirmation of herd instinct.
80. 'Dem Ideale der Naturwissenschaft, die Welt in ein Rechenexempel zu verwandeln, jeden Teil ihrer in mathematischen Formeln festzulegen, entspricht die rechnerische Exaktheit des praktischen Lebens, die ihm die Geldwirtschaft gebracht hat; sie erst hat den Tag so vieler Menschen mit Abwägen, Rechnen, zahlenmäßigem Bestimmen, Reduzieren qualitativer Werte auf quantative ausgefüllt.' 'Die Großstadt und das Geistesleben', Georg Simmel 1903, p.191.
81. 'Denn die gegenseitige Reserve und Indifferenz, die geistigen Lebensbedingungen großer Kreise, werden in ihrem Erfolg für die Unabhängigkeit des Individuums nie stärker gefühlt, als in dem dich-

testen Gewühl der Großstadt, weil die körperliche Nähe und Enge die geistige Distanz erst recht anschaulich macht; es ist offenbar nur der Revers dieser Freiheit, wenn man sich unter Umständen nirgends so einsam und verlassen fühlt, als eben in dem großstädtischen Gewühl.' Ibid, p.199.
82. This refers to Döblin's notion of the objective, 'thing-like' quality of city life.
83. Ketterer, *Kirchner*, p.139.
84. Simmel, 'Die Großstadt und das Geistesleben', p.194.
85. Ibid, p.187.
86. Le Bon, *Psychologie des Foules*.
87. Sigmund Freud, *Totem und Tabu*, 1911, and 'Psychoanalytical notes on an Autobiographical Account of a Case of Paranoia (The Case of Schreber)', in *The Complete Psychological Works*, ed. J Strachey, vol. XII, p.82. See also Ernst Blaß, 'Das alte Café des Westens', *Expressionismus Aufzeichnungen und Errinerungen der Zeitgenossen*, ed. Paul Raabe, Olten/Freiburg 1965, p.29: 'Van Gogh, Nietische, Freud und Wedekind waren in der Luft. A post-rational Dionysius was sought.'
88. 'Ich entwickelte sie aus der Schau der Bewegung. Das gibt eine Form, die auf der Beharrung der Lichteindrücke im Auge beruht. Der Hacken des gehenden Fußes zum Beispiel bleibt einen Moment länger im Auge als die Spitze, die sich konstant bewegt, so wird er größer für das Bild. Ich selbst bewege mich, und es wird die einseitige Ansicht der Perspektive ausgeschaltet...' Dube-Heynig, p.54.
89. *Davoser Tagebuch*, p.86.
90. Simmel, 'Die Großstadt und das Geistesleben', p.192.
91. D. Gordon, '*Modern Century Art Exhibitions 1900–1916*', Munich 1974, p.331 refers to five de Chirico exhibitions in Paris and Brussels between 1912 and 1914. Possibly Kirchner saw an illustrated review.
92. This applies to all the painted street scenes and some of the drawings too. Kirchner's studio sketch in pastel and crayon for *Friedrichstrasse*, 1914 (Ketterer, *Kirchner*, no.50) depicts a green pavement, prostitutes with green faces and green halo shapes around their heads. In several Berlin studio scenes Kirchner also plays more elaborately on the relationships between nature and artifice: in *The Toilette: Woman Before the Mirror* (1913; G.311), the reflected pose is quite different from that of the image before the mirror.
93. Lyonel Feininger was in touch with the *Brücke* artists from 1913. His own satirical caricatures of the 1890s published in *Lustige Blätter*, and other journals gave rise to caricatural city street scenes like *Pedestrians* 1912 (Hans Hess, *Lyonel Feininger*, Stuttgart 1959, p.254).
94. This notion of pictorial irony, resulting from Kirchner's fragile balance of analogy and contrast also has a parallel in Berlin city poetry. Hiller in particular stressed the rôle of irony in the psychology of the city. Jakob von Hoddis' *Weltende*, 1911 is one example where metaphors are stretched to new possibilities by suggesting both comparative and contrasting associations.
95. 'Die Briefe des Negers Lukunga Mukara: Die Forschungsreise des Afrikaners Lukunga Mukara ins innerste Deutschland'. Republished in book form, Bielefeld 1919.
96. Ibid, p.35.
97. In Paasche's text too, the 'revelation' at the end of the book does not involve Mukara's return to his own people; rather he finds a group of truly 'civilized' Europeans represented by the Youth Movement at Hohe Meißner. The book ends by

reaffirming the classical European ideas of balance and harmony. As Poliakov writes (p.272): 'On close inspection the Aryan appeared to be a Westerner of the male sex, belonging to the upper or middle classes who could be defined equally by reference to coloured men, proletarians or women.'
98. *BIZ* 1, 7 Jan. 1912, p. 8. Another photograph in the *BIZ* is worth mentioning in relation to the issue of conflating the 'primitive' and the modern into a single entity; namely 'The 230cm tall giant negress Abomah who is presently making a guest appearance at the Berlin Panoptikum Walking on Unter den Linden.' (*BIZ*; 11 Jan. 1911, p. 472) (see fig.200).
99. Alfred Kubin, *Die Andere Seite*, Munich 1975 (1st edition 1909) p.277.
100. See R.J. Evans, *The Feminist Movement in Germany 1894–1933*, London 1976.
101. In particular, Otto Conzelmann, *Der andere Dix: Sein Bild vom Menschen und vom Krieg*, Stuttgart 1983, and Matthias Eberle, *World War I and the Weimar Artists: Dix, Grosz, Beckmann, Schlemmer*, New Haven and London 1985. My interpretation of Dix's work places a different emphasis on the conservative aspects of his work. In the early 1920s, a comparison with Brecht is appropriate in as much as Dix combined a thoroughly 'realistic' appraisal of the brutality of mankind with a critical and artistically radical attack, inspiring political change. After 1923 Dix's work loses its critical edge, and his sense of 'unchanging' humanity dominates.

CHAPTER 9. EMIL NOLDE AND THE PARADOX OF PRIMITIVISM

1. Just one statement of this kind about Nolde's oeuvre should suffice. Eugene Victor Thaw, in the catalogue introduction to the Emil Nolde exhibition at the New Gallery, New York, Sept.–Oct. 1957, wrote: 'in his life and his work he (Nolde) seems like a druid priest practicing primordial spells and rituals, expressing the sensuality of primitive worship rather than of the streets and cellars of Berlin.'
2. *Davoser Tagebuch*, p.73 (1 Mar. 1923).
3. 1901 letter from Emil Nolde to Ada, Max Sauerlaendt ed. *Emil Nolde Briefe aus den Jahren 1894–1926*, Berlin 1927, p.85.
4. Gustav Hartlaub, *Kunst und Religion*, Leipzig 1919, p.85.
5. *JDK*, 1934, p.137.
6. 'Diese Liebe zum Ungewöhnlichen, die damals lebhaft in mir siedend war, ist immer mir geblieben; mein Herz stets pochte lebhafter, wenn ich künstlerisch gestaltend einem Russen, Chinesen, Südseeinsulaner oder einem Zigeuner gegenüberstand, ja selbst der nächtliche, verdorbene Großstädter erregte mich wie eine Fremdnatur, und die Neigung zum Gestalten rassiger jüdischer Typen, wie es sich später in meinen religiösen Bildern gab, geschah äußerlich wohl teils diesem Trieb folgend.' *DEL*, 1931, pp.108–9.
7. Bradley, *Emil Nolde*, pp.212ff.
8. See Georg Bussmann, 'Degenerate Art – A Look at a Useful Myth', *German Art in the 20th Century*, Royal Academy exhib. cat. London 1985, p.117.
9. Ernst Gosebruch, *Ansprach bei der Eröffnung der Emil Nolde Ausstellung im Folkwang Museum Essen am 17. Juli 1927*, reprinted in *Bilder von Emil Nolde*, Kunstring Folkwang, Essen 1957. Gosebruch's use of the term 'European' in this context refers to internationalism. Hence a national German style is described as non-European.

10. Ettlinger, 'German Expressionism', pp.199ff.
11. *JDK*, p.149. Nolde had been elected as a Secession member in 1908. He was expelled from the Berlin Secession in 1911 by a vote of forty to two with three abstentions. His attempt to sue the Secession for libel was thrown out of court.
12. There are several examples in Bradley's book. See in particular p.10, when he quotes from *JDK*, p.180: 'Mein Sturmlauf hatte in der Gründung vom deutsch-völkischen Studentenbund, die im gleichen Jahre erfolgte, gleichen Bestrebungen dienend, eine Parallele gefunden. Ich wußte es nicht.'
13. Compare, for example, *JDK*, 1934 p.146: 'The next thing I knew, I was decried as a virulent anti-semite and the witch hunt began,' ('Das nächste war, daß ich als wütiger Antisemit verschrieen wurde, und die Hetzjagd begann,') and *JDK*, 1956, p.150, 'The next thing I knew, I was being decried as a virulent anti-semite, which I never was,' ('Das nächste war, daß ich als wütiger antisemit verschrien wurde, das nie ich gewesen bin').
14. *Briefwechsel August Macke, Franz Marc*, pp.130–1. Letter dated June 1912.
15. See chapter 7, note 4. Also *JDK*, p.139: 'The Berlin Secession came into being as a union of younger artists. It was fresh and renewing at the beginning, stimulating the interest of broader circles, until after a decade they slid into the habit of French imitation and lost themselves in too much commercial activity'; ('Als Vereinigung jüngerer Künstler war die Berliner Sezession entstanden, in ihren Anfängen frisch und belebend, die Interessen weiterer Kreise anregend, bis dann schon nach einem Jahrzehnt sie zu französischer Nachahmung hinüberglitt und in übersteigertem geschäftlichem Betrieb sich verlor.')
16. *JDK*, p.159. Nolde's open letter to Liebermann was published in *Kunst und Künstler*, vol. IX, Jan. 1911, pp.210–11.
17. Paret, *Die Berliner Sezession*, pp.215–16.
18. Robert Pois, *Emil Nolde*, University Press of America 1982, p.98. Pois cites a letter from Nolde to Hans Fehr dated 21 Jul. 1910.
19. *JDK*, pp.163–4.
20. 'Unsere Malerei im 19. Jahrhundert wird für die Zukunft wohl nicht allzuviel bedeuten, denn sie steht fast ganz im Schatten der alten großen Meister, oder auch ist sie abhängig von dem französischen Impressionismus. Nur die Franzosen allein haben im letzten Jahrhundert bewiesen, daß neben der alten Kunst eine unabhängige neue große Kunst entstehen kann... Wenn unsere Kunst gleichwertig oder bedeutender sein wird als die französische, dann wird sie auch, ohne es besonders zu wollen, ganz deutsch sein. In der Industrie, im Handel, in der Wissenschaft u.a. sind wir allmählich nicht nur gleichwertig, sondern vorbildlich geworden und haben Selbstbewußtsein. In der Kunst wird gleiches kommen, alle schönsten Vorbedingungen sind der Nation eigen.' Ibid.
21. See chapter 4, p.65.
22. Vogt, *Museum Folkwang*, p.23.
23. Manfred Reuther, *Das Frühwerk Emil Nolde*, Cologne 1985. Reuther provides a detailed analysis of Nolde's relationship with Böcklin's work which he first saw in Munich in the mid-1890s. His discussion of Nolde's debt to nineteenth-century German peasant painting is less precise; for example, he does not emphasize the direct relationship with Wilhelm Leibl's work. Nolde's *Fishermen* (1901) and *Farmers* (1904) draw directly on the composition of Leibl's *The Village Politicians* (1876–7.) These paintings remake the subject of figures sitting around a table in the style of peasant painting,

whereas in Nolde's first major oil painting, *Mountain Giants* (1895–6) the same subject had been treated in an imaginative Böcklinesque way. In Nolde's 1909 religious paintings *Last Supper* and *Pentecost* both strands of nineteenth-century tradition are drawn together and translated into Expressionist terms, i.e. stylistically, the rough 'primitivist' handling, and thematically, the emphasis on spiritual transcendence.
24. The Berlin Secession had promoted French naturalist art in Germany. The 1910 Secession exhibition, from which the Expressionist generation as excluded, was crowned by Manet's *L'Execution de l'Empereur Maximilien*, 1867 (Kunsthalle Mannheim). In the catalogue introduction Manet was described as, 'der größte Maler des XIX Jahrhunderts', comparable to Goya in his ability to convey, 'reality without any trace of literary trappings... Faced with this painting we find that yesterday's revolutionaries have become today's classics.' ('die Wirklichkeit ohne irgend welchen literarischen Beigeschmack, so rein und restlos in malerische Werte umzusetzen... Angesichts des Bildes finden wir die Bestätigung der Wahrheit, daß die Revolutionäre von gestern, die Klassiker von heute sind').
25. Hartlaub, *Kunst und Religion*, p.85.
26. *JDK*, p.181.
27. *DEL*, 1931, pp.108–9.
28. *DEL*, 1949, p.96.
29. *JDK*, p.14.
30. Ibid, p.71: 'In Munich and Berlin I saw much recent art.'
31. Ibid, p.45.
32. Ibid, p.82.
33. '...wo fahl wie Puder und Leichengeruch impotente Asphaltlöwen und hektische Halbweltdamen in ihren elegant verwegenen Roben saßen, getragen wie von Königinnen... Ich zeichnete und zeichnete, das Licht der Säle, den Oberflächenflitter, die Menschen alle, ob schlecht ob recht, ob Halbwelt oder ganz verdorben, ich zeichnete diese Kehrseite des Lebens mit seiner Schminke, mit seinem glitschigen Schmutz und dem Verderb.' *JDK*, p.137.
34. Nolde records that Leo von König showed sympathy for him during the 1910 Secession affair. *JDK*, p.142.
35. Ibid, p.219.
36. Reuther, *Frühwerk Emil Nolde*, pp.53–4: 1) Veit, Stoß, *Madonna and Child*, from the St Lorenz medallion. Wrongly labelled by Nolde in the 1880s as the Nürnberg Sebaldus Kirche *Maria*, which he visited in 1910 (*JDK*, p.140). 2) Relief from Damanhur, the Egyptian goddess *Isis*. 3) Portal figure of *Ninive*, Assyrian sculpture from the Palace of Sargon II, excavated by the French in 1843/4. 4) *Sphinx*, Thebes.
37. Ibid, p.71.
38. *JDK*, p.98. In the 1920s Nolde was friendly with Hans Prinzhorn who was married to Hans Fehr's sister. In 1926 Nolde's photos of graffiti by prisoners on the wooden walls of Tondern prison were published in Prinzhorn's *Bildnerei der Gefangenen – Studie zur bildnerischen Gestaltung von Ungeübter* (*Paintings by Prisoners – studies on the artisitc expression of amateurs*) Berlin 1926, pp.29–35.
39. See Robert Layton, *The Anthropology of Art*, London 1981, 'Variations in aesthetic tradition', pp.15ff. Also Graburn, *Ethnic and Tourist Arts*, p.3.
40. Hans Schröter, 'Einflüsse der alten Kunst in Emil Nolde's frühen Werken.' *Edwin Redslob, zum 70. Geburtstag, eine Festgabe* (ed. by Georg Rohde) pp.321–31. *DEL*, 1931, p.143: '1900 brought numerous people to the world fair... The gongs in

the Maroccan rooms struck dull and dark.'
41. 'Als etwas Besonderes, wie eine Mystik, stand vor mir die Kunst der Ägypter und Assyrer. Ich konnte sie nicht wie damals fast allgemein, als 'geschichtliche Objekte' nur werten, ich liebte diese großen Werke, wenn auch es war, als ob ich es nicht dürfe. Aber solche Liebe manchmal brennt am glühendsten... Das folgende Jahrzehnt brachte Einsicht und Befreiung, ich lernte die indische, chinesische, die persische Kunst kennen, die primitiven seltsamen Erzeugnisse der Mexikaner und die Urvölker. Diese waren mir nicht mehr nur 'Kuriositäten, wie die Zünftigen sie benannten, nein, wir erhoben sie zu dem, was sie sind: die seltsame, herbe Volks- und Urkunst der Naturvölker. Der Wissenschaft der Völkerkunde aber sind wir heute noch wie lästige Eindringlinge, weil wir sinnliches Sehen mehr lieben als nur das Wissen. Auch Bode war noch großer Gegner künstlerischer Geltung des Urprimitiven. Unter einem Berg von üblicher Tüchtigkeit und Gelehrsamkeit war sein Sinn des Sehens vergraben.' *DEL*, 1949, p.265.
42. *JDK*, pp.172–8.
43. In the Berlin Ethnographic Museum the European section was not on show in 1911 due to lack of space. (*Führer durch das Museum für Völkerkunde, Königliche Museen zu Berlin*, 1911, pp.54–5.)
44. Catalogue introduction to the Internationale Volkskunst Ausstellung, Deutscher-Lyceum Club, Berlin, Jan.–Feb. 1909.
45. Ibid.
46. Particularly Alois Riegl.
47. 'Unsere Museen werden groß und voll und wachsen rapide. Ich bin kein Freund dieser durch ihre Masse tötenden Ansammlungen. Eine Reaktion gegen die Überhaufung wird sich wohl bald melden...vor nicht langer Zeit waren nur einige Kunstzeiten museumsreif. Dann aber kamen hinzu: koptische und frühchristliche Kunst, griechische Terrakotten und Vasen, persische und islamische Kunst. Warum aber wird immer noch die indische, chinesische und japanische Kunst unter Wissenschaft und Völkerkunde eingeordnet? Und die Kunst der Naturvölker als solche überhaupt nicht gewertet?' *JDK*, p.173. (Transl. in *Voices of German Expressionism*, ed. Victor H. Miesel, London 1970, p.34)
48. Despite recurrent debates about lack of popular appeal and accessibility, Bastian continued to promote a specialized, scientific approach, relegating the popular, propagandist functions to the Colonial Museum at Lehrter Bahnhof, which grew out of the German Colonial exhibition in 1896, and was installed in its own building in 1899. '100 Jahre Museum für Völkerkunde Berlin', *Baessler-Archiv*, vol. XXI, Berlin 1973. See in particular Sigrid Westphal-Hellbusch, 'Zur Geschichte des Museums', pp.16, 20–1, 79. For the debates about the relative scientific and popular worth of the museum see ibid, pp.23f. The Colonial Museum remained separate from the Ethnographic Museum until 1914 when the two institutions were joined, ibid, p.110.
49. Ibid, p.15. By 1903 conditions in Koniggrätzer Straße were so bad that the decision was taken to build a warehouse in Dahlem, and storing of surplus objects began in 1906. In 1907 the Museum was threatened with closure by the Berlin police if the stairways and corridors were not widened. Plans for a new building on the Dahlem site by Bruno Paul were agreed in 1912. In April 1914 building began but the outbreak of war in August halted further progress.
50. 'Man trat zwischen Bildern, man hätte unter Umständen auch ruhig darauf getreten. Nach fünf Minuten in dieser Moderatmosphäre mit dem Trieb

möglichst viel zu sehen und der absoluten Unmöglichkeit im Bewußtsein, auch nur das Geringste zu erfassen, wurde jeder bessere Instinkt von einer Gleichgültigkeit bezwungen, der nichts, aber auch gar nichts mehr auffiel...alles das gab eine merkwürdige Wut, den stillen Wunsch, den ganzen Kram ausnahmslos zu zerstören.' Meier-Graefe, 'Entwicklungsgeschichte' (1966 ed.) pp.744–5; transl. p.9.

51. Max Sauerlandt, *Im Kampf um die moderne Kunst, Briefe 1902–1933*, Munich 1957, pp.49–53. A much later letter dated 18 Jan. 1930, p.350, refers to Nolde's *support* of Bode at this date and reminds him of the latter's earlier attacks on modern art. See too Plietzsch, *Heiter ist die Kunst*, p.172: 'Bode doesn't have the first idea about modern painting and sculpture; he doesn't think it worth the trouble to get to grips with it.' ('Bode hat für die modernste Malerei und Plastik nicht den geringsten Sinn; er hielt es jedenfalls nicht der Mühe wert, sich mit ihr auseinanderzusetzen.')

52. 'Ich weiß ja nun, daß Sie die Eingeborenenkunst künstlerisch einzuordnen beabsichtigen und auch freute es mich sehr, daß bereits im Folkwang-Museum unsere sehr schönen exotischen Sachen eingeordnet sind, aber...ich glaube kaum, daß die Museumsdirektoren der älteren Generation mit der Auffassung der jüngeren Künstlerschaft einig sind und speziell in diesem Falle (wenn in Berlin Sie z.B. Bode fragen) mit Widerspruch zu erwarten.' Emil Nolde, *Briefe 1894–1926*, ed. Max Sauerlandt, Hamburg 1967, p.103.

53. 'Es wird den künstlerisch-ethnographischen-Erzeugnißen der Eingeborenen hier unten ein böser Raubhandel getrieben...deshalb sandte ich an Director Sauerlandt Halle – der die Absicht hat seine Eingeborenen neulich künstlerisch einzuordnen – eine Abschrift und auch Ihnen sende ich eine, Sie haben ja bereits – wohl auch hier als Erste – einige schöne Exotische Sachen in Ihrem Museum eingeordnet.' Nolde to Osthaus, 14 Apr. 1914, Rabaul Deutsch Neuguinea (Osthaus Archives Hagen). On their journey to New Guinea the Noldes had met Osthaus' emissary Karl With in Kyoto, buying material for the collection. Ada also arranged for some South Seas objects to be sold to Osthaus via the Hagen 'New Guinea German', Wiesener, *JDK*, p.77, *WuH* p.39. In 1911, just before he began to draw in the Berlin Ethnographic Museum, Nolde had seen a second non-European collection in the context of a *Jugendstil* environment at the new Palace Stoclet in Brussels, *JDK*, p.162. Nolde refers to East Asian art.

54. *JDK*, pp.75ff.

55. '...eine geschlossene Sammlung, von den deutschen Südseeinseln, die, vor langen Jahren gekauft, endlich ausgepackt ist. Anfangs gelindes Grauen, das sich bei sorgsamer Besichtigung in helle Freude wandelte. Die Sachen sind prachtvoll, und ich möchte sie in ganz einfachen weiß lackierten Schränken ordnen, nicht lokal, sondern nach technischen Gruppen, was vielleicht ungewöhnlich, aber hier aus besonderen Gründen geboten ist...' Sauerlandt, *Briefe*, p.41.

56. Ibid, p.279.

57. 'Unsere Zeit brachte es mit sich, daß für jedes Tongefäß oder Schmuckstück, für jeden Gebrauchsgegenstand oder jedes Kleidungsstück zuerst der Riß auf Papier entstehen mußte. – Mit dem Material in der Hand, zwischen den Fingern, entstehen die Werke der Naturvölker. Das sich äußernde Wollen ist Lust und Liebe zum Bilden...' *JDK*, p.173; transl. Miesel, *Voices of German Expressionism*, p.35.

58. Das Urgefühl und die plastisch – farbig –

ornamentalen Freuden der 'Wilden' an Waffen, Kult-und Gebrauchsgegenständen ist sicherlich oft viel schöner als die süßlich geschmäcklerischen Formen an Objekten, die in Glasschränken der Salons und in unseren Kunstgewerbemuseen stehen... überzüchtete, blasse, dekadente Kunstwerke gibt es genug, – daher mag es gekommen sein, daß werdende Künstler am Urwüchsigen sich orientieren.' Ibid, pp.173–4. This was not an unusual point of view at the time. In an article by Paul Reichard – sole survivor of an 1880 Congo expedition – in the *Original-Wochenbericht 1893*, we read: 'How does the interest of uncivilized peoples for fine art express itself?... In the case of our artists the hand executes that which the imagination conceives and the spirit already recognizes. There however the eye finds that which the hand creates by chance beautiful... Individual tribes reject the artefacts of European industry. You can't blame them for this because it's proof of their good taste, that they are able to produce similar, more 'tasteful' artefacts.' ('Wie äußert sich das Interesse der unzivilisierten Völkerschaften für bildende Kunst?... bei unseren Kunstgebilden die Hand dasjenige ausführt was die Phantasie ausgedacht und der Geist als schön erkannt hat. Dort aber findet das Auge schön was die Hand zufällig schuf... Einzelne Stämme weisen die Erzeugnisse europäischer Industrien zurück. Das kann man ihnen weder übelnehmen noch schlecht deuten, denn sie beweisen damit einen guten Geschmack, da sie selbst geschmackvollere Erzeugnisse der gleichen Art herstellen.') Quoted in Werner Doede, *Berlin Kunst und Künstler seit 1870, Anfänge und Entwicklungen*, Berlin 1961, p.62.

59. 'Die wirkliche Bedeutung von einem Kunstwerk ist doch nur dessen Kunstwert. Verschiedenste Kunstwerke nebeneinander isolieren sich gegenseitig und erhöhen den Eindruck. Es ist so bequem, alles in seiner Zeit und in sein Fach einzuordnen. Das kann man lernen... Es wäre so schön, wenn Ihre vielen verschiedensten herrlichen Werke einzig als Kunst im höchsten Sinne geordnet wären.' Nolde, letter to a collector 25 Jan. 1913, quoted in Max Sauerlandt, *Emil Nolde*, Munich 1921, p.73.

60. *JDK*, p.220. Kirchner too made an important distinction between art and photography in 1913 in his text 'Über die Malerei', which was meant to accompany the *Chronik der Brücke*: 'Today photography provides exact representation. Freed from this task painting has won back its original freedom of movement. The instinctive intensification of forms into sensual experience is impulsively carried onto the canvas.' ('In der heutigen Zeit übernimmt die Photographie die exacte Darstellung. Die davon frei gewordene Malerei bekommt ihre ursprüngliche Bewegunsfreiheit zurück. Die instinktive Steigerung der Form im sinnlichen Erlebnis wird impulsiv auf die Fläche übertragen.') *ELK*, p.67.

61. A postcard from Kirchner to Heckel dated 5 Jan. 1911 shows eskimo bone carvings from the Berlin collection (see chapter 3 note 29). August Macke, Franz Marc *Briefwechsel*, pp.39–40, letter dated 14 Jan. 1911, records Marc's visit to the museum. Macke to Marc, 21 Mar. 1912, and Marc to Macke, 28 Mar. 1913, record their first purchases of African art. Paul Klee too had begun his collection before 1912 (J.S. Pierce, *Paul Klee and Primitive Art*, New York 1976, p.35).

62. Reuther, *Das Frühwerk Emil Noldes*, chapters 4 and 5.

63. For example, Nolde's Berlin drawings like *Dancing Pair* (1910–11) and *Theatre Scene in a Forest* (1910–11).

64. *DEL*, 1949 p.50.

65. All the drawings relating to 1911 paintings are executed on loose pages measuring 18.6 × 30 cm; there are 31 drawings of this type. There are 8 stylistically similar drawings measuring 18.6 × 15 cm. Out of 29 animal drawings only 2 are on 18.5 × 30 paper and these are the only 2 relating to 1911 paintings, *Exotic Figures 1 and 11*, (a cat and a pig).

66. For example *Drawing Studies* 29, 30, 31, 32 (for *Figure and Mask* 1911) Urban 415, 33 (for *Little Devil* 1911).

67. This satirical use of masks is found, for example, in Ensor's *Entry of Christ into Brussels* (1888) and *Intrigue* (1890).

68. *Zeichnung Studie 75* (Archive, Stiftung Seebüll). Heads 1 and 2 in fig.214 refer to a Mexican Teotihuacan mask in the Berlin Museum, inv. no. CA3017. Head 3 relates to an Aztec ornament, Kat. Nr. IV CA977.

69. *Zeichnung Studie 25* (Seebüll) shows a canoe head from the Solomon Isles (inv. no. VI 28854). *Zeichnung Studie 36* (Archive, Stiftung Seebüll), shows a shrunken head of a Yuruna Indian from Brazil (inv. no. VB 4178). The division into Europe, Asia, Africa and Australia was implicit in the organization of the museum since its foundation in 1873.

70. The Hopi doll in *Exotic Figures 1*, *Zeichnung Studie 55* (Seebüll) appears in a pre-1926 photo published in the Baessler-Archiv, p.236. Nuwak-Chin Mana Hopi, collection von den Steinen (1899) inv. no. IV B 2305 (fig.219). The second doll is a Sootuknangwu Hopi from the Kearn collection (1901), inv. no. IVB 5112 (fig.220). The dolls were incorrectly named 'fetishes' by Nolde.

71. See for example, Pierce, p.37. Also Ettlinger, 'German Expressionism' p.192: 'At most, the artefacts of primitive peoples became exotic motifs for still life paintings, replacing traditional plaster casts and bronze cupids.'

72. Heckel also used the still-life genre on occasion merely to record the exotic and tribal objects in his studio, for example, in *Still Life with Mask* (Vogt 1912/48).

73. See too August Macke's *Walter's Play Things* (1912). Lovis Corinth also painted some still lifes with exotic objects: *Still Life with Buddha* (1910), *Still Life with gods* (1910) and *Still Life with Chinese Figures* (1911).

74. See chapter 1, pp.33ff.

75. *JDK*, p.173; transl. Miesel, *Voices of German Expressionism*, p.35.

76. The drawings relating to dated of 1912 paintings mostly continue the late 1911 style, i.e. pencil outline and coloured crayon. 54 drawings of this type (29 of which relate to still-life paintings I know of), are on a single size paper measuring 27.8 × 21.4 cm. A second group of 8 drawings on paper measuring c.26.1 × 21.5 tend towards more volumetric effects. Three of these are used in 1912 still-life paintings. About 15 of these 62 of 1912 drawings are simple outline sketches, similar to the first 1911 style. But they are all on 1912 page sizes.

77. In the *Blaue Reiter Almanach* (reprinted Munich 1967) childrens' drawings are praised by Kandinsky in 'Über die Formfrage', p.168, and by August Macke in 'Die Masken', p.55. Drawings said to be by children are also illustrated in the Almanach. In his review of the *Blaue Reiter* exhibition in February 1912, Paul Klee made the analogy between 'primitive' and child art (*Tagebücher*, pp.274–5 no.905). In the same year he suggested that the art of the insane be taken seriously (Pierce, p.138). In a letter from Kirchner to Eberhard Grisebach dated 7 Jul. 1918, he made a similar chain of associations:

'you wouldn't believe how interesting and stimulating it is to look at children's drawings, be they on paper or just on a fence, drawings by exotic people, drawings by the insane – and to compare all this with artistic production.' ('Sie glauben nicht wie interessant und auch wie anregend es ist, Kinderzeichnungen, sei es auf Papier, sei es nun auf Zaunen, Zeichnungen von exotischen Völkern, Zeichnungen von Kranken, zu betrachten und sie mit den künstlerischen Produktionen zu vergleichen.') (Eberhard Grisebach ed. *Maler des Expressionismus im Briefwechsel mit Eberhard Grisebach*, Hamburg 1962.)

78. *JDK*, p.218.

79. *JDK*, p.180.

80. The *Blaue Reiter Almanach* appeared in May 1912. The Munich group sent work to the fourth exhibition of the New Secession, November 1911–January 1912, where Nolde exhibited three paintings from *The Life of Christ*. One drawing by Nolde appeared as an illustration in the Almanach and in February 1912 he sent drawings to the second *Blaue Reiter* exhibition in Munich.

81. The male figure is taken from the right-hand figure on the throne of Sultan Njoya of Bamun, Cameroon Grasslands, wood and beadwork, 175 cm Ethnographic Museum, Berlin inv. no.111 C33341a, which entered the collection in 1908. The 'cat' comes from a wooden door panel, Nupe Nigeria (Ethnographic Museum, *Westafrikanische Plastik 11*, plate 115, Sammlung Flegel 1880).

82. Forty-four drawings are on a new paper size, measuring 26.1 × 20.5 cm, including the series of heads and medieval sculptures from the Thaulow-Museum in Kiel, none of which relate to pre-1913 paintings. Some animal drawings, for example, *Zeichnung Studien*, 135, 137, 139, 140, (Archive Stiftung Seebüll) are also on this paper size. In all of these drawings Nolde uses a dense waxy crayon. Some drawings on the new paper size are also in pencil and crayon.

83. 'Als wieder der Winter kam, stand ich innerem Bedürfnis folgend in den ägyptischen und koptischen Abteilungen der Museen, ich ging zu den Tanagras und zu den romanischen Figuren und den gotischen, immer zeichnete ich alle diese reichen Formen und auch Farben...in meinen späteren oft frei gemalten Stilleben kehren einige dieser gegenständlichen Wahrnehmungen wieder.' *JDK*, p.220.

84. Letter dated 12 Apr. 1912 from Ada Nolde to Osthaus: 'For some time my husband has been working in the Puhl and Wagner factory and a small madonna is ready circa 314 metres high. She is still to be set on a marble plate.' ('Schon längere Zeit hat mein Mann in der Fabrik Puhl und Wagner gearbeitet und eine kleine Madonna ist fertig ca. metr. hoch. Sie soll aber noch in einer Marmorplatte eingelassen werden.') (Archive, Karl Ernst Osthaus Museum, Herta Hesse-Freilinghaus ed. *Emil Nolde und Ada Nolde, Karl Ernst und Gertrud Osthaus, Briefwechsel*, Bonn 1985, p.78.

85. Emil Nolde, *Reisen Achtung Befreiung* (hereafter *RAB*), Cologne 1967, p.16.

86. C.G. Heise represents this position in his article 'Emil Nolde Wesen und Weg seiner religiösen Malerei', *Genius*, vol.1, no.1, 1919, pp.18ff.

87. Sauerlandt, *Briefe*, pp.54ff.

88. Martin Urban, *Emil Nolde Masken und Figuren*, exhib. cat. Kunsthalle Bielefeld 1971, p.4.

89. *DEL*, 1931, pp.108–9.

90. 'Seitdem hat sich manches geändert. Wir mögen Raphael nicht und verbleiben kühl vor den Plastiken der sogenannten griechischen Blütezeit... Die anspruchslosen Menschen, die in ihrer Werkstatt arbeiteten, von deren Leben man heute kaum etwas weiß, deren Namen uns nicht einmal erhalten sind, schätzen und lieben wir in ihren schlicht und groß gehauenen Plastiken der Dome zu Naumburg, Magdeburg, Bamberg.' *JDK*, p.172; transl. Miesel, p.34.

91. Walter Benjamin, 'Franz Kafka on the tenth anniversary of his death', *Illuminations*, London 1982, pp.120–1.

92. Silvio Vietta, 'Franz Kafka, Expression and Reification', *Passion and Rebellion*, ed. S. Bronner and D. Kellner, London 1983, pp.212–13.

93. G. Lukács, 'The Ideology of Modernism', 1955, pp.17–25, in *The Meaning of Contemporary Realism*, London 1963.

94. 'Ich finde es so selbstverständlich, daß wir in dieser kalten, frührot künstlerischer Intelligenz die Wiedergeburt unseres Kunstgefühles suchen und nicht in Kulturen die schon eine tausendjährige Bahn durchlaufen haben, wie die Japaner oder die italienische Renaissance...ich glaube allmählich wirklich zu begreifen, auf was es für uns ankommt, wenn wir uns überhaupt Künstler nennen wollen. Wir müssen tapfer fast auf alles verzichten, was uns als guten Mitteleuropäern bisher teuer und unentbehrlich war... Unsere Ideen und Ideale müssen ein härenes Gewand tragen, wir müssen sie mit Heuschrecken und wildem Honig nähren und nicht mit Historie, um aus der Müdigkeit unseres europäischen Ungeschmackes herauszukommen.' '*Briefwechsel*', Macke and Marc, p. 40. Nolde too connected Japan with decadent Western culture, see chapter 11, p.217.

95. Paul de Man, p.157. De Man is discussing Baudelaire's 1863 essay, *Le Peintre de la vie moderne*.

96. Bloch, *Aesthetics and Politics*, p.22.

97. Ibid, pp.17–18.

CHAPTER 10. A SOUTH SEAS ODYSSEY: MAX PECHSTEIN'S VISIONARY IDEALS

1. Mein alter Wunsch verwirklichte sich, *Europa zu verlassen und die Gefilde der Seligen in Palau zu suchen*... Pechstein, *Erinnerungen*, p.54.

2. See in particular, Eduard Said, *Orientalism*, New York 1978. Also, *The Orientalists, European Painters in North Africa and the Near East*, Royal Academy exhib. cat., London 1984.

3. See chapter 5, note 1.

4. Nolde went to Italy in 1905 because of Ada's poor health; Pechstein followed in 1907, 1908, 1911 and 1913. Heckel made one trip in 1909.

5. Gerhard Wietek, *Gemalte Künstlerpost*, Munich 1977, p.72.

6. Both Pechstein's *The Yellow Cloth* (fig.71) and Nolde's later engraving *Man and Young Woman* (1918; Schiefler/Mosel R.190), apparently refer to Gauguin's quotations from the carved frieze at the Javanese temple of Borubudur. Copies of these carved reliefs also existed in the Indian section at the Berlin Ethnographic Museum. See *Führer durch das Museum für Völkerkunde*, 'Die indische Sammlung', Berlin 1905. See also chapter 4, note 13.

7. *Kunst und Künstler*, 1908, pp.78–81, 125–7, 160–2. Gauguin's writings seem to have directly influenced Pechstein's memoirs. For example, the first of these instalments includes a passage affirming the irrelevance of money in the South Seas: 'In this respect I – the cultivated man – was way behind the natives. I envied them. I saw their happy, peaceful life around me, without any greater efforts than daily life demanded – without the least worry about money. Who would want to buy anything, when the products of nature were on offer to all?' ('Ich der Kulturmensch stand in dieser Hinsicht weit hinter den Wilden zurück. Ich beneidete sie. Ich sah ihr glückliches, friedliches Leben um mich her, ohne größere Anstrengung als die täglichen Bedürfnisse es erforderten – ohne die geringste Sorge um Geld. Wem sollte man etwas verkaufen, wo die Erzeugnisse der Natur jedem zu Gebote stehen?' (p.81). Compare with Pechstein's *Erinnerungen*, pp.77ff.

8. '...sein malerisches Werk blieb immer noch mit Paris verbunden. Geschmäcklerisches, Bewußtes, selbst ein – wenn auch raffiniert verhüllter-Rest von Sentimentalität bleibt erkennbar, aber wer 'Noa, Noa' gelesen hat weiß, wie der Mensch Gauguin über sein Werk emporwuchs. Ihm bleibt der Ruhm, durch die Tat einen neuen Weg zu großem Ziele freigemacht zu haben.' Osborn, *Pechstein*, pp.111–12.

9. See too Richard Janthur's painting, *The European* (fig.238), exhibited at the Berlin Secession in 1913.

10. Mary Evelyn Townsend, *The Rise and Fall of Germany's Colonial Empire 1884–1918*, New York 1930.

11. Ibid, chapter 4. See too M. Wertheimer, *The Pan German League*, New York 1924.

12. 'Die Bourgeoisie...zwingt alle Nationen, die Produktionsweise der Bourgeoisie sich anzueignen, wenn sie nicht zu Grunde gehen wollen; sie zwingt sie, die sogenannte Zivilisation bei sich selbst einzuführen, d.h. Bourgeois zu werden. Mit einem Wort, sie schafft sich eine Welt nach ihrem eigenen Bilde. ... Wie sie das Land von der Stadt, hat sie die barbarischen und halb barbarischen Länder von den zivilisierten, die Bauernvölker von den Bourgeoisievölkern, den Orient vom Okzident abhängig gemacht.' Karl Marx, Friedrich Engels, *The Communist Manifesto*, Penguin transl. 1976, p.84. M. Kautsky's *Sozialismus und Kolonialpolitik*, 1907, also avoids absolute opposition to colonial ambitions. Poliakov (1974 p.244), points out that Marxists could justify the notion of a superior white race as a tool of progress, and attack Jews as representatives of capitalist power. Georg Mosse in *Germans and Jews*, New York 1970, p.15, points out that attacks on imperialism came from the extreme right too: for example, Oswald Spengler's *Decline of the West*, written during the 1914–18 war, condemned imperialism as an aspect of 'civilization' rather than 'culture', thus as part of 'the externalization of life irrelevant to the development of a Volk soul'.

13. 'America, you are better off than our old continent you have no ruined castles And no basalt. You are not innerly disturbed In the living moment by useless memories And vain troubles.'
('Amerika, Du hast es besser/Als unserer kontinent, das alte,/Hast keine verfallene Schlößer/Und keine Basalte/Dich stört nicht im Innern/zu lebendigem Zeit/Unnützliches Erinnern/Und vergeblicher Streit).
The 'lack of history', which Goethe attributes to the new world, was also considered to be a positive aspect of modernity by Baudelaire in *The Painter and Modern Life*.

14. See also Professor Carl Meinhof, 'Ideale Aufgaben in unseren Kolonien', *Koloniale Rundschau*, 1909, pp.89ff. In 1912 the Social Democrats received 110 mandates in comparison to 43 in 1907. This has been interpreted as a sign of their success in toning down revolutionary fervour. In 1914 the SDP voted almost to a man in favour of the war loans.

15. Caricaturists almost invariably received their brief from the editorial board by the beginning of the twentieth century. Their work is not to be confused with nineteenth-century satire in the tradition of Daumier, which was used to express more directly

the artist's political viewpoint.

16. *Fliegende Blätter*, No. 2875, 1900, p.118.
17. Ibid, No.2931, 1901, p.167.
18. Ibid, No.3040, 1903, p.211.
19. Ibid, No.3079, 1904, p.55.
20. Ibid, No.3114, 1904, p.158.
21. Ibid, No.3125, 1905, p.289.
22. Ibid, No.3498, pp.76ff.
23. Ibid, No.3467, 1911, p.15.
24. Ibid, No.3470, 1911, p.52.
25. Pechstein was a founder member of the *Arbeitsrat für Kunst*. He was also active in the *Internationalen Arbeiterhilfe* and *Gesellschaft der Freunde des Neuen Rußland*, 1918–19.
26. See chapter 4, note 14. A similar type of exoticism recurs in E.R. Weiß' *Female Nudes in the Open* (1909.) Max Beckman was also looking towards French Romanticism in his *Battle of the Amazons* (1909) as were Lovis Corinth and Max Slevogt. Pechstein's *Salvation through Woman* (1911), and *Bacchus* (1912), tap a more violent vein of Romanticism.
27. Pechstein, *Erinnerungen*, p.35.
28. Osborn, *Pechstein*, p.88.
29. In the Pechstein literature, his artisan background is often stressed. For example, the first chapter of Osborn's monograph is titled 'The Proletarian and the Child of Nature', giving a romantic twist to his urban working-class origins. In Leopold Reidemeister's introduction to the exhib. cat. *Max Pechstein 1881–1955, Zeichnungen und Aquarelle, Stationen seines Lebens*, Brücke Museum, 19 Sep.–22 Nov. 1981, we read: 'Pechstein yearned to return to the sources...he was always a "young wild man"...he didn't need to try to adjust to simple, natural men, he belonged with his skin and hair and entire soul to the fishermen of Nidden and Monte Rosso al Mare – also to the children of nature on the Palau Isles.' ('Pechstein mußte aus dem Sehnen heraus zu den Quellen zurückkehren, er schöpfte aus ihnen seit seiner Kindheit im ländlichen Eckersbach bei Zwickau. Er war immer ein 'junger Wilder'... Er brauchte sich nicht um den Zugang zu den einfachen, natürlichen Menschen zu bemühen, er gehörte zu ihnen mit Haut und Haaren und mit ganzer Seele – zu den Fischern in Nidden und Monte Rosso al Mare ebenso wie zu den Naturkindern auf den Palauinseln. Er war mit starken, geschickten Händen begabt und konnte zupacken wie sie, konnte ihr einfaches Leben mit ihnen teilen.') Long passages of Pechstein's memoirs (written 1945–6), especially his account of the South Seas journey, draw on Osborn's 1922 text. Both refer to his surviving travel diaries in the possession of the Pechstein family.
30. Pechstein, *Erinnerungen*, p.36.
31. See Smith, *European Vision*, chapters 1–3. Kirk Varnedoe 'Gauguin' in *Primitivism*, p.187 reapplies Smith's terms to Gauguin's work.
32. Pechstein's 1909 paintings display a Post-Impressionist style, translating his 1907 Van Gogh drawing style into painterly terms. These works are much less daring than his 1908 Fauve-inspired canvases. *Fishermen* (1909) refers directly to Van Gogh's *Postman Roulin* (1889). A drawing for this Van Gogh painting was in the 1908 Berlin Secession Black-and-White exhibition and illustrated in *Kunst und Künstler*, 1908, p.199.
33. 'Ich bot einen tollen Anblick. Rotbraun, dunkelbraun wie ein Indianer, mit rauhem Schifferbart. Die Kopfhaare waren mir den Sommer über nach urtümlicher kurischer Sitte so zurechtgestutzt worden, daß man dem Schädel einen Topf überstreifte und abschnitt, was hinten herausguckte. Wie ein mittelalterlicher Krieger muß ich gewirkt haben...

schlecht und recht, aber mehr schlecht, überstand ich diese erste Nacht in der Zivilisation.' Pechstein, *Erinnerungen*, p.38.
34. Ibid, p.37.
35. Bürger, *Theorie der Avantgarde*.
36. Pechstein, *Erinnerungen*, p.50.
37. Osborn, *Pechstein*, p.40.
38. See chapter 4, p.56.
39. In 1909 Cézanne's *Grandes Baigneuses* (1906) (Philadelphia Museum of Art) was exhibited at the *rat für Kunst* and the *Novembergruppe* in 1918. Berlin Secession. Pechstein's *Blue Day* (1911), where the figures echo the tree formations, aims at a similar monumental effect. *Under the Trees* (1911) makes direct reference, like his contemporary studio decoration *At the Sea Shore* (1911), to Matisse's *La Dance* (1908).
40. See chapter 7, note 44.
41. See my discussion of 'primitive' women by Heckel and Kirchner in chapter 3, pp.39–4, chapter 7, pp.114 and chapter 8, pp.153–4. A passage from Osborn's 1922 monograph (p.58), shows how Pechstein's female bathers provide the opportunity for male social Darwinist fantasy to run wild: 'Real animal beings appear. Fleshy, compact, apparitions. Creatures of instinct, closely bound to nature. Created for brutal sensuality, to conceive, give birth, nourish...woman is seen as a primitive being. Long before Pechstein sought out exotic lands, the type of woman he was to find there already existed in his work.' ('Ganz animalische Wesen treten auf. Weibtiere. Fleischige, kompakte Erscheinungen. Instinktgeschöpfe, der Natur eng verbunden. Zu brutaler Sinnenfreude, zum Tragen, Gebären, Nähren geschaffen... Das Weib wird als ein primitives Geschöpf gesehen. Lange Jahre bevor Pechstein exotische Länder aufsuchte, steht der Typus Frauen, den er dort dann in Wahrheit vorfand, bei ihm fest.')
42. Werner Timm, exhib. cat. *Max Pechstein Ostsee-Bilder. Gemälde, Zeichnungen, Photographien*, July-August 1981, Ostdeutsche-Galerie, Regensburg, p.5.
43. Leopold Reidemeister, foreword to Pechstein's *Erinnerungen*.
44. Nolde, *RAB*, pp.40–1. Nineteen of Nolde's paintings were recovered in England.
45. Gordon, 'German Expressionism', p.403, Fig.245 is the sketch for this painting. There are several other anomalies in Gordon's text. For example, Pechstein's *Palau Triptych* is in the Ludwigshafen Museum and not, as Gordon suggests, only known in photographs. Gordon's interpretation of Pechstein's *Faces Surrounding me* (1920) as a naturalistic work, showing his collection of non-European art, is surely wrong. This painting is a symbolic work, comparable to *Self-portrait with Death* (1920) and indicative of Pechstein's disturbed mental state at this date. It is interesting that, in the tradition of Worringer, he uses 'primitive' masks to convey this mood of anxiety. Pechstein did have a collection of non-European art which begins to feature in his 1913 still lifes, before his South Seas trip. Some items he collected in 1914 have been preserved in the Pechstein estate in Hamburg, for example a Palau paddle, although the vast majority of the collection was lost during the Second World War. Gordon's claim that Pechstein and Schmidt-Rottluff were on friendly terms in Nidden in 1913 is certainly wrong; and his *Quarter Moon* bust is dated 1919 by Osborn, not, as Gordon suggests, 1917.
46. Varnedoe, 'Gauguin', pp.179ff. See too Bengt Danielsson, *Gauguin in the South Seas*, New York 1966.

47. Osborn, *Pechstein*, p.117.
48. *Deutsches Kolonialblatt*, 15 Dec. 1903, p.684. Pechstein's paintings are priced in the third and fourth New Secession exhib. catalogues, Feb.–April 1911, and Nov. 1911–Jan. 1912.
49. Pechstein, *Erinnerungen*, p.55.
50. Ibid, p.57.
51. Ibid, p.55.
52. Ibid, p.57.
53. Ibid, p.59.
54. 'Auf Angaur hockten mehrere europäische Angestellte in ihren nett eingerichteten Wohnungen, mit einem Messehaus und europäischen Brimborium, an dem der Zahn der Zeit schon genagt hatte, einem Store für die Lagerverwalter, Büroräumen und Häusern für die angeworbenen farbigen Arbeiter, chinesischen Waschmännern, Männern von Yap, Nauru, kurz allen möglichen Südseeinseln. Mit zweijährigem Kontrakt waren sie verpflichtet, den zu Tage liegenden Phosphat zu fördern, der dann gereinigt wurde und auf Phosphatschiffen als Dung in die Welt hinausging.... Nur ein Palaudorf war noch auf der Insel, eine friedliche Oase in dieser Welt geldgieriger europäischer Geschäftigkeit.' Ibid, pp.59–60.
55. Ibid, p.66.
56. 'Eine Natur von unerhörter Pracht umgibt mich, Üppigkeit des Wachstums ohnegleichen breitet sich aus, nie gesehene Pflanzen erheben sich, Palmen und Brotfruchtbäume, Bambus und Zuckerrohr. In diesem Grün flattern die großen, buntfarbigen Schmetterlinge – man könnte beinahe sagen, sie ersetzen die Blumen. Das ewige Meer schimmert in nie geglaubten Farben. Die glühende Sonne schüttet Helligkeiten aus, von denen der Europäer nichts ahnt.... In solche Natur, aus solche Natur heraus, wachsen die braunen Menschen auf. Schlanke, bronzene Gestalten in göttlicher Nacktheit, die Weiber nur mit kleinen Schürzen aus Kokos- oder Pisangfasern um die Hüften bekleidet.' Ibid, p.77.
57. Varnadoe, 'Gauguin', p.207, note 39. The relevant Pierre Loti novels are, *Rarahu* (1881) and *La Marriage de Loti* (1878).
58. Smith, *European Vision*, pp.133–7. The idealization of Mikronesian peoples was continued in the colonial literature. For example, in Alfred Wünsche, *Die deutsche Kolonien*, Leipzig 1912, p.205: 'they are pretty, chestnut–brown people, our Micronesians, with nothing negroid about them.' Dr Georg Buschan, in *Illustriertes Völkerkunde*, Stuttgart 1911, pp.187ff., writes: 'The Micronesians are fundamentally lovable, peaceful beings, but bad treatment from Europeans has often perverted their characters.'
59. 'Deutsch-Neuguinea Reise nach Palau, Sonsol und Tobi, Oct.–Dec. 1906', in *Deutsches Kolonialblatt*, Jg. 18, 15 Jun. 1907, p.662.
60. Ibid, Jg.11, 1 Feb. 1900, p.104.
61. See in particular Hermann Melville's *Omoo*, 'A Missionary's Sermon' and 'Tahiti as it is'. Also Robert Louis Stevenson, *Valima Letters* (1895) and *In the South Seas* (1896) and Jack London's *South Seas Tales* (1911). We find a less idealistic account of Palau in A. Tetens, *Among the Savages of the South Seas, 1862–1868*, Engl. ed. Stanford 1958. Tetens' original, liberal attitude to the natives gradually changed as he found himself repelled by their customs, and he describes violent military clashes with local chieftans. See K. Kiernan, *The Lords of Mankind. European Attitudes towards the Outside World in the Imperial Age*, London 1969. Tetens, a merchant shipping officer, provides a very different image of the Palau natives to the more familiar and positive descriptions by Gottfried Semper.

62. 'Es war, zum Lobe der deutschen Verwaltung sei es gesagt, alles in seiner Eigenart behütet worden. Nichts Europäisches gab es, außer den zwei Beamten und der etwas weiter weg auf Babeltaob liegenden Mission, der jedoch die hygienische Fürsorge ebenso wichtig war wie das Bestreben, die Palauer zu Christen zu machen.' Pechstein, *Erinnerungen*, p.62.

63. *Deutsches Kolonialblatt*, 1907, p.663.

64. Ibid, Jg.16, 15 Jan. 1905, p.50.

65. 'Dort hatten die um ihren schwindenden Einfluß besorgten Kalids, die geistlichen Häupter, Zauberer und Wunderdoktoren von Palau, Unruhen zu stiften gesucht. In höchst anerkennenswerter Weise ging der Stationsleiter Winkler trotz der Warnungen befreundeter Oberhäuptlinge mit seiner kleinen Polizeitruppe sofort nach Arekolong, legte das seinem Befehl zuwider errichtete Kalidhaus nieder und fing auch glücklich die sechs Rädelsführer ein. S.M.S. 'Condor' brachte sie nach Yap. von da auf meine Veranlassung nach Saipan, wo sie auf einige Zeit bei nützlichen Wegebauten und Pflanzungsarbeiten beschäftigt sind und ihren Zaubererhochmut hoffentlich bald verlieren werden.' Ibid, 1907, p.662.

66. 'Holzhäuser mit hohem, spitzem Dachfirst sind ihre Behausungen, und an diesen Häusern sehe ich nun in Wirkhlichkeit im Gebrauch des Alltags in der Umgebung, für die sie geschaffen sind, die geschnitzten und bemalten Balken, die einst in Dresden meine Einbildungskraft in Schwingung versetzten und den jetzt erfüllten Wunsch aufkommen ließen, sie an Ort und Stelle zu sehen.' Pechstein, *Erinnerungen*, p.77.

67. Ibid, p.78.

68. 'Ihr führt kein Familienleben; bis vor kurzem lebten die Männer in den Klubhäusern, dort wurden eure Mädchen verdorben. Jetzt ist das verboten zu eurem und eures Volkes wohl... Das Palauvolk soll wieder stark werden an Zahl. Ihr sollt auch ihre Kinder nicht fremden Leuten geben, sie sollen bei ihren Eltern bleiben. Ihr sollt ein gutes Familienleben führen, dann werden auch eure Frauen wieder fruchtbar sein.' Ibid, p.66.

69. *Deutsches Kolonialblatt*, 1907, p.663.

70. Buschan, *Illustrierte Völkerkunde*, p.205: 'In reality fishing played no real rôle in the nourishment of the people. The islanders live mainly from Coconut palms, bread fruit trees, bananas, taro and yams – more or less the same plants that nourish the inhabitants of New Guinea and the Bismarck-Archipelago.' ('In Wirklichkeit spielt der Fischfang für die Ernährung eine ganz untergeordnete Rolle. Die Insulaner leben in der Hauptsache von der Kokospalme, dem Brotfruchtbaume, der Banane, von Taro und Yams und ungefähr denselben Pflanzen wie die Bewohner Neuguineas und des Bismark-Archipels.')

71. Natives carrying guns are also depicted on the Dresden beams. Another misreading of the imagery of the Palau beams can be found in Heckel's engraving *Tight-Rope Dancer* (Dube R.81). Heckel draws on the images of natives carrying large round shapes, from the Berlin beams, for his depiction of tightrope dancers with sunshades. In fact, the large circular stones were used as native *money* (Wünsche, *Die deutsche Kolonien*, p.209) (fig.267). There is, of course, an added irony in this misunderstanding, as the Palau beams, like the cabaret, were seen as 'unalienated' art forms by *die Brücke*, signifying a new creative relationship between art and life beyond the confines of social and economic convention.

72. Osborn, *Pechstein*, p.130.

73. Pechstein, *Erinnerungen*, p.77.

74. Ibid, p.90.

75. 'Der Grund für die spärliche Produktion der Gruppe, die weit fruchtbar ist als Yap, liegt in dem eingewurzelten Übelstand, daß der Reiche den Armen ausplündern kann. In Palau herrscht die ausgeprägteste Plutokratie. Überall erhielt ich von dem gewöhnlichen Mann auf meine diesbezügliche Frage die Antwort: 'Warum soll ich denn mehr pflanzen oder fischen? Wenn ich mehr gewinne als ich brauche, nimmt es mir der Mächtigere ab.' *Deutsches Kolonialblatt*, Nr. 12, 15 Jun. 1902, p.263. Also Buschan, *Illustrierte Völkerkunde*, p.206: 'The social organization of the micronesians is feudal. One can distinguish an aristocratic class, a middle class and slaves. At the top of the pile there are princes.'

76. Konrad Lemmer, *Max Pechstein und der Beginn des Expressionismus*, Berlin 1949, introduction.

77. These stage-like effects sometimes occur in Pechstein's Nidden bather paintings too, for example *Clearing in the Forest* (1911).

78. The same can be said for Pechstein's diaries, which are transferred quite directly into his later memoirs.

79. Osborn, *Pechstein*, pp.101ff.

80. Varnedoe, 'Gauguin', pp.185ff.

81. 'Umso weniger gerieten sie in Gefahr, irgendwie in interessanter Sachlichkeit zu versinken. Umso königlicher wuchsen sie über alle Realität zu Sinnbildern urtümlichen Lebens, zu malerischen Bekenntnissen auf. Umso reiner löste sich das Motivische in ein künstlerisches Bauen mit Farben und Linien.' Osborn, *Pechstein*, p.149. See also Hamann and Hermand, *Stilkunst um 1900*, pp.93ff., 'Idealismus statt Materialismus', where they describe a move away from historical and empirical science and from specialization at the turn of the century. Instead there emerged a philosophical and theoretical search for fundamental 'laws' underlying scientific fact: 'Behind the multipally fractured disciplines and their narrow specializations there appeared increasingly a philosophical impulse towards unity which was more concerned with fundamentals and world-views than with individuals and historical singularity. In the wake of this individual values were raised to the level of genuine self justifying ideals.' ('Hinter den vielfältig ausgesplitterten Disziplinen und ihrer emsigen Fächerbetriebsamkeit tauchte daher in steigendem Maße ein philosophisches Einheitstreben auf, das sich weniger um das Individuelle und historisch Einmalige als um das Grundsätzliche und Weltanschauliche bemüht, wobei man in echt idealistischer Vermessenheit die eigenen Wertvorstellungen zu seinsollenden Idealen erhob.') The examples given regard Georg Lukács' *Die Seele und die Formen* (1911,) and Eduard Sprangers *Lebensformen* (1914). The interest in types and in abstracting generalization also characterizes Wilhelm Worringer's *Formprobleme der Gothik* (1911). Hamann and Hermand also point out the tendency to 'mythologize' history by treating each epoch according to its great heroic personalities, rather than studying individuals in their social contexts. Trietschke and Hermann Grimm are described as representatives of this new trend. Also Moeller van der Bruck's, *Die Deutschen* (1904–10.)

82. Bürger, *Theorie der Avantarde*, chapter 4, 'The negation of the autonomy of art by the avantgarde'.

83. Pechstein, *Erinnerungen*, p.95. Gustav Landauer (1870–1919), was an anarchist revolutionary, a writer, critic and translator involved in the 'back to nature' cult. See *Monte Verità, Berg der Wahrheit*, exhib. cat. Akademie der Künste, Berlin, 25 Mar.– 6 May 1979, pp.33ff.

84. Reprinted in Osborn, *Pechstein*, p.138.

85. Ibid, p.139.

86. Ibid, p.141.

87. Erich Frommhold, 'Zwischen Widerstand und Anpassung. Kunst in Deutschland 1933–1945', ed. Friedrich Möbius, *Stil und Gesellschaft*, Dresden 1984, p.262.

CHATPER 11: EMIL NOLDE'S CRITIQUE OF COLONIALISM

1. 'Man baut also die Wagen, um Kohlen zu holen, und holt Kohlen, um die Wagen zu bauen. Betrieb, Verkehr, Rauch, Lärm und Fortschritt, also das, was die Wasungu Kultur nennen, ist dann im Gange.' Paasche, *Die Briefe des Negers Lukanga Mukara*, p.39.

2. B. Bernard ed., *Anglo-Saxon Guide to the Paris Exhibition*, London 1900.

3. *JDK*, p.237. Hans Fehr hoped to accompany the Nolde's on their New Guinea journey in 1913, and to study native law. But these plans came to nothing. See Fehr, *Ein Buch der Freundschaft*, pp.64–5.

4. L. Brunet et L. Giethlen, *Le Dahomey et les Dépendances*, Paris 1900.

5. Pois, *Emil Nolde*, pp.185–6.

6. *DEL*, p.53.

7. Poliakov, p.140. Such doubts resemble those first surfacing in seventeenth-century responses to the discovery of a continent of unbaptized peoples in the Americas.

8. Manfred Schneckenberger, 'Bemerkungen zur "Brücke" und zur "primitiven" Kunst' in *Weltkulturen und Moderne Kunst*, 1972, p.460. This interpretation is repeated in Gordon, 'German Expressionism', p.382.

9. Smith, *European Vision*, chapter 11, 'The Ignoble and the Romantic Savage 1820–1850', particularly pp.222, p.317ff.

10. Schneckenberger, 'Bemerkungen zur "Brücke"' p.462. This god was a Korean idol protecting travellers.

11. Ettlinger, 'German Expressionism', p.201.

12. Pois, *Emil Nolde*, p.188.

13. *JDK*, p.124.

14. '...in weiter Sicht gesehen mag keine Rasse schlechter sein oder besser als die andere – vor Gott sind alle gleich – aber verschieden sind sie, sehr verschieden, in ihrem Stadium der Entwicklung, in ihrem Leben, in Sitten, Gestalt, Geruch und Farbe, und es ist wohl nicht die Absicht der Natur, daß sie sich vermischen sollen. Die Rassen als Massen lieben sich nicht, nur, wenn es hoch kommt, respektieren sie sich... Assyrer, Ägypter, Griechen, Chinesen, Hindus – ihre Kunstwerke sind alle herrlich verschieden; diejenigen der alten Italiener, der Deutschen, Spanier und Franzosen auch. Gemischtes nur ist zwitterhaft.' Ibid, p.123.

15. Uriel Tal, *Christians and Jews in German Religion, Politics and Ideology*, London 1975, p.302. Georg Mosse, *Germans and Jews. The Right, the Left and the Search for a Third Force in pre-Nazi Germany*, N.Y. 1970, p.54. Both historians point out, however, that the intellectual roots of racial anti-semitism are to be found before 1914. Tal points to the writings of Julius Langbehn and Paul de Lagarde, and the racial theories of Gobineau, Richard Wagner, Ernst Renan, Houston Stewart Chamberlain. He also mentions the popular Darwinism of Heinrich Czolbe and Ernst Haeckel. Mosse places a strong emphasis on the popular dissemination of these ideas through novels, in particular Gustav

16. *RAB*, p.42.
17. Bradley, *Emil Nolde*, chapter 3, pp.87ff. Bradley refers to the volkish ideas about a 'Germanic' Christ, popularized by de Lagarde and Langbehn. His argument that Nolde's 1909 religious paintings relate to these ideas is quite convincing. But Bradley does not adequately explain Nolde's representation of Jewish characters in the 1912 religious paintings.
18. *JDK*, p.170.
19. Ibid, p.171. Discussion about mixed race filtered down onto many levels of historical consciousness Freytag's *Soll und Haben* (1855), and Wilhem Raabe's *Hungerpastor* (1862). Mosse records that Freytag still drew up plans for complete Jewish assimilation in 1893 (Ibid, pp.42-3).
 during the pre-war years. For example, in 1911, there was an outrage in the popular press when an American heiress returned to claim her fortune with her African husband (fig. 262). The situation was satirized in the New York cabaret. *BIZ*, 1 Apr. 1911.
20. *JDK*, p.171.
21. There is no reason to suspect that Nolde understood Korean art to be inferior or 'racially mixed'. On the contrary, a letter dated November 1913 (*WuH*, p.48), praised Korean art. Nolde apparently thought of the Koreans as a 'pure' culture, under threat from outside influence, as he wrote: 'The Koreans appear tired, not fit to work, but sympathetic. It won't be long before they are decomposed by foreign influence.' This was written a year after completing the still-life painting, *The Missionary*.
22. Pois, *Emil Nolde*, pp.98, 189–190.
23. *JDK*, p.172. A rudimentary knowledge of Worringer's theories on Nolde's part is very likely. See, for example, an entry in the fourth volume of the autobiography, *RAB*, pp.57–8: 'The southern peoples are more at ease than us with delicate, soft sensibilities, and they don't like the tarter, dynamic roughness of Northern people. In driving rain, in frost and tempests and snow storms we men born in the cold feel at our best. We love the battle of the elements which make Southern people freeze. In art it's just the same. ('Die südlich geborenen Menschen sind gewandter als wir, mit zartem weicherem Sinn, und sie mögen das herbere, dynamisch Eckige der nordischen Völker nicht. In peitschendem Regen, in Frost und Sturm und Schneegestöber fühlen wir in der Kälte geborenen Menschen uns herzlich wohl, ja wir lieben das Toben der Elemente dort, wo der Südländer friert. In der Kunst ist es auch so.')
24. 'Jeder starke Künstler, wo er auch arbeitet, gibt seiner Kunst den Stempel seiner Persönlichkeit, den Stempel seiner Rasse. Was ein befähigter Japaner malt, wird japanische Kunst, was ein deutscher charakterstarker Künstler schafft, wird deutsche Kunst, ganz gleich, ob es in engster Heimat geschieht oder in entferntesten Weltteilen. Was Schwächlinge tun, hin und her wankend, gibt seichtes Gemisch.' Ibid, p.177.
25. Ibid.
26. Ibid, p.178.
27. *WuH*, p.11.
28. Ibid, p.14. Fehr, *Ein Buch der Freundschaft*, p.64.
29. *JDK*, p.29. *WuH*, p.174.
30. Ibid, p.145.
31. Ibid. Fehr, *Freundschaft*, p.73. The fifty drawings were donated to the Nationalgalerie Berlin in 1919, following the dissolution of the colonial office. In 1938, 24 of these drawings were confiscated by the Nazis; and the remaining 26 drawings are now in the Department of Prints and Drawings, Nationalgalerie, East Berlin.

32. *WuH*, p.174. In the *Zentralen Staatsarchiv Potsdam*, surviving correspondence between Prof. Leber and the colonial office makes clear that he requested the presence of the Noldes on the South Seas journey. See, *Emil Nolde, Reise in der Südsee 1913–1914*, exhib. cat. Altes Museum, East Berlin, April–June 1984, pp.45ff.
33. *WuH*, p.174. The woodcut of Dr Leber is illustrated in G. Schiefler (revised expanded and illustrated by Christel Mosel), *Emil Nolde. Das graphische Werk*, Cologne 1967, vol. II, woodcut no. 103, 1912.
34. He just missed an ancient Russian wooden relief but bought a Han horse in Mukden. *WuH*, pp.28, 39.
35. 'Lieber Freund… Es ist betrübend zu beobachten, wie die ganzen Länder hier von den allerschlechtesten europäischen Galanteriewaren überschwemmt sind, von der Petroleumlampe bis zum allerordinärsten Baumwollstoff, gefärbt in unechtester Anelinfarbe. Die an sich guten und besten Rohstoffe gehen nach Europa und kommen in billigster Ausführung als Ware zurück, die hier heimatlichen, guten Erzeugnisse verdrängend. Unser gutes Deutschland leistet sein gut Teil Unerträglichstes, aber die Ein- und Ausfuhrziffern daheim steigen rapide, der Gewinn sammelt sich in Berlin, Hamburg und in den Industrieprovinzen.' Ibid, p.48.
36. 'Die fremden Kulturstaaten arbeiten mit China genau wie die Wucherer mit dem Schuldner. Das Bestreben geht dahin, möglichst China Geld zu leihen, dafür von China Land, Konzessionen, Minen, Zölle, Eisenbahnbauten u.s.w. zu erhalten, erstmal nur als Garantie, dann wird der Strick etwas angezogen und es wird Besitz. Die vielen gierigen Arme strecken ihre langen Finger immer tiefer ins Land hinein.' Ibid, p.50.
37. Ibid, p.48.
38. Ibid.
39. Ibid, p.57.
40. P.J. Hempenstall, *Pacific Islanders under German Rule*, London 1978, chapter 1.
41. Ibid, 'The Reich and Race Relations in the New Guinea Islands.'
42. Wünsche, *Die deutsche Kolonien*, p.192.
43. Buschan, *Illustrierte Völkerkunde*, pp.183–4.
44. *WuH*, pp.58ff. In a recent catalogue (Altes Museum, 1984, p.14), it has been suggested that all Nolde's drawings were made after the recovery from his illness in March 1914. But no explanation is given for this chronology.
45. Ibid, p.146.
46. Reuther, *Frühwerk Emil Nolde*, pp.231ff.
47. Fehr, *Ein Buch der Freundschaft*, p.62.
48. Buschan, *Illustrierte Völkerkunde*, p.189.
49. Südsee Zeichnung no.94 (Seebüll), shows a group of natives with weapons, and at least two drawings in the group bought for the colonial office also represent armed natives, (*Three Large and One Small Native in War Costume in front of a Yellow Fence* and *Warrior carrying a Spear*). The choice of these subjects – which are rare in the drawings as a whole – is an interesting one.
50. Südsee Zeichnungen, nos. 93, 108 (Seebüll).
51. Martin Urban, *Emil Nolde. Südseeskizzen*, Munich 1980.
52. *WuH*, pp.97–8.
53. Ibid, p.68.
54. Hempenstall, *Pacific Islanders*, p.134.
55. *WuH*, p.57.
56. 'Sie waren wild, mit ihrem mächtigen Haar, mit ihrem Schmuck aus Muscheln und Bein an den Armen, um den Hals, oder in den Ohren hängend; manche hatten einen weißen, krummen Knochen durch die Nase gesteckt. Kannibalen waren es, diese

Menschen. Für uns Europäer ein unheimlicher Begriff.' Ibid.
57. Ibid, p.59.
58. Ibid, p.57.
59. 'Aus ihren Dörfern von Frauen und Kindern waren sie weggeholt worden. Das war radikal und roh. Das Kolonisieren ist eine brutale Angelegenheit… Wenn, von den farbigen Eingeborenen aus gesehen, eine Kolonialgeschichte einmal geschrieben wird, dann dürfen wir weißen Europäer uns verschämt in Höhlen verkriechen. – Es wird aber nicht geschehen. Die einzigen Naturvölker, welche dem zersetzenden Ausrottungstrieb der Weißen widerstehen werden, mögen, abgesehen von Chinesen und Indern, werden wohl nur die robusten Afrikaner sein.' Ibid, p.58.
60. *Deutsches Kolonialblatt*, no. 17, Sept. 1914, pp.782–9.
61. *WuH*, p.93.
62. 'Weder Zeichen der Degeneration noch der Inzucht, noch Anhaltspunkte für einen allgemeinen Bevölkerungsrückgang, sind bei diesem Stamm vorhanden. Es ist im Gegenteil bestimmt anzunehmen, daß eine erneute Volkszählung eine nicht unerhebliche Zunahme ergeben wird. Das Beispiel der Kanaken zeigt, daß die Berührung mit europäischer Kultur nicht an sich schon zum Niedergang eines primitiven Volkes zu führen braucht, wenn sie nur, wie hier bewußt von der Verwaltung geschehen ist, in nicht' überstürzter, schönender Weise vermittelt wird.' *Deutsches Kolonialblatt*, 1914, p.787.
63. Ibid, p.788.
64. Ibid, p.000.
65. *WuH*, p.99.
66. 'Auf einer jener kleinen Inseln dieser Gegend war seit 15 Jahren kein Kind mehr geboren worden. Die Eingeborenen wollten aussterben. Lieber dies, als für Fremde arbeiten. – Ihre fruchtbare, eigene schöne Insel war ihnen von einem Weißen genommen, sie selbst waren auf eine öde, kleine Nachbarinsel versetzt worden und mußten nun, um leben zu können, in den fremden Kokospflanzungen ihrer Heimatinsel die Arbeiten tun.' Ibid.
67. Smith, *European Vision*, pp.328ff.
68. *Südseezeichnungen*, nos. 46 and 86 (Seebüll).
69. *Family* (Schiefler/Mosel H.128), refers back very directly to a 1912 woodcut, *Man and Woman* (Schiefler/Mosel H.111). This latter work picks up directly on the exaggerated gestures and expression in the 'ethnographic' still lifes.
70. *WuH*, p.58.
71. 'Mit rührender Hingabe, mit seinem besten Wissen und Wollen und mit dem bescheidensten Erfolg beginnend, sucht der fromme, weiße Mann missionierend den Kult, Selbstbewußtsein und Willen der Urmenschen zu lockern, zu untergraben. Er arbeitet mit der Energie des milden Fanatikers, bis ein harmloses Opfer nach dem andern gefügig ihm zufällt. Er opfert sich selbst bis in den Tod, den Märtyrertod, und dann kommen die Soldaten mit scheinbarem Recht und Schärfe, ihn zu rächen. Das erste größere Tor wird hierbei geöffnet für Abenteuerer, für zweifelhaftes, geschlechtkrankes Europäergesindel, und den habgierigen Kaufmann. Die Kolonie ist erschlossen!' 'Ein erster Abschnitt des Seins geht mit dem Verschwinden des Urzustands der Naturvölker vorüber. Die menschliche Entwicklung aber befindet sich noch in steigender Linie und wohl erst, wenn eine zweite sekundäre Blüte der Völker begonnen hat, ist auch mit ihr eine Abwartsbewegung des Kulturzustandes begonnen…
 Auf unserem Planeten können wir Menschen in unserem eigenen Sein einiges ein klein wenig aufhalten, anderes ein klein wenig beschleunigen, im gan-

zen aber geht Vorwärtsentwicklung und Abstieg einzelner Völker als auch der ganzen Menschheit seinen unabänderlichen gemessenen Gang.' Ibid, pp.88–9.

72. Compare E. Gobineau, *Versuch über die Ungleichheit der Menschenrassen*, 4 vols. German translation 1898–1901.

73. *JDK*, p.177.

74. Smith, *European Vision*, p.330.

75. *WuH*, p.95.

76. Ibid, p.99.

77. 'Ich finde es bedauerlich, daß auf diese Weise viele unersetzliche Stücke Deutschlands verloren gehen. Dort bricht sich jetzt die Überzeugung Bahn, daß in den Erzeugnissen der sogenannten Naturvölker neben dem wissenschaftlichen auch ein künstlerischer Wert liegt, der um so höher anzuschlagen ist, als diese Erzeugnisse die letzten Überbleibsel einer Urkunst sind, von der sich bei den sogenannten Naturvölkern kaum noch Spuren finden...

Es ist meines Erachtens Ehrensache für das Deutsche Reich, die Reste dieser Kunst zu erhalten, und zwar für Deutschland zu erhalten. Ich gebe mich der Hoffnung hin, daß die Kolonialverwaltung dem steigenden Interesse der heimlichen künstlerischen Kreise für die Kunsterzeugnisse der Eingeborenen des Südseegebietes Rechnung tragen und schützende Maßnahmen treffen wird.' Sauerlaendt, *Briefe*, pp.102–3.

78. S.E. Bronner, 'Emil Nolde and the Politics of Rage', *Passion and Rebellion*, p.301.

79. Hempenstall, *Pacific Islanders*, p.243.

80. South Seas pastels, nos. 60, 49 (Seebüll).

81. *Tropical Sun* (1914) is based on Nolde's South Seas pastels, no. 46.

82. *JDK*, p.177.

83. 'In den Häusern und an den Menschen ist alles 'dirty too much', wie man hier sagt...die Frauen ...sind nicht schön, haben ganz kurz geschorene Haare, sind schrecklich, durch die Missionare (!) angezogen und sehen meistens verarbeitet aus. Viel Krankheit herrscht unter den Leuten. Manche haben keine Nase, manche keine Zehe, sie faulen ihnen ab. Bisher sind die Geburtenziffern sehr hoch; aber die Sterblichkeitsziffern sind auch hoch. In anderen Gegenden werden keine Kinder mehr geboren, auf einer Insel ist der jüngste Sohn 15 Jahre alt.' Fehr, *Ein Buch der Freundschaft*, p.67.

84. 'Die Eingeborenen sind ein herrliches Volk, soweit sie nicht schon durch die Berührung mit der Kultur der Weißen verdorben sind. Wir haben nur einige Male Gelegenheit gehabt, ganz ursprüngliche Menschen in ihren Dörfern kennenzulernen. Aber wie war das schön. Prächtige Gestalten mit mächtigem Haarwuchs, und Ohren und Hals voll schwerem Schmuck... Die rotbraunen Menschen, Männer und Frauen, fast ohne Bekleidung, nur im Schmuck, gehen auf die weißen Sande zwischen den fruchttragenden Palmen oder Bananen, oder den gelbroten Büschen um die Wohnstätten, eine seltsame, starke Harmonie. – Wenn ich an unsere deutschen Wohnungen voll von dem niedrigsten Sammelsarium billigster Flitter und Fabrikwaren denke, oder an die durch Kleidung und Schuhputz verkrüppelten, dem Modejournal huldigenden Körper!... Die Eingeborenen an den Plätzen der Europäer sind unerträglich, verlogen, verseucht und mit Lappen und Flitter elendster art behangen...Aber sage bitte nichts! – Psst! – Kein weißer Mann darf es sehen, wer es sieht, schließe hübsch die Augen, der 'wirtschaftliche Nutzen' überragt alle Bedenken.' Ibid, pp.70–1.

Bibliography

The literature on German Expressionism is extremely extensive. This bibliography refers only to the texts directly cited in my text. It is organized alphabetically according to author, and, in the case of exhibition catalogues, according to place. Publications containing full bibliographies for the individual artists are marked with a *.

In the course of my research I have used the following archives:

Altonaer Museum Hamburg (Brücke correspondence)
Brücke-Museum, Berlin
Günter Krüger, Berlin (personal archive)
Karl Ernst Osthaus Museum, Hagen
Kunstbibliothek Berlin (newspaper archive)
Museum für Völkerkunde Dresden
Museum für Völkerkunde Hamburg
Museum für Völkerkunde Berlin
Landesbibliothek Dresden (newspaper archives)
Max Pechstein family archive, Hamburg
Gustav Schiefler archive, Hamburg
Stadtsbibliothek, Berlin (newspaper archive)
Stiftung Seebüll Ada und Emil Nolde

Adorno, Theodor *Über Walter Benjamin*, Frankfurt a.M. 1970.

Bahr, Hermann. *Expressionismus*, Munich 1916.

*Barron, Stephanie ed. *German Expressionist Sculpture (Skulptur des Expressionismus)*, exhib. cat. Los Angeles County Museum, October 1983-January 1984, Josef Haubrich Kunsthalle, Cologne, July-August 1984.

Baudelaire, Charles. *Oeuvres Completes*, Paris 1937.

Beckmann, Max. 'Gedanken über zeitgemäße und unzeitgemäße Kunst', *Pan*, March 1912, pp. 499ff.

Behrendt, Walter Cuhrt. 'Werkbund Ausstellung 1914', *Kunst und Künstler* XII, 1914, pp. 615–16.

Benjamin, Walter. *Versuche Über Brecht*, Frankfurt/M. 1966.

—— *Charles Baudelaire: A Lyric Poet in the Era of High Capitalism*, transl. by Harry Zohn, London 1973.

Beradt, Martin. 'Tagebuch eines Dekadenten', *Hyperion*, vol. 2, 1909.

Berger, Peter. *Facing Up to Modernity*, New York 1977.

Berlin, Akademie der Künste. *Das Ursprüngliche und die Moderne*, exhib. cat. 1964.

—— *Avantgarde Osteuropa 1910–1930*, exhib. Cat. October–November 1967.

—— *Monte Verità Berg der Wahrheit*, exhib. cat. March–May 1979.

Berlin (Ost), Altes Museum. *Emil Nolde, Reise in die Südsee 1913–14*, exhib. cat. April–June 1984.

Berlin, Bahaus-Archiv. *Kunstschule-Reform 1900–1930*, exhib. cat. 1977.

Berlin, Brücke-Museum. *Künstler der Brücke in Berlin*, exhib. cat. September 1972

—— *E.L. Kirchner. Die Aquarelle und Pastelle in eigenem Besitz*, exhib. cat. 16 September 1978–15 February 1979.

—— *Die Brücke im Aufbruch*, exhib. cat., 7 June 13 July 1980.

—— *Max Pechstein 1881–1955. Zeichnungen und Aquarelle, Stationen seines Lebens*, exhib. cat. 19–22 November 1981.

Berlin, Nationalgalerie. *Liebermann in seiner Zeit*, exhib. cat. September 1979.

*—— *E.L. Kirchner 1880–1938*, exhib. cat. November 1979–January 1980

Bernard, B. *Anglo-Saxon Guide to the Paris Exhibition*, London 1900.

Beulitz, Dietrich von. 'The Perls House by Ludwig Mies Van der Rohe', ed. Doug Clelland, *Berlin: An Architectural History*, Architectural Design Profile, vol. 53, no. 11/12, London 1983.

Bierbaum, Otto Julius. *Stilpe. Roman aus der Froschperspektive*, Berlin 1987.

—— *Deutsche Chansons*, Berlin and Leipzig, 1900.

Biermann, Georg. *Max Pechstein*, Junge Kunst, vol. 1, Leipzig 1919.

Bilang, Karla. *Die Rezeption ozeanischer und afrikanischer Kunst in der Künstlergemeinschaft Brücke und der Exotismus in der bürglichen Malerei*, Dissertation, Greifswald 1982.

Billeter, Erika. 'Ernst Ludwig Kirchner: Kunst als Lebensentwurf', *E.L. Kirchner 1880–1938, exhib. cat. op. cit. 1979–80*.

Blaβ, Ernst. 'Das alte Café des Westens', Paul Raabe ed. *Exressionismus Aufzeichnungen und Erinnerungen der Zeitgenossen* Olten/Freiburg 1965.

Bleyl, Fritz. 'Erinnerungen', in 'Fritz Bleyl, Gründungsmitglied der Brücke', *Kunst in Hessen und am Mittelrhein*, no. 8, 1968.

Bloch, Ernst. 'Diskussion über Expressionismus', *Das Wort*, 1938.

—— *Erbschaft dieser Zeit*, Frankfurt/M. 1962.

Bolliger, Hans and Kornfeld, E.W. eds. *Künstlergruppe Brücke Jahresmappen 1906–1912*, exhib. cat. Kornfeld und Klipstein Bern, 19–27 October 1958.

Bolliger, Hans and Reinhardt, Georg. 'Ernst Ludwig Kirchner. Eine Biographische Text-Bild Dokumentation', E.L. Kirchner 1880–1938, exhib. cat. Nationalgalerie Berlin, 1979–1980.

Bon, Gustav le. *Psychologie des Foules*, Paris 1895.

*Bradley, William S. *The Art of Emil Nolde in the Context of North German Painting and Volkish Ideology*, Northwestern University PhD 1981.

Brecht, Berthold. *Schriften zur Kunst und Literatur*, Frankfurt/M. 1967.

Brieger, Lothar and Steiner, Hans eds. *Zirkus Berlin*, Berlin 1919.

Bronner, Stephen and Kellner, Douglas. *Passion and Rebellion, The Expressionist Heritage*, London 1983

Brunet, L. *Le Dahomey et les dépendances*, Paris 1900.

Buchheim, Lothar. *Die Künstlergemeinschaft Brücke*, Feldafing 1966.

Bürger, Peter. *Theorie der Avantgarde*, Frankfurt/M. 1974. transl. by M. Shaw, *Theory of the Avantgarde*, Manchester 1984.

Buschan, Georg. *Illustrierte Völkerkunde*, Stuttgart 1911.

Bussmann, Georg. 'Degenerate Art – a Look at a Useful Myth.' *German Art in the 20th Century*, exhib. cat. Royal Academy of Art, London 1985.

Carpenter, Edmund. *'Do you have the same thing in green?' Or Eskimos in New Guinea*, Toronto 1977.

Cologne, Kölnische Stadmuseum. *Expressionisten. Sammlung Buchheim*, exhib. cat. 2 April 31 May 1981.

Cologne, Sonderbund. *Ausstellungskatalog*, 1912.

Cologne, Wallraf-Richartz Museum. *Maler suchen Freunde. Jahresmappen, Plakate und andere werbende Graphik der Künstlergruppe Brücke*, exhib. cat. 26 May–25 July 1971.

*—— *Emil Nolde, Gemälde, Aquarelle, Zeichnungen und Druckgraphik*, exhib. cat. February–April 1973.

Cologne, Werkbund. *Ausstellungskatalog*, 1914 (reprint 1981).

Conzelmann, Otto. *Der andere Dix: Sein Bild vom Menschen und vom Krieg*, Stuttgart 1983.

Danielsson, Bengt. *Gauguin in the South Seas*, New York 1966.

Denis, Maurice. 'Definition du neo-traditionisme', *Art et Critiquè*, Paris 23 and 30 August 1890.

Deutsch, Rosalynd. 'Alienation in Berlin, Kirchner's Street Scenes', *Art in America*, January 1983 pp. 65–72.

Döblin, Alfred. 'Die Tänzerin und ihr Leib', *Der Sturm*, no. 2, 10 March 1910.

—— 'Zirkus Pantomime', *Der Sturm*, no. 3, 24 March 1910.

—— 'Die Bilder der Futuristen', *Der Sturm*, no. 110. May 1912, pp. 41ff.

—— 'Futuristische Worttechnik', *Der Sturm*, no. 150/1, March 1913, pp. 280–2.

—— 'An Romanautoren und ihre Kritiker', *Der Sturm*, no.158/9, May 1913, pp. 17ff.

—— *Die drei Sprünge des Wang-lun*, Berlin 1915.

Dube, Annemarie and Wolf-Dieter. *Erich Heckel. Das graphische Werk*, 2 vols. New York 1964.

—— *E.L. Kirchner. Das graphische Werk*, 2 vols. Munich 1967.

Dube, Wolf-Dieter. *Der Expressionismus in Wort und Bild*, Stuttgart and Geneva, 1983.

Dube-Heynig, Annemarie. *E.L. Kirchner. Graphik*, Munich 1961.

—— *E.L. Kirchner, Postkarten und Briefe an Erich Heckel im Altonaer Museum Hamburg*, Cologne 1984.

Düring, Kurt. 'Das Siedlungsbild der Insel Fehmarn 1937,' *Forschungen z.d. Landes-und Volkskunde*, vol. 32, pp. 7–135.

Düsseldorf, Kunsthalle *Die Gemälde E.L. Kirchners*, exhib. cat. September–October 1960.

Eberding, Walter. '35 Jahre Obstbausiedlung Eden', *Biologische Heilkunst*, 1928, no. 17.

Eberle, Matthias. *World War 1 and the Weimar Artists: Dix, Grosz, Beckmann, Schlemmer*, New Haven and London, 1985.

Eimert, Dorothea. *Der Einfluß des Futurismus auf die deutsche Malerei*, Cologne 1974.

Einstein, Carl. 'Bebuquin oder die Dilettanten des Wunders', *Die Aktion*, 1912.

—— 'Brief an die Tänzerin Nalierkowska', *La Phalange*, January 1912, pp. 73–6.

—— *Negerplastik*, Leipzig 1915.

—— *Werke*, 3 vols. ed. R.P. Baacke, Berlin 1980–5.

Elias, Norbert. *Über den Prozeß der Zivilisation*, 2 vols. Bern 1969.

Endell, August. *Die Schönheit der großen Stadt*, Stuttgart 1908.

Ettlinger, L.D. 'German Expressionism and Primitive Art', *Burlington Magazine*, 1968, pp. 192ff.

Evans, Richard J. *The Feminist Movement in Germany 1894–1933*, London 1976.

Fechter, Paul. *Expressionismus*, Munich 1914.

Fehr, Hans. *Ein Buch der Freundschaft*, Munich 1960.

Flensburg, Städtischen Museum. *Heinrich Sauermann (1842–1904). Ein Flensburger Möbelfabrikant des Historismus*, exhib. cat. July–September 1979.

Frecot, J., Geist, J.F., and Kerbs. D. *Fidus 1868–1958. Zur aesthetischen Praxis bürgerlicher Fluchtbewegungen*, Munich 1972.

Freud, Sigmund. *Totem und Tabu*, 1911.

—— 'Psychoanalytical Account of a Case of Paranoia (the case of Schreber)'

—— *The Complete Psychological Works*, ed. J. Strachey, vol. 12.

Freyer, Kurt ed. *Museum Folkwang, Moderne Kunst, Plastik, Malerei, Graphik*, vol. 1, Hagen 1912.

Frisby, David. *Sociological Impressionism. A Reassessment of Georg Simmel's Social Theory*, London 1981.

Fuchs, Edward. *Die Karikatur der europäischen Völker*, 3 vols., Berlin 1901–3.

Fuhrmann, Ernst. *Tlinkit und Haida, Kulturen der Erde, Indianerstämme von Nordamerika*.

Gabler, Karlheinz ed. *E.L. Kirchner Dokumente*, Aschaffenburg 1980.

—— *Ernst Ludwig Kirchner, Zeichnungen, Pastelle, Aquarelle*, Aschaffenburg 1980.

—— *Erich Heckel und sein Kreis. Dokumente, Fotos, Briefe, Schriften*, Stuttgart 1983.

—— *Erich Heckel, Zeichnungen, Aquarelle*, Stuttgart 1983.

Gay, Peter. *Freud, Jews and other Germans. Masters and Victims in Modernist Culture*, Oxford 1978.

Glaser, Kurt. 'Neue Galerien in Berlin', *Kunst und Künstler*, December 1913.

Goldwater, Robert. *Primitivism in Modern Painting*, N.Y. 1938, revised editions 1967, 1987.

Gordon, Donald E. 'Kirchner in Dresden', *Art Bulletin* vol. 48, 1966, pp. 335–66.

*—— *Ernst Kudwig Kirchner*, critical study and oeuvre catalogue of the paintings. New York 1968.

—— *Modern Art Exhibitions 1900–1916*, Munich 1974.

—— 'Content by Contradiction,' *Art in America*, December 1982, pp. 76ff.

—— *Expressionism: Art and Idea*, New Haven and London 1987.

—— 'German Expressionism,' ed. William Rubin, *Primitivism in 20th Century Art*, vol. 2, New York 1984, pp. 369ff.

Gosebruch, Ernst. 'Ansprache bei der Eröffnung der Emil Nolde Ausstellung in Museum Folkwang Esseu am 17, Juli 1927', Reprinted in *Bilder von Emil Nolde*, Kunstring Folkwang, Essen 1957.

Graburn, Nelson H. *Ethnic and Tourist Arts. Cultural Expressions from the Fourth World*, Univ. California Press 1976.

Griffith, J. *The Paintings of the Buddhist Cave Temples of Ajanta Khandesh, India*, London 1896/7.

Grisebach, Lothar, ed. *E.L. Kirchners Davoser Tagebuch*, Cologne 1968.

Grisebach, Lucius. 'Kirchner und Cranach', *E.L. Kirchner Aquarelle, Zeichnungen und Druckgraphik aus dem Besitz des Städel Frankfurt a.M.* exhib. cat. Wissenschaftszentrum Bonn-Bad Godesberg, 18 April to 1 June 1980.

Grohmann, Will. *E.L. Kirchner*, Stuttgart 1958.

Grosse, Ernst. *Die Anfänge der Kunst*, Freiburg 1894.

Halbe, Dr A. 'Gedanken und Vorschläge zur Durchführung einer wirtschaftlichen Organization der Künstlerschaft', *Werkstatt der Kunst*, no. 38, 1913, pp. 523–5.

Hamann, Richard and Hermand, Jost. *Stilkunst um 1900, Epochen deutscher Kultur von 1870 bis zur Gegenwart*, vol. 4, Berlin 1969.

Hamburg, Kunsthalle. *Menzel der Beobachter*, exhib. cat. May–July 1982.

Hansen, A. *Charakterbilder aus den Herzogthümern Schleswig-Holstein und Lauenburg*, 1858.

Hartlaub, Gustav. *Kunst und Religion*, Leipzig 1919.

Hartley, Keith. *The City as Seen by Artists in Berlin 1911–1914*, Courtauld Institute of Art, London University, unpublished M.A. thesis 1975.

Hegemann, Werner. 'Soll Berlin Wolkenkratzer bauen?, *Berlin Illustrierte Zeitung*, January 1913.

Heinersdorff, Gottfried. *Die Glasmalerei*, Berlin 1913.

Heise, Carl Georg. 'Arnold Böcklin, 1936', *Arnold Böcklin*, exhib. cat. Kunstmuseum Düsseldorf 1974.

Hempenstall, P.J. *Pacific Islander under German Rule*, London 1978.

Hentzen, Alfred. 'Kunsthandwerkliche Arbeiten der deutschen Expressionisten und ihrer Nachfolger', *Festschrift für Erich Meyer zum 60. Geburtstag*, Hamburg 1957, pp. 319ff.

—— *Emil Nolde, Das Abendmahl*, Stuttgart 1964.

Hermann, Georg. 'Die Sehnsucht des Großstädtens', *Berliner Illustrierte Zeitung*, July 1914.

Hess, Hans. *Lionel Feininger*, Stuttgart 1959.

Heym, Georg. *Der Ewige Tag*, Berlin 1911.

—— *Dichtungen*, Stuttgart 1965.

Hildebrand, G. 'Die Stellung der Sozialdemokratie zur Kolonialpolitik', *Koloniale Rundschau*, Berlin 1911, pp. 23ff.

Hiller, Kurt. *Die Weisheit der Langeweile*, Leipzig 1913.

Hirschfeld, Georg. 'Bellowische Ecke', *Berliner Illustrierte Zeitung*, June 1913.

Holz, Arno. *Buch der Zeit. Großstadt-Dichtungen*, Berlin 1885.

Hünlich, Berndt. 'Dresdener Motive in Werken der Künstlergemeinschaft *Brücke*. Ein Beitrag zur topographisch-kritischen Bestandsaufnahme', *Jahrbuch der staatlichen Kunstsammlungen Dresden*, 1981 pp. 67ff.

—— 'Heckel und Kirchner auf der Berliner Straße in Dresden', *Dresdener Kunstblätter, Staatliche Kunstsammlungen Dresden*, 27 Jg. 1983, vol. 4.

—— 'Heckel und Kirchners verschollene Plakatenentwürfe für die Internationale Hygiene Ausstellung Dresden 1911', *Dresdener Kunstablätter*, 1984, no. 5, pp. 145ff.

—— 'Wohnstätten und Lebensumstände der vier Brücke-Gründer in Dresden', *Dresdener Kunstblätter*, 1985 no. 3, pp. 80ff.

—— 'Heckel und Kirchner im Dresdener Flora-Varieté', *Dresdener Kunstblätter*, 1986 no. 3, pp. 83ff.

Junghaus, Ingolf. 'Eine Insel ohne Märchen', *Merian*, Jg. 9, no. 8, 1956, pp. 42–7.

*Kaiserslauten, Pfalzgalerie. *Max Pechstein*, exhib. cat. July–August 1982.

Kandinsky, Wassily. *Über das Geistige in der Kunst*, Munich 1911.

Kandinsky and Marc, Franz ed. *Der Blaue Reiter Almanach*, Munich 1912.

Kautsky, Max. *Sozialismus und Kolonialpolitik*, Berlin 1907.

Kehrer, Hugo. *Die Kunst des Greco*, Munich 1914.

Kessler, Charles S. 'Sun Worship and Anxiety', *Magazine of Art*, November 1952.

*Ketterer, Roman Norbert unter Mitwirkung von Hentzen, Wolfgang. *E.L. Kirchner, Zeichnungen und Pastelle*, Zurich 1979.

Keyser, Marja. 'Hochverehrtes Publikum. Ein Streifzug durch die Circusgeschichte,' *Zirkus, Circus, Cirque*, exhib. cat. Nationalgalerie Berlin 1978.

Kleist, Heinrich von. 'Über das Marionettentheater., Leipzig 1803.

Kohm, Hans. 'Interview mit Erich Heckel', *Das Kunstwerk*, vol. 3, 1958/9, pp. 24ff.

Kramer, Fritz. *Verkehrte Welt. Zur imaginären Ethnographie des 19. Jahrhunderts*. Frankfurt a.M. 1977.

Kroeber, A.L. and Kluckhorn, Clyde. *Culture, a Critical Review*, New York, undated.

Krüger, Günter. 'Die Jahreszeiten, ein Glasfensterzyklus von Max Pechstein', *Zeitschrift des deutschen Vereins für Kunstwissenschaft*, vol. 19, 1965, no.1/2, pp.77ff.

—— 'Glasmalerei der Brücke-Künstler', *Brücke-Archiv* 1, Berlin 1967, pp. 19ff.

Kubin, Alfred. *Die andere Seite*, Munich 1909.

Langbehn, Julius. *Rembrandt als Erzieher*, Leipzig 1890.

*Lankheit, Klaus. *Franz Marc. Sein Leben und seine Kunst*, Cologne 1976.

Laqueur, Walter. *Young Germany*, London 1962.

Lemmer, Konrad. *Max Pechstein und der Beginn des Expressionismus*, Berlin 1949.

Lukács, Georg. 'Es geht um den Realismus', *Das Wort*, 1938.

—— *Essays über Realismus*, Neuwied 1971.

Macke, August and Marc, Franz. *Briefwechsel 1910–1914*, Cologne 1964.

Marbach-am-Neckar. *Alfred Döblin 1878–1978*, exhib. cat. June–December 1978.

Man, Paul de. *Blindness and Insight: Essays in the Rhetoric of Contemporary Criticism*, New York, 1971.

Marsalle, Louis de (E.L. Kirchner) 'Über Kirchners Graphik', *Genius*, vol. 1 no. 2, 1919, pp. 351–63.

—— 'Zeichnungen von E.L. Kirchner', *Genius*, vol. 2, no. 2, 1920, pp. 221ff.

—— 'Über die plastischen Arbeiten von E.L. Kirchner', *Die Cicerone*, 17, no. 14, 1925, pp. 695–701.

Martensen-Larsen, Britta. 'Primitive Kunst als Inspirationsquelle der Brücke', *Hafnia*, 7, 1980, Copenhagen, pp. 90ff.

Maschek, Joseph. 'Primitive Authenticity and German Expressionism', *RES*, 4, 1982.

Mayer, A.L. *El Greco*, Leipzig 1911. 'El Greco', *Kunst für Alle*, May 1914 pp. 358ff.

McCullagh, J. 'The Tightrope Walker: An Expressionist Image'. *Art Bulletin*, vol. 66, December 1984, pp. 633–44.

McEvilley, Thomas. 'Doctor, Lawyer, Indian Chief', *Art Forum*, November 1984, pp. 56ff.

Meidner, Ludwig. 'Anleitung zum Malen von Großstadtbildern', *Kunst und Künstler*, 12, 1914, pp. 299ff.

Meier-Graefe, Julius. 'Henri Van der Velde', *Dekorative Kunst* Jg.3 1899/1900, pp. 139–42 223–5.

—— *Die Entwicklungsgeschichte der modernen Kunst*, Munich 1904, 2 vols.

—— *Die spanische Reise*, Berlin 1910.

—— *Der Fall Böcklin und die Lehre von den Einheiten*, Stuttgart 1905.

—— *Ausgewählte Schriften*, ed. Carl Linfert Munich 1959.

Meinhof, Carl 'Ideale Aufgabe in unseren Kolonien', *Koloniale Rundschau*, 1909, pp. 89ff.

Mesurier, Le. 'Tibetan Art', *Studio*, vol. 31, 1904 pp. 294ff.

Mitchell, B.R. *European Historical Statistics 1870–1970*, London 1975.

Möbius, Friedrich ed. *Stil und Gesellschaft*, Dresden 1984.

Mosse, Georg. *The Crisis of German Ideology*, London 1966.

—— *Germans and Jews. The Right the Left and the Search for a Third Force in pre-Nazi Germany*, New York 1970.

Moszeik, Otto. *Die Malerei der Buschmänner in Sudafrika*, 1910.

Müller, Johann Heinrich. 'Die Folkwang-Idee des Karl Ernst Osthaus', *Karl Ernst Osthaus*, exhib. cat. Karl Ernst Osthaus Museum Hagen 25 March–20 June 1984 (Der Westdeutsche Impuls 1900–1914, Kunst und Umweltgestaltung im Industriegebiet, 1984).

*Münster, Westfälisches Landesmuseum für Kunst und Kulturgeschichte *August Macke, Gemälde Aquarelle Zeichnungen*, exhib. cat. 7. December 1986–8, February 1987.

Munich, Haus der Kunst. *Weltkulturen und moderne Kunst*, exhib. cat. 1972.

Munich, Galerie Wolfgang Ketterer *Ernst Ludwig Kirchner*, exhib. cat. 6, September–26 October 1985.

Munich, Galerie im Lenbachhaus. *Franz Marc 1880–1916*, exhib. cat. 27, August–12, October 1980.

Nettmann, Heinrich. 'Osthaus wollte die Gesellschaft veredeln . . .' *Südwestfälische Wirtschaft – Kunst und Wirtschaft*, April 1971, pp. 1–3.

New York, New Gallery. *Emil Nolde*, exhib. cat. September–October 1957.

Nietzsche, Friedrich. *Der Wille zur Macht*, Stuttgart 1906.

—— *Thoughts Out of Season*, London 1909.

—— *Also sprach Zarathustra*, 1883–5.

—— *Kritische Gesamtausgabe*, ed. Giorgio Golli and Mazzino Montanari, vol. 6, Berlin 1968.

—— *Briefe, April 1869–Mai 1877*, ibid. vol. 1, Berlin 1978.

Nolde, Emil. *Das eigene Leben*, Berlin 1931.

—— *Jahre der Kämpfe*, Berlin 1934.

—— *Welt und Heimat*, Cologne 1965.

—— *Reisen, Ächtung, Befreiung*, Cologne 1967.

Obrist, Hermann. 'Eine Methode des Kunstunterrichts', *Der Kunst*, vol. 7, 1904, pp. 288ff.

—— *Neue Möglichkeiten*, Leipzig 1905.

Osborn, Max. *Max Pechstein*, Berlin 1922.

Osthaus, Karl Ernst. *Worin hat die Entfremdung unserer Malerei vom deutschen Volk ihren Grund?*, 1894.

—— 'Ex Unque Leonem', *Genius*, vol. 1, 1919 pp. 91–2.

Oswald, Hans ed. 'Das erotische Berlin', *Großstadt Dokumente*, vol. 1, Berlin 1910.

Otten, C.M. ed. *Anthropology and Art*, 1971.

Paasche, Hans. *Die Briefe des Negers Lukanga Mukara: Die Forschungsreise des Afrikaners Lukanga Mukara in innerste Deutschland*, Bielefeld, 1919.

Paret, Peter. *Die Berliner Sezession. Moderne Kunst und ihre Feinde im kaiserlichen Deutschland*, Berlin 1981.

Pechstein, Max. *Erinnerungen*, Wiesbaden, 1960.

Peppiatt, Michael. 'Sujet Tabou, Exposition Risquée', Connaissance des Arts, Paris no. 391, September 1984.

Perry, Gillian. *Paula Modersohn-Becker*, New York and London 1979.

Pevsner, Nicholas. 'Möglichkeiten und Aspekte des Historismus', *Historismus und bildender Kunst des 19. Jahrhunderts*, vol. 1, Munich 1965.

Plietzsch, Eduard. *Heiter ist die Kunst. Erlebnisse mit Künstlern und Kennern.* Cologne 1955.

Plietzsch, Friedrich. *Schinkels Austattungen von Innenräumen*, Mannheim 1911.

Poggioli, R. *Theory of the Avant-garde*, Cambridge Mass. 1968.

Praetorius, Charles. 'The Art of New Guinea', *Studio*, vol. 30, pp. 51ff.

—— 'Art in the Solomon Islands', *Studio*, vol. 34, 1905, pp. 118ff.

Pross, Harry. 'Youth Movements in Germany', *German Art in the 20th Century*, exhib. cat. Royal Academy, London 1985, pp. 83–91.

Pudor, Heinrich. 'Nackende Menschen, Jauchzen der Zukunft', *Dresdner Wochenblätter*, 1893 pp. 23ff.

—— 'Jungbrunnen, Offenbarungen der Natur', Leipzig 1894.

Rees, Paul 'Edith Buckley, Ada Nolde and *die Brücke*, Bathing, Health and Art in Dresden 1906–1911', *German Expressionism in the U.K. and Ireland*, ed. Brian Keith Smith, University of Bristol 1985.

Read, Herbert. 'Tribal Art and Modern Man', *The New Republic*, September 1953.

Reidemeister, Leopold. *Künstler der Brücke an den Moritzburger Seen 1909–1911*, exhib. cat. Brücke Museum, Berlin 1970.

—— *Künstler der Brücke, Gemälde der Dresdener Jahre 1905–1911*, Brücke Museum, Berlin 1973.

—— *Künstlergruppe Brücke. Fragment eines Stammbuches*, Berlin 1975.

—— 'Die vier Evangelisten von Karl Schmidt-Rottluff und die Sonderbundausstellung in Köln', *Brücke-Archiv*, 8, 1975/6, pp. 13–26.

Regensburg, Ostdeutsche-Galerie. *Max Pechstein, Ostsee-Bilder. Gemälde, Zeichnungen, Fotographien*, exhib. cat. July–August 1981.

*Reinhardt, Georg. *Die frühe Brücke*, Brücke-Archiv, no. 9/10 Berlin 1977/8.

Reuther, Manfred. *Das Frühwerk Emil Noldes*, Cologne 1985.

Riegl, Alois. *Stilfragen, Grundlegungen zu einer Geschichte der Ornamentik*, Berlin 1893.

—— *Die spätrömische Kunstindustrie nach den Funden in Österreich-Ungarn*, Vienna 1901.

Riehl, Wilhelm. *Land und Leute*, Berlin 1857–62.

Rössler, R.O.W. *Kabarettgeschichte*, Berlin 1977.

Rohde, Horst. *Das Fehmarnhaus und sein Dorf*, Neumünster 1984.

Rosenthal, Donald. 'Two Motifs from Early Africa in Works by Ernst Ludwig Kirchner', *Abhandlungen und Berichte des Staatlichen Museums für Völkerkunde*, vol. 35, Dresden 1976.

Roskill, Mark. *Van Gogh, Gauguin and the Impressionist Circle*, London 1970.

Roters, Eberhard. 'Beiträge zur Geschichte der Künstlergruppe Brücke', *Jahrbuch der Berliner Museen*, 11, 1960, pp. 172–210.

*Rubin, William ed. *Primitivism in 20th Century Art*, 2 vols. N.Y. 1984.

Sauerlaendt, Max. *Emil Nolde. Briefe aus den Jahren 1894–1926.*, Berlin 1927, revised ed. 1965.

—— 'Die Holzbildwerke von Kirchner, Heckel und Schmidt-Rottluff im Hamburgischen Museum für Kunst und Gewerbe', *Museum der Gegenwart, Zeitschrift der deutschen Museen für neuere Kunst*, no. 1, 1930/1 pp. 101ff.

Schaafhausen, H. 'Les Questions anthropologiques de nôtre temps', *Revue Scientifique*, 1866, pp. 769–76.

Schapire, Rosa. 'Siegfried Levinsteins Kinderzeichnung bis zum 14, Lebensjahr', *Monatshefte der Kunstwissenschaftlichen Literatur*, vol. 2, Hamburg 1906, pp. 92–3.

—— 'Conrado Riccis Kinderkunst', ibid. vol. 3, 1907, p. 113.

—— 'Umélécký Mésíčnék', *Beiblatt der Zeitschrift für Bücherfreunde*, N.F. 5, 1913.

—— 'Paul Fechters Expressionismus', ibid. N.F. 6, 1914, pp. 243–4.

—— 'Carl Einsteins Negerplastik', ibid. N.F. 7, 1915, pp. 500–01.

Scheffler, Karl *Die fetten und die mageren Jahre*, Munich 1948.

Schiefler, Gustav. *Emil Nolde. Das graphische Werk. Neu bearbeitet, ergänzt und mit Abbildungen versehen von Christa Mosel*. 2 vols, Cologne 1966, 1967.

—— *Meine Graphiksammlung*, Hamburg 1974.

Schleswig-Holsteinisches Landesmuseum. *Plastik und Kunsthandwerk von Malern des deutschen Expressionismus*, exhib. cat. 28 August–2 October 1960.

Schmalenbach, Fritz. *Jugendstil. Ein Beitrag zur Theorie und Geschichte der Flächenkunst*, Würzburg 1935.

Schneider, Karl Ludwig. 'Themen und Tendenzen der Expressionistischen Lyrik', *Zerbrochene Formen, Wort und Bild im Expressionismus*, Hamburg 1967.

Schneider, K.L. and Burckhardt, G. *Georg Heym, Dokumente zu seinem Leben und Werk*, vols 1–4, Munich 1968.

Schreinert, Kurt ed. *Theodor Fontane, Briefe*, Heidelberg 1954.

Schumacher, Fritz. 'Aus der Vorgeschichte der Brücke', *Der Kreis*, vol. 9, January 1932, p. 10.

Schur, Ernst. *Die steinere Stadt*, Berlin 1905.

*Selz, Peter. *German Expressionist Painting*, Berkeley 1957.

Semper, Gottfried. *Der Stil in den technischen und tektonischen Künsten*, Berlin 1860.

Simmel, Georg. *Philosophie des Geldes.* Leipzig 1900.

—— 'Die Großstadt und das Geistesleben', *Jahrbuch der Gehe-Stiftung zu Dresden*, 1903.

—— *Philosophische Kultur*, Leipzig 1911.

Smith, Bernard. *European Vision and the South Pacific*, 2nd ed., New Haven and London 1985.

Stern, Fritz. *The Politics of Cultural Despair*, Berkeley and Los Angeles, 1961.

Strindberg, August. *The Cloister*, London 1969.

Swarzenski, Georg. 'Künstler und Kunstpreise', *Deutsche Kunst und Dekoration*, 1911/12, pp. 370–82.

Tal, Uriel, transl. by *Christians and Jews in German Religion Politics and Ideology*, Ithaca and London 1975.

Tetens, A. *Among the Savages of the South Seas, 1862–1868*, Stanford 1958.

Tiesler, Frank. 'Hausbalken von den Palau-Inseln, Mikronesien', *Beiträge aus dem Staatlichen Museum für Völkerkunde Dresden*, no. 4, 1981, pp. 3ff.

Townsend, Mary Evelyn. *The Rise and Fall of Germany's Colonial Empire 1884–1918*, New York 1930.

Ungewitter, Richard. *Die Nacktheit in entwicklungsgeschichtlicher, gesunheitlicher moralischer und künstlerischer Beleuchtung*, Berlin 1905.

Urban, Martin. *Emil Nolde Südseezeichnungen*, Munich 1980.

Velde, Henry van der. 'Apercus en vue d'une synthese d'art', *Pan*, 1899/1900 vol. 4, pp. 261–79.

Vinnen, Carl. *Protest deutscher Künstler*, Jena 1911.

*Vogt, Paul. *Erich Heckel*, Recklinghausen, 1965.

—— *Das Museum Folkwang in Hagen 1902–1927*, Cologne 1965.

Warnod, André. 'L'Art Nègre', *Comoedia* 2, 1912.

Weightman, J. *The Concept of the Avant-garde, Explorations in Modernism*, London 1973.

Werenskiold, Marit. *The Concept of Expressionism, Origin and Metamorphoses*, Oslo 1984.

Wertheimer, M. *The Pan-German League*, New York 1924.

Wietek, Gerhard. *Maler der Brücke in Dangast 1907–1912*, exhib. cat. Oldenburg 1957.

——— *Karl Schmidt-Rottluff, Bilder aus Nidden 1913, Werkmonographien zur Bildenden Kunst*, no. 91, Stuttgart 1963.

——— 'Dr. Phil. Rosa Schapire', *Jahrbuch der Hamburgischer Kunstsammlungen*, vol. 9, 1964.

——— 'Der finnische Maler Axel Gallén-Kallela als Mitglied der Brücke', *Brücke-Archiv*, nos. 2/3, 1968/69, pp. 3–24.

——— *Schmidt-Rottluff Graphik*, Munich 1971.

——— *Gemalte Künstlerpost*, Munich 1977.

Worringer, Wilhelm. *Abstraktion und Einfühlung*, Munich 1908.

——— *Formprobleme der Gothik*, Leipzig 1911.

Wünsche, Alwin. *Die deutsche Kolonien*, Leipzig 1912.

Zurich, Kunsthaus. *Cuno Amiet und die Maler der Brücke*, exhib. cat. May–August 1979.

Acknowledgements

Many people have helped in very various ways with the preparation and completion of this book. I have been generously aided by grants from the British Council, the Deutsche Akademische Austausch Dienst and University College, London University.

I would like to take this opportunity to thank the staff and curators of the following libraries, museums and archives: the Altonaer Museum, Hamburg; the British Library, London; the Brücke-Museum, Berlin; the Courtauld Institute Library, London; the Folkwang Museum, Essen; the Goethe Institute Library, London; the Karl Ernst Osthaus Museum, Hagen; the Karl May Museum, Radebeul; the Kunstbibliothek, Hamburg; the Kunstbibliothek, Berlin; the Kunstmuseum, Düsseldorf; the Kupferstichkabinett, Dresden; the Landesbibliothek, Dresden; the Museum für Völkerkunde, Dresden; the Museum für Völkerkunde, Hamburg; the Museum für Völkerkunde, Berlin; the Nationalgalerie, Berlin; the Neuenationalgalerie, Berlin; the Staatsbibliothek, Berlin; the Stiftung Ada und Emil Nolde, Seebüll; The Tate Gallery Library, London; University College Library, London; the Wallraf-Richartz Museum, Cologne; the Warburg Institute Library, London.

For their help and encouragement I would also like to thank the following: Patricia Barnes, Sir Alan Bowness, Mary Carruthers, Dr Lynne Cooke, Dr Matthias Eberle, Dr Janos Frecot, Karlheinz Gabler, Dr Christopher Green, Dr Lucius Grisebach, Natalie Higgs, Bernd Hünlich, Dr Günther Krüger, Professor Peter Lasko, Dr Wolf Lohse and Brigitte Lohse, Professor Norbert Lynton, John Nicoll, Mr and Mrs Max Pechstein, Michael Peppiatt, Dr Hans Albert Peters, Professor Leopold Reidemeister, Dr Manfred Reuther, Dr Irit Rogoff, Juliet Thorp, Dr Frank Tiesler, Professor Martin Urban, Professor William Vaughan, Professor J.E.C. White and Dr Sarah Wilson.

Photographic Credits

The publishers are particularly grateful to: The Max Pechstein Estate, Hamburg; Nachlass Erich Heckel, Gaienhofen; Photo archiv H. Bolliger and R.N. Ketterer and Galleria Henze, Campione d'Italia and Stiftung Seebüll Ada und Emil Nolde, Neukirchen.

We are also grateful to the following institutions for their help in providing illustrations:
Bildarchiv Preussischer Kulterbesitz, Berlin 31, 50, 72, 160, 168, 178, 182, 202, 204, 215, 217, 219–20, 248
Berlinische Galerie, Berlin 191 © Ludwina Richter
Brücke-Museum, Berlin 82, © R. Friedrich, 19, 32, 72, 152, 155–6, 158, 159, 164, 250
Staatliche Museum zu Berlin, Berlin 10, 61, 72–3
Galleria Henze, Campione d'Italia 38, 74–5, 77, 91, 143, 57, 58, 196
The Art Institute of Chicago 261, © 1990 The Art Institute of Chicago. All rights reserved, Gift of Mr and Mrs Charles Deering McCormick, 1980.613.
Bunder Kunstmuseum, Chur 69, 101
Museen des Stadt Koln, Rheinisches Bildarchiv, Cologne 189, 223
Gemaldegalerie Neue Meister, Staatliche Kunstsammlungen, Dresden 132
Staatliche Kunstsammlungen, Kupferstichkabinett, Dresden 249, 251, 273–4
Kunstsammlung Nordrhein-Westfalen, Dusseldorf 39, 118
Zentrale Museumsverwaltung, Essen 100, 103, 159, 163
Nachlass Erich Heckel, Gaienhofen 22, 46, 52
Groniger Museum, Gronigen 221
Altonaer Museum, Hamburg 17, 24, 25–6, 30, 35–7, 45, 49, 55, 96, 97, 106–8, 114, 118, 120, 145, 157
Museum fur Kunst und Gewerbe, Hamburg 83, 130
Staatlichen Kursthalle, Karlsruhe 134–5
The Nelson-Atkins Museum of Art, Kansas City, Missouri (Gift of the Friends of Art 54–90) 216
Staatliche Kunsammlungen Kassel, Kassel 193–4
The British Library, London 9, 20–1
The Courtauld Institute, 142
Fischer Fine Art Ltd, London 213
The Tate Gallery, London 144
Thyssen-Bornemisza Foundation, Lugano 98
Staatsgalerie moderner Kunst, Munich 146
Galerie Stangl, Munich 218
Westfalisches Landesmuseen fur Kunst und Kulturgeschichte, Münster 173
Stiftung Seebüll Ada und Emil Nolde, Neukirchen 205–12, 214, 225–6, 229–37, 264–5, 268–72, 274–5, 277, 280–6, © Nolde-Stiftung Seebüll
The Museum of Modern Art, New York 179
Nasjonalgalleriet, Oslo 99
Arthotek, Peissenberg 166, 183
Saarland Museum, Sarrbrucken 224
Serge Sabarsky, New York 51
Staatsgalerie Stuttgart 76, 201
Schleswig-Holsteinisches Landesmuseum, 241
Mueller and Schmidt-Rottluff works reproduced © COSMO-PRESS, Geneva and DACS, London 1991
Pechstein works reproduced © DACS, London 1991

All Pechstein and Mueller works reproduced © DACS 1991.

Index

This index lists the principal people and institutions of the text; key topics, which form the subject of separate chapters or sub-sections, do not appear.

Adorno x
Ajanta 10, 21, 24–5, 34, 44, 75, 94, 95, 125, 155
Amiet, Cuno 8, 16, 22, 23, 24, 26, 42, 67, 138
Antwort 56, 57, 133
Arago Jacques 227; fig. 279
Arutz, Wilhelm 20
Avebury, Lord 4
Avenarius 15

Bahr, Hermann 18, 116
Baessler, A. 69
Baluschek, Hans 139
Barlach, Ernst 80
Barrison Sisters 87, 97, 99
Bastian, Adolf von 171
Baudelaire, Charles (*Le Peintre de la vie moderne*) viii, 87, 102, 105, 116, 146, 187
Bebel, August 192
Beckmann, Max 85, 143, 157, 158; fig. 185
Behrens, Peter 8, 14, 61
Bengen, Harald 53
Benjamin, Walter 186
Beradt, Martin 98
Berger, Peter (*Facing up to Modernity*) vii
Berlin Ethnographic Museum 27, 29, 69, 75, 171, 173, 174, 187, 199, 203, 219
Berlin Secession 42, 50, 52, 85, 103, 131, 138–9, 163, 164, 185, 188
Berliner Illustrierte Zeitung (BIZ) 14, 19, 43, 90, 99, 105, 125, 133, 155, 156; figs. 1, 13, 14, 43, 113, 133, 136, 153, 169, 170, 174, 197, 199, 200, 262
Bernard, Emil 11
Biallowns, Hugo 44
Bierbaum, Julius 96
Biermann, Georg 54, 55
Billeter, Erika 60
Bilz, Eduard 110, 112
Bismark 130, 192
Blass, Ernst 139, 139
Blaue Reiter vi, 9, 45, 60, 56, 59, 72, 86, 180, 181
Blaue Reiter Almanach 10, 38, 42, 50, 54, 70, 181, 184, 186
Bleyl, Fritz 13, 15, 22, 23, 67
Bloch, Ernst viii, 81, 186, 188
Bülow, von Chancellor 193
Böcklin, Arnold 103, 114, 165, 186, 191
Bode, Wilhelm 170, 171, 172
Bolliger, H. 107

Bomberg, David 216
Bondy 70
Botticelli 56, 197
Bougainville, Antoine-Louis de 201
Bradley, William 162, 215
Brant-Sero, Otjatekha 19; fig. 13
Braque, Georges 70
Bronner, Stephen 231
Brucke, Moeller van der 57
Brücke, die vi, xi, x, 3, 6, 8, 9, 10–24, 26, 29–31, 34, 38–9, 42–3, 45–8, 51–2, 67–70, 75, 80–2, 86–89, 91, 94–7, 101, 103, 106–8, 110, 115, 118–21, 134–5, 137–43, 165, 171, 181, 184, 195, 205, 206, 216; figs. 59, 61, 64,
Brummer, Charles 71
Brummer, Karl 10
Bruun, Laurids 201
Buchheim, Lothar 119
Bülow, von Chancellor 193
Bürger, Pèter (*Theorie der Avantgarde*) ix, 20, 56, 81, 210
Burckhardt, Max 118
Bussman, Georg 162, 163
Byron, Lord 227

Cabaret (and circus) 86–101, 106, 139, 167
Cassirer, Paul 113, 138, 142
Cézanne, Paul 11, 113, 114, 164, 178, 197
Chirico, de 157
Chronik der Brucke 18, 23, 138
Cook 214
Cooke, Thomas 19
Courbet 103
Cranach, Lucas 59, 75, 103

Darwin, Charles 18, 47, 66, 104, 108, 116
 Darwinism 138, 155, 156, 161, 195, 216, 227
Davoser Tagebuch 34, 82
Degas, Edgar 38, 87, 164
Degenerate Art Exhibition viii
Dehmel, Richard 96, 139
Dekorative Kunst 6
Delacroix, Eugène 52, 195
Denis, Maurice 50, 113
Der Sturm 139
Derain, André 113, 199
Deutsch, Rosalynd 147
Diez, Julius 5; fig. 4
Disler, Arthur 215
Dix, Otto ix, 159, 160; fig. 203
Döblin, Alfred 140, 141, 145, 147, 150, 152, 153
Dresden Academy 13

Dresden Ethnographic Museum x, 8, 14, 26, 31, 34, 68, 73, 114, 201, 203, 205
Dresdener Illustrierte Neueste 90; figs. 2, 110, 112
Dresdener Neveste Nuchrichter 30, 105, 138; fig. 81
Dresdener Rundschau 88, 108
Dresden School of Decorative Arts 13, 52
 1906 Exhibition 14, 24, 31, 38, 46
Dürer 60, 146
Durieux, Tilla 99

Einstein, Carl 71, 72, 81, 96
El Greco 50, 181, 186
Endell, August 131, 133, 153, 157
Endlein, Otto 90
Ensor, James 174, 175
Erna, *see* Schilling
Ettlinger, L.O. (*German Expressionism and Primitive Art*) x, 15, 38, 162, 214
Ethnographic Institut, Hamburg 10, 70

Fauconnier, le 11
Fauve 31, 87
Fechter, Paul 50, 72, 87, 138
Fehmarn 123–8, 143, 147, 153
Feinhals, Joseph 61, 65
Fehr, Hans 164, 213, 216, 220
Feldmann, Wilhelm 70
Fidus (alias Hugo Hoppener) 108, 110, 112; figs. 138–9
Folkwang Museum 8, 10, 12, 14, 24, 52, 65, 66, 67, 70, 76, 165, 172, 191, 217
Frank, Patty 95
Fränzi (Heckel's model) 36, 38, 76
Freud, Sigmund 38, 150
Frecot, Janos 112
Frederick the Great 103
Frobenius 10
Fry, Roger 50

Gabler, Karlheinz 31, 64
Gallery Arnold 16, 26
Gallery Emil Richter 31, 87, 101, 198
Gauguin, Paul vii, viii, 8, 10, 15, 24, 26, 31, 38, 45, 52, 68, 76, 85, 102, 141, 164, 186, 191, 192, 195, 199, 203, 206, 208, 209; figs. 99, 258
Gérard, Carl 8
German Association for Informative Living 107
Gesamtkunstwerk 4, 14
Gewecke, Hans 9, 124
Giotto 54
Glaser, Kurt (*Die Glasmalerei*) 53, 54, 70
Gordon, Donald x, 21, 26, 31, 38, 50, 52, 60, 110, 199

Gotheim, Werner 9, 124
Goethe 104, 105, 192
Gosebruch, Ernst 23, 162
Graef, Botho 20
Griffith, John 10, 24, 26, 95; figs. 9, 20–1
Grisebach, Lucius 20
Grohmann 38, 142
Grohse, Doris; fig 48
Grosse, Ernst 4
Grosz, Georg ix, 159
Grünewald 13
Grütter, J.B. 220
Guillaume, Paul 10
Gurlitt, Wolfgang 200, 205, 206
Gussmann, Otto 13, 14, 52
Guttman, Simon 97, 139
Guys, Constantin vii, 146

Habermas ix
Hahl, Dr Alfred 200, 217, 225, 231
Hagemann, Carl 146
Hagenbeck 89, 106
Halbe, Dr 17, 20
Hamburg Ethnographic Museum 69
Hartlaub, Gustav 161, 166
Hauptmann, Carl 215
Hausenstein, Wilhelm 72
Heckel, Erich 5, 8, 9, 13–18, 20, 22–4, 26, 27, 30–2, 34, 36, 38, 39, 42, 43, 50, 52, 59, 60, 67, 68, 72, 75, 76, 80, 86, 87, 88, 91, 93, 95–9, 110, 111, 114, 117, 118, 123, 134, 135, 138, 139, 142, 164, 178, 191, 195, 199; figs. 16–18, 22, 35, 45–7, 50–2, 56, 74, 82–5, 108, 114, 125, 166, 178
Heckel, Manfred 39
Heinersdorff, Gottfried 51, 53, 54, 61
Heise, Georg 162
Hentzen, Alfred 43
Hermann, Georg 134
Heym, Georg 139, 157
Hiller, Kurt 139, 141, 143, 147
Hirschfeld, Georg 134
Hoddis, Jakob von 157
Hoffmann, Josef 61
Hoffman, Ludwig von 90, 114
Holbein 57
Holländer, Felix 99
Holz, Arno 96, 139
Hünlich, Berndt 91, 134
Hygiene Exhibition 117

Ibsen 17

Jacob, Julius 142
Jahre der Kämpfe 162, 163, 164, 172, 215
Janthur, Richard 157
Josephson, Ernst 170
Jugend 5, 6, 155, 166, 193; figs. 3–7, 198, 239
Jugendstil ix, 3–9, 12–18, 21, 22, 24, 31, 44–6, 59, 60, 68, 81, 96, 108, 173, 191

Kafka, Franz 186, 187
Kahnweiler, Henri 87
Kampf, Arthur 211
Kandinsky, Vassily vi, 11, 57, 60, 86
Kardorff, Konrad von 131
Keates, George 201
Kirchner, Ernst Ludwig x, 3, 5, 8–10, 13–16, 18, 21–4, 26, 27, 30–2, 34, 36, 38, 39, 43–5, 47–50, 59, 60, 61, 64, 65, 67, 69, 71, 72, 75, 76, 78–82, 85–8, 90, 91, 93–5, 97–9, 103, 106, 107, 110–21, 123–5, 128, 129, 134–42, 194, 195, 199, 209, 210; figs. 8, 11, 12, 15, 19, 23, 24, 25, 26, 28, 30, 32–3, 36–40, 44, 49, 57, 58, 59, 64, 73–6, 78, 91, 92, 94–96, 98, 101–2, 105, 115, 116, 118,

120–2, 126–8, 137, 144–6, 154–63, 165, 167–8, 177, 179, 181, 183–4, 186–9, 192–6, 221
Klee, Paul 180
Klinger, Max 14, 52, 147, 191
Klimt, Gustav 46
Koch, Gerd 199
Koch-Grunberg 38
Köhler-Haussen, Ernst 23
Kokoschka, Oskar 11, 181
Kollwitz, Kathe 139
Kraus, Karl 147
Kreiss, Wilhelm 13–15, 24
Krüger, Günter 56, 138
Kubin, Alfred 156, 157, 218
Kubista, Bohumil 51
Kuehl, Gotthardt 13, 38
Kuhne, Hans 14
Külz, Professor 225–7, 229
Kunstwart 14, 15, 155

Lahmann, Heinrich 108, 115
Lamarck 108
Landaver, Gustav 133
Langbehn, Julius 8, 56, 103, 108, 110, 215
Lasalle, Ferdinand 103
Lavweriks 9
Le Bon, Gustav 133, 150
Lechter, Melchior 54
Leibl, Wilhelm 57, 103
Levinstein, Siegfried
Liebermann, Max 103, 107, 131, 162, 164, 165
Liliencron, Deflev, von 96
Livingstone, Dr 214
Loewenson, Ernst 139
Loti, Pierre 201
Lukács, Georg viii, 20, 41, 186, 187

Macke, August 9, 60, 70, 86, 133, 187; fig. 173
Magdeburg 216
Makart, Hans 5, 48; fig. 65
Man, Paul de 146, 187
Manet, Edouard 87, 11, 164
Mann, Heinrich 130
Mannheim, Ron 50
Marc, Franz 60, 72, 85, 164, 173, 187
Marcella 38
Marcuse ix
Marees, Hans von 60, 197
Marinetti 140, 141
Marquardt, Carl 30
de Marsalle, Louis (pseudonym) 80
Marx, Karl 192
Martensen-Larsen, Britta x, 24, 34, 68, 71, 76
Maschek, Joseph 4, 59
Matisse, Henri 11, 24, 42, 45, 50, 70, 85, 113, 178, 197
May, Karl 30, 48, 64, 86, 95, 110, 115
Mayer, August 50
Mayerheim, Paul 105; fig. 132
Meier-Graffe, Julius 6, 8, 17, 18, 51, 80, 171
Meidner, Ludwig 85, 86, 142, 157, 158, 159, 194; figs. 201–2
Melville, Hermann 202, 227
Menzel, Adolf von 102, 103, 104, 105, 106, 107, 133, 135, 153, 155, 159, 160, 191; figs. 129–31
Michaelangelo 72, 164
Minne, Georg 66, 67, 79; fig. 103
Modersohn-Becker, Paula 103, 170
Monet, Claude 164
MOMA vii, ix, 199
Morgner, Wilhelm 191
Moritzburg 29, 30, 31, 38, 46, 67, 107, 110–116, 118–21, 123–7, 135, 142, 146, 153, 166, 178, 197; fig. 141

Mosse, Georg 215
Mueller, Maschka 34
Mueller, Otto 23, 34, 39, 42, 75, 87, 94, 96; figs. 54–5
Muenter, Gabriele 179
MUIM (Institut) 9, 10, 13, 34, 39, 44, 46, 72, 124, 155; fig. 8
Multscher, Hans 60
Munch, Edvard 76, 136, 137, 153; fig. 99
Münzer, Adolf fig. 7

Nansen, Fritz 217; fig. 263
Naumberg 216
Nettmann, Dr Heinrich 66
New Secession 34, 42, 50, 109, 118, 167
Niemeyer 57, 59, 165
Nietzche, Friedrich 17, 18, 24, 34, 82, 97, 98, 99, 103, 108, 110, 114–16, 118, 121, 135, 139, 140, 157, 187, 195
Nolde, Ada 67, 108, 161, 167, 184, 214, 216, 220, 224, 232; fig. 287
Nolde, Emil viii, ix, x, 3, 5, 9, 11, 12, 16, 45, 59, 61, 67, 85, 91, 99, 106, 125, 155, 161–7, 169–75, 177, 179–81, 184–8, 194–5, 199–200, 205, 213–21, 224–7, 229–33; figs. 204–14, 216, 218, 224–6, 228–30, 232–7, 260, 264–5, 269–72, 274–7, 279–82, 284

Obrist, Hermann 5, 15, 61
Orlik, Emil 191
Osborn, Max 52, 87, 101, 191, 195, 197, 204, 206, 210
Osthaus, Karl Ernst 7, 8, 9, 10–12, 14, 20, 32, 50, 52, 54, 59, 60, 61, 65, 66, 70, 165, 171, 172, 184, 217, 230

Paasche, Hans 155, 233
Palau 21, 29, 31, 32, 38, 45, 46, 75, 94, 95, 114, 191, 195, 199, 200–13, 218, 219, 232
Paret, Peter 164
Pascini 70
Pastor, Willy 164
Paul, Brund 61
Pechstein, Lotte 196, 199
Pechstein, Max x, 3, 4, 5, 8, 9, 13, 14, 16, 31, 39, 42, 45, 46, 47, 50, 51, 53, 54, 55, 56, 59, 66, 70, 71, 72, 86, 87, 88, 91, 93, 96, 110, 114, 118, 125, 138, 169, 178, 188, 191, 192, 194–7, 199–206, 208–11, 213, 218, 220, 221, 224, 232, 233; figs. 10, 53, 59, 60–2, 66–72, 88, 90, 106, 117, 150–2, 222, 240–3, 245, 247, 249–57, 259, 273
Perkins, Geoffrey 50
Perls, Hugo 46, 52
Pevsner, Nikolaus 5
Plietzsche, Friedrich 47
Picasso, Pablo 51, 70, 113
Piper, Reinhold 56
Pois, Robert 214, 216
Poliakov, Leon 105
Praetorius 15
Prochàzkwa, Anton 136; fig. 80
Pudor, Heinrich 108, 109, 116, 125, 133

Raphael 164, 186
Reidemeister, Leopold 18, 60, 199
Reimann, Hans 139
Reinhardt, Georg 3, 16, 18, 20, 22, 39, 42, 98, 107, 115, 135
Reinhardt, Max 52, 167, 169, 184, 185
Reinicke, E 193
Rembrandt 110
Renoir, Pierre-Auguste 164
Reuther, Manfred 165
Richter, Emil 87

Richter-Berlin, Heinrich 150, 167; fig. 191
Riegl, Alosi 4, 57, 172
Riehl 102
Riha, Sidi 34, 39, 43
Robertus 116
Rodin, Anguste 164
van der Rohe, Mies
Rohlfs, Christian 165
Rosenberg 162, 163
Roskill, Mark 21
Rössler, Paul 117
Rubin, William ix, x
Runge, Phillip 107

Sachsen 13, 14, 15
Sauerlandt, Max 68, 162, 171, 172, 185, 230
Sauerman 78
Schaafhausen 104
Schapire, Rosa 23, 38, 71
Scheffler, Karl 59
Schiefler, Gustav 9, 20, 23, 39, 44, 60, 67, 72, 78,
 125, 147, 164
Schiefler, Louise 44, 75, 138
Schilling, Erna 10, 44, 64, 78–9, 153, 155
Schilling, Gerdi 44
Schinkel 47
Schirach, Baldor von 162
Schmidt-Rotluff, Karl 9, 13, 16, 17, 22, 42, 60, 61,
 67, 68, 70, 71, 72, 75, 97, 110, 125, 134, 138, 139,
 142, 145, 164, 178, 179; figs. 86–7, 164, 176,
 182, 223
Schneckenburger, Manfred 214
Schneider, Karl 139
Schneider, Sascha 110
Schroter, Hans 170
Schumacher, Fritz 13, 14, 15, 16, 81
Schulte-Sasse, Jochen ix
Schwechten, Paul 51

Seifert, Max 15
Seifert, Oskar 45
Semper, Carl 29, 201, 205
Semper, Gottfried 4
Seurat, Georges 38, 87
Simmel, Georg (Philosophie des Geldes) vi, vii, 6, 7,
 17, 51, 53, 67, 80, 81, 86, 139, 141, 147, 150, 153,
 167, 173, 179
Slevogt, Max 47, 131, 227; fig. 63
Sisley, Alfred 164
Skarbina, Franz 131
Skupina, Výtvarných Umélcu 51
Smith, Bernard 227, 230
Society for sexual reform 112
Sonderbund vi, 9, 50, 59, 60, 61, 64, 81, 109, 175
Stanley 241
Steinhardt, Jacob 157
Stevenson, Robert Louis 202
Stiassny, Robert 48
Stiller, Richard 101, 138
Strindberg, August 17
Stravinsky 56
Studio, The 15
Swarzenski, Georg 17

Tal, Uriel 215
Tappert, Georg 42, 91, 167, 191
Tetzner 52, 54
Theatre 168–9
Thode, Henry 164
Thorn-Prikker, Jan 53, 59, 60
Tiffany 54
Timm, Werner 199
Titian 164
Toulouse-Lautrec, Henri de 87
Tuch, Kurt 199; fig. 244

Umělecký, Měsíćník 51, 71

Umlauff, Julius 10, 70
Urban, Henry 133
Urban, Martin 3, 185
Ury, Lesser 131

Van Dongen, Kees 70, 87
Van Gogh, Vincent 15, 17, 38, 142, 164
Vanselow, Karl 112
Van de Velde, Henry 4, 8, 54, 61, 66
Varnedoe, Kirk vii, viii
Vegetarian and Fruit Tree Colony 107, 111
Vietta, Silvio 186
Vinci, da Leonardo 164
Vinnen, Carl (Protest Deutscher Künstler) 56, 57,
 103, 133, 164, 165, 166, 171, 216
Valminck, Maurice de 70
Volz, Wilhelm fig. 5
Vriesen 68

Walden, Herworth 99, 138, 150
Wedekind, Frank 96, 97
Weimar, Bauhaus 14
Werenskiold, Marit 50
Werkbund 14
Wietek, Gerhard 72
Williams, Rhys 72
Wolzogen, Ernst von 93, 96, 97
Worringer, Wilhelm 51, 59, 60, 72, 81, 110, 147, 150,
 181, 216
Wünsche, Alfred 52
Wünsche, Alwin 217, 219; figs. 266–7

Zimmerman, Ernst 14, 24
Ziji, Lambertus 67
Zirkus, Angelo 88, 89
Zirkus, Schumann 34
Zwinger Museum 16, 30, 68